A WORLD HISTORY
OF PHOTOGRAPHY

HISTORY

PHOTOGRAPHY

by Naomi Rosenblum

with contributions by
Diana C. Stoll

FIFTH EDITION

ABBEVILLE PRESS PUBLISHERS
NEW YORK · LONDON

The cover illustrations are details of pictures that appear in full and are credited in the captions for the following plates.

TOP ROW (LEFT TO RIGHT)
William Henry Fox Talbot. *Botanical Specimen*, 1839. See pl. no. 21.
Sherril V. Schell. *Brooklyn Bridge*, n.d. See pl. no. 540.
Arthur Rothstein. *Dust Storm, Cimarron County*, 1937. See pl. no. 450.
Johann Kaspar Lavater. *Silhouette Machine*, c. 1780. See pl. no. 29.
Gerd Volkerling. *Oak Trees in Dessau*, 1867. See pl. no. 125.

SECOND ROW
Reutlinger Studio. *Mlle. Elven*, 1883. See pl. no. 63.
Jean Tournassoud. *Army Scene*, c. 1914. See pl. no. 345.

THIRD ROW
Eugène Durieu. *Figure Study No. 6*, c. 1853. See pl. no. 242.
Mary Ellen Mark. *"Tiny" in Her Halloween Costume, Seattle*, 1983.
See pl. no. 689.

FOURTH ROW
Félice Beato (attributed). *Woman Using Cosmetics*, c. 1867.
See pl. no. 333.
Eadweard Muybridge. *Studies of Foreshortenings: Mahomet Running*, 1879.
See pl. no. 291.
Dorothea Lange. *Migrant Mother, Nipomo, California*, 1936.
See pl. no. 451.
Lumière Brothers. *Lumière Family in the Garden at La Ciotat*,
c. 1907–15. See pl. no. 342.

FIFTH ROW
Susan Meiselas. *Nicaragua*, 1978. See pl. no. 794.
Heinrich Tönnies. *Four Young Blacksmiths*, c. 1881. See pl. no. 69.

SIXTH ROW
Disdéri Camera, c. 1864. See pl. no. 226.
William Rau. *Produce*, c. 1910. See pl. no. 347.

SEVENTH ROW
Cindy Sherman. *Untitled (#156)*, 1985. See pl. no. 744.
Unknown. *"What an Exposure!"* from *Amateur Photographer*,
Sept. 23, 1887. See pl. no. 306.
Charles Sheeler. *Industry*, 1932. See pl. no. 585.
Lumière Brothers. *Untitled*, c. 1907–15. See pl. no. 343.

TITLE PAGE
Laura Gilpin. *Still Life*, 1912. See pl. no. 352.

Editors: Walton Rawls, Nancy Grubb, Erin Dress, and Amy K. Hughes
Designers: Philip Grushkin, Barbara Balch, Ada Rodriguez, and
 Misha Beletsky
Production Editors: Robin James, Owen Dugan, and Matt Garczynski
Picture Editors: Jain Kelly, Paula Trotto, Erin Dress, and Amanda Killian
Production Managers: Dana Cole, Lou Bilka, and Louise Kurtz

A previous edition of this work was cataloged as follows:
Rosenblum, Naomi.
A world history of photography/by Naomi Rosenblum. — 4th ed.
 p. cm.
Includes bibliographical references and index.
1. Photography—History. I. Title.
TR15.R67 2007
770'.9 — dc20 96-36153

Fifth hardcover edition, 2019
ISBN 978-0-7892-1344-0
10 9 8 7 6 5 4 3 2 1

Fifth paperback edition, 2019
ISBN 978-0-7892-1343-3
10 9 8 7 6 5 4 3 2 1

For bulk and premium sales and for text adoption procedures, write to Customer Service Manager, Abbeville Press, 655 Third Avenue, New York, NY 10017, or call 1-800-ARTBOOK.

Visit Abbeville Press online at www.abbeville.com.

Contents

Preface to the Fifth Edition

DIANA C. STOLL

Naomi Rosenblum's *A World History of Photography* has been treasured by researchers since its first publication in 1981 and through three subsequent editions. With this latest revised edition, this valuable resource will serve new generations of scholars and practitioners.

A great deal has transpired in the arena of photography since the book's last edition, published in 2007; indeed, new technologies and changing sociological awarenesses have modified our very understanding of the medium. Some 50 new images have been added in this iteration of the volume to illustrate a number of these movements. Chapter 11 ("Photography since 1950: The Straight Image") and Chapter 12 ("Photography since 1950: Manipulations and Color") have been amended and expanded to reflect shifting historical focuses and to encompass a geopolitical purview that extends Rosenblum's already generous reach. And a new Chapter 13, "Navigating New Seas: Photography at the Start of the 21st Century," has been added to address the state of the medium in 2020 and to discuss a selection of its proponents. "A Short Technical History: Part III" has been updated by photography journalist and educator Miriam Leuchter to encompass new trends in technology, including digital cameras, image-processing programs, online platforms, and beyond. The research resources in the back of the book, including the bibliography and time line, have likewise been significantly revised and expanded.

The task of providing an overview of the contemporary field—a field that is still very much in flux—is a daunting prospect but perhaps not entirely unfeasible. One approach, when observing a fluctuating landscape (photo media) from the vantage of a moving vehicle (history), is to attempt to discern and identify patterns of activity, concepts repeatedly visited, tendencies that seem likely to become trends, movements that might characterize this moment when viewed from the perspective of another decade's or century's passing. It may go without saying that such patterns will be perceived differently by different observers: this author brings her own proclivities and preferences and opinions, as well as the limitations of her knowledge, to the process. One can only go from here.

It is not, however, a matter of opinion that the digital advent, which was still in a relatively nascent stage in 2007, can now be understood as the defining transformation of photography in this era. We are experiencing a true paradigm shift. Digitization has permitted countless new possibilities in the medium, including a ubiquity of cameras (most of them in smartphones) and photographic images—trillions upon trillions of images—ushering in a new democratization of photography and radically altering humans' relationship to the medium. Our ability to share images globally, inexpensively, and instantaneously through the World Wide Web has changed the terrain of production as well: no longer must a photographer be located in a particular urban center or on a particular continent in order for his or her work to be recognized. The field of photography is expanding far beyond its long-established geographic hubs and beyond other hegemonies such as race, ethnicity, gender, and sexual preference or identification. Rosenblum has been making these points since this book's earliest iteration; the additions to this latest edition follow her lead, now taking into account technologies that have altered both the medium itself and its modes of dissemination, and examining how these new potentials are inspiring photographers and other photomedia artists today.

A World History of Photography is by its nature understood as a canonical volume. But are canons and counter-canons still relevant in this hub-free, image-inundated moment? Are they possible when the floodgates of production are so wide open? When perspectives on history are so mutable? And if a canon *is* possible—is photography too young to have one? In Ruth Iskin's 2017 book *Re-Envisioning the Contemporary Art Canon*, curator Camille Morineau proposes that a canon takes, if not centuries, then certainly dozens of years to build. Photography, born in the 1830s, is still a junior member of the arts club, and its many tangents—from film and video to Instagram and virtual reality—are even younger. If it is possible, and necessary, to make a canon, photography's is still in the works and will be for a long time to come.

Relatively brief as it is, though, photography's history is abundantly complex and fascinating. And it is precisely because those floodgates are so open that some synthesis and sorting, some navigational tools, are indispensible for the photographer, the scholar, the historian, the amateur: any interested reader. This book is here for them.

Acknowledgments

My thanks go first to Naomi Rosenblum, whose research and extraordinary dedication to telling the story of photography honestly, thoroughly, and compellingly, in this book and others, have been an inspiration. I am grateful to Abbeville Press for the invitation to help revise and expand the book, especially to Robert E. Abrams for his leadership, and to David Fabricant, Matt Garczynski, Misha Beletsky, Louise Kurtz, and Amanda Killian, as well as outside editor Amy K. Hughes, for their hard work on this volume. I am also deeply obliged to the following colleagues who generously made suggestions and offered guidance on how to approach the charge of providing an overview of the medium's busy contemporary landscape: Eric Baden, Peter C. Bunnell, Elinor Carucci, Charlotte Cotton, Amelia Lang, Lesley A. Martin, Sarah Hermanson Meister, Carole Naggar, Lyle Rexer, and Fred Ritchin. In addition to suggesting artists and resources for inclusion here, my wonderful colleagues Melissa Harris and Ivan Vartanian gave valuable feedback on an initial draft of the manuscript of Chapter 13, and Alison Nordström, whose knowledge of the history of photography is formidable, greatly enriched this volume's "Photography Time Line"; I extend a very special thanks to them. I have had the extraordinary good fortune to work with some of the most gifted figures of our time in the world of photography; my interactions with them played a formative role in my understanding of photography. In addition to those already mentioned, I would like express my gratitude to the following people (some of whom, sadly, are no longer living): John Berger, David Campany, Henri Cartier-Bresson, Vicki Goldberg, Philip Jones Griffiths, Michael E. Hoffman, Mary Ellen Mark, Jonathan Williams, and Deborah Willis. Finally, I must acknowledge in particular the writings of Peter Bunnell, Fred Ritchin, and David Levi Strauss, to which many of the ideas in Chapter 13 are indebted.

D.C.S.

Preface to the Fourth Edition

Naomi Rosenblum

As a way of making images, photography has flourished in unprecedented fashion ever since its origins over 150 years ago. From Paris to Peking, from New York to Novgorod, from London to Lima, camera images have emerged as the least expensive and most persuasive means to record, instruct, publicize, and give pleasure. Not only are photographs the common currency of visual communication in the industrialized nations, they have become the paradigmatic democratic art form—more people than ever before use cameras to record familial events or to express personal responses to real and imagined experiences. Because of their ubiquity, photographs (whether originals or reproductions) have been paramount in transforming our ideas about ourselves, our institutions, and our relationship to the natural world. That the camera has altered the way we see has become accepted wisdom; that it has confirmed that no single view of reality can be considered imperishably true has also become evident.

Used in a multitude of ways and with varying intentions, photographs have served to confuse and to clarify, to lull and to energize. Interposed between people and their direct experiences, they often seem to glorify appearance over substance. They have endowed objects, ideologies, and personalities with seductive allure, or clothed them in opprobrium. They have made the extraordinary commonplace and the banal exotic. At the same time, photographs have enlarged parochial perspectives and have impelled action to preserve unique natural phenomena and cherished cultural artifacts. On their evidence, people have been convinced of the inequity of social conditions and the need for reform.

Photography has affected the other visual arts to a profound degree. Now accepted for itself as a visual statement with its own aesthetic character, the photograph had an earlier role in replicating and popularizing artistic expression in other media, and thus had an incalculable effect on the taste of vast numbers of people in urbanized societies. Photography has made possible an international style in architecture and interior design. It has inspired new ways of organizing and representing experience in the graphic arts and sculpture. How and why the medium has attained the position it occupies in contemporary life are questions that this history explores.

Throughout the 19th century, expanding interest in photography provoked curiosity about its origins and stimulated investigations into its invention, developments, and the contributions of individual photographers. The first histories, which began to appear soon after 1839 and became exhaustive toward the end of the century, were oriented toward technological developments. They imposed a chronology on discoveries in chemistry, physics, and applied mechanics as these disciplines related (at times tenuously) to photography. Exemplified by Josef Maria Eder's *Geschichte der Photographie* (*History of Photography*), first published under a different title in 1891, revised several times, and issued in English in 1945, these histories were not at all concerned with the aesthetic and social dimensions of the medium, which they barely acknowledged.

Soon after 1900, as the art movement in photography gained adherents, histories of the medium began to reflect the idea that camera images might be considered aesthetically pleasing artifacts as well as useful technological products. The concept that photographs serve the needs of both art and science and that, in fact, the medium owes its existence to developments in both these spheres of activity is basic to the best-known general history that has appeared in the 20th century: *The History of Photography, from 1839 to the Present*, by Beaumont Newhall, first published as an exhibition catalog in 1937, rewritten in 1949, and revised in 1964 and 1982. Another redoubtable work—*The History of Photography, from the Camera Obscura to the Beginning of the Modern Era*, by Helmut and Alison Gernsheim, first published in 1955, revised by both in 1969 and again by Helmut Gernsheim as two volumes in the 1980s—also includes a discussion of the emergence of artistic photography and situates scientific developments within a social framework. Besides acknowledging the aesthetic nature of camera images, these works reflect the influence of the socially oriented temper of the mid-20th century in that they concede the relationship of photography to social forces.

To an even more marked degree, a conception of photography as a socio-cultural phenomenon informs *Photography and the American Scene: A Social History, 1839–1889*, by Robert Taft (1938), and *Photographie et société* by Gisèle Freund—the latter based on investigations begun

in the 1930s but not published until 1974 in France and not until 1980 in English translation. "The Work of Art in the Age of Mechanical Reproduction," by Walter Benjamin, which had its genesis in 1931 as a three-part article entitled "Kleine Geschichte der Photographie," is a seminal early discussion of the social and aesthetic consequences of mass-produced camera images, which has stimulated many later ruminations. A recent survey that places photographic imagery within an aesthetic and social context is *Nouvelle Histoire de la photographie* (1994), edited by Michel Frizot and translated into English in 1998.

The obvious impress of camera images on the painting styles of the 1960s, combined with the affirmation at about the same time of the photographic print as an artistic commodity, may account for the appearance of histories concerned primarily with the effects of photography on graphic art. *The Painter and the Photograph, from Delacroix to Warhol*, by Van Deren Coke (1964), and *Art and Photography, by Aaron Scharf* (1968), are two early books that examined the role played by the medium in developments in the traditional visual arts. Within the past several decades, topical histories have appeared that survey the origins of documentation, photojournalism, and fashion photography. Monographs on historical figures and compendiums that offer a selection of images from the past without being historical have enriched our knowledge of the medium. Our understanding of developments in all spheres—technological, aesthetic, and social—has been amplified through articles appearing in periodicals, notably *History of Photography*. A scholarly journal initiated in 1977 by Professor Heinz Henisch of Pennsylvania State University and continued in England under the editorship first of Mike Weaver and then others, *History of Photography* expands the horizons of historical research in photography. All these inquiries into specific aesthetic, scientific, and social facets of photography have made it possible to fill in a historical outline with concrete facts and subtle shadings.

In view of this storehouse of material, my own book, *A World History of Photography*, is designed to distill and incorporate the exciting findings turned up by recent scholarship in a field whose history continues to be discovered. It summarizes developments in photography throughout the world and not just in Europe and the Americas—areas that in the past received almost exclusive attention. It presents the broad applications that photography has had, and it articulates the relationship of the medium to urban and industrial developments, to commerce, to ideas of progress, and to transformations in the visual arts. While dealing with historical context, it also examines the role of photography as a distinctive means of personal expression. In sum, this book is intended to present a historical view that weaves together the various components that have af-fected the course of photography, revealing an overall design without obscuring individual threads.

To do justice to these objectives, the material in this book is structured in a somewhat unusual way. The chapters are organized chronologically around themes that have been of special significance in the history of the medium—portraiture, documentation, advertising and photojournalism, and the camera as a medium of personal artistic expression. This organization makes visible both the similarity of ideas and images that have recurred in widely separated localities and the changes that have sometimes occurred in the work of individual photographers over the course of time. This treatment means that the work of an individual may be discussed in more than one chapter. Edward Steichen, for example, began his career around 1900 as a Pictorialist, was then in charge of American aerial documentation during World War I (and again in World War II), later became a highly regarded magazine photographer, and finally was director of a museum department of photography; his contributions are examined both in the chapter on Pictorialism and in the one devoted to advertising and photojournalism. While this organization of the chapters emphasizes the subject matter and the context within which photographers work, in select instances short biographies, called "profiles," have been included at the end of the appropriate chapter in order to underscore the contribution of those whose work epitomizes a style or has proved a germinal force.

Photography is, of course, the result of scientific and technical procedures as well as social and aesthetic ideas. Because large amounts of technical detail inserted into a narrative tend to be confusing rather than enlightening, summaries outlining changes in equipment, materials, and processes during three separate eras have been isolated from the descriptive history and placed at the end of each relevant period. Although not exhaustive, these short technical histories are meant to complement the discussions of social and aesthetic developments in the preceding chapters.

A great aid in the task of weaving everything together is the generous number of illustrations, which will permit the reader to relate facts and ideas within a general historical structure not only to familiar images but also to lesser-known works. In addition to the photographs interwoven throughout the text, the book includes albums of prints designed to highlight a few of the many themes that photographers have found compelling. They comprise outstanding examples in portraiture, landscape, social and scientific documentation, and photojournalism.

The study of photography is constantly being transformed by fresh information and insights, which recently have accumulated with particular rapidity as a result of

changes in technology and the appearance of large numbers of new scholarly publications and exhibitions. These developments have made it necessary to add new information, interpretations, and images to *A World History of Photography*. Changes have been made throughout the text and captions, and Chapters 11 and 12 have been revised and expanded to encompass recent developments in traditional and experimental photography. The discussion of digital technology, which was added to the final technical history, has been further elaborated. The bibliography also has been expanded to include books related to these topics as well as a selection of recent critical histories and monographs.

Keeping all of this material within the confines of a one-volume history has been especially challenging because of the current burgeoning of traditional photographic activity and the emergence of digital image-making capabilities throughout the world. In addition, new and valuable scholarship about the medium has been exceptionally abundant. It is my hope that the additions and changes in this fourth revised edition will bring the reader up-to-date, fill in some lacunae, and inspire further investigation of the means by which photographs have come to play such a central role in our lives.

Acknowledgments

That this work is so well provided with visual images is owed to my publisher, Robert E. Abrams, whose personal interest in producing a generously illustrated history of photography is hereby gratefully acknowledged. In all respects, my association with Abbeville Press has been pleasurable; I am indebted to my first editor, Walton Rawls, to the editor of the third edition, Nancy Grubb, and to Erin Dress, editor for this edition, for their unfailing kindness and respect for my ideas; to the book's designer, Philip Grushkin, for his sensitivity and meticulousness in dealing with text and image; to Jain Kelly (ably succeeded on the third edition by Paula Trotto), whose grace and dexterity in pursuing pictures for reproduction turned an involved chore into a pleasant undertaking.

In writing this survey, I had the help of many individuals who collected information, corrected misapprehensions, pointed out omissions, and suggested sources for pictures. I thank them all. In particular, I am grateful to Gail Buckland, Cornell Capa, Alan Fern, William I. Homer, Anne Hoy, William Johnson, Fred Ritchin, and Larry Schaaf for helpful suggestions regarding portions of the text. My thanks also to Terence Pitts and Amy Rule of the Center for Creative Photography; to Rachel Stuhlman and Becky Simmons in the Library and to Therese Mulligan, Janice Mahdu, and David Wooters in the Archive of the International Museum of Photography at George Eastman House; to Judith Keller and Weston Naef and the entire staff of the Department of Photographs, the J. Paul Getty Museum; to Tom Beck of the Edward L. Bafford Photography Collection, University of Maryland, Baltimore County Library; to Verna Curtis of the Library of Congress; to Mary Panzer of the National Portrait Gallery, Smithsonian Institution; to Susan Kismaric of the Museum of Modern Art; to Sharon Frost, Richard Hill, Anthony Troncale, and Julia Van Haaften of the New York Public Library; to Miles Barth and Anna Winand of the International Center of Photography; to Gary Einhaus and Michael More of the Eastman Kodak Company; to Ann Thomas of the National Gallery of Canada; and to Sarah Greenough of the National Gallery of Art in Washington, D.C., for expediting my researches.

I am indebted also to Mark Albert, Jaroslav Andel, Felicity Ashbee, Ellen Bearn, Margaret Betts, A. D. Coleman, Franca Donda, Karen Eisenstadt, Mary Engel, Helen Gee, George Gilbert, Arthur T. Gill, Andy Grundberg, Jon Goodman, Scott Hyde, Rune Hassner, Edwynn Houk, Ann Kennedy, Hildegarde Kron, Alexander Lavrientiev, Barbara Michaels, Arthur Ollman, Eugene Prakapas, Sandra Phillips, William Robinson, Howard Read, Olga Suslova, David Travis, and Stephen White for information and leads to photographs and collections. In particular, I thank those who helped with the material on China: Judith Luk and H. Kuan Lau in New York, and Elsie Fairfax Cholmeley, Zang Suicheng, and Lin Shaozhong of the Chinese Photographers Association in China. My French connections, Madeleine Fidell-Beaufort and Thomas Gunther, were especially efficient with regard to photographs in French collections. My assistant, Georgeen Comerford, brought her orderly nature to the problem of providing a visual record of hundreds of images. My thanks to Joan Powers and Fred Ritchin for their help with matters regarding digital photography.

The support of Professor Milton W. Brown, formerly executive officer of the Art History Program at the Graduate Center of the City University of New York, and of Martica Sawin, formerly chair of the Liberal Studies Department of Parsons School of Design, where I was teaching during the genesis and writing of most of this book, was invaluable.

I could not have embarked on this project without the support of my family. I am grateful for the enthusiasm of my daughters, Nina and Lisa, and deeply appreciative for the constant and loving understanding offered by my husband, Walter.

N.R.

About the Illustrations

Few readers mistake the reproduction of a painting for the original work, but with illustrations of photographs the distinctions between the two sometimes become clouded and the viewer assumes that the original print and its image in printer's ink are interchangeable. It is important to realize that in the photographic medium (as in other forms of visual expression), size, coloration, and surface appearance may be significant aspects of the photographic statement, and that these attributes are affected by being translated from their original form into a mechanical reproduction.

The question of size can be especially confusing. Positive prints of varying sizes can be obtained by making enlargements from glass plates or negatives of a specific dimension, and the size of the images may change again when the work is transferred to gravure or a lithographic reproduction. This is especially true in the era since the invention of the 35mm camera, since negatives made with this apparatus were meant to be enlarged rather than printed in their original size. As a consequence, for modern viewers the exact size of an original negative, even in works produced before the advent of 35mm cameras, has assumed a less significant role. Photographic prints also are easily cropped—by either photographer or user—and the print may represent only a portion of the original negative. Furthermore, the images in this book have been found in hundreds of archives, libraries, museums, and private collections, some of which were unable to provide information about original size. In view of the reasons outlined above, and in the interest of consistency, the dimensions of both negative and positive images have been omitted in the captions.

A more significant problem in reproducing photographs concerns the coloration of the image. With the exception of the color plates, in which the colored dyes of the original print or transparency have been translated with reasonable accuracy into pigmented ink, all the images have been printed here as duotones, in the same two colors of ink. It is obvious that the silver and gold tonalities of the metal daguerreotype plates have not been duplicated and must be imagined by the viewer; this is true also for many of the monochromatic prints on paper included in the book. From the inception of photography, paper prints were produced in a range of colors that include the reddish-orange tones of salt prints, the siennas and brown-blacks of carbon prints, the mulberry and yellow-brown hues of albumen prints, and the warm silvery tones of platinum paper. In numerous instances, colored pigments were added by hand to metal plate or paper to enhance the image. The coloration that became possible with the manipulative processes that flowered around the turn of the century will also, in general, have to be seen in the mind's eye. However, in order to provide the reader with some indication of the variety and richness of coloration in photography, an album of images entitled "The Origins of Color" has been included as one of a group of special sections. In it are reproduced the actual colors found in hand-tinted daguerreotypes, paper prints, carbon prints, and bichromate prints as well as in several of the earliest color-process prints.

In addition to distinctive colors, photographic prints sometimes display significant differences in surface appearance and texture, the result of using different processes and printing on different papers; these, too, do not translate easily in reproduction. In all cases, the reader should keep in mind that in addition to the variety of theme and the broad range of aesthetic treatment visible in the illustrations, photographs may exhibit a distinctiveness of color and texture that can be appreciated only in the original.

Because photographs are fragile and for a long time were thought not to be important enough to merit special handling, some images selected for illustration contain extraneous marks caused by the deterioration of the emulsion on the negative. In other cases, scratches and discoloration on the metal daguerreotype plates or cracks and tears in the paper on which the print was made also are visible. No effort has been made to doctor such works so that they look new or to add pieces of the image that might be missing in the original photograph. Care has been taken, whenever possible, to reproduce the entire image even when the edges of a print are damaged.

About the Captions

Caption information is structured as follows: name of the photographer, where known; title of the work, with foreign titles other than place names translated into English; medium in terms of the positive print from which the reproduction was made; and the owner of the print. In the case of 19th-century paper prints, the term *calotype* has been used to denote all prints on salted paper, whether made from paper negatives produced by Talbot's calotype process or a variation thereof. *Salt print* is used when the negative medium is not known. Dimensions of the original negatives are not given, but *carte-de-visite* and stereograph formats are indicated. When two credits are given at the end of a caption, the first is the owner of the work, the second is the source of the reproduction.

1.

THE EARLY YEARS: TECHNOLOGY, VISION, USERS *1839–1875*

What is the secret of the invention? What is the substance endowed with such astonishing sensibility to the rays of light, that it not only penetrates itself with them, but preserves their impression; performs at once the function of the eye and the optic nerve—the material instrument of sensation and sensation itself?

—*"Photogenic Drawing," 1839*[1]

IN THE YEAR 1839, two remarkable processes that would revolutionize our perceptions of reality were announced separately in London and Paris; both represented responses to the challenge of permanently capturing the fleeting images reflected into the *camera obscura*. The two systems involved the application of long-recognized optical and chemical principles, but aside from this they were only superficially related. The outcome of one process was a unique, unduplicatable, laterally reversed monochrome picture on a metal plate that was called a daguerreotype after one of its inventors, Louis Jacques Mandé Daguerre *(pl. no. 1) (see Profile)*. The other system produced an image on paper that was also monochromatic and tonally as well as laterally reversed—a negative. When placed in contact with another chemically treated surface and exposed to sunlight, the negative image was transferred in reverse, resulting in a picture with normal spatial and tonal values. The result of this procedure was called photogenic drawing and evolved into the calotype, or Talbotype, named after its inventor, William Henry Fox Talbot *(pl. no. 2) (see Profile)*. For reasons to be examined later in the chapter, Talbot's negative-positive process initially was less popular than Daguerre's unique picture on metal, but it was Talbot's system that provided the basis for all substantive developments in photography before the advent of digital images.

By the time it was announced in 1839, Western industrialized society was ready for photography. The camera's images appeared and remained viable because they filled cultural and sociological needs that were not being met by pictures created by hand. The photograph was the ultimate response to a social and cultural appetite for a more accurate and real-looking representation of reality, a need that had its origins in the Renaissance. When the idealized representations of the spiritual universe that inspired the medieval mind no longer served the purposes of increasingly secular societies, their places were taken by paintings and graphic works that portrayed actuality with greater verisimilitude. To render buildings, topography, and figures accurately and in correct proportion, and to suggest objects and figures in spatial relationships as seen by the eye rather than the mind, 15th-century painters devised a system of perspective drawing as well as an optical device called the *camera obscura* that projected distant scenes onto a flat surface *(see A Short Technical History, Part I)*—both

means remained in use until well into the 19th century.

Realistic depiction in the visual arts was stimulated and assisted also by the climate of scientific inquiry that had emerged in the 16th century and was supported by the middle class during the Enlightenment and the Industrial Revolution of the late 18th century. Investigations into plant and animal life on the part of anatomists, botanists, and physiologists resulted in a body of knowledge concerning the internal structure as well as superficial appearance of living things, improving artists' capacity to portray organisms credibly. As physical scientists explored aspects of heat, light, and the solar spectrum, painters became increasingly aware of the visual effects of weather condi-

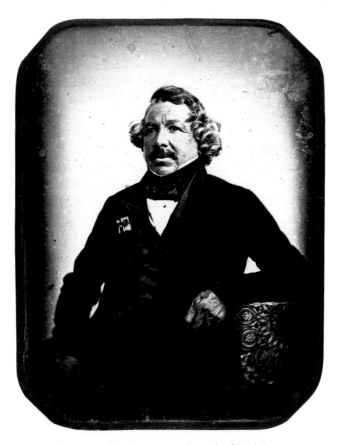

1. JEAN BAPTISTE SABATIER-BLOT. *Portrait of Louis Jacques Mandé Daguerre*, 1844. Daguerreotype. International Museum of Photography at George Eastman House, Rochester, N.Y.

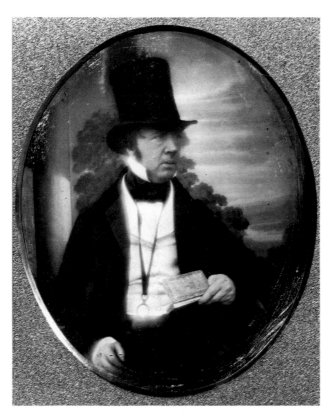

2. Antoine Claudet. *Portrait of William Henry Fox Talbot*, c. 1844. Daguerreotype. Fox Talbot Museum, Lacock, England.

tions, sunlight and moonlight, atmosphere, and, eventually, the nature of color itself.

This evolution toward naturalism in representation can be seen clearly in artists' treatment of landscape. Considered a necessary but not very important element in the painting of religious and classical themes in the 16th and 17th centuries, landscape had become valued for itself by the beginning of the 19th. This interest derived initially from a romantic view of the wonders of the universe and became more scientific as painters began to regard clouds, trees, rocks, and topography as worthy of close study, as exemplified in a pencil drawing of tree growth by Daguerre himself *(pl. no. 3)*. When the English landscapist John Constable observed that "Painting is a science and should be pursued as an inquiry into the laws of nature,"[2] he voiced a respect for truth that brought into conjunction the aims of art and science and helped prepare the way for photography. For if nature was to be studied dispassionately, if it was to be presented truthfully, what better means than the accurate and disinterested "eye" of the camera?

The aims of graphic art and the need for photography converged in yet another respect in the 19th century. In accord with the charge of French Realist painter Gustave Courbet that it was necessary "to be of one's time," many artists rejected the old historical themes for new subjects dealing with mundane events in contemporary life. In addition to renouncing traditional subject matter, they also sought new ways to depict figures in natural and lifelike poses, to capture ephemeral facial and gestural expression, and to represent effects of actual conditions of illumination—information that the camera image was able to record for them soon after the middle of the century.

Another circumstance that prepared the way for photography's acceptance was the change in art patronage and the emergence of a large new audience for pictorial images. As the church and noble families diminished in power and influence, their place as patrons of the arts was taken by the growing middle class. Less schooled in aesthetic matters than the aristocrats, this group preferred immediately comprehensible images of a variety of diverting subjects. To supply the popular demand for such works, engravings and (after 1820) lithographs portraying anecdotal scenes, landscapes, familiar structures, and exotic monuments were published as illustrations in inexpensive periodicals and made available in portfolios and individually without texts. When the photograph arrived on the scene, it slipped comfortably into place, both literally and figuratively, among these graphic images designed to satisfy middle-class cravings for instructive and entertaining pictures.

Though the birth of photography was accompanied by incertitude about scientific and technical matters and was plagued by political and social rivalries between the French and the British, the new pictorial technology appealed enormously to the public imagination from the first. As photographs increasingly came to depict the same kinds of imagery as engravings and lithographs, they superseded the handmade product because they were more accurate in the transcription of detail and less expensive to produce and therefore to purchase. The eagerness with which photography was accepted and the recognition of its importance in providing factual information insured unremitting efforts during the remainder of the century to improve its procedures and expand its functions.

The Daguerreotype

The invention of the daguerreotype was revealed in an announcement published in January, 1839, in the official bulletin of the French Academy of Sciences, after Daguerre had succeeded in interesting several scientist-politicians, among them François Arago, in the new process of making pictures. Arago was an eminent astronomer, concerned with the scientific aspects of light, who also was a member of the French Chamber of Deputies. As spokesman for an enlightened group convinced that researches in physics and chemistry were steppingstones to national economic

supremacy, Arago engineered the purchase by France of the process that Daguerre had perfected on his own after the death of his original partner, Joseph Nicéphore Niépce *(pl. no. 4) (see A Short Technical History, Part I)*. Then on August 19, 1839, with the inventor at his side, Arago presented the invention to a joint meeting of the Academies of Sciences and of Fine Arts *(pl. no. 5)*; the process was later demonstrated to gatherings of artists, intellectuals, and politicians at weekly meetings at the *Conservatoire des Arts et Métiers*.

The marvel being unveiled was the result of years of experimentation that had begun in the 1820s[3] when Niépce had endeavored to produce an image by exposing to light a treated metal plate that he subsequently hoped to etch and print on a press. He succeeded in making an image of a dovecote *(pl. no. 6)* in an exposure that took more than eight hours, which accounts for the strange disposition of shadows on this now barely discernible first extant photograph. When his researches into heliography, as he called it, reached a standstill, he formed a partnership with the painter Daguerre, who, independently, had become obsessed with the idea of making the image seen in the *camera*

3. LOUIS JACQUES MANDÉ DAGUERRE. *Woodland Scene*, n.d. Pencil on paper. International Museum of Photography at George Eastman House, Rochester, N.Y.

obscura permanent. Daguerre's fascination with this problem, and with the effects of light in general, is understandable in view of his activities as a painter of stage sets and illusionistic scenery for The Diorama, a popular visual entertainment in Paris. Evolved from the panorama, a circular painted scene surrounding the viewers, The Diorama contrived to suggest three-dimensionality and atmospheric effects through the action of light on a series of realistically painted flat scrims. The everyday world was effectively transcended as the public, seated in a darkened room, focused on a painted scene that genuinely appeared to be animated by storms and sunsets.

In promoting The Diorama into one of Europe's most popular entertainments, Daguerre had shown himself to be a shrewd entrepreneur, able to gauge public taste and balance technical, financial, and artistic considerations, and he continued this role with respect to the new invention. He understood, as his partner Niépce had not, that its progress and acceptance would be influenced as much by promotional skill as by intrinsic merit. After the death of Niépce in 1833, Daguerre continued working on the technical problems of creating images with light, finally achieving a practicable process that he offered to sell in 1838, first for a lump sum and then by subscription. When these attempts failed, he altered his course to a more politically inspired one, a move that culminated in the acquisition of the process by the French government[4] and led to the painter's presence beside Arago at the gathering of notables in the Palace of the Institute in August, 1839.

In an electric atmosphere, Arago outlined Daguerre's methods of obtaining pictures (basically, by "exposing" a silver-coated copper plate sensitized in iodine vapor and "developing" its latent image by fuming in mercury vapor), enumerated potential uses, and prophetically emphasized unforeseen developments to be expected. The making of inexpensive portraits was one possibility keenly desired, but in 1839 the length of time required to obtain a daguerreotype image ranged from five to 60 minutes, depending on the coloring of the subject and the strength of the light—a factor making it impossible to capture true human appearance, expression, or movement. For instance, in one of two views from his window of the Boulevard du Temple *(pl. no. 7)* that Daguerre made in 1838, the only human visible is the immobile figure of a man with a foot resting on a pump, all other figures having departed the scene too quickly to have left an imprint during the relatively long exposure. Therefore, efforts to make the process practicable for portraiture were undertaken immediately *(see Chapter 2)*.

Shortly after the public announcement, Daguerre published a manual on daguerreotyping, which proved to many of his readers that the process was more easily

written about than executed. Nevertheless, despite the additional difficulty of transporting unwieldly cameras and equipment to suitable locales—not to mention the expenditure of considerable time and money—the process immediately attracted devotees among the well-to-do, who rushed to purchase newly invented cameras, plates, chemicals, and especially the manual—about 9,000 of which were sold within the first three months. Interest was so keen that within two years a variety of cameras, in addition to the model designed by Daguerre and produced by Alphonse Giroux in Paris, were manufactured in France, Germany, Austria, and the United States. Several knowledgeable opticians quickly designed achromatic (non-distorting) lenses for the new cameras, including the Chevalier brothers in Paris and Andrew Ross in London, all of whom had been providing optical glass for a wide range of other needs, as well as the Austrian scientist Josef Max Petzval, a newcomer. Focusing on monuments and scenery, daguerreotype enthusiasts were soon to be seen in such numbers in Paris, the countryside, and abroad that by December, 1839, the French press already characterized the phenomenon as a craze or *"daguerréotypomanie" (pl. no. 8)*.

One of the more accomplished of the gentlemen ama-

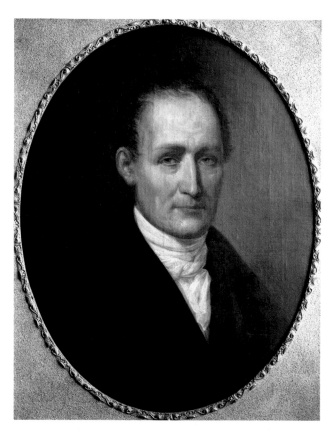

4. Léonard-François Berger. *Portrait of Joseph Nicéphore Niépce*, 1854. Oil on Canvas. Musée Nicéphore Niépce, Ville de Chalon-sur-Saône, France.

teurs who were intrigued by daguerreotyping was Baron Jean Baptiste Louis Gros, who made the first daguerreotype images of the Parthenon while on a diplomatic mission to Greece in 1840. After returning to Paris, he was fascinated by his realization that, unlike hand-drawn pictures, camera images on close inspection yielded minute details of which the observer may not have been aware when the exposure was made; far removed from the Acropolis, he found that he could identify sculptural elements from the Parthenon by examining his daguerreotypes with a magnifying glass. The surpassing clarity of detail, which in fact still is the daguerreotype's most appealing feature, led Gros to concentrate on interior views and landscapes whose special distinction lies in their exquisite attention to details *(pl. no. 9)*.

At the August meeting of the Academies, Arago had announced that the new process would be donated to the world—the seemingly generous gift of the government of Louis Philippe, the Citizen King. However, it soon became apparent that before British subjects could use the process they would have to purchase a franchise from Daguerre's agent. Much has been written about the chauvinism of Daguerre and the French in making this stipulation, but it should be seen in the context of the unrelenting competition between the French and British ruling-classes for scientific and economic supremacy. The licensing provision reflected, also, an awareness among the French that across the Channel the eminent scientist Talbot had come up with another method of producing pictures by the interaction of light and chemicals.

Regularly scheduled demonstrations of Daguerre's process and an exhibition of his plates took place in London in October, 1839, at the Adelaide Gallery and the Royal Institution, the two forums devoted to popularizing new discoveries in science. Daguerre's manual, which had appeared in translation in September (one of 40 versions published within the first year), was in great demand, but other than portraitists, whose activities will be discussed in the next chapter, few individuals in England and Scotland clamored to make daguerreotypes for amusement. Talbot, aware since January of Daguerre's invention from reports in the French and British press and from correspondence, visited the exhibition at the Adelaide Gallery and purchased the equipment necessary for making daguerreotypes; however, even though he praised it as a "splendid" discovery, he does not appear to have tried out the process.

Reaction to the daguerreotype in German-speaking cities was both official and affirmative, with decided interest expressed by the ruling monarchs of Austria and Prussia.[5] Returning from a visit to Paris in April, 1839, Louis Sachse, owner of a lithographic firm, arranged for French cameras, plates, and daguerreotype images to be sent to Berlin by

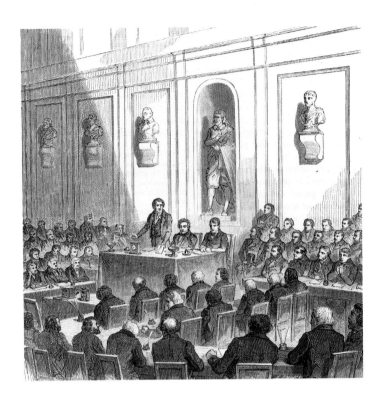

5. UNKNOWN. *Joint Meeting of the Academies of Sciences and Fine Arts in the Institute of France, Paris*, August 19, 1839. Engraving. Gernsheim Collection, Humanities Research Center, University of Texas, Austin.

6. JOSEPH NICÉPHORE NIÉPCE. *View from His Window at Le Gras*, c. 1827. Heliograph. Gernsheim Collection, Humanities Research Center, University of Texas, Austin.

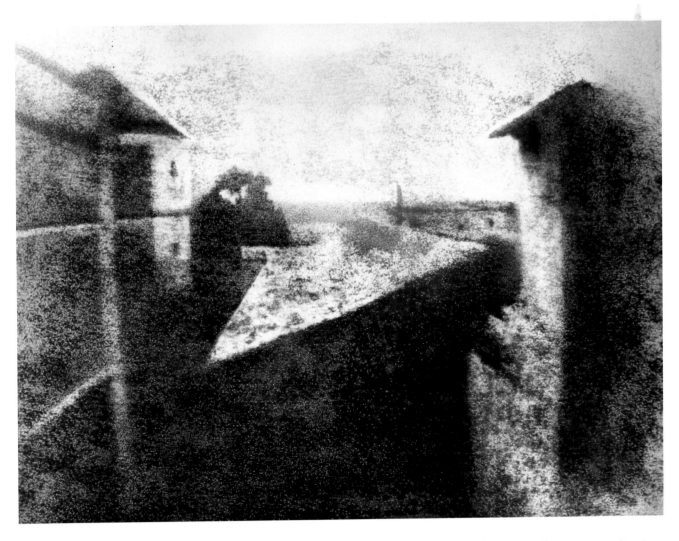

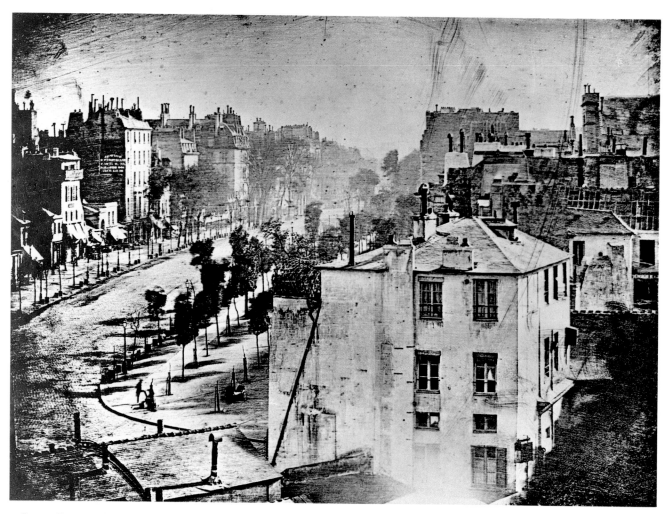

7. Louis Jacques Mandé Daguerre. *Boulevard du Temple, Paris*, c. 1838.
Daguerreotype. Bayerisches Nationalmuseum, Munich.

mid-year; a few months later, views taken with locally constructed apparatus also were being shown. However, even though urban scenes in a number of cities were recorded quite early, among them an 1851 view of Berlin by Wilhelm Halffter *(pl. no. 10)*, daguerreotyping for personal enjoyment was less prevalent in Central Europe because the *bourgeoisie* were neither as affluent nor as industrially advanced as their French counterparts. As in all countries, German interest in the daguerreotype centered on expectations for a simple way to make portraits.

Avid interest in the new picture-making process, a description of which had appeared in scientific journals following the January announcement in Paris, motivated Anton Martin, librarian of the Vienna Polytechnic Institute, to attempt daguerreotype images in the summer of 1839, even before Daguerre had fully disclosed his procedures or had his plates exhibited in Vienna that fall. *Winter Landscape (pl. no. 11)*, a view made two years later by Martin, is mundane in subject matter and artlessly organ-

ized. But by the 1830s this kind of scene already had begun to appeal to artists, and it is possible that the documentary camera image, exemplified by this work, hastened the renunciation of romantic themes and bravura treatment of topographical scenes in the graphic arts.

One of the earliest Europeans to embrace and extend the possibilities of the daguerreotype was the Swiss engraver Johann Baptist Isenring who, between 1840 and 1843, exhibited plates of native scenery, colored by hand, in Augsburg, Munich, Stuttgart, and Vienna. He also was among the first to publish aquatint views *(pl. no. 12)* based on daguerreotypes, signaling the form in which the unique image would begin to reach a larger public. His subject matter, too, anticipated the attraction that Continental landscape was to have for a great many photographers working between 1850 and 1880, many of whom continued the tradition begun in the late 18th century of publishing landscape views.

Curiosity about the new picture processes was pro-

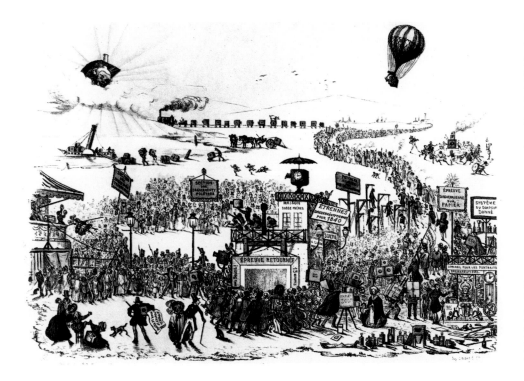

8. THÉODORE
MAURISSET. *La
Daguerréotypomanie*,
December, 1839.
Lithograph. Gernsheim
Collection, Humanities
Research Center,
University of Texas,
Austin.

9. JEAN BAPTISTE LOUIS
GROS. *Bridge and Boats
on the Thames*, 1851.
Daguerreotype.
Bibliothèque Nationale,
Paris.

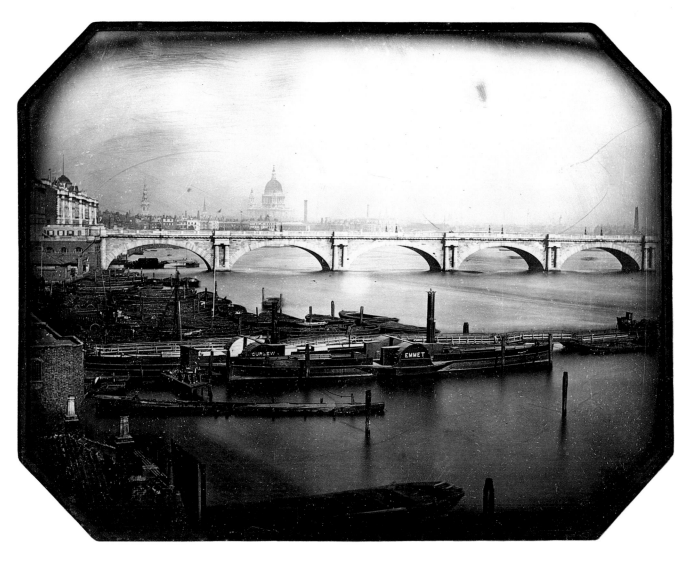

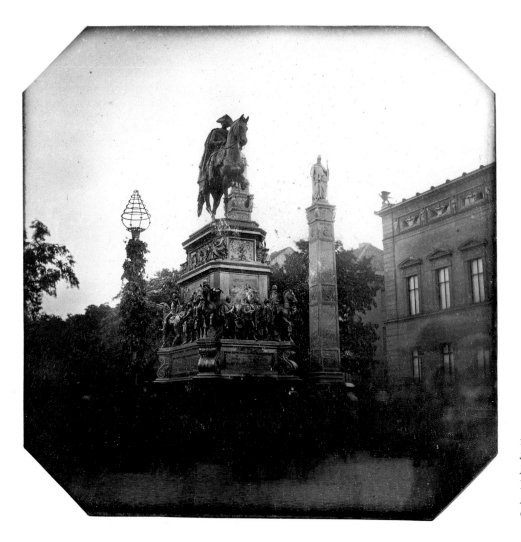

10. WILHELM HALFFTER.
Statue of Frederick the Great,
Berlin, May 31, 1851.
Daguerreotype.
Agfa-Gevaert Foto-Historama,
Cologne, Germany.

11. ANTON MARTIN. *Winter*
Landscape, Vienna, c. 1841.
Daguerreotype. Museum für
Kunst und Gewerbe, Hamburg.

nounced among scientists, artists, and travelers in Italy. In addition to translations of French manuals, which started to appear in 1840, visitors from the north brought along their own equipment for both the daguerreotype and Talbot's negative–positive process. Among the early Italian daguerreotypists, Lorenzo Suscipj was commissioned to make views of the Roman ruins for English philologist Alexander John Ellis. Indeed, the presence of classical ruins and the interesting mix of French, British, German, and American nationals living and traveling in Rome and Florence during mid-century gave Italian photography in all processes a unique character in that the rapid commercialization of scenic views and genre subjects became possible. For example, within ten years of the introduction of photography, camera images had taken the place of the etchings, engravings, and lithographs of ruins that tourists traditionally had purchased.

As one moved farther east and north from Paris, daguerreotyping activity became less common. News of the discovery, reprinted from the January notices in the French press, reached Croatia, Hungary, Lithuania, and Serbia in February, 1839, and Denmark, Estonia, Finland, and Poland during the summer, with the result that a number of scientific papers on the process began to appear in these localities. In Russia experimentation succeeded in producing a less expensive method of obtaining images on copper and brass rather than silver, and by 1845 a Russian daguerreotypist felt confident enough to exhibit landscape views of the Caucasus Mountains in a Paris show. Nevertheless, early photography in all these distant realms reflected the absence of a large and stable middle class. Only in the three primary industrial powers—England, France, and the United States—was this group able to sustain the investment of time and energy necessary to develop the medium technically and in terms of significant use.

The Daguerreotype in America

As had been the case with other technologies originating in Europe, Americans not only embraced the daguerreotype, but quickly proceeded to turn it to commercial advantage. The view that "the soft finish and delicate definition of a Daguerreotype has never yet been equalled by any other style of picture produced by actinic agency,"[6] which appeared in the photographic magazine *Humphrey's Journal* in 1859, was only one expression of an opinion held especially by the first generation of American photographers. Daguerreotyping remained the process of choice for 20 years—long beyond the time that Europeans had turned to the more flexible negative–positive technology. The reasons for this loyalty are not entirely clear, but a contributing factor must have been the excellent quality attained by

American daguerreotypists. The sparkling North American light, envied by fog-enshrouded Londoners, was said to have been partly responsible, but social and cultural factors undoubtedly were more significant. Considered a mirror of reality, the crisp, realistic detail of the daguerreotype accorded with the taste of a society that distrusted handmade art as hinting of luxuriousness and was enamored of almost everything related to practical science. With its mixture of mechanical tinkering and chemical cookery, the daguerreotype posed an appealing challenge to a populace that was upwardly and spatially mobile despite periods of economic depression. As a means of livelihood, it combined easily with other manual occupations such as case- or watchmaking, and those who wished to follow a western star were to find it a practicable occupation while on the move.

Some Americans had higher aspirations for the daguerreotype. As an image produced by light, it appeared in their minds to conjoin the Emersonian concept of the "divine hand of nature" with the practicality of scientific positivism. Some hoped that the new medium might help define the unique aspects of American history and experience as expressed in the faces of the citizenry. Others believed that because it was a picture made by machine it would avoid too great artifice and, at the same time, would not demonstrate the obvious provinciality of outlook and training that often characterized native graphic art at mid-century.

The daguerreotype reached America after it had been seen and praised by Samuel F. B. Morse *(pl. no. 13)*, a skillful painter who also invented the electro-magnetic telegraph. His enthusiastic advocacy in letters to his brother in the spring of 1839 helped spur interest in the first manuals and descriptions that arrived in New York late in September by packet ship from England. By early October, details were available in the press, enabling Morse and others to attempt daguerreotyping, but although he worked with esteemed scientist John William Draper and taught others, including Mathew Brady, few images produced by Morse himself have survived.

Another factor that contributed to the rapid improvement of the daguerreotype in the United States was the arrival in November, 1839, of the French agent François Gouraud, with franchises for the sale of equipment. His demonstrations, along with exhibitions of Daguerre's images, evoked interest in the many cities where they were held, even though Americans did not consider it necessary to purchase rights or use authorized equipment in order to make daguerreotypes. As in Europe, technical progress was associated with portraiture, but improvement also was apparent in images of historical and contemporary monuments and structures. Owing to the primitive nature of his

12. JOHANN BAPTIST ISENRING. *View of Zurich*, n.d. Aquatint. Burgerbibliotek Bern, Switzerland.

equipment and the experimental state of the technique, engraver Joseph Saxton's very early view of the Arsenal and Cupola of the Philadelphia Central High School *(pl. no. 14)*, made in October, 1839, is not nearly as crisply defined as John Plumbe's *Capitol Building (pl. no. 15)* of 1845/46 and William and Frederick Langenheim's 1844 view of the Girard Bank, occupied by the Philadelphia Militia *(pl. no. 16)*.

Plumbe, a visionary businessman who built and then lost a small daguerreotyping empire, was interested mainly in portraits, but the Langenheim brothers, of German extraction, hoped to improve American photographic technology by introducing German daguerreotype cameras, the calotype, and photography on glass. John Adams Whipple, of Boston, was similarly concerned with expanding the frontiers of the medium. In addition to a partnership in a fine portrait practice, Whipple attempted to make

daguerreotypes by artificial light and to experiment with images on albumen-coated glass. His special interest was astrophotography; in March, 1851, after three years of experimentation, he produced successful daguerreotypes of the moon *(pl. no. 17)*. The Langenheims and Whipple were among the small group of Americans who realized the drawbacks of the daguerreotype; the populace, however, was too engrossed by the seeming fidelity of "the mirror with a memory"[7] to deplore its limitations.

The Calotype

For much of its existence, photography has been understood by most to be a process resulting in a negative image that can be replicated almost endlessly to produce positives in which tonal and spatial values are in normal relationship.[8] Using the same matrix, the picture can be made

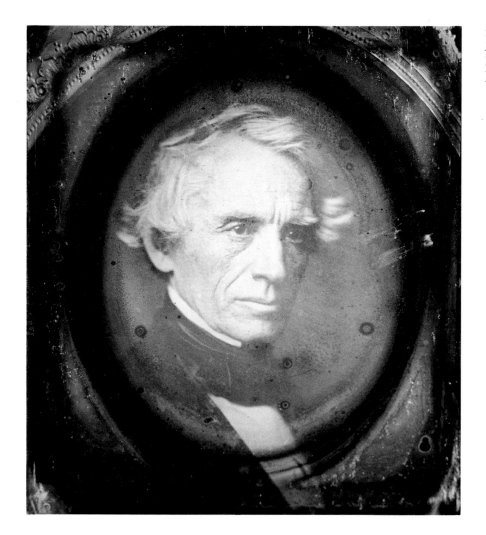

13. PHOTOGRAPHER UNKNOWN. *Portrait of Samuel F. B. Morse*, c. 1845. Daguerreotype. Collection Mrs. Joseph Carson, Philadelphia.

14. JOSEPH SAXTON. *Arsenal and Cupola, Philadelphia Central High School*, October 16, 1839. Daguerreotype. Historical Society of Pennsylvania, Philadelphia.

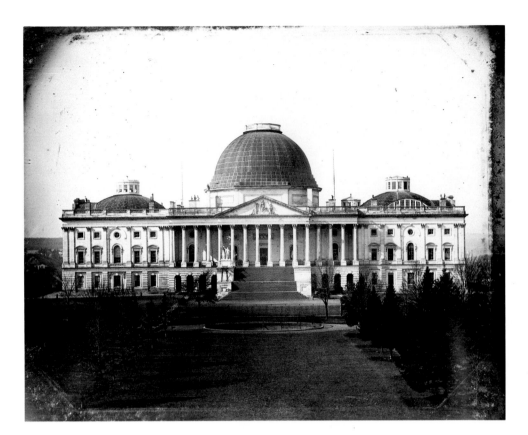

15. JOHN PLUMBE. *Capitol Building, Washington, D.C.*, 1845–46. Daguerreotype. Library of Congress, Washington, D.C.

16. WILLIAM and FREDERICK LANGENHEIM. *Girard Bank*, May, 1844. Daguerreotype. Library Company of Philadelphia.

larger and, because of the light weight of the support (paper, fabric, plastic), it can be inserted into books and albums, attached to documents, and sent through the mails, as well as framed and hung on the wall. The photograph's physical and utilitarian advantages over the daguerreotype are so obvious that it may seem incredible that when first announced the negative–positive process took a most definite second place in the public mind.

The reasons are complex, involving timing, technique of production, aesthetic standards, and social factors. Photogenic drawing, as Talbot first called the paper image, was made public by the inventor in London in February, 1839, only after the news of Daguerre's discovery had been relayed from across the Channel. For most people, the potential value of replication may have seemed too abstract an idea at the time, while the actual process of turning negative into positive was perceived as rather complicated. Most important, however, was the fact that—even to Talbot's most ardent supporters—the fuzziness of his earliest results was demonstrably less pleasing than the finely detailed daguerreotype image.[9] Furthermore, the French invention, sponsored by scientist-politicians, had received official government sanction while Talbot had to steer his discovery himself through the quicksands of the British scientific and patenting establishments, at the same time pursuing improvements and attempting to realize a commercial return.

A patrician background and university training had enabled Talbot to become involved with the most advanced thinking of his time. This resourceful scientist was drawn more to astronomy, mathematics, and optics than to chemistry (which in any case was barely a discipline at the time), and his interests also embraced linguistics and literature. For a man of science he was a somewhat romantic and antisocial figure who traveled incessantly; it was while sketching on a honeymoon trip to Italy in 1833 *(pl. no. 18)* that he conceived the notion of making permanent the image visible on the translucent ground-glass surface of the *camera obscura*. Taking up this idea on his return to England, Talbot managed first to expose and thereby transfer leaf forms directly onto chemically sensitized paper *(pl. no. 21)*. Then, in the summer of 1835, with treated paper inserted in small specially constructed cameras, he succeeded in producing a number of negatives of his ancestral home, Lacock Abbey, including a tiny postage-stamp-size image of a latticed window *(pl. no. 20)* with diamond panes initially distinct enough to count.

In common with Daguerre, Talbot first used a solution of ordinary table salt to stop the continuing action of light on the silver deposits, but it was not until both inventors had switched to hyposulphite of soda (hypo, as it is still called even though its scientific name is now sodium thio-

sulphate) that the unexposed silver salts were completely removed and the image satisfactorily stabilized. This characteristic of hypo had been discovered in 1819 by John Herschel (later knighted), a prominent astronomer, physical scientist, and friend of Talbot, who informed both inventors of this fact. Herschel's contributions to the chemistry of photography reveal both scientific brilliance and disinterested generosity. Returning in 1838 after several years as an independent researcher in South Africa where he had himself made drawings with optical devices *(pl. no. 19)*, Herschel learned of the experiments in England and France to produce images by the action of light. He proceeded to conduct his own intensive researches to discover the effectiveness of different silver halides and other chemicals, among them ferric salts from which cyanotypes, or blueprints, are made.

Herschel's suggestions with regard to terminology were especially effective in that he convinced Talbot to consider, instead of photogenic drawing, the broader term photography—light writing—a term believed to have been first used by both the Brazilian Hercules Florence and the German astronomer Johann H. von Maedler.[10] Herschel also coined the terms negative and positive to refer to the

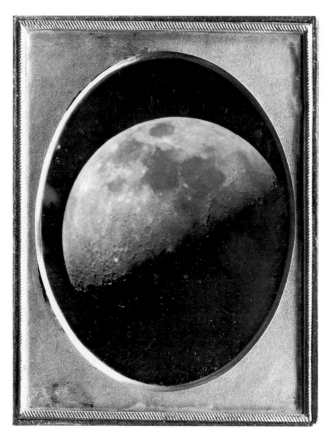

17. JOHN ADAMS WHIPPLE. *Moon*, 1851. Daguerreotype. Science Museum, London.

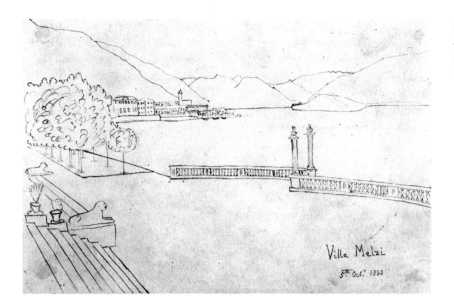

18. WILLIAM HENRY FOX TALBOT. *Villa Melzi*, October 5, 1833. Camera lucida sketch on paper. Fox Talbot Collection, Science Museum, London.

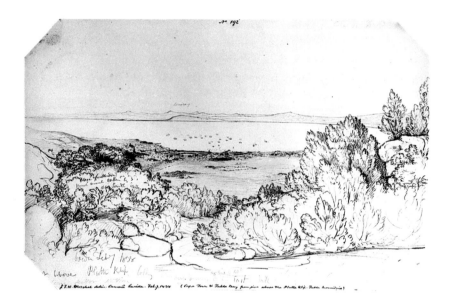

19. JOHN HERSCHEL. *Cape Town and Table Bay from Just Above Platte Klip Gorge, Table Mountain*, February 7, 1838. Camera lucida sketch on paper. Special Collections, South African Library, Capetown.

20. WILLIAM HENRY FOX TALBOT. *Latticed Window at Lacock Abbey*, 1835. Photogenic drawing. Fox Talbot Collection, Science Museum, London.

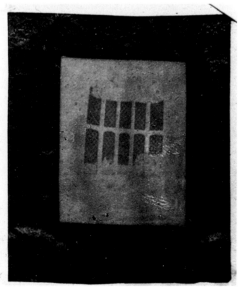

inverse and reverted images that were basic to the system. Had he wished, he probably could have arrived at a patentable process at the same time as Talbot, but his interests lay elsewhere. His intellectual openness has been contrasted with Talbot's more secretive attitudes, but the two were mutual admirers, with Herschel refreshingly liberal about sharing the experimental results of his genius.

The report in January, 1839, of Daguerre's discovery forced Talbot to make public his process even though he had done little work on it since 1837. His initial announcements, made to the Royal Society, the Royal Institution, and the French Academy of Sciences at the end of January and in February were received with interest and evoked a small flurry of excitement among a few individuals in the scientific community and in Talbot's circle of family and friends. However, in comparison with the verisimilitude of the finely detailed daguerreotype, this image, incorporating the texture intrinsic to its paper support, was too broad and indistinct to have wide appeal despite Talbot's description of the effect as "Rembrandtish."

Another disadvantage at first was the length of time required to make an exposure. Talbot had not then discovered the possibility of latent development, a procedure Daguerre had stumbled on, whereby the image, invisible on the exposed plate or paper, was made to appear by treatment with a chemical solution (developer). When he did discover this in the fall of 1840, his exposure time was decreased from about half an hour to as little as 30 seconds on a very bright day, making possible portraiture and a much broader selection of subjects and atmospheric effects, as seen in one of the inventor's early views of London (*pl. no. 22*).

In 1841 Talbot took out the first of his patents,[11] using the word calotype to describe the resulting image, which he also referred to as a Talbotype. This action initiated a ten-year period during which English scientific and artistic endeavor in photography became entangled in problems of commercial exploitation. Both during his lifetime and long afterward, Talbot was accused of obstructing the development of photography because of his intransigence with regard to the four patents he held on the calotyping process. Critics have suggested that he regarded them as covering all advances in photographic technology occurring between 1841 and 1851 and that he included as his own the contributions of others, in particular Herschel's suggestion of hyposulphite of soda as a fixer. However, Talbot's biographer, H. J. P. Arnold, notes that a close reading of the language indicates that the patents protected methods of utilizing substances rather than the chemical agents themselves.[12]

Talbot himself was caught up in a controversy over the moral and practical effects of patenting inventions, a di-

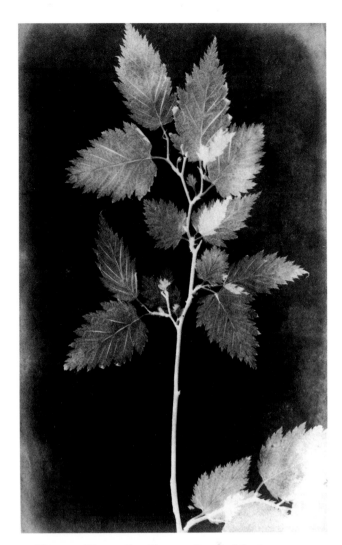

21. WILLIAM HENRY FOX TALBOT. *Botanical Specimen,* 1839. Photogenic drawing. Royal Photographic Society, Bath, England.

lemma that occupied the British from mid-century on. While some individuals maintained that patent fees were too high and rules too lax for protection, others argued that patents were indefensible because inventions "depended less on any individual than on progress in society."[13] Talbot may have agreed, but he patented his processes because, like countless others in Britain, France, and the United States at the time, he considered that those who had invested considerable effort should reap the material rewards of their genius and industry. That he did not benefit financially was because he was an indifferent businessman with a more compelling interest in intellectual matters—an attitude bolstered by the fact that he could count on income from his landed estate. Neither the surge of amateurs photographing in calotype for their own pleasure nor the utilization of the process for commercial portraiture materialized. Among the well-to-do who did take

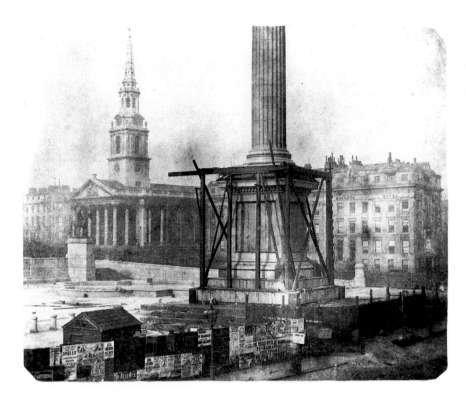

22. WILLIAM HENRY FOX TALBOT. *The Nelson Column, Trafalgar Square, London, under Construction*, c. 1843. Salted paper print from a calotype negative. Fox Talbot Collection, Science Museum, London.

23. WILLIAM HENRY FOX TALBOT. *The Open Door*, 1843. Salted paper print from a calotype negative. (Plate VI, *The Pencil of Nature*, 1844-46.) Fox Talbot Collection, Science Museum, London.

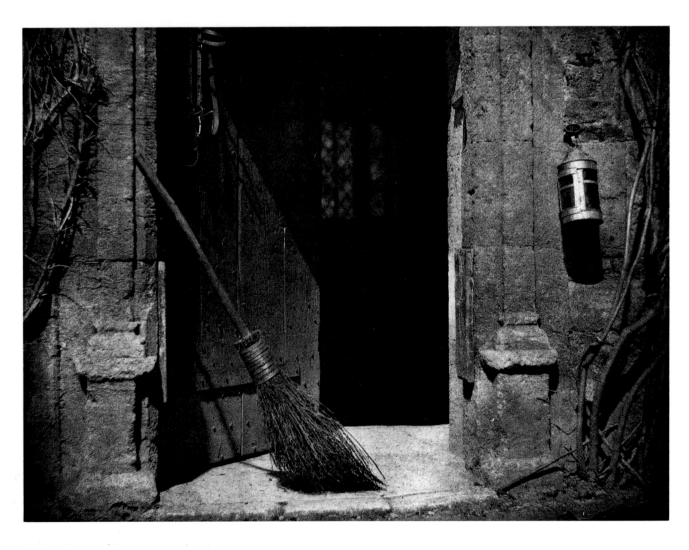

up calotyping were Talbot's wife Constance, his Welsh relatives Emma and John Dillwyn Llewelyn, and two friends, the Reverends Calvert Richard Jones and George W. Bridges, both of whom conceived the idea of making a calotype record of their travels abroad *(see Chapter 3)*.

Paper photography occasioned a more significant response in Scotland where no licensing arrangements were necessary. With the help of Sir David Brewster, an eminent scientist who corresponded frequently with Talbot, Robert Adamson, a young Scottish chemist, was able to perfect the calotype technique and open a studio in Edinburgh in 1841. Two years later, he and painter-lithographer David Octavius Hill began to produce calotypes; these images, mainly portraits *(see Chapter 2)*, still are considered among the most expressive works in the medium.

Talbot, though disinclined to pursue the commercial exploitation of his discovery actively, was keenly concerned with the potential uses of the medium. In setting up a publishing establishment at Reading under the supervision of Nicolaas Henneman, an assistant he personally had trained, Talbot promoted the use of the photographic print itself in book and magazine illustration. The *Pencil of Nature*, issued serially between 1844 and 1846 with text and pictorial material supplied by Talbot, was the first publication to explain and illustrate the scientific and practical applications of photography. One of the plates, *The Open Door (pl. no. 23)* was singled out in the British press for its exceptional tonal range and textural fidelity, its "micro-

scopic execution that sets at nought the work of human hands."[14]

Talbot regarded photography as important primarily for its role in supplying visual evidence of facts, but this "soliloquy of the broom," as Talbot's mother called *The Open Door*, reveals a telling interest in the artistic treatment of the mundane. Along with the theme, the careful attention to the way light and shadow imbue a humble scene with picturesque dimension suggests the inventor's familiarity with examples of Dutch genre painting of the 17th century—works that enjoyed considerable esteem in Victorian England and, in fact, were specifically mentioned in the *Pencil of Nature*. Several other calotype images in the same style bear witness to Talbot's conviction that photography might offer an outlet for artistic expression to those without the talent to draw or paint.

Other publications by Talbot included *Sun Pictures of Scotland*, for which he made 23 photographs in 1844, and *Annals of Artists in Spain*, the first book to utilize the photograph for reproducing works of art. However, he disposed of the Reading firm in 1848 because of managerial and technical problems in running a large-scale photographic printing enterprise, not the least of which was the fact that calotypes were subject to fading. This instability was to trouble photographers who worked with paper prints throughout the next 25 years.

In France, where the daguerreotype held the general populace enthralled, artists were greatly interested in the

calotype. In their view, the paper process offered a greater range of choices within which one might fashion an affective image. In addition to view, pose, and lighting—the sole aesthetic decisions for the daguerreotypist—the calotypist could exercise interpretive judgment in the production of subsequent prints from the same negative. Aesthetic decisions concerning tonality and coloration could be made by adjustments in the toning and sensitizing baths and by the choice of paper itself, while retouching on the negative (or print) could alter forms. In this respect, the paper process called to mind traditional procedures in etching and engraving, lending the calotype greater esteem among those interested in photography as a creative pursuit.

Other Developments in Paper Photography

Actually, a paper process had been discovered independently in France. Early in 1839, Hippolyte Bayard, a civil servant in the Ministry of Finance, had made and exhibited both photogenic drawings and direct positive paper images exposed in a camera *(see A Short Technical History, Part I)*, among them a view of a rural enclave in Paris in the process of being urbanized *(pl. no. 24)*. These works were produced soon after the first reports of Talbot's process reached France but before the official announcement in August of Daguerre's process. However, political pressure, especially from Arago, who had committed himself to the promotion of the daguerreotype, kept the discovery from the public. Bayard expressed his indignation at this shabby treatment by the French establishment[15] by creating an image of himself as a suicide victim *(pl. no. 25)*; nevertheless, he soon went on to become a prominent member of the photographic community in Paris.

Aware of Bayard's discoveries and concerned that this other paper process might achieve precedence on the Continent, Talbot sought to promote the calotype in France. Although he signed a contract for its promotion with Joseph Hugues Maret (known as the Marquis de Bassano), and traveled to Paris in 1843 to demonstrate the procedure, his associates in France turned out to be incompetent and the project a fiasco. Loath to purchase franchises directly from Talbot in England, French artists and photographers preferred to wait until 1847 when Louis Désiré Blanquart-Evrard, a photographer in Lille who was to become an influential figure in book publication, announced a modified paper process based on Talbot's discoveries. One of the most ardent champions of paper photography in France was the painter Gustave Le Gray, who in 1851 described a method of waxing the negative before exposure to improve definition and tonal sensitivity. The calotype, employed by

Le Gray and other French photographers in an 1851 project to document historic monuments *(see Chapter 3)*, enjoyed spirited acclaim by French critics before it was made obsolete by the new collodion technology discussed below.

Early in 1839, two Munich scientists, Carl August von Steinheil and Franz von Kobell, had experimented with paper negatives as a result of a report on Talbot's discoveries given at the Bavarian Royal Academy of Sciences, but even though successful results were exhibited in July, on hearing of the wonderful detail possible with the daguerreotype Von Steinheil switched to metal plates. In the United States as in England, the soft forms of the calotype appealed mainly to a small group of intellectual lights (many of whom lived in Boston), but on the whole reaction to paper photography was cool. Following an unproductive business arrangement with Edward Anthony, a prominent figure in the photographic supply business in New York, Talbot sold the patent rights to the Langenheims who, in turn, expected to sell licenses for the process throughout the United States. The calotypes made by the Langenheims were admired in the press, but the firm soon was forced into bankruptcy as the American public continued its allegiance to the daguerreotype.

Introduction of the Glass Plate and Collodion

Lack of definition and fading were considered the two most pressing problems in paper photography, especially by portraitists and publishers with commercial interests. To improve sharpness, efforts to replace the grainy paper negative with glass—a support that both Niépce and Herschel had already used—gained ground. The first practicable process, using albumen, or egg white, as a binder for the silver salts, was published in France in 1847, while in the United States Whipple and the Langenheims also had succeeded in making finely detailed glass negatives with these substances, from which they made prints called crystalotypes and hyalotypes, respectively. Glass also provided a suitable material for experimentation undertaken by the Langenheims to produce stereographic images (see below) and positive slides for projection. But while albumen on glass resulted in negatives without grain, the procedures were complicated and the exposure time was longer than that required for the daguerreotype.

An effective alternative materialized in 1850 when Frederick Scott Archer, an English engraver turned sculptor, published a method of sensitizing a newly discovered colorless and grainless substance, collodion, to be used on a glass support *(see A Short Technical History, Part I)*. Because exposure time decreased dramatically when the plate was used in a moist state, the process became known as the wet

25. HIPPOLYTE BAYARD. *Self-Portrait as a Drowned Man*, 1840. Direct paper positive. Société Française de Photographie, Paris.

plate or wet collodion method. Today one can scarcely imagine the awkwardness of a procedure that required the user to carry a portable darkroom about in order to sensitize each plate before using it and to develop it immediately afterward. Still, the crisp definition and strong contrast afforded by sensitized collodion on glass proved to be just what many in the photographic profession had hoped for in a duplicatable process. Its discovery initiated an era of expanded activity in professional portraiture, in the publication of views, in amateur photographic activity around the globe, and led to numerous collateral photographic enterprises. The introduction of collodion also signaled the end of Talbot's exasperating efforts to litigate his patent rights against those who had taken up calotyping for commerce without purchasing a franchise. The gift of the collodion process to the public by Archer (who was to die impoverished in 1857) was in noticeable contrast to Talbot's attempts to cover all his inventions. When he claimed in 1854 that collodion, too, was protected by his 1843 calotype patent, the outrage expressed in the press made a favorable decision on his pending infringement cases impossible.[16] Talbot gave up his photography patents in 1855, but by then the calotype had faded from sight, in many cases quite literally.

Developments in the Paper Print

Besides the soft definition, the other problem that plagued calotypists involved the quality of the print. Uneven and blotchy tonalities and, of greater concern, the tendency for rich-looking prints to fade and discolor were nightmares, especially for those in commercial enterprises. In addition, satisfactory salt prints—positives produced by exposing sensitized paper in contact with a negative until the image appeared—were thought to look lifeless by a public enticed by superior contrast and clarity. Because the problems were perceived as intrinsic to paper manufacture, an emulsion consisting of albumen and light sensitive silver salts was proposed as a surface coating to keep the image from penetrating into the paper structure itself.

Coming into use at about the same time as the collodion negative, the albumen print rapidly became part of a new photographic technology. Lasting some 30 years, it promoted a style that featured sharp definition, glossy surface, and strong contrasts. In response to this preference, Blanquart-Evrard's *Imprimerie Photographique* (Photographic Printing Works) at Lille, the first successful photographic printing plant to employ a substantial labor force of men and women, began to process prints for the

dozen different publications issued during the 11 years of its existence. Similar firms soon appeared in Alsace, Germany, England, and Italy, as photographically illustrated books and portfolios became popular.

However, despite the optimistic scenario for the future of the albumen print, problems with stability continued to haunt photographers, making large-scale production a demanding undertaking. At times the unappealing yellow-brown tonality of faded albumen prints was likened to that of stale cheese. Again, sizings were blamed, and it was determined that impurities in the water used in paper manufacture also left a residue that caused the discoloration; only two mills in northeastern France were thought capable of producing paper free from such mineral contamination. Stock from these mills was shipped to nearby Dresden to be albumenized, establishing this German city as the main production center for photographic paper throughout the collodion era.

Other causes of fading, among them imperfect washing, inadequate fixing with hypo baths, interaction with mounting adhesives and air pollution, were confirmed by individuals and by committees set up to study the situation by the two most prominent photographic organizations of the era—the Photographic Society of London and the *Société Française de Photographie*. A two-part prize offered in 1856 by an eminent French archeologist, Honoré d'Albert, Duc de Luynes, testified to the fact that the solution would be found in two spheres of activity related to photography. In offering a larger sum for photomechanical procedures and a smaller one for the discovery of a truly permanent method of chemical printing, De Luynes and other French industrialists recognized the importance of mechanical over hand methods for reproducing photographs. Alphonse Louis Poitevin, a noted French chemist who was recipient of both parts of the prize, worked out a photolithographic process called the collotype *(see A Short Technical History, Part II)* and a non-silver procedure for printing collodion negatives. Based on researches undertaken in 1839 by the Scottish scientist Mungo Ponton that established the light-sensitivity of potassium bichromate, this process, called carbon printing, used a mixture of bichromated gelatin and powdered carbon instead of silver salts to effect a positive image.

During the 1860s, the results obtained by printing with carbon were greatly admired for their deep, rich tonalities as well as their resistance to fading. The technique was actively promoted in Europe, especially after Joseph Wilson Swan, the holder of numerous British patents in the photochemical field (and the inventor of the incandescent light bulb), simplified manipulation by manufacturing carbon tissues in various grades and tonalities. Called Autotype in England, the Swan carbon process was franchised to the Annan brothers in Scotland, Hanfstaengl in Germany, and Braun in France, rendering these large-scale photographic publishing firms more productive than formerly. However, despite a campaign to promote the carbon method by a leading American publication, *The Philadelphia Photographer*, no great interest developed in the United States, perhaps because efforts already were underway to find a method of printing photographs on mechanical presses through the creation of a metal matrix. Another process that utilized similar chemical substances—the Woodburytype, named after its English creator Walter Woodbury—began to supplant carbon production printing in the early 1870s. It, too, produced a richly pigmented permanent image, but because it incorporated elements of mechanical printing technology it was more productive. Despite these improvements in positive printing materials, albumen paper continued in use for portraits and scenic views until the 1880s when significant new developments in both negative and printing materials made it obsolete. The pigmented carbon process was used less frequently in commercial photographic printing after the 1880s; however, it then became a means of individualized artistic expression for pictorialist photographers.

The Stereograph and Stereoscope

One final element in this inaugural period of photography helped assure the medium's incredible popularity. This was the invention of the stereograph and stereoscope —an image and a device that fused photographic technology with entertainment. Stereographs—two almost identical images of the same scene mounted side by side on a stiff support and viewed through a binocular device to create an illusion of depth—held late-19th-century viewers in thrall. Early examples, which had used daguerreotypes to create this effect, were not entirely successful because reflections from the metal surfaces interfered with the illusion; but after collodion/albumen preempted other technologies, stereograph views became more convincing and immensely salable. Produced in large editions by steam-driven machinery and mounted on cards using assembly-line methods, they reached a substantial clientele, especially in the United States, through mail-order and door-to-door sales. Stereograph publishers offered an unparalleled selection of pictorial material; besides the landscapes, views of monuments, and scenes of contemporary events that often were available in regular format photographs also, there were educational images of occupations and work situations around the globe, reproductions of works of art, especially sculpture, and illustrations of popular songs and anecdotes—all of which provided middle-class viewers with unprecedented materials for entertainment.

26. Holmes-Bates Stereoscope with stereograph. Keystone-Mast Collection, California Museum of Photography, University of California, Riverside.

Histories of the medium have acknowledged this popular appeal, but the stereograph should be seen as more than a faddish toy. After Queen Victoria had expressed her approval at the Crystal Palace Exhibition of 1851, where stereographs were on public display for the first time, the purchase, exchange, and viewing of stereographs became a veritable mania. It was promoted in the United States as a significant educational tool by Oliver Wendell Holmes in two long articles in the *Atlantic Monthly*, in 1859 and 1862. Besides envisioning "a comprehensive and systematic library . . . where all . . . can find the special forms they desire to see as artists . . . as scholars, . . . as mechanics or in any other capacity,"[17] Holmes suggested that in the future the image would become more important than the object itself and would in fact make the object disposable. He designed an inexpensive basic viewer *(pl. no. 26)* to enable ordinary people of little means to enjoy these educational benefits. In the latter part of the 19th century, stereography filled the same role as television does today, providing entertainment, education, propaganda, spiritual uplift, and aesthetic sustenance. Like television, it was a spectator activity, nourishing passive familiarity rather than informed understanding. Long viewed as a pleasant household pastime, its effect on attitudes and outlook in the 19th century eventually became the subject of serious study.[18]

Looking back at the evolution of the medium during the first half of the 19th century, it is obvious that photography's time had come. Industrialization and the spread of education mandated a need for greater amounts of comprehensible pictorial material encompassing a broader range of subjects—a necessity to which only the camera image was able to respond. Besides the figures mentioned in this chapter, other all-but-forgotten individuals were attempting to produce images by the means of light. And as soon as the glimmers of success were hinted at in London and Paris, people in outlying areas of Europe and the Americas began to embrace the new technology, hoping to expand its possibilities and, in the process, to make or improve their own fortunes.

Within 25 years of Niépce's first successful image, enough of the major technical difficulties had been worked out to insure that both daguerreotype and photograph could be exploited commercially. This activity, which centered on two areas—portraiture and the publication of scenic views—created a photographic profession with its own organizations and publications. Amateurs employed the medium for documentation and for personal expression, while graphic artists came to rely on photography as an indispensable tool for providing a record of appearances and, eventually, for suggesting different ways of viewing actuality. As will become apparent in the chapters that follow, the traditional divisions separating amateur from professional, art from commerce, document from personal expression were indistinct from the earliest days of the medium, and any boundaries that did exist became even more indefinite as camera images increased their authority and scope.

Profile: Louis Jacques Mandé Daguerre

Nothing in Daguerre's early career as a successful scenic designer hinted that eventually he would become transfixed by the problems of producing permanent images by using light. He was born in 1787 into a *petit bourgeois* family in Cormeilles-en-Parisis; when his natural artistic gifts became apparent he was apprenticed to a local architect. Paris beckoned in 1804, the year of Napoleon's coronation, so Daguerre served another apprenticeship in the studio of the stage designer Ignace Eugène Marie Degotti. His intuitive sensitivity to decorative effect enabled him to rise quickly, and in 1807 he became an assistant to Pierre Prévost, who was renowned for his realistically painted panoramas. During the nine years that Daguerre worked for Prévost, he occasionally submitted oils to the Paris Salon and made sketches and topographical views for the 20-volume *Voyages pittoresques et romantiques en l'ancienne France (Picturesque and Romantic Travels in Old France)*, a work to which the painters Géricault, Ingres, and Vernet also contributed.

In 1816, Daguerre's exceptional skill and imagination

were recognized by his appointment as stage designer to one of the best-known small theaters in Paris; three years later he also was designer for the *Opéra*. The audience for these entertainments was drawn from the new urban middle class, whose taste ran to verisimilitude in execution and romanticism in content. When, in 1821, Daguerre undertook to promote a new entertainment, The Diorama, he was convinced that the public would pay for illusionistic deception on a grand scale. The Diorama, which opened in July, 1822, with his own deceptively real-looking representation of "The Valley of the Sarnen" (and one of "The Interior of Trinity Chapel, Canterbury Cathedral," painted by his partner Charles Marie Bouton) achieved its striking effects by the manipulation of light that transformed the scene from a serene day to one of tempestuous storminess, underscoring the desolation of the painted landscape. Despite a temporary setback during the political troubles of 1830, The Diorama continued to offer romantic subjects until 1839, when it was entirely destroyed by fire.

To achieve the perspective effects on the large scrims, and on the easel paintings that he sometimes painted of the same subjects, Daguerre used the conventional tool of his trade—the *camera obscura*. At what point he began to consider how to make the view on the translucent glass surface permanent is not known, but in 1824 he started to frequent the shop of the Chevalier brothers, well-known Parisian makers of optical instruments. The result was an association with Niépce, through the Chevaliers, that led first to an agreement to perfect Niépce's process and finally to the daguerreotype.

After the French government had acquired the process, Daguerre occasionally demonstrated its methods and entered into arrangements to supply cameras and manuals of instruction, but he was considerably less active than others in perfecting his discovery. He preferred creating scenic effects on his estate in Bry-sur-Marne and in the local church where he painted a large *trompe l'oeil* perspective scene behind the altar. Although at Bry he made a small

27. Louis Jacques Mandé Daguerre. *Still Life*, 1837. Daguerreotype. Société Française de Photographie, Paris.

number of daguerreotypes of family and scenery, no further discoveries issued from his workshop nor did he develop artistically between 1839 and his death in 1851.

On the whole, Daguerre's output in the new medium reveals the influence of his artistic training and experience as the creator of picturesque yet convincing-looking scenes. His earliest surviving metal-plate image, an 1837 still life of plaster casts *(pl. no. 27)*, discloses a subject dear to Romantic artists, one to which he returned on a number of occasions. These works, and views made in Paris and Bry, demonstrate sensitivity to tonal balance, feeling for textural contrast, and a knowledge of compositional devices such as diagonal framing elements to lead the eye into the picture, but from Daguerre's complete output—some three dozen plates according to Helmut and Alison Gernsheim[19]—it is difficult to credit him with exceptional perception regarding the stylistic or thematic possibilities of the new pictorial medium.

Profile: William Henry Fox Talbot

As an heir of the Enlightenment, Talbot was concerned with practical application as well as with scientific theory, with combining intellectual interests and commercial endeavor. A patrician background, close and supportive family relationships, and the ownership of a lucrative estate, Lacock Abbey, made it possible for him to pursue his multifarious interests to successful conclusions. Besides inventing the first duplicatable image system generated by light, he envisaged the many uses to which photography has since been put, prophesying that "an alliance of science with art will prove conducive to the improvement of both."[20]

Born in 1800, shortly after the death of his father, Talbot was educated at Harrow and Cambridge and became learned in several fields of science. Despite the paltriness of scientific instruction in English universities of the time, he received satisfactory grounding in mathematics and optics, two areas that remained fundamental to his interests throughout his lifetime. Talbot augmented his for-

mal training by closely following the work of British and foreign scientists, including Brewster, Herschel, Arago, Joseph von Fraunhofer, and Augustin Jean Fresnel, and during the 1830s and '40s he traveled abroad almost yearly on scholarly pursuits.

In 1839, events forced Talbot's hand with reference to the researches in photography that he had commenced in 1834—efforts to make images appear on light-sensitive materials—which he then had put aside to continue studies in optics and spectrology. In order to establish the priority of his discovery, Talbot exhibited at the Royal Society the photogenic drawings he had made in 1835 both by direct contact and in the camera, although he apparently had not considered them especially significant prior to the French announcement. His pictures' unflattering comparison with the daguerreotype's greater detail and shorter exposure time, coupled with the realization that his system possessed greater potential, caused Talbot to resume experimentation and resulted shortly in his perfection of the negative/positive process that he called calotype (a name derived from the Greek *kalos*: beautiful), which he patented in 1841. Unlike Daguerre, Talbot continued to improve the discovery, to envision its possibilities, and to devise practical methods of reproducing photographic images by photomechanical means, at the same time producing some 600 photographs, among them genre subjects, landscapes, urban views, and portraits.

In the 1850s, following unsuccessful legal battles to secure his patent rights, he turned again to studies in theoretical mathematics and etymology, and to a new interest, Assyriology, contributing substantially to the decipherment of Assyrian cuneiform. After his death in 1877, the achievements of this fine, if somewhat unfocused scholar were obscured for a long period despite the fact that he had written seven books and more than 50 papers on a variety of scientific topics, held 12 significant patents, and made at least eight comprehensive translations from Assyrian literature, besides discovering the system of photographic image-making that continues in use today.

2.

A PLENITUDE OF PORTRAITS

1839–1890

From that moment onwards, our loathsome society rushed, like Narcissus, to contemplate its trivial image on a metallic plate. A form of lunacy, an extraordinary fanaticism took hold of these new sun-worshippers.

—*Charles Baudelaire, 1859*[1]

It is required of and should be the aim of the artist photographer to produce in the likeness the best possible character and finest expression of which that face and figure could ever have been capable. But in the result there is to be no departure from truth in the delineation and representation of beauty, and expression, and character.

—*Albert Sands Southworth, 1871*[2]

VIRTUALLY FROM ITS INCEPTION, photography has been involved with portraiture, continuing in a new medium the impulse to represent human form that goes back to the dawn of art. The daguerreotype and negative–positive technologies provided the basis for flourishing commercial enterprises that satisfied the needs for public and private likenesses, while individuals who wished to express themselves personally through portraiture were able to do so using the calotype and collodion processes. Approaches to camera likenesses, whether made for amateur or commercial purposes, ranged from documentary to artistic, from "materialistic" to "atmospheric," but whatever their underlying aesthetic mode, photographic portraits reflected from their origin the conviction that an individual's personality, intellect, and character can be revealed through the depiction of facial configuration and expression.

Indeed, from the Renaissance on, portraits have been most esteemed when they portrayed not only the sitter's physical appearance but inner character as well. Toward the end of the 18th century, the concept that pose, gesture, and expression should reveal the inner person became codified in a number of treatises that exhorted the portraitist to rise above merely mechanical graphic representation of the human features. The most significant expression of this idea was contained in the 1789 publication *Essays on Physiognomy* by Johann Kaspar Lavater, a work that proposed that painters develop the "talent of discovering the interior of Man by his exterior—of perceiving by certain natural signs, what does not immediately attract the senses."[3] These ideas still were current when the early promoters of photography were endeavoring to provide quickly made and inexpensive likenesses, and they have continued to inform serious portrait photography on into the 20th century.

Before photography was invented, however, artists already had devised methods to respond to the demand for portraits from a new clientele emerging as a result of the rise of bourgeois societies in England, France, Holland, and America from the 17th century on. Earlier, the painted portrait had been largely the privilege of aristocrats and the very wealthy, but simplifications in terms of what was included in the painting, and transformations in size and materials enabled merchants and farming gentry in the 18th and early 19th centuries to contemplate having portraits made of themselves and their families. By the mid-19th century, in addition to the large, officially sanctioned portraits of royalty and public figures that still were being commissioned, the miniature, the silhouette, the physionotrace, the *camera lucida* drawing, and finally the photograph had arrived to accommodate the needs of new patrons for likenesses. Of these, the miniature was most like the traditional large-scale portrait. Although small, it was painted in full color, often on an ivory surface, and required imaginative skill and a delicate touch to evoke the character of the sitter. Regarded as precious keepsakes, miniatures such as the American example shown—a portrait of Eben Farley by Edward Greene Malbone *(pl. no. 28)*—usually were enclosed in elegant cases or inserted in lockets, the manner in which the daguerreotype portrait would be pre-

28. EDWARD GREENE MALBONE. *Eben Farley*, 1807.
Miniature on ivory. Worcester Art Museum, Worcester, Mass.

sented also. The silhouette, on the other hand, might be considered the poor man's miniature, though it was not always small and often it appealed to those who could also afford a painted likeness. Traced from a cast shadow and inked in, or cut freehand from black paper, which then was mounted on a lighter ground, the silhouette showed only the profile, which would seem to leave little room for disclosing expression. Nevertheless, the conviction that profiles were as strong a key to character as other views impelled Lavater to include an illustration of a silhouetting device *(pl. no. 29)* in his work on physiognomy.

Both miniature and silhouette were unique objects— one-of-a-kind images. For duplicates of the same likeness, whether for personal use or in conjunction with a printed text, different systems were required—among them one made possible by a device called the physionotrace. Invented in France in 1786 by Gilles Louis Chrétien, it consisted of a pointer attached by a series of levers to a pencil, by means of which the operator could trace on paper a profile cast onto glass. A pantograph reduced and transferred the image to a copper plate, which, when engraved and inked, would permit the printing of an edition.[4] From Paris, the physionotrace was introduced to other cities in Europe and taken to the United States by a French émigré, Charles Fevret de Saint-Memin, who practiced the technique in the major New World centers between 1793 and 1844. Numerous figures in the arts, sciences, and public life, among them Thomas Jefferson *(pl. no. 30)*, sat for the four minutes required to make a portrait tracing by physionotrace.

Daguerreotype Portraits

That the photograph might provide a more efficient method than either physionotrace or silhouette to produce faithful likenesses seems obvious today, but when first announced, neither Daguerre's nor Talbot's process was capable of being used to make portraits. In 1839, sittings would have required about 15 minutes of rigid stillness in blazing sunshine owing to the primitive nature of the lenses used and the insufficient sensitivity to light of the chemically treated plates and paper. Because the highly detailed daguerreotype was considered by many the more attractive of the two processes and, in addition, was unrestricted in many localities, individuals in Europe and the United States scrambled to find the improvements that would make commercial daguerreotype portraits possible. They were aided in their purpose by the general efforts in progress to improve the process for all kinds of documentation.

Among the means used to accomplish this goal were the reduction of plate size, the improvement of lenses, the use of mirrors to reverse the plate's laterally inverted image back to normal, the shortening of exposure times by the addition of chemical accelerants in the sensitizing process, and the toning of the plate. Experimentation along these lines took place wherever daguerreotypes were made—in France, the German-speaking countries, and the United States—even in England where there was less commercial daguerreotyping activity owing to patent restrictions.

The earliest improvements were made to cameras and lenses. Daguerre's cumbersome experimental camera was redesigned, and lighter models, accommodating smaller plates, were manufactured in France by both amateurs and optical-instrument makers, among them Alphonse Giroux, a relative of Daguerre's wife who became the first commercial producer of the daguerreotype camera. These changes made it possible to carry the equipment to the countryside or abroad and even to make likenesses, provided the sitter did not object to holding absolutely still for two minutes. But commercial portraiture could not be contemplated until after chemical procedures were improved and a faster portrait lens, designed by Viennese scientist Josef Max Petzval to admit more than 20 times as much light, was

29. JOHANN KASPAR LAVATER. *Silhouette Machine*, c. 1780. Engraving from *Essays on Physiognomy*. Gernsheim Collection, Humanities Research Center, University of Texas, Austin.

30. CHARLES FEVRET DE SAINT-MEMIN.
Thomas Jefferson, 1804. Pastel, charcoal
and chalk on paper. Worcester Art
Museum, Worcester, Mass.

introduced in 1840 by his compatriot Peter Friedrich Voigtländer.

The first efforts to make the silver surface more receptive to light resulted from experiments conducted late in 1840 by English science lecturer John Frederick Goddard. By fuming the plate in other chemicals in addition to mercury vapor, he decreased exposure time considerably; plates sensitized in this manner and used in conjunction with the Petzval lens required exposures of only five to eight seconds. Alongside these developments, a method of gilding the exposed and developed plate in a solution of gold chloride—the invention of Hippolyte Fizeau in 1840—made the image more visible and less susceptible to destruction, and prepared the daguerreotype for its first paying customers.

With the stage set for the business of making portraits by camera, one might ask where the photographers would be found. As is often true when older professions seem on the verge of being overtaken by new technologies, members drift (or hurry) from allied fields into the new one. A large number of miniature and landscape painters, in France especially, realized during the 1840s that their experiences as craftsmen might fit them for making camera portraits (and other documents). French author Charles Baudelaire's contention that the photographic industry had become "the refuge of failed painters with too little talent"[5] may have been too harsh, but it is true that unemployed and poorly paid miniaturists, engravers, and draftsmen turned to portrait photography for the livelihood it seemed to promise. Watchmakers, opticians, tinkers, and

31. ANTOINE FRANÇOIS
CLAUDET. *The Geography
Lesson*, c. 1850.
Daguerreotype. Gernsheim
Collection, Humanities
Research Center,
University of Texas,
Austin.

other artisans also were intrigued by the new technology
and the chance it offered to improve their material well-
being.

In England and the United States, portraiture some-
times attracted businessmen who hired artists and others
to make exposures and process plates. Antoine François
Claudet, a French émigré residing in London, had been in
the sheet glass business before opening a daguerreotype
studio. Eminently successful as a portraitist, Claudet also
demonstrated a broad interest in photography in general—
in technical problems, paper processes, and aesthetic mat-
ters. In spite of his belief that the process was so difficult
that "failure was the rule and success the exception,"[6] the

portraits made in his studio are exceptional in their fine
craftsmanship and in the taste with which groups of fig-
ures were posed, arranged, and lighted *(pl. no. 31)*.

Richard Beard, partner in a coal firm who had bought
a patent from Daguerre's agent in 1841 to sell the rights in
England, Wales, and the colonies, started his portrait stu-
dio with the idea that the new American Wolcott camera,
in which he held an interest, would insure the financial
prospects of daguerreotype portraiture. In addition to sell-
ing licenses to others, Beard eventually owned three estab-
lishments in London, with daguerreotypists hired to oper-
ate the cameras, as seen in the image of Jabez Hogg *(pl. no.
32)* making an exposure in Beard's studio (Hogg, however,

is believed to have been an associate rather than a paid employee).

Since this image may be the earliest representation of the interior of a portrait studio showing a photographer at work, it affords an opportunity to examine the equipment and facilities in use in the opening years of portraiture. A tripod—actually a stand with a rotating plate—supports a simple camera without bellows. It is positioned in front of a backdrop painted in rococo style, against which female figures probably were posed. The stiffly upright sitter—in this case a Mr. Johnson[7]—is clamped into a head-brace, which universally was used to insure steadiness. He clutches the arm of the chair with one hand and makes a fist with the other so that his fingers will not flutter. After being posed, the sitter remains in the same position for longer than just the time it takes to make an exposure, because the operator must first obtain the sensitized plate from the darkroom (or if working alone, prepare it), remove the focusing glass of the camera, and insert the plate into the frame before beginning the exposure. Hogg is shown timing the exposure with a pocket watch by experience while holding the cap he has removed from the lens, but in the course of regular business this operation was ordinarily left to lowly helpers. In all, the posing process was nerve-wracking and lengthy, and if the sitter wished to have more than one portrait made the operator had to repeat the entire procedure, unless two cameras were in use simultaneously—a rare occurrence except in the most fashionable studios. No wonder so many of the sitters in daguerreotype portraits seem inordinately solemn and unbending.

Following the exposure, the plate, with no image yet visible, would have been removed from the camera and taken to the darkroom to develop by fuming in mercury vapor. By 1842/43, when this image was made, darkroom

32. UNKNOWN PHOTOGRAPHER. *Jabez Hogg Making a Portrait in Richard Beard's Studio*, 1843. Daguerreotype. Collection Bokelberg, Hamburg.

33. Daguerreotype case, frame, and matte. International Museum of Photography at George Eastman House, Rochester, N.Y.

operations already were performed under red safelight, an invention Claudet devised to facilitate development. The plate then would have been fixed in hypo and washed in chloride of gold. Because the daguerreotype's principal drawback was thought to be its "ghastly appearance . . . like a person seen by moonlight, or reflected in water,"[8] the portrait would have been hand-colored by a method Beard patented in 1842, but such coloring was practiced almost universally in all the better studios. Although gold toning had made the daguerreotype less susceptible to oxidation, its delicate pigmented surface required protection and was sheathed in a metal mat, covered with glass, and enclosed in a case (pl. no. 33), lending the final assemblage the appearance of the more expensive painted miniatures. Daguerreotype portraits were made in a variety of sizes, all derived from the standard "whole plate," which measured 6½ x 8½ inches. The most common portrait sizes were "quarter plate," 3¼ x 4¼ inches—the size of the Hogg image—and "sixth plate," 2¾ x 3¼ inches.

Unfortunately, the interior shown in the Hogg portrait does not reveal the method of lighting the subject, for illumination was a most important factor in the success of the portrait. Early studios usually were situated on the roofs of buildings where sunlight was unobstructed. On clear days, exposures might be made out-of-doors, although not ordinarily in direct sunlight because of the strongly cast shadows, while interior rooms somewhat resembled greenhouses with banks of windows, adjustable shades, and, occasionally, arrangements of blue glass to soften the light and keep the sitter from squinting in the glare.

With the introduction of the Petzval portrait lens and

the knowledge of the accelerating action of a combination of chemicals in sensitizing the plate, portrait daguerreotyping began to expand throughout Europe. Its popularity in France was immediate. In 1847 some thousand portraits were exhibited in Paris alone, and daguerreotypists were active in many provincial cities as well. A hand-tinted daguerreotype of a family group, made in Paris in the 1850s, is typical of the general level and style of commercial portraiture in that it conveys the manner in which the figures were disposed in the space and the handling of lighting directed to focus the eye both on the familial relationship and on material facts (pl. no. 34).

In the German-speaking cities of Berlin, Hamburg, Dresden, Vienna, and Bern, the volume of daguerreotype portraiture was smaller than that produced in France but seems otherwise comparable in style and craftsmanship. Although artists who took up daguerreotyping occasionally were denounced as "paint-sputterers" who had turned themselves into artistic geniuses with the help of sunlight,[9] they produced skillfully realized and authoritative images, among them Alexander von Humboldt (pl. no. 35) by Hermann Gunther Biow and Mother Albers (pl. no. 36) by Carl Ferdinand Stelzner, a miniature painter of repute who for a brief period was associated with Biow in a Hamburg daguerreotype studio. Another example, an 1845 portrait of three young girls (pl. no. 37) by Berlin daguerreotypist Gustav Oehme, displays a feeling for grace and symmetry in the grouping of the figures and an unusual sense of presence in the direct level gaze of the three youngsters. The Dresden photographer Hermann Krone was acclaimed not only for excellent portrait daguerreotypes but for his topographical views, nude studies, and still lifes (see Chapters 3 and 5); like a number of serious daguerreotypists of this era, he was interested in the widest application of the medium and in its potential for both art and documentation.

The taking of likenesses by daguerreotype spread more slowly through the rest of Europe during the 1840s and '50s. Investigations have turned up a greater amount of activity than once was thought to exist, but, other than in the larger cities, portrait work in Central Europe was done mainly by itinerants. However, much of that was lost in the nationalistic and revolutionary turmoils of the 19th century. In a number of countries, the daguerreotype and, later, photography on paper and glass came to be considered apt tools for ethnic self-realization. One example entitled A Magyar Föld és Népei (The Land of Hungary and Its People), published in 1846/47, was illustrated with lithographs based on daguerreotypes thought to have been made by János Varsányi, and included ethnographic portraits as well as the expected images of landscape and monuments.

34. D. F. MILLET. *Couple and Child*, 1854–59. Daguerreotype. Bibliothèque Nationale, Paris.

Farther east, the progress of both daguerreotype and calotype in France and England was monitored in Russia by the Petersburg Academy of Sciences, and in 1840 Aleksei Grevkov, who tried to work with the less costly metals of copper and brass for the sensitized plate, opened the first daguerreotype studio in Moscow. Sergei Levitskii, who started a portrait studio in Petersburg in 1849 following a period of practice in Italy and study in Paris, experimented with the electroplating of daguerreotypes and with calotype procedures before turning to collodion photography; he sought also to combine electric and natural light in order to shorten the lengthy exposure times made necessary by the long Russian winters. In general, however, the profession of portrait photography in all of these localities, whether practiced for commercial or artistic purposes, was not able to expand until about 40 years after its debut, an understandable state of affairs when one realizes that in the 1840s in Belgrade, for instance, a daguerreotype cost as much as a month of daily dinners in the finest restaurant.[10]

Daguerreotype Portraiture in America

Daguerreotype portraiture was made to order for the United States, where it reached a pinnacle of success dur-

35. HERMANN GUNTHER BIOW. *Alexander von Humboldt, Berlin,* 1847. Daguerreotype. Museum für Kunst und Gewerbe, Hamburg.

ing the 20 years that followed its introduction into the country. In the conjunction of uncanny detail, artless yet intense expression, and naive pose, Americans recognized a mirror of the national ethos that esteemed unvarnished truth and distrusted elegance and ostentation. The power of "heaven's broad and simple sunshine" to bring out "the secret character with a truth that no painter would ever venture upon," which Nathaniel Hawthorne praised in *The House of the Seven Gables,*[11] helped propel the silver camera likeness into an instrument through which the nation might recognize its best instincts. Furthermore, the cohesive bodies of work produced to distill this message were the products of commercial studios, a fact that accorded with the native respect for entrepreneurial initiative.

Attempts to make daguerreotype portraits preoccupied Americans from the start. Shortly after instruction manuals arrived from England in September, 1839, Samuel F. B. Morse, his colleague John William Draper, Professor of Chemistry at New York University, Henry Fitz in Boston, and Robert Cornelius in Philadelphia managed to overcome the estimated 10-20 minute exposure time and produce likenesses—some with eyes closed against the glaring sunlight—by reducing the size of the plate and whitening the sitter's face. The exposure time for Draper's well-known 1840 portrait of his sister, Dorothy Catherine *(pl. no. 38)* (sent by the chemist to John Herschel as a token of esteem for the English scientist's contributions to photography), was 65 seconds, still too long for commercial

portraiture, and an image produced around the same time by Henry Fitz, Jr., a telescope maker, showed the face with eyes closed on a plate the size of a large postage stamp.

Europeans had to wait until 1841 to sit before the studio daguerreotype camera, but in America the first commercial enterprises were opened in New York City by Alexander S. Wolcott and John Johnson and in Philadelphia by Cornelius in the spring of 1840. Working with Fitz, Wolcott and Johnson patented a camera of their own design (mentioned previously in connection with Beard) and installed an ingenious plate glass mirror arrangement in their studio window that increased illumination on the sitter, softening the glare with a baffle of glass bottles filled with a blue liquid. Although their mirror camera was eventually discarded, improvements in daguerreotype technology in the United States were rapid. The finest lenses and

plates continued to be imported, but, during the 1840s, optical systems and cameras as well as plates and chemicals also were manufactured locally, resulting in less expensive products and in the setting-up of photographic supply houses, the forerunners of the giant companies of today. Techniques for harnessing the buffing and polishing machinery to steam power and for creating a rational assembly line—the so-called German system—in manufacturing and studio processing procedures soon followed.

The absolute frontality in Draper's portrait of Catherine, the result of his scientific intent, is nevertheless emblematic of the approach taken by a great many early daguerreotypists in America. The work of John Plumbe, an enterprising businessman out to make a success of selling equipment, supplies, and lessons as well as inexpensive likenesses, who opened a studio in Boston in 1841 and by the mid-'40s was the owner of a chain of portrait estab-

36. CARL FERDINAND STELZNER. *Mother Albers, The Family Vegetable Woman*, 1840s. Daguerreotype. Museum für Kunst und Gewerbe, Hamburg; Staatliche Landesbildstelle, Hamburg.

37. GUSTAV OEHME. *Three Young Girls*, c. 1845. Daguerreotype. Collection Bokelberg, Hamburg.

lishments in 14 cities, is typical of this style. As in the Draper image, the portrait of Mrs. Francis Luqueer *(pl. no. 39)*, taken in one of the Plumbe studios, fills the space frontally and centrally, with no attempt at artistic pose, dramatic lighting, or grandiloquent props such as the drapery swags and statuary found in European daguerreotype portraits. This style must have appealed to Americans in part because of its similarity to the solemn portraits by native limners, exemplified in the likeness of Mrs. John Vincent Storm *(pl. no. 40)* by Ammi Phillips, made just a few years earlier. Nor was the sober approach limited to ordinary folk; the same directness and lack of artifice is seen in an 1847 daguerreotype, by an unknown maker, of the future abolitionist leader Frederick Douglass *(pl. no. 41)*. In this work, the absence of artistic pretension is mod-

erated by the sense of powerful psychological projection, by the suggestion of a distinctive presence.

The successes of the portrait establishments in New York and Washington started by Mathew Brady *(see Profile, Chapter 4)* are now legendary *(pl. no. 42)*. After taking lessons in the daguerreotype process from Morse, this former manufacturer of cases for jewelry and daguerreotypes opened his first "Daguerrean Miniature Gallery" on lower Broadway in 1844. His stated aim, "to vindicate true art" by producing better portraits at higher prices than the numerous competitors who were to be found in the same part of the city, was realized in part as a result of the patronage of Tammany Hall politicians and entertainment entrepreneur P. T. Barnum, and in part because Brady seems to have recognized the value of public relations.[12] By

38. JOHN WILLIAM DRAPER. *Dorothy Catherine Draper*,
1840. Original ruined. Collotype from a daguerreotype.
Chandler Chemical Museum, Columbia University, New York.

39. JOHN PLUMBE. *Mrs. Francis Luqueer*, n.d.
Daguerreotype. New-York Historical Society, New York.

sending portraits of celebrities and views of the gallery
interior to the newly launched picture journals, *Frank
Leslie's* and *Harper's Weekly*, for translation into wood-
engraved illustrations *(pl. no. 43)*, he was able to focus
attention on his own enterprise and on the role the daguer-
reotype might play in urban communication despite the
fact that it was a one-of-a kind image.

This limitation had prompted the enterprising Plumbe
to circumvent the unduplicatable nature of the daguerreo-
type by issuing in 1846 a series of engravings entitled *The
National Plumbeotype Gallery*, based on his camera portraits
of national figures. Brady followed with his *Gallery of Illus-
trious Americans*. Issued in 1850, it comprised 12 lithographs
by François D'Avignon based on Brady studio daguerreo-
types of famous Americans, among them the artist John
James Audubon *(pl. no. 44)*. In both publications, the
implicit assumption that the character of an individual's
contribution to public life can be seen in physical features
and stance is testament to the continuing vigor of Lavater's
ideas about physiognomy.

An even stronger belief in the conjunction of appear-
ance and moral character is evident in the fine daguerreo-
type portraiture that issued from the Boston studio of

40. AMMI PHILLIPS. *Mrs. John Vincent Storm*, c. 1835–40. Oil
on canvas. Brooklyn Museum; gift of Mrs. Waldo Hutchins, Jr.

Albert Sands Southworth and Josiah Hawes. In business for almost 20 years—1843 to 1862—during the ascendancy of transcendentalist thought in that city, the partners approached portraiture with a profound respect for both spirit and fact. Convinced that "nature is not at all to be represented as it is, but as it ought to be and might possibly have been," they sought to capture "the best possible character and finest expression"[13] of which their sitters were capable without departing from the truth. Southworth and Hawes made more than 1,500 likenesses, a great many of which exhibit the exceptional authority apparent in an 1856 image of Charles Sumner *(pl. no. 45)*. A medallion portrait of an unknown sitter *(pl. no. 46)*, made with a sliding plateholder patented by Southworth in 1855, is un-

usually fine. The varied positions of the head, the split dark and light backgrounds, and the arrangement of ovals to suggest a lunar cycle convey the sense that camera images can ensnare time as well as depict physical substances.

It would be a mistake to think that most American daguerreotype portraiture attained the level of the work produced by Southworth and Hawes or even Brady. Most likenesses were simply records, whether made in fashionable studios or by small-town or itinerant daguerreotypists who charged little enough—from 25 cents to one dollar—to enable a broad sector of the populace to afford a portrait. On occasion, such images are appealing because of unusual pose or piquant expression or because of boldness and singular subject matter, as in a portrait of the Sauk chief

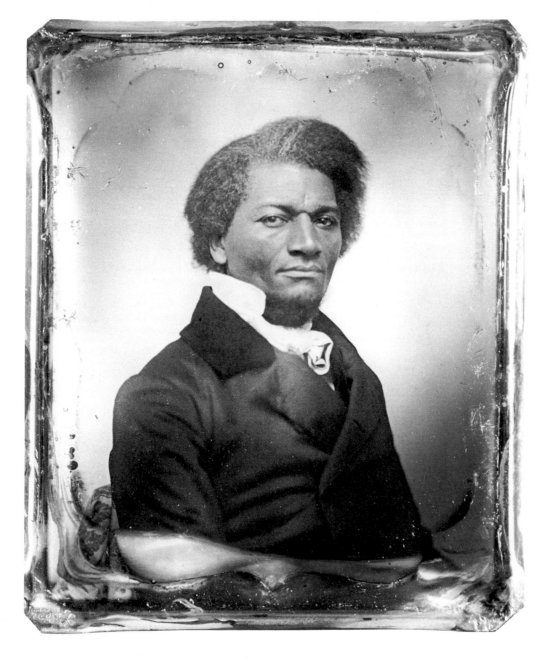

41. UNKNOWN PHOTOGRAPHER. *Frederick Douglass*, 1847. Daguerreotype. Collection William Rubel; National Portrait Gallery, Smithsonian Institution, Washington, D.C.

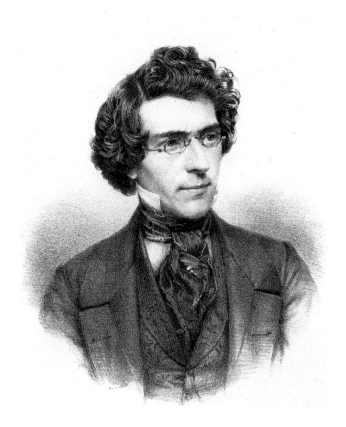

42. FRANÇOIS D'AVIGNON. *Portrait of Mathew Brady* from *The Photographic Art Journal*, Vol. I. 1851. Lithograph. Print Collection, New York Public Library, Astor, Lenox, and Tilden Foundations.

Keokuk *(pl. no. 47)* made by Thomas Easterly, working in Missouri in 1847. On the whole, however, daguerreotype likenesses were remarkably similar to each other in their unrelieved straightforwardness and the solemn, almost frozen demeanor of the sitters. As a writer for *Ballou's Pictorial Drawing-Room Companion* of 1855 observed of a daguerreotype display: "If you have seen one of these cases you have seen them all. There is the militia officer in full regimentals . . . there is the family group, frozen into wax statuary attitudes and looking . . . as if . . . assembled for a funeral. . . . the fast young man, taken with his hat on and a cigar in his mouth; the belle of the locality with a vast quantity of plaited hair and plated jewelry . . . the best baby . . . the intellectual . . . and the young poet. . . . There is something interesting in the very worst of these daguerreotypes because there must be something of nature in all of them."[14]

43. A. BERGHAUS. *M. B. Brady's New Photographic Gallery, Corner of Broadway and Tenth Street, New York* from *Frank Leslie's Illustrated Newspaper*, Jan. 5, 1861. Engraving. Library of Congress, Washington, D.C.

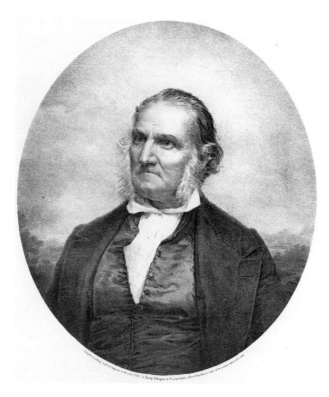

44. FRANÇOIS D'AVIGNON. *John James Audubon* from *Gallery of Illustrious Americans*, 1850. Lithograph after a photograph by Brady. Print Collection, New York Public Library, Astor, Lenox, and Tilden Foundations.

Of course, the unrelieved seriousness of expression in daguerreotype portraiture was in part the result of the lengthy process of arranging the sitter, head in clamp and hand firmly anchored, and then making the exposure, but spontaneity not only was technically difficult to achieve, it also was considered inappropriate to the ceremonial nature of an undertaking that for most sitters required proper deportment and correct attire. Even more joyless were the images of the dead *(pl. no. 48)* made as keepsakes for bereaved families for whom they possessed "the sublime power to transmit the almost living image of . . . loved ones."[15] Nevertheless, this "Phantom concourse . . . mute as a grave,"[16] evoked a singular response in the United States. As Richard Rudisill has pointed out in a provocative study, "the daguerreotypists employed their mirror images for the definition and recording of their time and their society. . . . They confronted Americans with themselves and sought to help them recognize their own significance."[17]

In the rest of the Americas, both north and south, portraiture followed a course similar to that in eastern Europe, with the exception that the first portraits in Canada and Latin America often were made by itinerants from the United States and Europe seeking a lucrative employ-

ment. By the 1850s permanent studios had been established in the major cities of Canada and South America, where despite the provincial character of urban life in those regions, both metal and paper portraits were seen as symbols of economic well-being and national self-realization.

Among the itinerant photographers traveling to Canada, mention is made of a female daguerreotypist who spent a month making likenesses in Montreal in 1841. The names of other women crop up in notices and reports on photography's early years to suggest that in spite of the medium's association with chemicals and smelly manipulations, it was not in itself regarded as an unsuitable pastime for women. Anna Atkins, Julia Margaret Cameron, Geneviève Elizabeth Disdéri, Lady Clementina Hawarden, Mrs. John Dillwyn Llewelyn, and Constance Talbot in Europe and Mary Ann Meade in the United States are only the best known of the women drawn to photography either in association with other members of the family or on their own. Women also were active behind the scenes in daguerreotype and paper printing establishments where they worked on assembly lines; later they were employed in

45. ALBERT SANDS SOUTHWORTH and JOSIAH JOHNSON HAWES. *Charles Sumner*, 1856. Daguerreotype. Bostonian Society, Boston.

46. ALBERT SANDS SOUTHWORTH and JOSIAH JOHNSON HAWES. *Unknown Lady*, n.d. Medallion daguerreotype.
Museum of Fine Arts, Boston; gift of Edward Southworth Hawes in Memory of his Father, Josiah Johnson Hawes.

47. THOMAS EASTERLY. *Keokuk, Sauk Chief*, 1847. Modern gelatin silver print from a copy negative of the original daguerreotype in the collection of the Missouri Historical Society. National Anthropological Archives, Smithsonian Institution, Washington, D.C.

firms that produced and processed photographic materials, among them those owned by George Eastman and the Lumière brothers.

Portraits on Paper: The Calotype

Calotype portraiture never achieved the commercial popularity of the daguerreotype. Talbot's first successes in portraying the human face occurred in October, 1840, when he made a number of close-ups of his wife Constance, among them a three-quarter view of exceptional vitality requiring a 30 second exposure *(pl. no. 50)*. Convinced that paper portraiture was as commercially feasible as the daguerreotype, Talbot entered into an arrangement with a painter of miniatures, Henry Collen, to make calotype likenesses, but the resulting portraits, including one of Queen Victoria and the Princess Royal *(pl. no. 49)*, often were so indistinct that considerable retouching—at which Collen excelled—was necessary. Since neither Collen nor Talbot's next partner in portraiture, Claudet, were able to convince the public that the duplicatable paper image with its broad chiaroscuro style was preferable to the fine detail

48. UNKNOWN PHOTOGRAPHER (American).
Dead Child, c. 1850. Daguerreotype. Collection Richard
Rudisill, Santa Fe, N.M.

49. HENRY COLLEN. *Queen Victoria with Her Daughter,
Victoria, Princess Royal*, 1844–45. Calotype. Royal Library,
Windsor Castle. Reproduced by Gracious Permission of
Her Majesty Queen Elizabeth II.

of the daguerreotype, commercial paper portraiture in En-
gland languished until the era of the glass negative.

The situation was different in Scotland, where, as noted
in Chapter 1, Talbot's associate Sir David Brewster was
instrumental in introducing the calotype to David Octavius
Hill and Robert Adamson *(see Profile)*. In an endeavor to
record the 400 or so likenesses to be included in a painting
that Hill decided to make in 1843 commemorating the
separation of the Church of Scotland from the Church of
England, the two became so caught up in photography
that they also produced hundreds of commanding por-
traits of individuals who had no relationship to the reli-
gious issues that were the subject of the painting. Aware
that the power of the calotype lay in the fact that it looked
like the "imperfect work of man . . . and not the perfect
work of God,"[18] Hill and Adamson used the rough texture
of the paper negative to create images with broad chiaro-
scuro effects that were likened by contemporaries to the
paintings of Sir Joshua Reynolds and Rembrandt.

Among the sitters, who posed for one to two minutes
either in an out-of-doors studio in Edinburgh, with a
minimum of furnishings arranged to simulate an interior,
or on location, were artists, intellectuals, the upper-class
gentry of Scotland, and working fisherfolk in the nearby
town of Newhaven. Simplicity of pose and dramatic yet
untheatrical lighting emphasize the solid strength of the
sitter James Linton *(pl. no. 51)*, a working fisherman. On
the other hand, the genteel character of well-bred Victorian
women is brought out in the poses, softer lighting, and
gracefully intertwined arrangement of the three figures in
The Misses Binny and Miss Monro (pl. no. 52). Such Hill and
Adamson images recall the idealized depictions of women
in paintings by Daniel McClise and Alfred Chalons, pop-
ularized in the publication *Book of Beauty*, but as photo-
graphs they gain an added dimension because the camera
reveals a degree of particularity entirely lacking in the
paintings.

In artistic and literary circles in Britain and France, these
photographs were considered the paradigm of portrait
photography in that they made use of traditional artistic
concepts regarding arrangement and employed atmo-
spheric effects to reveal character. During the 1850s, a

50. WILLIAM HENRY FOX
TALBOT. *"C's Portrait"*
(Constance Talbot), Oct. 10,
1840. Calotype. Royal
Photographic Society, Bath,
England.

group that included William Collie in the British Isles and
Louis Désiré Blanquart-Evrard, Charles Hugo, Gustave
Le Gray, Charles Nègre, and Victor Regnault on the Con-
tinent followed a similar path, using themselves, members
of their families, and friends to make calotype portraits
that emphasize light and tonal masses and suppress fussy
detail.

Portraits on Paper: Collodion/Albumen

For commercial portraitists, Frederick Scott Archer's
invention of the collodion negative seemed at first to solve
all problems. The glass plate made possible both sharp
definition and easy duplication of numbers of prints on
paper from one negative, while the awkward chemical pro-

cedures that the wet-plate process entailed were minimized
in a studio setting. Collodion opened up an era of com-
mercial expansion, attracting to the profession many pho-
tographers who resorted to all manner of inducements to
entice sitters—among them elegantly appointed studios;
likenesses to be printed on porcelain, fabric, and other
unusual substances, as well as on paper; or set into jewelry;
photosculpture; and the most popular caprice of them
all—the *carte-de-visite*.

But before public acceptance of paper portraiture was
established, photographers were occupied for a number of
years with a half-way process, in which the collodion glass
negative was used to create a one-of-a-kind image that was
less costly than the daguerreotype. While both Talbot and
Archer had been aware that a bleached or underexposed

51. DAVID OCTAVIUS HILL and ROBERT ADAMSON. *Redding the Line (Portrait of James Linton)*,
c. 1846. Calotype. Scottish National Portrait Gallery, Edinburgh.

52. DAVID OCTAVIUS HILL and ROBERT ADAMSON. *The Misses Binny and Miss Monro*, c. 1845.
Calotype. Metropolitan Museum of Art, New York; Harris Brisbane Dick Fund, 1939.

53. UNKNOWN PHOTOGRAPHER (American). *Untitled Portrait*, c. 1858. Ambrotype with backing partially removed to show positive and negative effect. Gernsheim Collection, Humanities Research Center, University of Texas, Austin.

glass negative could be converted to a positive by backing the glass with opaque material (paper or fabric) or varnish *(pl. no. 53)*, the patent for this anomaly was taken out by an American, James Ambrose Cutting, in 1854. Called ambrotypes in the United States and collodion positives in Great Britain, these glass images were made in the same size as daguerreotypes and were similarly treated— hand-colored, framed behind glass, and housed in a slim case. In an unusual cultural lag, Japanese photographers adopted and used this technique until the turn of the century, long after it had been discarded in Europe and the United States. Framed in traditional kiri-wood boxes, the portraits were commissioned by Japanese sitters rather than intended for sale to foreign visitors.

By the mid-1850s, when this process was supplanting the metal image in Europe (though not yet in the United States), the case-making industry was expanding. The earliest daguerreotypes had been enclosed in cases of *papier mâché* or wood covered with embossed paper or leather and usually were lined with silk in Europe and velvet in the United States, when they were not encased in lockets, brooches, and watchcases. In 1854, the "union" case was introduced. Made in the United States of a mix-

ture of sawdust and shellac, these early thermoplastic holders were exported globally, eventually becoming available in a choice of about 800 different molded designs.

The tintype, even less expensive than the ambrotype (to which it was technically similar), was patented in 1856 by an American professor at Kenyon College in Ohio.[19] Like the daguerreotype, it was a one-of-a-kind image on a varnished metal plate (iron instead of silvered copper) that had been coated with black lacquer and sensitized collodion. Dull gray in tone without the sheen of the mirrorlike daguerreotype, the tintype was both lightweight and cheap, making it an ideal form for travelers and Civil War soldiers, many of whom were pictured in their encampments by roving photographers with wagon darkrooms.

The combination of a negative on glass coated with sensitized collodion and a print on paper coated with sensitized albumen—the collodion/albumen process— made commercial portraiture possible on a previously undreamed-of scale, despite the fact that the prints themselves were subject to fading and discoloration. From the 1850s until the 1880s, studios in the major capitals of the world invested in ever-more elegant and unusual furnishings in order to attract a well-paying clientele. As the display of status through attire and props grew more prominent, the goal of revealing character became secondary, and portraits often seemed merely to be topographies of face and body, "dull, dead, unfeeling, inauspicious,"[20] as expressed in the words of the time.

The skillful handling of pose, lighting, props, and decor visible in the works of the highly regarded European portraitists Franz Hanfstaengl, Antoine Samuel Adam-Salomon, and Camille Silvy became models for emulation. Hanfstaengl, already renowned as a lithographer, opened a photographic art studio in Munich in 1853. He soon won acclaim internationally for the tasteful poses, modulated lighting, and exceptional richness of his prints on toned albumen paper, as exemplified by *Man with Hat (pl. no. 54)*. Hanfstaengl's earlier work—exhibited at the 1855 *Exposition Universelle* in Paris, where it was criticized for extensive retouching on the negative—is believed to have inspired Adam-Salomon to change his profession from sculptor to photographer. The poses (modeled on antique sculpture) preferred by Adam-Salomon and his penchant for luxurious fabrics and props appealed to the materialistic French bourgeoisie of the Second Empire. The photographer's heavy hand with the retouching brush—the only thing considered disagreeable about his work—is apparent in the lighter tonality behind the figure in this image of his daughter *(pl. no. 55)*.

Besides attesting to the sitter's status, props and poses could offer clues to personality, enriching the image psychologically and visually. The oval picture frame used

54. FRANZ HANFSTAENGL. *Man with Hat,* 1857. Salt print. Agfa-Gevaert Foto-Historama, Cologne, Germany.

55. ANTOINE SAMUEL ADAM-SALOMON. *Portrait of a Girl,* c. 1862. Albumen print. Daniel Wolf, Inc., New York.

coyly as a lorgnette and the revealing drapery in the portrait of the Countess Castiglione *(pl. no. 56)* by Louis Pierson,[21] a partner in the Paris studio of Mayer Brothers and Pierson, suggest the seductive personality of Napoleon III's mistress (who was rumored to be an Italian spy). Oscar Gustav Rejlander's portrait of Lewis Carroll (the Reverend Charles L. Dodgson—*pl. no. 57),* which depicts the author of *Alice in Wonderland* holding a lens and polishing cloth, suggests through his expression and demeanor the sense of propriety that Carroll believed he was bringing to his photography. This work is one of Rejlander's numerous portraits, which include images of friends as well as amusing views of himself, his female companion, and the children who figured in the genre scenes for which he is better known *(pl. no. 266).*

As studio photography preempted the role of the portrait painter, the aesthetic standards of handmade likenesses were embraced by the photographic portraitists. Manuals appeared early in the daguerreotype era and continued through the collodion period (and into the 20th century), giving directions for appropriate dress and the correct colors to be worn to take advantage of the limited sensitivity of daguerreotype and glass plates. Included also were instructions for the proper attitudes that sitters should assume when posing. Because the public still believed that hand-painted portraits were more prestigious than photographs, likenesses often were painted over in watercolors, oils, or pastels, without entirely obliterating the underlying trace of the camera image, as in a typical example *(pl. no. 332)* from the studio of T. Z. Vogel and C. Reichardt, in Venice.

Meanwhile, the professional portrait painter, aware of the public appetite for exactitude, found the photograph a convenient crutch, not just for copying the features but actually for painting upon. Projection from glass positives to canvas was possible as early as 1853; shortly afterward, several versions of solar projection enlargers—including one patented in 1857 by David Woodward, a professor of fine arts in Baltimore—simplified enlargement onto sensitized paper and canvas. When partially developed, the image could be completely covered with paint—as X-rays have disclosed was the case in the life-size painted portrait of Lincoln *(pl. no. 58)* by Alexander François. This practice, common in the last half of the 19th century, was not considered reprehensible because in the view of many painters the role of photography was to be the artist's helpmate in creative handwork. Although such photographic "underpainting" was rarely acknowledged, the desire for verisimilitude on the part of painter and public and the hope for artistic status on the part of the photographer resulted in a hybrid form of portraiture—part photochemical and part handwork.

56. LOUIS PIERSON. *Countess Castiglione*, c. 1860. Albumen print (previously attributed to Adolphe Braun). Metropolitan Museum of Art, New York; David Hunter McAlpin Fund, 1947.

Carte-de-visite and Celebrity Portraits

With the possibility of endless replication from the collodion negative, it was only a matter of time before a pocket-size paper portrait was devised. Suggestions along this line, made by several photographers in Europe and the United States, included the substitution of a likeness for the name and address on a calling card—the traditional manner of introducing oneself among middle- and upper-class gentry—and the affixing of small portraits to licenses, passports, entry tickets, and other documents of a social nature. However, André Adolphe Disdéri, a photographer of both portraits and genre scenes who also was active in improving processes and formulating aesthetic standards, patented the *carte-de-visite* portrait in 1854. This small image—3½ x 2½ inches, mounted on a slightly larger card—was produced by taking eight exposures during one

58. ALEXANDER FRANÇOIS. *Abraham Lincoln*, n.d. Oil on canvas. Collection George R. Rinhart.

57. OSCAR GUSTAV REJLANDER. *Lewis Carroll (Rev. Charles L. Dodgson)*, March 28, 1863. Albumen print. Gernsheim Collection, Humanities Research Center, University of Texas, Austin.

sitting, using an ingenious sliding plate holder in a camera equipped with four lenses and a vertical and horizontal septum *(pl. no. 226)*. A full-length view of the figure in more natural and relaxed positions became possible, and it was not necessary for each pose to be exactly the same, as can be seen in an uncut sheet of *carte-de-visite* portraits taken by Disdéri *(pl. no. 59)*.

The reasons why the *carte* portraits became so enormously popular after 1859 are not entirely clear, but for a considerable part of the next decade this inexpensive format captured the public imagination in much the same way the stereograph view had. Portrait studios everywhere—in major cities and provincial villages—turned out millions of full- and bust-length images of working and trades people as well as of members of the bourgeoisie and aristocracy. These could be sold inexpensively because unskilled labor cut the images apart after processing and pasted them on mounts on which trademarks or logos of the maker appeared either on the front of the card, discreetly placed below the image, or on the reverse. Frequently, elaborate displays of type and graphic art suggested the connections between photography and painting. Backgrounds still included painted gardens, balustrades, drapery swags, and furniture, but sitters also were posed against undecorated walls, and vignetting—in which the

background was removed—was not uncommon. Adults displayed the tools of their trade, the marks of their profession, and the emblems of their rank; children were shown with toys; and attention was paid to women's attire and hair arrangements. Nevertheless, apart from the informality of pose that imbues some of these images with a degree of freshness, *carte* portraits offered little compass for an imaginative approach to pose and lighting as a means of evoking character.

As their popularity continued, famous works of art, well-known monuments, portraits of celebrities and of fashionably attired women (at times pirated and reproduced from other *cartes* rather than from the original collodion negative) appeared on the market. That the wide dispersal of celebrity images had consequences beyond that of a pleasant pastime can be seen in the fact that already in the 1860s such images influenced the course of a public career. Both the moderately gifted Jenny Lind and the unexceptional Lola Montez became cult figures in the United States largely owing to their promotion through *carte* portraits. Lincoln is said to have ascribed his election to the Presidency at least in part to Brady's *carte* of him when he still was an unknown, and both the French and British Royal families permitted the sales of *carte* portraits of themselves; on the death of Prince Albert, for example, 70,000 likenesses of Queen Victoria's consort were sold. *Cartes* also took over the function formerly performed by lithographs and engravings in popularizing types of female

59. ANDRÉ ADOLPHE EUGÈNE DISDÉRI. *Portrait of an Unidentified Woman*, c. 1860–65.
Uncut albumen print from a *carte-de-visite* negative. Gernsheim Collection, Humanities Research Center, University of Texas, Austin.

beauty and fashionable attire. Silvy, a French photographer of artistic taste who in 1859 opened a studio in his lavishly decorated London residence, specialized in posing his upper-class sitters in front of mirrors so that the softly modulated lighting not only called attention to attire and hairstyle—fore and aft, so to speak—but surrounded them also with an aura of luxuriousness.

Cartes were avidly collected and exchanged, with ornate albums and special holders manufactured to satisfy the demand for gimmickry connected with the fad. This activity received a boost from the enthusiasm of Queen Victoria, who accumulated more than one hundred albums of portraits of European royalty and distinguished personages. Indeed, the British royal family was so taken with photography that they not only commissioned numberless portraits but purchased genre images, sent photographs as state gifts, underwrote photographic ventures, and were patrons of The Photographic Society; in addition they installed a darkroom for their own use in Windsor Castle. British and French monarchs staunchly supported photography in general because it represented progress in the chemical sciences, which was emblematic of the prosperity brought to their respective nations, and also because the easily comprehended imagery accorded with the taste for

60. SPENCER Y CIA.
Chilean Ladies, n.d.
Albumen print. Neikrug
Photographica, Ltd., New
York.

61. UNKNOWN PHOTOGRAPHER (American). *Seventy Celebrated Americans Including All the Presidents*, c. 1865. Albumen print. Library Company of Philadelphia.

verisimilitude evinced by the middle class and their royal leaders.

During the 1860s, portrait studios began to assemble a selection of individual likenesses on a single print. Produced by pasting together and rephotographing heads and portions of the torso from individual *carte* portraits, these composites paid scant attention to congruences of size and lighting, or to the representation of real-looking space. Designed as advertising publicity to acquaint the public with the range and quality of a particular studio's work, as in this example from the studio of a portrait photographer

in Valparaiso and Santiago, Chile *(pl. no. 60)*, the format was taken over as a means of producing thematic composites of political *(pl. no. 61)* or theatrical figures that might be sold or given away as souvenirs.

One form of commercial exploitation of portrait photography in Europe that did not fare as well as *cartes* was called photosculpture. Invented by François Willême in France in 1860, this three-dimensional image was produced by a company whose English branch briefly included the usually prudent Claudet as artistic director. The procedure necessitated a large circular studio in which 24

62. Adolphe Jean François Marin Dallemagne. *Gallery of Contemporary Artists,* c. 1866. Albumen prints assembled into *Galerie des artistes contemporaines.* Bibliothèque Nationale, Paris.

63. REUTLINGER STUDIO. *Mlle. Elven*, 1883. Albumen or gelatin silver print. Bibliothèque Nationale, Paris.

64. PAUL NADAR. *Lillie Langtry*, n.d. Gelatin silver print. Bibliothèque Nationale, Paris.

cameras were positioned to take simultaneous exposures of a centrally placed sitter. These were processed into lantern slides, projected, and traced in clay (or wood in one adaptation) with a pantograph, theoretically insuring a head start on exactitude for the sculptor. Despite royal patronage, photosculpture had a short life, although every once in a while this gimmick crops up again as an idea whose time has come.

Editions of prints on paper in sizes and formats other than *cartes* also were popular from the 1860s on. Because the problems with albumen prints mentioned in Chapter 1 never were completely solved, carbon printing—often referred to as "permanent"—and Woodburytype reproduction were favored for the production of celebrity likenesses that appeared in the "galleries" and albums issued by photographers and publishers in western Europe and the United States. Well-known examples are Hanfstaengl's *Album der Zeitgnossen* (*Album of Contemporary Figures*), portraits of German scientists, writers, and artists; the British *Gallery of Photographic Portraits*, undertaken by the studio of Joseph John Elliott and Clarence Edmund Fry

(who encountered refusals from politicians who found their likenesses too realistic); and the *Galerie des contemporaines* (*Gallery of Contemporaries*)—initiated in 1859 in Paris by Pierre Petit. This project was a precursor of the highly regarded French series, *Galerie contemporaine, litteraire, artistique* (*Contemporary Gallery of Writers and Artists*), published intermittently by Goupil and Company between 1876 and 1884, to which all the major portraitists of the period contributed. Less concerned than most studio portraiture with fashionable decor and dress, this collection was "physiognomic" in intent—to evoke the character of the giants of French literary and artistic life through pose and expression, as in the commanding presence projected in Etienne Carjat's portrait of Victor Hugo (*pl. no. 94*). Other such publications catered to the taste for elaborate decor, as in Adolphe Jean François Marin Dallemagne's *Galerie des artistes contemporaines* (*Gallery of Contemporary Artists*) of 1866 (*pl. no. 62*), a group of 50 portraits of artists shown posing in *trompe l' oeil* frames that are suggestive of the conceits of baroque portrait painting.

The best-known photographer of French intellectual,

65. Nadar (Gaspard Félix Tournachon). *Sarah Bernhardt*, 1865. Albumen print. Bibliothèque Nationale, Paris.

literary, and artistic figures during the collodion era is Gaspard Félix Tournachon, known as Nadar *(see Profile)*. His aim in portraiture was to seek, as he wrote, "that instant of understanding that puts you in touch with the model—helps you sum him up, guides you to his habits, his ideas, and character and enables you to produce . . . a really convincing and sympathetic likeness, an intimate portrait."²² One example—a portrait of the young Sarah Bernhardt in 1865 *(pl. no. 65)*—typifies Nadar's ability to organize the baroque forms of drapery, a truncated classical column, and the dramatic contrasts of hair and skin and still suggest character—in this case both the theatricality and vulnerability of a young actress who had just achieved her first stage success. As French art critic Philippe Burty wrote of Nadar's entries exhibited at the *Société Française de Photographie* exhibition in 1859, "his portraits are works of art in every accepted sense of the word," adding that "if photography is by no means a complete art, the photographer always has the right to be an artist."²³ Nadar's later output included many unexceptional portraits of entertainers and modishly dressed women, a direction necessitated by the demands of the middle class for glamorous images that became even more marked when his son Paul took control of the studio in the late 1880s. The style of Paul Nadar's portrait of the royal mistress Lillie Langtry *(pl. no. 64)*, like that of contemporaries such as Charles and Émile Reutlinger *(pl. no. 63)* whose firm began to specialize

in fashion photography in the same years, was oriented toward evoking glamour by seductive pose, bland expression, and attention to elegant attire.

By the time collodion/albumen photographs had begun to displace daguerreotypes and ambrotypes in the United States, the Civil War had erupted, relegating portraiture to a secondary place in the minds of many photographers. Brady, whose Washington studio had been opened in 1858 to take advantage of the concentration of political figures in the Capital, turned his attention to war reportage (to be discussed in Chapter 4), but continued to make portraits. In addition, Lincoln, his family, the Cabinet members and the Army generals all sat for other well-known portraitists, among them Alexander Gardner, a former manager of Brady's Washington gallery who took what may be the last likeness of the President in April, 1865, shortly before his assassination *(pl. no. 68)*.²⁴

In the period after the Civil War, besides *cartes* and cabinet-size images (approximately 4 x 5½ inches, mounted on a slightly bigger card), larger formats called Promenade, Boudoir, and Imperial Panel were introduced to appeal to the newly rich bourgeoisie that had emerged. Fashionable portrait studios in large cities, among them Fredericks, Gurney, Falk and Kurtz in New York, Gutekunst in Philadelphia, and Bachrach in Baltimore, served as pacesetters in terms of pose, decor, lighting, and the manner of presenting the finished image. As in Europe, there was a

68. ALEXANDER GARDNER. *Abraham Lincoln*, April, 1865. Albumen print. Library of Congress, Washington, D.C.

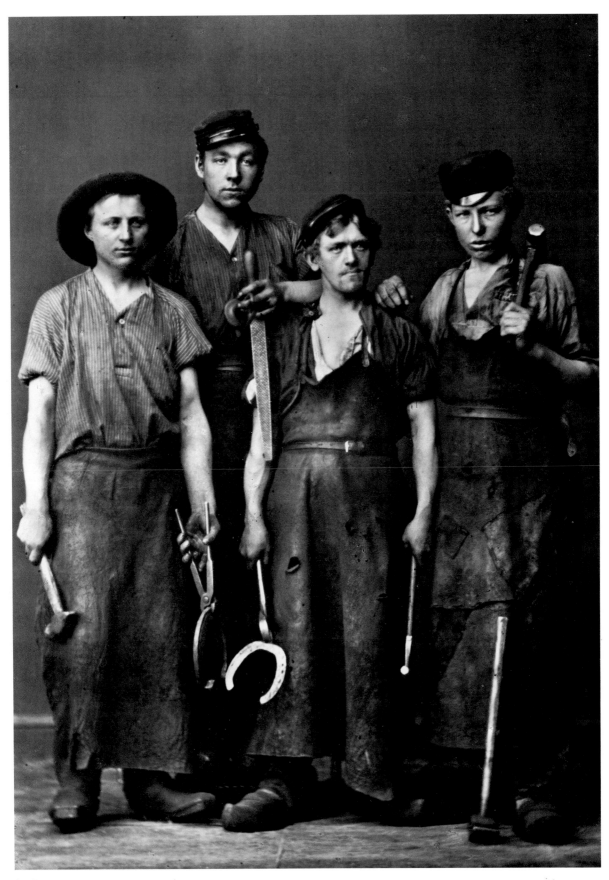

69. HEINRICH TÖNNIES. *Four Young Blacksmiths,* c. 1881. Modern gelatin silver print from original negative. Formerly collection Alexander Alland, North Salem, N.Y.

70. AWIT SZUBERT. *Amelia Szubert*, c. 1875. Albumen print. Collection Konrad Pollesch, Cracow; International Center of Photography, New York.

71. WILL SOULE. *Brave in War Dress*, c. 1868. Albumen print. Western History Collection, Natural History Museum of Los Angeles County, Los Angeles.

demand for images of theatrical and entertainment personalities that was satisfied in the main by the New York studios of Napoleon Sarony and his competitor José Mora. A prominent lithographer before the War, Sarony made over 40,000 negatives of celebrities, some of whom were paid extravagantly for the sitting. The eclectic decor visible in his images of Sarah Bernhardt *(pl. no. 66)* and strongman Eugene Sandow *(pl. no. 67)* necessitated a large collection of fusty props and led to a reference to his studio as a "dumping ground . . . for unsaleable idols, tattered tapestry and indigent crocodiles."[25]

During the last 40 years of the 19th century, portraiture expanded more rapidly in the less-industrialized portions of Europe, and in Australia, India, China, Japan, Mexico, and South America. Owing to the fact that owners of commercial studios in provincial towns frequently served a clientele drawn from all classes, they sometimes produced extensive documentations not only of physiognomies but of social and psychological attitudes. One such example is the large output of portraits by Danish photographer

Heinrich Tönnies, working in Aalborg from the 1860s into the 1900s, which includes some 750 portraits of working people attired in the garments and displaying the tools of their occupations. Despite the formality of the poses in studio settings *(pl. no. 69)*, these images are not merely descriptive but suggest prevailing attitudes toward work on the part of both photographer and sitters. In some localities, patriots saw the camera as a means of emphasizing ethnic or national origin. A fine line may separate the portrait taken by Polish photographer Awit Szubert of his wife in native dress *(pl. no. 70)* from many similar images of locally costumed figures that were made and sold in *carte* and cabinet size for the tourist trade, but even in some of these images a sense of national pride is discernible.

Besides playing a role in the development of cultural nationalism in Europe, portraits also reflected the rising interest in anthropology. In the western hemisphere, early manifestations of the interest in native types included portraits of individual members of the Indian tribes indigenous to the West, made in the course of the land surveys

and explorations *(see Chapter 3)* that followed the end of the Civil War. In the wake of these expeditions, several frontier studios opened their doors to Native American sitters, among them that of Will Soule, in Fort Sill, Oklahoma, which specialized in commercial portrayals of individuals posed formally in front of painted backdrops, as in an 1868 photograph titled simply *Brave in War Dress (pl. no. 71)*. In South America, Marc Ferrez, the best-known Brazilian photographer of the 19th century, photographed Indians of the Amazon region while on expeditions to the interior in the mid-1870s; in the same years strong interest in images of indigenous peoples prompted studios in Australia to photograph the Aborigines of the region.

Camera Portraits in Asia

The introduction of portrait photography in the Far East coincided with changes from insular traditionalism to the acceptance of modern ideas in science, symbolized by the 1854 American diplomatic ultimatum that Japan be opened to the West; indeed, the ideographs used to denote photograph in Japanese *(shashin)* literally mean "copy truth." The first portrait daguerreotypes made in that country appear to be those by Eliphalet Brown, Jr., American artist and photographer attached to Commodore Matthew Perry's expedition to Japan, but experimentation with the daguerreotype process had been going on since 1848 when a Nagasaki merchant imported the first camera.[26] However, successful daguerreotypes by Japanese photographers were not made until 1857, only a year before the first collodion portraits by a Japanese photographer. As shown in a woodblock print of 1861, *French Couple with a Camera (pl. no. 72)*, photographers working in Japan during the early period were foreigners who not only provided views and portraits but taught the process to the Japanese. Apparently by the mid- to late-'70s they were so successful that professional studios were opened in all the major cities of Japan, with more than 100 in the Tokyo area alone; even the unapproachable royal family permitted members to sit for camera likenesses.

Although China remained isolated from Western ideas of progress longer than Japan, photographers from the West began to make portraits there, too, during the 1860s. Among the succession of foreigners, Milton Miller, a Californian who ran a studio in Hong Kong in the early 1860s, made formally posed yet sensitive portraits of Cantonese merchants, Mandarins, and their families, while the Scottish photographer John Thomson photographed workers and peasants as well, including their portraits in his ambitious four-volume work *Illustrations of China and Its People*, published in England in 1873/74. It is thought that native Chinese photographers were introduced to photography

when they were employed during the 1850s as copyists and colorists in the Hong Kong studios run by foreigners, but while some 20 native studios with Chinese names are known, little else has been discovered about these portraitists. The studio of Afong Lai appears to have been the most stable of the native-owned commercial enterprises, lasting from 1859 on into the 20th century and with the artistry of its work acclaimed by Thomson.

On the Indian subcontinent, however, photography in all its varieties, including portraiture, was promoted by the British occupying forces and eagerly taken up by Indian businessmen and members of the ruling families. Commercial firms owned by Indian photographers, individuals appointed by the courts, and those working in bazaars began to appear in large cities after the 1860s in order to supply the British and Indian ruling class with images of themselves. The most renowned enterprise was that started

72. YOSHIKAZU ISSAN. *French Couple with a Camera,* 1861. Color woodblock print. Agfa-Gevaert Foto-Historama, Cologne, Germany.

73. LEWIS CARROLL (REV. CHARLES L. DODGSON). *Edith, Lorina, and Alice Liddell*, c. 1859. Albumen print. Photography Collection, Humanities Research Center, University of Texas, Austin.

by Lala Deen Dayal, owner of studios in Indore, Bombay, and Hyderabad from the 1880s on, who became court photographer to the nizam of Hyderabad. Many portraits made in India during this period were painted over in the traditional decorative style of Indian miniatures, just as in the West painted camera portraits were treated naturalistically. This attitude toward the photographic portrait in India has led to the suggestion that the camera itself was used in a different fashion than in the West, that Indian photographers were somehow able to avoid the representation of space and dimensionality even before the paint was added.[27] However, allowing for obvious differences in pose, dress, and studio decor, Indian photographic portraits that were not painted over do not seem remarkably different from the general run of commercial portraiture elsewhere.

The Portrait as Personal Expression

Alongside the likenesses produced by commercial studios, a more intimate style of portraiture developed in the work of amateurs—men and women in mostly comfortable circumstances who regarded photography as an agreeable pastime but did not make their living from it. During the 1860s and '70s this group—which included Olympe Count Aguado and Paul Gaillard on the Continent and Julia Margaret Cameron, Lewis Carroll, Cosmo Innes, and Clementina, Lady Hawarden, in Britain—used the collodion process to portray family and associates, at times

in elaborately casual poses, in actual domestic interiors and real gardens. When Carroll photographed his artistic and intellectual friends and their children, he favored the discreet and harmonious arrangements seen in his grouping of the Liddell sisters—Edith, Lorina, and Alice *(pl. no. 73)*. At the same time, his stress on the virginal beauty of these young sitters (also evident in his nude photos, *pl. no. 334*) reflects an ambivalence that embraced ideals of feminine innocence and his own deep-seated sexual needs.

Cameron, the most widely known Victorian portraitist (usually considered an amateur even though she sold and exhibited her work), also used the camera to idealize her subjects. Seeking out men and women whose individuality or impressive artistic and literary contributions appeared to her to redeem the materialism of the time, she importuned them to pose so that she might record, in her words, "faithfully, the greatness of the inner as well as the features of the outer man."[28] Avoiding sharp focus, she concentrated on the evocative handling of light, seen at its most effective in portraits of Sir John Herschel—a family friend of many years *(pl. no. 74)*—and of her niece Julia Jackson, who had just wed Herbert Duckworth and was to be the mother of novelist Virginia Woolf *(pl. no. 75)*.

Cameron's work, like that of Carroll, can be related to the Pre-Raphaelite search for ideal types, but her portrait style especially seems to have been inspired by the paintings of her artistic mentor, George Frederic Watts, which in turn reflected the taste among the British intelligentsia for Rembrandt-like chiaroscuro effects in the treatment of

74. JULIA MARGARET CAMERON. *Sir John Herschel*, April, 1867. Albumen print.
Museum of Fine Arts, Boston; Gift of Mrs. J. D. Cameron Bradley.

75. Julia Margaret Cameron. *My Niece Julia Jackson*, 1867. Albumen print. National Portrait Gallery, London.

form. Critical reaction from Cameron's contemporaries was divided; while art critics for the general press and a number of photographers in England and abroad approved of her approach, the medium's most vocal proponents of art photography criticized the "slovenly manipulation" and regarded her work as "altogether repulsive."[29]

Newly emerging scientific ideas provided still other uses for the photographic portrait during the collodion era. Aside from the documentation of strictly medical problems (skin lesions, hydrocephalism, etc.), the camera was called upon to document psychological reactions and mental aberrations. Dr. Hugh Welch Diamond, who became interested in the calotype shortly after the announcement of Talbot's discovery, was one of the first to advocate such scientific documentation. After he was introduced to collodion by Archer—a former patient—he used the new technology to photograph female inmates in the Surrey County Asylum *(pl. nos. 76–77)*, where he was superintendent. In a paper read to the Royal Society in 1856, Dr. Diamond outlined the relationship of photography to psychiatry, suggesting that portraits were useful in diagnosis, as treatment, and for administrative identification of the patients. In *The Physiognomy of Insanity*, illustrated with engravings based on Dr. Diamond's likenesses, physiognomic theories that had related photography to the depiction of normal character were extended to embrace the mentally abnormal.

Fleeting facial expressions were photographed in 1853 by Adrien Tournachon (brother of Félix) for a work on human physiognomy by the noted Dr. Guillaume Benjamin Duchenne de Boulogne, the founder of electrotherapy, and in 1872 Charles Darwin chose to use photographs to illustrate *The Expression of the Emotions in Man and Animals*, for which he approached Rejlander. In addition to images supplied by Duchenne, and by two lesser-known figures, the book included a series showing emotional states, and for five of them Rejlander himself posed as model *(pl. nos. 78–79)*. Despite the theatricality of a number of the expressions depicted in these portraits, the use of the camera image in this capacity relegated to a minor role the traditional graphic conventions for portraying the human passions.

In the 30 years following the discovery of photography, the camera portrait occupied center stage. Images on metal, glass, and paper provided likenesses for large numbers of people—the newly affluent as well as many who formerly could not have imagined commissioning a painted portrait. Many of these images can be regarded today as no more than "archeological relics," but in their time they served to make generations of sitters more aware of their position in society and of themselves as individuals, even when they glossed over physiological and psychological

76–77. Dr. Hugh Welch Diamond. *Inmates of Surrey County Asylum*, 1852. Albumen prints. Royal Photographic Society, Bath, England.

78, 79. OSCAR GUSTAV REJLANDER, GUILLAUME BENJAMIN DUCHENNE DE BOULOGNE. Illustrations for *The Expression of the Emotions in Man and Animals,* by Charles Darwin, 1872. Heliotypes. Photography Collection, The New York Public Library, Astor, Lenox, and Tilden Foundations.

frailties. In addition, photographs taken at various stages of life—youth, middle age, and elderly—made people more conscious of mortality and their relationship to ephemeral time. The cult of individualism also was promoted by the practice of publishing and selling likenesses of famous persons. With the image as a surrogate, more people were made to feel closer to political and cultural figures, even while the likenesses themselves emphasized distinctiveness. On the whole, the general run of commercial camera portraiture is quickly exhausted in terms of insight or aesthetic interest, yet in the hands of creative individuals (both amateur and professional), among them Southworth and Hawes, Hill and Adamson, Cameron, Carroll, and Nadar, portraits seemed to distill an artistic ideal while still probing individual personality. The importance of studio portraiture was diminished by the invention of new cameras and technologies that permitted people to make likenesses of family and friends at home, but the portrait itself—as a mirror of personality, as an artistic artifact, and as an item of cultural communication—has remained an intriguing challenge to photographers.

Profile: David Octavius Hill and Robert Adamson

At his death in 1870, David Octavius Hill was mourned for being a deeply religious but blithe spirit who had devoted his life to improving the arts in Scotland. An unexceptional though competent painter of the Scottish countryside *(pl. no. 80)*, Hill played an important role in the cultural life of Edinburgh. He was born into a family of booksellers and publishers in Perth and learned lithography early in his career, publishing, in 1821, the first lithographic views of Scotland in *Sketches of Scenery in Perthshire*. In association with other artists who were dissatisfied with the leadership of the Royal Institution, Hill established the Scottish Academy in 1829, and remained connected with it in unpaid and, later, official capacity until his death. By the 1830s, Hill's interest turned to narrative illustration; among his works were lithographs for *The Glasgow and Garnkirk Railway Prospectus*, The Waverly Novels, and *The Works of Robert Burns*.

Involvement in the Scottish Disruption Movement, which led to the establishment of the Free Church of Scotland and independence from the Church of England, inspired in Hill a wish to commemorate this event in a painting of the clergymen who took part in the dispute. Introduced by Sir David Brewster to Robert Adamson *(pl. no. 81)*, through whom he became aware of Talbot's process, Hill planned to use photography as an aid in painting the likenesses of the 400 members of the Disruption Movement. In 1843 he entered into a partnership with Adamson, about whom relatively little is known, to produce calotypes in a studio at Rock House, Calton Hill, Edinburgh, and

80. DAVID OCTAVIUS HILL. *On the Quay at Leith*, 1826.
Oil on wood. Scottish National Portrait Gallery, Edinburgh.

81. DAVID OCTAVIUS HILL. *Robert Adamson*, c. 1843.
Calotype. Gernsheim Collection, Humanities Research
Center, University of Texas, Austin.

sometimes on location. In their joint work, each man pro-
vided an element missing in the other. Before 1843,
Adamson's work was wanting in composition and light-
ing, while, on the evidence of work done with another
collaborator some 14 years after Adamson's premature
death, Hill lacked sensitivity and skill in handling the
camera. During the partnership, Hill energetically organ-
ized the sittings for his proposed painting, but as the two
partners became more deeply involved with the medium,
they calotyped subjects, persons, and landscape views that
had no relation to the Disruption painting, producing
between 1843 and 1848 about 2,500 separate calotypes.
Unfortunately, Hill discovered that many of the negatives
tended to fade, a circumstance that along with Adamson's
death seemed to make further involvement in photography
unattractive.

After 1848, Hill continued to use photographs as studies
for his paintings and to sell individual calotypes from his
brother's print shop, while devoting time to the affairs of
the Scottish Academy and other local art associations. Fol-
lowing a second marriage in 1862 and the unsuccessful
attempt to photograph in collodion with another partner,
Hill returned to the Disruption painting, completing it in
1866. Compared with the vitality and expressiveness of the
calotype studies, the painted figures are unconvincing and
seem to exist without air or space; the picture, however,
was greeted with kindness, and Hill's last photographic
project involved an endeavor to make photographic fac-
similes of this work. Had he not become involved with
photography, it is unlikely that Hill would have merited
more than a footnote in the history of the arts of the 19th
century.

82. JULIA MARGARET CAMERON. *The Rising of the New
Year*, 1872. Albumen print. Private Collection.

Profile: Julia Margaret Cameron

One of seven daughters of a prosperous British family stationed in India, Julia Margaret Pattle was regarded by friends as generous, impulsive, enthusiastic, and imperious—"a unique figure, baffling beyond description."[30] Educated in England and France after the death of her parents, she returned to India and in 1838 married Charles Hay Cameron, an eminent jurist and classical scholar, who invested his fortune in coffee plantations in Ceylon. In the ten years prior to their return to England, Mrs. Cameron assumed the social leadership of the Anglo-Indian colony, raised money for victims of the Irish Famine, and translated the well-known German ballad *Lenore,* but her boundless energy craved even greater challenges.

After settling in Freshwater, on the Isle of Wight, Cameron, using a camera given her by her daughter in 1863, embarked on a career in photography, concentrating on portraits and allegorical subjects. Models, at times paid but mainly importuned, were drawn from among her family; the household staff at the Cameron residence, *Dimbola;* and the households and visitors to the homes of Alfred, Lord Tennyson, and Sara Prinsep, Cameron's sister. These were many of the most famous figures in British artistic and literary circles, including Thomas Carlyle, Darwin, Herschel, Marie Spartali, Ellen Terry,

and Watts, but the photographer also was interested in portraying the unrenowned as long as she found them beautiful or full of character. Besides hundreds of idealized portraits, she created allegorical and religious subjects, particularly of angels *(pl. no. 82)* and the Madonna, which emphasized motherhood. Because of her disappointment with the poor quality of the woodcut transcriptions of Tennyson's *Idylls of the King,* Cameron raised money to issue two editions that were photographically illustrated.

Cameron's attitude toward photography was that of a typical upper-class "amateur" of the time. She refused to consider herself a professional, although the high cost of practicing the medium led her to accept payment for portraits on occasion and to market photographic prints through P. and D. Colnaghi, London printsellers. They often bore the legend: "From Life. Copyright Registered Photograph. Julia Margaret Cameron," to which she sometimes added that they were unretouched and not enlarged. Her work was shown at annual exhibitions of the Photographic Society of London and in Edinburgh, Dublin, London, Paris, and Berlin; at the latter it was acclaimed by Hermann Wilhelm Vogel and awarded a gold medal in 1866. In 1875, the Camerons returned to Ceylon, where for the three years before her death she continued to photograph, using native workers on the plantations and foreign visitors as models.

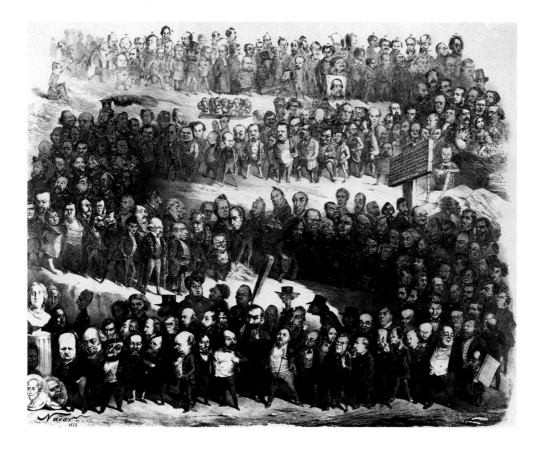

83. Nadar (GASPARD FÉLIX TOURNACHON). *Panthéon Nadar,* 1854. Lithograph. Bibliothèque Nationale, Paris.

84. NADAR (GASPARD FÉLIX TOURNACHON). *Self-Portrait,* c. 1855. Salt print. J. Paul Getty Museum, Los Angeles.

85. ADRIEN TOURNACHON. *Emile Blavier*, c. 1853. Albumen print. Bibliothèque Nationale, Paris.

86. UNKNOWN PHOTOGRAPHER (French). *Façade of Nadar's Studio at 35 Boulevard des Capucines, Paris,* after 1880. Albumen print. Bibliothèque Nationale, Paris.

Profile: Nadar

In many ways Nadar (Gaspard Félix Tournachon) *(pl. no. 84)* typifies the best qualities of the bohemian circle of writers and artists that settled in Paris during the Second Empire. Born into a family of printer tradespeople of radical leanings, young Nadar became interested in many of the era's most daring ideas in politics, literature, and science. After an ordinary middle-class education and a brief stab at medical school, he turned to journalism, first writing theater reviews and then literary pieces. Although a career in literature seemed assured, he gave up writing in 1848 to enlist in a movement to free Poland from foreign oppressors, an adventure that ended suddenly when he was captured and returned to Paris. There followed a period of involvement with graphic journalism, during which he created cartoons and caricatures of well-known political and cultural figures for the satirical press. This culminated in the *Panthéon Nadar (pl. no. 83)*, a litho-

graphic depiction of some 300 members of the French intelligentsia. Only mildly successful financially, it made Nadar an immediate celebrity; more important, it introduced him to photography, from which he had drawn some of the portraits.

In 1853, Nadar set up his brother Adrien as a photographer and took lessons himself, apparently with the intention of joining him in the enterprise. However, despite the evident sensitivity of Adrien's portrait of the sculptor Emile Blavier *(pl. no. 85)*, his lack of discipline is believed to have caused Nadar to open a studio on his own, moving eventually to the Boulevard des Capucines *(pl. no. 86)*, the center of the entertainment district. He continued his bohemian life, filling the studio with curiosities and *objets d'art* and entertaining personalities in the arts and literature, but despite this flamboyant personal style he remained a serious artist, intent on creating images that were both life-enhancing and discerning.

Ever open to new ideas and discoveries, Nadar was the first in France to make photographs underground with artificial light and the first to photograph Paris from the basket of an ascendant balloon. Even though a proponent of heavier-than-air traveling devices, he financed the construction of *Le Géant*, a balloon that met with an unfortunate accident on its second trip. Nonetheless, he was instrumental in setting up the balloon postal service that made it possible for the French government to communicate with those in Paris during the German blockade in the Franco-Prussian War of 1870.

Ruined financially by this brief but devastating conflict, Nadar continued to write and photograph, running an establishment with his son Paul that turned out slick commercial work. Always a rebel, at one point he lent the recently vacated photo studio to a group of painters who wished to bypass the Salon in order to exhibit their work, thus making possible the first group exhibition of the Impressionists in April, 1874. Although he was to operate still another studio in Marseilles during the 1880s and '90s, Nadar's last photographic idea of significance was a series of exposures made by his son in 1886 as he interviewed chemist Eugène Chevreul on his 100th birthday, thus foreshadowing the direction that picture journalism was to take. During his last years he continued to think of himself as "a daredevil, always on the lookout for currents to swim against."[31] At his death, just before the age of ninety, he had outlived all those he had satirized in the famous *Panthéon*, which had started him in photography.

The Galerie Contemporaine— *Appearance and Character in 19th-Century Portraiture*

The *Galerie Contemporaine*, a series of 241 portraits of celebrated artistic, literary, and political figures in France during the Second Empire and Third French Republic, was issued in Paris between the years 1876 and 1894. A different portrait, accompanied by biographical text, appeared each week from 1876 to 1880; after that the album became an annual devoted almost exclusively to those in the mainstream pictorial arts. The images were the work of some 28 photographers who operated studios in Paris during this period; they were published in different sizes, depending on the dimensions of the original negative or plate, and usually were presented within a decorative border. Because in some cases they were taken long before they were used in the *Galerie*, the individual portraits are difficult to date. Whether these photographs were produced by carbon process or Woodburytype has not been definitively established, but the fact that the publisher, Goupil et Cie., had purchased a franchise for the Woodburytype process in France some years earlier suggests that the images were made by this method.

In this selection, portraits by noted photographers Etienne Carjat and Nadar exemplify the pictorial excellence possible through adroit manipulation of pose, demeanor, and lighting, while the image by Tourtin indicates that the work of little-known portraitists included in this ambitious publication also achieved a high level of excellence.

87. ETIENNE CARJAT. *Alexandre Dumas*, from *Galerie Contemporaine*, 1878. Woodburytype.
International Museum of Photography at George Eastman House, Rochester, N.Y.

88. NADAR (GASPARD FÉLIX TOURNACHON). *George Sand*, from *Galerie Contemporaine*, 1877.
Woodburytype. International Museum of Photography at George Eastman House, Rochester, N.Y.

89. ETIENNE CARJAT. *Gioacchino Antonio Rossini*, from *Galerie Contemporaine*, 1877.
Woodburytype. International Museum of Photography at George Eastman House, Rochester, N.Y.

90. NADAR (GASPARD FÉLIX TOURNACHON). *Eugène Emmanuel Viollet-le-Duc,* from *Galerie Contemporaine,* 1878.
Woodburytype. International Museum of Photography at George Eastman House, Rochester, N.Y.

91. ETIENNE CARJAT. *Emile Zola*, from *Galerie Contemporaine*, 1877.
Woodburytype. Private Collection.

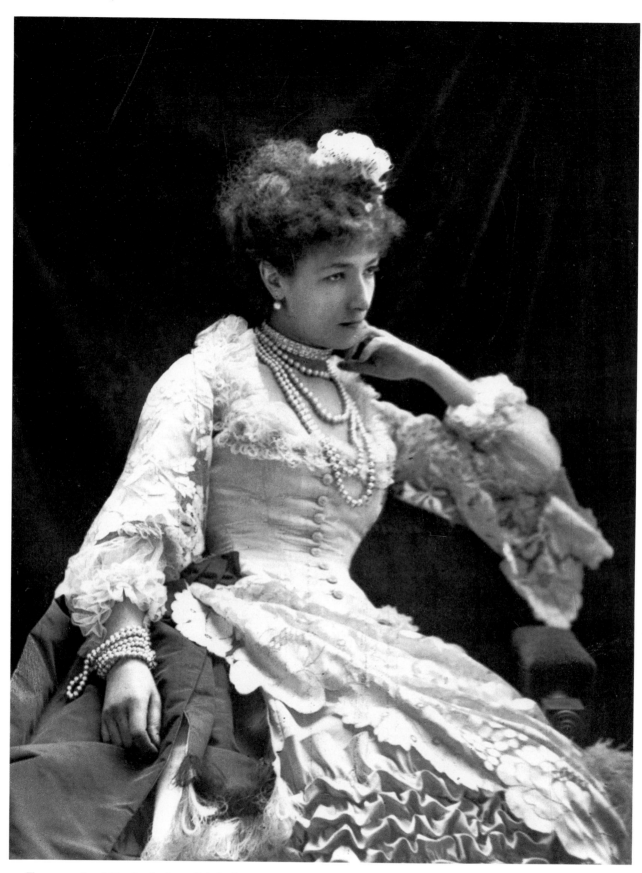

92. TOURTIN. *Sarah Bernhardt*, from *Galerie Contemporaine*, 1877. Woodburytype.
International Museum of Photography at George Eastman House, Rochester, N.Y.

93. ETIENNE CARJAT. *Charles Baudelaire*, from *Galerie Contemporaine*, 1878. Woodburytype.
International Museum of Photography at George Eastman House, Rochester, N.Y.

94. Etienne Carjat. *Victor Hugo*, from *Galerie Contemporaine*, 1876. Woodburytype. Private Collection.

95. ETIENNE CARJAT. *Emile Louis Gustave de Marcère*, from *Galerie Contemporaine*, 1878. Woodburytype. Private Collection.

3.

DOCUMENTATION: LANDSCAPE AND ARCHITECTURE *1839–1890*

To represent . . . the beautiful and the sublime in nature . . . demands qualities alike of head and of heart, in rapt accordance with the Infinite Creative Spirit.

—*Marcus Aurelius Root, 1864*[1]

There is only one Coliseum or Pantheon; but how many millions of potential negatives have they shed,—representatives of billions of pictures,—since they were erected! Matter in large masses must always be fixed and dear; form is cheap and transportable. . . . Every conceivable object of Nature and Art will soon scale off its surface for us.

—*Oliver Wendell Holmes, 1859*[2]

EASY OF ACCESS, generally immobile, and of acknowledged artistic appeal, landscape, nature, and architecture provided congenial subjects for the first photographers. The desire for accurate graphic transcription of scenery of all kinds—natural and constructed—had led to the perfection of the *camera obscura* in the first place, and it was precisely because exactness was so difficult even with the aid of this device that Talbot and others felt the need to experiment with the chemical fixation of reflected images. Beginning with the daguerreotype and the calotype, 19th-century scenic views evolved along several directions. They provided souvenirs for the new middle-class traveler, and brought the world into the homes of those unable to make such voyages. Photographs of natural phenomena provided botanists, explorers, geologists, and naturalists with the opportunity to study previously undocumented specimens and locations. And as scientific knowledge increased, as changing conditions of life in urban centers promoted new concepts of how to understand and represent the material world, the camera image itself became part of the shifting relationship between traditional and modern perceptions of nature and the built environment.

From the Renaissance up until the middle of the 18th century, painted landscape, with few exceptions, had been considered important mainly as a background for historical and religious events; landscape as such occupied a low position in the hierarchy of artistic subjects. With the relaxation of academic art strictures and the introduction during the Romantic era of a more sensuous depiction of nature, artists turned to a wider range of motifs from the material world. These extended from pastoral landscapes, seen from afar, to depictions of singular formations—water, skies, trees, rocks, and fruits of the field. As heirs to these evolving attitudes toward nature, photographers, armed with a device they believed would faithfully record actuality, approached the landscape with the conviction that the camera might perform a dual function—that photographs might reveal form and structure accurately and at the same time present the information in an artistically appealing fashion.

The public appetite for scenic views had a significant effect on early landscape photographs also. Through most of the 18th century, oil paintings, watercolors, engravings, and (after 1820) lithographs of topographical views (often

96. FREDERICK CATHERWOOD. *The Ruins of Palenqué, Casa No. 1*, 1841. Lithograph from *Incidents of Travel in Central America, Chiapas, and Yucatan*, vol. II, 1841, by John Lloyd Stephens. Collection George R. Rinhart.

based on drawings made with the *camera obscura* or *camera lucida, see A Short Technical History, Part I*) had become increasingly popular. The landscape or view photograph was welcomed not only because it was a logical extension of this genre, but also for its supposedly more faithful representation of topography, historic monuments, and exotic terrain. As an example of the overlap that came about in the wake of changing technologies, drawings made by the American explorers Frederick Catherwood and John L. Stephens of their findings on expeditions to the Yucatan peninsula *(pl. no. 96)* in 1839 and 1841 were based on unaided observation, on the use of a *camera lucida*, and on daguerreotypes the two had made. Since many views, including these, were made with publication in mind, the camera image promoted a more accurate translation from drawing to mechanically reproduced print, supplying the engraver or lithographer with detailed information at a time when inexpensive methods of transferring the photograph directly to the plate had not yet been developed.

Landscape Daguerreotypes

Truthful representation of the real world without sentimentality presented itself as an important objective to many

19th-century scientists and intellectuals, including French novelist Gustave Flaubert, who held that the artist should be "omnipotent and invisible."[3] This position reflected one aspect of the positivist ideas of social philosopher Auguste Comte and others who were convinced that a scientific understanding of material reality was the key to economic and social progress. The camera image was regarded as a fitting visual means for just such an impersonal representation of nature. Nevertheless, it is difficult to determine the full extent of daguerreotyping activities with reference to views of nature, architecture, and monuments. Many plates have been lost or destroyed; others, hidden away in archives or in historical and private collections, have been surfacing in recent years, but no overall catalogs of such images exist. From the works most often seen, it seems apparent that the finely detailed daguerreotype was supremely suited to recording architectural features while somewhat less useful for pure nature. The influential British art critic John Ruskin, who in 1845 began to make his own daguerreotypes as well as to use those of others in preparing the drawings for his books on architecture, praised the verisimilitude of the daguerreotype image as "very nearly the same thing as carrying off the palace itself."[4]

Daguerreotype scenic views made on both sides of the Atlantic reveal attitudes about nature and art of which neither the photographer nor the viewer may have been aware at the time. The stark mountains and graceless buildings in an 1840 image by Samuel Bemis of a farm scene in New Hampshire *(pl. no. 97)* seem to suggest the solitary and obdurate quality of the New England countryside. Admittedly, this Boston dentist, who acquired his photographic equipment from Daguerre's agent Gouraud, was working at the very dawn of photography, when materials and processes were in a state of flux. In contrast, the harmonious landscape *(pl. no. 98)* by Alexandre Clausel, probably made near Troyes, France, in 1855, attests to not only a firmer grasp of technique but also to a greater sensitivity to the manner in which the traditional canons of landscape composition were handled.

Landscape photography evolved as a commercial enterprise with the taking of views of well-known or extraordinary natural formations for the benefit of travelers. A favorite site in the United States, Niagara Falls was daguerreotyped by Southworth and Hawes in 1845, ambrotyped as well as daguerreotyped by George Platt Babbitt in 1848, and photographed on stereographic glass plates by the Langenheim brothers in 1855. Albumen prints from collodion negatives of the Falls were made by English commercial photographers John Werge and William England in 1853 and 1859 respectively, and from dry plates by George Barker. In the Midwest, daguerreotypes of similar scenic wonders were made by Alexander Hesler and others in

97. SAMUEL BEMIS. *New Hampshire Landscape*, 1840. Daguerreotype. Collection Ken Heyman, New York.

98. ALEXANDRE CLAUSEL. *Landscape, Probably Near Troyes, France*, c. 1855. Daguerreotype. International Museum of Photography at George Eastman House, Rochester, N.Y.

larger numbers than is generally appreciated today.

The urban scene also was considered appropriate for the daguerreotypist. *Bridge and Boats on the Thames (pl. no. 9)* of 1851 by Baron Jean Baptiste Louis Gros typifies the incredible amount of detail made visible by this process, and indicates the way bodies of water might be used to unify sky and foreground, a solution that virtually became a formula for many landscape photographers. The drama of dark silhouette against a lighter sky, seen in Wilhelm Halffter's image of Berlin *(pl. no. 10)* demonstrates another method of treating the problem of visually unrelated rectangles of light and dark areas that the actual land- or cityscape frequently presented; this, too, became a commonplace of view photography.

Most landscape imagery was designed for a broad market—the buyers of engraved and lithographed scenes—so the problem of the nonduplicatable metal plate was solved by employing artists to translate the daguerreotype into engravings, aquatints, and lithographs. One of the first publishers of an extensive work based on daguerreotypes, Noël Marie Paymal Lerebours (an optical-instrument maker who had been associated with Daguerre's endeavors), made use of daguerreotyped scenes from Europe, the Near East, and the United States; these were either commissioned or purchased outright as material for engravings, with figures and fillips often added by artists. Among the daguerreotypists whose work appeared in Lerebours's *Excursions daguerriennes: Vues et monuments les plus remarquables du globe (Daguerrian Excursions: The World's Most Remarkable Scenes and Monuments)*, issued between 1840 and 1843, were Frédéric Goupil-Fesquet, Hector Horeau *(pl. no. 99)*, Joly de Lote-binière, and Horace Vernet, all of whom supplied views of Egypt. Daguerreotyping, it seems, had become indispensable both for travelers who could not draw and artists who did not have the time to make drawings.

Interest in unusual scenery and structures was so strong that even though daguerreotyping in the field was not easy, a number of other similar projects were initiated in the early 1840s, generally by affluent individuals who hired guides and followed safe routes. Dr. Alexander John Ellis, a noted English philologist, was inspired by *Excursions daguerriennes* to conceive of *Italy Daguerreotyped*, comprising views of architecture engraved from full-plate daguerreotypes that he had supervised or made himself in 1840–41; the project was abandoned, although the plates still exist. The British physician Dr. George Skene Keith and a well-to-do French amateur, Joseph Philibert Girault de Prangey, took daguerreotypes, hoping to publish works on Near Eastern architecture that might show details and structure in close-ups and suggest connections between architecture and biblical history. In Switzerland, Johann Baptist Isenring, a painter and engraver turned daguerreotypist, and Franziska Möllinger, one of the early women daguerreotypists, each traveled by caravan throughout the country taking views of scenery to be engraved and published.

Panoramic Views

Before giving way to the more practicable negative-positive process, the daguerreotype achieved a measure of additional popularity with respect to panoramic views—images that are much wider than they are high. It will be recalled that panoramas (and in Paris, The Diorama) with minutely rendered landscape detail were among the most popular entertainments of the early 1800s in Europe and the United States.[5] Soon after the announcement of the daguerreotype, photographers attempted to capitalize on the appetite for this kind of encompassing yet accurate visual experience. At first, series of individual daguerreotypes arranged in contiguous order to depict a wider prospect were popular, especially in the United States. There the urge to document urban development occupied photographers in virtually all major cities, as exemplified by *Fairmount Waterworks (pl. no. 100)*, a series by William Southgate Porter consisting of eight plates made in Philadelphia in 1848. Photographers throughout the nation made panoramic views of the cities in an attempt to encompass the urban growth taking place before their eyes; a 360-degree panorama of Chicago made by Alexander Hesler in 1858 was possibly the first such effort. Wilderness landscape was treated similarly by the San Francisco daguerreotypist Robert Vance and by John Wesley Jones, early American daguerreotypists of western scenery. Jones took 1,500 views in the Rockies and the Sierra Nevada (none of which has survived) on which to base a painted panorama entitled *The Great Pantoscope*.[6]

Panoramic views also were made on single plates of extended width, achieved either by using a wide-angle lens, or by racking the camera to turn slowly in an arc

99. HECTOR HOREAU. *Abu Simbel*, 1840. Aquatint. Collection Gérard-Lévy, Paris.

100. WILLIAM SOUTHGATE PORTER. *Fairmount Waterworks*, 1848. Daguerreotype panorama in eight plates. International Museum of Photography at George Eastman House, Rochester, N.Y.

while the plate moved laterally in the opposite direction. In 1845, Fredrich von Martens, a German printmaker living in Paris, was the first to work out the optical and mechanical adjustments necessary to make single panoramic daguerreotypes of his adopted city, then he turned to a similar format in collodion for Alpine landscapes. Indeed with the advent of the wet plate, the panorama came into its own, even though panoramas on paper had been made by the calotype process. While exposure time for the glass negative often remained long, the resulting sharply detailed segments of a scene, printed and glued together to form an encompassing view, were taken as embracing reality even though the human eye could not possibly have seen the landscape in that fashion. However, these panoramas were more realistic than the lithographed bird's-eye views that were so popular. By using panoramic cameras that rotated in an arc of approximately 120 degrees, photographers might avoid the exacting calculations needed to assure that the panels of the panorama would join properly without overlaps or missing segments, but these devices could not encompass as wide an angle as the segmented panoramas and consequently seemed less dramatic. Panoramas were produced by photographers everywhere, by the Bisson brothers, Adolphe Braun, Samuel Bourne, and many now-unknown figures in Europe, Asia, and India, and by American photographers of both urban development and western wilderness. George Robinson Fardon, William Henry Jackson, Carleton E. Watkins, and especially Eadweard Muybridge, who devoted himself to making panoramic views of San Francisco on three different occasions, were among the more successful panoramists in the United States during the collodion/albumen era *(pl. no. 165)*.

Landscape Calotypes

Despite unparalleled clarity of detail in landscape daguerreotypes, the difficulties in making and processing exposures in the field and the problems of viewing an image subject to reflections and of replicating the image for publication made it an inefficient technology with respect to views. From the start, the duplicatable calotype was accepted by many as a more congenial means of capturing scenery, and it achieved greater sensitivity and flexibility for this purpose after improvements had been made by Louis Désiré Blanquart-Evrard and Gustave Le Gray. Between 1841 and about 1855, when collodion on glass supplanted paper negatives entirely, calotypists documented cityscape, historic and exotic monuments, rural scenery, and the wilder, less-accessible terrains that were beginning to appeal to Europeans who had wearied of the more familiar settings. Because of their broad delineation, calotype views more nearly resembled graphic works such as aquatints, and this tended to increase their appeal to both artists and elitists in the intellectual community who preferred aesthetic objects to informational documents. Nevertheless, the calotype still had enough detail to recommend it as a basis for copying, as the British publication *The Art Union* pointed out in 1846 when it noted that painters, not being as enterprising as photographers, could depend on "sun-pictures" (calotypes) of places such as "the ruins of Babylon or the wilds of Australia"[7] for accurate views from which they could make topographical paintings.

Somewhat easier to deal with than daguerreotyping in the field, the chemistry of the early calotype still was complicated enough to make its use in travel a problem. Never-

theless, a number of British amateurs (often aided by servants and local help) transported paper, chemicals, and cameras to the Continent and the Near East soon after Talbot's announcement. Three members of his circle—Calvert Jones, George W. Bridges, and Christopher Rice Mansel Talbot—were the first hardy souls to journey from Great Britain to Italy, Greece, and North Africa with calotype equipment. Through its high vantage point and pattern of light and shade, a view of the Porta della Ripetta in Rome *(pl. no. 101)* suggests that Jones (who photographed in Italy and Malta) was interested in atmospheric and artistic qualities as much as in description. Bridges, who traveled in the region for seven years, made some 1,700 pictures, which he found were subject to serious fading; a small group was published in 1858 and 1859 in an album entitled *Palestine as It Is: In a Series of Photographic Views . . . Illustrating the Bible.* Another group of calotypes of the area by Dr. Claudius Galen Wheelhouse was gathered together in an album entitled *Photographic Sketches from the Shores of the Mediterranean.* Ernest De Caranza in Anatolia, Maxime Du Camp in Egypt *(pl. no. 111)*, and Pierre Trémaux in the Sudan were others among the early figures who attempted, with varying degrees of success, to use the calotype process to photograph in North Africa and the Near East. These works were forerunners of the numerous views on paper whose appeal to the Victorian public may have been in part because they afforded a contrast between the progress visible at home and the undeveloped landscape of the region and in part because they recalled to viewers their biblical and classical heritage.

In spite of these efforts and even though Talbot placed no restrictions on the noncommercial use of calotypes, view-making did not exactly flourish in England during the first ten years of the process's existence. Instead, images of landscape and architecture achieved a pinnacle of excellence in France during the 1850s, as a result of interest by a small group of painter-photographers in an improved paper process that had evolved from experiments by Blanquart-Evrard and Le Gray. By waxing the paper negative before exposure, Le Gray achieved a transparency akin to glass, making the paper more receptive to fine detail. The spread of this improved technique in France during the early 1850s gave the calotype a new life and resulted in images of extraordinary quality. This flowering coincided with the concern among Barbizon landscape painters for capturing the quality of light and revealing the value of unspoiled nature in human experience.

The improved calotype also made conceivable the photographic campaign—government or privately sponsored commissions to produce specific images. One of the earliest was financed in 1850 by the Belgian treasury, but the most renowned, the *Missions héliographiques,* was

101. REV. CALVERT JONES. *Porta della Ripetta, Rome,* 1846. Calotype. Science Museum, London.

102. HENRI LE SECQ. *Strasbourg Cathedral*, 1851.
Calotype. International Museum of Photography at
George Eastman House, Rochester, N.Y.

organized in 1851 by the *Commission des Monuments his-
toriques* (Commission on Historical Monuments) to pro-
vide a pictorial census of France's architectural patrimony.
Undertaken initially during the Second Republic, in
accord with continuing efforts by Napoleon III to preserve
and modernize France, it involved the documentation of
aged and crumbling churches, fortresses, bridges, and
castles that were slated for restoration under the guidance
of the architect Eugène Emmanuel Viollet-le-Duc.

The five photographers engaged in this innovative doc-
umentation were Edouard Denis Baldus, Hippolyte
Bayard, Le Gray, Henri Le Secq, and O. Mestral. Photo-
graphers received itineraries and instructions, quite exact at
times, detailing the localities to be photographed. Among
the most accomplished of the group were Le Gray and Le
Secq, both of whom had been trained as painters in the
studio of Paul Delaroche (along with the British photog-
rapher Roger Fenton). Le Secq's *Strasbourg Cathedral (pl.
no. 102)*, one of a series of architectural monuments, is an

exhilarating organization of masses of sculptural detail. Le
Gray *(see Profile)*, in whose studio many calotypists first
learned the process, was a demanding technician who also
was involved in making collodion negatives; his images will
be discussed shortly in the context of developments in that
material. Little is known of Mestral, a former daguerreo-
typist and an associate of Le Gray, other than that he pho-
tographed in Brittany and Normandy on his own and
from the Dordogne southward in company with Le Gray.
The image of the bridge Pont Valentré *(pl. no. 103)* in
Cahors, included because of impending plans to restore
what was then considered the finest example of medieval
military architecture in France, suggests a distinctive feel-
ing for volume and silhouette.

Unhappily, the *Missions* project never reached full
fruition. Negatives—some 300—and prints were filed away
without being reproduced or published, either because the
project's sole aim was to establish an archive or because the
photographers depicted these ancient structures in too
favorable a light for the images to serve as propaganda
for restoration efforts.[8] Individually, they were used by
architects and masons working under Viollet-le-Duc's
guidance in matching and fabricating decorative elements
that had been destroyed. (More than a century later,
these early photographs still proved to be useful guides in
the restoration of ancient monuments.) Nevertheless, the
government of France under Napoleon III continued to
regard photography—whether calotype or collodion/
albumen—as a tool integral to its expansive domestic and
foreign programs, commissioning documentation of the
countryside, the railroad lines, and of natural disasters as
evidence of its concern for national programs and prob-
lems. Baldus produced about 30 large-format negatives of
the flooding of the Rhône River in 1856 *(pl. no. 104)*. It is
apparent from the amplitude of his vision and the sense of
structure in the example seen here that no dichotomy
existed in the photographer's mind between landscape art
and documentation.

Not all French landscape calotypists were trained artists,
nor was their work invariably commissioned. Indeed, one
of the intriguing aspects of the epoch is that scientists as
well as painters found the paper negative a congenial
process for representing nature. Victor Regnault, director
of the Sèvres porcelain factory (after 1852) and president of
both the French Academy of Sciences and the *Société
Française de Photographie*, had first become curious about
paper photography when Talbot disclosed the process, but
only pursued this interest in 1851 after improvements had
been made by Blanquart-Evrard. Using the waxed-paper
process, he experimented with exposure and produced a
number of idyllic, mist-shrouded views of the countryside
around the factory, among them *The Banks of the Seine at*

7511 CAHORS (Lot). — Pont

103. O. MESTRAL. *Cahors: Pont Valentré*, c. 1851.
Calotype. Caisse Nationale des Monuments
Historiques et des Sites, Paris. © Arch. Phot.
Paris/SPADEM.

104. EDOUARD DENIS BALDUS. *The Flooding of
the Rhône at Avignon*, 1856. Calotype. Caisse
Nationale des Monuments Historiques et des
Sites, Paris. © Arch. Phot. Paris/SPADEM.

105. VICTOR REGNAULT. *The Banks of the Seine at Sèvres*, 1851–52. Calotype. Collection André Jammes, Paris. Art Institute of Chicago.

106. LOUIS ROBERT. *Versailles, Neptune Basin*, c. 1853. Calotype. Collection André Jammes, Paris. Art Institute of Chicago.

Sèvres (pl. no. 105), in which he included the everyday objects of rural existence such as casks and barrow. Louis Robert, chief of the painters and gilders at the porcelain factory, worked both at Sèvres and Versailles, using the calotype process before turning to albumen on glass; a number of his calotypes were included in Blanquart-Evrard's 1853 publication *Souvenirs de Versailles (pl. no. 106)*. These images display a sensibility that is similar to that of Barbizon painters in their lyrical approach to the homely and simple aspects and objects of nature and rural life.

British amateur photographers welcomed the improved calotype for its greater sensitivity and definition. As heirs to picturesque and topographical traditions in landscape imagery, they sought to maintain a delicate balance between affective expression and the descriptive clarity that the improved process made possible. At times, English camera images of buildings and their surroundings seem to reflect the notion put forth by contemporary writers that architectural structures have expressive physiognomies much like those of humans. For example, *Guy's Cliffe, Warwickshire (pl. no. 107)* by the English amateur Robert Henry Cheney brings to mind a melancholy spirit, a phrase used by Ruskin to describe the character of certain kinds of buildings. The most celebrated English photographer of this period, Roger Fenton (to be discussed shortly), was extravagantly praised in the British press for the marked "character" of his architectural images.

Benjamin Brecknell Turner, an English businessman who made pure landscape calotypes *(pl. no. 108)* as well as portraits and architectural views, found the paper negative so sympathetic to his vision of untrammeled nature that he continued to work with the material until 1862, long after most photographers had switched to glass plates. On the other hand, Thomas Keith, a Scottish physician, practiced the calotype for only a very few years, and then only on occasions when the quality of light enabled him to make negatives of great tonal range. Keith's interest in the expressive nature of light, inspired perhaps by his acquaintance with Hill and Adamson, is apparent in images made in 1856 on the island of Iona, among them *Doorway, St. Oran's Chapel (pl. no. 109)*, where the factual record of ancient church architecture is given unusual force by strongly accentuated illumination.

Calotyping also appealed to Englishmen who made their homes outside the British Isles, among them Maxwell Lyte and John Stewart, who lived in Pau in the Pyrenees in the 1850s. Stewart's views of the rugged terrain of this region *(pl. no. 110)*, published by Blanquart-Evrard and exhibited in England, were praised by his father-in-law Sir John Herschel for the artistic effects of their "superb combination of rock, mountain, forest and water."[9] Both Lyte and Stewart were members of the *Société Française de Photo-*

107. ROBERT HENRY CHENEY. *Guy's Cliffe, Warwickshire*, 1850s. Albumen print. Collection Centre Canadien d'Architecture/Canadian Centre for Architecture, Montréal.

108. BENJAMIN BRECKNELL TURNER. *Old Willows*, c. 1856. Waxed paper negative. Collection André Jammes, Paris. Art Institute of Chicago.

graphie. Along with Thomas Sutton, the first in Britain to use Blanquart-Evrard's process in a publishing venture, they kept open the channels of communication between the French and British regarding the latest in photochemical technology.

French and British imperial interest in the countries of the Near East, Egypt in particular, continued to lure photographers using paper (and later glass) negatives into these regions. In 1849, the wealthy French journalist

Maxime Du Camp, accompanied by the young Flaubert, was sent on an official photographic mission to Egypt. Trained by Le Gray and equipped with calotyping apparatus "for the purpose of securing, along the way, and with the aid of this marvelous means of reproduction, views of monuments and copies of inscriptions," Du Camp also was expected to make facsimile casts of hieroglyphic inscriptions.[10] The calotypes, printed in 1852 by Blanquart-Evrard for his first publication, *Egypte, Nubie, Palestine et Syrie*,[11] display a concern for establishing accurate scale, as seen in the human yardstick provided by a native assistant in *The Colossus of Abu Simbel (pl. no. 111),* but they also demonstrate the definition and clarity that the improved calotype made possible.

Five years later, the amateur French archaeologist Auguste Salzmann briefly used the calotype with similar authority to make documents of architectural ruins in Jerusalem in order to "render a service to science"[12] and to help solve a controversy about the antiquity of the monuments. Working with an assistant, Salzmann was able to produce about 150 paper negatives under difficult circumstances; these, too, were printed at the Blanquart-Evrard establishment at Lille. In addition to an avowed scientific aim, images such as *Jerusalem, Islamic Fountain (pl. no. 112)* indicate the photographer's mastery of composition and sensitivity to the effects of light. The work of both Du Camp and Salzmann indicates that in the hands of imaginative individuals the camera image might develop a unique aesthetic, an ability to handle volume and light in an evocative manner while also documenting actuality.

Landscapes in Collodion/Albumen

The new collodion technology, discovered and publicized by Archer in 1850 and 1851, forced landscape photographers and documentarians operating in the field to transport an entire darkroom—tent, trays, scales, chemicals, and even distilled water—besides cameras and glass plates *(pl. nos. 113 and 114)*. It may seem astonishing today that, under such circumstances, this technique should have been considered an improvement over the calotype, which also was somewhat more sensitive to natural tonalities and had greater range. But paper negatives required time-consuming skills for complete realization. With the promise of sharper and more predictable results in less time, the glass negative with its coating of collodion and silver-iodide preempted all other processes for the next 30 years. Together with the albumen print, which retained the sharpness of the image because the printing paper was also coated with an emulsion, collodion made the mechanization of the landscape view possible, turning the scenic landscape into an item of consumption, and landscape photography into photo-business.

Limitations in the sensitivity of the collodion material itself were responsible for evoking contradictory aesthetic attitudes about images made from glass plates. Because of the limited responsiveness of silver-iodide to the colors of spectral light other than blue (and ultraviolet radiation), landscape images that displayed blank white skies and dark, relatively undifferentiated foregrounds were not uncommon. While commercial publishers seem not to have been unduly disturbed, this characteristic was decried by Lady Elizabeth Eastlake, one of the first serious English critics of photography. Writing in the *Quarterly Review* in 1857, she observed, "If the sky be given, therefore, the landscape remains black and underdone; if the landscape be rendered, the impatient action of light has burnt out all cloud form in one blaze of white."[13] She added that the collodion landscape photograph was unable to represent the tonal gradations that the eye accepts as denoting spatial recession, and that by its combined lack of atmosphere and too great precision, the image showed both too little and too much. Among others who objected to the lack of realism in the extreme contrast between dark and light areas in landscape photographs was Hermann Wilhelm Vogel, an influential German photographer, critic, and photo-chemical researcher, whose opinions appeared frequently in American periodicals during the 1860s and '70s, and who was successful in his efforts to improve the sensitivity of the silver halides to the various colors of light.

Photographers concerned with artistic landscapes avoided these problems with what was called "artifice." This involved using masks and combining two negatives on the same print—one for the sky and one for the ground—or employing hand-manipulations to remove unattractive mottled and gray areas. *Valley of the Huisne (pl. no. 115)* by Camille Silvy, praised as a "gem" when exhibited in 1858, exemplifies the possibilities of this technique for creating scenes that a contemporary critic characterized as "rich in exquisite and varied detail, with broad shadows stealing over the whole."[14] Le Gray, whose role in paper photography has been noted, used double printing in a number of collodion seascapes made at Sète (Cette) *(pl. no. 116)* around 1856—works similar in theme and style to seascapes painted by French artists Eugène Delacroix and Gustave Courbet at about the same time. Less traditionally picturesque than Silvy's scene, Le Gray transformed clouds, sea, and rocks into an evocative arrangement of volume and light, into an "abstraction called art," in today's language.[15] That composite landscapes of this period could be and often were unconvincingly pieced together is apparent from contemporary criticism that complained of pictures with clouds that were not reflected in the water or of foregrounds taken in early morning joined to skies taken at noon.

In Europe, where landscape views were considered souvenirs for travelers and restoratives for businessmen

110. JOHN STEWART. *Passage in the Pyrenees*, n.d. Calotype. Royal Scottish Academy, Edinburgh.

III. MAXIME DU CAMP. *The Colossus of Abu Simbel*, c. 1850. Calotype. Victoria and Albert Museum, London.

112. AUGUSTE SALZMANN. *Jerusalem, Islamic Fountain*, 1854. Calotype. National Gallery of Canada, Ottawa.

tied to the city, hundreds of thousands of scenes on albumen paper were turned out to be sold and pasted into albums or used in stereograph viewers. To satisfy this market, freelance photographers were dispatched around the globe by enterprising publishers, or they set up their own view-making businesses. Others, John Henry Parke among them, photographed to create accurate archaeological records. As a consequence, artistic effects were not usually considered of primary import in images intended to present information palatably. For example, Francis Frith and George Washington Wilson, to name two prominent publishers of landscape views for a mass audience, embraced artistic considerations insofar as they contributed to producing agreeable compositions. They aimed for the best vantage point and most harmonious tonalities but avoided expressive or dramatic effects of light and shadow such as had greatly delighted Keith, Salzmann, Baldus, and Le Gray. As Wilson noted, he had to "study the popular taste . . . and not only to get a pleasing picture of a place, but one also that can be recognized by the public."[16] Besides promoting a style that might be called "straight," this mass consumption of images had a profound if not always determinable effect on the viewing public, in that photographic evidence was considered synonymous with truth and the image as a substitute for firsthand experience.[17]

The government of Napoleon III, which had promoted the calotype as a means of documenting both scientific progress and royal patronage, continued to regard collodion images in the same light. What at first glance may

113–114. UNKNOWN. *European-style Portable Darkroom Tent*, 1877. Wood engravings from *A History and Handbook of Photography*, edited by J. Thompson, 1877. Metropolitan Museum of Art, New York; gift of Spencer Bickerton, 1938.

115. CAMILLE SILVY. *Valley of the Huisne, France,* 1858. Albumen print. Victoria and Albert Museum, London.

seem to be landscape pure and simple, such as views taken in the Alps by the Bisson brothers, was motivated by the Imperial desire to celebrate territorial acquisition—in this case the ceding to France of Nice and Savoy by the Kingdom of Sardinia. During the collodion era, the Bissons had rapidly extended their range of subjects to embrace art reproductions, architecture, and landscapes, often in very large format. *Passage des Echelles (pl. no. 117),* one of the six views made by Auguste-Rosalie as a participant in the second scaling of Mont Blanc in 1862, integrates the description of distinctive geological formations with a classical approach to composition, achieving in its balance of forms and tonalities a work of unusually expressive power. A similar evocation of solitary nature unaltered by human effort can be seen in *Gorge of the Tamine (pl. no. 118)* by Charles Soulier, a professional view-maker who is better known for his urbane Paris scenes than for Alpine landscapes. In view of steadily encroaching urbanization, these images suggest a public nostalgia for virgin nature that will be encountered again, more forcefully, in camera images of the American wilderness during the 1860s and '70s.

Scenic views found an avid entrepreneur as well as photographer in Adolphe Braun. With studios in both Paris and Alsace, he was not only a prolific view-maker, but a large-scale publisher who supplied prints in a variety of formats—stereoscope to panoramic—to subscribers in England, France, Germany, and the United States. Responding to the imperial desire to make Alsatians aware of their French heritage, Braun first photographed the landscape and monuments of this province and then went on to make more than 4,000 images of Alpine, Black Forest, and Vosges mountain scenery, eventually printing in carbon instead of albumen in order to insure print stability. Braun's views, of which *Lake Steamers at Winter Mooring, Switzerland (pl. no. 119)* is an outstanding example, display a skillful blend of information and artistry but also present the landscape as accessible by the inclusion of human figures or structures.

England, too, had landscapists with an authentic respect for what the collodion process could accomplish, but government patronage was limited to royal acclaim and, at times, purchase of individual images by members of the royal family, with documentations of the countryside and historical monuments initiated by photographers them-

selves or by private publishers rather than by the state. Fenton, the commanding figure in English photography before his retirement in 1862, had made calotypes of architectural monuments in Russia in 1852. He changed to collodion in 1853, and after his return from the Crimean War *(see Chapter 4)*, he had another traveling darkroom constructed to facilitate making views of rugged rocks, mountain gorges, waterfalls, and ruins—romantic themes to which the British turned as industrialization advanced. Contemporary critics on both sides of the Channel considered his landscapes to have reached the heights to which camera images could aspire, especially with respect to capturing atmosphere and a sense of aerial perspective. However, because Fenton refused to combine negatives or do handwork, images with strong geometric pattern, such as *The Terrace and Park, Harewood House (pl. no. 120)*, were criticized as offensive.[18] A number of Fenton's landscapes were

published as stereographs in *The Stereoscopic Magazine (see below)*, as photoengravings in *Photographic Art Treasures*, and as albumen prints in albums and books devoted to native landscape—these being the forms in which scenic images found an audience in the 1850s and '60s.

Albumen prints became popular as book illustration between 1855 and 1885 when, it is believed, more than a thousand albums and books, sponsored by private organizations and public personalities, were published, mainly in England, Scotland, France, India, and the United States.[19] Original photographs provided artistic, biographical, historical, and scientific illustration as well as topographical images to supplement and enhance texts on a wide variety of subjects. Even the small, relatively undetailed stereograph view was considered appropriate to illustrate scientific and travel books; one of the first to use the double image in this manner was C. Piazzi Smyth's *Teneriffe*,

116. GUSTAVE LE GRAY. *Brig Upon the Water*, 1856. Albumen. Albumen print. Victoria and Albert Museum, London.

117. AUGUSTE-ROSALIE BISSON. *Passage des Echelles (Ascent of Mt. Blanc)*, 1862.
Albumen print. Bibliothèque Nationale, Paris.

which appeared in 1858 with 18 stereograph views of the barren island landscape where Smyth and his party conducted astronomical experiments. It was soon followed by *The Stereoscopic Magazine*, a monthly publication that lasted five years and included still lifes and land- and cityscape stereographs. The success of illustration with photographic prints of any kind may be ascribed to their fidelity and cheapness and to the relative rapidity with which paper prints could be glued into the publication, while the decline of this practice was the result of even more efficient photomechanical methods that made possible the printing of text and image at the same time.

Wales and Scotland provided other English photographers besides Fenton with localities for wilderness images, among them Francis Bedford who made *Glas Pwil Cascade (pl. no. 122)* in 1865. In common with many landscapists of the period, Bedford issued stereographs as well as larger-format views because they were inexpensive and in popular demand. However, it was the Scottish photographer Wilson, probably the most successful of the view publishers, who is believed to have had the world's largest stock of scenic images in the 1880s *(pl. no. 121)*. Interested also in instantaneous pictures *(see Chapter 6)*, Wilson

noted that "considerable watching and waiting is necessary before the effect turns up which is both capable and worthy of being taken."[20] Using a tent darkroom in the field to prepare the exposures, this meticulous former portrait painter employed over 30 assistants in his Aberdeen printing establishment to carefully wash and gold-tone the prints in order to remove all chemical residue. As a consequence, Wilson albumen prints are of greater richness and stability than was usual for the era. Other British landscapists of the collodion era included Frith *(see below)*, William England, and James Valentine whose successful enterprise in Dundee, Scotland, turned out views similar to those by Wilson. While competently composed and well-produced, the absence of atmosphere and feeling in commercial views were contributing factors in the endeavors that began in the 1870s to fashion a new aesthetic for landscape photography.

Similar ideas about landscape motivated German viewmakers of the 1850s and '60s. Outstanding calotype views had been made in the early 1850s by Franz Hanfstaengl and Hermann Krone, before these individuals changed to collodion. Krone, the more versatile of the two, who advertised his *Photographisches Institut* in Dresden as a source for

118. CHARLES SOULIER. *Gorge of the Tamine*, c. 1865. Albumen print. Collection Gérard-Lévy, Paris.

119. ADOLPHE BRAUN. *Lake Steamers at Winter Mooring, Switzerland*, c. 1865.
Carbon print. J. Paul Getty Museum, Los Angeles.

scenic views and stereographs as well as portraits, was commissioned by the crown to produce views of the countryside and cityscape throughout Saxony, which resulted in the appearance in 1872 of his *Koenigs-Album der Stadte Sachsens (King's Album of Saxon Cities)* to celebrate the golden wedding anniversary of the rulers of Saxony. Though less idealized than some, these views of Dresden and its natural environs, exemplified by *Waterfall in Saxon Switzerland (pl. no. 123)*, still reflect the romantic attitude of the view painters of the early 19th century. Romanticism also suffuses *Bridge Near King's Monument (pl. no. 124)*, an 1866 image by Vogel, but the focus of this work is light and not locality. In a still different vein, studies of forest foliage and trees *(pl. no. 125)* made in the mid- to late-1860s and typified by the work of Gerd Volkerling suggest the influence of the Barbizon style of naturalism.

Landscape photography developed in the Scandinavian countries in the 1860s and '70s in response to the tourism that brought affluent British and German travelers to the rocky coasts of this region in search of untamed nature. Photographers Marcus Selmer of Denmark, Axel Lindahl and Per Adolf Thören of Sweden, and the Norwegians Hans Abel, Knud Knudsen, and Martin Skøien, all supplied good souvenir images to voyagers who, there as elsewhere, wished to individualize their recollections with picturesque travel images. The most dramatic of these views—the mist-shrouded mountains and tormented ice and rock formations *(pl. no. 126)* captured by Knudsen during his 35 or so years as an outstanding scenic photographer—reflect the prominent influence of the German Romantic style of landscape painting in that they not only serve as remembrances of places visited but encapsulate a sense of the sublime.

Landscape photographs of Italy were made almost

120. ROGER FENTON. *The Terrace and Park, Harewood House*, 1861. Albumen print. Royal Photographic Society, Bath, England.

121. GEORGE WASHINGTON WILSON. *The Silver Strand, Loch Katrine*, c. 1875–80. Albumen print. George Washington Wilson Collection, Aberdeen University Library.

THE SILVER STRAND, LOCH KATRINE. 10652. G.W.W.

exclusively as tourist souvenirs. A continuing stream of travelers from northern Europe and the United States ensured an income for a group of excellent foreign and Italian photographers. Here, especially, the romantic taste for ruins was easily indulged, with most images including at least a piece of ancient sculpture, building, or garden. As photography historian Robert Sobieszek has pointed out, because Italy was seen as the home of civilization, early photographers were able to infuse their views with a sense of the romantic past at almost every turn.[21] In *Grotto of Neptune, Tivoli (pl. no. 127)*, taken in the early 1860s, Robert

MacPherson, a Scottish physician who set himself up as an art dealer in Rome, captured the strong shadows that suggest unfathomable and ancient mysteries while fashioning an almost abstract pattern of tonalities and textures. Interest in romantic effects is apparent also in *Night View of the Roman Forum (pl. no. 128)* by Gioacchino Altobelli, a native Roman who at times collaborated with his countryman Pompeo Molins on scenic views. Altobelli, later employed by the Italian Railroad Company, was considered by contemporaries to be especially adept at combining negatives to recreate the sense of moonlight on the ruins—a popular

122. FRANCIS BEDFORD. *Glas Pwil Cascade (Lifnant Valley)*, 1865. Albumen print. National Gallery of Canada, Ottawa.

123. HERMANN KRONE. *Waterfall in Saxon Switzerland,* 1857. Albumen print. Deutsches Museum, Munich.

124. HERMANN VOGEL. *Bridge near King's Monument,* 1866. Albumen print. Agfa-Gevaert Foto-Historama, Cologne, Germany.

image because of the touristic tradition of visiting Roman ruins by night.

The best known by far of the Italian view-makers were the Brogi family and the Alinari brothers; the latter established a studio in Florence that is still in existence. Like Braun in France, the Alinari ran a mass-production photographic publishing business specializing in art reproductions, but their stock also included images of fruit and flowers and views of famous monuments and structures in Rome and Florence. In the south, Giorgio Sommer, of German origin, began a similar but smaller operation in Naples in 1857, providing genre scenes as well as landscapes. In Venice, tourist views were supplied by Carlo Ponti, an optical-instrument maker of fine artistic sensitivity that is apparent in *San Giorgio Maggiore Seen from the Ducal Palace (pl. no. 129)*, made in the early 1870s. Given the long tradition in Italy of *vedute*—small-scale topographical scenes—it is not surprising that camera views of such subject matter should so easily have become accomplished and accepted.

Other European nations on the Mediterranean such as Spain and Greece, while renowned for scenic beauty and ruins, were not documented with nearly the same enterprise as Italy, probably because they were outside the itineraries of many 19th-century travelers. The best-known photographs of Spain were made by Charles Clifford, an expatriate Englishman living in Madrid, who was court photographer to Queen Isabella II. Working also in other cities than the capital, Clifford photographed art treasures as well as landscapes and architectural subjects; his view *The Court of the Alhambra in Granada (pl. no. 130)* suggests a sense of sunlit quietude while still capturing the extraordinary richness of the interior carving. As one might anticipate, views of Greece, particularly the Acropolis, were somewhat more common than of Spain and also more commonplace. Photographed by native and foreign photographers, the most evocative are by James Robertson, Jean Walther, and William Stillman, an American associated with the British Pre-Raphaelites who had turned to photography as a result of disappointment with his painting. Stillman's images, published in 1870 as *The Acropolis of Athens Illustrated Picturesquely and Architecturally (pl. no. 131)*, were printed by the carbon process, which in England was called Autotype.

125. GERD VOLKERLING.
Oak Trees in Dessau, 1867.
Albumen print. Agfa-
Gevaert Foto-Historama,
Cologne, Germany.

Landscape Photography in the Near East and the Orient

Tourists were the main consumers of the views of Italy, but armchair travelers bought scenes from other parts of the world in the hope of obtaining a true record, "far beyond anything that is in the power of the most accomplished artist to transfer to his canvas."[22] These words express the ambitious goal that Frith set for himself when he departed on his first trip to the Nile Valley in 1856. Before 1860, he made two further journeys, extending his picture-taking to Palestine and Syria and up the Nile beyond the fifth cata-

ract *(pl. no. 132)*. In addition to photographing, he wrote voluminously on the difficulties of the project, especially owing to the climate, commenting on the "smothering little tent" and the collodion fizzing—boiling up over the glass—as well as on the sights in which he delighted—temples, sphinxes, pyramids, tombs, and rock carvings.

Frith's discussion of the compositional problems of view photography throws light on an aspect of 19th-century landscape practice often ignored. This was "the difficulty of getting a view satisfactorily in the camera: foregrounds are especially perverse; distance too near or too far; the falling away of the ground; the intervention of some brick

126. KNUD KNUDSEN. *Torghatten, Nordland,* c. 1885. Albumen print. Picture Collection, Bergen University Library, Bergen, Norway.

127. ROBERT MACPHERSON. *Grotto of Neptune, Tivoli*, 1861. Albumen print. J. Paul Getty Museum, Los Angeles.

RIGHT ABOVE:

128. GIOACCHINO ALTOBELLI. *Night View of the Roman Forum*, 1865–75. Albumen print.
International Museum of Photography at George Eastman House, Rochester, N.Y.

RIGHT BELOW:
129. CARLO PONTI. *San Giorgio Maggiore Seen from the Ducal Palace*, 1870s. Albumen print.
Smith College Museum of Art, Northampton, Mass.

wall or other common object. . . . Oh what pictures we would make if we could command our points of view."[23] While Frith undoubtedly had traditional painting concepts in mind when he wrote this, images such as *Approach to Philae (pl. no. 133)* show that he was capable of finding refreshing photographic solutions to these problems. The Egyptian and Near Eastern views were published by Frith himself and by others in a variety of sizes, formats, and in a number of different volumes, some in large editions. The most ambitious, *Egypt and Palestine Photographed and Described,*[24] had a significant effect on British perceptions of Egypt, as Frith had hoped it would, because the photographer, in addition to sensing the money-making possibilities of the locality, had voiced the belief that British policy-makers should wake up to the pronounced French influence in North Africa.

Some 40 photographers, male and female, from European countries and the United States, are known to have been attracted to the Near East before 1880, among them Bedford, who accompanied the Prince of Wales in 1862, the Vicomte of Banville, Antonio Beato, Félice Beato, Felix and Marie Bonfils, Wilhelm Von Herford, and James Robertson. Studios owned by local photographers also sprang up. Due to the superficial similarities of subject and identical surnames, for many years the two Beatos, Antonio and Félice, were thought to be the same individual, com-

130. CHARLES CLIFFORD. *The Court of the Alhambra in Granada,* c. 1856. Albumen print. J. Paul Getty Museum, Los Angeles.

131. WILLIAM STILLMAN. *Interior of the Parthenon from the Western Gate,* 1869. Carbon print. Photograph Collection, New York Public Library, Astor, Lenox, and Tilden Foundations.

132. FRANCIS FRITH (?). *Traveller's Boat at Ibrim*, c. 1859. Albumen print. Francis Frith Collection, Andover, England.

133. FRANCIS FRITH. *Approach to Philae*, c. 1858. Albumen print. Stuart Collection, New York Public Library, Astor, Lenox, and Tilden Foundations.

134. FELIX BONFILS, or family. *Dead Sea, A View of the Expanse*, 1860–90. Albumen print. Semitic Museum, Harvard University, Cambridge, Mass.

muting heroically between the Near and Far East, but now it is known that Antonio was the proprietor of an Egyptian firm based in Luxor that produced thousands of tourist images after 1862, among them this view of the interior of the Temple of Horus at Edfu *(pl. no. 135)*, while his brother, after a brief visit to Egypt with Robertson, was responsible for photographic activities in India and the Orient.[25]

The Bonfils family enterprise, operating from Beirut where they had moved from France in 1867, is typical of the second generation of Near East photographers. In a letter to the *Société Française de Photographie* in 1871, Bonfils reported that he had a stock of 591 negatives, 15,000 prints, and 9,000 stereographic views, all intended for an augmented tourist trade. Because the business was handed down from generation to generation, and stocks of photographs were acquired from one firm by another, there is no way of deciding exactly from whose hand images such as *Dead Sea, A View of the Expanse (pl. no. 134)* actually comes. Furthermore, by the 1880s, scenic views of the region and its monuments had lost the freshness and vitality that had informed earlier images, resulting in the trivialization of the genre even though a great number of photographers continued to work in the area.

Photographers working with paper and collodion began to penetrate into India and the Far East toward the end of the 1850s, but providing images for tourists was not their only goal. In India, photography was considered a documentary tool with which to describe to the mother

country the exotic and mysterious landscape, customs, and people of a subject land; as such it was supported by the British military and ruling establishment. Dr. John McCosh and Captain Linnaeus Tripe were the first to calotype monuments and scenery, the latter producing prize-winning views that were considered "very Indian in their character and picturesquely selected."[26] As a consequence of imperialistic interest, a spate of photographically illustrated books and albums issued from both commercial and military photographers during the 1860s and '70s, with illustrations by Félice Beato, P. A. Johnston, and W. H. Pigou. Samuel Bourne, the most prominent landscapist working in collodion in India, was a partner with Charles Shepherd in the commercial firm of Bourne and Shepherd, and traveled at times with 650 glass plates, two cameras, a ten-foot-high tent, and two crates of chemicals. He required the assistance of 42 porters, without whom, it was noted in the British press, photography in India would not have been possible for Europeans.[27] As part of an endeavor to produce *A Permanent Record of India*, Bourne explored remote areas in the high Himalaya mountains and in Kashmir during his seven-year stay. A perfectionist who had left a career in banking to photograph, he claimed that he waited several days for the favorable circumstances that might allow him to achieve the tonal qualities seen in, for example, *Boulders on the Road to Muddan Mahal (pl. no. 136)*.[28] Colin Murray, who took over Bourne's large-format camera when the latter returned to England, apparently

135. Antonio Beato.
Interior of Temple of Horus, Edfu, after 1862. Albumen print. National Gallery of Canada, Ottawa.

also inherited his approach to landscape composition; both believed that a body of water almost inevitably improved the image. The lyrical *Water Palace at Udaipur (pl. no. 137)* is one of a group of landscapes that Murray made for a publication entitled *Photographs of Architecture and Scenery in Gujerat and Rajputana*, which appeared in 1874.

Lala Deen Dayal, the most accomplished Indian photographer of the 19th century, and Darogha Ubbas Alli, an engineer by profession, appear to have been the only Indian photographers to publish landscape views. Deen Dayal of Indore began to photograph around 1870, becoming official photographer to the viceroy and soon afterward to the nizam (ruler) of Hyderabad; his studios in Hyderabad and Bombay, known as Raja Deen Dayal and Sons, turned out portraits, architectural views, and special documentary projects commissioned by his patron *(see Chapter 8)*. Architectural images by Ubbas Alli of his native city Lucknow, issued in 1874, are similar in style to

those produced by the Europeans who were responsible for the majority of Indian scenic views.

As on the Indian subcontinent, scenic views in China and Japan were made first by visiting Europeans who brought with them, in the wake of the rebellions and wars that opened China to Western imperialism, equipment, fortitude, and traditional Western concepts of pictorial organization. The earliest daguerreotypists of the Orient included Eliphalet Brown, Jr., who arrived with Commodore Perry's expedition, and Hugh McKay, who operated a daguerreotype studio in Hong Kong in the late 1840s; they were followed by other Westerners who arrived in China hoping to use wet-plate technology to record scenery and events in commercially successful ventures. Sev-

eral of these photographers purchased the negatives of forerunners, amassing a large inventory of views that were turned out under the new firm name. Among the outsiders who were active in China during this period were M. Rossier, sent by the London firm of Negretti and Zambra (large-scale commercial publishers of stereographic views), and Félice Beato, who in addition to recording episodes in the conquests by the Anglo-French North China Expeditionary Force in 1860 *(see Chapter 4)* photographed landscapes and daily activities. Between 1861 and 1864, the American photographer Milton Miller, apparently taught by Beato and recipient of many of his negatives, worked in Hong Kong, specializing in portraiture and street scenes.

The most energetic outsider to photograph in China

136. SAMUEL BOURNE. *Boulders on the Road to Muddan Mahal,* c. 1867. Albumen print.
Royal Photographic Society, Bath, England.

137. COLIN MURRAY. *The Water Palace at Udaipur*, c. 1873. Albumen print. Collection Paul F. Walter, New York.

was John Thomson, originally from Scotland. Using Hong Kong as home base and traveling some 5,000 miles throughout the interior and along the coast—usually accompanied by eight to ten native bearers—Thomson worked in China between 1868 and 1872 before returning to England to publish a four-volume work on Chinese life. His images display a genuine interest in Chinese customs and seem influenced by traditional Chinese painting, as exemplified by his treatment of the landscape in *Wu-Shan Gorge, Szechuan (pl. no. 138)*.

Commercial view-making by native photographers began very slowly, but in 1859 a studio was opened in Hong Kong by Afong Lai, who was to remain preeminent in this area throughout the remainder of the century. Highly regarded by Thomson as "a man of cultivated taste" whose work was "extremely well executed,"[29] Afong Lai's images, such as a view of Hong Kong Island *(pl. no. 139)*, also reveal an approach similar to that seen in traditional Chinese landscape painting. Although Afong Lai was virtually alone when he began his commercial enterprise, by 1884 it was estimated that several thousand native photographers were in business in China, although not all made scenic views.

Amateur photography also appears to have begun slowly, with neither foreign residents nor native Chinese merchants expressing much interest in this form of expression before the turn of the century. One exception was Thomas Child, a British engineer working in Peking in the 1870s, who produced (and also sold) nearly 200 views he had taken of that city and its environs, including an image of a ceremonial gate *(pl. no. 140)*. After 1900, Ernest Henry Wilson, a British botanist made ethnographic views, while Donald Mennie, also British and the director of a well-established firm of merchants, approached Chinese landscape with the vision and techniques of the Pictorialist, issuing the soft-focus romantic-looking portfolio *The Pageant of Peking* in gravure prints in 1920.

Social and political transformations in Japan during the 1860s—the decade when the Meiji Restoration signaled the change from feudalism to capitalism—created an atmosphere in which both foreign and native photographers found it possible to function, but besides Beato, who appears to have come to Japan in 1864, few photographers were interested at first in pure landscape views. In general, a truly native landscape tradition did not evolve in India or the Far East during the collodion era, and, in the period that followed, the gelatin dry plate and the small-format snapshot camera combined with the influence of imported Western ideas to make the establishment of an identifiable national landscape style difficult.

138. JOHN THOMSON. *Wu-Shan Gorge,
Szechuan*, 1868. Albumen print.
Philadelphia Museum of Art.

139. AFONG LAI. *Hong Kong Island*, late
1860s. Albumen print. Collection
H. Kwan Lau, New York.

140. THOMAS CHILD. *Damaged Portal of Yuen-Ming-Yuan, Summer Palace, Peking, after the Fire of 1860, set by English and French Allied Forces*, 1872. Albumen print. Collection H. Kwan Lau, New York.

141. DÉSIRÉ CHARNAY. *Chichén-Itzá, Yucatan*, c. 1858. Albumen print. Collection Centre Canadien d'Architecture/Canadian Centre for Architecture, Montréal.

Landscape in the Americas

On the opposite site of the Pacific, Mexico was seen by some sectors of the French government as a possible area of colonialist expansion and therefore came under the scrutiny of the camera lens. Désiré Charnay, a former teacher with an itch for adventure and a belief in France's destiny in the Americas, explored and photographed in the ancient ruined cities of Chichén-Itzá, Uxmal, and Palenque between 1858 and 1861 (and was again in Mexico from 1880 to 1882). The first in this part of the world to successfully use the camera as a research tool in archeological exploration, Charnay published the views in an expensive two-volume edition of photographs with text by himself and French architect Viollet-le-Duc, and he made images available for translation into wood engraving to accompany articles in the popular press.[30] Despite the fantasy of ideas put forth by the authors concerning the origins of the ancient cities of the new world, the photographs themselves, in particular those of the ornately carved facades of the structures at Chichén-Itzá *(pl. no. 141)*, reveal a mysterious power that most certainly served to promote popular

and scientific interest in the cultures that had created these edifices. Though Charnay later worked on expeditions to Madagascar, Java, and Australia, this first group of images appears to be the most completely realized.

Urban topographical views—harbors, public buildings, and town squares—comprise a large portion of the photographic landscape documentation made in South America after mid-century. Supported in some cases by the avid interest of the ruling family, as in Brazil under Emperor Dom Pedro II—himself an amateur camera enthusiast—and in other countries by the scientifically minded European-oriented middle class, professional view-makers turned out images that sought to present topography and urban development in a favorable if not especially exalted light. The most renowned South American photographer of the time, Marc Ferrez, a Brazilian who opened his own studio in Rio de Janeiro after spending part of his youth in Paris, advertised the firm as specializing in Brazilian views. Introducing figures to establish scale in his 1870 *Rocks at Itapuco (pl. no. 142)*, Ferrez's image balances geological descriptiveness with sensitivity to light to create a serene yet visually arresting image.

North American attitudes about scenery reflected the unique situation of a nation without classical history or fabled ruins that shared a near religious exaltation of virgin nature. Many Americans were convinced that the extensive rivers and forests were signs of the munificent hand of God in favoring the new nation with plenty; others recognized the economic value of westward expansion and found photography to be the ideal tool to enshrine ideas of "manifest destiny." Painters of the Hudson River School and photographers of the American West recorded landscape as though it were a fresh and unique creation, but while the optimism of many East Coast artists had vanished in the aftermath of the Civil War, photographers (and painters) facing untrammeled western scenery continued to express buoyant reverence for nature's promise.

In a literal sense, a photographic "Hudson River School" did not exist. Eastern landscapists working in the Hudson Valley and the Adirondack and White mountains regions,

among them James Wallace Black, the Bierstadt and Kilburn brothers, John Soule, and Seneca Ray Stoddard, were concerned largely, though not exclusively, with a commerce in stereograph views, a format in which it was difficult to express feelings of sublimity. On occasion, a sense of the transcendent found its way into images such as Black's mountain scene *(pl. no. 143)*; Stoddard's *Hudson River Landscape (pl. no. 144)*, in which the horizontal format, luminous river, and small figure suggest the insignificance of man in relation to nature, is another such example. Although American view photographers were urged to avoid "mere mechanism" by familiarizing themselves with works by painters such as Claude, Turner, and Ruisdael, as well as by contemporary American landscape painters, artistic landscapes in the European style were of concern only to a small group working out of Philadelphia in the early 1860s. These photographers responded to a plea by a newly established journal, *Philadelphia Photographer*, to

142. MARC FERREZ. *Rocks at Itapuco*, 1870. Albumen print. Collection H. L. Hoffenberg, New York.

143. JAMES WALLACE BLACK. *In the White Mountain Notch*, 1854. Albumen print. Art Museum, Princeton University, Princeton, N.J.; Robert O. Dougan Collection.

144. SENECA RAY STODDARD. *Hudson River Landscape*, n.d. Albumen print. Chapman Historical Museum of the Glens Falls-Queensbury Association, Glens Falls, N.Y.

145. JOHN MORAN. *Scenery in the Region of the Delaware Water Gap*, c. 1864. Albumen stereograph. Library Company of Philadelphia.

146. VICTOR PRÉVOST. *Reed and Sturges Warehouse*, c. 1855. Calotype. New-York Historical Society, New York.

create a native landscape school to do "really first class work," that is, to imbue landscape with a distinctive aura. *Scenery in the Region of the Delaware Water Gap (pl. no. 145)* by John Moran, who had been trained as a painter along with his more famous brother Thomas, is representative of the work by the Philadelphia naturalists, whose photographic activities were strongly colored by a conscious regard for artistic values. Farther west, the Chicago-based, Canadian-born Alexander Hesler had switched to making collodion negatives of the natural wonders of the upper Mississippi Valley with similar objectives in mind. Nevertheless, despite the promotion of native landscape expression in art and photography periodicals, this genre flowered only after photographers became involved in the western explorations.

At the same time, it is apparent from early camera documentation of buildings and the cityscape that most photographers made little effort to do more than produce a prosaic record of architectural structures. Images of buildings by George Robinson Fardon in San Francisco; James McClees, Frederick Debourg Richards, and even John Moran, working in Philadelphia; and the anonymous recorders of architecture in Boston and New York, are largely unnuanced depictions of cornices, lintels, and brick and stone work. With the exception of the photographs by Victor Prévost—a calotypist from France whose views of Central Park and New York buildings, made around 1855, are informed by a fine sense of composition and lighting and, in the *Reed and Sturges Warehouse (pl. no. 146)*, by a respect for the solid power of the masonry—camera pictures of cities often appear to be a record of urban expansion, a kind of adjunct to boosterism.

Western Views

Photographs of western scenery were conceived as documentation also, but they project a surpassing spirit, a sense of buoyant wonder at the grandeur of the wilderness. These images embody the romanticism of mid-century painting and literature—the belief that nature in general and mountains in particular are tangible evidence of the role that the Supreme Deity played in the Creation. Though necessarily different in scale and subject from paintings that depict the discovery and exploration of the North American continent, these photographs reflect the same confidence in the promise of territorial expansion that had moved painters of the 1840s and '50s.

Photography became a significant tool during the 1860s, when railroad companies and government bodies recognized that it could be useful as part of the efforts by survey teams to document unknown terrain in the Far West. Scientists, mapmakers, illustrators, and photogra-

phers were hired to record examples of topography, collect specimens of botanical and geological interest, and make portraits of Native Americans as aids in determining areas for future mineral exploitation and civilian settlements. In addition to being paid for their time, and/or supplied with equipment, individual photographers made their own arrangements with expedition leaders regarding the sale of images. Views were issued in several sizes and formats, from the stereograph to the mammoth print—about 20 by 24 inches—which necessitated a specially constructed camera. For the first time, landscape documentation emerged as a viable livelihood for a small group of American photographers.

Whether working in the river valleys of New York, New England, and Pennsylvania, or the mountains of the West, American wet-plate photographers transported all their materials and processing equipment without the large numbers of porters who attended those working in Europe and the Orient, although assistance was available from the packers included on survey teams. Besides the cameras (at times three in number), photographers carried glass plates in various sizes, assorted lenses, and chemicals in special vans and by pack animals. Tents and developing boxes, among them a model patented by the photographer John Carbutt in 1865 *(pl. no. 147)*, enabled individuals to venture where vehicles could not be taken. Constant unpacking and repacking, the lack of pure water, the tendency of dust to adhere to the sticky collodion—problems about which all survey photographers complained—make the serene clarity of many of these images especially striking.

Following efforts by Solomon Nunes Carvalho to make topographical daguerreotypes on Colonel John C. Frémont's explorations west of the Mississippi, the

147. *Carbutt's Portable Developing Box.* Wood engraving from *The Philadelphia Photographer*, January, 1865. Private Collection.

American painter Albert Bierstadt, accompanying an expedition to the Rocky Mountains in 1859, was among the first to attempt to publicize the grandeur of western scenery. His wet-plate stereographs are visually weak, but they (and articles written on the subject for *The Crayon*, a periodical devoted to the support of a native landscape art) exemplify the interest in the West by scientists and writers as well as artists. California, especially, became the focus of early documentation, including that by Charles L. Weed and Carleton E. Watkins, who began to photograph the scenery around Yosemite Valley in the early 1860s. Both had worked in the San Jose gallery of daguerreotypist Robert Vance, who stocked a large inventory of scenic views taken in Chile and Peru as well as in the West. By 1868, Watkins—who had made his first views of Yosemite five years earlier and had worked on the Whitney Survey of the region in 1866, when he shot *Cathedral Rock (pl. no.*

148)—had become internationally recognized in photographic circles for establishing the mountain landscape as a symbol of transcendent idealism. Impelled perhaps by the controversies then current among naturalists, including expedition leader Clarence King, regarding the relationship of religion to geology and evolution, Watkins's images of rocks seem to emphasize their animate qualities.

Eadweard Muybridge, Watkins's closest competitor, produced views of Yosemite in 1868 and 1872 that likewise enshrine the wilderness landscape as emblematic of the American dream of unsullied nature. Muybridge sought to imprint his own style on the subject by the selection of unusual viewpoints and the disposition of figures in the landscape. Sensitive to the requirements of artistic landscape style, he at times printed-in the clouds from separate negatives to satisfy critics who found the contrast between foreground and sky too great, but he also devised a more

148. CARLETON E. WATKINS. *Cathedral Rock, 2,600 Feet, Yosemite, No. 21*, published by I. Taber, c. 1866. Albumen print. Metropolitan Museum of Art, New York; Elisha Whittelsey Collection, Elisha Whittelsey Fund, 1922.

149. EADWEARD MUYBRIDGE. *A Study of Clouds*, c. 1869. Albumen stereographs.
Bancroft Library, University of California, Berkeley, Cal.

authentically photographic method—the sky shade—a shutterlike device that blocked the amount of blue light reaching the plate. As has been noted, cloud studies, similar to this group by Muybridge *(pl. no. 149)*, were made by photographers everywhere during this period, in part to redress the problem of an empty upper portion of the image and in part because of the photographers' fascina-tion with the ever-changing formations observable in the atmosphere. Muybridge, whose deep interest in ephemeral atmospheric effects was perhaps inspired by association with Bierstadt in 1872, also made a number of remarkable pictures in 1875 of smoke and mist-filled latent volcanoes in Guatemala *(pl. no. 150)*.

Timothy O'Sullivan, a former Civil War photographer

150. EADWEARD MUYBRIDGE. *Volcano Quetzeltenango, Guatemala*, 1875. Albumen print.
Department of Special Collections, Stanford University Library, Palo Alto, Cal.

who became part of Clarence King's 40th Parallel Survey in 1867 *(see Profile)*, was exceptionally fitted by nature and experience on the battlefield for the organizational and expressive demands of expedition photography. O'Sullivan photographed the volcanic formations of desolate areas, among them Pyramid Lake (pl. no. *151*), with an accuracy—the rocks were photographed in varying light conditions—that reflected King's absorption with geological theory. His images surpass scientific documentation, however, and create an unworldly sense of the primeval, of an untamed landscape of extraordinary beauty. Furthermore, by his choice of vantage point he was able to evoke the vastness and silence of this remote area in intrinsically photographic terms without resorting to the conventions of landscape painting. The work of William Bell, O'Sullivan's replacement on the Wheeler Survey of 1871–72, reveals a sensitivity to the dramatic qualities inherent in inanimate substances; his *Hieroglyphic Pass, Opposite Parowan (pl. no. 152)* is also unusual in its absence of atmosphere or sense of scale.

In 1871, an expedition down the Colorado River, headed by John Wesley Powell, included E. O. Beaman, an eastern landscape photographer, whose image of a magnificent and lonely mountain pass, *The Heart of Lodore, Green River*

(pl. no. 154), is given scale and a touch of humanity by the inclusion of a small seated figure. John K. Hillers learned photographic techniques from Beaman, whom he eventually replaced; his view of *Marble Canyon, Shinumo Altar (pl. no. 153)*, a place that he characterized as "the gloomiest I have ever been in—not a bird in it,"[31] displays imaginative as well as technical skill. A similar capacity to both document and infuse life into obdurate substances can be seen in *Hanging Rock, Foot of Echo Canyon, Utah (pl. no. 168)*, taken by Andrew Joseph Russell, a former painter and Civil War photographer, while he was documenting the construction of the Union Pacific Railroad.

William Henry Jackson, employed for eight years on the western survey headed by geologist Ferdinand V. Hayden, was in a privileged position to evolve from journeyman photographer to camera artist of stature. That survey *(pl. no. 155)*, begun in 1870 in the Uintas Mountains and expanded in the following years to embrace the Grand Canyon and the Yellowstone River, included artists Sanford R. Gifford and Thomas Moran, whose landscape paintings helped shape Hayden's and Jackson's pictorial expectations. The close relationship that developed between Jackson and Moran enabled the photographer to

refine his vision, even to the point of setting up his camera in positions scouted by Moran, who is seen in Jackson's view of *Hot Springs on the Gardiner River, Upper Basin (pl. no. 156)*.

Unlike the fate of the photographs made for France's *Missions héliographiques*, American survey images were seen by a large public. In addition to satisfying the voracious appetite of publishers for marketable landscape stereographs, they also were presented in albums and as lantern slides to members of Congress and other influential people to drum up support for funding civilian scientific expeditions and creating national parklands. For example, besides the sketches that Moran made available to *Scribner's Magazine (pl. no. 157)* in support of Hayden's campaign for a Yellowstone National Park, Jackson printed up albums of *Yellowstone Scenic Wonders* to convince the United States Congress of the distinctive grandeur of the scenery.[32] In later years, Jackson established a successful commercial

enterprise in western images, but it is his work of the mid-'70s, inspired by the land itself and by the artistic example of Moran, that is most compelling.

At about the same time that western survey photography was getting under way, photographers were also included on expeditions to Greenland, organized by Isaac Hayes, and to Labrador, sponsored by the painter William Bradford. John L. Dunmore and George Critcherson, of Black's Boston studio, worked with the painter to photograph icebergs and glacial seas, providing plates for Bradford's publication *The Arctic Regions* as well as material for his intensely colored Romantic seascapes. Besides recording the forms of icebergs, the incisive reflections and sharp contours of *Sailing Ships in an Ice Field (pl. no. 158)*, for example, suggest the sparkling sharpness of the polar climate. Photography of the polar regions continued into what has been called the heroic period of Polar exploration, with expeditions led by Amundsen, Mawson, Peary, and

151. TIMOTHY O'SULLIVAN. *Tufa Domes, Pyramid Lake*, 1867. Albumen print. National Archives, Washington, D.C.

152. WILLIAM BELL. *Utah Series No. 10, Hieroglyphic Pass, Opposite Parowan, Utah*, 1872. Albumen print. Art, Prints and Photograph Division, New York Public Library, Astor, Lenox, and Tilden Foundations.

153. JOHN K. HILLERS. *Marble Canyon, Shinumo Altar*, 1872. Albumen print. National Archives, Washington, D.C.

154. E. O. BEAMAN. *The Heart of Lodore, Green River*, 1871. Albumen print. National Archives, Washington, D.C.

155. WILLIAM HENRY
JACKSON. *Members of the
Hayden Survey*, 1870.
Albumen print. National
Archives, Washington,
D.C.

Scott in the early years of the 20th century, and it is not surprising that some of these later images, among them *An Iceberg in Midsummer, Antarctica (pl. no. 159)* by British photographer Herbert Ponting, made between 1910 and 1913 while accompanying Scott to Antarctica, should recall the freshness of vision that characterized the first views of the western wilderness.

Influenced by westward movements in the United States and by the discovery of gold in British Columbia, the Province of Canada funded an expedition in 1858 to what is now Manitoba; although images made by staff photographer Humphrey Lloyd Hime, a partner in a Toronto engineering firm, were concerned mainly with inhabitants of the region, the few rather poor landscapes indicate the nature of the problems of expedition photography at this early date. Hime noted that to make adequate topographical pictures he required better equipment, pure water, and, most important, more time for taking and processing than expedition leaders were willing to spend.[33] Other Canadian surveys made in connection with railroad routes or border disputes also employed photographers, most of whom produced documents that are more interesting as sociological information than as evocations of the landscape.

Among the few Canadians to imbue scenic images with a sense of atmosphere were Alexander Henderson and

William Notman, the best-known commercial photographer in Canada. Henderson, a latecomer to photography and a well-to-do amateur, may have been influenced by English landscape photography with which he was familiar through his membership in the Stereoscope Exchange Club. But *Spring Flood on the St. Lawrence (pl. no. 160)* of 1865 also seems close in spirit to the idyllic outlook of the American Hudson River artists.

Surveys had provided an effective structure for the documentation of the West, but during the 1880s their functions, including photography, were taken over by the newly established United States Geological Survey and the Bureau of Ethnology. While areas of the West continued to attract individual photographers, most of the images made in frontier studios or in the field during the last quarter of the century consisted of documentation of new settlers or of native tribespeople and their customs, with landscape a byproduct of these concerns. Furthermore, as the nation moved into high gear industrially, the natural landscape no longer was seen as a symbol of transcendent national purpose.

Scenic views made during the 1880s, after the gelatin dry plate had begun to supplant collodion, embodied varied attitudes toward nature. Many landscapists on both sides of the Atlantic were influenced by the ideas of Naturalism, an attitude that celebrated the ordinary and un-

156. WILLIAM HENRY JACKSON. *Hot Springs on the Gardiner River, Upper Basin (Thomas Moran Standing)*, 1871. One-half of an albumen stereograph. International Museum of Photography at George Eastman House, Rochester, N.Y.

157. THOMAS MORAN. *Bathing Pools, Diana's Baths*, 1872. Engraving. Library of Congress, Washington, D.C.

158. JOHN L. DUNMORE and GEORGE CRITCHERSON. *Sailing Ships in an Ice Field*, 1869. Albumen print.
International Museum of Photography at George Eastman House, Rochester, N.Y.

spectacular both in landscape and social activity *(see Chapter 5)*. Some Americans, among them George Barker, continued their romance with the magnificence of native scenery, but a different sensibility is apparent in images such as Barker's *Moonlight on the St. Johns River (pl. no. 161)*—one suggestive of the end of an era rather than the onset of a period of promise. Barker was nationally renowned for views of Niagara Falls, in which rock and water spray are invested with spectacular drama rather than with the noble clarity that had characterized earlier images. Another landscapist of the period, Henry Hamilton Bennett, proprietor of a commercial studio in Kilbourn, Wisconsin, domesticated the wilderness photograph in his views of picnicking and boating parties on the Wisconsin Dells *(pl. no. 162)*, an area that formerly had been famed for its wilderness of glorious valleys and lofty perpendicular rocks.

The flowering of landscape and scenic views during the eras of the calotype and collodion was partly the result of the general urge in all industrialized societies to measure, describe, and picture the physical substances of all things on earth and in the heavens. It was partly a reaction to urbanization—an attempt to preserve nature's beauty. The compelling power of many of these images also flows in a measure from the difficulty of the enterprise. Whether in the Alps, Himalayas, or Rockies, on the Colorado, Nile, or Yangtze, the photographer had to be profoundly committed to the quest for scenic images before embarking on an arduous journey, with the result that many images embody

159. HERBERT PONTING. *An Iceberg in Midsummer, Antarctica*, 1910–13. Carbon print. Original Fine Arts Society Edition print from the Antarctic Divisions Historical Print Collection, University of Melbourne, Parkville, Australia.

160. ALEXANDER HENDERSON. *Spring Flood on the St. Lawrence*, 1865. Albumen print.
National Gallery of Canada, Ottawa, Ralph Greenhill Collection.

this passion and resolve. After 1880, the ease and convenience first of the gelatin dry plate, and then of the roll-film camera, made landscape photographers out of all who could afford film and camera, and led to an inundation of banal scenic images that often were, in Bourne's words, "little bits, pasted in a scrapbook."[34]

Profile: Gustave Le Gray

Gustave Le Gray combined the imaginative curiosity and skill of both artist and scientist. While still a student in the studio of the academic salon painter Paul Delaroche, he became aware of photography but did not involve himself in the new medium until the end of the 1840s. His inability to survive as a painter in the overcrowded art field of Second Empire France kindled an enthusiasm for working with the paper negative. A strong interest in the chemistry of paint, applied now to the problems of the calotype, led him to perfect in 1849 the dry waxed-paper process that came to be utilized, at least briefly, by most of the major figures in mid-19th-century French photography. Although Le Gray also had worked out a collodion process at the same time, he was uninterested in glass at first and did not

publish either discovery until 1851, when they appeared in his publication *Nouveau Traité théorique et pratique de photographie sur papier et sur verre (New Treatise on the Theory and Practice of Photography on Paper and Glass)*, by which time Archer already had made the first public disclosure of a collodion method.

The instructor of many artists and intellectuals eager to learn photography, including Du Camp, Fenton, Le Secq, Marville, and Nègre, Le Gray was held in uniformly high esteem by his contemporaries for his ability to use light suggestively. He was invited to participate in important photographic projects, among them the *Missions héliographiques*, where he photographed by himself as well as with O. Mestral, and in 1856 he was asked to provide a reportage on the newly established Imperial Army camp at Châlons *(pl. no. 199)*. Enshrouded in mist and surrounded by silent, empty terrain, the groups of soldiers in these images suggest an unworldly convocation, a vision that accorded with the emperor's almost religious regard for this military encampment. On his own, Le Gray made artistic calotype photographs in the Barbizon tradition at Fontainbleau forest in 1849 and five years later, in collodion, of the movement of clouds and sea at Sète (Cette) *(pl. no. 116)*, and

161. GEORGE BARKER. *Moonlight on the St. Johns River*, 1886. Albumen print. Library of Congress, Washington, D.C.

162. HENRY HAMILTON BENNETT. *Sugar Bowl with Rowboat, Wisconsin Dells*, c. 1889. Albumen print. © H.H. Bennett Studio, Wisconsin Dells, Wis.

at Dieppe where he recorded Napoleon III's naval fleet. These images, exhibited repeatedly, were highly acclaimed, inviting a first prize at the 1855 *Exposition Universelle*.

In view of these successes, Le Gray's withdrawal from the photographic scene after 1858 may seem difficult to understand, but his situation reveals some of the problems confronting photographers in France in the 19th century. Lacking independent means, Le Gray was able to support himself by commercial photography—portraiture, technical illustration, reproductions of artwork—and indulge his high standards through the generosity of a patron, the Comte de Briges. However, as the medium itself became more competitive and commercial, and the count's patronage ended, Le Gray found himself more interested in problems of light and pictorial organization than in making salable views that "were got up in a style that renders them a fit ornament for any drawing room."[35] What his friend Nadar characterized as poor business sense was more probably Le Gray's reluctance to accept prevailing marketplace standards; in any event, he left family and associates and traveled to Italy, Malta, and finally Egypt, where he finished his career as professor of design in a polytechnic institute.

The acclaim accorded Le Gray was for the exceptional quality of his salt and albumen prints as well as for his innovative vision. His technical mastery of gold-chloride toning, which permitted the revelation of details buried in the deepest shadows, derived from a conception of printing as an integral aspect of an entire process by which the photographer transforms nature into art.

Profile: Timothy O'Sullivan

Timothy O'Sullivan came to landscape photography after four years of experience photographing behind the lines and on the battlefields of the Civil War. A former assistant in Mathew Brady's New York studio, in 1861 he had joined the group known as "Brady's Photographic Corps," working with Alexander Gardner. Because Brady refused to credit the work of individual photographers, Gardner, taking O'Sullivan along, established his own Washington firm to publish war views. War images taken by O'Sullivan are wide-ranging in subject and direct in their message, including among them the weariness of inaction and continual waiting, and the horror of fields of the dead *(pl. no. 209)*.

After the war, O'Sullivan, faced with the dullness of commercial studio work, discovered an optimum use for his energies and experience as a photographer on the survey teams that were being organized under civilian or military leadership to document wilderness areas west of the Mississippi. Departing from Nevada City with 9 x 12 inch and stereograph cameras, 125 glass plates, darkroom equipment, and chemicals, for more than two years he explored the strange and inhospitable regions along the 40th Parallel with a group headed by the eminent geologist Clarence King. Following a brief period with the Darien Survey to the Isthmus of Panama, where both the humid atmosphere and the densely foliated terrain made photography difficult, he found another position on a western survey. As Weston Naef has pointed out,[36] photography on the Geological Surveys West of the 100th Meridian, as the expedition commanded by Lieutenant George M. Wheeler of the Army Corps of Engineers was called, "was not so much a scientific tool as it was a means of publicizing the Survey's accomplishments in the hopes of persuading Congress to fund military rather than civilian expeditions in the future."

O'Sullivan's purpose in joining this team was more likely personal than political in that he was allowed by Wheeler to be his own master, in charge of portions of the expedition, and thus did not have to take orders from geologists. Involved in the dramatic if not scientifically defensible exploit of attempting to ascend the Colorado River through the Grand Canyon, Wheeler noted O'Sullivan's professionalism in producing negatives in the face of all obstacles, including a near drowning. Following another brief period with King, O'Sullivan joined a Wheeler-led survey to the Southwest where he documented not only geological formations but members of the pueblo and rock-dwelling tribes in the region of the Canyon de Chelle *(pl. no. 163)*. After 1875, O'Sullivan's problematical health and the winding down of survey photography put an end to further involvement with the western landscape. Following a brief period in 1879 as photographer in the newly established United States Geological Survey, of which King was first director, and a position with the Treasury Department in Washington, O'Sullivan was forced by his tubercular condition to resign; he died a year later in Staten Island at age forty-two.

O'Sullivan approached western landscape with the documentarian's respect for the integrity of visible evidence and the camera artist's understanding of how to isolate and frame decisive forms and structures in nature. Beyond this, he had the capacity to invest inert matter with a sense of mysterious silence and timelessness; these qualities may be even more arresting to the modern eye than they were to his contemporaries, who regarded his images as accurate records rather than evocative statements.

The Western Landscape— Natural and Fabricated

This selection of early views of the American West suggests the dual role that the photograph played after the Civil War in the exploration and development of this relatively unknown part of the continent. Taken between the years 1867 and 1878, these pictures are the work of five among the numerous photographers who either accompanied geological survey teams, were employed by railroad companies, or were professionals with established studios in West Coast cities. Beyond their roles as documenters, all were inspired by the spectacular scale and breadth of the pristine wilderness landscape, by its strange rock formations, its steamy geysers, and its sparkling waterfalls. Using the cumbersome wet-plate process, they sought out the vantage points that might make it possible to recreate for Easterners a sense of the immensity and primordial silence of the region.

A number of the same photographers were called upon to document the building of rail lines, bridges, water sluices, and urban centers. Eadweard Muybridge produced a panorama of the young and growing metropolis of San Francisco, from which four of the thirteen mammoth (18 x 24 inch) plates are reproduced, showing cable cars, churches, and public and commercial buildings as well as dwellings laid out in a well-defined street system. As the frontier moved westward and industrialization began to change the character of the landscape, Americans increasingly turned to the photograph as a means of both celebrating technology and of expressing reverence for the landscape being threatened by its advance.

163. TIMOTHY H. O'SULLIVAN. *Ancient Ruins in the Canyon de Chelle, New Mexico*, 1873. Albumen print. International Museum of Photography at George Eastman House, Rochester, N.Y.

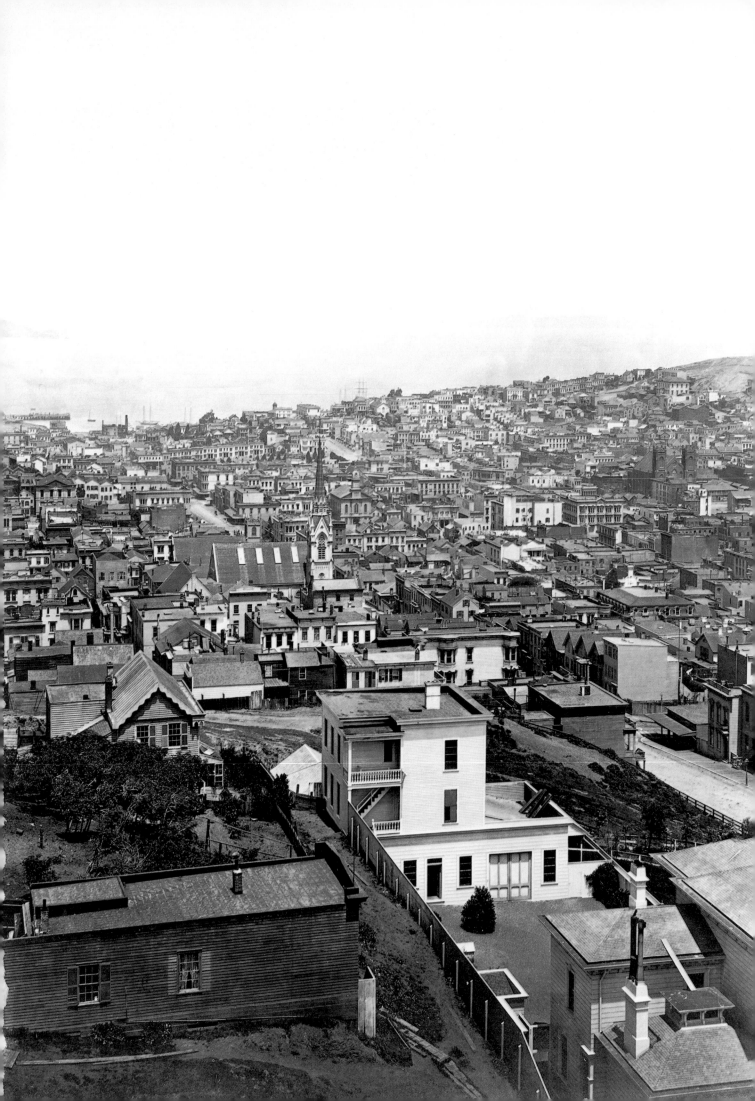

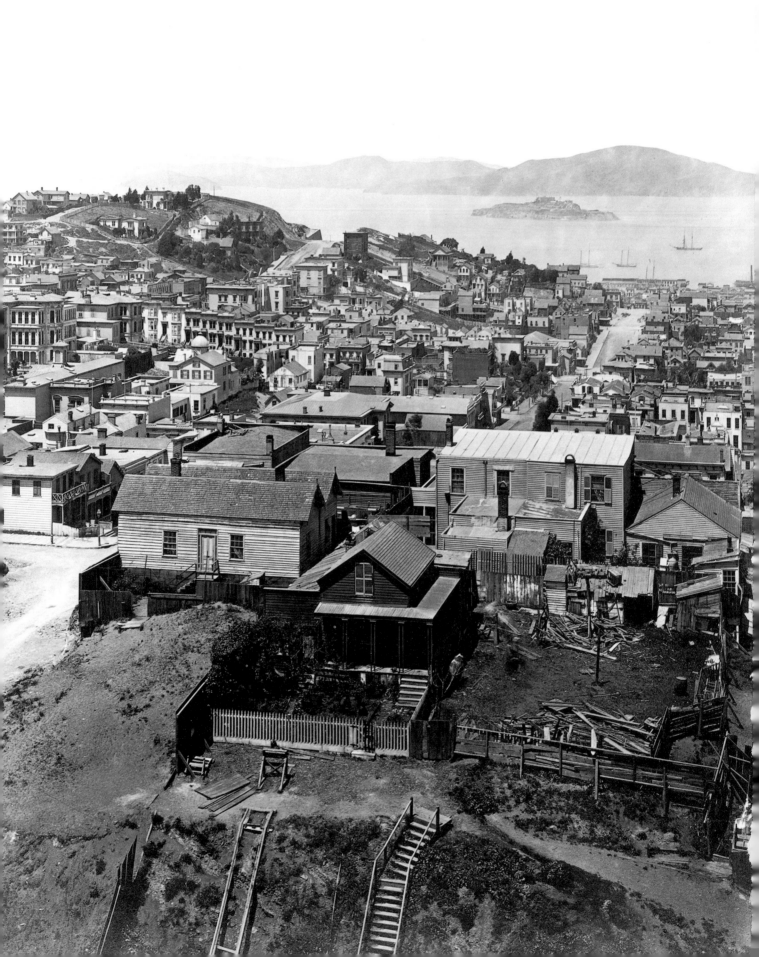

164. CARLETON E. WATKINS. *Magenta Flume, Nevada Co., California*, c. 1871. Albumen print.
Baltimore Museum of Art; Purchase with exchange funds from the Edward Joseph Gallagher III Memorial Collection;
and Partial Gift of George H. Dalsheimer, Baltimore.

OPEN FOR FOLDOUT:

165. EADWEARD MUYBRIDGE. *Panorama of San Francisco from California Street Hill*, 1878.
Panorama in 13 plates (four plates reprinted here). Albumen prints. Bancroft Library, University of California, Berkeley.

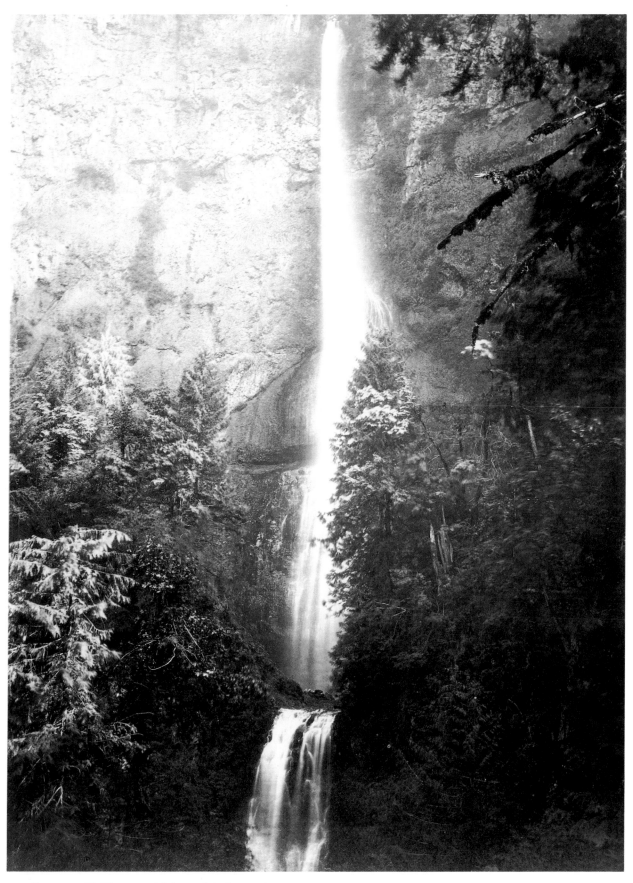

166. Carleton E. Watkins. *Multnomah Fall Cascade, Columbia River,* 1867.
Albumen print. Gilman Paper Company, New York.

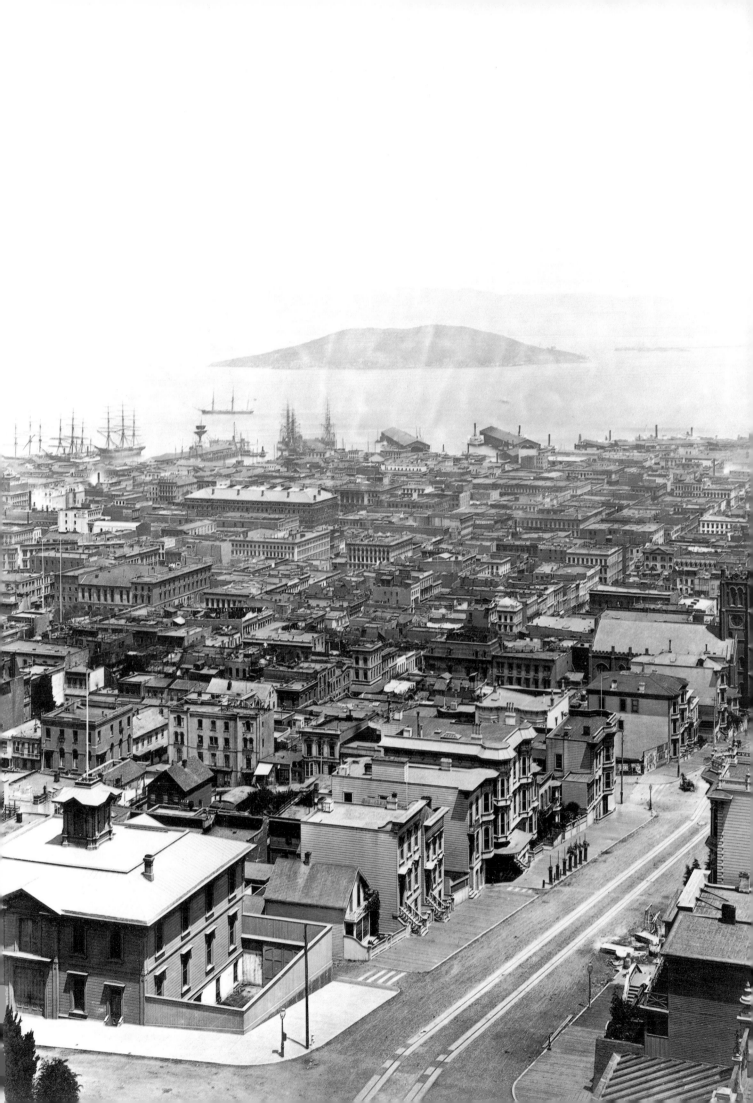

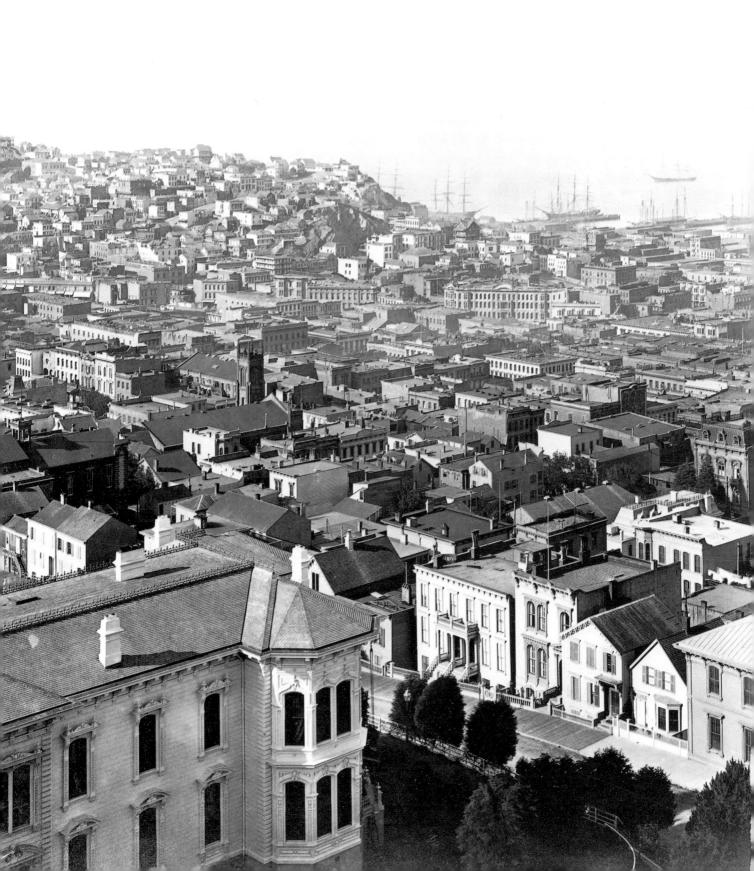

167. Frank J.
Haynes. *Geyser,
Yellowstone, Wyoming,*
c. 1885. Albumen
print. Daniel Wolf,
Inc., New York.

168. Andrew J.
Russell. *Hanging
Rock, Foot of Echo
Canyon, Utah,* 1867–68.
Albumen print.
Western Americana
Collection, Beinecke
Rare Book and
Manuscript Library,
Yale University,
New Haven, Conn.

169. WILLIAM HENRY JACKSON. *Grand Canyon of the Colorado*, 1870s–80s.
Albumen print. Private collection.

4.

DOCUMENTATION: OBJECTS AND EVENTS *1839–1890*

Let him who wishes to know what war is look at this series of illustrations.

—Oliver Wendell Holmes, 1863[1]

NEARLY ALL CAMERA IMAGES that deal with what exists in the world may be considered documents in some sense, but the term *documentation* has come to refer to pictures taken with an intent to inform rather than to inspire or to express personal feelings (though, of course, such images may answer these needs, too). The materialistic outlook of the industrialized peoples of the 19th century, their emphasis on the study of natural forces and social relationships, and their quest for empire promoted the photographic document as a relatively unproblematical means of expanding knowledge of the visible world. Depictions of topography and architecture (addressed in the previous chapter); of the physical transformation of city and countryside; of wars, uprisings, revolutions, and natural disasters; of sociological and medical conditions and oddities—all were considered by intellectuals, scientists, artists, and the general public to be eminently suitable themes for camera images.

The photograph was regarded as an exemplary record because it was thought to provide an objective—that is, unaltered—view of solid fact and achievement. This faith in the capacity of light to inscribe truth on a sensitized plate, which lay behind the acceptance of camera documentation, was given its most persuasive verbal argument by the American Oliver Wendell Holmes, whose contributions to the popularization of stereography have been mentioned earlier. Suggesting that the "perfect photograph is absolutely inexhaustible,"[2] because in theory everything that exists in nature will be present in the camera image (in itself a dubious statement), Holmes also felt that incidental truths, missed by participants in the actual event, would be captured by the photograph and, in fact, might turn out to be of greater significance. As "form divorced from matter" but mirroring truth, documentary photographs were believed to be such accurate catalogs of fact that they were surrogates of reality. Specific temporal meanings might be obscure, contextual relationships unexplained, but these images, which by a miracle of technology had found their way into stereoscopes and picture albums far removed in time and place from the actual object or event, increasingly became the data to which the public turned for knowledge of complex structures and occurrences. According to the American art historian William M. Ivins, Jr., "The nineteenth century began by believing that what was reasonable was true, and it wound up by believing that what it saw a photograph of, was true."[3]

The need for pictorial documentation had been recognized even before the invention of photography. In the 1830s and '40s, publishers of periodicals in Europe sought to enliven informational texts with graphic illustrations directed to a diversified mass audience. The *Penny Magazine*, an early starter in London, was followed by the *Illustrated London News*, *L'Illustration* in Paris, *Illustrierte Zeitung* in Leipzig, and, in the United States, *Harper's Weekly* and *Frank Leslie's Illustrated Newspaper*. To make good their promise to present a living and moving panorama of the world's activities and events, these journals began in the 1850s to use the photographic document as a basis for graphic imagery. The need to translate photographs quickly into wood engravings to meet publication deadlines led to the practice of dividing up an illustration into sections and farming out the parts to a number of woodblock engravers, after which the pieces were reassembled into a unified block for printing. In 1857, George N. Barnard invented a process whereby the collodion negative could be printed directly onto the block, bypassing the artist's drawing and incidentally substituting a more realistic facture, which the engraver then endeavored to represent. Until the 1890s, when the printing industry began to use the process halftone plate, documentation based on photographs reached the public in several forms—as original albumen, carbon, or Woodburytype prints (stereograph and other formats), as lantern slides, or transformed by engravers and lithographers into graphic illustrations for the publishing industry.

Photographic documentation might be commissioned by the government (primarily in France and the United States), by private companies and individuals, or by publishers. Albumen prints, more sharply defined and easier to produce in large numbers than calotypes, were organized into presentation albums made up for selected individuals and governing bodies, while thousands upon thousands of stereographs reached mass audiences through the sale and distribution activities of companies such as T. & E. Anthony in New York, the Langenheim brothers' American Stereoscopic Company in Philadelphia, the London Stereoscopic and Photographic Company, Gaudin in Paris, and Loescher and Petsch in Germany.

Camera Documentation: Industrial Development

"Objective" documentation by camera coincided with the physical transformation of industrialized countries during the mid-19th century. The role played by photography in the campaign to restore the architectural patrimony of France has been mentioned, but, in addition, images were commissioned to show the demolition and reconstruction of urban areas, the erection of bridges and monuments, and the building of transportation facilities and roads. The industrial expositions and fairs that were mounted every several years in Britain, France, and the United States during this period both symbolized and displayed the physical changes made possible by new technologies and new materials, which were contrasted with the exotic products of underdeveloped nations. The directors of the first important exposition, at the Crystal Palace in London in 1851—the Great Exhibition—were eager to document the event as well as to display camera equipment and pictures, but the insufficiencies of Talbot's calotype process limited the effort to a visual catalog of the exhibits, which was included in *Report by the Juries*.[4] However, shortly after the decision was made to rebuild the Crystal Palace at Sydenham, collodion technique made it possible to document the entire reconstruction. Photographing weekly for about three years—1851 to 1854—the noted painter-photographer Philip Henry Delamotte recorded the rebirth of the glass hall in its new location *(pl. no. 170)* and the installation of the exhibits. In itself, the iron structure of Sir Joseph Paxton's huge pavilion provided interesting shapes and forms, but Delamotte's obvious delight in the building's airy geome-

170. PHILIP HENRY DELAMOTTE. *The Open Colonnade, Garden Front*, c. 1853.
Albumen print. Greater London History Library, London.

171. ROBERT HOWLETT (?).
The "Great Eastern"
Being Built in the Docks at
Millwall, November 30, 1857.
Albumen print.
J. Paul Getty Museum,
Los Angeles.

try contributes to the pleasurable satisfaction these images still afford, and indeed this first record is among the more interesting documentations of the many that were made of the industrial fairs that followed.

From the 1850s on, the mechanical-image maker frequently was called upon to record other feats served up by the age of mechanization. The usefulness of such records was demonstrated by the documentation *(pl. no. 171)* of Isambard Kingdom Brunel's British steamship *Great Eastern,* an enormous coal-driven liner capable of carrying 4,000 passengers. The vivid handling of light, form, and volume seen in views by Robert Howlett and Joseph Cundall of this "leviathan"—made for the *Illustrated Times* of London and the London Stereoscope Company—was praised because it embraced real rather than synthetic situations. Contrasting these works with artistically conceived and reenacted studio compositions that were being turned out at about the same time *(see Chapter 5)*, critics suggested that the true measure of camera art was in the sensitive treatment of actuality.

Soon after mid-century, photographers were called upon to record the building of rail routes in France and the United States, both latecomers in this endeavor compared with Britain. One such commission, initiated by the French rail magnate Baron James de Rothschild, went to Edouard Denis Baldus, who in 1855 and 1859 followed the building of the north–south line from Boulogne to Paris, Lyons, and eventually to the Mediterranean ports. These large-format prints, exemplified by *Pont de la Mulatière (pl. no. 172),* were made up into "presentation albums," one of which was given to Queen Victoria; they also were exhibited at the major industrial expositions where they were acclaimed for elegant clarity of vision and superb tonal range. Gallic respect for order and precision also characterizes an image of engines in the roundhouse at Nevers *(pl. no. 173),* taken between 1860 and 1863 by the little-known French photographer A. Collard, whose work for the *Departement de Ponts et Chaussées* (Department of Bridges and Roads) resulted in impressive views that emphasized the geometric rationality of these structures.

Baldus, whose other commissions included the previously mentioned reportage on the Rhone floods and a documentation of the building of the new Louvre Museum was entirely committed to the documentary mode. His images established the paradigm documentary style of the era in that he brought to the need for informative visual material a sure grasp of pictorial organization and a feeling for the subtleties of light, producing works that transcend immediate function to afford pleasure in their formal resolution. When increasing commercialization—the need to mass-produce albumen prints for indiscriminate buyers of stereographs and tourist images—made this approach to

172. EDOUARD DENIS BALDUS. *Pont de la Mulatière*, c. 1855. Albumen print.
International Museum of Photography at George Eastman House, Rochester, N.Y.

documentation financially untenable, Baldus turned to re-printing his negatives and reproducing his work in gravure rather than alter the high standards he had set for himself. His attitude may be compared with that of William England, a highly competent British photographer who traveled widely to provide his publisher with images for stereoscopes and albums. As John Szarkowski has pointed out,[5] England's view of the Niagara Suspension Bridge *(pl. no. 174)* has something for everyone—scenery, human interest, an engineering marvel, and the contrast between old and new means of transportation. Nevertheless, though well-composed and satisfying as a document, it lacks the inspired tension that put Baldus's work onto another plane of visual experience, perhaps because its aim was simply to provide the kinds of information the public wanted in the clearest fashion.

The character of new engineering materials and construction methods that were altering the appearance of Europe at mid-century seems to have had a special appeal to photographers called upon to document bridges and railway construction. To select only one example, *Two Bridges (pl. no. 175)*, a work by Louis Auguste Bisson whose portrait firm sought to expand with such documentary

commissions, explores the geometries of arc and rectangles to enhance the contrast between the traditional stone of the past and the modern metal span. At times, fascination with the design properties of construction materials became so pronounced as to almost obscure the utilitarian purpose of the structure; in an 1884 image of the building of the Forth Bridge in Scotland by an unknown photographer *(pl. no. 176)*, the angled beams take on an animated life of their own, swallowing up the small figures in the foreground.

Photographs of industrial activity that included the work force also were made, although often they were less formally conceived. Taken for a variety of purposes—as a record of engineering progress, as material for illustrators —many such records were not deemed important, with the result that in time the names of the makers or the particulars of their careers became lost. Yet these images, too, can exert a spell through a formal structure that converts mundane activity, such as work, into evocative experience. Few images in either Europe or the Americas were concerned with the actual conditions of work, an interest that did not manifest itself photographically until late in the century *(see Chapter 8)*.

173. A. COLLARD. *Roundhouse on the Bourbonnais Railway, Nevers,* 1860–63. Albumen print.
International Museum of Photography at George Eastman House, Rochester, N.Y.

174. WILLIAM
ENGLAND. *Niagara
Suspension Bridge,*
1859. Albumen print.
Museum of Modern
Art, New York.

175. AUGUSTE
ROSALIE AND LOUIS
AUGUSTE BISSON.
Two Bridges, n.d.
Albumen print.
Bibliothèque
Nationale, Paris.

176. UNKNOWN
PHOTOGRAPHER
(probably Scottish).
*Construction of the Forth
Bridge*, c. 1884. Gelatin
silver print. Collection
Centre Canadien
d'Architecture/Canadian
Centre for Architecture,
Montréal.

The transformation of Paris from a medieval to a modern city, ordered by Prefect of the Seine Baron Haussmann (who took office in 1853), provided an exceptional opportunity for urban camera documentation. Old buildings and neighborhoods scheduled for demolition were photographed in collodion in the 1860s by Charles Marville *(pl. no. 177)*, a former illustrator, whose early work in the waxed-paper process appeared in many of Blanquart-Evrard's publications. These images display a poignant regard for the character and texture of vanishing ways, indicating again that documentary records might be invested with poetic dimension. Working on his own (after recovering from the disappointing events of 1839, in which his own paper process was suppressed), Hippolyte Bayard made decorous views of the streets and buildings of Paris *(pl. no. 24)*. In all major cities, the urban milieu offered photographers a chance to capture the contrast of old and new and also to document aspects of anonymous street life, producing views that after 1859 were much in demand by the buyers of stereographs *(see below)*.

Another aspect of Victorian photographic activity concerned the appropriation of the physical remains of the past. Popular interest in archeology, initiated in the 18th century with the finds at Troy, Pompeii, and Herculaneum, was further stimulated by the acquisition of works unearthed by 19th-century European scholars and diplomats investigating ancient cultures in Egypt, Greece, and the Near East, often while pursuing imperialistic interests.

177. CHARLES MARVILLE. *Tearing Down the Avenue of the Opera*, c. 1865. Albumen print. Musée Carnavalet, Paris.

Fortunately, Europeans did not heed Holmes's quintessentially American view that the artifacts themselves might be dispensed with as long as their images remained; instead, their goal was to disinter and relocate actual objects. Though frequently wrenched from historical context and incorrectly restored, these works confirmed a sense of continuous history for Europeans experiencing the unsettling advance of industrialization. The excavation, transportation, and restoration of this cultural booty produced some visually stimulating camera images. Almost every aspect of industrial Europe's romance with the past, from the pilgrimage to ancient lands *(pl. no. 178)*, to the installation of the object in a modern setting *(pl. no. 179)* was captured by the camera. And while by mid-century European museums already had become the repositories of statuary and decorative objects from all over the ancient world, the growing popular interest in archeology and its finds must be attributed in some measure to the camera.

Monumental contemporary works of statuary also provided subjects for photographers intrigued by the contrast

in scale afforded by such pieces. The documentation of the production of the Statue of Liberty in France, by Albert Fernique *(pl. no. 180)*, and its installation in the United States was just one of a number of such picturizations of an activity that was going on in other industrial countries, too. One suspects that the amusing contrast between the lively figures of the real workmen and the grandiose inertia of the idealized effigy, seen in this work and also in Aloïs Löcherer's record of the construction and transport of the mammoth statue *Bavaria (pl. no. 181)*, constituted at least part of the appeal of such images.

Camera Documentation: United States

Camera documentation of industrial progress in North America differed significantly from that of Europe, primarily because of America's lack of historical monuments and its attitude to photography in general. Drawn largely from the ranks of graphic artists, mid-century European photographers were influenced by attitudes instilled in

them about art in general, but in the "new world" sound academic training in the arts was limited. With few exceptions, Americans regarded photography as a business and the camera as a tool with which to record information. Neither poets nor reformers, many photographers in the United States were unconcerned with subtleties, endeavoring instead to present material objects in a clear-cut and competent fashion without involvement in the artistic effects of light and shade or unusual compositional angles.

This said, it still is curious that in a country so con-sumed by interest in mechanical devices, few images that take advantage of the forceful geometry of engineering structures were made. From the daguerreotype era to the end of the century, when Americans photographed bridges, railways, machinery, and buildings—emblems of the growing industrialization of the nation—their major concern was to be informative rather than inspirational. The choice of camera position in *Brooklyn Bridge Under Construction* (by an unknown photographer) *(pl. no. 182)* diminishes the scale and beauty of the pylons in order to direct attention

178. HENRI BÉCHARD. *Ascending the Great Pyramid*, c. 1878. Phototype from *L'Egypte et la Nubie*, 1888. Charles Edwin Wilbour Library of Egyptology, Brooklyn Museum.

179. PHILIP HENRY
DELAMOTTE. *Setting up the
Colossi of Rameses the Great*, 1853.
Albumen print. Greater
London History Library.

180. ALBERT FERNIQUE (?).
*Construction of the Statue of
Liberty, Workshop View, Paris*,
c. 1880. Albumen print. Rare
Books and Manuscripts
Division, New York Public
Library, Astor, Lenox, and
Tilden Foundations.

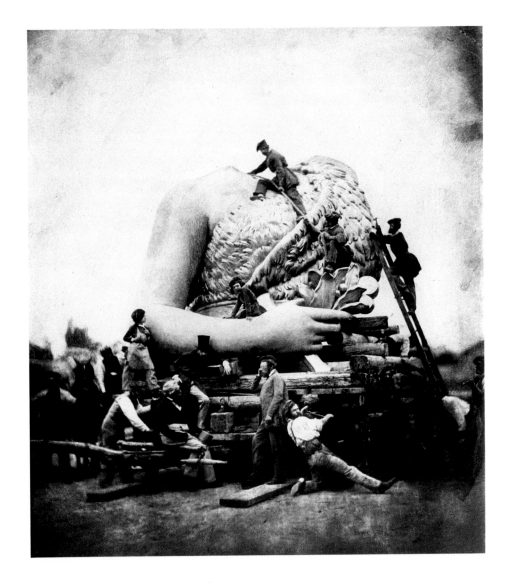

181. ALOÏS LÖCHERER. *Transport of the Bavaria (Torso)*, 1850. Albumen print. Agfa-Gevaert Foto-Historama, Cologne, Germany.

to the small group of top-hatted figures. Typical of the many views of this project, the image falls short of embodying the daring energy which the bridge itself still symbolizes. In comparison, Canadian William Notman's 1859 photograph of the framework and tubing of the Victoria Bridge *(pl. no. 183)* creates an arresting visual pattern that also is suggestive of the thrust and power of the structure. As F. Jack Hurley points out, 19th-century photographs of American industry concentrate on depicting the individuals responsible for "taming, dominating and bending to their wills . . . the vast virginity of the continent"[6] rather than on the expressive possibilities inherent in structural and mechanical forms.

However, there are exceptions: in the years following the Civil War, photographic documentation of the western rail routes—in particular the construction of track-beds and spans and the laying of rails—resulted in images of decided visual impact. Inspired by the grandeur of the wilderness, the photographers, among them Alexander Gardner, Alfred A. Hart, William Henry Jackson, Andrew Joseph Russell, and Charles R. Savage, recorded not only actual construction but settlements along the way, unusual vegetation, geological formations, and Indian tribal life. The best-known of these images—a work by Russell of the joining of the cross-continental tracks at Promontory Point, Utah Territory, in 1869 *(pl. no. 184)*—is in the mainstream tradition of American documentation, with workers and dignitaries the focus of the celebratory occasion, but in other works, typified by Russell's *The Construction of the Railroad at Citadel Rock (pl. no. 185)*, landscape predominates—the understandable effect of an attitude that regarded the western wilderness with near-religious awe. Many of Russell's images emphasize curving rails and intricately constructed bridge spans, foreshadowing the handling of similar themes by William Rau, official photographer of the Pennsylvania and Lehigh Valley railroads at the end of the century. The clean, formal organization of track-beds and rails in Rau's images *(pl. no. 186)* suggests that indus-

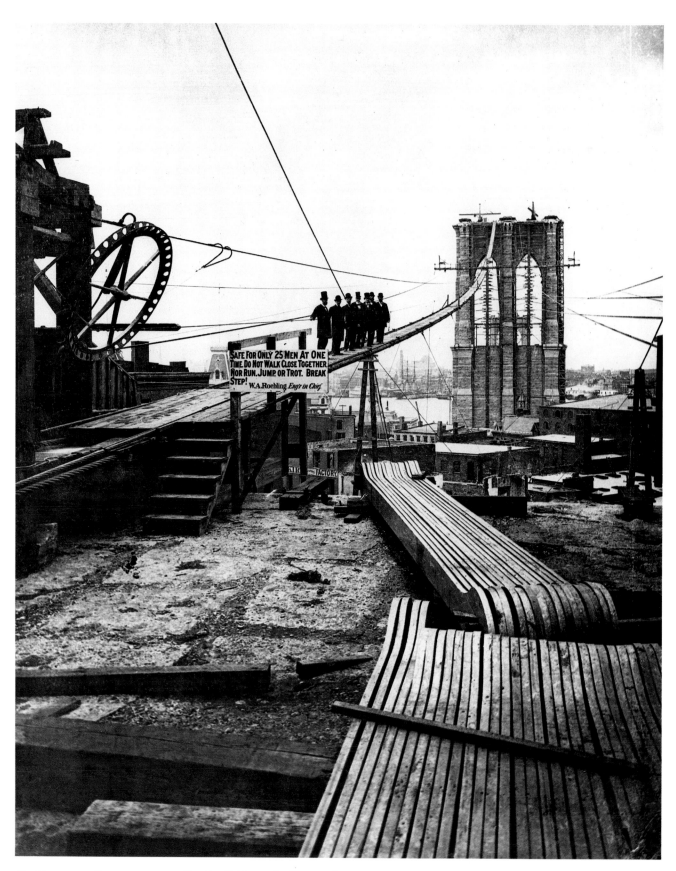

182. UNKNOWN PHOTOGRAPHER. *Brooklyn Bridge under Construction*, c. 1878.
Albumen print. New-York Historical Society, New York.

trial might had emerged without trauma or exertion—a view that was to gain ascendancy in visual expressions of machine culture in the 1920s. As was true of western scenic photographs, railroad images were sold in stereograph and large-format, used to make up presentation albums, shown in photographic exhibitions, and copied by engravers for the illustrated press.

Newsworthy Events and Instantaneous Views

Large-format documentary images required that human figures, when included, remain still during exposure, as can be seen in the posed stance of the workers in the Russell photograph. Recording events that were in a state of flux on this size plate would have resulted in blurring sections of the image, an effect that 19th-century viewers regarded as a sign of imperfection. In fact, during the 1840s and '50s, in order to present occurrences in which there was continuous, if not very rapid, action, it was necessary to restage the scene, as was done for the daguerreotypes by Southworth and Hawes taken in the operating room of Massachusetts General Hospital in 1848 *(pl. no. 187)*. Nonetheless, the inadequacy of the earliest technology

had not prevented daguerreotypists from attempting to capture images of fires, floods, and storms—catastrophes over which people have little control but show strong interest in. George N. Barnard was able to make a daguerreotype during an actual conflagration that took place in Oswego, New York, in 1851 *(pl. no. 188)*. Even after glass plates took over, however, on-the-spot news photography was difficult because the photographer had to arrive on the scene armed with chemicals and equipment to sensitize the plates before they could be exposed in the camera. Luck obviously played a great role in mid-19th-century documentation of such events, which frequently were translated into engravings in the illustrated press.

With the perfection during the 1850s of shorter focal-length (4½ to 5 inches) stereographic cameras, accompanied by the publication in 1856 of Sir David Brewster's manual on stereography, photography became capable of freezing certain kinds of action. "Instantaneous" views made in stereograph format began to appear around 1858; among the earliest in America was a series taken of long stretches of lower Broadway, commissioned by the E. and H. T. Anthony Company, of which this street scene *(pl. no. 189)* is a typical example. In Great Britain, William England and George Washington Wilson began to market

183. WILLIAM NOTMAN. *Victoria Bridge, Framework of Tube and Staging, Looking in*, May, 1859. Albumen print. Notman Photographic Archives, McCord Museum, McGill University, Montréal.

"instantaneous" images of crowded street scenes while Adolphe Braun and Hippolyte Jouvin *(pl. no. 190)* were involved with the same kind of imagery in France. In addition to the stereograph cameras produced in all three countries, small single-lens apparatuses designed to arrest action began to appear *(see A Short Technical History, Part I)*, but despite these refinements, collodion technology still was burdensome, preventing action photography of the sophistication and speed to which modern viewers are accustomed.

Documentation: Daily Life and Ethnic Customs

Curiosity about the everyday lives of the world's peoples predates the invention of photography, but as indus-

trial nations involved themselves in imperialist adventures around the globe, the camera emerged as a most apt tool for satisfying the thirst for sociological information that emerged. Between 1855 and about 1880, collodion/albumen technology made it possible for resolute photographers, both amateur and professional, to follow their countrymen to Africa, the Americas, Asia, and the Near East in order to record, besides scenery, aspects of daily life and ethnic customs. Though under the impression that these documentations were "objective"—that is, truthful records of what exists—those behind the cameras were guided in their selection and treatment of material both by a sense of being emissaries of a "higher civilization,"[7] as John Thomson called it, and by the desire for commercial success. Nevertheless, despite assumptions of superiority, the close observation of indigenous customs altered ethnocen-

184. ANDREW J. RUSSELL. *Meeting of the Rails, Promontory Point, Utah*, 1869.
Albumen print. Union Pacific Historical Museum, Omaha, Neb.

185. ANDREW J. RUSSELL. *The Construction of the Railroad at Citadel Rock, Green River, Wyoming,* 1867–68. Albumen print. Western Americana Collection, Beinecke Rare Book and Manuscript Library, Yale University, New Haven, Conn.

186. WILLIAM RAU. *New Main Line at Duncannon,* 1906. Gelatin silver print. J. Paul Getty Museum, Los Angeles.

tric attitudes and in some cases even evoked admiration for elements of so-called "backward" cultures among photographers.

India under British rule provided the greatest opportunity to satisfy the desire for this kind of imagery on the part of occupying residents and folks back home. Among those portraying native life in the areas where Britons maintained interests in the jute, tea, and teak industries were Félice Beato (a naturalized British subject of Italian birth whose biography has recently emerged), Samuel Bourne (whose catalog listings included "Groups of Native Characters"), and John Burke, who worked in the Punjab and in Kashmir before recording the course of the Second Afghan War. The now little-known William Johnson, a founder of the Bombay Photographic Society, published his views of Indian teachers, vendors, and workers periodically in 1856 in *The Indian Amateur's Photographic Album* and then in a single volume containing 61 photographs. *Group of Cotton*

Carders (pl. no. 191) has a mannered quality common to many such staged indoor scenes of the time, whereas the out-of-doors settings that served as the locales for Captain Willoughby Wallace Hooper gave his images of lower-caste Hindu life and famine victims a more natural-looking aspect.

Known or unknown, British photographers sent to oversee or to document colonial activities in other parts of the empire on which "the sun never set" sent home views of the native peoples of South Africa, Australia, and New Zealand, as well as of India. The effects on Western viewers of scores of camera pictures of scantily clad, sometimes tattooed or painted humans of color from unindustrialized parts of the world are difficult to determine. No doubt as a group these images stimulated 19th-century positivists in their quest for anthropological information, but whether they reinforced dominant stereotypes against nonwhites or made viewers more conscious of individual differences

187. ALBERT SANDS SOUTHWORTH and JOSIAH JOHNSON HAWES. *Operating Room, Massachusetts General Hospital, Woman Patient*, 1846–48. Daguerreotype. Massachusetts General Hospital News Office, Boston.

188. GEORGE N. BARNARD. *Burning Mills,
Oswego, New York,* 1851. Daguerreotype.
International Museum of Photography at
George Eastman House, Rochester, N.Y.

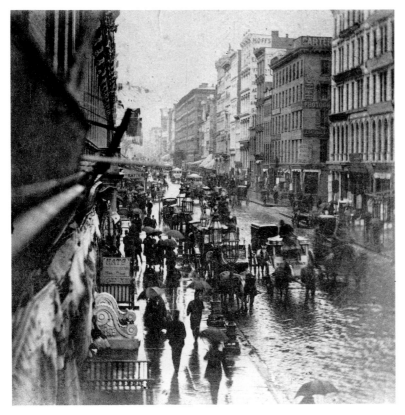

189. EDWARD ANTHONY. *New York Street Scene,*
1859. One-half of an albumen stereograph.
Collection George R. Rinhart.

among subjected peoples depended in part on the individual photographer's attitude and approach and in part on the context in which they were seen.

In China, posed studio photographs simulating typical occupations appeared on *cartes-de-visite* made in the port cities during the 1850s, but actual views of street life did not reach the West until John Thomson issued *Illustrations of China and Its People* in 1873–74. The 200 photographs reproduced in heliotype with descriptive texts—the result of nearly five years spent in Hong Kong, Formosa, and on the mainland—include, besides portraits and scenery, images of people engaged in mundane activities, among them *Itinerant Tradesmen, Kiu Kiang Kiangsi (pl. no. 192)*. This image may suggest a staged view, but its sharpness and detail were meant to convince 19th-century viewers of the reality of a scene happened upon by accident.

Views of everyday life in Japan (based on photographs) appeared in the *Illustrated London News* soon after the country was opened to Western exploitation by Commodore Matthew C. Perry; on that occasion, a camera was given to the shogun. The peripatetic Félice Beato arrived in Japan about 1863, and five years later his *Photographic Views of Japan with Historical and Descriptive Notes* appeared; one of its two volumes is devoted to "Native Types." Though similar in intent to Thomson's views of China, many of Beato's portrayals depict aristocrats, military men, laborers, vendors, and geisha *(pl. no. 333)* posed in the studio holding emblems of their rank or trade. Gracefully composed against simple backgrounds and delicately hand-colored by Japanese artists, these works suggest the influence of the decorative *ukiyo-e* woodblock depictions of daily life. Similar amalgams of sociological information and artistic effect designed to attract travelers constitute the work of Baron Reteniz von Stillfried, an Austrian who settled in Yokohama in 1871, bought Beato's studio, and produced, with a partner and Japanese assistants, an album entitled *Views and Costumes of Japan (pl. no. 193)*. The genre was further refined by the Japanese photographer Kusakabe Kimbei, an assistant to von Stillfried who took over the latter's studio around 1885 *(pl. no. 194)*. Following the Meiji Restoration of the late 1860s, which introduced modern industrial ideas to Japan, photography began to spread; by 1877 there were 100 photographers in Tokyo alone, working mainly for the wealthy.

Tribal peoples played similar roles for those intrigued by exotic customs in the western hemisphere. In the United States, railroad, survey, and frontier photographers—including Gardner, Jackson, and John K. Hillers (first official photographer for the Bureau of Ethnology)—documented Indian life in the course of other work. To the north, Humphrey Lloyd Hime included "native races" in his portfolio on the Assiniboine and Saskatchewan expe-

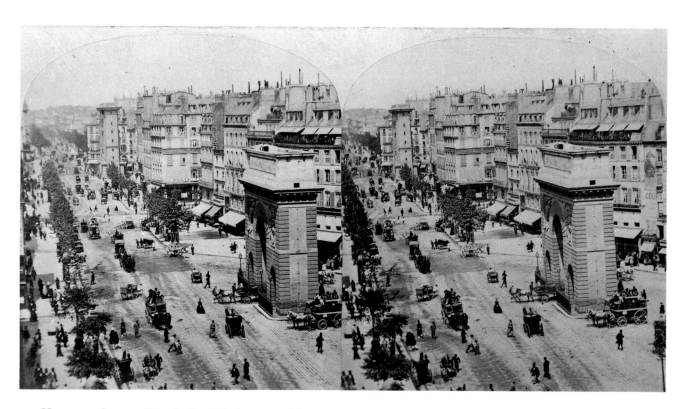

190. Hippolyte Jouvin. *Porte St. Denis, Paris,* c. 1860. Albumen stereograph. Collection Ivan Christ, Paris.

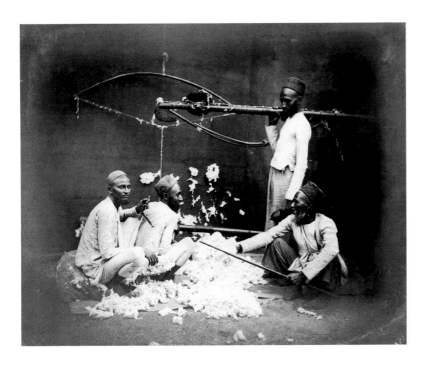

191. WILLIAM JOHNSON. *Group of Cotton Carders* from *The Indian Amateur's Photographic Album*, 1856. Albumen print. India Office Library and Records Department, British Library, London.

192. JOHN THOMSON. *Itinerant Tradesman, Kiu Kiang Kiangsi,* c. 1868. Albumen print. Philadelphia Museum of Art; Purchase of Stieglitz Restricted Fund.

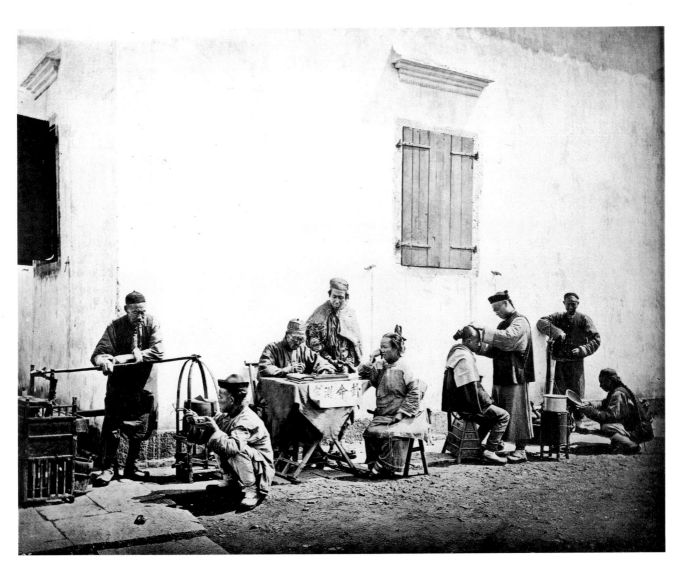

193. BARON RETENIZ VON STILLFRIED. *Rain Shower in the Studio*, c. 1875. Albumen print.
International Museum of Photography at George Eastman House, Rochester, N.Y.

194. KUSAKABE KIMBEI. *New Year Drill of Japanese Fire Brigade*, c. 1890. Albumen print.
International Museum of Photography at George Eastman House, Rochester, N.Y.

195. ADAM CLARK
VROMAN. *Hopi Maiden*,
c. 1902. Platinum print.
Private Collection.

196. EDWARD S. CURTIS. *The Vanishing Race*, c. 1904. Platinum print. San Francisco Museum of Modern Art; extended loan of Van Deren Coke.

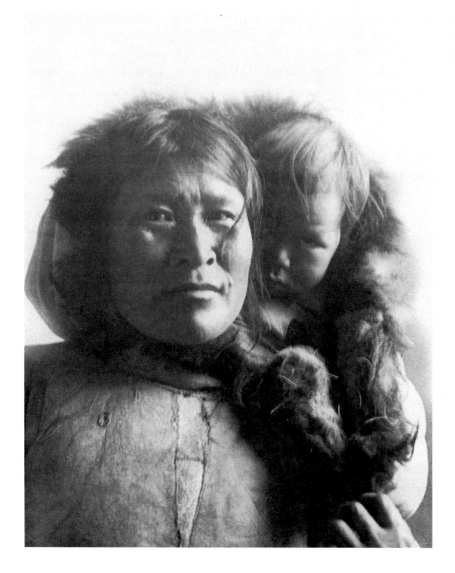

197. ROBERT FLAHERTY. *Portrait of Mother and Child, Ungava Peninsula*, 1910–12. Gelatin silver print. Public Archives of Canada, Ottawa.

ditions in 1858. As the open lands and simple life of the West began to attract escapees from densely settled industrialized regions (and nations), straightforward documentation of Indian life became tinged with idealizing intentions. Individuals such as Adam Clark Vroman, a California bookseller who first accompanied a party of ethnologists to the Southwest in 1895, used the camera to emphasize the dignity, industriousness, and charm of the Hopi and Zuni (*pl. no. 195*) as well as to depict their customs and ceremonies. Besides donating images to the Bureau of Ethnology archives, Vroman employed them in slide lectures and publications. Ten or so years later, the photographic logging of archaeological excavations was introduced by the Harvard professor George Reisner.

In the same era, Edward S. Curtis, an ambitious commercial photographer in Seattle, felt moved to record vestiges of the culture of what he perceived as a "vanishing race,"[8] eventually creating a 20-volume survey of the customs, habitations, and dress of the Indians of North America. Supported initially by financial help from the investment banker J. P. Morgan, Curtis saw tribal life through a veil of cultural preconceptions that at times led him to introduce into his documentation traditional costumes and artifacts no longer in general use. Working at a time before standards for ethnological photography had been formulated, Curtis treated this subject matter aesthetically, softening forms and obscuring detail to emphasize his overall concept of the mythic nature of American Indian life. Often haunting in character (*pl. no. 196*), these images of Native American life could be considered within the framework of Pictorialism rather than of documentation (*see Chapter 7*). Similarly, *Portrait of Mother and Child, Ungava Peninsula* (*pl. no. 197*), one of some 1,500 still photographs by the filmmaker Robert Flaherty (whose wife, Frances, often worked with him), combines sociological information with a heroicizing vision that celebrates the unspoiled essence of Inuit life.

Scientific and Medical Documentation

The second half of the 19th century was also an era of expanding use of photography in connection with scientific documentation. The first daguerreotype microphotographs, by John Benjamin Dancer in the 1840s, reduced a 20-inch document to 1/8 of an inch using a camera with a microscope lens. Other early experiments in both calotype and daguerreotype produced micrographs of bones, teeth, butterfly wings, and seed pods that were harbingers of the contributions anticipated when the camera was harnessed to the microscope. However, the daguerreotype was too unwieldy and the calotype too indistinct to be of great service to science, even though a textbook and

atlas based on micro-daguerreotypes taken by Jean Bernard Foucault was issued by Alfred Donné, the chief clinical physician of a Paris hospital, in 1845. With the development of the glass-plate negative, along with the refinement of microscopes, lenses, and shutters, ever-more-minute analyses of unseen and barely seen forms and structures became possible. An important contribution in this advance was *Human Physiology* by Professor John William Draper, whose portrait experiments were discussed in Chapter 2. Published in 1856 with woodcuts based on photographs, it was, according to *Harper's New Monthly Magazine,* the first "attempt . . . on an extensive scale to illustrate a book on exact science with the aid of photography."[9] Not long afterward, the first text on the use of photography in microscopic research was written by a German physiologist, Joseph Gerlach, according to Alison Gernsheim (one of the first writers to investigate the historical uses of the camera in medicine). A *Photographic Atlas of the Nervous System of the Human Frame* was projected for publication in Munich in 1861.[10]

Used at first in England and Germany to provide before-and-after records, camera images soon began to illustrate medical texts on diverse problems, from skin lesions to glandular and skeletal aberrations. In 1858, the London *Photographic Journal* prophesied that every medical school soon would be furnished with a library of photographic illustrations of disease, and by 1861 the medical profession acknowledged that stereographs and the stereoscope had become "important adjuncts to the microscope for representing the appearance of different phases of disease."[11]

In the study of mental instability, photography assumed administrative, diagnostic, and therapeutic functions. Dr. Hugh Welch Diamond's 1852 portraits taken in a mental asylum have been mentioned, but photography already had been used a year earlier as a component of a concept known as "moral treatment"[12]—an intervention that sought to provide confined mental patients with antidotes to boredom and nonconstructive activity by showing them lantern slides. In what may have been the first use of photographic rather than hand-painted slides, the Langenheim brothers collaborated with the chief physician of the Philadelphia Hospital for the Insane in this magic-lantern therapy.

The Documentation of Wars and Conflicts

War coverage did not really become feasible until the collodion era. It was obvious from the first that the slow, one-of-a-kind daguerreotype was ill suited for war coverage, although some portraits of army personnel were made by this method. The laborious procedures of the

198. HIPPOLYTE BAYARD. *Remains of the Barricades of the Revolution of 1848, rue Royale, Paris*, 1849. Albumen print. Société Française de Photographie, Paris.

199. GUSTAVE LE GRAY. *Souvenirs du Camp de Châlons au Général Decaën*, 1857. Albumen print. Collection Paul F. Walter, New York; Museum of Modern Art, New York.

200. UNKNOWN. *Roger Fenton's Photographic Van with Aide Sparling.* Woodcut from *The Illustrated London News*, Nov. 10, 1855. Gernsheim Collection, Humanities Research Center, University of Texas, Austin.

calotype process, although used by Bayard to depict the barricades set up in Paris during the revolution of 1848 *(pl. no. 198)* and by British Army surgeon John McCosh to record episodes in the wars between British and native troops in India and Burma in the mid-19th century, made it, also, a difficult technique for successful battlefield photography. Collodion glass-plate photographers showed themselves capable of exceptional documentation of actuality in relation to military conflicts, perhaps because they recognized that such events were of unusual historical significance. Though somewhat static by modern standards, compelling images of imperialistic adventures, civil disorders, and revolutionary uprisings often go beyond the description of surface appearance to express in visual terms the psychological and physical trauma that such conflicts occasion.

The awkwardness for the photographer of transporting an entire darkroom and of processing the plates on the battlefield is hard to imagine. This incumbrance was balanced, however, by the wet plate's capacity for sharply defined images that could be easily duplicated—factors that made the commercialization of such photographs possible. Still, those working in collodion concentrated on portraying war-related activities rather than action under fire, in part for logistical reasons but also because documentary images were expected to be in sharp focus, a virtual impossibility for photographers using the collodion process in the midst of battle. The documentation of army life by Le Gray made at an encampment of soldiers during peace-

time reflects the near religious exultation with which Napoleon III regarded his army camp at Chalons *(pl. no. 199)*.

Photography entered the arena of war on the wings of politics. Ironically, the first large group of sustained images that have survived[13] was commissioned because the British Establishment wished to present evidence to controvert written reports by William Russell, correspondent for *The Times* of London, detailing the gross inefficiency of military leaders during the Crimean War. The images were made by Roger Fenton, a founder of the elitist Photographic Society of London, during four months spent with the British Army at Sebastopol on the shores of the Black Sea. Bankrolled by a Manchester publishing firm and blessed by Prince Albert, Fenton arrived at Balaclava Harbor in March, 1855, with two assistants, five cameras, 700 glass plates, and a horse-drawn van (formerly that of a wine merchant) converted into a darkroom *(pl. no. 200)*. Working at times in insufferable heat, with plates constantly being ruined by dust and insects, and besieged by the curious crowds of soldiers that flocked around begging for portraits, he complained of getting little done, but by the time he arrived back in England he had produced some 360 photographs.[14]

To modern eyes, these images, especially the portraits, may seem static and contrived. This was partly the result of

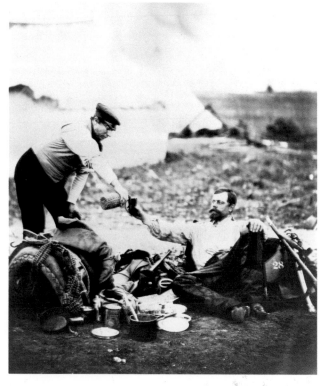

201. ROGER FENTON. *Lt. Col. Hallewell—28th Regiment—His Day's Work Over,* 1855. Albumen print. National Army Museum, London.

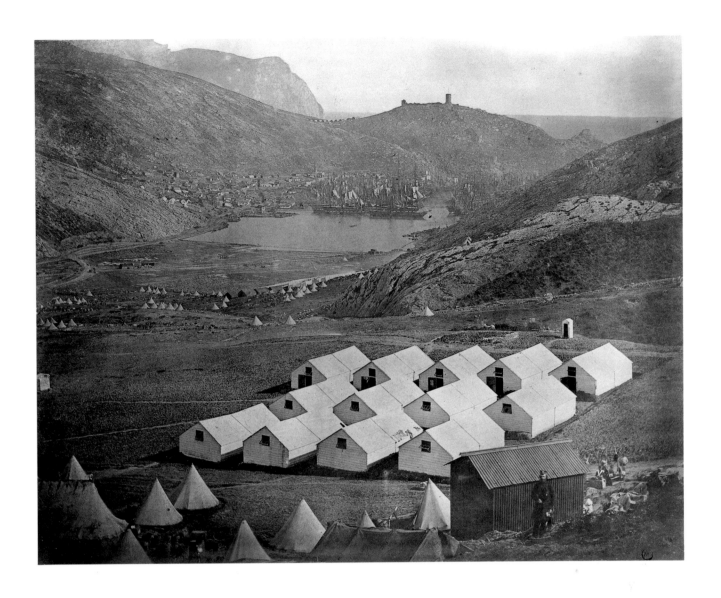

202. JAMES ROBERTSON.
Balaclava Harbor, Crimean War,
1855. Albumen print. Victoria and
Albert Museum, London.

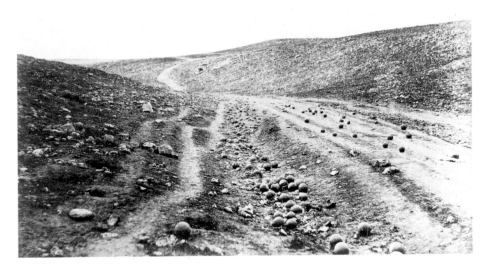

203. ROGER FENTON. *Valley of the
Shadow of Death*, 1855. Albumen
print. Science Museum, London.

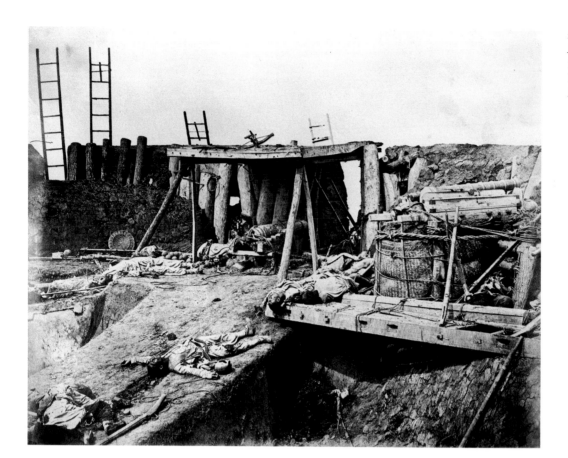

the limitations of collodion—exposures required from about 3 to 20 seconds—but their character also reflects Fenton's commission to present British Army personnel and ordnance in the best light. *Lt. Col. Hallewell—28th Regiment—His Day's Work Over (pl. no. 201)*, an almost bucolic scene despite the embattled surroundings in which class hierarchies are still—incredibly—observed, is typical of many of the portraits. At the same time, Fenton acknowledged a broader mission. Noting that despite the arduousness of the project he could not leave until he had "secured pictures and subjects most likely to be historically interesting,"[15] he made views of the harbor and deserted battlefields that are visual expressions of the suffering and destruction, of the longing for home, of which he wrote so movingly.

James Robertson, the British Superintendent of the Mint at Constantinople, who for 15 years had been making occasional scenic photographs of the Near East, took over in the Crimea after Fenton returned to England. The 60 or so images he produced after the British had conquered Sebastopol are well-composed but far less artful documents of ruins, docks, left-over ammunition piles, and hospital facilities. Among the evidences of the disastrous incursions wrought by foreign forces on the landscape is a view by Robertson of *Balaclava Harbor (pl. no. 202)* show-

ing an army encampment in what formerly had been a magnificent wooded wilderness. Both Fenton and Robertson's photographs were assembled into presentation albums for British and French royalty, were exhibited in London and Paris, and sold individually in these cities and New York; in addition, they provided material for engraved illustrations in the London press.

Photographs of desolation and destruction, among them Fenton's own *Valley of the Shadow of Death (pl. no. 203)*, had a profound effect on viewers used to artistic depictions of wartime heroics. They were completely unlike drawings made by artists sent to the Crimea, which Fenton criticized for their "total want of likeness to reality."[16] The absence of uplifting tone in camera documentations was especially shocking because the images were unhesitatingly accepted as real and truthful; indeed, discussing Fenton's Crimean pictures in a review of 1855, an *Art Journal* critic held that the "palpable reality" of which the camera was capable could be matched by no other descriptive means.[17] Robertson's photographs received fewer accolades, and one wonders if the warmer reception of Fenton's work was a consequence of his friendships among the British upper class. However, by the time Robertson's images were exhibited, the war was about over, and public sentiment in Britain had turned from concern to indifference, with

205. UNKNOWN
PHOTOGRAPHER. *Communards
in Their Coffins*, May, 1871.
Albumen print. Gernsheim
Collection, Humanities
Research Center, University
of Texas, Austin.

206. EUGÈNE APPERT. *The
Massacre of the Arcueil Dominicans*,
May 25, 1871. Albumen print.
Bibliothèque Nationale, Paris.

CRIMES DE LA COMMUNE

VICTIMES

T. R. P. CAPTIER
R. P. BOURARD
R. P. DELHORME
R. P. COTRAULT
R. P. CHATAGNERET
R. P. GUILLEMET
 GAUQUELIN (Louis)
 VOLAND (François)
 GROS (Aimé)
 MARCE (Antoine)
 CATHALA (Théodore)
 DINTROZ (François)
 CHEMINAL (Joseph)
 PETIT (Germain)

ÉCHAPPÉS AU MASSACRE

L'abbé GRANCOLAS (Joseph)
 BERTRAND (Édouard)
 REZILLOT (Jean-Baptiste)
 GAUVAIN (Édouard)
 DELAISTRE (Prosper)
 DUCHÉ (Antoine)
 BROUHO (Simon)

FÉDÉRÉS

LÉO MEILLET, membre de la
 Commune
LUCIPIA, procureur de la Com-
 mune
SERIZIER, colonel du 101ᵉ
BOUIN, capitaine au 101ᵉ
BEAUFILS, lieutenant au 101ᵉ
ROUILLAC, lieutenant au 101ᵉ
THALER, gouverneur du fort de
 Bicêtre
BOUDAILLE, lieutenant du 101ᵉ
PASCAL, lieutenant au 177ᵉ
QUESNOT, commandant du 120ᵉ
GIRONCE, lieutenant au 120ᵉ
GRAPIN, fédéré au 176ᵉ
FRAISE, fédéré au 101ᵉ
BUSQUANT, lieutenant au 102ᵉ
GAMBETTE, tambour au 101ᵉ
BUFFO, fédéré au 101ᵉ
AMAT, fédéré au 101ᵉ

E. APPERT, PHOT EXPERT
24 Rue Taitbout

Reproduction interdite.

MASSACRE DES DOMINICAINS D'ARCUEIL
Route d'Italie N° 38, le 25 Mai 1871, à 4 heures et demie.

the result that even Fenton's work did not sell to the extent anticipated by its publisher.

No full-scale wars occupied Europeans for the remainder of the century, but uprisings, mutinies, and imperialist adventures were fairly continuous on the Continent, and in Africa, the Far East, and Latin America. Returning from the Crimea to Constantinople, Robertson and his former partner, Félice Beato, traveled east to record the aftermath of the Indian Mutiny of 1857, in which the Indian Sepoy regiments rebelled (unsuccessfully) against the British garrisons and, ultimately, against British rule in India. In addition to an interest in architecture, social customs, and landscape, Beato apparently was fascinated by scenes of devastation. In China in 1860 he documented the destruction of the Taku forts near Tientsin (Tianjin) during the Second Opium War *(pl. no. 204)*, then, in Japan, the fighting at Shimonoseki Strait, and, during the 1880s, he turned up on the battlefields of the Sudan. Carefully composed and printed, his photographs present the aftermath of battles somewhat in the manner of ghoulish still lifes, an approach that has been characterized as "distant and detached."[18] However, considering the state of photographic technology, the fact that Beato was an outsider representing an oppressor nation in both China and Japan, and that the public was as yet unused to such photodocumentation, the reproach may be irrelevant; these images must have evoked a powerful response that current jaded perceptions can no longer imagine. Others whose approach to war documentation was also that of a "distant witness," but whose work has less visual interest, were John Burke, working in India and Afghanistan in the 1870s, and Sergeant Harrold, photographing for the British Royal Engineers in Abyssinia between 1868 and 1870.

Between 1855 and 1870, camera images of wars and insurrections generally were accepted as truthful, if painful, mirrors of reality, but after the Paris Commune of 1871, other issues emerged in connection with documentations of politically controversial events. One involved the uses to which such photographs might be put, a problem that arose when portraits of the Communard leaders, made during the brief two-and-one-half months of their ascendancy, were used afterward by political opponents to identify and round up participants for trial and execution *(pl. no. 205)*. The other problem concerned authenticity; documents purported to be of Communard atrocities were later shown to be fakes *(pl. no. 206)* issued by the Thiers government that took power after the fall of the Commune.[19] Though not the first time that photographs had been doctored, the acknowledgment that documentary images could be altered marked the end of an era that had believed that such photographs might be pardoned anything because of their redeeming merit—truth.

Documenting the Civil War in the United States

The American Civil War was the first conflict to be thoroughly photographed, with cameramen on hand from the early Union defeat at Bull Run in 1861 to the final surrender of the Confederate forces at Appomattox in 1865. The thousands of photographs that issued from this enterprise were considered by William Hoppin, a prominent member of the New-York Historical Society at the time, to be "by far the most important additions to the pictorial history of the war."[20] Hoppin went on to suggest that because successful views of action were not possible under battle conditions, most of the images were of the dead or dying, but, in fact, photographers documented a broad range of behind-the-lines activities. In today's terms, the frontal poses and clearly defined detail in the majority of images have a static quality that has been ascribed, generally, to the limitations of collodion technology. However, ideological factors also were significant; in order to accept the photograph "as an unmediated medium of picture-making," viewers expected the image to appear technically unflawed, to be clear, inclusive, and finely detailed— indeed, to present itself as reality itself.[21]

There can be little disagreement that the extensive coverage and excellent quality of Civil War photography stemmed largely from Mathew Brady's visionary belief in the role of the camera as historian, even though it is now acknowledged that he actually made few of the images that bore his name. Convinced, as were most people at the time that the conflict would be of short duration, Brady claimed to have obeyed an inner "spirit" that commanded him to leave his lucrative portrait business to demonstrate the role that photography might play in the conflict. In truth, his connections with influential Northern politicians made it possible for him to outfit a wagon darkroom and participate in the First Battle of Bull Run in July, 1861.[22] From then on, Brady regarded himself as an "impresario" —organizer, supplier, and publisher—for a corps of about 20 men, among them the former employees of the Brady portrait studios, Gardner and Timothy O'Sullivan. Using 16 x 20 inch, 8 x 10 inch, and stereograph cameras, these men photographed bridges, supply lines *(pl. no. 207)*, bivouacs, camps, the weary, the bored, the wounded, and the dead—just about everything except actual battles, which would not have been sharp because exposure time was still counted in seconds. Published as Incidents of the War, and sold by Brady and the Anthonys, the images appeared with the Brady imprint only. This angered Gardner (and others) and led to the establishment in 1863 of an independent corps and publishing enterprise that credited the images to the individual photographers. Although most cameramen

working during the Civil War were attached to units of the U.S. Army, George Cook, a daguerreotypist in Charleston who had managed Brady's New York studio in 1851, photographed for the Confederate forces *(pl. no. 208)*.

Much scholarship has gone into separating the work of the various Brady field operatives, with the result that our knowledge and appreciation of individual contributions have increased, but the effect of the enormous body of work—some seven to eight thousand images—is and was independent of considerations of attribution. The extensive coverage also reflected the increased need by the contemporary media—the weekly illustrated journals *Harper's* and *Frank Leslie's*—for images of catastrophic events. By reproducing on-the-spot graphic illustrations, and hiring artists to transform photographs into wood engravings, these magazines brought the battlegrounds into comfortable drawing rooms for the first time. As the documentation proceeded, readers of the illustrated press and purchasers of stereograph views were made acutely aware of what the *New York Times* called "the terrible reality." *A Harvest of Death, Gettysburg, Pennsylvania (pl. no. 209)*, taken by O'Sullivan (printed by Gardner) and later included in *Gardner's Photographic Sketchbook of the Civil War*, is a pictorial evocation rather than merely an illustration in that it encapsulates the tone of Lincoln's sorrowful words com-

memorating the battle. It brought home the anonymity of modern warfare, in which it was realized that shoeless soldiers, their pockets turned out, "will surely be buried unknown by strangers, and in a strange land."[23] The haunting stillness of *Ruins of Richmond (pl. no. 210)*, made toward the end of the war and frequently attributed to Gardner, is a quintessential evocation of the desolation occasioned by four years of death and destruction.

Civil War reportage owed its successes also to the readiness of the military to accept photography as a new visual tool, hiring photographers other than "Brady's Men" to work with various units. Barnard, the well-respected former daguerreotypist, worked with Brady briefly and then was attached to the Military Division of the Mississippi, where he documented the aftermath of General Sherman's march across Georgia in 1863; three years later he published a selection of images as *Photographic Views of Sherman's Campaign*. The surpassing "delicacy of execution . . . scope of treatment and . . . fidelity of impression,"[24] noted by a reviewer for *Harper's Weekly*, are evidences of Barnard's commitment to a style that included the printing-in of sky negatives when he believed they might enhance the truthfulness of the image. One such photograph *(pl. no. 211)*, a view of the deserted rebel works occupied by Sherman's forces following the battle that

207. MATHEW BRADY
OR ASSISTANT.
*Landing Supplies on
the James River,*
c. 1861. Albumen print.
Library of Congress,
Washington, D.C.

208. GEORGE COOK. *Charleston Cadets Guarding Yankee Prisoners*, 1861. Albumen print.
Cook Collection, Valentine Museum, Richmond, Va.

delivered Atlanta to the Union Army, is especially moving as an emblem of the nation's psychological and physical exhaustion.

Sometime around the surrender of the Confederate Army at Appomattox, April 10, 1865, Gardner took what would be the last portrait of Lincoln *(pl. no. 68)*.[25] Following the assassination, he photographed the President's corpse four days later, and arranged to make portraits of those involved in the plot. Gardner was on hand July 7, 1865, with camera set up on a balcony overlooking the Arsenal Penitentiary courtyard, and from this position he made a sequence of exposures of the hangings of the conspirators—one of the earliest photographic essays on a specific event of political or social significance. The views that issued from this seminal documentation constitute a bleakly powerful story.

War photographers of the collodion period were inter-ested in objectivity and craftsmanship. Through choice of subject, position, and exposure, they attempted to present accurately the localities, events, and methods of war, in the light of what they conceived to be the national interest. While close-ups, blurring, and distortion—the modern stylistic devices used by contemporary photographers in conflict situations—would have been antithetical to both the goals of the photographers and the desire by the public for clear pictorial records, there still was a need to invest the images with dramatic qualities consistent with their objectives but transcending temporal limitations. One frequently used approach was to incorporate silhouetted forms and figures within the frame; the stark *Ruins of Richmond (pl. no. 210)* and Gardner's *General John F. Hartranft Reading the Death Warrant (pl. no. 235)* illustrate how this stylistic device serves to isolate and emphasize certain forms while investing the image with a sense of timelessness.

Photographic Documentation and Graphic Art

Pictorial documentation of the Crimean and Civil wars was commissioned also of graphic artists by periodical publications on both sides of the Atlantic. In fact, the illustrator Alfred Waud, a competent if uninspired draftsman, accompanied Brady on his first foray. Today, the most renowned of the Civil War "sketch artists" is Winslow Homer, at the time a young unknown sent by *Harper's Weekly* to cover front-line action in 1861. Besides turning out on-the-spot drawings that engravers converted into magazine illustrations, Homer collected material that he developed into paintings to create the only body of work of consistently high caliber with the Civil War as theme. His unconventional realism and his preference for mundane scenes that express the human side of army experience imbue these oils with a nonheroic modernity similar to that found in many camera images of the war. Although there is no evidence that Homer used actual photographs in his compositions of camp-life, his painting, *A Trooper Meditating Beside a Grave (pl. no. 212)*, evokes the same sense of direct experience visible in *Three Soldiers (pl. no. 213)*, a stereograph by an unknown maker.

Homer aside, there is no question that soon after their appearance, photographic documentations, with their keen sense of being an on-the-spot witness to reality, affected the course of the graphic arts in terms of theme and treatment. Though the camera lens might seem to be a more efficient tool than the brush for excising discrete moments of reality, the urge to recreate the daily dramas of ordinary people and the political events of the time on canvas also moved painters—especially the group in France known as Realists. That these artists consciously sought to

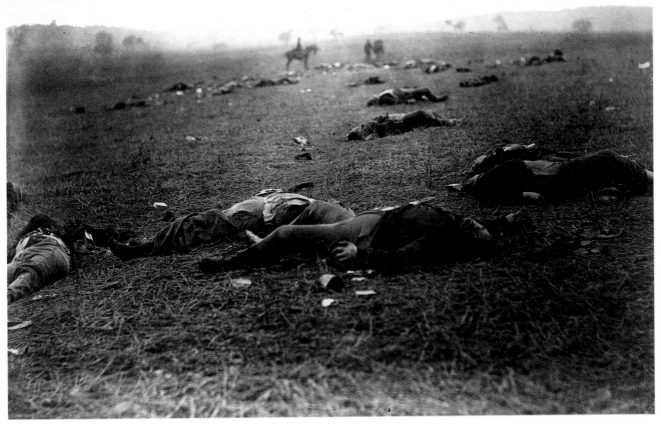

209. TIMOTHY H. O'SULLIVAN (originally printed by Alexander Gardner). *A Harvest of Death, Gettysburg, Pennsylvania*, July, 1863. Albumen print. Rare Books and Manuscript Division, New York Public Library, Astor, Lenox, and Tilden Foundations.

emulate photography, to capture "the temporal fragment as the basic unit of perceived experience," as American art historian Linda Nochlin has observed,[26] can be seen in the *Execution of Maximilian*, an 1867 work by Edouard Manet. Availing himself of news reports and using actual photographs of the shooting by firing squad as a basis for this work, the painter endeavored to de-heroicize and de-mythicize a political occurrence that artists had classically treated with reverence. By emphasizing what the eye sees rather than invoking timeless moral or religious truths, both Realist painters and documentary photographers provided the public with alternative concepts about valor on the battlefield, triumph in death, and the sanctity of life.

It is a paradox nevertheless that documentary photographs are most memorable when they transcend the specifics of time, place, and purpose, when they invest ordinary events and objects with enduring resonance. Sensitivity to the transforming character of light, to the way it structures, reveals, and dramatizes, enabled 19th-century photographers to infuse gesture, expression, and, especially, portions of the built and natural world with feeling. In transmuting bits and pieces of an uninflected, seamless reality into formally structured entities, these pioneers of the medium demonstrated the unique potential of the camera to illuminate as well as record.

Profile: Roger Fenton

"Gentleman photographer" might be an apt description of Roger Fenton, although his images are neither effete nor languid. His outlook, associations, and activities were reflections of his firmly established position in the comfortable reaches of British society in the mid-1800s. For about 15 years, starting in the late 1840s, he was in the forefront of activity in the medium, producing art photographs and documentation, traveling widely, and organizing activities to promote photography. In 1862, without explanation he suddenly renounced all interest, sold his equipment and negatives, and returned his mind to the legal interests that had occupied him before photography.

From his youth, Fenton's interest was in art rather than in his family's textile and banking businesses. After graduating from college, he pursued training in Paris in common with other aspiring painters, studying with the French salon artist Paul Delaroche in 1841. This fortunate choice led to an acquaintanceship with photography and with several other young artists who were interested in the new field, including Le Gray. Eventually, Fenton returned to England and trained also for a more practical career in law, but he retained an interest in painting, exhibiting at the Royal Academy, and in photography, dabbling in the calotype.

In 1847, he joined with Frederick Archer, Hugh Welch Diamond, Robert Hunt, and William Newton to form the Photographic Club of London (also called the Calotype Club). Three years later, he proposed the establishment of a formal society, modeled on the French *Société héliographique*, that would meet regularly, publish a journal, and maintain a library and exhibition rooms. This entity, The Photographic Society of London (later the Royal Pho-

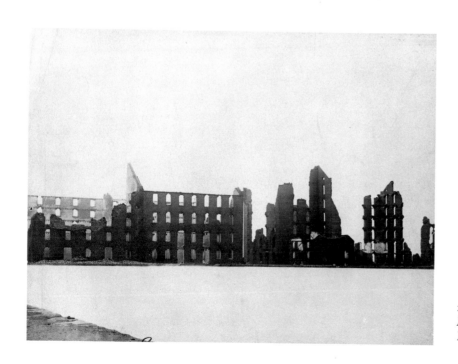

210. UNKNOWN PHOTOGRAPHER.
Ruins of Richmond, 1865. Albumen print.
Museum of Modern Art, New York.

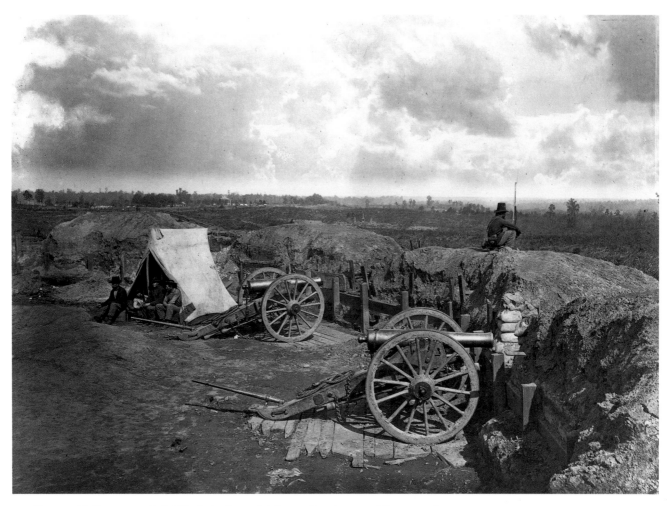

211. GEORGE N. BARNARD. *Rebel Works in Front of Atlanta, Georgia*, 1864. Albumen print.
Stuart Collection, Rare Books Division, New York Public Library, Astor, Lenox, and Tilden Foundations.

tographic Society), was finally inaugurated in 1853, after the relaxation of a part of Talbot's patent, with Sir Charles Eastlake as president and Fenton as honorary secretary. Fenton's influential associations brought about the patronage of Queen Victoria and Prince Albert for the new society. In addition, he was a member of the Photographic Association, a professional body, and sat on committees to consider problems related to the fading of paper and copyright laws.

Fenton also photographed. In 1853 he made a number of portraits of the royal family; a year later he traveled to Russia to document the building of a bridge in Kiev, stopping to make calotypes in St. Petersburg and Moscow, as well. On his return, he was employed by the British Museum to document collections of classical art and drawings. For a good part of 1855, he was involved with the Crimean War project, presenting his pictures and experiences to the crowned heads of Britain and France and trying to regain his health after a bout with cholera. The next year, he

returned to his post at the museum. From this time until 1862, he was involved with art photography, with landscape documentation, with a publication devoted to engravings made from photographs, and with stereography. After providing 21 images for a work entitled *Stereoscopic Views of Northern Wales*, he contributed regularly to *Stereoscopic Magazine*, a publication founded by Lovell Reeves that lasted for about five years. Aside from the documentations and landscapes already mentioned, he turned out images of models posed in exotic costumes and mannered still lifes, some replete with the overdecorated crockery dear to Victorians *(pl. no. 260)*.

Fenton did not explain or justify his abrupt renunciation of photography, but a number of factors probably were involved. On the technical side, the instability of paper images continued to present problems; an album of his photographs done for the British Museum faded for no apparent reason. Perhaps of greater importance, in view of his own excellent craftsmanship that has kept most of his

212. WINSLOW HOMER. *A Trooper Meditating Beside a Grave*, c. 1865. Oil on canvas. Joslyn Art Museum, Omaha, Neb.; gift of Dr. Harold Gifford and Sister Ann Gifford Forbes.

work remarkably well preserved, was the changing attitudes toward the medium that became apparent as collodion technology turned photography into business. His arrangements with the British Museum reflected the fact that the photographer was considered by many to be an artisan with little to say over the sales of images. Furthermore, photographs hung in the 1862 International Exhibition had been relegated to the machinery section, despite a

spirited campaign in the photographic press to consider them as art. Like contemporaries in France who also withdrew (Le Gray, Baldus), Fenton may have found these events too discouraging.[27]

In some ways, Fenton's activities are of as great interest as his images. While he made fine landscapes and still lifes, and some compelling views of the Crimean conflict, his campaigns to promote photography are indicative of the concern displayed by many young camera artists about the rapid commercialization of the field. In organizing photographic societies, they were attempting to control and maintain standards that would prevent the medium from being used as a purely mechanical picture-maker. This elitism was only partially successful, as first collodion, then the dry plate, and finally the snapshot camera pushed photographic practice in the opposite direction, making the battle for standards a recurring feature in the history of the medium.

Profile: Mathew Brady

As unlikely as it may at first seem, Mathew Brady was in some ways the New World counterpart of Roger Fenton. Differing in background, class position, training, and range of subjects, Brady nevertheless shared with Fenton a sense of mission as well as high critical esteem. Son of poor Irish farmers, Brady arrived in New York City from upstate, probably in the mid-1830s. He was introduced by the painter William Page to Samuel F. B. Morse, from whom he may have learned daguerreotyping, although there is no mention in Morse's papers of Brady as a student. His early years in the city are scantily documented, but sometime in 1844 he opened a portrait studio in what was the busiest commercial section of lower Broadway. By the late 1850s, after one failure in Washington and several moves in New York, he was the owner of fashionable portrait establishments in both cities. Friend to politicians and showmen, he was known to all as the foremost portraitist of the era.

Brady's success was based on high standards of craftsmanship and an unerring feeling for public relations. To this end his luxuriously appointed studios turned out a well-made but not exceptional product that cost more than the average daguerreotype or, later, albumen portrait. In Brady's establishments, the line between a painted and a camera portrait was dim: daguerreotypes could be copied life-size on albumen paper, inked or painted in by well-trained artists, while collodion glass negatives often were enlarged for the same purpose. In addition to displays of portraits of celebrities, his studios contained stereoscope apparatus with which customers could view the latest cards by a variety of makers. It is little wonder that the well-to-do and influential were attracted to Brady's studios.

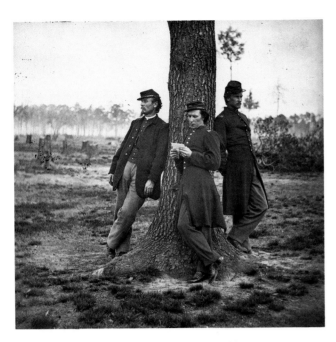

213. UNKNOWN PHOTOGRAPHER. *Three Soldiers*, 1860s.
One-half of an albumen stereograph. Library of
Congress, Washington, D.C.

Brady was an entrepreneur, setting up the studios,
cajoling famous sitters, and arranging for reproductions of
his work in the illustrated press, but the actual exposures
were made by "operators," among them James Brown,
George Cook, O'Sullivan, and, Gardner. In addition, a line
of assembly workers that included many women saw to it
that the firm's daguerreotypes and, later, its albumen prints
were properly finished and presented. Nevertheless, at the
time it was taken for granted that honors for excellence in
portraiture, starting with a silver medal at the 1844 Ameri-
can Institute Exhibition and extending into the collodion
era, should go to Brady himself. His greatest critical
triumph was at the Crystal Palace Exhibition of 1851, where
the Americans swept the field. It was on the trip to Europe
for this event that Brady first investigated collodion and
made the acquaintance of Gardner, who was to be influen-
tial in the success of his Washington portrait gallery.

Had Brady contented himself with commercial portrai-
ture, it is doubtful that his role in the history of the
medium would have been prominent, but he seems always
to have been aware that photography could be more than
just a successful commercial enterprise. In 1845, he proposed

the publication of a series of portraits of famous American
personalities in all professions. Issued in only one edition,
A Gallery of Illustrious Americans, with lithographs by
François D'Avignon based on Brady daguerreotypes, was
premature and did not sell. However, a portrait of Lincoln,
the first of many, became so well-known that the President
ascribed his election to this likeness. Taken just before the
famous Cooper Union campaign address, this work
showed a beardless Lincoln with softened features to make
him appear more agreeable.

When the Civil War broke out, Brady's sense of photog-
raphy's destiny finally could be tested. He was able to
demonstrate not only that war reportage was possible but
also his own personal courage in continuing the mission
after his photographic wagon was caught in shell-fire at
Bull Run. In the spring of 1862, Brady trained crews of
photographers, assigned them to various territories, had
wagons especially constructed in order to transport the
photographic gear securely, and arranged for materials and
equipment to be supplied from the New York house of T.
and E. Anthony. Brady had expected to make back the ex-
penses of his ambitious undertaking by selling photo-
graphs, mainly in stereograph format, but after the war
the demand for such images ceased as Americans, engulfed
in an economic recession, tried to forget the conflict and
deal with current realities. Debts incurred by the project,
the slow trade in portrait studios generally, and the down-
fall of Brady's New York political patrons—coupled with
the panic of 1873—resulted in the eventual loss of both
his enterprises. At the same time, Brady's efforts to interest
the War Department in his collection of Civil War images
were unavailing. One set of negatives was acquired by the
Anthony company as payment for the supplies, and another
remained in storage, slowly deteriorating. When this collec-
tion of more than 5,000 negatives came up at auction in
1871, it was bought by the government for the storage
charges of $2,840; somewhat later the sick and by-now
impoverished Brady was awarded $25,000 in recognition
of the historic services he had performed. At the time, it
was impossible for most bureaucrats to realize the signifi-
cance of the Civil War project. This vast enterprise not
only had made it possible for photographers to gain the
kinds of experience needed for the documentation of the
West, but it had, for the first time in the United States,
given shape to photography's greater promise—that of
transforming momentary life experiences into lucid visual
expression.

A Short Technical History: Part I

PRE-PHOTOGRAPHIC OPTICAL AND CHEMICAL OBSERVATIONS AND EARLY EXPERIMENTS IN PHOTOGRAPHY

Before Photography

In China in the 5th century B.C., Mo Ti recorded his observation that the reflected light rays of an illuminated object passing through a pinhole into a darkened enclosure resulted in an inverted but otherwise exact image of the object. In the following century in the West, Aristotle described seeing, during a solar eclipse, a crescent-shaped image of the sun on the ground beneath a tree, which was projected by rays of light passing through the interstices of foliage onto a darkened surface. In the 10th century, the Arabian scholar Abū 'Ali al-Hasan ibn al-Haytham (Alhazen) added the observation that an image thus formed was sharply defined when the aperture through which it was projected was small and became diffuse as the hole was enlarged to admit more light. Similar optical phenomena were noted by Roger Bacon in the 13th century and Reinerius Gemma-Frisius in the 16th.

During the Renaissance, efforts to control and direct this phenomenon resulted in the concept of a *camera obscura*—literally, a dark room—that enabled light to enter through a hole in a wall facing another wall or plane on

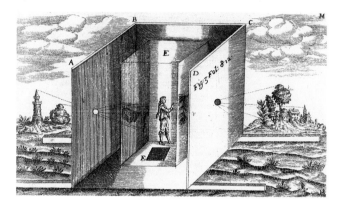

215. ATHANASIUS KIRCHER. *Large Portable Camera Obscura*, 1646. Engraving. Gernsheim Collection, Humanities Research Center, University of Texas, Austin.

which the projected image appeared in natural colors. Sixteenth-century descriptions by Leonardo da Vinci, Vitruvius, and Girolamo Cardano in Italy and by Erasmus Reinhold and Gemma-Frisius in Northern Europe make it difficult to assign exact dates or authorship to the construction of the first *camera obscura*, but references to Giovanni Battista della Porta's *Magiae naturalis* of 1558 indicate that by then the device had become familiar to scientists, magicians, and artists. By the 17th century, the camera obscura had emerged as a necessary tool for the working out of new concepts of pictorial representation, in which artists and draftsmen depicted objects and space as if seen from one position and one point in time *(pl. no. 214)*.

From the 17th to the 19th century, the *camera obscura* underwent continual improvement. Better lenses sharpened the image, and mirrors corrected the inversion and projected the picture onto a more convenient surface for drawing. Portable models were popular among European geographers as well as artists, including a tentlike collapsible version by Athanasius Kircher *(pl. no. 215)* illustrated in his 1646 treatise on light as a suitable instrument for drawing the landscape. That scientists and artists regarded it as a device both for aiding graphic representation and for ascertaining basic truths about nature is apparent from the Dutch philosopher Constantijn Huygens's descrip-

214. STEFANO DELLA BELLA. *Camera Obscura with View of Florence*, n.d. Ink drawing. Library of Congress, Washington, D.C.; Lessing J. Rosenwald Collection.

tion of the *camera obscura* image as "life itself, something so refined that words can't say," while others of the 17th century remarked on its ability to produce a "picture of inexpressible force and brightness . . . of a vivacity and richness nothing can excell."[1]

During the 18th century, fantastic literary and graphic explanations about phenomena caused by light rays appeared, among them an allusion in Tiphaigne de la Roche's fictional work *Giphantie* to a canvas as a mirror that retains images that light transmits, and a visual representation of this concept is seen in an anonymous engraving, *The Miraculous Mirror (pl. no. 216)*. Actual *camera obscurae*, used by artists to improve the accuracy of their depictions, were shown on occasion in portrait paintings *(pl. no. 217)*, as though suggesting that the portrait was a truthful image of the pictured individual. Interest in faithfully transcribing the visible world from the point of view of the individual led to the invention of other devices besides the *camera obscura*. For example, the *camera lucida*, invented by William Hyde Wollaston in 1807, is an arrangement of a prism and lens on a stand that enables the draftsman to see a distant object superimposed on the drawing paper, theoretically making transcription easier.

The chemical components necessary for photography were not recognized until some 200 years after the *camera obscura* was first conceived. From antiquity to the Renaissance, the mystery surrounding organic and mineral substances and their reactions to light and heat made chemical experimentation an inexact exercise practiced mainly by alchemists. In the 17th century, more accurate observation led to the identification of silver nitrate, silver chloride, and ferrous salts, the first chemical substances used in the experiments that led to photography. The accidental discovery in 1725 by Johann Heinrich Schulze, Professor of Medicine at the University of Altdorf, that silver nitrate

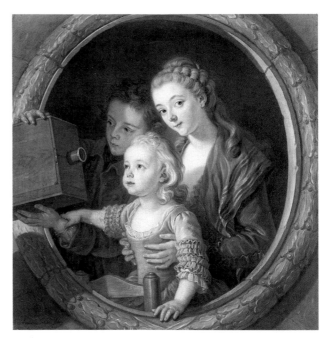

217. CHARLES AMÉDÉE PHILIPPE VAN LOO. *The Magic Lantern*, 18th century. Oil on canvas, National Gallery of Art, Washington, D.C.; Gift of Mrs. Robert W. Schuette, 1945.

darkened when exposed to sunlight and that this change was the result of exposure to light and not heat was crucial to photography. The light sensitivity of silver chloride was the subject of experiments by Swedish Chemist Carl Wilhelm Scheele who published his results in 1777, unaware that at mid-century an Italian, Giacomo Battista Beccaria, had discovered the same phenomenon. Scheele also established that the violet end of the solar spectrum was actinically[2] more active in producing this effect and that the darkened material consisted of particles of metallic silver that could be precipitated by ammonia. Silver chloride was one of the many elements tested in 1782 by Jean Senebier, the Chief Librarian of Geneva, in order to determine the time required for various degrees of light to darken the chemical salts. He also studied the reaction of the chloride to different portions of the spectrum, foreshadowing later experiments that demonstrated that the spectrum reproduced itself in natural colors on the chloride surface.

Two 18th-century English scientists, Dr. William Lewis and Joseph Priestley, formed the link between these early chemical experiments and later efforts to find a way to retain an image produced by the darkening of silver halides by light. The notebooks of Dr. Lewis, who had repeated Schulze's experiments by painting designs in silver nitrate on white bone that he exposed to sunlight, were acquired by Josiah Wedgwood, the British commercial potter, who may have become interested in finding a photochemical process when he was commissioned by Catherine the Great

216. UNKNOWN. *The Miraculous Mirror*, 18th century. Engraving. International Museum of Photography at George Eastman House, Rochester, N.Y.

of Russia to provide a table service with 1,282 views of country mansions and gardens, many of which were made with the aid of the *camera obscura*.[3] As a member of Wedgwood's Lunar Society discussion group, Priestley imparted information about the photochemical properties of silver halides that he gathered from his association with prominent figures in the European scientific community. In 1802, young Thomas Wedgwood attempted to transfer paintings on glass to white leather and paper moistened with a solution of nitrate of silver, describing the resulting negative image as follows: "where the light is unaltered, the color of the nitrate is deepest."[4] Neither Wedgwood nor his associate in the experiments, chemist Humphry Davy, were able to find a way to arrest the action of light on the silver salts; unless kept in the dark the picture eventually was completely obliterated. Their early experiments demonstrated, however, that it was possible to chemically transfer by means of light not only pictures but objects in profile such as leaves and fabrics.

First Successful Experiments

Interest in the practical uses of new scientific discoveries developed among both the enlightened British and French bourgeoisie during the early years of the 19th century and led the brothers Joseph Nicéphore Niépce (*pl. no. 4*) and Claude Niépce, who returned to the family estates at Chalon-sur-Saône after the Napoleonic Wars, to become involved with a series of inventions, including a motor-driven rivercraft (the *pyréolophore*), a method of making indigo dye, a device for printing lithographs, and a process for obtaining images by the action of light. In 1816, Nicéphore and Claude produced an image in the *camera obscura* using paper sensitized with silver chloride,[5] but because the tones were inverted and efforts to make positive prints were unsuccessful, Nicéphore eventually turned to using bitumen, an ingredient in resist varnish that hardens and becomes insoluble when exposed to light. Between 1822 and 1827, while his brother was abroad, Nicéphore produced transfers of engravings, first on glass and then on pewter, by coating the plates with bitumen, placing them against engravings made translucent by oiling or varnishing, and exposing the sandwich to sunlight. The bitumen hardened on the portions not covered by the lines of the print and remained soluble on the rest of the plate; after washing, an image appeared with the bare pewter forming the lines. It was Niépce's plan to etch these plates, thus creating an intaglio matrix from which inked prints might be pulled. Heliography, as he called this process, was the forerunner of photomechanical printing processes.

In the summer of 1827, Niépce exposed a pewter plate

coated with bitumen in the *camera obscura*, achieving after some eight hours an image of a dovecote on his estate at Le Gras (*pl. no. 6*). Although he changed from pewter to silver and silver-coated copper plates, and introduced iodine to increase the sensitivity of the silver surface to light, he was unable to decrease substantially the exposure time needed to obtain an image. In his search for improved optical elements for his work, Niépce had contacted the Parisian optical-instrument maker Vincent Chevalier, who in turn acquainted scenic designer and Diorama owner Jacques Louis Mandé Daguerre with the nature of the experimentation at Le Gras. Daguerre's parallel interest in obtaining a permanent image in the *camera obscura* led to contacts with Niépce and resulted in a meeting in 1827 and the signing of a deed of partnership in 1829 to pursue the process together.

Following Niépce's death in 1833, activity shifted to Paris as Daguerre continued to work with iodized silver plates, discarding bitumen altogether. However, he, too, was not notably successful in reducing the time needed for the image to appear until 1835, when he hit upon a phenomenon known as latent development, which means that the photographer does not have to wait to see the image appear on the plate during exposure, but can bring it out by chemical development—in this case, mercury vapor—making possible a radical reduction in exposure time. A problem that remained unsolved was how to stop the continued action of light on the silver halides, which caused the image to darken until it was no longer visible, but in 1837 Daguerre found a way to arrest the action of light with a bath of sodium chloride (common table salt), a method he used until March, 1839, when he learned about the property of hypo (hyposulphite of soda now called sodium thiosulphite) to wash away unexposed silver salts indirectly from its discoverer, the English scientist John Herschel. The daguerreotype, as he called his product, was delicate—easily damaged by fingerprints and atmospheric conditions—and therefore needed the protection of being enclosed in a case under glass (*pl. no. 33*).

In 1833, at about the same time as Daguerre's early experiments, English scientist and mathematician William Henry Fox Talbot conceived of making a permanent image of what could be seen in the *camera obscura*; within two years he had succeeded in obtaining pictures by the action of light on paper treated with alternate washes of sodium chloride and silver nitrate. His first pictures were of flat objects, made by placing leaves, lace, or translucent engravings against the sensitized paper and exposing both to sunlight to produce a tonally and spatially inverted image in monochrome on the paper. Also in 1835, Talbot carried this discovery a step forward when he produced a one-inch-square negative image of his ancestral home, Lacock

Abbey *(pl. no. 20)*, made by inserting sensitized paper in a very small camera with a short focal length (the distance between lens and film) for about ten minutes in bright sunshine. To stabilize these early images, Talbot employed either potassium iodide or table salt, but early in 1839 he changed to hypo on Herschel's advice. Calling these images "photogenic drawings," Talbot proposed to correct their tonal and spatial inversions by placing another sheet of silver-sensitized paper against the paper negative image (waxed to make it translucent) and exposing both to light, but it is doubtful that he actually made such positive prints at this time.[6]

Apart from the profoundly ingenious concept of a negative from which multiple positives could be made, Talbot's most significant invention was latent development, which he arrived at independently in 1840. He sensitized paper by swabbing it with a combination of silver nitrate and gallic acid solutions that he called gallo-nitrate of silver, exposed it in the camera, removed the seemingly blank paper after a time, and then bathed it in the same chemical solutions until the image gradually appeared. Having reduced exposure time by chemical development to as little as 30 seconds on a bright day, Talbot took out his first patent in February, 1841, for a negative/positive process he called the calotype.

Other Experiments

Widespread interest during the early 19th century in light-related phenomena led to similar experiments by others. Among them was Hercules Florence, a French-born artist who had joined a Russian expedition to the interior of Brazil in 1828. He began to work with paper

219. *Daguerre-Giroux Camera*. Giroux's camera of 1839, based on Daguerre's patent, was the first camera to be sold in any numbers to the public. The lens was fitted with a pivoted cover plate (A), which acted as a shutter. A plaque (B) bore Daguerre's signature and Giroux's seal.

sensitized with silver salts (the exact composition of which is unknown) in an effort to produce images of drawings by a process he actually called photography (from the Greek *phos*—light—and *graphos*—writing)—apparently the first recorded use of the word, which came into general usage in Europe in 1839. Florence and his work were forgotten until 1973, when his journals and examples of his work came to light in Brazil.[7] Also in 1839, Friederike Wilhelmine von Wunsch, a German painter living in Paris, claimed to have come up with a photographic process that produced both miniature and life-size portraits.

In May, 1839, Hippolyte Bayard, a French civil servant, announced a direct positive process for obtaining photographic images on paper, which he achieved by darkening a sheet of paper with silver chloride and potassium iodide, upon which light acted as a bleach when the plate was exposed in the camera. Bayard's contribution was largely ignored at the time, owing to France's official support for the daguerreotype,[8] but since some French photographers evinced strong interest in a paper process in preference to the daguerreotype, experimentation along this line continued.

By 1847, Louis Désiré Blanquart-Evrard, a leading figure in the improvement of the calotype in France, had developed a method of bathing the paper in solutions of potassium iodide and silver nitrate rather than brushing these chemical baths on the surface, as Talbot had done. Exposed in a damp state (as Talbot's had been), the resulting negative showed improved tonal range because the paper fibers were more evenly saturated.

218. *Talbot's Mousetrap Camera*. In 1839 Talbot made cameras with removable paper-holders (A). The image produced by the lens (B) on the thin, sensitive paper could be inspected from behind through a hole, which normally was covered by a pivoted brass plate (C).

Further improvements in definition followed when the French painter Gustave Le Gray developed the waxed-paper process—a method of using white wax on the paper negative before it was sensitized. After being immersed in a solution of rice water, sugar of milk, potassium or ammonium iodide, and potassium bromide, and being sensitized in silver nitrate and acetic acid, the paper was ready to use in either damp or dry state. Le Gray's attentiveness to the aesthetics of photography led him to experiment with the timing of various chemical baths in an effort to produce different colorations in his prints.

In 1839 Herschel had suggested glass as a support for negatives, but it was not until 1847 that a procedure evolved for making albumen negatives on glass plates. Claude Félix Abel Niepce de Saint-Victor (a relative of the Niépce brothers) proposed a mixture of eggwhite with potassium iodide and sodium chloride to form a transparent coating on glass, which then was immersed in silver nitrate solution and, after exposure, developed in gallic and pyrogallic acid. A similar process, called Crystalotype, was perfected by the American John Adams Whipple; both processes were slow but produced excellent glass lantern slides.

Those working with glass then turned to collodion—a derivative of guncotton, which became liquid, transparent, and sticky when dissolved alcohol and ether.[9] Experiments with collodion were undertaken by Le Gray and Robert Bingham in France in 1850, but the first practicable directions for using it as a binder for light-sensitive silver salts appeared in 1850 and 1851 in a two-part article in *The Chemist* written by Frederick Scott Archer, an English sculptor. The viscous collodion, which contained potassium iodide (potassium bromide was later added), was poured evenly onto a glass plate, which was then immersed in a silver nitrate bath to form silver iodide. The exposure time was shortened considerably, but only if the plate was used immediately in its wet state. Because it had to be developed—usually in ferrous sulphate—while still moist, the "wet plate," as it came to be called, made portable darkrooms for outdoor work a necessity.

Before the collodion process became used exclusively for negatives, it enjoyed a period of popularity in the form of the glass positive, or Ambrotype—as its American version, patented in 1854 by James Ambrose Cutting of Boston, was called. By adding chemicals to the developer and backing the glass negative either with black cloth or black varnish, the image was reversed visually from a negative into a one-of-a-kind positive *(pl. no. 53)* that usually was presented to the client encased in the same type of frame as a daguerreotype. Sensitized collodion also figured in the production of direct positive images on sheet iron. Known generally as tintype, but also called ferrotype

and Melainotype, the process was discovered in 1853 in France and in 1856 in both England and the United States; a dry tintype process was introduced in 1891. Since tintypes were quickly made (requiring just over a minute from start to finish), inexpensive to produce, and easy to send through the mails, they were popular with soldiers during the American Civil War; they continued to be made of and for working-class people into the 20th century.

The same albumen or eggwhite suggested by Niepce de Saint-Victor as a binder for glass negatives was also used to close the pores of photographic printing papers, to prevent silver salts from penetrating the irregular fiber structures or affecting the chemical sizings used in paper manufacture. The first practicable process for making albumen paper, announced in 1850 by Blanquart-Evrard, required coating the paper with a mixture of eggwhite and either table salt or ammonium chloride, after which it was dried and kept until needed. Before exposure, the paper was sensitized by floating it albumen-side down in a strong solution of silver nitrate. After drying, it was exposed in contact with a negative for as long as was needed to achieve a visible image—that is, no chemical developer was used. Blanquart-Evrard also contrived a paper that was chemically developed in gallic acid after exposure with the negative—a procedure that enabled his printing plant in Lille, France, to turn out from 300 to 400 prints a day from a single negative. Fine prints resulted when, after exposure of both negative and sensitized paper in a

220. *Wolcott Camera.* In Wolcott's camera, as patented in 1840, a large, concave mirror (A) was placed at the back of an oblong box. A small, sensitized daguerreotype plate (B) was fitted into a wire frame and was held in place by a spring clip. A surviving example of the camera has, however, a more elaborate holder. The frame could be moved backward and forward on a track (C) to focus the image on the sensitive surface of the plate, which faced the mirror. The exposure was made by opening a door on the camera front. Other doors gave access to the mirror and the plate frame and allowed the focus to be checked. The camera took plates measuring about 2 x 2.5 inches (51 x 64 mm).

221. *Lewis Folding Camera*. The Lewis daguerreotype camera of 1851 had a fixed, chamfered front panel (A), connected to a sliding box (B) at the rear by bellows (C), which gave extra extension. A door (D) gave access to the plate-holder and focusing screen.

dampened state in a holder, the print was developed in gallic acid, left for a longer period of time in the fixing bath, and exposed to sunlight afterward in order to change its color from russet to a deep, rich, almost-black tonality. During the mid-1850s, albumen papers with a glossy surface became popular. The combination of collodion glass negative and albumen paper made large-scale commercial printing feasible, but because "no preparation made for photography caused so many complaints as albumen paper,"[10] the search for a stable printing medium continued.

The carbon process, based on researches into the light sensitivity of dichromate (then called bichromate) of potassium by Scottish scientist Mungo Ponton in 1839 (continued in France by Edmond Becquerel in 1840 and Alphonse Poitevin in 1855, and in England by John Pouncy in 1858), substituted chromated gelatin mixed with pigment for silver salts as a light-sensitive agent for positive prints. When exposed against a negative, a sheet of paper coated with a mixture of gelatin, coloring matter—which initially was carbon black, hence the name—and potassium dichromate received the image in proportion to the amount of light passing through the negative; where thin, the gelatin hardened, where dense—the light areas of the scene—it remained soluble and was washed away with warm water after exposure. In its early applications, the light areas in the carbon print tended to become completely washed out, but this problem was solved in 1864 when British inventor Joseph Wilson Swan discovered that by using carbon tissue coated with pigmented gelatin in conjunction with a transfer tissue of clear gelatin, the lightest tonalities were retained. This material became commercially available in 1866, and Swan shortly thereafter sold franchises for the

mass production of carbon prints to the Autotype Company in England, Adolphe Braun in Dornach, and Franz Hanfstaengl in Munich.

Another nonsilver process, the cyanotype or blueprint (first described by Sir John Herschel in 1842) is based on the photosensitivity of ferric (iron) salts, which are reduced by light to a ferrous state so it can thereby combine with other salts to produce an image. For his experiments, Herschel used either ferric chloride or ferric ammonium citrate, and potassium ferricyanide. In the mid-1840s, this simple and inexpensive system was used to reproduce botanical specimens *(pl. no. 329)*, and around 1890 it attracted amateur photographers, but its use during the 20th century has been mainly for duplicating industrial drawings. While in the past, aesthetic photographers found the brilliant blue color intrusive, cyanotype is one of the processes currently being employed by contemporary artistic photographers.

A somewhat different system of obtaining permanent nonsilver positive prints, patented in 1865 as the Woodburytype after its inventor Walter Woodbury, involved making a relief image from a negative in dichromated gelatin from which a thin lead mold was formed in a hydraulic press. Filled with warm, pigmented gelatinous ink, the mold was brought into contact with the paper in a hand press, thereby transferring the pigmented image from mold

222. *Edwards' Dark-Tent*. The "perambulator" or "wheelbarrow" form of dark-tent devised by Ernest Edwards was popular with wet-collodion photographers. When packed up, the handcart was easily taken along. All the apparatus and chemicals required were stowed in compartments under the lid, which formed the back of the tent (A) when it was all rigged.

223. *Claudet Stereoscope.* The top opened up to form the back, into which the stereoscopic daguerreotypes (A) were fitted; the lenses (B) were set in telescoping mounts.

224. *Holmes-Bates Stereoscope.* Joseph Bates manufactured an inexpensive viewer invented in 1861 by Oliver Wendell Holmes; it was sold in this improved form from the mid-1860s until 1939. The stereograph was held on the cross-piece (A), which could be slid up and down the central strip for focusing. A folding handle (B) and a curved eyeshade (C) were fitted.

to paper surface under pressure and necessitating, after the hardening of the gelatin in an alum bath, the trimming of its borders to remove the colored ink that had overrun the edges of the image. A photomechanical, rather than a strictly photochemical procedure, Woodburytype (confusingly called *photoglyptie* in France) produced rich-looking prints without grain structure of any kind.

Early Equipment

The earliest cameras used by Niépce, Daguerre, and Talbot were modeled on *camera obscurae* in use since the

17th century. Those of Niépce and Daguerre consisted of two rectangular boxes, one sliding into the other, with an aperture to receive the lens and a place to position the plate. Talbot's first small instruments, referred to as "mousetraps" *(pl. no. 218)*, were crude wooden boxes; later British and French makers provided him with better-crafted instruments that incorporated besides the lens a hole fitted with a cork or brass cover through which one could check focus and exposure. The first commercial photographic camera was designed by Daguerre and was manufactured by Alphonse Giroux (a relative by marriage) from 1839 on *(pl. no. 219)*. A unique design was made by Alexander S. Wolcott, an American who in 1840 substituted for the lens a concave mirror that produced a brighter image by concentrating the light rays and reflecting them onto the surface of the daguerreotype plate *(pl. no. 220)*. Conical and metal cameras appeared in Austria and Germany in 1841, the same year that a cylindrical instrument enclosed in a wooden box was manufactured in Paris, but these did not catch on. A bellows focusing system for a camera was first suggested in 1839, but did not come into use until 1851 when it was incorporated into a rectangular camera made by the firm of W. and W. H. Lewis in New York *(pl. no. 221)*. A number of folding cameras, on view first at the Great Exhibition in 1851, with either rectangular or tapered bellows, were manufactured during the 1850s mainly by British firms. By the 1860s many bellows cameras included rising fronts, and swing fronts and backs.

The first arc-pivoted camera, devised in 1844 by Friederich von Martens, was capable of taking a panoramic view of about 150 degrees on a curved daguerreotype plate measuring approximately 4½ by 15 inches. Curved glass plates were required for the similar apparatus in use during the collodion era. A Pantascope camera, patented in England in 1862 by John R. Johnson and John A. Harrison, rotated on a circular base, as a holder containing a wet collodion plate was moved by a string and pulley arrangement past an exposing slot.

Photographic accessories such as buffing tools and sensitizing boxes had been necessary for daguerreotyping; during the collodion or wet plate era, photographers in the field were required to carry even greater amounts of additional equipment besides camera and tripod. Portable hand-carts and perambulator tents were devised to stow chemicals and apparatus and to allow the photographer to erect a light-tight tent virtually anywhere in order to sensitize plates before exposure and to develop them immediately afterward. The most popular design in England, that of Ernest Edwards, was a type of suitcase mounted on a wheelbarrow or tripod that opened to form a darkroom within a cloth tent *(pl. no. 222)*.

The stereoscope, conceived by Charles Wheatstone in

1832 before the invention of photography, originally was a device that permitted a view by means of mirrors of a pair of superimposed pictures that had been drawn as if seen by each eye individually, but appeared to the viewer to be a single three-dimensional image. In 1849, Scottish scientist David Brewster adapted the stereoscopic principle to lenticular viewing, devising a viewer with two lenses placed about 2½ inches apart laterally for viewing the stereograph —an image consisting of two views appearing side by side either on a daguerreotype plate, a glass plate, or on paper mounted on cardboard. Stereographic calotypes were made for viewing by Talbot, Henry Collen, and Thomas Malone after photography was invented. Stereographs and stereoscopes manufactured by the French optical firm of Duboscq and shown at the Great Exposition in 1851 became exceedingly popular and were produced for all tastes and pocketbooks. The viewers ranged from the simple devices invented by Antoine Claudet *(pl. no. 223)* and Oliver Wendell Holmes *(pl. no. 224)* to elaborately decorated models for the very wealthy to large stationary floor viewers that housed hundreds of cards that could be rotated past the eyepieces.

Stereographic views could be made by moving a single camera laterally, a few inches, but care was needed to make sure that the two images were properly correlated. In 1853,

226. *Disdéri Camera.* André Adolphe Eugène Disdéri's stereoscopic camera of c. 1864: the upper compartment was equipped with a pair of lenses (A), which were matched to the taking lenses (B) and were focused on a ground-glass screen (C), fitted in the back of the compartment in the same plane as the plate-holder below. A vertical, sliding shutter (D) was opened by pulling a string (E).

225. *Dancer Camera.* Dancer's stereoscopic camera of 1856 had two lenses, which were fitted with a pivoted shutter (A) and with aperture wheels (B). In addition, some models had a lens shade (C) in the form of a pivoted flap. Dry plates could be drawn up, one by one, by means of a screwed rod (D), from a plate-changing box (E). The number on the exposed plate could be read through a window (F).

a means of moving the camera laterally along a track was devised. Another method, first described by John A. Spencer in England in 1854, involved moving a plateholder in a stationary camera equipped with an internal septum so that the images did not overlap. During the 1850s, a binocular camera with two lenses was patented in France by Achille Quinet, and a twin-lens stereoscopic camera designed by John Benjamin Dancer *(pl. no. 225)* was offered for general sale in 1856. A number of other designs appeared during the 1860s, including a folding bellows binocular camera made by George Hare and a stereoscopic sliding box camera divided into an upper and lower compartment, each with a pair of lenses, designed by André Eugène Disdéri *(pl. no. 226)*.

In 1857, David A. Woodward, an American artist, patented a device he called a "solar microscope or magic lantern"[11] for the enlargement of photographic negatives. A mirror fixed at a 45-degree angle to receive the rays of the sun reflected them onto a condensing lens inside a box into which a negative on paper or glass could be fitted, throwing an enlargement of the image onto a sensitized support placed at a suitable distance away. Woodward actively promoted this device in the United States and Europe. Along with a similar apparatus developed by the Belgian scientist Desiré von Monckhoven, this forerunner of the enlarger proved to be a significant tool in graphic as well as photographic portraiture.

A 19th-Century Forerunner of Photojournalism— The Execution of the Lincoln Conspirators

The events that followed the assassination of Abraham Lincoln in the Presidential Box at the Ford Theater on the night of April 14, 1865, provided sensational pictorial material for graphic artists and photographers. Sketch artists for the weekly magazines turned out drawings of the theater interior, the death scene, the funeral cortege, and the capture of those involved, but it is the photographs of the individual conspirators, and above all of the hanging of four of them on July 7th, that remain by far the most vivid representations of this tragedy. The portraits, other than that of Booth, who perished in an ambush during his capture, were made by Alexander Gardner, presumably aboard the ironclad monitors *Montauk* and *Saugus*, where the conspirators were held while awaiting trial by a military tribunal. For the views of the actual execution, Gardner set up his camera on a roof overlooking the gallows erected in the courtyard of the Arsenal (or Old) Penitentiary and made a sequence of seven exposures of the preparations for and the hanging of George Atzerodt, David E. Herold, Lewis Payne, and Mary E. Surratt. This series appears to be the first photographic picture story of an event as it happened, and was all the more remarkable because of the secrecy surrounding the affair. While it was not possible at the time to reproduce these images by halftone in the popular press, this group of photographs signaled the important role that sequential images would play in news reporting in the future.

227. UNKNOWN PHOTOGRAPHER. *John Wilkes Booth*, n.d. Albumen *carte-de-visite*.
International Museum of Photography at George Eastman House, Rochester, N.Y.

228. ALEXANDER GARDNER. *Edward Spangler, a Conspirator*, April, 1865. Albumen print. Library of Congress, Washington, D.C.

229. ALEXANDER GARDNER. *Samuel Arnold, a Conspirator*, April, 1865. Albumen print. Library of Congress, Washington, D.C.

230. ALEXANDER GARDNER. *George A. Atzerodt, a Conspirator*, April, 1865. Albumen print. International Museum of Photography at George Eastman House, Rochester, N.Y.

231. ALEXANDER GARDNER. *Lewis Payne, a Conspirator, in Sweater, Seated and Manacled*, April, 1865. Albumen print. Library of Congress, Washington, D.C.

232. ALEXANDER GARDNER. *General John F. Hartranft and Staff, Responsible for Securing the Conspirators at the Arsenal. Left to Right: Capt. R. A. Watts, Lt. Col. George W. Frederick, Lt. Col. William H. H. McCall, Lt. D. H. Geissinger, Gen. Hartranft, unknown, Col. L. A. Dodd, Capt. Christian Rath,* 1865. (Cracked Plate). Albumen print. Library of Congress, Washington, D.C.

233. ALEXANDER GARDNER. *Execution of the Conspirators: Scaffold Ready for Use and Crowd in Yard, Seen from the Roof of the Arsenal, Washington, D.C.,* July 7, 1865. Albumen print. Library of Congress, Washington, D.C.

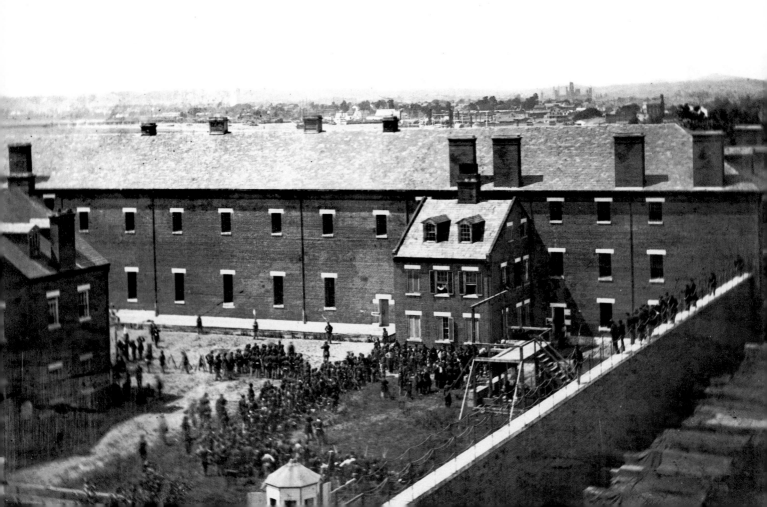

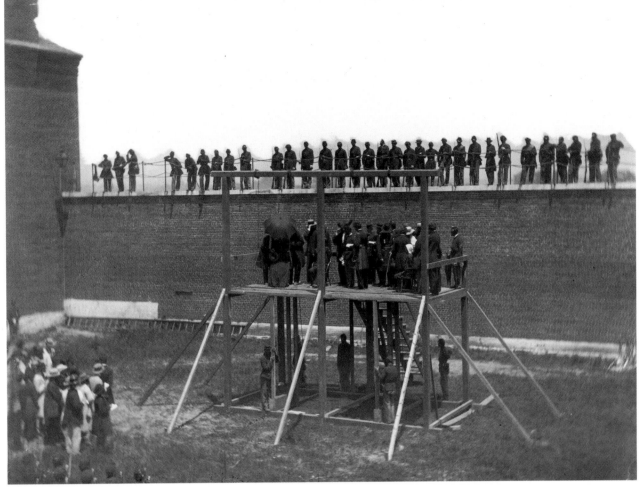

234. ALEXANDER GARDNER. *The Four Condemned Conspirators (Mrs. Surratt, Payne, Herold, Atzerodt), with Officers and Others on the Scaffold; Guards on the Wall, Washington, D.C.,* July 7, 1865. Albumen print. Library of Congress, Washington, D.C.

235. ALEXANDER GARDNER. *General John F. Hartranft Reading the Death Warrant to the Conspirators on the Scaffold, Washington,* D.C., July 7, 1865. Albumen print. Library of Congress, Washington, D.C.

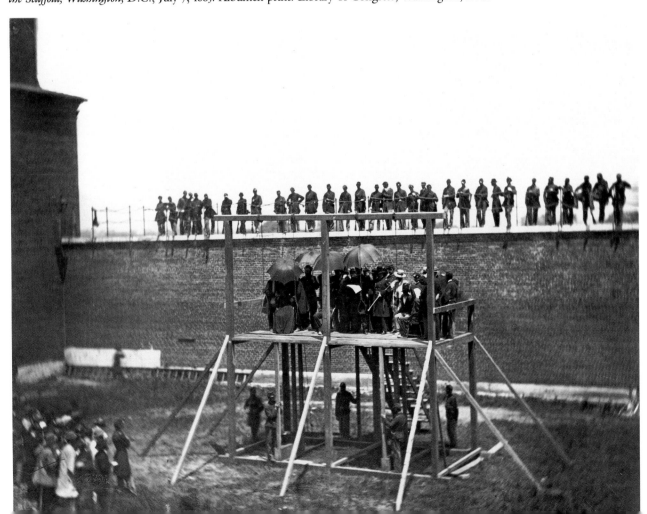

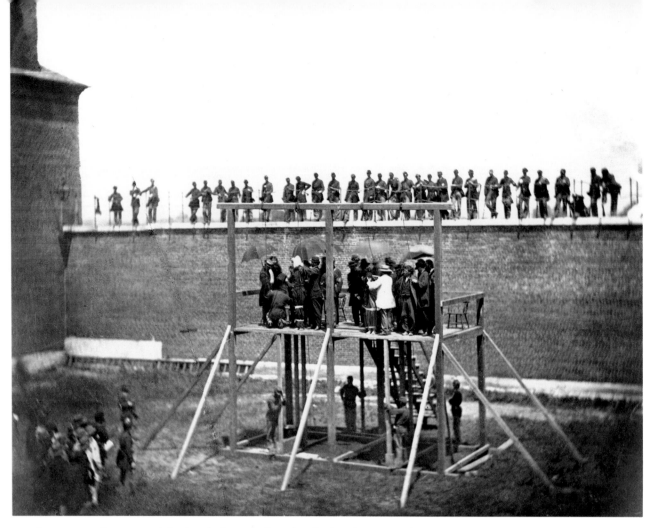

236. ALEXANDER GARDNER. *Adjusting the Ropes for Hanging the Conspirators, Washington, D.C.*,
July 7, 1865. Albumen print. Library of Congress, Washington, D.C.

237. ALEXANDER GARDNER. *Hanging at Washington Arsenal; Hooded Bodies of the Four Conspirators; Crowd Departing,*
Washington, D.C., July 7, 1865. Albumen print. International Museum of Photography at George Eastman House, Rochester, N.Y.

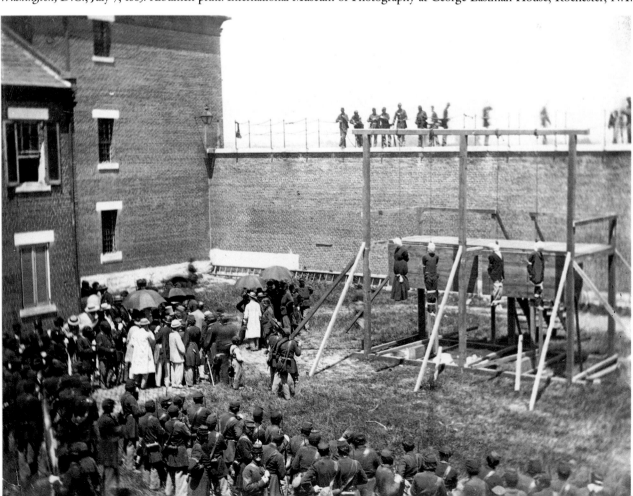

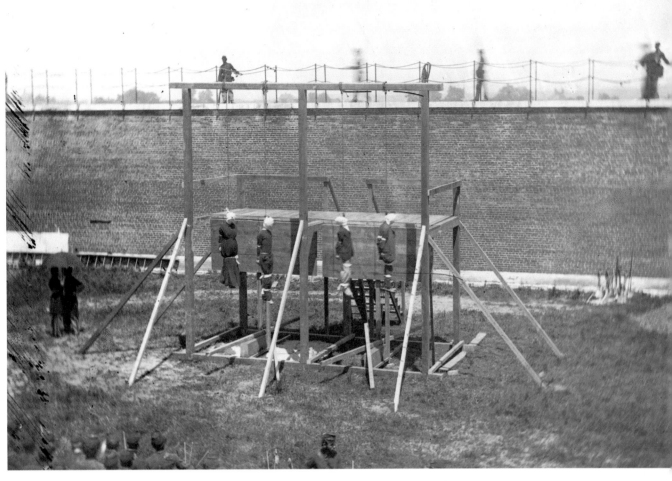

238. ALEXANDER GARDNER. *Hanging Bodies of the Conspirators; Guards Only in Yard*, Washington, D.C., July 7, 1865. Albumen print. Library of Congress, Washington, D.C.

239. ALEXANDER GARDNER. *Coffins and Open Graves Ready for the Conspirators' Bodies at Right of Scaffold*, *Washington, D.C.*, July 7, 1865. Albumen print. Library of Congress, Washington, D.C.

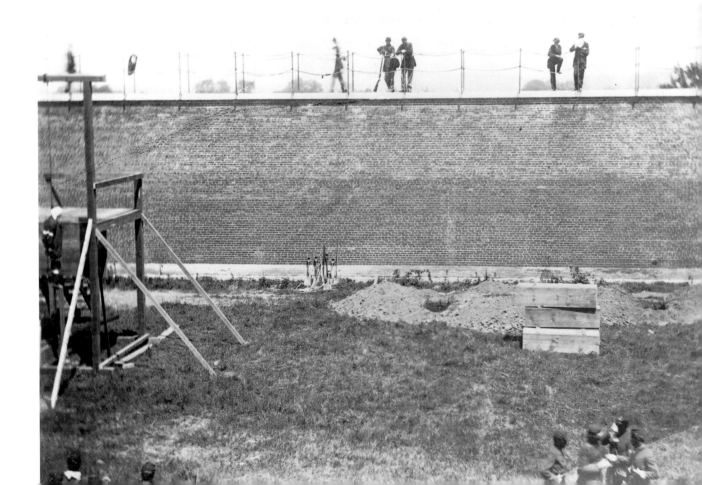

5.

PHOTOGRAPHY AND ART: THE FIRST PHASE *1839–1890*

. . . of all the delusions that possess the human breast, few are so intractable as those about art.

—*Lady Elizabeth Eastlake, 1857*[1]

When photography was invented artists thought that it would bring ruin to art but it is shown that photography has been an ally of art, an educator of taste more powerful than a hundred academies of Design would have been. . . .

—*"Photography and Chromo-lithography," 1868*[2]

"IS PHOTOGRAPHY ART?" may seem a pointless question today. Surrounded as we are by thousands of photographs of every description, most of us take for granted that in addition to supplying information and seducing customers, camera images also serve as decoration, afford spiritual enrichment, and provide significant insights into the passing scene. But in the decades following the discovery of photography, this question reflected the search for ways to fit the mechanical medium into the traditional schemes of artistic expression. Responses by photographers, which included the selection of appropriate themes and the creation of synthetic works, established directions that continue to animate photography today. And while some photographers used the camera to emulate the subjects and styles of "high" art, graphic artists turned to photographs for information and ideas. The intriguing interplay that ensued also has remained a significant issue in the visual arts. Photographs that reproduce art objects also have had a profound effect on the democratization of public taste and knowledge, changing public perceptions of visual culture and making possible the establishment of art history as a serious discipline.

The much-publicized pronouncement by painter Paul Delaroche that the daguerreotype signaled the end of painting is perplexing because this clever artist also forecast the usefulness of the medium for graphic artists in a letter to François Arago in 1839.[3] Nevertheless, it is symptomatic of the swing between the outright rejection and qualified acceptance of the medium that was fairly typical of the artistic establishment. It was satirized in a group of cartoons by Nadar (pl. nos. 240–241) depicting an artistic community that denied photography's claims while using the medium to improve its own product. Discussion of the role of photography in art was especially spirited in France, where the internal policies of the Second Empire had created a large pool of artists, but it also was taken up by important voices in England. In both countries, public interest in this topic was a reflection of the belief that national stature and achievement in the arts were related. In central and southern Europe and the United States, where the arts played a lesser role, these matters were less frequently addressed.

From the maze of conflicting statements and heated articles on the subject, three main positions about the potential of camera art emerged. The simplest, entertained by many painters and a section of the public, was that photographs should not be considered "art" because they were made with a mechanical device and by physical and chemical phenomena instead of by human hand and spirit; to some, camera images seemed to have more in common with fabric produced by machinery in a mill than with handmade creations fired by inspiration. The second widely held view, shared by painters, some photographers, and some critics, was that photographs would be useful to art but should not be considered equal in creativeness to drawing and painting. Lastly, by assuming that the process was comparable to other replicatable techniques such as etching and lithography, a fair number of individuals realized that camera images were or could be as significant as handmade works of art and that they might have a beneficial influence on the arts and on culture in general.

Artists reacted to photography in various ways. Many portrait painters—miniaturists in particular—who realized that photography represented the "handwriting on the wall" became involved with daguerreotyping or paper photography; some incorporated it with painting, as in the case of Queen Victoria's painter Henry Collen, while others renounced painting altogether. Still other painters, the most prominent among them Ingres, began almost immediately to use photography to make a record of their own output and also to provide themselves with source material for poses and backgrounds, vigorously denying at the same time its influence on their vision or its claims as art. While there is no direct evidence to indicate that Ingres painted from daguerreotypes, it has been pointed out that in pose, cropping, and tonal range, the portraits made by the painter after Daguerre's invention virtually can be characterized as "enlarged daguerreotypes."[4] Yet, this politically and artistically conservative artist was outspoken in contesting photography's claims as art as well as the rights of photographers to legal protection when their images were used without permission. The irony of the situation was not lost on French journalist Ernest Lacan, who observed that "photography is like a mistress whom one cherishes and hides, about whom one speaks with joy but does not want others to mention."[5]

The view that photographs might be worthwhile to artists—acceptable for collecting facts, eliminating the

drudgery of study from the live model, and expanding the possibilities of verisimilitude—was enunciated in considerable detail by Lacan and Francis Wey. The latter, a philologist as well as an art and literary critic, who eventually recognized that camera images could be inspired as well as informative, suggested that they would lead to greater naturalness in the graphic depiction of anatomy, clothing, likeness, expression, and landscape configuration. By studying photographs, true artists, he claimed, would be relieved of menial tasks and become free to devote themselves to the more important spiritual aspects of their work, while inept hacks would be driven from the field of graphic art.[6]

Wey left unstated what the incompetent artist might do as an alternative, but according to the influential French critic and poet Baudelaire, writing in response to an exhibition of photography at the Salon of 1859, lazy and "unendowed" painters would become photographers. Fired by a belief in art as an imaginative embodiment of cultivated ideas and dreams, Baudelaire regarded photography as "a very humble servant of art and science, like printing and stenography"—a medium largely unable to transcend "external reality."[7] For this critic as well as for other idealists, symbolists, and aesthetes, photography was linked with "the great industrial madness" of the time, which in their eyes exercised disastrous consequences on the spiritual qualities of life and art. Somewhat later, the noted art critic Charles Blanc made the same point when he observed that because "photography copies everything and explains nothing, it is blind to the realm of the spirit."[8]

Eugène Delacroix was the most prominent of the French artists who welcomed photography as helpmate but recognized its limitations. Regretting that "such a wonderful invention" had arrived so late in his lifetime, he still took lessons in daguerreotyping, made *cliché verre* prints *(see below)*, joined the recently established *Société héliographique*, and both commissioned and collected photographs. These included studies of the nude made by the amateur Eugène Durieu *(pl. no. 242)*, with whom the artist collaborated on arranging the poses. Delacroix's enthusiasm for the medium can be sensed in a journal entry noting that if photographs were used as they should be, an artist might "raise himself to heights that we do not yet know."[9]

The question of whether the photograph was document or art aroused interest in England also. *A Popular Treatise on the Art of Photography*, an 1841 work by Robert Hunt, emphasized processes rather than aesthetic matters, but noted that "an improvement of public taste," which had devolved from the fact that "nature in her rudest forms is more beautiful than any human production," already was discernible because of photography.[10] The most important statement on this matter was the previously mentioned

240–241. NADAR (GASPARD FÉLIX TOURNACHON). Two cartoons. "Photography asking for just a little place in the exhibition of fine arts." Engraving from *Petit journal pour rire*, 1855. "The ingratitude of painting refusing the smallest place in its exhibition to photography to whom it owes so much." Engravings from *Le journal amusant*, 1857. Bibliothèque Nationale, Paris.

242. EUGÈNE DURIEU. *Figure Study No. 6*, c. 1853.
Albumen print. Bibliothèque Nationale, Paris.

243. DAVID OCTAVIUS HILL and ROBERT ADAMSON.
Portrait of Elizabeth Rigby, Later Lady Eastlake, c. 1845.
Calotype. National Portrait Gallery, London.

unsigned article by Lady Eastlake *(pl. no. 243)*, "Photography." Concerned with the relationship of "truth" and "reality" to "beauty," she contended that while depictions of the first two qualities were acceptable functions of the camera image, art expression was expected to be beautiful also. And beauty was a result of refinement, taste, spirituality, genius, or intellect—qualities not found in minutely detailed super-realistic visual descriptions made by machine. This formulation was addressed to collodion–albumen technology and enabled her to exempt the "Rembrandt-like" calotypes of Hill and Adamson from her condemnation. In addition to the broadly handled treatment seen in her own portrait or in *The Misses Binny and Miss Monro (pl. no. 52)*, for example, Hill's and Adamson's images expressed the refinement of sentiment that Lady Eastlake considered an artistic necessity. She concluded that while photography had a role to play, it should not be "constrained" into "competition" with art; a more stringent viewpoint led critic Philip Gilbert Hamerton to dismiss camera images as "narrow in range, emphatic in assertion, telling one truth for ten falsehoods."[11]

These writers reflected the opposition of a section of

the cultural elite in England and France to the "cheapening of art," which the growing acceptance and purchase of camera pictures by the middle class represented. Collodion technology made photographic images a common sight in the shop windows of Regent Street and Piccadilly in London and the commercial boulevards of Paris. In London, for example, there were at the time some 130 commercial establishments (besides well-known individual photographers like Fenton and Rejlander) where portraits, landscapes, genre scenes, and photographic reproductions of works of art could be bought in regular and stereograph formats. This appeal to the middle class convinced the elite that photographs would foster a taste for verisimilitude instead of ideality, even though some critics recognized that the work of individual photographers might display an uplifting style and substance that was consonant with art.

John Ruskin, the most eminent figure in both English and American art at mid-century, first welcomed photography as the only 19th-century mechanical invention of value, and then reversed himself completely and denounced it as trivial.[12] He made and collected daguerreotypes as well

244. JEAN BAPTISTE
CAMILLE COROT. *Five
Landscapes*, 1856. *Cliché
verre*. © 1982 Founders
Society, Detroit Institute
of the Arts; Elizabeth P.
Kirby Fund.

as paper prints of architectural and landscape subjects, and counseled their use to students and readers of his *Elements of Drawing*. Both academic and Pre-Raphaelite painters, among them William Frith, John Millais, Ford Madox Brown, Dante Gabriel Rossetti, and the American Pre-Raphaelite William Stillman, employed photographs of costumes, interiors, models, and landscapes taken from various vantage points as study materials. While they insisted that their canvases were painted strictly from nature, some of their productions seem close enough in vision to extant photographs to suggest "that the camera has insinuated itself" into the work.[13] English painters may have been even more reticent than the French about acknowledging their use of photographs because of the frequent insistence in the British press that art must be made by hand to display a high order of feeling and inspiration.

The 20 years following the introduction of collodion in 1851 was a period of increased activity by the photographic community to advance the medium's claims as art. Societies and publications were founded in England, France, Germany, Italy, and the United States, with the Photographic Society of London (now the Royal Photographic Society) and the *Société Française de Photographie*, established in 1853 and 1854 respectively, still in existence. Professional publications, including *La Lumière* in Paris, the *Photographic Journal* in London, and others in Italy, Germany, and the

United States, were in the vanguard of discussions about photographic art, devoting space to reviews of exhibitions of painting as well as photography.

Between 1851 and 1862, individual photographers, among them Antoine Claudet, André Adolphe Disdéri, and numbers of the now-forgotten, joined artistic photographers Rejlander, Henry Peach Robinson, and William Lake Price in publishing articles and letters to the professional journals that attempted to analyze the aesthetic similarities and differences between graphic works and photographs and to decide if photography was or was not Art. Notwithstanding their long-winded, often repetitious contentions, the photographers and their allies evolved a point of view about the medium that still forms the basis of photographic aesthetics today. Summed up in a piece by an unknown author that appeared in the *Photographic Journal* at the beginning of 1862, ostensibly it addressed the immediate question of whether photography should be hung in the Fine Arts or Industrial Section of the forthcoming International Exposition. The author observed that "the question is not whether photography is fine art per se—neither painting nor sculpture can make that claim—but whether it is capable of artistic expression; whether in the hands of a true artist its productions become works of art."[14] A similar idea, more succinctly stated, had illuminated the introduction by the French naturalist Louis

Figuier to the *Catalogue of the 1859 Salon of Photography* (the exhibition that apparently inspired Baudelaire's diatribe). Figuier was one of a number of scientists of the era who were convinced that artistic expression and mass taste would be improved by photography, just as the general quality of human life would benefit from applied science. He observed that "Until now, the artist has had the brush, the pencil and the burin; now, in addition, he has the photographic lens. The lens is an instrument like the pencil and the brush, and photography is a process like engraving and drawing, for what makes an artist is not the process but the feeling."[15]

The leading French painters of landscapes and humble peasant scenes—known as the Barbizon group—as well as the Realists and Impressionists who concerned themselves with the depiction of mundane reality, accepted photographs more generously than Ingres and the Salon painters, in part because of their scientific interest in light and in the accurate depiction of tonal values. A number of them, including Camille Corot, Gustave Courbet, and Jean François Millet, collected calotypes and albumen prints, apparently agreeing with Antoine Claudet that when a painter desires to imitate nature, there could be

nothing better than to consult the "exacting mirror" of a photograph. These artists considered the camera a "wonderfully obedient slave," and while not all of them painted from photographs directly, such camera "notes" had an important effect on their handling of light and tonality.

Frequenting the forests around Arras and Fontainebleau, the haunt also of a number of photographers, Barbizon painters became acquainted with *cliché verre*, a drawing on a collodion glass plate that is a hybrid form—part drawing, part photographic print.[16] Known since the early days of photography and included in both Hunt's treatise and a French work on graphic art processes, it was taught by Adalbert and Eugène Cuvelier, whose images have only recently come to light.[17] It could be used as a sketching technique, as in a set of *Five Landscapes (pl. no. 244)* by Corot, or to yield a more finely detailed print, exemplified by *Woman Emptying a Bucket (pl. no. 245)*, an 1862 work by Millet. *Cliché verre* seems to have been exceptionally congenial to painters working in and around Barbizon, but an American artist, John W. Ehninger, supervised an album of poetry illustrated by this technique. Entitled *Autograph Etchings by American Artists*, it included the work of Asher B. Durand *(pl. no. 246)*, one of the nation's most prominent mid-century landscapists. In England, its primary use was as a method of reproduction (called electrography) rather than as an expressive medium.

The effect of photography on the handmade arts became irreversible with the spread of collodion technology. Besides using camera images as studies of models and draperies and for portraits that were to be enlarged and printed on canvas, painters began to incorporate in their work documentary information and unconventional points of view gleaned from familiarity with all sorts of photographs. The high horizons, blurred figures, and asymmetrical croppings visible in many Impressionist and post-Impressionist paintings, which seem to establish a relationship between these works and camera vision, have been discussed by Scharf, Van Deren Coke, and others.[18] To cite only one of numerous examples of the complex fashion in which painters incorporated camera vision into their work, an 1870 collaborative painting by the Americans Frederic E. Church, G. P. A. Healy, and Jervis McEntee, entitled *The Arch of Titus (pl. no. 247)*, makes use of a studio portrait of the American poet Henry Wadsworth Longfellow and his daughter Edith *(pl. no. 248)* as a focal point. But in addition to this obvious usage, the extreme contrast between monochromatic sky and the dark under the portion of the arch, the transparency of the shadow areas, and the pronounced perspective of the view through the arch all suggest the close study of photographs. Artists using photographs in this way usually did not obtain permission or give credit to photographers, and it is not surprising that a

245. JEAN FRANÇOIS MILLET. *Woman Emptying A Bucket,* 1862. *Cliché verre.* © 1983 Founders Society, Detroit Institute of the Arts; John S. Newberry, Jr., Fund.

246. ASHER B. DURAND. *The Pool, No. 1, 1859. Cliché verre* albumen print from *Autograph Etchings by American Artists,* supervised by John W. Ehninger, 1859. Stuart Collection, Rare Books and Manuscripts Division, New York Public Library, Astor, Lenox, and Tilden Foundations.

not only emulated the conventional subject matter of paintings but manipulated their photographs to produce "picturesque" images.

Starting in the early 1850s, photographic prints were shown in exhibition rooms and galleries and selected for inclusion in expositions where problems of classification sometimes resulted. For instance, nine Le Gray calotypes, submitted to the 1859 Salon, were first displayed among the lithographs and then, when their technique became known, were removed to the science section. For the remainder of the century, photographers attempted to have camera images included in the fine arts sections of the expositions, but indecision on the part of selection committees continued. On the other hand, exhibitions organized by the photographic societies in the 1850s at times included many hundreds of images that were displayed according to the conventions of the academic painting salons, eliciting criticism in the press and eventual repudiation in the late 1880s. "How is it possible," wrote an English reviewer in 1856,

247. G.P.A. HEALY, FREDERIC E. CHURCH, AND JERVIS McENTEE. *The Arch of Titus,* 1871. Oil on canvas. Newark Museum, Newark, N.J.; Bequest of J. Ackerman Coles.

number of court cases occurred involving better-known photographers who contested the right of painters to use their images without permission, a situation that has continued to bedevil photographers up to the present.[19]

While painters were using photographs and critics were arguing the merits of this practice, how did the photographers themselves feel about the medium's status as art? Coming from a spectrum of occupations and class positions, and approaching the medium with differing expectations, they displayed a range of attitudes. Several, among them Sir William Newton, a painter–photographer who helped found the Photographic Society of London, and the fashionable society portraitist Camille Silvy, were outspoken in claiming that the medium was valuable only for its documentary veracity. Others, including Fenton, Edouard Denis Baldus, and Charles Nègre, endeavored to infuse photographic documentation with aesthetic character in the belief that camera images were capable of expression, while still others, notably Rejlander and Robinson,

248. UNKNOWN
PHOTOGRAPHER.
*Longfellow and Daughter in
the Healy Studio in Rome,*
1868–69. Albumen print.
Marie de Mare Papers,
Archives of American Art,
Smithsonian Institution,
Washington, D.C.

"for photographs, whose merit consists in their accuracy and minuteness of detail, to be seen to advantage when piled, tier upon tier, on the crowded walls of an exhibition room?"[20] As if in answer to this criticism, photographers turned to the album as a format for viewing original photographs.

Photography and the Nude

That camera studies of both nudes and costumed figures would be useful to artists had been recognized by daguerreotypists since the 1840s; Hermann Krone's *Nude Study (pl. no. 249)* is typical of the conventional Academy poses produced for this trade. A calotype of a woman with a pitcher, by former French painter Julien Vallou de Ville-neuve *(pl. no. 251)*, exemplifies the numerous studies on paper of models costumed as domestic servants—designed to serve the same clientele—that probably were inspired by the work of French painters like François Bonvin; these simply posed and dramatically lighted figure studies continued a tradition of painted genre imagery with which photography—on the occasions when it was judged to be

249. HERMANN KRONE.
Nude Study, c. 1850.
Daguerreotype.
Deutsches Museum,
Munich.

250. UNKNOWN
PHOTOGRAPHER.
Nude, 1870s.
Albumen print.
Private Collection.

251. JULIEN VALLOU DE VILLENEUVE. *Woman with Pitcher*, c. 1855. Calotype. Bibliothèque Nationale, Paris.

252. OSCAR GUSTAV REJLANDER. *Study of Hands,* c. 1854. Albumen print.
Gernsheim Collection, Humanities Research Center, University of Texas, Austin.

253. OSCAR GUSTAV REJLANDER. *Two Ways of Life,* 1857. Albumen print.
International Museum of Photography at George Eastman House, Rochester, N.Y.

254. THOMAS EAKINS OR STUDENT. *Eakins's Students at the Site of "The Swimming Hole,"* 1883. Gelatin silver print. Hirshhorn Museum and Sculpture Garden, Smithsonian Institution, Washington, D.C.

255. THOMAS EAKINS. *Swimming Hole,* 1885. Oil on canvas. Amon Carter Museum, Fort Worth, Texas (1990.19.1); purchased by the Friends of Art, Fort Worth Art Association, 1925; acquired by the Amon Carter Museum, 1990, from the Modern Art Museum of Fort Worth through grants and donations from the Amon G. Carter Foundation, the Sid W. Richardson Foundation, the Anne Burnett and Charles Tandy Foundation, Capital Cities/ABC Foundation, *Fort Worth Star-Telegram,* The R. D. and Joan Dale Hubbard Foundation, and the people of Fort Worth.

art—was invariably associated. Even well-known photographers provided studies of all aspects of the human figure for artists, as can be seen in Rejlander's *Study of Hands* *(pl. no. 252).*[21]

Predictably, photographs of nudes appealed to others besides graphic artists. Indeed, soon after the invention of the medium, daguerreotypes (followed by ambrotypes, albumen prints, and stereographs, often hand-colored to increase the appearance of naturalness) were made expressly for salacious purposes *(pl. no. 250).* Photographic journals inveighed against this abuse of the camera, and some studios were raided as a result of court findings in Britain and the United States that photographs of nudes were obscene, but erotic and pornographic images continued to find an interested market. More to the point is the fact that to many Victorians no clear distinctions existed between studies of the nude made for artists, those done for personal expression, and those intended as titillating commercial images. In a milieu where people were scandalized by realistic paintings of unclothed figures except in mythological or historical contexts, where Ruskin was allowed to destroy J. M. W. Turner's erotic works, it would have been too much to expect that the even more naturalistic camera depiction of nudity would be accepted, no matter what purpose the images were designed to serve.

This was true even when such images were conceived with high artistic principles in mind, as with Rejlander's *Two Ways of Life (pl. no. 253),* to be discussed shortly. The same Victorian moral code no doubt accounts for Lewis Carroll's decision to destroy the negatives of his own artistically conceived images of nude young girls which he realized "so utterly defied convention," and to have the photographs of the daughters of his friends, including *Beatrice Hatch (pl. no. 334),* painted in by a colorist who supplied the fanciful outdoor decor. In this context, a comparison between the painted and photographed nudes by the American painter Thomas Eakins, who made some 200 such camera studies, is instructive. Photographs of a group of swimmers *(pl. no. 254)*—made by Eakins or a student—for the painting *The Swimming Hole (pl. no. 255)* capture movement and anatomical details with lively accuracy. Nevertheless, the painter, apparently concerned with avoiding anything that his Philadelphia patrons and critics might find offensive, discreetly (but unavailingly) rearranged the poses of the nude boys in the final work.[22]

Artistic Photography

With works of art in all media attracting the interest of the urban bourgeoisie during the second half of the 19th century, critics became more vocal in their exhorta-

256. CHARLES NÈGRE. *Young Girl Seated with a Basket,* 1852. Salt print. Collection André Jammes, Paris; National Gallery of Canada, Ottawa.

tions to photographers as well as painters to select themes and treatments that not only would delineate situations naturalistically but would also embody uplifting sentiments. Especially in England, articles and papers read before the professional photographic societies as well as reviews of annual and special exhibitions translated traditional precepts of art into huffy "dos and don'ts" for photographers. The demand that photographs be at once truthful, beautiful, and inspirational influenced the making of still lifes, genre scenes, portraits of models in allegorical costume, and finally, composite images that aimed to compete with the productions of "high art." To overcome the sharp definition decried by some as being too literal for art, photographers were urged to use slower collodion or inferior optical elements, to smear the lens or kick the tripod during exposure, or to blur the print during processing.

Efforts to transcend the literalness of the lens without aping too closely the conventions of graphic art were most successful in France. As a consequence of their art training, the several painters associated with Delaroche who became adept at the calotype process around 1850 understood the importance of "effect"—a treatment that involved the suppression of excess detail. For example, in *Young Girl Seated with a Basket (pl. no. 256),* Nègre *(see Profile below)* concentrated the light on the head, hands, and basket rim,

purposefully leaving the texture of wall and background indistinct. His choice of subject—an Italian peasant in France—derived from the painting tradition that counted Murillo and Bonvin among its advocates and conformed to the idea that lower-class themes were acceptable in art as long as they were treated picturesquely. This concept also had inspired Hill and Adamson in their photographs of the fisherfolk of Newhaven *(see Chapters 2 and 8)* and William Collie in his calotypes of rural folk on the Isle of Jersey.

While a variant of this theme appealed to Baron Humbert de Molard, a founding member of the *Société*

Française de Photographie who posed gamekeepers, hunters *(pl. no. 257)*, milkmaids, and shepherds against real or reconstituted rural backgrounds, genre scenes generally were made less frequently in France than in England and the United States, where a taste for narrative content was explicit. Still another variety of posed imagery involving humble pursuits used more sophisticated settings and pastimes, as in an 1850 calotype, *Chess Game (pl. no. 258)* by Aloïs Löcherer; later German examples of the same type in collodion were called *Lebende Bilder (Living Pictures)* because they portrayed costumed models, often artists and students, posing as knights, literary figures, or as well-

257. HUMBERT DE MOLARD. *The Hunters*, 1851. Calotype. Société Française de Photographie, Paris.

258. ALOÏS LÖCHERER. *Chess Game*, c. 1850. Calotype. Gernsheim Collection, Humanities Research Center, University of Texas, Austin.

known painting subjects. These genre images with their artistic intent should not be confused with the posed portraits of men and women in ethnic costume meant as souvenirs for tourists or as reflections of nationalistic aspirations among middle-Europeans who had not yet established political identities.

Before discussing the irruption of storytelling imagery that characterized English photography during the collodion era, the photographic still life as an acceptable artistic theme should be mentioned. Tabletop arrangements of traditional materials—fruit, crockery, statuary, subjects that had appealed to Daguerre and Talbot as well as to conventional painters—continued to attract photographers on the continent during the calotype and collodion eras. While these arrangements also made it possible for photographers to study the effects of light on form, the conventions of still life painting appear at times to have been transferred to silver with little change in style and iconography *(pl. no. 260)*; other works, exemplified by Krone's *Still Life of the*

Washerwoman (pl. no. 259), are captivating because they embrace less conventional objects.

Arrangements of flowers, which at first might seem to be singularly unsuited to a monochromatic medium, were successfully photographed perhaps because in some cases the images were regarded as documents rather than purely as artistic expressions. In the early 1850s, close-up studies of leaves, blossoms, and foliage arranged by Adolphe Braun in formal and casual compositions were highly praised for their intrinsic artistry as well as their usefulness *(pl. no. 261)*; these prints may have inspired Eugène Chauvigne and Charles Aubry, among others, to attempt similar themes. In the dedication to *Studies of Leaves (pl. no. 262)*, Aubry wrote that they were made to "facilitate the study of nature" in order to "increase . . . productivity in the industrial arts."[23] Nevertheless, other flower still lifes by the same artist included skulls and props, suggesting that he also wished them to be comparable to painted counterparts, although the simple arrangements and crisp detailing of

259. HERMANN KRONE. *Still Life of the Washerwoman*, 1853. Albumen print. Deutsches Museum, Munich.

260. ROGER FENTON.
Still Life of Fruit, c.
1860. Albumen print.
Royal Photographic
Society, Bath, England.

261. ADOLPHE BRAUN.
Flower Study, c. 1855.
Modern gelatin silver
print. Private collection.

262. CHARLES AUBRY. *Leaves,* 1864. Albumen print. J. Paul Getty Museum, Los Angeles.

LEFT:

263. ADOLPHE BRAUN. *Still Life with Deer and Wildfowl,* c. 1865. Carbon print. Metropolitan Museum of Art, New York; David Hunter McAlpin Fund, 1947.

BELOW LEFT:

264. VALENTIN GOTTFRIED. *Hunt Picture,* late 17th–early 18th century. Oil on canvas. Musée des Beaux-Arts, Strasbourg, France.

BELOW RIGHT:

265. CHARLES PHILIPPE AUGUSTE CAREY. *Still Life with Waterfowl,* c. 1873. Albumen print. Bibliothèque Nationale, Paris.

foliage in the studies suggests that his work was most original when not competing with paintings of similar themes.

But, as always, there are exceptions. A group of large-format "after-the-hunt" still lifes by Braun *(pl. no. 263)*, portraying arrangements of hung game, waterfowl, and hunting paraphernalia, successfully emulated works of graphic art that had been popular with painters of Northern Europe for two centuries. That painters and photographers both drew upon a common tradition can be seen in an oil painting *(pl. no. 264)* of the same theme by Valentin Gottfried, who worked near Strasbourg in the late 17th and early 18th centuries.[24] For his images, Braun printed collodion negatives of approximately 23 x 30 inches on thin tissue, using the carbon process to achieve a broad range of delicate tones *(see A Short Technical History, Part I)*. After-the-hunt scenes similar in size and generally less complex in arrangement were made also by Dr. Hugh Welch Diamond, Fenton *(pl. no. 260)*, William Lake Price, Louise Laffon, Charles Philippe Auguste Carey *(pl. no. 265)*, and

others, but the difficulties of transcribing this theme from painting to photography is apparent in the many cluttered compositions and lack of saving gracefulness.

Composite Photography

Convinced that visual art should uplift and instruct, some English photographers specialized in producing reenacted narratives synthesized in the darkroom, an enterprise known as combination printing. By staging tableaux and then piecing together separate images to form a composition, photographers were able to choose agreeable models and control the narrative content of the work. The technique was adopted briefly—with unfortunate results to be discussed shortly—by Rejlander, but its high esteem during the 1860s was the result of the tireless efforts of Robinson, who saw himself both as a theoretician with a mission to elevate photography and as a practitioner. He wrote numerous articles and eleven books on aesthetics

266. OSCAR GUSTAV REJLANDER. *Hard Times*, 1860. Albumen print.
International Museum of Photography at George Eastman House, Rochester, N.Y.

267. HENRY PEACH
ROBINSON.
*Preliminary Sketch
with Photo Inserted*,
c. 1860. Albumen
print and pastel
collage on paper.
Gernsheim
Collection,
Humanities
Research Center,
University of Texas,
Austin.

268. HENRY PEACH
ROBINSON. *Fading
Away*, 1858. Albumen
composite print.
Royal Photographic
Society, Bath,
England.

269. WILLIAM LAKE PRICE. *Don Quixote in His Study*,
c. 1890. Albumen print. Gernsheim Collection,
Humanities Research Center, University of Texas, Austin.

and techniques, several of which were translated into French and German. His first and most widely read work, *Pictorial Effect in Photography, Being Hints on Composition and Chiaroscuro for Photographers*, of 1869, emphasized traditional artistic principles of pictorial unity and concluded with a chapter on combination printing.

However, Rejlander was the first to make imaginative use of combination printing despite what some may consider the flawed judgment that led him in 1857—two years after his first attempt—to work on a major opus entitled *Two Ways of Life (pl. no. 253)*. At least five versions existed of this large bathetic composition (31 x 16 inches) formed from some 30-odd separate negatives posed for by 16 professional and other models. Loosely based on Raphael's *School of Athens* fresco, it represents an allegory of the choice between good and evil (also between work and idleness) that was meant to compete thematically and stylistically with the paintings and photographs entered in the Manchester Art Treasures Exhibition of 1857, and, incidentally, to serve as a sampler of photographic figure studies for artists.[25] With such vaunting, if disparate ambitions, it is little wonder that despite the seal of approval from Queen Victoria and Prince Albert, who purchased a version, critics termed it unsuccessful as allegory; works of "high art,"

they claimed, should not be executed by "mechanical contrivances."[26] When exhibited in Edinburgh in 1858, the partially nude figures were covered over while a discussion ensued as to whether or not the work was lascivious. Reacting to the criticism, Rejlander deplored "the sneering and overbearing manner in which . . . [critics] assign limits to our power,"[27] but he refrained from further grandiose compositions. Though sentimental at times, Rejlander's less ambitious combination prints—*Hard Times (pl. no. 266)* with its social and surreal overtones is one example—and his many posed figure pieces, including studies of workers, are among the thematically and visually more interesting works of this nature.

After seeing Rejlander's work, Robinson, a fellow painter-turned-photographer who had started as a portraitist but had set his sights on a higher purpose, adopted combination printing. Claiming that "a method that will not admit of modifications of the artist cannot be art,"[28] he first worked out preliminary sketches *(pl. no. 267)* into which the photographic parts were fitted in the manner of a puzzle or patchwork quilt. *Fading Away (pl. no. 268)*, his inaugural effort created from five different negatives—also acquired by the royal couple—was praised for "exquisite sentiment" by some and criticized as morbid by others. Though Robinson avoided such emotion-laden subjects again, for 30 or so years he continued to mix the "real with the artificial," as he described it, using models "trained to strict obedience"[29] in order to produce scenes agreeable to a public that esteemed engravings after the genre paintings of Sir David Wilkie and Thomas Faed.

270. WILLIAM GRUNDY. *A Day's Shooting*, c. 1857.
Albumen print. BBC Hulton Picture Library/Bettmann
Archive.

Narrative, Allegorical, and Genre Images

The precepts that photographic art should deal with
suitable themes, that the image be judiciously composed
and sharply defined, dominated the theoretical ideas of a
generation of amateur photographers in England. Among
them, William Grundy specialized in what the French
publication *La Lumière* called "a peculiar type of rustic
humor" *(pl. no. 270)* while Price, a watercolorist and author
of a popular manual on artistic photography, produced
besides landscapes and still lifes, literary figure pieces of
which *Don Quixote (pl. no. 269)* is an example. Though some
critics denounced this kind of photography as inadequate
for conveying moral messages, theatrically contrived liter-
ary and allegorical subjects continued to appeal, as can be
seen in Silvy's portraits of a middle-class sitter, Mrs. Leslie,
garbed in the mantle of truth *(pl. no. 271)*. In its concentra-
tion on narrative, its avoidance of sensuous and atmos-
pheric effects, its preference for sharp definition, the work

272. CLEMENTINA, LADY HAWARDEN. *Young Girl with Mirror
Reflection,* 1860s. Albumen print. Victoria and Albert Museum,
London.

271. CAMILLE SILVY. *Mrs. John Leslie as Truth,* March 16,
1861. Albumen print. National Portrait Gallery, London.

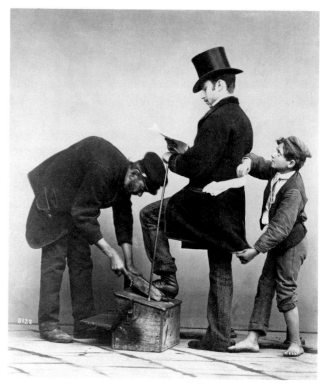

273. GIORGIO SOMMER. *Shoeshine and Pickpocket,* 1865–70.
Albumen print. Museum of Fine Arts, Boston; Abbott
Lawrence Fund.

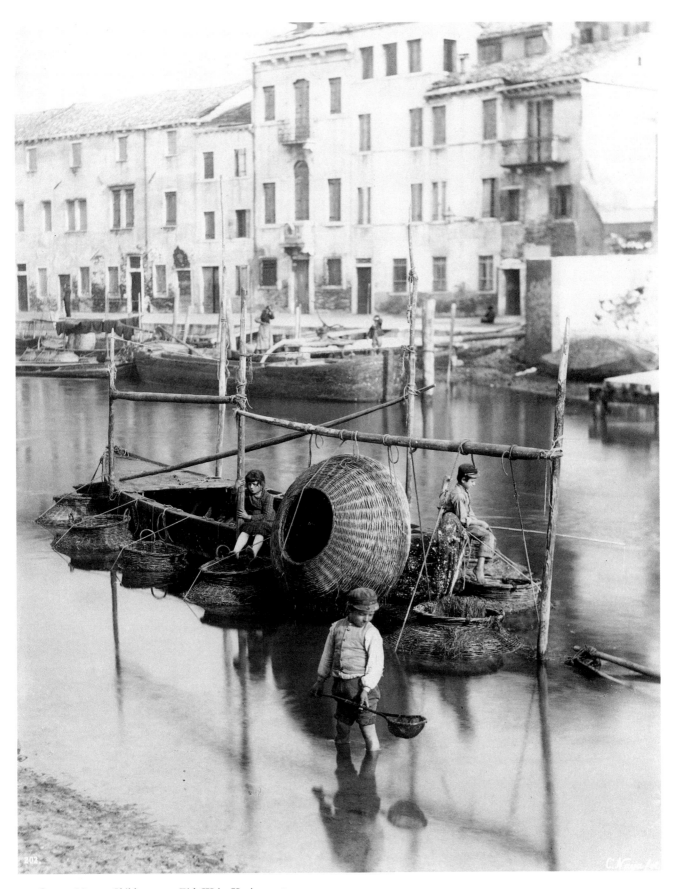

274. CARLO NAYA. *Children on a Fish Weir, Venice*, c. 1870s.
Albumen print. Museum of Fine Arts, Boston; Abbott Lawrence Fund.

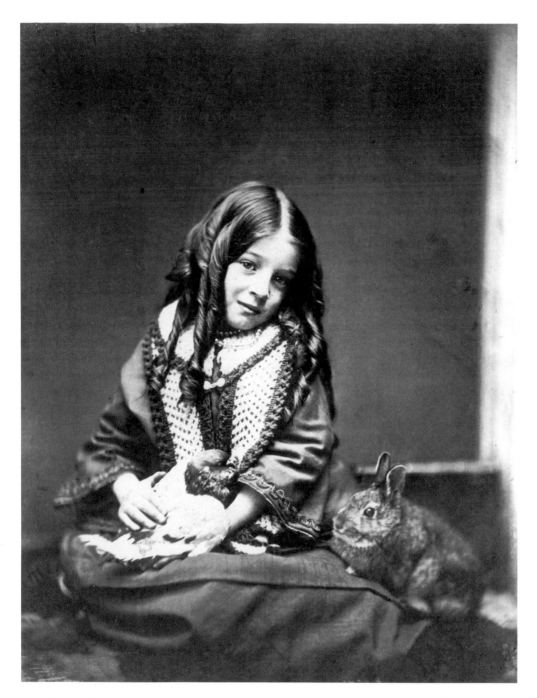

275. ALEXANDER HESLER.
Three Pets, c. 1851.
Crystalotype from original
daguerreotype in
*Photographic and Fine Arts
Journal*, April, 1854.
International Museum of
Photography at George
Eastman House,
Rochester, N.Y.

of the English Pictorial photographers of the 1860s and '70s mimics effects and themes found in both Pre-Raphaelite and academic paintings.

A different concept of photographic aesthetics informed literary and allegorical images by Julia Margaret Cameron *(see Profile, Chapter 2),* whose purposefully out-of-focus technique was derided by Robinson as inexcusable. Cameron drew upon an extensive knowledge of the Bible and English literature for her themes, using the same props, draperies, and models time and again. *The Rising of the New Year (pl. no. 82),* one of many images using the children of her friends and servants, reflects the ideas of her artistic mentor, the painter George Frederic Watts, whose great admiration for the themes of Renaissance art communicated itself to the photographer through his canvases, writings, and close friendship. Cameron's intuitive empathy as well as her understanding that light can mystify and illuminate invests these tableaux with more interest than their derivative subject matter deserves. Imaginative handling of tonal contrast characterizes the large body of work produced by Clementina, Lady Hawarden, whose posed and cos-

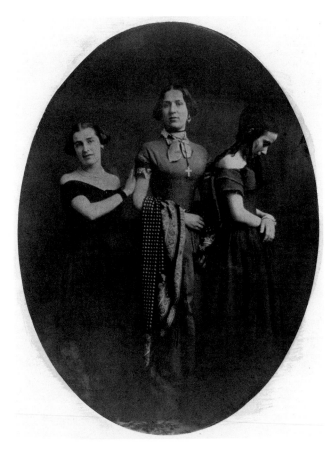

276. GABRIEL HARRISON. *Past, Present, Future*, c. 1854. Crystalotype. International Museum of Photography at George Eastman House, Rochester, N.Y.

tumed figures *(pl. no. 272)* reveal an ardent sensuality different from that seen in Cameron's narrative works.

Picturesque genre images were made in Italy for the tourist trade rather than as examples of high art. Most were contrived reenactments, similar in theme and treatment to the theatrical vignettes staged in the Naples studio of Giorgio Sommer. Given titles like *The Spaghetti Eaters* or *Shoeshine and Pickpocket (pl. no. 273),* they were supposedly humorous reminders of what travelers from the north might expect to find in Italian cities. Staged and unstaged images of bucolic peasant and street life, produced by the Alinari brothers in Florence and by Carlo Naya in Venice, were intended for tourists who wished to point out to the folks back home both the simple pleasures and sharp practices one might expect when visiting Italy. Naya, a well-educated dilettante who at first regarded photography as a curiosity rather than a livelihood, eventually was considered by his contemporaries to have "transformed this art into an important industry while retaining its aesthetic character."[30] In effect, by posing the beadworkers, beggars, and street vendors of Venice against real and studio backgrounds, he transformed social reality into mementos for tourists *(pl. no. 274).*

Artistic Photography in the United States

"The sharp contest going on abroad between advocates of painting and photography"[31] was less engaging to most Americans. A number of photographers—among them, George N. Barnard, Gabriel Harrison, Alexander Hesler, and John Moran—were convinced that both media spoke the same language and addressed the same sentiments; but even though they were concerned with photography as art, the prevailing climate was one of indifference to theoretical issues. This probably was due to the low esteem for the arts in general in America, to the continued success of commercial daguerreotyping long after its eclipse in Europe, and to the upheaval caused by the Civil War. The situation began to change toward the end of the 1860s, largely through the urging of publications such as the *Philadelphia Photographer* that photographers give greater consideration to photographic aesthetics.

On the other hand, painters in the United States were not in the least hesitant about using photographs in their work. Agreeing with Samuel F. B. Morse's judgment of the medium as a utilitarian tool that would supply "rich materials . . . an exhaustive store for the imagination to feed upon . . . [and] would bring about a new standard in art,"[32] portrait and genre painters began to copy from photographs soon after the daguerreotype was introduced. The lucrative business of enlarging and transferring photographic portraits to canvas, mentioned in Chapter 2, continued, but even before the Civil War, landscape painters—including Albert Bierstadt, Thomas Cole, and Frederic E. Church—also welcomed the photograph as an ally. It served landscapists particularly well in their endeavors to represent scientific fact animated by heavenly inspiration—a visual concept reflective of Ralph Waldo Emerson's New World philosophy of the divinity of the native landscape. In terms of style, the stereograph was especially important. Contemporary critics noted the minutely detailed foregrounds, misty panoramic backgrounds, and powerful illusion of depth in the work of Church and Bierstadt, the two most renowned painters of their era. These effects are exactly those of the stereograph image seen on a much reduced scale through the viewing device.[33] Furthermore, references in Church's diaries and the evidence of a large collection of photographs found in his studio reinforce the suspicion that this painter, along with many others, collected stereographs and regular-format photographs for information and, at times, to paint over. Also, between 1850 and 1880, artists explored the West and the Northeast in the company of photographers, resulting

277. WILLIAM NOTMAN.
*Caribou Hunting: The Return of
the Party*, 1866. Albumen print.
Notman Photographic
Archives, McCord Museum,
McGill University, Montréal.

278. JAMES INGLIS. *Victorian
Rifles*, 1870. Composite albumen
print; painting by W. Lorenz.
Notman Photographic
Archives, McCord Museum,
McGill University, Montréal.

in an opportunity for interchange of ideas and images that affected both media.

Curiously, American photographers did not at first manifest the widespread interest in genre themes apparent in painting at mid-century. Individual daguerreotypists who were determined to rescue the medium from what they called "Broadway operators" arranged mundane, sentimental, and allegorical subjects. *Three Pets (pl. no. 275)*, a daguerreotype by Hesler, which was awarded a gold medal at the 1851 London Great Exhibition and then reproduced as a crystallotype in *American Photography and Fine Art Journal*, is an example of the sentimental subjects chosen by this individual to demonstrate the artistic possibilities of the medium. In concert with Marcus Aurelius Root and Henry Hunt Snelling (early critics and historians of the medium), Hesler urged photographers to interest themselves in something more than paltry gain.

A similar motive prompted Harrison, a prominent New York daguerreotypist, to improve his compositions by studying the works of European and American painters. In selecting allegorical subjects such as *Past, Present and Future (pl. no. 276)*, this friend of Walt Whitman, who furnished the portrait of the poet for the frontispiece of *Leaves of Grass*, hoped to show that photographs could reflect "merit, taste and a little genius," that they might embody the unifying thread of human experience that he perceived in the poetry. According to the *Photographic Art Journal*, Harrison's images on metal were eagerly collected by contemporary painters in New York, but even this recognition was insufficient to sustain him in his pursuit of art photography.[34]

Aside from these examples, posed genre compositions and combination printing were not widely favored in the United States at this time owing to both the general dis-

279. L. M. MELENDER and BROTHER. *The Haunted Lane*, c. 1880. One-half of an albumen stereograph. Library of Congress, Washington, D.C.

trust of mannerism in the arts and the firm conviction that the camera should not tamper with reality. *The Philadelphia Photographer* may have believed that such practices would improve the quality of photographic expression, but the more common view, enunciated by Holmes, was that composite images were "detestable—vulgar repetitions of vulgar models, shamming grace, gentility and emotion by the aid of costumes, attitudes, expressions and accessories."[35] Indeed, this enthusiastic realist was scornful of any kind of hand manipulation on photographs; his preference for the stereograph to other formats was in part because it was too small for retouching.

Genre photographs became more acceptable after the Civil War, but the most proficient producer was the Canadian William Notman. His Montreal studio was claimed to be "all alone in this branch of photography on our side of the water," and was outfitted with a full complement of properties and a wind machine for creating the illusion of snowy outdoor climate and landscape, as in *Caribou Hunting: The Return of the Party (pl. no. 277).*[36] Both Notman and James Inglis, also of Montreal, were among the very few who made composite images using methods akin to those of Rejlander and Robinson in that they pasted prints into place and retouched and rephotographed them to form compositions such as Inglis's *Victorian Rifles (pl. no. 278)* of 1870, truly a pastiche of handwork and photochemical processes.

Holmes's repudiation notwithstanding, stereograph format and genre themes were made for each other. By the 1860s, when many painters were turning away from narrative and sentimental subjects, publishers of stereographs were discovering the public taste for pictures of love, death, domestic tribulation, and rustic humor—a taste that formerly had been satisfied by lithographic prints as well as works in oil. Since these images were considered popular entertainment rather than "high art"—in effect, forerunners of the situation comedies and dramas of television—viewers did not fault the stiff postures, exaggerated perspective, or absence of atmosphere. Made in Europe also, most notably by the London Stereograph Company and the German firm of Loescher and Petsch, their chief appeal was in the United States where it was said that no parlor was without a stereoscope.

Large-scale manufacturers, notably the Weller and Melender companies, produced a considerable portion of the genre subjects in the United States before 1890, but local photographers turned out a variety of such images, often stressing regional characteristics. An exceptionally popular subject—one that figured also in regular-format photographs of the time, was the "spirit" image. Dealing with some aspect of the supernatural, as in *The Haunted Lane (pl. no. 279)* published in 1880 by L. M. Melender and Brother, these pictures were made by allowing the model for the "spirit" to leave the scene before exposure was

280. JULES BASTIEN-LEPAGE. *Reapers at Damville*, 1879. Etching. Metropolitan Museum of Art, New York; Harrison Brisbane Dick Fund, 1927.

completed and by resorting to complicated techniques. They were taken seriously by many photographers and appealed to the same broad audience for whom seances, Ouija boards, and spiritualism seemed to provide a release from the pressures caused by urbanization and industrialization.

Naturalism

Reaction was inevitable to the mannered contrivance of combination images and to the trivialization of photography by mass-production genre images. The former subverted an inherently direct process with a superabundance of handwork while the latter submerged photographic expression in a wash of banal literalism. And toward the end of the 1880s, a further lowering of standards appeared certain with the invention and marketing of new equipment and processes designed to make photographers out of just about everyone *(see Chapter 6)*.

The most irresistible protest against these developments was embodied in the theory of "naturalism" pro-

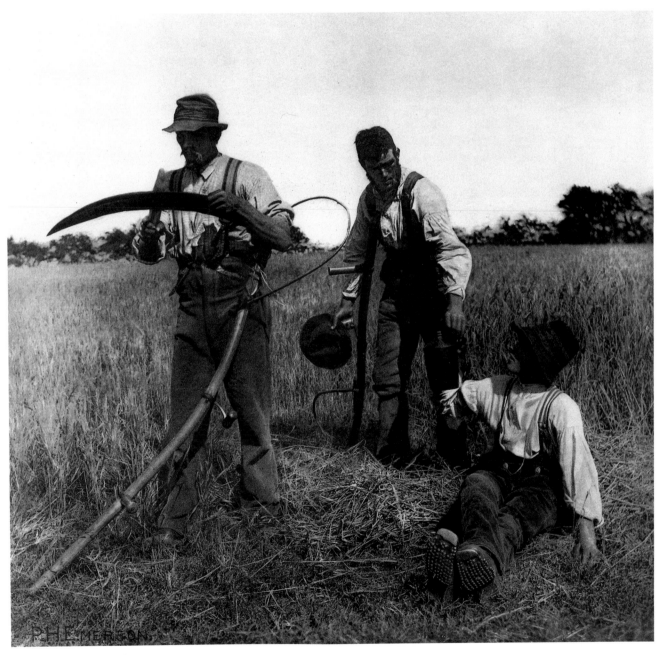

281. PETER HENRY EMERSON. *In the Barley Harvest* from *Pictures of East Anglian Life*, 1888. Gravure print. Royal Photographic Society, Bath, England.

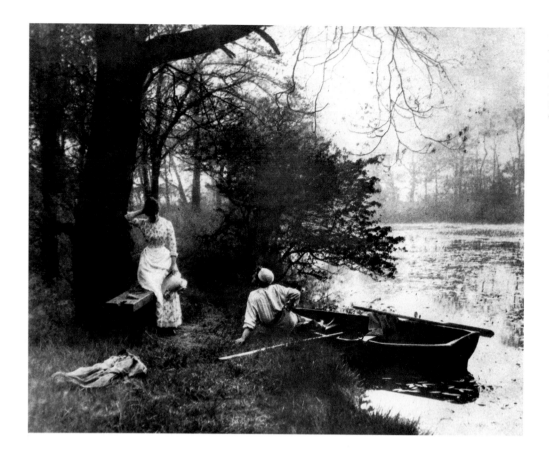

claimed by the English photographer Peter Henry Emerson *(see Profile below)*. In an 1889 publication entitled *Naturalistic Photography,* Emerson held that camera images (and all visual art) ought to reflect nature with "truth of sentiment, illusion of truth . . . and decoration,"[37] that only by following this path would photographs achieve an aesthetic status independent of and equal to the graphic arts without resorting to handwork on print or negative.

In Emerson's lexicon, *Naturalism* was a substitute for *Impressionism,* a word he felt was limited in connotation and too closely associated with controversial artists such as his friend James McNeill Whistler. Asserting that the role of the photographer was to be sensitive to external impressions, he observed that "nature is so full of surprises that, all things considered, she is best painted (or photographed) as she is." At the same time, his emphasis on the importance of selection and feeling made his ideas congenial to the aesthetic artists of the late 19th century. In a field already confused by inaccurate terminology, Emerson compounded the problem by stating that realism was "false to nature" because it was descriptive, while Naturalism was both "analytical and true."[38]

For eight years, beginning in 1882, Emerson photographed in the tidal areas of East Anglia. A careful observer, he probed beyond the surface to expose in both word and image the difficult existence of the English rural poor while also documenting their fast-disappearing customs and traditions. In exalting the sturdy folk and quiet beauty of the countryside, he showed himself to be one of a group of comfortably situated English artists and intellectuals who sought to make a statement about the incivility of modern industrial life. Despite his insistence on a distinctive aesthetic for photography, however, these images reflect the heroicizing attitudes of painters such as Jean François Millet, Jules Breton, and Jules Bastien-Lepage, who had idealized French peasant life a few decades earlier. *Reapers at Damville (pl. no. 280),* an etching of 1879 by Bastien-Lepage, is both visually and ideologically a forerunner of *In the Barley Harvest (pl. no. 281),* a plate from Emerson's *Pictures of East Anglian Life* of 1888.

Emerson's Naturalist concepts and techniques challenged Robinson's Pictorialist dictates, initiating an acrimonious dispute in the photographic journals; ideas about class and aesthetics engaged other photographers and editors as well. In addition, the Naturalist approach began to influence the work of other established English camera artists. *In the Twilight (pl. no. 282)* by Lidell Sawyer, a Pictorialist "born, nursed and soaked" in photography who deplored the fragmentation of the medium into schools,

incorporates a sense of atmosphere into a carefully composed genre scene in an effort to balance contrivance and naturalness. One of the most renowned Pictorialist photographers in England, Frank M. Sutcliffe worked in Whitby, a fishing village that was at the time a mecca for painters and amateur photographers. Interested in the hand camera as well as in portraiture, landscapes, and genre scenes made with a stand camera, Sutcliffe's work displays a sensitive application of the Naturalistic precept of spontaneity. The conscious selection of an expressive vantage point, along with carefully controlled printing techniques enabled him to invest *Water Rats (pl. no. 283)* with both the immediacy of real life and a transcendent lyricism.

Emerson renounced his great expectations for artistic photography in 1890, convinced that the pioneering studies in sensitometry—the scientific relation of tonality to exposure—published in the same year by Frederick Hurter and Vero Driffield *(see A Short Technical History, Part II)*, proved that photographers could not truly control the

tonal quality of the print, and therefore the medium was at best a secondary art. Despite this turnabout, however, Naturalism—refined and reinterpreted—continued to find adherents, providing a foundation for the photographic art movements that developed throughout Europe and North America after 1890. This "second coming" of pictorial or art photography will be the subject of Chapter 7.

Art Works in Photographic Reproduction

While the struggle for the acceptance of camera pictures as art was being carried on by a small group of aesthetically minded photographers, a development of much greater consequence for the general population was underway. Realizing that the accurate reproduction of works of art could be both commercially and culturally beneficial, a number of professional photographers throughout Europe started in the 1850s to publish photographic prints of the masterworks of Western art. There is little question that

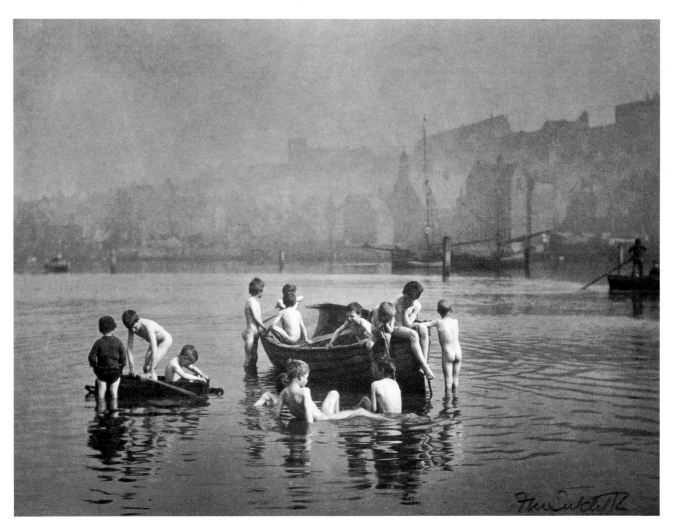

283. FRANK M. SUTCLIFFE. *Water Rats*, 1886. Albumen print. Private Collection.

284. JAMES ANDERSON. *Michelangelo's Moses from the Tomb of Julius II*, early 1850s. Albumen print. Collection Centre Canadien d'Architecture/ Canadian Centre for Architecture, Montréal.

since that time the camera image has been the most significant purveyor of visual artifacts, revolutionizing public access to the visual art heritage of the world. The same verisimilitude denounced by elitists as too real when applied to recording actuality was welcomed when used for reproducing art objects, because it was believed that familiarity with masterful works of art through facsimiles would not only uplift the spirit but would improve taste and enable people to make better selections of decor and dress in their daily lives.

It will be recalled that photographs of engravings and casts were among the earliest themes in daguerreotypes and calotypes, in part because these objects provided unmoving subjects but also because they established the possibility of making graphic art available to a wide audience. With the inclusion of the *Bust of Patroclus* and a drawing of *Hagar in the Desert* in *The Pencil of Nature*, and a publication on Spanish painting, Talbot specifically pointed to this important application of photography. Instructions for photographing works of art, notably by Blanquart-Evrard and Disdéri, appeared during the 1850s, at the same time that photographers in Italy were including such works in views made for tourists. James Anderson (born Isaac Atkinson), an English watercolorist, was one of the first to make photographic reproductions of paintings and sculpture along with the better-known architectural monuments of Rome. Considering the dimness of the interior of the Church of San Pietro in Vincoli, Anderson's achievement

285. ADOLPHE BRAUN. *Holbein's Dead Christ*, 1865. Albumen print. Société Française de Photographie, Paris.

in conveying both the sculptural form and expressive drama of *Michelangelo's Moses from the Tomb of Julius II (pl. no. 284)* is remarkable.

During the 1850s, a considerable number of photographers outside of Italy, among them Antoine Samuel Adam-Salomon, Baldus, Diamond, Disdéri, Fenton, and Franz Hanfstaengl in Europe and John Moran in the United States, began to photograph art objects ranging from those in royal and renowned collections to obscure artifacts in antiquarian societies. As a result of the favorable response by prestigious art critics to the photographic reproductions at the *Exposition Universelle* of 1855, a more programmatic approach ensued. Between 1853 and 1860, Fenton worked for the British Museum, providing them with negatives and selling prints to the public, from which he garnered a not inconsiderable income; besides sculpture and inscribed tablets, he photographed stuffed animals and skeletons. The Alinari brothers of Florence, Braun in Dornach, Hanfstaengl in Munich, and, later, Goupil in Paris—to name the most famous companies—organized large enterprises for the publication and sale of art reproductions. In spite of objections from painters in Italy who regarded photographs as a threat to their livelihood as copyists, these projects all prospered.

Braun, who was said to have higher ambitions than mere commercial success and who might be considered the exemplar of this activity, began modestly by photographing rarely seen Holbein drawings *(pl. no. 285)* in the museum at Basel, not far from his studio at Dornach; when access to other collections became possible through favorable publicity in the press and a bit of lobbying in the proper circles, the company he established photographed some forty collections of drawings, frescoes, paintings, and sculpture in Paris, Rome, Florence, Milan, Dresden, and Vienna.[39] During the mid-1860s, the firm changed from albumen to carbon printing in order to produce permanent images, but the change also made possible exact facsimiles because the photographs incorporated earth pigments similar to those used in the original drawings in the carbon

tissues. Widely acclaimed for the improvement in taste engendered by the excellence of his work, Braun kept abreast of changing technologies in both photography and printing, and at the time of his death in 1877 had begun to solve the problem of reproducing oil paintings in color.

The effect of this large-scale activity on the part of Braun and others was to increase the accuracy of representation, making low-cost reproductions of artworks available not only to individuals but to art schools in Europe and the United States. One English enthusiast even suggested that both the expenses and cultural risks of sending English students to study in France and Italy might be avoided because such excellent reproductions had become obtainable! While students thoughtfully continued to insist on contact with real works, photographic reproductions did have a profound effect on the discipline of art history. For the first time, identically replicated visual records enabled scholars in widely separated localities to establish chronologies, trace developments, and render aesthetic judgments. Besides familiarizing people with the acknowledged masterpieces of Western art, photographs made lesser works visible and awakened interest in artifacts and ceremonial objects from ancient cultures and little-known tribal societies. As a substitute for actual visual and tactile experiences, especially in the case of multifunctional three-dimensional structures (architecture), camera images clearly present problems,[40] but it is all but impossible to imagine how the study of visual artifacts would have fared without photography.

In its early struggles to show itself capable of artistic expression, photography wandered down some uneasy byways, and its practitioners initiated some enduring arguments about camera art. These developments were due in part to the hesitation by critics and painters to acknowledge the camera's expressive potential and in part to confusion among photographers themselves as to what constituted artistic images. From a historical perspective, it seems possible to conclude that the medium was at its best when

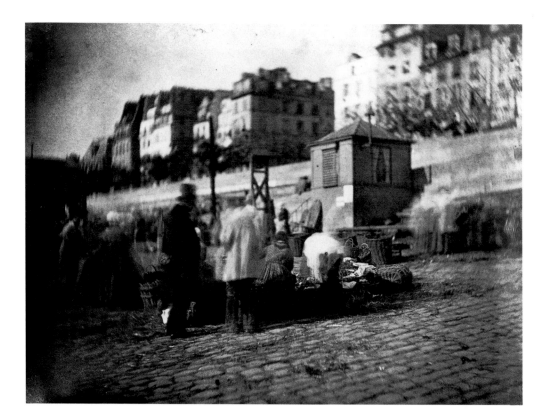

286. CHARLES NÈGRE.
*Market Scene at the Port de
L'Hôtel de Ville, Paris, 1851.*
Salt print. Collection
André Jammes, Paris;
National Gallery of
Canada, Ottawa.

illuminating aspects of the real world, and least inspiring when emulating the sentimental conventions of genre (or other) painting. Sensitivity to the disposition of form, to the varieties of textural experience, and to the nuances and contrasts of light rather than emphasis on narrative content gave photographs their unique power, whether their makers called their images documents or art.

During the same period, painters faced with the threat presented by a potentially rival visual medium found a variety of ways to use the photograph, whether or not they admitted doing so. Of even greater significance was the transformation that occurred in the handmade arts as camera images began to suggest to artists new ways to delineate form and new areas of experience worthy of depiction. Tenuous at first, these interconnections between graphic and photographic representation have gained strength over the years and continue in the present to invigorate both media.

Profile: Charles Nègre

Charles Nègre was an established painter of some repute who became interested in photography for its expressive and technical capabilities as well as its possible commercial exploitation. Born in Grasse, France, in 1820, the nineteen-year-old Nègre arrived in Paris determined to become an artist in the classical tradition. He enrolled

first in the studio of Delaroche, with Fenton, Le Gray, and Le Secq as classmates, and later studied with Ingres. A canvas was accepted for exhibition in the Paris Salon of 1843, and for the next ten years Nègre regularly exhibited under this prestigious sponsorship.

In common with other Delaroche students, Nègre experimented with daguerreotyping, producing a number of landscapes, and around 1849–50 he began to make calotypes as an aid in painting. In the following years, Nègre began to photograph actively, drawing upon the picturesque tradition made popular in France by François Bonvin. In his portrayals of beggars, shepherds, peasants, and the working-class poor of the city, he subordinated detail to overall effect by the careful manipulation of light and shade exemplified by *Young Girl Seated with a Basket* *(pl. no. 256)*. The delicate pencil shadings that Nègre applied to the paper negatives in order to adjust values and subdue sharpness were all but invisible on the rough-textured paper surface of the calotype print.

Attracted by spontaneous street activity, the photographer invented a combination of fast lenses to capture aspects of passing life such as market scenes *(pl. no. 286),* one of which he translated almost directly into a small oil in 1852. He also undertook an ambitious architectural documentation in the south of France, culminating in a portfolio of some 200 prints of buildings, ruins, and landscapes of the Midi, which he endeavored to publish but without

much success. Eventually, the project led to a government commission for a series of photographs of Chartres Cathedral. The rich architectural textures and clear details revealed in these images suggest that Nègre had found an inherently photographic aesthetic that was not dependent on painted antecedents.

Besides perfecting calotyping techniques, Nègre displayed an interest in the craft aspect of photography that led to an involvement with printing processes. Convinced that gravure printing would solve the problems of permanence and make possible the inexpensive distribution of photographs, he improved on the process developed by Niepce de Saint Victor, receiving his own patent in 1856. One year earlier, his gravure prints had been commended for "subtlety of detail, tonal vigor and transparency of middle tones,"[41] but to his great disappointment and the surprise of many, the Duc de Luynes prize for a photographic printing technology went in 1867 to Alphonse Louis Poitevin. Nègre, by then a drawing master in Nice, continued to work for several years on a gravure project but seems to have lost interest in photography. At their best, his calotypes demonstrate a respect for the integrity of the medium informed by exceptional sensitivity to light and form.

Profile: Peter Henry Emerson

Peter Henry Emerson, a gifted but contentious individual who practiced only briefly the medical profession for which he was trained, was involved with photography for some 30 years, but all his important contributions were made between 1885 and 1893. During this period, as he developed, refined, and then denounced a theory of aesthetics, he also documented aspects of rural life in England with the stated aim of "producing truthful pictures."[42]

Born in Cuba of a family distantly related to Ralph Waldo Emerson, Peter Henry arrived in England in 1869 to begin a disciplined education that eventually was crowned with degrees in medicine and surgery. In 1882 he began to photograph, and three years later, on gaining his last medical title, embarked on a documentation of the marshy region of East Anglia inhabited mainly by poor farm laborers, fishermen, hunters, and basket-makers. Hiring a boat to cruise through the inland waterways and fens, Emerson met the landscape painter T. F. Goodall, with whom he collaborated on a book of images of this area, *Life and Landscape on the Norfolk Broads*—40 platinum prints with text, issued in 1886. Over the next five years, despite his avowedly aesthetic outlook, Emerson continued to work in this region and to publish images in book form—that is, as sequential statements rather than as individual works of art.

In considering techniques for capturing the "truth" of the real world on photographic plates, Emerson was motivated both by his revulsion against what he considered the meretricious art of the past and by his scientific outlook. A trip to Italy in 1881 had convinced him that the renowned masterpieces of church art, from the mosaics at Ravenna to Michelangelo's frescoes in the Sistine Chapel, were unnatural and mannered—that one might learn more from a walk "in the fields of Italy" than from visits to museums and churches to see "some middle-age monstrosity."[43] His scientific background led him to examine physiological factors in human vision, and on the basis of the optical theories of Hermann Ludwig Ferdinand von Helmholtz, he argued that during a momentary glance human vision is sharp only at the point of focus, whereas the camera lens produces an image that is equally sharp over the entire field; therefore, photographers should use long-focal-length soft lenses to approximate natural vision—that is, to replicate instantaneous perception. He ignored the fact that the human eye does not fix itself on one point but travels rapidly over the visual scene, communicating as it does so a sharply defined picture to the brain. It is ironic, also, that his call for softer delineation came at the very moment when the sharpest lenses developed were being introduced into Europe.

That Emerson sought a scientific basis for truthfully depicting actuality while concluding that the goals of art and science were incongruous is one of the paradoxes of his career. It also is puzzling that he could so deftly renounce his great expectations for photography when presented with a means for controlling the relationship of exposure and development. Apart from these inconsistencies, his contributions include the promotion of platinum printing paper for its subtle gradations and permanence, of hand-pulled gravure for reproduction, and of sensible rules for the submission and display of photographs in competitions and exhibitions. As a means of avoiding the fictive and the false in art, his theory of Naturalism inspired a generation of photographers to seek both truth and beauty in actuality.

6.

NEW TECHNOLOGY, NEW VISION, NEW USERS
1875–1925

. . . photography, from being merely another way of procuring or making images of things already seen by our eyes, has become a means of ocular awareness of things that our eyes can never see directly. . . . it has effected a very complete revolution in the ways we use our eyes and . . . in the kinds of things our minds permit our eyes to tell us.

—*William M. Ivins, Jr., 1953* [1]

IN THE FIFTY YEARS that followed the announcement that pictures could be made with sunlight, processes and ideas were continuously tried and discarded as people involved with the medium sought answers to the technical problems created by the expanding aesthetic, commercial, and scientific demands upon photography. As these needs unfolded it became apparent that professional photographers were looking for more sensitive film and for stable, standardized products to document an ever-widening range of subjects; that the scientific community required refined and specialized equipment; that artistic photographers were seeking materials of long tonal range and permanence. Still another constituency was added to those who made and used camera images when at the end of the 1880s simplified apparatus and processing methods—"push button" photography—turned potentially everyone into a photographer. During the same period, the persistent struggle to produce images in color in the camera was won, even though the solution turned out to be one of limited application. This explosion of products, techniques, and processes (detailed in A Short Technical History, Part II) produced significant changes in the kinds of images made and how they were used, and as a consequence established new audiences for photographic images. In turn, the increasing numbers of images provided information that altered public attitudes and perceptions of reality.

By 1890, photographic technology had taken wing. Wet collodion, in use for some 25 years before going the way of the daguerreotype, was supplanted by the dry plate—a silver-bromide gelatin emulsion available first on glass plates and later on lightweight, flexible celluloid film. This material was not only easier to use; it was more sensitive to light, thus shortening exposure time, and eventually it became orthochromatic—corrected for all colors of the spectrum except red (and blue, to which it was oversensitive). Camera design also flourished; during the final decades of the 19th century, photographers could choose from among a variety of instruments designed for different purposes. For professional work in the field there were view cameras in several sizes with extension bellows, swings, and tilts; for the serious amateur, hand-held reflex cameras. Stereographic and panoramic apparatus was available, as were tiny detective cameras—so named because they might be concealed in clothing or in other artifacts to make picture-taking unobtrusive. Concurrently, manufacturers began to produce faster lenses, shutters, exposure meters, flash equipment—all of which gave the photographer greater control over capturing on the negative what was occurring in actuality. At the same time, printing papers that satisfied both artistic and commercial purposes appeared on the market.

Standardization—the rational production of photographic materials and processes—accelerated toward the end of the 19th century for a number of reasons. Basic among them was the continuing trend in Western capitalist countries toward the regularization of all manufactured goods and many services, with photography considered an intrinsic part of industrial capacity. Another stimulus was the growth of the chemical and dye industries, especially in Germany after its unification in 1871, which led to competition (in other countries, too) in the manufacture of new sensitizing materials and more refined apparatus. Possibly the most important stimulus was the realization that photography had shown itself to be more than a craft that reproduced what the eye could see, that its potential as a tool for revealing scientific, sociological, and physical phenomena never actually seen had transformed it into the most significant pictorial means in modern industrial society. And as printing technology progressed to make possible the direct transcription of photographic illustration in news and informational media (see Chapter 10), the pressure for more accurate equipment and flexible materials increased.

Photography from the Air

The expanded roles that the medium would presently assume had been hinted at soon after mid-century as photographers attempted to depict the physical universe from unusual vantage points or under abnormal conditions using the unwieldy collodion wet plate. For example, in connection with the growing interest in "flying machines," efforts were begun in the late 1850s to photograph from the sky, to reaffirm scientifically the vision of artists who from the Renaissance on had imagined a "bird's-eye view" of the earth. In 1858, Nadar became the first to succeed, producing a somewhat murky image of Paris while stripped to the skin (for lightness) and concealed behind a dark curtain in

287. NADAR (GASPARD FÉLIX TOURNACHON). *The Arc de Triomphe and the Grand Boulevards, Paris, from a Balloon*, 1868. Modern gelatin silver print from the original negative. Caisse Nationale des Monuments Historiques et des Sites, Paris.

the basket of a captive balloon manned by the famous Goddard brothers. He spent the next two years promoting his own lighter-than-air creation *(see Profile)*, but his greatest success in aerial photography stemmed from the views of the *Arc de Triomphe (pl. no. 287)* taken in 1868 with a multilens camera from the basket of another balloon, the Hippodrome.

Aside from the romance associated with the balloon—called the "ultimate engine of democracy" by the French—the practical nature of balloon transport was demonstrated when it turned out to be one of the two ways that mail could be delivered to and from the besieged city of Paris during the Franco-Prussian War (1870–71). The other way, by carrier pigeon, involved photography in that the written messages were reduced microphotographically and later enlarged for reading in a projection enlarger, foreshadowing the V-mail of the second World War.

At about the same time as Nadar's experiments—1860—the Boston photographer James Wallace Black, a partner in the astrophotographic research conducted at Harvard by John Adams Whipple *(see Chapter 1)*, ascended 1,200 feet in a balloon tethered over the Boston Common. Black used a Voigtländer camera and a shutter of his own contrivance to make the first aerial photographs in America, six of which are extant. Although the extraordinary feat of viewing the city "as the eagle and the wild goose saw it" *(pl. no. 288)* was praised by Oliver Wendell Holmes,[2] and the photographer himself suggested that reconnaissance photography by balloon be tried during the Civil War, no action was taken. Despite attempts by several other photographers to make topographical views from the air, at times with balloon and kite cameras, the airborne camera seems not to have evoked further interest until the 20th century.[3]

288. JAMES WALLACE BLACK. *Boston from the Air*, 1860. Albumen print. Boston Public Library, Boston.

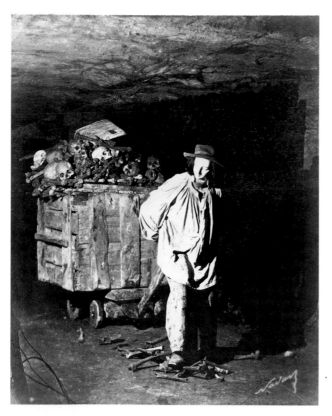

289. NADAR (GASPARD FÉLIX TOURNACHON). *Workmen in the Paris Catacombs*, 1861. Albumen print. Bibliothèque Nationale, Paris.

Photography by Artificial Light

Another group of experiments undertaken to extend the scope of the medium soon after its invention involved artificial illumination. Electric batteries made it possible for Talbot in 1851 to produce a legible image of a swiftly revolving piece of newsprint *(see below)* and also provided artificial light for Nadar's experiments in this realm. Using Bunsen batteries[+] and reflectors, Nadar first made portraits and then, in 1861, took the complicated apparatus below the streets to photograph in the sewers and catacombs (ancient burial grounds) of Paris. Some of the exposures took as long as 18 minutes, necessitating the substitution of manikins for humans *(pl. no. 289)*, but despite having to cart lights, reflectors, rolls of wire, and camera and collodion equipment through narrow and humid corridors, Nadar produced about 100 underground scenes. Views of the pipes and drains, the walls of bones, and the tomb markers that constitute the nether regions of the city demonstrated the medium's potential to disclose visual information about a wide range of physical facts.

Commercial portraiture by electric light using Bunsen cells was attempted by Adolphe Ost in Vienna in 1864, but it was not until the end of the following decade that the quality of portraits made by electric light became almost indistinguishable from those made with natural lighting. Because electric batteries initially were both weak and costly, photographers experimented with other chemical agents, including oxyhydrogen flame directed against lime (limelight) and magnesium wire. The latter substance was first put to the test in attempts to picture mine interiors in England in 1864; soon afterward it made possible images taken inside the Great Pyramid, and in 1866 the American Charles Waldack employed it for a series inside Mammoth Cave in Kentucky *(pl. no. 290)*. This substance was also used for indoor portraiture; a group portrait, one of a series of early experiments with magnesium light made by John C. Browne in 1865, includes the editor of the *Philadelphia Photographer*, the journal most eager to promote new photographic technologies in the United States. In its most common form—flash-powder (used from the 1880s on)—magnesium emitted a cloud of acrid white smoke when ignited, and its intense light created harsh tonal contrasts, but until the flash bulb was invented in Germany in 1925 there was no practical alternative portable lighting agent.

Urban nighttime views presented another intriguing problem for photographers, but during most of the 19th century the gaslight used in street lamps was so weak in its illuminating power that exposures of from three to four hours were required to represent the tonalities of the night scene. In an early experiment by Whipple in 1863, photographs of the Boston Common, where the illumination had been boosted with the aid of electric light, still required exposures about 180 times as long as those taken in sunlight. Following the gradual electrification of cities from the 1880s on, there were more frequent attempts to capture people, carriages, and especially the street lighting itself at night. Works by Paul Martin in London and Alfred Stieglitz in New York in the 1890s are among the numbers of images testifying to the fact that both documentary and pictorialist photographers were fascinated by night scenery, especially the reflections of electric lights on glistening pavements and the tonal contrasts between virgin snow and velvety night sky.

The keen interest shown by Talbot and other photographers in objects and phenomena not ordinarily visible to the human eye *(see Chapter 1)*, in conjunction with the increasing need on the part of the scientific community for precise information about microorganisms, prompted improvements in the design of equipment and methods that enabled scientists to study such matter as the structure of crystals and the forms of cells. At the same time, astrophotography gained ground with the capability of photographing, besides sun and moon, planetary bodies; by 1877 it was possible to contemplate a complete photographic mapping of the fixed star firmament. In the following decade,

Austrian and German photographers succeeded in making clear images of the phases of lightning in the night sky. Toward the end of the century, X-rays—spectral rays that penetrate opaque structures—were discovered by Conrad Wilhelm Roentgen (recipient of a Nobel prize in 1901) at the University of Würzberg, stimulating their immediate use in camera images for medical diagnoses; within a year more than a thousand publications about X-rays appeared.

The Photography of Movement

The most dramatic developments in terms of popular acclaim occurred in the realm of motion study as the camera began to provide artists, scientists, and the lay person with visual evidence about ordinary matters that the unaided eye could not see, such as walking and running. Talbot's success in stopping action with the aid of an electric flash (mentioned earlier) was acclaimed because it pointed the way to photographing "with all the animation of full life . . . the most agile dancer during her rapid movements . . . the bird of swiftest flight during its passage,"[5] but these experiments were not followed up until the 1880s, when Austrian scientist Ernst Mach, working in Prague, made exposures of flying projectiles, sound waves, and air streams using electric flash as a lighting source. Incidentally, although concerned with providing scientific

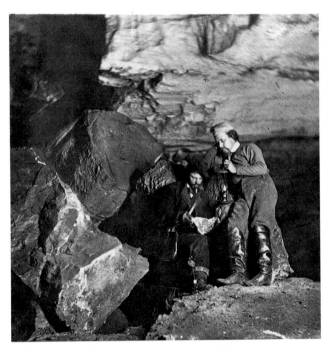

290. CHARLES WALDACK. *Beyond the "Bridge of Sighs"* from *Mammoth Cave Views*, 1866. Albumen print. New-York Historical Society; George T. Bagoe Collection, gift of Mrs. Elihu Spicer.

information, Mach also wished these images to be visually pleasing, arguing that aesthetic quality in no way detracts from usefulness. Simultaneously, experimentation in stop-action photography also took off in other directions—one based on the capacity of the short-focal-length lens used on stereograph cameras to freeze motion in street photography *(see below)* and the other on the ability of successive exposures to record the discrete stages of a movement.

Throughout the 19th century, the need to institute proper training programs for horses and the desire by painters of history pictures for greater accuracy in the depiction of battle scenes had led to efforts by scientists to graphically analyze motion; after its invention, photography became the favored instrument for this endeavor. Beginning in 1872, the analysis of motion by the camera was carried on for some 20 years by Eadweard Muybridge and Thomas Eakins in the United States, by Etienne Jules Marey in France, and by Ottomar Anschütz in Germany.

Muybridge's prominent role in this adventure was the result of what he called an "exceptionally felicitous alliance" with Leland Stanford, ex-governor of California, president of the Central Pacific Railroad, and owner of the Great Palo Alto Breeding Ranch (who nevertheless eventually disavowed the collaboration).[6] Curiosity among racing enthusiasts about the positions of the legs of a horse running at full gallop prompted Stanford to call upon Muybridge—by 1872 the most renowned cameraman in the American West—to photograph his trotter Occident in motion. Though not remarkably clear, the first images from Muybridge's camera established to Stanford's satisfaction that at one point all four of the animal's hooves left the ground *(pl. no. 292)*—although not, it should be added, in the position usually shown in painted representations.[7]

This experiment initiated a collaboration, beginning in 1877, between Stanford and Muybridge with the goal of providing visual information about animal movement useful in the training of horses and human athletes *(pl. no. 291)*. This time, the animals were photographed as they moved in front of a calibrated backdrop, tripping specially designed, electrically operated shutters of 12 cameras equipped with Dallmeyer stereographic lenses at one-thousandth of a second. News of the sensational photographs that resulted— photographs that documented what the human eye had never registered—appeared in the California press in 1877, in the prestigious *Scientific American* the following year, and in journals in London, Paris, Berlin, and Vienna soon afterward. Having become an international celebrity, Muybridge lectured in the United States and Europe, where his work was acknowledged by the French physiologist Marey.

Late in 1883, as a result of the withdrawal of Stanford's patronage, Muybridge accepted an invitation to continue

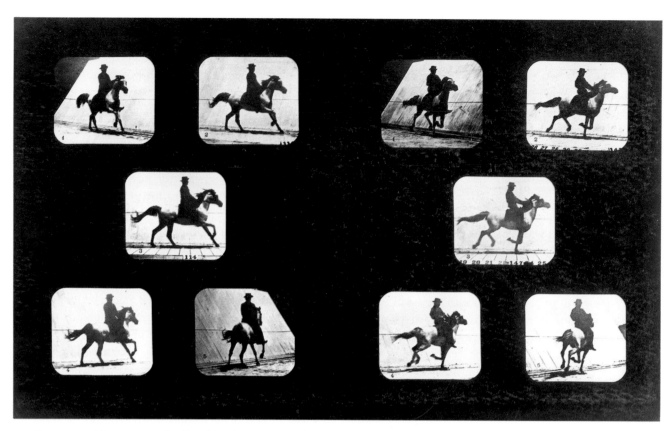

291. EADWEARD MUYBRIDGE. *Studies of Foreshortenings; Mahomet Running*, 1879.
Modern print from a wet-plate glass collodion negative. Stanford University Art Museum, Stanford, Cal.

his work at the University of Pennsylvania where he boldly extended the cast of characters and the range of movements. His human subjects were drawn from the teaching staff at the university, from professional models for the female nudes (about whose lack of grace he complained!), and from friends in the arts, among them Eakins, whose hand he photographed in various positions *(pl. no. 293)*. In an elaboration of the California experiments, the movements generally were performed in front of a backdrop marked with a grid of vertical and horizontal lines and before a battery of 24 cameras about six inches apart in a line parallel with the grid, while smaller groups of cameras were maneuvered into position to capture frontal, rear, and foreshortened views, as in *Woman Emptying a Bucket on a Seated Companion (pl. no. 294)*. By the time the Pennsylvania project began in 1884, advances in technology enabled Muybridge to use more sensitive dry plates instead of collodion, and to afix a roller shutter in front of each camera lens. These were operated by an electromagnetic system (designed by the photographer) that tripped the shutters in succession and at the same time operated a chronograph or timing device. In a year-and-a-half of work, Muybridge produced some 100,000 images analyzing the movements involved in walking, running, playing

ball, pirouetting, curtseying, and laying bricks, among other activities. The university selected 781 plates for *Animal Locomotion*, an expensive publication, after which Muybridge issued smaller editions entitled *Animals in Motion* and *The Human Figure in Motion*.[8]

Eakins, the American painter whose long-standing interest in the accurate graphic representation of movement had prompted him to correspond with Muybridge and to purchase a set of studies of the horse in motion,[9] applied the knowledge he gained to the depiction of the horse's legs in his first Philadelphia commission—the oil painting, *The Fairman Rogers' Four in Hand (pl. no. 295)*, in which ironically the carriage wheels are blurred as if moving while the horses' hooves are frozen in one phase of their movement. In his own studies of motion, Eakins, who started to make photographs as soon as dry plates became available *(see Chapter 5) (pl. no. 297)*, preferred to work with apparatus that registered the successive phases of action on one plate, as can be seen in *History of a Jump (pl. no. 298)*, a frequently reproduced work.

Marey's contribution to the photographic documentation of movement was made in conjunction with his primary vocation of physiology, for which he initially had devised graphic methods of recording skeletal and muscle

movements. After reading about Muybridge's experiments in *La Nature* in 1878 (and later through personal contact with him), Marey turned to the camera as a more accurate tool for such documentation. Because he was more interested in schematic diagrams of muscle movements than in random, if timed, depictions of moving figures, he adapted for his own use the *fusil photographique* (photographic gun)—a camera inspired by the rotating bullet cylinder of a revolver—which Eakins also used. Originally, Marey produced a series of separate images with this apparatus but soon realized that more precise information could be gained if the sequential movements appeared on the same plate. For these timed images—called chronophotographs *(pl. no. 299)*—Marey employed a rotating slit shutter and experimented with a variety of black and white garments on models who moved against similarly colored backdrops; eventually he settled on a figure clothed entirely in black with bright metal bands attached to the sides of the arms and legs, photographed against a black background. This yielded a "working geometric drawing"—a linear graph of 60 skeletal movements per second.[10] As was true of other kinds of instantaneous studies, these images were to have a telling effect on concepts and styles in art as well as on the scientific understanding of movement.

Similar experiments in arresting motion were made by Anschütz, who had studied photography in Berlin, in Munich with Franz Hanfstaengl, and in Vienna before returning to his native Prussia. Building on a series of stills of horses in motion that he had made with a shutter mounted in front of the plate, Anschütz embarked on a project to produce instantaneous photographs of animals

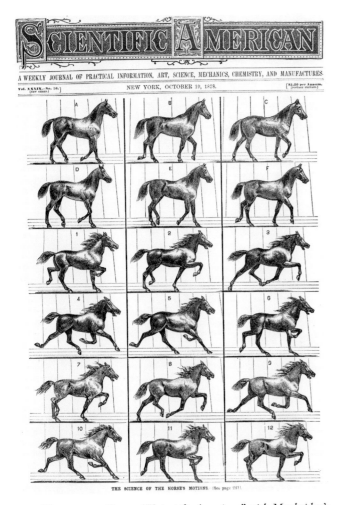

292. UNKNOWN. *Cover of "Scientific American" with Muybridge's Series of Horses,* October 19, 1878. Engraving. New York Public Library, Astor, Lenox, and Tilden Foundations.

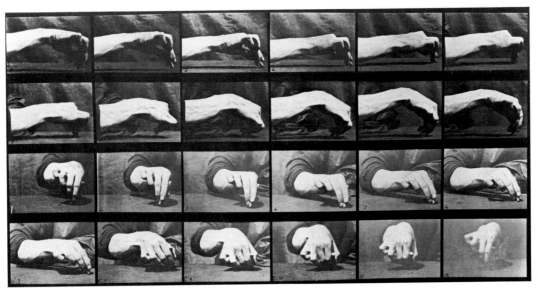

293. EADWEARD MUYBRIDGE. *Eakins's Hand,* from *Animal Locomotion,* 1887. Collotype. Museum of the Philadelphia Civic Center.

294. EADWEARD MUYBRIDGE.
Plate 408 from *Animal
Locomotion*, 1887. Collotype.
Photograph Collection, New
York Public Library, Astor,
Lenox, and Tilden Foundations.

295. THOMAS EAKINS. *The
Fairman Rogers' Four-in-Hand*,
1879. Oil on canvas.
Philadelphia Museum of Art;
gift of William Alexander Dick.

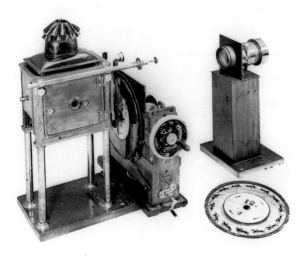

296. EADWEARD MUYBRIDGE. *Zoöpraxiscope*, c. 1870.
Eadweard Muybridge Collection, Kingston Upon
Thames Museum, England.

in the Breslau Zoo. Widely publicized, the most famous among these images are 120 exposures of the activities of a family of storks *(pl. no. 300)*. By 1886 Anschütz had adapted Muybridge's system of using multiple cameras to the very small instruments with which he worked, and with the aid of the Prussian ministries of war and education he continued to photograph both animal movements and army maneuvers, using a specially designed "Anschütz" lens manufactured by the Goerz Company.

Three of the photographers involved in stop-motion experimentation envisaged the next logical step—the reconstitution of the appearance of movement by viewing the separate analytical images in rapid sequence. For this purpose Marey and Muybridge turned to a range of so-called philosophical toys, among them the Phenakistoscope (or zoetrope) and the Praxinoscope, both of which involved rotating cylinders or disks with a sequence of images on one moving element viewed through either counter-rotating or stationary slots on the other. This reconstitution of motion, suggested first by Sir John Herschel in 1867 and later by Marey in 1873,[11] struck Stanford as a means to test the correctness of the photographic evidence seen in the stills; therefore Muybridge worked out the Zoöpraxiscope *(pl. no. 296)*, a device consisting of a glass disk on which images were arranged equidistantly in consecutive order, with a slotted counter-rotating viewer; its function, as stated by its designer, was "for synthetically demonstrating movements analytically photographed from life."[12] These first "motion pictures" were seen by the Stanford family in Palo Alto in 1879, and two years later during Muybridge's trip abroad they were projected for audiences of influential European artists and intellectuals. Anschütz's endeavor in 1887 to reconstruct movement employing an Electro-Tachyscope, a device in which enlarged diapositives (slides), illuminated by a spark, revolved in sequence on a disk, was limited in effect because the small-format images were not projected but had to be viewed directly.

Science and art became more profoundly intertwined when the camera began to supply evidence of animal movement beyond what even the most naturalistically inclined artist was capable of seeing. Stop-motion photography and the various publications attracted a wide spectrum of artists working in a variety of styles, among them the salon painters Adolphe William Bouguereau and Franz von Lenbach, the realist Edgar Degas, the Pre-Raphaelite John Everett Millais, the expressionist Auguste Rodin, and the symbolist James Abbott McNeill Whistler. As in the past, many painters used the newly revealed information to correct inaccurate representation and to make their work appear more naturalistic, as was true of Jean-Louis Meissonier, a French painter of prestigious historical battle

297. THOMAS EAKINS. *Amelia Van Buren with a Cat*, c. 1891. Platinum print.
Metropolitan Museum of Art, New York; David Hunter McAlpin Fund, 1943.

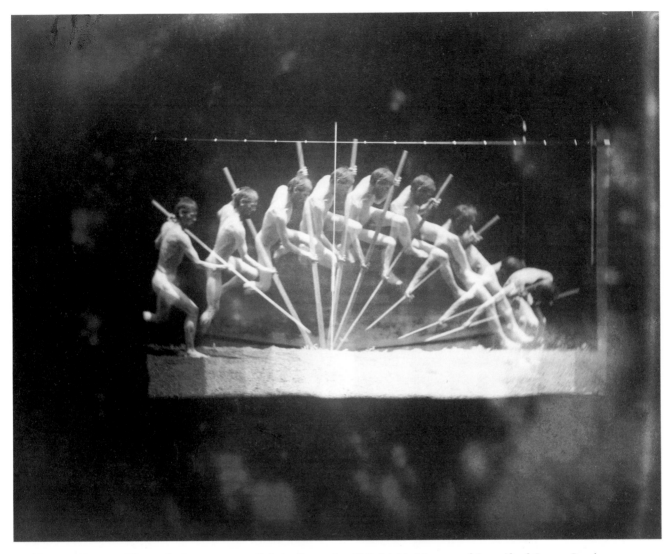

298. THOMAS EAKINS. *History of a Jump*, 1884–85. Gelatin silver print. Philadelphia Museum of Art; gift of George Bregler.

scenes, some of which he altered to conform to the new knowledge. Other artists became engrossed with the idea of movement and time, integrating various views of the same object seen in several positions as the theme of their paintings and creating images suggestive of the fluidity of situations and events. For example, Degas, an enthusiast who was himself a sensitive photographer, conveyed lively animation by painting on a single canvas the same seated dancer in a variety of positions *(pl. no. 301)*.

Time, movement, and change exerted an even greater fascination on the early-20th-century European painters who sought a new language to express the shifting realities of their own era. Photography may have been blamed by a small group of these avant-garde artists for a "disgraceful alteration" in seeing, but, as Aaron Scharf has pointed out, "stop-motion camera imagery, in particular the geometric diagrams of Marey, with their emphasis on pattern and

movement, offered Cubist, Vorticist, and Futurist painters a fresh vocabulary."[13] In the most famous of a number of such examples, *Nude Descending a Staircase (pl. no. 302)*, French artist Marcel Duchamp adapted Marey's schema to transform the posed female nude—conventionally an expression of immobility—into a supremely energetic statement that proclaims its modernism while maintaining a tie to hallowed tradition. Of all those seeking to embody the vitality of their time in the painted image, Duchamp most clearly recognized that photography in all its ramifications had subverted the long-standing relationship between the artists and the conventions of painting. Interest in the graphic depiction of movement based on Marey's studies reached a climax among European artists of the Cubist and Futurist movements between 1911 and 1914, but other kinds of stop-motion photographs have continued to inspire artists everywhere up to the present.

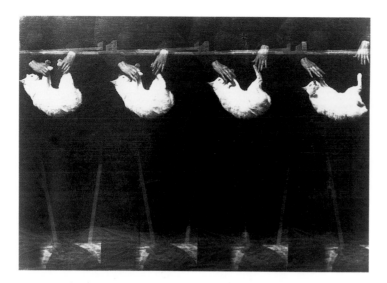

299. ETIENNE JULES MAREY. *Falling Cat Sequence,* c. 1880s. Gelatin silver prints. National Museum of American History, Smithsonian Institution, Washington, D.C.

RIGHT:

300. OTTOMAR ANSCHÜTZ. *Series of Storks in Flight,* 1884. Gelatin silver prints. Agfa-Gevaert Foto-Historama, Cologne, Germany.

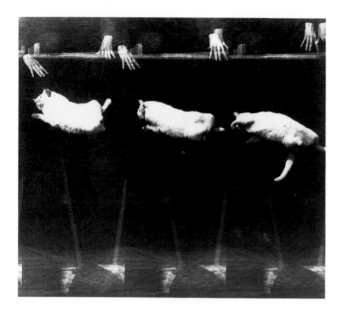

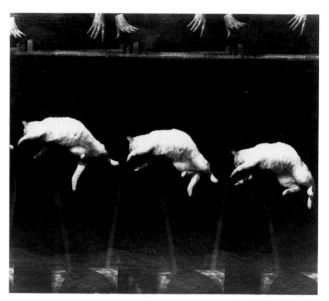

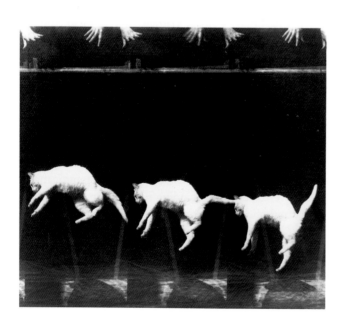

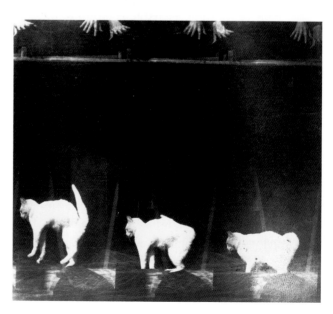

301. EDGAR DEGAS. *Frieze of Dancers*, c. 1883. Oil on canvas. Cleveland Museum of Art; gift of the Hanna Fund.

302. MARCEL DUCHAMP. *Nude Descending a Staircase #2*, 1912. Oil on canvas, Philadelphia Museum of Art; Louise and Walter Arensberg Collection. © Association Marcel Duchamp/ADAGP, Paris/Artists Rights Society (ARS), New York, 2019.

Instantaneous Photographs of Everyday Life

Whether facing the natural landscape or the urban scene, many photographers other than those investigating motion for scientific reasons found that they, too, were eager to arrest the continuous flux of life, to scrutinize and savor discrete segments of time, and to capture them on glass plates and, later, film. As noted, this first became possible with the short-focal-length lenses on stereograph cameras. Roger Fenton, for example, was able to capture the forms of flowing water and fleeting clouds on the stereograph plate. By 1859, Edward Anthony in New York (*pl. no. 189*), George Washington Wilson in Edinburgh, and Adolphe Braun and Hippolyte Jouvin in Paris (*pl. no. 190*)—among others—had begun to make and publish stereograph views of the "fleeting effects" of crowds and traffic on the principal streets of urban centers and, in Jouvin's case, in marketplaces, public gardens, and at festive events. Acclaimed because they seemed to embody "all . . . life and motion,"[14] these views also disclose the distinctiveness of different cultural environments. Stereographs of city streets reveal at a glance the profound dissimilarities between public life in New York and Paris, for example, while others make visible the contrast between social conditions in industrialized countries and in those being opened to colonization and exploitation (*see Chapter 8*).

That this interest in the flux of urban life engaged painters of the time as well as photographers is apparent in canvases by the French Impressionists that seem to capture as if by camera the moving forms of people and traffic in the streets and parks of Paris. Besides a preference for high horizons and blurred figures, similar to that seen in numbers of stereographs of city streets and exemplified in Claude Monet's *Boulevard des Capucines (pl. no. 303)*—a view actually painted from Nadar's studio—the Impressionists broke with tradition in their preference for accidental-looking arrangements of figures that appear to be sliced through by the edges of the canvas in the manner of the photographic plate. Certain canvases by these painters also mimic the optical distortions of figure and space visible in stereographs, suggesting that, as Scharf observed, "photography must be accorded consideration in any discussion of the character of Impressionist painting."[15]

The appeal of the spontaneous and informal continued unabated during the last decade of the 19th century and resulted in the extraordinary popular interest in small, hand-held single-lens cameras that would simplify the taking of informal pictures (*see A Short Technical History, Part II*). Of all the apparatus developed to fulfill this need, the most sensational was the Kodak camera, first marketed in 1888 by its inventor George Eastman.

303. CLAUDE MONET. *Boulevard des Capucines, Paris (Les Grands Boulevards)*, 1873–74. Oil on canvas. Nelson-Atkins Museum of Art, Kansas City, Mo.; Kenneth A. and Helen F. Spencer Foundation Acquisitions Fund.

However, this fixed-focus box did more than make it easy for people to take pictures of everyday events; by making the developing and printing independent of the exposure it encouraged a new constituency to make photographs and inaugurated the photo-processing industry.

The Kodak and the snapshot (Herschel's term to describe instantaneous exposures) were promoted through astute advertising campaigns that appealed to animal lovers, bicyclists, campers, women, sportsmen, travelers, and tourists. Freed from the tedium of darkroom work, large numbers of middle-class amateurs in Europe and the United States used the Kodak during leisure hours to depict family and friends at home and at recreation, to record the ordinary rather than the spectacular. Besides serving as sentimental mementos, these unpretentious images provided later cultural historians with descriptive information about everyday buildings, artifacts, and clothing—indisputable evidence of the popular taste of an era.

The convenience of merely pressing the button resulted in a deluge of largely unexceptional pictures. Despite the

304. EMILE ZOLA. *A Restaurant, Taken from the First Floor or Staircase of the Eiffel Tower, Paris*, 1900. Gelatin silver print. Collection Dr. François Emile Zola, Gif-sur-Yvette, France.

suggestion today that the "aesthetic quality of the snapshot has received less attention than it deserves,"[16] most were made solely as personal records by individuals of modest visual ambitions. Untutored in either art or science, they tended to regard the image in terms of its subject rather than as a visual statement that required decisions about where to stand, what to include, how best to use the light. Further, since they were untroubled by questions of print size or quality, they mostly ignored the craft elements of photographic expression. This attitude, coupled with the fact that "every Tom, Dick and Harry could get something or other onto a sensitive plate,"[17] contributed to the emerging polarity between documentary images—assumed to be entirely artless—and artistic photographs conceived by their makers (and others) to embody aesthetic ideas and feelings.

Nevertheless, whether by accident or design, snapshots do on occasion portray with satisfying formal vigor moments that seem excised from the seamless flow of life. For one thing, the portability of the instrument enabled the user to view actuality from excitingly different vantage points, as in a 1900 image made by French novelist Émile

305. HORACE ENGLE. *Unknown Subject, Roanoke, Virginia*, c. 1901. Gelatin silver print from the original negative. Pennsylvania State University Press, University Park; courtesy Edward Leos.

306. UNKNOWN. "What an Exposure!" from *The Amateur Photographer*, Sept. 23, 1887. Engraving. Gernsheim Collection, Humanities Research Center, University of Texas, Austin.

Zola from the Eiffel Tower looking down *(pl. no. 304)*. In its organization of space it presented an intriguing pattern of architectural members and human figures, foreshadowing the fascination with spatial enigmas that would be explored more fully by photographers in the 1910s and '20s. In a different vein, the small camera made possible the refreshing directness visible in images of small-town life by Horace Engle *(pl. no. 305)*, an American engineer who used a Gray Stirn Concealed Vest camera before turning to the Kodak. Because the camera was so easy to use, a photographer stationed behind a window or door, as Engle sometimes was, might intuitively manage light and form to explore private gestures and expressions that almost certainly would be withheld were his presence known. This urge to ensnare ephemeral time, so to speak, also foreshadowed developments of the late 1920s when the sophisticated small Leica camera made "candid" street photography a serious pursuit among photojournalists. Viewed in sequence rather than singly, snapshots sometimes suggest an underlying theme or the emotional texture of an event in the manner of later photojournalistic picture stories and might be considered forerunners in this sense, too.

However, despite the claim that "the man with a box-camera has as many chances of preserving pleasure as those blessed (?) *[sic]* with the more expensive instruments,"[18] the Kodak in itself was limited in scope. But the spontaneity it emblematized appealed to many serious photographers, who armed themselves with a more sensitive apparatus of a similar nature—the hand camera. Individuals of both sexes, from varying backgrounds and classes, of differing aesthetic persuasions, who usually processed their own work, produced the kind of imagery that for want of a better term has come to be called documentation. Turning to the quotidian life of cities and villages for inspiration, artists used the hand camera as a sketchbook, pictorialists tried to evoke the urban tempo, and still others found it a disarming device with which to conquer the anonymity of modern life. Serious workers rather than snapshooters, this new breed of image-maker sought to express a personal vision that embraced the special qualities of the time and place in which they lived.

The invasion of personal privacy that the small camera user could effect with ease became an issue in the late 19th century—one that still elicits discussion today. The question of propriety was raised when individuals and groups of amateurs, often organized into camera and bicycle clubs, began to photograph unwitting people in the streets and at play. Reaction ran the gamut from the gentle satire of an 1887 cartoon in Britain's *Amateur Photographer (pl. no. 306)* to more strident denunciations in which "hand-camera fiends" were admonished to refrain from photographing "ladies as they emerge from their morning dip, loving couples, private picnicking parties" under threat of having their cameras "forcibly emptied."[19] Indeed, it has been suggested that the many images of working-class people in the streets around the turn of the century may reflect the fact that they were less likely than middle-class folk to protest when they saw strangers approaching with a camera.[20]

Street life began to attract hand-camera enthusiasts

(and some using larger equipment, as well) partly because it offered an uncommon panorama of picturesque subjects. Previously, photographers in search of visual antidotes for the depressing uniformity of life in industrialized societies had either ventured abroad to exotic lands or had searched out quaint pastoral villages as yet untouched by industrial activity. They also had photographed the city's poor and ethnic minorities for their picturesqueness. As urbanization advanced, documentarians, Pictorialists, hand-camera enthusiasts, and even some who worked with large-format cameras were drawn by the animated and vigorous street life in the city to depict with less artifice the variety of peoples and experiences to be found in urban slum and working-class neighborhoods.

To some extent, the career of Paul Martin, working in London from about 1884 on, typifies the changes that occurred in the practice, usage, and character of photography everywhere. When Martin began an apprenticeship as an engraver, he first came in contact with photography as a useful resource for the illustrator. He taught himself the craft from magazines that, along with amateur photography clubs, provided technical assistance and aesthetic guidelines to growing numbers of hand-camera enthusiasts. Some, like Martin, were working people from moderate backgrounds who were unable to afford expensive camera equipment or time-consuming processes that used the platinum and carbon materials favored by aesthetic photographers. Martin became an accomplished craftsman nevertheless, adept at making composites, vignetting, and solving technical problems connected with photographing out-of-doors at night. During the 1890s, a number of his straight silver prints were awarded prizes in competitions despite being judged at times as lacking in atmosphere and being too "map-like."[20]

Recent investigations have turned up numbers of photographers of the quotidian scene, both in cities and in rural localities. In many cases the photographers remain unknown, despite the fact that such images frequently

307. PAUL MARTIN. *Entrance to Victoria Park*, c. 1893. Gelatin silver print.
Gernsheim Collection, Humanities Research Center, University of Texas, Austin.

308. GIUSEPPE PRIMOLI. *Procession, Ariccia*, c. 1895. Gelatin silver print. Fondazione Primoli, Rome.

were reproduced on postcards when this form of communication grew in popularity. Among those who supplied images for this purpose were Roll and Vert in France and Emil Mayer in Austria. Photographing daily life attracted women, who were beginning to become involved in photography in greater numbers. Amélie Galup and Jenny de Vasson in France, Christina Broom in England, and Alice Austen and Chansonetta Stanley Emmons in the United States (*see below*) were among the many who took cameras into streets and rural byways. Because the images are of scenes that take place in the home and workplace as well as on the street, at times they may seem similar to the social imagery by John Thomson in London and Jacob Riis in New York—social photographers who worked in the slums of their respective cities (*see Chapter 8*). However, the emotional tone in these works usually is lighthearted and the scenes casually composed.

Martin claimed that he became a street photographer because he lacked the financial means to become a Pictorialist,[21] but in fact, enthusiasm for "real life" cut

across class lines, appealing to a broad sector of the population that included wealthy individuals typified by Giuseppe Primoli and Jacques Henri Lartigue. Primoli, a Bonaparte descendant who numbered among his circle the intellectual and cultural elite of Italy and France, worked between 1889 and 1905 (at first with a brother) to document the doings of beggars, laborers, street vendors, and performers, as well as the carefree pursuits of his own social class. Mostly amiable in tone, with open space surrounding the figures that are the focus of attention, Primoli's images could also be intense, as evidenced by the strong contrasts and spatial compression in a view of a religious procession in Ariccia (*pl. no. 308*).

The search for the unexpected in the tedium of daily occurrence was another aspect of hand-camera street photography of the time. As urbanization advanced, it swept away the distinctive physical and social characteristics of the culture of the past, substituting undifferentiated built environments and standardized patterns of dress and behavior. Hand-camera users endeavored to reaffirm individ-

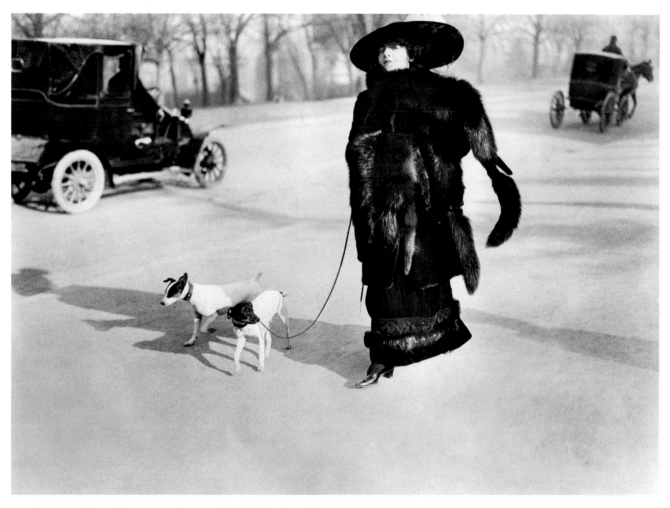

309. JACQUES HENRI LARTIGUE. *Avenue du Bois de Boulogne*, January 15, 1911.
Gelatin silver print. © Association Lartigue/SPADEM/VAGA

uality and arrest time in the face of the encroaching deper-
sonalization of existence. The French photographer Lar-
tigue was exceptional in that he was given a hand camera
in 1901 at the age of seven and continued to use it through-
out his lifetime to chronicle the unexpected. His early work
portrayed the idiosyncratic behavior of his zany upper-class
family whose wealth and quest for modernity impelled
them to try out all the latest inventions and devices of
the time, from electric razors to automobiles to flying ma-
chines. The young Lartigue's intuitive sensitivity to line,
strong contrast, and spatial ambiguity, as seen in a view
made in the Bois de Boulogne in 1911 *(pl. no. 309)*, evokes
the insouciance of affluent Europeans before the first World
War, a quality that is visible also in many images by un-
named photographers who worked for the illustrated press
at the time.

Other photographers sought out moments of extreme
contrast of class and dress, as in *Fortune Teller (pl. no.
310)* by Horace W. Nicholls, a professional photojournalist
who recorded the self-indulgent behavior of the British

upper class before World War I. Others celebrated moments
of uncommon exhilaration, a mood that informs *Hand-
stands (pl. no. 311)* by Heinrich Zille, a graphic artist who
used photography in his portrayal of working-class life in
Berlin around 1900. Still others, Stieglitz among them,
looked for intimations of tenderness and compassion to
contrast with the coldness and impersonality of the city,
exemplified in *The Terminal (pl. no. 312)* and other works
made soon after Stieglitz returned to New York from
Germany in 1890.

Indeed, in the United States at the turn of the century,
photographers were specifically urged to open their eyes to
the "picturesqueness" of the city, to depict its bridges and
structures, to leave the "main thoroughfares" and descend
to the slums where an animated street life might be seen.[22]
In part, this plea reflected the conviction held by Realist
painters, illustrators, pictorial and documentary photog-
raphers, joined by social reformers, educators, and novel-
ists, that the social life of the nation was nurtured in the
cities, that cities held a promise of excitement in their free-

310. HORACE W. NICHOLLS. *The Fortune Teller*, 1910. Gelatin silver print. Royal Photographic Society, Bath, England.

311. HEINRICH ZILLE. *Handstands*, c. 1900. Gelatin silver print. Schirmer/Mosel, Munich.

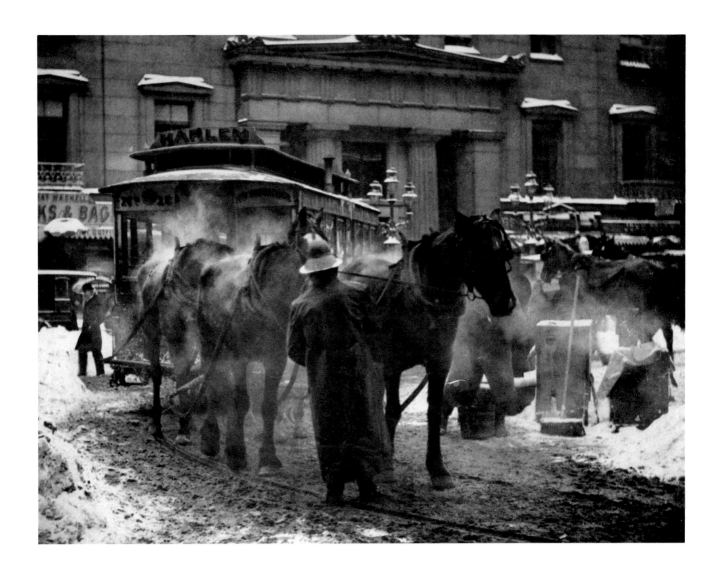

312. ALFRED STIEGLITZ. *The Terminal, New York*, 1892. Gravure print. From *Camera Work*, 1911, No. 36. Museum of Modern Art, New York; gift of Georgia O'Keeffe.

313. ROBERT L. BRACKLOW. *Statue of Virtue*, New York, after 1909. Gelatin silver print from the original negative. New-York Historical Society; Alexander Alland Collection.

dom from conformity and ignorance. Stieglitz, in whose magazine the article appeared, confessed in 1897 that after opposing the hand camera for years, he (and other Pictorialist photographers) had come to regard it as an important means of evoking the character of contemporary life. His suggestion that those using the hand camera study their surroundings and "await the moment when everything is in balance"[23] seems to have forecast a way of seeing that 30 years later became known as the "decisive moment." Whether undertaken consciously or not, the endeavor to assert the prodigal human spirit by capturing the fortuitous moment long remained one of the leitmotifs of 20th-century small-camera photography.

Nor was this development limited to New York. Soon after arriving in California from Germany in 1895, the young Arnold Genthe obeyed his "vagabond streak," as he called it,[24] to photograph with a concealed hand camera in the reputedly inhospitable Chinese quarter of San Francisco. Over the next ten years, he returned continually to the "Canton of the West" in search of tantalizing glimpses of an unusual culture. The images range from the Pictorial to the reportorial *(pl. no. 314)*, a dichotomy that continued to characterize his work. As owner of a professional studio in San Francisco at the time of the 1906 earthquake, Genthe documented the aftermath of the disaster with fine dramatic clarity, but after relocating in New York he specialized in polished soft-focus portraits of dancers and theatrical figures.

Ethnic enclaves were not the only source nor was the small camera the only instrument for capturing the kinds of subjects now considered picturesque. Countless photographers began to document aspects of the life around them using large-plate view cameras to penetrate beyond surface appearances. That the city could be approached as a subject using a large-format camera and photographed with reserved grace rather than subjective urgency can be seen in the images made by Robert L. Bracklow, an amateur photographer of means, to document the physical structures, architectural details, and street activity in New York at the turn of the century *(pl. no. 313)*. With a flair for well-organized composition, Bracklow's photographs of slums, shanties, and skyscrapers suggest that by the end of the 19th century both hand and view cameras had become a significant recreational resource. For instance, E. J. Bellocq, a little-known commercial photographer working in New Orleans during the 1910s, was able to pierce the facade of life in a Storyville brothel. Whether commissioned or, as is more likely, made for his own pleasure, these arrangements of figure and decor *(pl. no. 315)* project a melancholy languor that seems to emanate from both real compassion and a voyeuristic curiosity satisfied by the camera lens.[25]

The new photographic technologies had a signal

314. ARNOLD GENTHE. *Man and Girl in Chinatown,* c. 1896. Gelatin silver print. Sheldon Memorial Art Gallery, University of Nebraska, Lincoln; F.M. Hall Collection.

effect on the role of American women in photography.[26] Simplified processing enabled greater numbers of "genteel" women to consider photography a serious avocation and even a profession, because by the late 1880s they were able to take advantage also of the availability of domestic help and store-bought food, both of which provided some relief from household routines. At about the same time, writers in the popular and photographic press, suggesting that the medium was particularly suited to "the gentler sex," urged women to consider "an accomplishment which henceforth may combine the maximum of grace and fascination."[27] Encouragement came also from the Federation of Women Photographers and from competitions designed especially for female photographers. Unlike the older arts, photography did not require training in male-dominated academies, long periods of apprenticeship, or large commitments of time to practice, although greater involvement in the medium usually yielded more impressive results.

315. E. J. BELLOCQ. From *Storyville Portraits*, c. 1913. Silver print on printing-out paper,
made by Lee Friedlander from the original plate. © Lee Friedlander, New City, N.Y.

316. CHANSONETTA
STANLEY EMMONS.
Children at Well, 1900.
Gelatin silver print.
Culver Pictures, New
York.

317. ALICE AUSTEN.
*Hester Street, Egg
Stand*, 1895. Gelatin
silver print. Staten
Island Historical
Society, Staten Island,
N.Y.; Alice Austen
Collection.

In addition to those who became prominent in photo-journalism and Pictorialism *(see Chapters 8 and 9),* many women used both hand and view cameras to document family life and domestic customs, recreational and street activities. Chansonetta Stanley Emmons and Alice Austen were two such women. Images of small-town life, typified by a scene in the village of Marlborough, New Hampshire *(pl. no. 316),* were made in 1900 by the recently widowed Emmons, who had turned to photography as a solace and a means of augmenting a meager income. Nurtured on genre imagery, Emmons's domestic scenes often were sentimental and derivative, but she also could capture evanescent moments of childhood play with refreshing directness. Austen, originally from a well-to-do Staten Island family, was less typical in that she not only devoted some 25 years to a visual exploration of her own social milieu, but she also investigated the vibrant working-class neighborhoods of lower Manhattan *(pl. no. 317)* with an eye for expressive lighting and gesture. In Austen's case, as was undoubtedly true of other women, the camera provided a

means to overcome psychological and social barriers, enabling a shy and conventionally reared Victorian "lady" to participate in the excitement of urban street life.

In the decade before 1900, the possibility that camera views of the city might be a salable commodity began to interest individuals and commercial studios. Using view cameras and tripods as well as hand cameras, photographers working on their own or for photographic enterprises undertook to provide images for postcards and magazine reproduction, for antiquarian societies and libraries, and for artists and decorators, creating in the process a formidable number of such visual documentations. For instance, in New York between 1890 and 1910, Joseph Byron (descendant of a family of English photographers) was involved in a business with his wife and five children, including the well-known Percy; they exposed and processed almost 30,000 large-format views both on commission and on speculation. A similar pictorial record of Paris can be seen in the work of Paul Géniaux, Louis Vert, and the Seeberger brothers. These images comprise scenes of urban

318. JULES, HENRI, and LOUIS SEEBERGER (SEEBERGER FRÈRES). *Fishermen near Washerwoman's Boats,* c. 1905–10. Gelatin silver print. Caisse Nationale des Monuments Historiques et des Sites, Paris. © Arch. Phot. Paris/SPADEM.

labors *(pl. no. 318)* as well as the activities of the bourgeoisie on their daily rounds. With exceptions, these competent if detached records of buildings, neighborhoods, sporting and theatrical events, people at play and at work are interesting mainly for their rich fund of sociological information.

The most extensive and in some judgments the most visually expressive document of the urban experience—also of Paris—was begun just before 1900 by Eugène Atget *(pl. no. 326) (see Profile)*. Using a simple 18 x 24 centimeter camera mounted on a tripod, this former actor began to document the city and its environs for a varied clientele that included architects, decorators, painters, publishers, and

sculptors. Aside from their value and use as descriptive records of buildings, decor, statuary, storefronts *(pl. no. 319)*, costumes, and gardens, these beautifully composed images resonate with an intense though not easily defined passion. Rich in detail but not fussy, affecting but not sentimental, this great body of work represents Atget's yearning to possess all of old Paris and in so doing to embrace the authentic culture of France that modern technology was destroying.

Other large-scale commercial documents often exhibited a patriotic character, reflecting the growing movements for national self-determination taking place in various parts of Europe. Forty thousand views of Irish life,

320. ROBERT FRENCH. *Claudy River, Gweedore, County Donegal*, c. 1890.
Gelatin silver print. National Library of Ireland, Dublin.

which include scenes of work and play, of city thorough-
fares and serene country landscape *(pl. no. 320)*, were made
by Robert French for the firm of William Lawrence in
Dublin. And in view of the political agitation for indepen-
dence among groups inhabiting the vast reaches of Russia,
it is not surprising to find the tradition of ethnographic
images, mentioned earlier, continuing into the dry-plate
era, with photographers from many sections documenting
places and customs in order to bolster feelings of national
identity. Just as ethnographers in Eastern Europe were
determined to collect evidence of a distinctive literature
and folk music, photographers in Latvia, Bulgaria, Croatia,
and Poland contributed to this surge of nationalism with
images of national costume, typical environments, and
regional customs. Since in these less industrialized regions
the medium received less financial support from the urban
populace than in Western Europe and the United States,
distinctions between professional and amateur, between

documentary and artistic were not as codified; the same
individual might fulfill all these roles, might at the same
time make commercial post cards and other documenta-
tions and submit works to the local camera club exhibitions.

A similar ethnic consciousness emerged among black
photographers in the United States in the early 20th cen-
tury. The demand for portraits and other kinds of pictorial
records, coupled with easier access to equipment, materials,
and processing resulted in an increase in the number of
commercially successful studios run by black entrepreneurs
in their own communities. From the early days of the me-
dium, daguerreotypes and other camera portraits had been
made by unheralded black photographers, but these later
enterprises produced images that depicted, in addition,
the social activities of upwardly mobile urban dwellers and
life in rural communities, made both for commerce and as
expressions of black pride. Addison N. Scurlock started a
portrait studio in Washington in 1904 and soon began

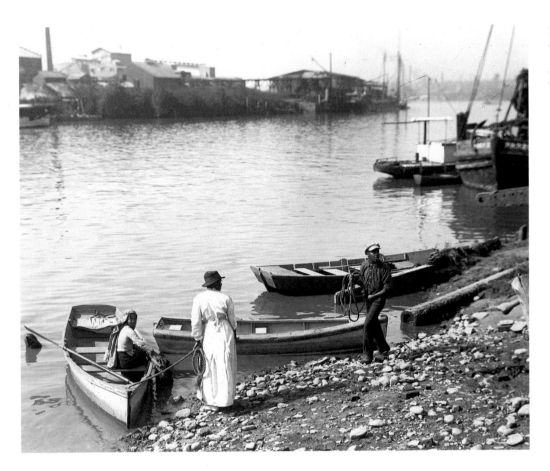

321. ADDISON N. SCURLOCK. *Waterfront,* 1915. Gelatin silver print. © Scurlock Studio, Washington, D.C.

322. JAMES VAN DER ZEE. *Couple in Raccoon Coats,* 1932. Gelatin silver print. James Van Der Zee Estate, New York; © 1969 James Van Der Zee.

323. UNKNOWN PHOTOGRAPHER (American). *Untitled*,
c. 1900–10. Gelatin silver post card. Private Collection.

IN MEMORY OF

IDA BRAYMAN

17 YEARS OLD

who was shot & killed by an Employer
Feb. 5th 1913 during the great struggle
of the Garment Workers of Rochester.

Copyrigted 1913 by U. G. W. Local 14 Rochester N. Y.

324. UNKNOWN PHOTOGRAPHER (American). *In Memory
of Ida Brayman*, 1913. Gelatin silver post card. Gotham
Book Mart, New York.

to document activities at Howard University where he was
official photographer; *Waterfront*, 1915, *(pl. no. 321)* is sug-
gestive of his feeling for mood and texture when not
confined to portraiture or straight documentation. James
Van Der Zee, probably the best-known black studio pho-
tographer in the United States, began a professional career
in 1915, opening an establishment in Harlem a year later to
which the well-to-do and famous came for portraits *(pl. no.
322)*. He also documented social activities for the com-
munity and made genre images for his own pleasure. Had
these photographers not faced the necessity of earning a
living in studio work, both might have produced such
images more frequently, a situation that obviously was true
also for the majority of commercial photographers every-
where who were able to make affecting documents of their
social milieu only in the time spared from studio work.
Unlike white Americans, however, black photographers

could not afford the leisure and financial freedom to in-
dulge in personal expression nor were they able to find
a niche in photojournalism, advertising photography, or
social documentation until after the second World War.

Anyone who has poked around attics, antique shops,
and secondhand bookstores is aware of the formidable
quantities of photographic post cards that have accumu-
lated since camera techniques were simplified in the late
19th century. The post card format—approximately 3¼ x
5½ inches—appeared in Europe in 1869 and shortly after in
the United States, but it was not until after the happy
conjunction of new rural postal regulations, hand cameras,
and special printing papers that occurred shortly after the
turn of the century that the picture card became immensely
popular with Americans—individuals and commercial stu-
dios alike. Artless yet captivating, post card images (even
when turned out in studios) display a kind of irreverent

good humor in their depictions of work, play, children, and pets *(pl. no. 323),* although they also could deal with grimmer realities *(pl. no. 324).* In the absence of telephones, glossy picture magazines, and television, the photographic postcard was not merely a way to keep in touch but a form of education and entertainment as well.

Photographs in Color

Of all the technological innovations occurring in photography between 1870 and 1920, none was more tantalizing or possessed greater potential for commercial exploitation than the discovery of how to make images in color. This search, which had begun with the daguerreotype, entailed much dead-end experimentation before a practicable if temporary solution was found in the positive glass Autochrome plate, marketed in 1907 by its inventors the Lumière brothers *(pl. no. 325) (see A Short Technical History, Part II).* Though easy to use, the process required long exposures, was expensive, and though the colors were subtle they were not faultless. Because a simple, efficient method of turning the transparencies into satisfactory photographic color prints was not available, the images had to be viewed in a diascope (single) or stereograph viewer; as late as the 1920s commercial portraitists still were being advised to send black and white work out to be hand-painted when a color image was desired. Nevertheless, Autochrome from the start attracted amateurs with leisure and money, photographers of flowers and nature, and in the United States, especially, individuals and studios involved in producing commercial images for publication. It also appealed briefly to aesthetic photographers who recognized at the time that rather than augmenting reality, color was best treated as another facet of artistic expressiveness *(see Chapter 7).*

French *"autochromistes"* followed the example of the Lumières *(pl. nos. 342 and 343)* in documenting family activities at home, at play, and in their professions. Among professionals, Jules Gervais-Courtellemont photographed in the Near and Far East *(pl. no. 344)* and documented aspects of World War II; views of military life *(pl. no. 345)* by Jean Tournassoud (later director of photography for the French Army) are other examples of interest in this theme. Autochrome appealed to Lartigue; convinced that "life and color cannot be separated from each other,"[28] he took elegant if somewhat mannered snapshots exemplified by *Bibi in Nice (pl. no. 351),* and for a brief while this color process was used in a similar fashion throughout Europe.

Not surprisingly, amateurs who liked to photograph flowers were delighted by Autochrome, but it also attracted a serious nature photographer, Henry Irving, who was quick to recognize the value of even a flawed system for botanical studies *(pl. no. 348).* While employed less frequently by documentary photographers, Autochrome was used by William Rau, the Philadelphia commercial photographer of railroad images who by the turn of the century had become interested in artistic camera expression; *Produce (pl. no. 347)* is an example of a subject and treatment unusual in the color work of the time.

While Autochrome (and its commercial variants) was based on the theory of adding primary colors together on one plate to effect the full range of spectral hues, experiments that led to the production of three different color negatives that subsequently were superimposed and either projected or made into color prints were also in progress *(see A Short Technical History, Part II).* Around 1904, this procedure was used for an extensive documentation of Russian life conceived by Sergei Mikhailovich Prokudin-Gorskii, a well-educated member of the Russian Imperial Technological Society. An educational and ethnographic project made with the tsar's patronage, it involved the production of three color-separation negatives on each plate by using a camera with a spring-operated mechanism that changed filters and repeated the exposures three times. After development, these were projected in an apparatus

325. UNKNOWN PHOTOGRAPHER (French). *Lumière Brothers,* n.d. Gelatin silver print. La Fondation Nationale de la Photographie, Lyon, France.

that used a prism to bring the three color plates into one sharply focused image. Because of the cumbersomeness of tripling the exposure, the subjects, taken throughout Russia, had to be more or less immobile, but despite the technical and logistical difficulties of this complicated undertaking, Prokudin-Gorskii produced what surely must be the most ambitious color documentation of the time.

In its early stages, it was hoped that color would add an element of naturalness to the image—the missing ingredient in verisimilitude—since actuality obviously was many-hued rather than monochromatic as shown in photographs. However, as photographers began to work with the materials they realized that rather than making camera images more real, color dyes comprised another element that had to be considered in terms of its expressive potential. The recognition that the seductiveness of color—its capacity to make ordinary objects singularly attractive—would have a powerful effect on the fields of advertising and publicity was the paramount stimulus in efforts that led to another breakthrough in color technology in the 1930s.

By 1890, photography no longer was an arcane craft practiced by initiates for whom artistic, informational, and social purposes were conjoined in the same image. Transformed and compartmentalized as a result of changes in materials, processes, techniques, and equipment, photographs became at once highly specialized and everybody's

business (and for some, big business). In the face of the medium's capacity to provide information and entertainment on such a broad scale, a small group of photographers struggled to assert the medium's artistic potential, to lend weight to an observation made some 40 years earlier that photography had "two distinct paths"—art and science—"to choose from."[29]

Profile: Eugène Atget

Eugène Atget *(pl. no. 326)*, the photographer whose extraordinary documentation of Paris in the first quarter of the 20th century was for many years uncelebrated, was born in Libourne, near Bordeaux, in 1857. Orphaned at an early age, he was employed as cabin boy and seaman after completing his schooling. During the 1880s, Atget took up acting, playing in provincial theaters, but having settled permanently in Paris in 1890 he realized the impossibility of a stage career in the capital. Instead, he turned to the visual arts, deciding on photography because of his limited art training and also because he expected that it was a profession that might yield income from the sale of camera images to his artist-neighbors in Montparnasse.

Between 1898 and 1914, Atget received commissions from and sold photographs to various city bureaus, including the archive of the national registry, *Les Monuments historiques,* and the recently established Musée Carnavalet, which had been set up to preserve a record of the history of Paris. He also supplied documents to a clientele of architects, decorators, and publishers as well as artists,

328. EUGÈNE ATGET. *La Marne à la Varenne*, 1925–27. Gold-toned printing-out paper.
Museum of Modern Art, New York; Abbott-Levy Collection; partial gift of Shirley C. Burden.

keeping records of both subjects and patrons. One project, for a book on brothels planned but never realized by André Dignimont in 1921, is said to have annoyed the photographer, but the images for this work *(pl. no. 327)* have the same sense of immutable presence as those of other working people photographed by Atget in the streets or shops of Paris. Often self-motivated rather than directly commissioned, Atget nevertheless followed in the tradition marked out by the photographers of the 1850s *Monuments historiques* project and by Charles Marville, who had photographed the neighborhoods about to be replaced by Baron Haussmann's urban renewal projects. In common with these photographers, Atget did not find documentation and art antithetical but attempted to invest even the most mundane subject with photographic form. He showed no interest in the art photography movement that already was well established when he began to work in the medium, seeking instead to make the expressive power of light and shadow as defined by the silver salts evoke resonances beyond the merely descriptive.

Beyond supplying images to clients, Atget seems to have had an overall design or intention for many of his projects. A voracious reader of 19th-century French literature, he sought to re-create the Paris of the past, photographing buildings and areas marked for demolition in the hope of preserving the ineffable imprint of time and usage on stone, iron, and vegetation. A series of tree and park images *(pl. no. 328)* that Atget made in the outlying sections around Paris suggest a compulsion to preserve natural environments from the destruction already visible in the industrialized northern districts of the city. In the same way, his images of working individuals may have been made to record distinctive trades before they were swept away by the changes in social and economic relationships already taking place.

In the manner of a film director, Atget made close-ups, long shots, details, views from different angles, in different lights, at different times, almost as though he were challenging time by creating an immutable world in two dimensions. The vast number of his images—perhaps 10,000—of storefronts *(pl. no. 319)*, doorways, arcades, vistas, public spaces, and private gardens, of crowds in the street and workers pursuing daily activities—of just about everything but upper-class life—evoke a Paris that appears as part legend, part dream, yet profoundly real.

During the 1920s, the extent and expressive qualities of Atget's work were unknown to all but a small group of friends and avant-garde artists, among them Man Ray, who arranged for several works to be reproduced in the magazine *La Révolution Surréaliste* in 1926. Atget's final year, made especially difficult by the death of a longtime companion as well as by his insecure financial situation, brought him into contact with Berenice Abbott, who at the time was Man Ray's technical assistant. After Atget's death in August 1927, Abbott was able to raise funds to purchase the photographer's negatives and prints and thus bring his work to the attention of American photographers and collectors when she returned to the United States in 1929. In 1968 this vast but still uncataloged collection was acquired by the Museum of Modern Art in New York, which has since displayed and published Atget's exceptional images.[30]

The Origins
of Color
in Camera
Images

The images reproduced in this section constitute a brief pictorial survey of the ways in which color was made part of the photographic image from the inception of the medium up through the invention of the first viable additive color process. It opens with an example of a cyanotype, an early discovery whose brilliant blue was thought to be too unrealistic, and follows with a selection of daguerreotypes and paper prints that were hand-colored by tinting or painting to make them more lifelike or artistic. This group also includes works in carbon and gum bichromate—the manipulative processes that permitted photographers working from about the 1860s through the turn of the century to introduce colored pigments into their positive prints. These are succeeded by examples of the early efforts to produce color images by using colored filters or incorporating dyes into the light-sensitive film emulsions. The first such color experiment—an image of a tartan ribbon— is the work of James Clerk Maxwell, a theoretical physicist who used the additive system to demonstrate color vision by projecting three black and white images through colored filters to achieve a surprising full-color image. The experiments of Ducos du Hauron, John Joly, and Auguste and Louis Lumière—the inventors of Autochrome—are shown, as are examples of work in Autochrome by enthusiasts in Europe and the United States who in the early years of the 20th century recorded family and friends, documented nature, and made aesthetic statements using its mellow hues.

329. ANNA ATKINS. *Lycopodium Flagellatum (Algae)*, 1840s–50s. Cyanotype.
Gernsheim Collection, Humanities Research Center, University of Texas, Austin.

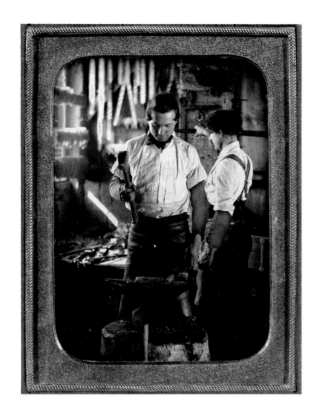

LEFT:

330. UNKNOWN PHOTOGRAPHER (AMERICAN). *Blacksmiths,* 1850s. Daguerreotype with applied color. Collection Leonard A. Walle, Northville, Mich.

BELOW:

331. W. E. KILBURN. *The Great Chartist Meeting on Kennington Common,* April 10, 1848. Daguerreotype with applied color. Royal Library, Windsor Castle, England. Reproduced by Gracious Permission of Her Majesty Queen Elizabeth II.

RIGHT:

332. T. Z. VOGEL AND C. REICHARDT. *Seated Girl,* c. 1860. Albumen print with applied color. Agfa-Gevaert Foto-Historama, Cologne, Germany.

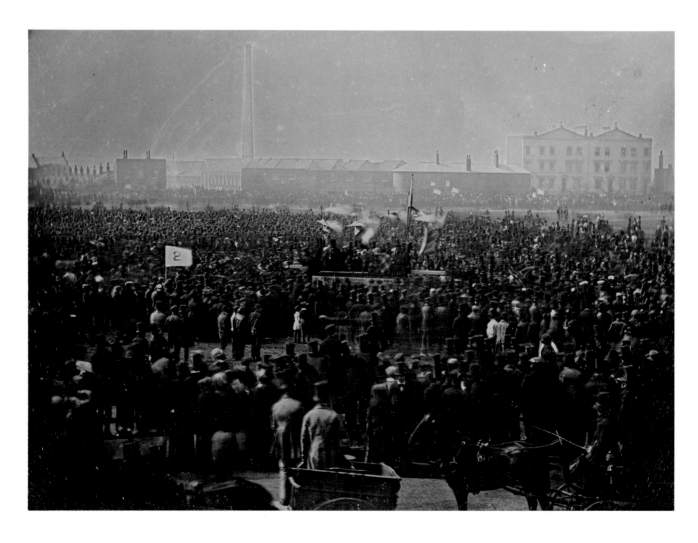

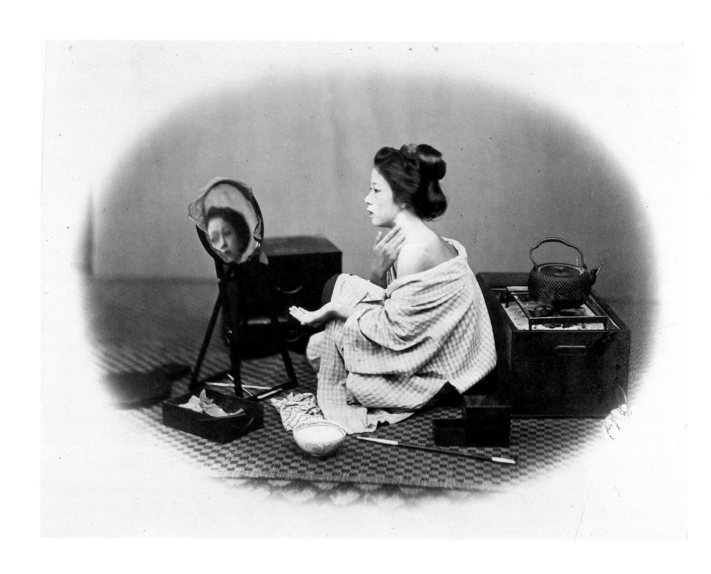

ABOVE:

333. FÉLICE BEATO (ATTRIBUTED). *Woman Using Cosmetics,* c. 1867. Albumen print with applied color, from a published album now without title, Yokohama, Japan, 1868. Art, Prints, and Photographs Division, New York Public Library, Astor, Lenox, and Tilden Foundations; Gift of Miss E. F. Thomas, 1924.

LEFT:

334. LEWIS CARROLL (REV. CHARLES L. DODGSON). *Beatrice Hatch,* 1873. Albumen print with applied color. Rosenbach Museum and Library, Philadelphia. Trustees of the C. L. Dodgson Estate.

RIGHT:

335. ADOLPHE BRAUN. *Still Life with Deer and Wildfowl,* c. 1865. Carbon print. Metropolitan Museum of Art, New York; David Hunter McAlpin Fund, 1947.

336. EDWARD STEICHEN. *The Flatiron*, 1905. Gum-bichromate over platinum. Metropolitan Museum of Art, New York.

337. JAMES CLERK MAXWELL. *Tartan Ribbon*, 1861. Reproduction print from a photographic projection. Science Museum, London.

338. LOUIS DUCOS DU HAURON. *Diaphanie (Leaves)*, 1869. Three-color carbon assembly print. Société Française de Photographie, Paris.

339. LOUIS DUCOS DU HAURON.
View of Angoulëme, France (Agen),
1877. Heliochrome (assembly)
print. International Museum of
Photography at George Eastman
House, Rochester, N.Y.

340. LOUIS DUCOS DU HAURON.
Rooster and Parrot, 1879.
Heliochrome (assembly) print.
International Museum of
Photography at George Eastman
House, Rochester, N.Y.

341. JOHN JOLY. *Arum Lily and Anthuriums*, 1898. Joly process print. Kodak Museum, Harrow, England.

342. LUMIÈRE BROTHERS. *Lumière Family in the Garden at La Ciotat*, c. 1907–15. Autochrome. Ilford S.A., France.

343. LUMIÈRE BROTHERS. *Untitled*, c. 1907–15. Autochrome. Fondation Nationale de la Photographie, Lyon, France.

344. JULES GERVAIS-
COURTELLEMONT. *Canal at
Bièvre*, 1907–20. Autochrome.
Cinémathèque Robert Lynen
de la Ville de Paris.

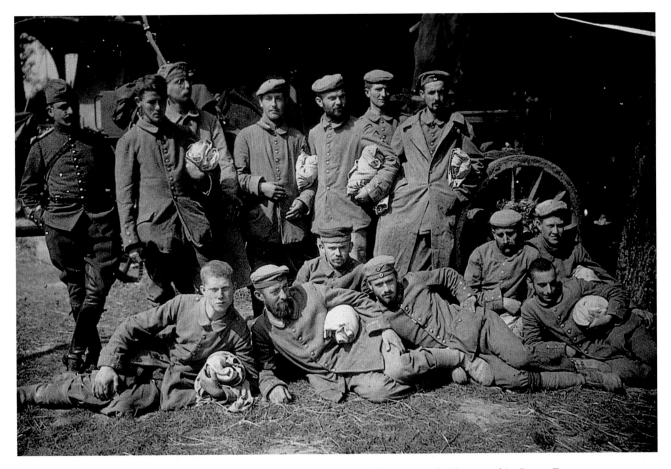

345. JEAN TOURNASSOUD. *Army Scene*, c. 1914. Autochrome Fondation Nationale de la Photographie, Lyon, France.

346. STÉPHANE PASSET.
Mongolian Horsewoman,
c. 1913. Autochrome.
Albert Kahn Collection,
Hauts-de-Seine, France.

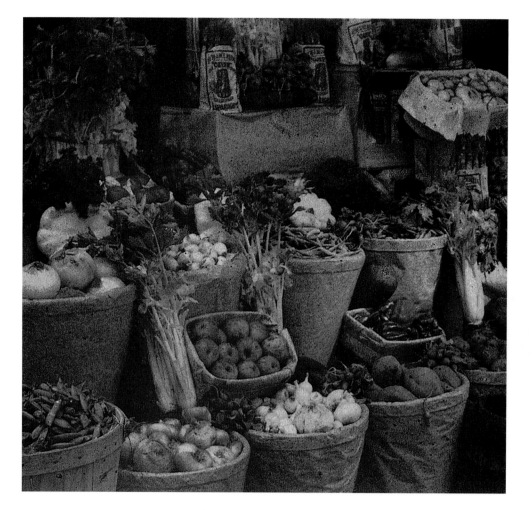

347. WILLIAM RAU.
Produce, c. 1910.
Autochrome. Library
Company of
Philadelphia,
Pennsylvania.

RIGHT:

348. HENRY IRVING.
*Cornflowers, Poppies, Oat,
Wheat, Corncockle*,
c. 1907. Autochrome.
British Museum (Natural
History), London.

349. HEINRICH KUEHN. *Mother and Children on the Hillside*, 1905. Autochrome. Robert Miller Gallery, New York.

350. FRANK EUGENE. *Emmy and Kitty, Tutzing, Bavaria*, 1907. Autochrome. Metropolitan Museum of Art, New York.

351. JACQUES HENRI LARTIGUE. *Bibi in Nice*, 1920. Autochrome. © Assocation Lartigue/SPADEM/VAGA.

352. LAURA GILPIN. *Still Life*, 1912. Autochrome. © 1979 Amon Carter Museum, Fort Worth, Texas. Gift of the artist (P1979.95.42).

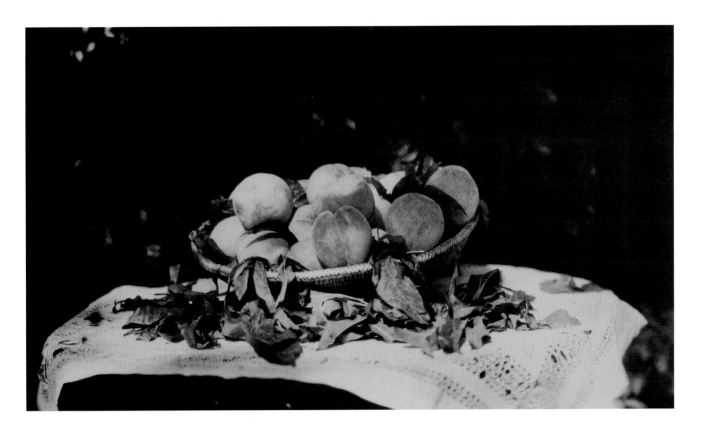

7.

ART PHOTOGRAPHY: ANOTHER ASPECT

1890–1920

*Art is not so much a matter of methods and processes as it is an affair of
temperament, of taste and of sentiment. . . . In the hands of the
artist, the photograph becomes a work of art. . . . In a word, photography
is what the photographer makes it—an art or a trade.*

—William Howe Downes, *1900* [1]

THE PROMOTION OF THE PHOTOGRAPH to the status of an art object was the goal of a movement known as Pictorialism. Based on the belief that camera images might engage the feelings and senses, and nourished initially by the concept of Naturalism articulated by Peter Henry Emerson, Pictorialism flourished between 1889 and the onset of the first World War as a celebration of the artistic camera image. The aesthetic photographers who were its advocates held that photographs should be concerned with beauty rather than fact. They regarded the optical sharpness and exact replicative aspects of the medium as limitations inhibiting the expression of individuality and therefore accepted manipulation of the photographic print as an emblem of self-expression. Animated by the same concern with taste and feeling as other visual artists, Pictorialists maintained that artistic photographs should be regarded as equivalents of work in other media and treated accordingly by the artistic establishment. Many of the images made under the banner of Pictorialism now seem little more than misdirected imitations of graphic art, as uninspired as the dull documentary images to which they were a reaction, but a number have retained a refreshing vitality. More significantly, the ideas and assumptions that sparked the movement have continued to inspire photographers, even though as style Pictorialism became outmoded around 1912.

Why the growing interest in artistic camera images in the last decade of the 19th century? It followed from the simplification of processes and procedures discussed in Chapter 6, and reflected the divergent uses to which the medium was being put as industrialization and urbanization proceeded. The dramatic expansion in the number of photographers (owing to the introduction of dry film and hand cameras) permitted many individuals to regard the photograph simply as a visual record, but it encouraged others to approach the medium as a pastime with expressive potential. Simultaneous with the publication of photographs of daily events, social conditions, and scientific phenomena in reading matter for the increasingly literate public, the wide dissemination of accurate reproductions of masterworks of visual art—also made possible by photographic and printing technologies—made the public more aware of visual culture in general. Furthermore, the emphasis on craft and artistry in journals and societies devoted to amateur photography was specifically aimed at fostering an aesthetic attitude toward the medium on the part of photographers.

This multiform expansion in photography took place against a background of stylistic transition in all the arts. As a consequence of greater familiarity with the arts of the world through reproductions, art collections, and increased travel, artists were able to expand their horizons, confront new kinds of subject matter, and embrace new concepts and ideologies. Within the diversity of styles that emerged, an art of nuance, mystery, and evocation, an art "essentially concerned with personal vision" held a special attraction.[2] Realism, the ascendant motif in the visual arts during much of photography's early existence, was challenged by Symbolists and Tonalists who proclaimed new goals for the arts. Less involved with the appearances of actuality, or with the scientific analysis of light that had engaged artists from Courbet to Monet, Symbolists maintained that while science might answer the demand for truthful information, art must respond to the need for entertainment and stimulation of the senses. However, in photography the situation was complicated by the fact that while some aesthetic photographers held truth and beauty to be antithetical aims, others viewed the medium as a means of combining the aims of art and science and imbuing them with personal feeling.

Pictorialism: Ideas and Practice

During the 1890s, serious amateurs as well as professionals deplored the "fatal facility"[3] that made possible millions upon millions of camera images of little artistic merit. In seeking to distinguish their own work from this mass of utilitarian photographs, Pictorialists articulated a dual role for the medium in which images would provide an unnuanced record on the one hand, and, on the other, provoke thought and feeling. Aesthetic photographers were convinced that in the past "the mechanical nature" of photography had "asserted itself so far beyond the artistic, that the latter might . . . be described as latent,"[4] and they sought to redress this perceived imbalance by selecting subjects traditional to the graphic arts, by emphasizing individualistic treatment and by insisting on the artistic presentation of camera images. Photographs, they held,

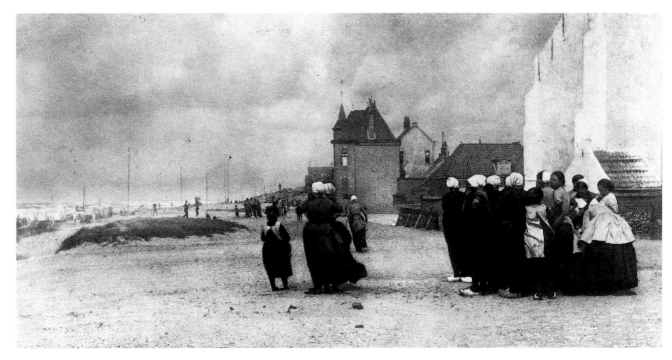

353. ALFRED STIEGLITZ. *Waiting for the Return*, c. 1895. Gravure print. Royal Photographic Society, Bath, England.

should be regarded as "pictures" in the same sense as images made entirely by hand; that is, they should be judged for their artistry and ability to evoke feeling rather than for their powers of description. In their insistence that photographs show the capacity to handle "composition, chiaroscuro, truth, harmony, sentiment and suggestion,"[5] Pictorialists hoped to countervail the still prevalent attitude among graphic artists and the public in general that the camera could not duplicate "the certain something . . . personal, human, emotional . . . in work done by the unaided union of brain, hand and eye."[6] They hoped also to appeal to collectors of visual art for whom aesthetic quality and individuality were important considerations.

Individuality of style was expressed through the unique print, considered by many at the time to be the hallmark of artistic photography. Using non-silver substances such as bichromated[7] gelatin and carbon *(see A Short Technical History, Part II)*—materials originally perfected to assure permanence—photographers found that they were able to control tonalities, introduce highlights, and obscure or remove details that seemed too descriptive. Many of these effects were accomplished by using fingers, stumps, pencils, brushes, and etching tools to alter the forms in the soft gum, oil, and pigment substances before they hardened, or by printing on a variety of art papers, from heavily textured to relatively smooth Japanese tissues. In that no positive print emerged as an exact version of the negative, or an identical duplicate of itself, these manipulations and materials, in addition to serving the expressive needs of the

photographer, also satisfied collectors who preferred rare or singular artifacts. Gum printing, which involves a combination of gum arabic, potassium bichromate, and colored pigment, became popular after 1897 when photographers Robert Demachy in France and Alfred Maskell in England together published *Photo-Aquatint, or the Gum-Bichromate Process*. In 1904 a method of printing in oil pigments evolved, resulting in a greater range of colors available to the photographer. These procedures could be used only if the print were the same size as the negative, but in 1907, the Bromoil process made it possible to work with enlargements as well as contact prints.

These procedures, sometimes called "ennobling processes"[8] because they permitted the exploration of creative ideas by hand manipulation directly on the print, provoked a lively controversy among aesthetic photographers themselves as well as among critics. Excessive handwork produced photographs that at times were indistinguishable from lithographs, etchings, and drawings and led some Pictorialists to deplore the eradication of the unique qualities of the photograph; others cautioned discretion, observing that gum printing "is only safe in exceptionally competent hands,"[9] which regrettably were not numerous. During the early 1900s, the viewpoint that initially had held that the artistic quality of the final work would justify whatever choice of printing materials and techniques had been made gave way, as prestigious figures in artistic photography joined with less sympathetic critics to decry murky, ill-defined photographs as "fuzzygraphics."

Pictorialist advocates of straight printing did not usually intervene directly in the chemical substances of the print, although on occasion they might dodge or hold back portions of the negative. In the main, they followed the course marked out by Emerson, finding in carbon- and platinum-coated paper (Platinotype) the luminous tonalities and long scale of values they believed were unique to the expressive character of the medium. Again like Emerson, many preferred to make multiple images by the hand-gravure process—a method of transferring the photograph to a copper plate that was etched, inked, and printed on fine paper on a flatbed press to produce a limited edition of nearly identical prints.

Pictorialism: Styles and Themes

In looking to painting for inspiration, late-19th-century aesthetic photographers were confronted by a confusing array of outmoded and emerging artistic ideologies and stylistic tendencies, from Barbizon naturalism to Impressionism, Tonalism, and Symbolism. Not surprisingly, many were attracted by motifs that already had been found acceptable by art critics and the public, among which the idealization of peasant life, first explored by Barbizon painters at mid-century, ranked high. This concept in the work of Emerson and Frank Sutcliffe is expressed with down-to-earth robustness, while other aesthetic photographers turned such scenes into embodiments of the picturesque and artful. In one example, *Waiting for the Return (pl. no. 353)* [10]—a photograph of the wives of fishermen waiting on the beach at Katwyck, Holland, for the boats to come in—Alfred Stieglitz selects a vantage point from which he can create an uncluttered arrangement; he controls the tonalities to suggest an atmospheric haze that softens the forms and at the same time endows the women with larger-than-life stature. The horizontal format, the flat tonalities of the figural groups, and the treatment of recessional space also suggest the influence of Japanese woodblock prints.

A theme that attracted both aesthetic photographers and painters was the pure natural landscape. In common with the Symbolist and Tonalist painters who viewed nature as the only force "undisturbed by the vicissitudes of man,"[11] aesthetic photographers in Europe and America regarded landscape with a sense of elegiac melancholy. Taking their cues from the Nocturnes of Whistler, the mystic reveries of the Swiss painter Arnold Boecklin, or the poetic impressions of the Americans George Inness and Henry Ward Ranger, they regarded suggestiveness as more evocative than fact, and preferred the crepuscular moment to sun-drenched daylight, the quiet, intimate pond to dramatic mountain wilderness. Instead of the crisply de-fined forms and strong contrasts of earlier topographical imagery, they offered the vague shapes and subdued tonalities visible in *Woods Interior (pl. no. 354)* by Edward Steichen, a work obviously related in its organization, treatment, and mood to Ranger's scene, *Bradbury's Mill Pond, No. 2 (pl. no. 355)*.

The female figure, both as a study in beauty and a symbol of motherhood was another subject of common interest to painters and aesthetic photographers. Softly focused portraits of elegantly attired enigmatic women—favored by Pictorialists everywhere—stressed stylishness and charm rather than individual strength of character. A related theme, women and children engaged in leisurely domestic activity or at play in home and garden, appealed to both men and women photographers, who produced idealized visions of intimate family life, transforming what formerly had been a prosaic genre subject into a comforting visual idyll of middle-class gentility. With its seemingly random arrangement, curvilinear forms, and delicate tonalities, *The Picture Book* (also called *Instruction, pl. no. 356*) by the renowned American portraitist Gertrude Käsebier isolates its two intertwined figures in a peaceable terrain untroubled by domestic or social friction.

Few motifs better illustrate the gulf that developed between aesthetic camera "pictures" and straight camera documents than the nude figure. Around the turn of the century, Pictorialists on both sides of the Atlantic approached the unclothed body with great diffidence, picking their way timidly through the "canons of good taste." Camera studies of the nude by artists, among them those made by Czechoslovak painter Alphonse Marie Mucha for various decorative commissions in his native land, France *(pl. no. 357)*, and the United States, or the numerous studies of the undraped figure taken by Thomas Eakins (or his students) as study materials for paintings, or for anatomy classes as celebrations of the human form *(pl. no. 254)* were not intended for exhibition or public delectation. Convinced that "ART alone"[12] might sanction this troublesome yet attractive subject, photographers avoided ordinary or coarse-looking models and selected ideally proportioned females whose bodies, it was believed, would suggest beauty rather than sensuality *(pl. no. 358)*. Combining classical poses in landscape settings, to which props suggestive of the "Antique" were sometimes added, with artistic lighting and handwork (at times, extensive) to obliterate telling details, aesthetic photographers hoped to prove that in photography "nude and lewd" need not necessarily be "synonymous terms."[13]

Other than those engaged in a commerce in erotic images, early photographers of the nude had been constrained by the realistic nature of the medium and by Victorian attitudes toward the unclothed human body to

354. EDWARD STEICHEN.
Woods Interior, 1898.
Platinum print.
Metropolitan Museum of
Art, New York; Alfred
Stieglitz Collection, 1933.

FACING PAGE ABOVE:

355. HENRY WARD
RANGER. *Bradbury's Mill
Pond, No. 2*, 1903. Oil on
Canvas. National Museum
of American Art,
Smithsonian Institution,
Washington, D.C.; gift of
William T. Evans.

FACING PAGE BELOW:

356. GERTRUDE KÄSEBIER.
The Picture Book, 1903.
Gravure print. Library of
Congress, Washington,
D.C.

endow their images with allegorical dimension (when they did not direct them to the needs of graphic artists, *see Chapter 5)*. Attitudes began to change shortly before the turn of the century, and as the nude in painting and graphic art emerged from a long history of masquerading as goddess or captive slave (or as in Edouard Manet's *Olympia* as prostitute), the female nude figure became a motif in and for itself in both painting and aesthetic photography. Some photographers still cast their nude figures as sprites and nymphs, but others no longer felt the need to obscure their attraction to the intrinsically graceful and sensuous forms of the unclothed female. Indeed, the very absence of allegory or narrative in this treatment served to emphasize the new role of the photograph as a strictly aesthetic artifact.

While Pictorialists everywhere photographed the nude, aesthetic photographers working in France and the United States most enthusiastically explored the expressive possibilities of this motif. Conventional academic poses and extensive manipulation of the print, typified by the works of French photographers Demachy and René LeBègue *(pl. no. 359)* and the American Frank Eugene *(pl. no. 360)*, rendered some photographs of the nude almost indistinguishable from etchings and lithographs, while a group portrait of nude youngsters by American Pictorialist Alice Boughton *(pl. no. 361)* exemplifies the less derivative arrangement and more direct treatment of light and form that also was possible.

The great majority of aesthetic images of the nude were of adult females, the undraped male body being con-

357. ALPHONE MARIE MUCHA. *A Study for "Figures Décoratives," No. 39*, 1903. Gelatin silver print. Collection Jiri Mucha, Prague.

358. CLARENCE WHITE. *Nude*, c. 1909. Platinum print. Private collection.

359. RENÉ LEBÈGUE. *Académie*, 1902. Gum bichromate print.
Metropolitan Museum of Art, New York; Alfred Stieglitz Collection, 1933.

360. FRANK EUGENE. *Study*, 1899 or
before. Platinum print. Metropolitan
Museum of Art, New York; Alfred
Stieglitz Collection, 1949.

sidered by nearly everyone as too flagrantly sexual for depiction in any visual art intended for viewers of mixed sexes. However, articles on nudity in photography (written largely by men), which had begun to appear in camera journals after 1890, suggested that young boys would make especially appropriate models because their bodies were less sensually provocative than those of women.[14] Wilhelm von Gloeden and F. Holland Day were two significant figures of the period who chose to photograph not only adolescent boys but older males, too. Von Gloeden, a trained painter who preferred the mellow culture of the Mediterranean to that of his native Germany, worked in Taormina, Sicily, between 1898 and 1913 *(pl. no. 362)*, while Day, an early admirer of Symbolist art and literature, was

an "improper" Bostonian of means working in Massachusetts and Maine during the same period. Their images display a partiality to the trappings of classical antiquity, perhaps because they realized that to be artistically palatable the male nude—youthful or otherwise—needed a quasi-allegorical guise. However, although the head wreaths, draperies, and pottery that abound in Von Gloeden's works may have suggested elevated aesthetic aims, and the images were in fact proposed as "valuable for designers and others,"[15] his young Sicilians often seem unabashedly athletic and sexual to modern eyes. On the other hand, Day handled the poses and lighting of the nude male presented in the guise of pastoral figures with such discretion that a contemporary critic observed that "his nude studies

361. ALICE BOUGHTON. *Children—Nude*, 1902. Platinum print. Metropolitan Museum of Art, New York; Alfred Stieglitz Collection, 1933.

are free of the look that makes most photographs of this sort merely indecent."[16]

Some Pictorialist photographers embraced allegorical or literary themes, posing costumed figures amid props in the manner of the Pre-Raphaelites and Julia Margaret Cameron, with results that ranged from merely unsuccessful to what some consider ridiculous. Among the more controversial examples of this penchant for historical legend were reconstituted "sacred" images by Day, by the French Pictorialist Pierre Dubreuil, by Lejaren à Hiller (an American photographer who eventually turned this interest into a success in commercial advertising), and by Federico Maria Poppi, an Italian Pictorialist. The fact that Day's series of religious images were obviously staged, with the photographer himself posing for the Christ figure *(pl. no. 363)*, prompted the critic Charles H. Caffin to call "such a divagation from good taste intolerably silly."[17]

Possibly even more misguided because they lacked any originality, subtlety, or psychological nuance were camera images that aimed to emulate high art by appropriating actual compositions painted by Renaissance masters or Dutch genre painters. Guido Rey and Richard Polack *(pl. no. 364)*, from Italy and the Netherlands respectively, photographed costumed models arranged in settings in which props, decor, and lighting mimicked well-known paintings. In view of the absence of conviction or genuine emotion in all of these works, one could conclude that the orchestration necessary to re-create religious or historical events or painted scenes conflicts with the nature of pure photography. As one critic noted about Day's tableaux, "In looking at a photograph, you cannot forget that it is a representation of something that existed when it was taken."[18]

A strong interest in light and color, which for some Pictorialists had found an outlet in pigment printing processes, prompted others to experiment with Lumière Autochrome plates when this color material reached the market in 1907. In general, European Pictorialists who favored gum and oil pigment processes for working in color regarded Autochrome as too precise for artistic effects.[19] An exception was the Austrian Heinrich Kuehn *(see Profile)*, who joined with the Americans Alvin Langdon Coburn, Frank Eugene *(pl. no. 350)*, Steichen, and Stieglitz to investigate the range and possibilities of the material. Kuehn was highly successful in harmonizing the dyes—cool, airy blues and greens—to achieve a sense of spontaneous intimacy in views of family life *(pl. no. 349)*, despite the long exposures required. Works in Autochrome by members of the American Photo-Secession *(see below)*, several of which also pictured family members and their activities, are somewhat more static in organization and more mellow in color, reflecting the somber harmonies of some *fin-de-siècle* painting in Europe and the United States. The fact that Autochrome transparencies were difficult to exhibit and to reproduce may account for their relatively brief popularity among the leading Photo-Secessionists, but other (later) American Pictorialists, including Arnold Genthe and Laura Gilpin *(pl. no. 352)*, continued to use the material into the 1920s.

Pictorialist Societies: Goals and Achievements

By the early 1890s, established photographic societies, set up in an era when objectives in photography were largely undifferentiated, no longer served the needs of all photographers. Unconcerned with, and indeed often contemptuous of, the commercial and scientific aspects of photography that the older societies accommodated, partisans of aesthetic photographs began to form groups whose sole

362. WILHELM VON GLOEDEN. *Study, Taormina, Sicily*, 1913. Gelatin silver print. International Museum of Photography at George Eastman House, Rochester, N.Y.

aim was to promote camera art. The Secession movement led to the formation of the Wiener Kamera Klub in 1891, The Linked Ring in 1892, the Photo-Club de Paris in 1894, and the Photo-Secession in New York in 1902. In the same years, amateur photographic societies in Germany, Italy, the Hapsburg domains, Russia, and the smaller cities of the United States made available forums for the exchange of information about aesthetic concepts and processes, and provided exhibition space for the work of local Pictorialists and that of the better-known figures of the Secession movement.

Exhibiting aesthetic photographs in an appropriate context was a paramount goal of the movement. Besides sponsoring their own gallery spaces, the most famous of which was the Little Galleries of the Photo-Secession in New York (known as "291"), photographers attempted to interest galleries, museums, and fine arts academies in displaying camera images either alone or in conjunction

363. F. HOLLAND DAY. *Untitled (Crucifix with Roman Soldiers)*, c. 1898.
Platinum print. Library of Congress, Washington, D.C.

364. RICHARD POLACK. *The Artist and His Model*, 1914. Platinum print.
Royal Photographic Society, Bath, England.

365. ALFRED HORSLEY
HINTON. *Recessional*, c. 1895.
Gravure print. Royal
Photographic Society, Bath,
England.

with examples of graphic art. They urged also that photographers be represented on the juries of selection for photographic shows, since they alone would have the experience to separate imaginative and tasteful from uninspired works. Starting in 1893, and continuing into the 20th century, a number of prestigious institutions in Germany and the United States began to exhibit camera images, among them the Royal Academy in Berlin, the Hamburg Künsthalle, and the Albright, Carnegie, and Corcoran galleries in the United States. Artistic photographs were exhibited at several of the large fine and decorative art exhibitions, including one sponsored by the Munich Secession in 1898, and the international shows at Glasgow in 1901 and in Turin in 1904. An exhibition devoted entirely to artistic photography held in 1891 under the auspices of the *Club der Amateur-Photographien* of Vienna became a model for annual exhibitions or Salons that were started in London and Hamburg in 1893, in Paris in 1894, and in Brussels, Vienna, and The Hague in the following years.

Art photography attracted articulate support in periodi-

cals and books. Before 1890, photographic, literary, and general interest journals in Europe and the United States had devoted space to a discussion of the artistic merits of the medium, and while they continued to do so, after 1890 a literature whose sole purpose was to promote the movement flowered not only in the cosmopolitan centers of the west but in Russia, Italy, and Eastern Europe. *Camera Work*, launched in New York in 1903 by members of the Photo-Secession, and praised for the exceptional level of design and gravure reproduction it maintained throughout its 14 years of existence, was one of a number of periodicals that included *Photogram, La Revue Photographique* and *Photographische Kunst* in which similar aesthetic positions were as lucidly (if not as tastefully) embraced. Magazines with a popular readership also included articles on artistic photography. Between 1898 and 1918, for example, American art critic Sadakichi Hartmann, who was eulogized "as the first art critic who realized the possibility of photography being developed into a fine art,"[20] placed some 500 articles on artistic photography in a variety of American and European journals. Around 1900, full-length works conceived in the tradition of earlier tracts on photographic art by Emerson or Henry Peach Robinson formulated the theoretical arguments for aesthetic photography. To cite but two, *La Photographie est-elle une art?* by French critic Robert de la Sizeranne—a work exceptionally influential in Eastern Europe as well as in France—and *Photography as a Fine Art*, by the American critic Charles Caffin, attempted to convince the cultivated viewer that since the same expressive concerns animated all artists no matter what medium they used, the same criteria should be applied to images made by camera and by hand.

The Linked Ring—the first major organization to institutionalize the new aesthetic attitudes—was formed by a number of English amateurs whose disenchantment with The Photographic Society of London (renamed the Royal Photographic Society in 1894) prompted them to secede from that body in 1891 and 1892. This group, which included George Davison, Alfred Horsley Hinton (editor after 1893 of *Amateur Photography*), Maskell, Lydell Sawyer, and Henry Peach Robinson, modeled their organization on a contemporary art group—the New English Art Club—and encouraged members, accepted by invitation only, to pursue "the development of the highest form of Art of which Photography is capable."[21] Though Emerson himself was not a member, the Ring followed his precept that "a work of art ends with itself; there should be no ulterior motive beyond the giving of aesthetic pleasure. . . ."[22] They established relationships with Pictorialist photographers in other countries, some of whom were honored with invitations to become "Links" and to submit work to the yearly exhibitions at the annual Salon of Pictorial Photography, known as the London Salon. British members seem to have been inspired primarily by landscape; their work is marked by the unusually somber moods visible in gum prints by Hinton *(pl. no. 365)* or in Davison's *The Onion Field* (also called *An Old Farmstead, pl. no. 366)*, made using a camera with a pinhole instead of a lens. Combining the rural subject matter of Naturalistic photography with an impressionistic treatment that makes all substances—fields, buildings, sky, and clouds—appear to be made of the same stuff, this work was exceptionally influential among photographers of the time. For example, it prompted Alexander Keighley, a photographer of somewhat derivative genre scenes, to turn to romantic soft-focus treatments of landscape *(pl. no. 367)*. A similar use of atmospheric haze and broad shapes and tonalities in dealing with city themes can be seen in John Dudley Johnston's *Liverpool—An Impression (pl. no. 368)*, a pensive view with subtle Whistler-like nuances achieved by consummate handling of the gum process.

James Craig Annan, Frederick H. Evans, and Frank M. Sutcliffe represent members of the Ring who favored straight printing and chose to evoke poetic feelings through means other than the manipulation of printing materials. Annan, an accomplished gravure printer,[23] produced artistic effects by the subtle handling of light and shadow seen in the linear patterns in the water in *A Black Canal (pl. no. 369)*. Sutcliffe suggests the ethereal quality of fog-enshrouded places in *View of the Harbor (pl. no. 370)* by his control of the relationship of foreground to background tonalities. In *Kelmscott Manor: In the Attics, (pl. no. 371)* Evans, the Ring's most esteemed architectural photographer, summons up a serene sense of peacefulness and of humane order in the arrangement of architectonic elements and delicate tonalities.

The *Photo-Club de Paris* was organized in 1894 by Maurice Bucquet to provide an alternative to the professionally oriented *Société Française de Photographie*; in the same year it inaugurated an annual Salon. Members included Demachy, LeBègue, and E. J. Constant Puyo, all ardent enthusiasts of handwork. Up until 1914, when he gave up the medium, Demachy used his considerable means and leisure to promote artistic photography and its processes, collaborating, as has been noted, with Maskell in 1897 and with Puyo in 1906 on a manual of artistic processes in photography.[24] In his own work, he favored nudes, bucolic landscapes, and dancers, and frequently printed in red, brown, and gray pigments using the gum process. The images of ballet dancers *(pl. no. 372)* were considered "delightful" by his contemporaries, but when compared with paintings and drawings on this theme by Edgar Degas, they seem derivative and lacking in vitality. Puyo, a former commandant in the French army, at times favored impressionistic effects in landscape and genre scenes *(pl.*

366. GEORGE DAVISON.
The Onion Field, 1890.
Gravure print. Kodak
Museum, Harrow, England.

LEFT:

367. ALEXANDER
KEIGHLEY. *Fantasy*, 1913.
Carbon print. Royal
Photographic Society, Bath,
England.

RIGHT:

368. JOHN DUDLEY
JOHNSTON. *Liverpool—An
Impression*, 1906. Gum
bichromate print. Royal
Photographic Society, Bath,
England.

ABOVE:

369. JAMES CRAIG ANNAN. *A Black Canal (Probably Venice)*, 1894. Gravure print. Metropolitan Museum of Art, New York; Alfred Stieglitz Collection, 1949.

LEFT:

370. FRANK MEADOW SUTCLIFFE. *View of the Harbor*, 1880s. Carbon print. Photography Collection, New York Public Library, Astor, Lenox, and Tilden Foundations.

RIGHT:

371. FREDERICK H. EVANS. *Kelmscott Manor: In the Attics*, 1896. Platinum print. J. Paul Getty Museum, Los Angeles.

372. ROBERT DEMACHY. *A Ballerina*, 1900. Gum bichromate print. Metropolitan Museum of Art, New York; Alfred Stieglitz Collection, 1949.

373. E. J. CONSTANT PUYO. *Summer*, 1903. Green pigment ozotype. Metropolitan Museum of Art, New York; Alfred Stieglitz Collection, 1933.

no. 373) and at other times sharply defined Art Nouveau decorative patterns, especially in portraits of fashionable women. He designed and used special lenses to create these effects but also condoned extensive manipulation as a way of vanquishing what he called "automatism"—that is, the sense that the image was produced by a machine without feeling. Other members included Leonard Misonne, a Belgian photographer of city and rural scenes, and Dubreuil, who portrayed pastoral landscapes around Lille (pl. no. 374) in the manner of the French painter Constant Troyon, but later adopted modernist ideas.

The earliest international exhibition of Pictorialist works in German-speaking countries took place in Vienna in 1891 under the auspices of the *Wiener Kamera Klub*. It was seen by the Austrian Kuehn and the Germans Hugo Henneberg (*pl. no. 375*) and Hans Watzek (*pl. no. 376*); three years later these three emerged as the most prominent art photographers in central Europe, exhibiting together as the *Trifolium* or *Kleeblatt*. In Germany, the exhibitions held at Berlin, Hamburg, and especially Munich toward the end of the 19th century had made it clear that the camera was more than a practical tool and that the photograph might be a source of aesthetic pleasure as well as information.

Portraiture was one of the first motifs to be affected by the new sensibility, with inspiration coming from an exhibition of portraits by David Octavius Hill and Robert Adamson included in the Hamburg International Exhibition in 1899 and in an exhibition in Dresden in 1904. Portrait photographers began to realize that artistic discrimination in lighting, combined with attention to expressive contour, might create more evocative works than was possible with the unmodulated studio illumination that played evenly over conventionally posed sitters. This awareness prompted a new approach by the well-known portrait team of Rudolf Dührkoop and his daughter Minya Diez-Dührkoop (*pl. no. 377*) in Hamburg and by Hugo Erfurth in Dresden. The strong tonal contrast and attention to contour in Erfurth's portrait of Professor Dorsch (*pl. no. 378*) continued to mark the persuasive portraits made by this photographer into the 1920s. Other portraitists of the time whose work reflected an interest in artistic lighting and treatment were Nicola Perscheid, working in Berlin and Leipzig, and the partners Arthur Benda and Dora Kallmus—better known as Madame D'Ora—who maintained a studio in Vienna from 1907 through 1925. Besides printing in silver and gum, all three were interested in a straight color printing process known as Pinatype, a forerunner of dye-transfer printing invented in France in 1903 (*see A Short Technical History, Part II*).

Landscapes, still life, and figural compositions, many of which were subject to extensive manipulation, absorbed

374. PIERRE DUBREUIL. *Dusk on the Marsh in the Snow*, 1898. Silver bromide print. Museum für Kunst und Gewerbe, Hamburg.

both professional and amateur photographers in Germany. Large works in gum in strong colors, produced jointly by the Hamburg amateurs Oskar and Theodor Hofmeister (*pl. no. 379*), were exhibited at the London Salon and 291, and collected by Stieglitz, but other German Pictorialists were equally adept and turned out images similar in style and quality; *The Reaper (pl. no. 380)*, a gum print in blue pigment by Perscheid, is typical of the genre. Heinrich Beck, a minor government official, was awarded a silver medal at the 1903 Hamburg exhibition of art photography (*pl. no. 381*); Georg Einbeck, a former painter, combined graphic and photographic techniques to create exhibition posters; and Gustav E. B. Trinks, an employee of an import-export company, exhibited silver bromide and gum prints at all the important Pictorialist exhibitions. Otto Scharf, in his time one of the most respected art photographers in Germany, was extravagantly praised for the brilliance with which he handled silver, platinum, and colored gum materials to evoke mood and feeling in scenes typified by *Rhine Street, Krefeld (pl. no. 382)*, a green gum print of 1901.

Artistic photography made headway elsewhere in Europe, too, with individuals in Holland, Belgium, and the Scandinavian countries drawing inspiration from Pictorialist activity in France and Germany. The work of

375. HUGO HENNEBERG. *Italian Landscape and Villa,* 1902. Pigment gum print. Metropolitan Museum of Art, New York; Alfred Stieglitz Collection, 1933.

376. HANS WATZEK. *Still Life,* from the portfolio *Gummidrucke,* c. 1901. Gravure print. Art Museum, Princeton University, Princeton, N.J.

377. RUDOLF DÜHRKOOP AND MINYA DIEZ-DÜHRKOOP. *Alfred Kerr,* 1904. Oil pigment print. Royal Photographic Society, Bath, England.

378. HUGO ERFURTH. *Professor Dorsch,* 1903. Gum bichromate print. Staatliche Landesbildstelle, Hamburg; Museum für Kunst und Gewerbe, Hamburg.

ABOVE:

379. OSKAR AND THEODOR
HOFMEISTER. *The Haymaker,*
c. 1904. Gum bichromate print.
Royal Photographic Society,
Bath, England.

LEFT:

380. NICOLA PERSCHEID.
The Reaper, 1901. Gum bichromate
print. Museum für Kunst und
Gewerbe, Hamburg.

ART PHOTOGRAPHY :: 317

381. HEINRICH BECK.
Childhood Dreams, 1903.
Gum bichromate print.
Museum für Kunst und
Gewerbe, Hamburg.

382. OTTO SCHARF.
Rhine Street, Krefeld,
1898. Gum bichromate
print. Museum für
Kunst und Gewerbe,
Hamburg.

383. JOSÉ ORTÍZ ECHAGÜE. *Young Singers*, c. 1934. Direct carbon print. San Diego Museum of Art; purchased by the Fine Arts Society, 1934.

384. SERGEI LOBOVIKOV. *Peasant Scene*, probably late 1890s. Gelatin silver print. *Sovfoto Magazine* and VAAP, Moscow.

Finnish photographers Konrad Inha (born Nyström) and Wladimir Schohin suggests the range of artistic camera work outside the better-known cosmopolitan centers of Europe. Inha, a journalist, made romantic images of rural landscape and peasant life in the Naturalist mode, which he published in 1896 as *Pictorial Finland*, while Schohin, owner of a retail business in Helsinki, used carbon, gum, and bromoil processes, and experimented with Autochrome, in his depictions of the middle-class life of his milieu.

To the south, the city of Turin, Italy, played host to the International Exposition of Modern Decorative Art in 1903, thereby providing Italians with an opportunity to see a collection of American works selected by Stieglitz. A year later, *La Fotografica Artistica*, an Italian review of international pictorial photography was founded, and a small group began to make artistic works in the medium. Their work ran a gamut from the previously mentioned reconstructed religious scenes to genre studies of provincial life to atmospheric landscapes. The Spanish amateur photographer José Ortíz Echagüe began to work in the Pictorialist style around 1906, continuing in this tradition until long

after the style had become outmoded; his artfully posed and lighted genre images *(pl. no. 383)*, reproduced in several publications on Spanish life that appeared during the 1930s, tend toward picturesqueness.[25]

Despite the political instability and economic changes taking place in eastern Europe and the continued emphasis in many localities on ethnographic photographs to advance the cause of nationalism, a strong interest in photography as self-expression led to the formation of amateur Pictorialist societies in the major cities of an area that now includes Czechoslovakia, Rumania, and Hungary, with the movement especially vital in Poland. The Club of Photographic Art Lovers and the journal *Photographic Review*, established in Lvov in 1891 and followed by similar groups in other Polish cities, provided an opportunity for the exhibition and reproduction of the works of important Pictorialists, including Demachy, Kuehn, and Steichen. The president of the Lvov group, Henryk Mikolasch, observed that artistic photographs might "reflect thought, soul, and word," in place of "tasteless and pedantic . . . exactness,"[26] a concept that led him to idealize peasant life in his own images, which he printed in gum. In common

385. ALEXIS MAZOURINE. *River Landscape with Rowboat*, n.d. Platinum print. Staatliche Landesbildstelle, Hamburg; Museum für Kunst und Gewerbe, Hamburg.

that avoids sentimentality. In contrast, Alexis Mazourine, descendant of an esteemed Moscow family, sought inspiration in the more cosmopolitan centers of Hamburg and Vienna, where his platinum landscapes *(pl. no. 385)* and figure compositions were as well known as in his own country. A group that emerged in Japan around 1904 devoted itself to art photography, producing lyrical, soft-focus scenes that often resemble popular paintings.

Pictorialism in the United States

American photographs shown at the London Salon in 1899 were singled out for the "virtues" of "concentration, strength, massing of light and shade and breadth of effect"[27]—qualities exemplified in Day's unusual portrait of a young black man entitled *An Ethiopian Chief (pl. no. 386)*. Several factors made American work appear vigorous in European eyes. For one, the Pictorialist movement was exceptionally broad-based, with activities in small towns and major cities, and it attracted people from varied economic, social, and regional backgrounds. Unlike their European counterparts, who were mainly men of means or in the arts, Americans of both sexes, active in commercial photography, in the arts, in business, in the professions, and as housewives, joined photographic societies, giving the movement a varied and democratic cast.

Women, who were more active in all aspects of photography in the United States, were especially prominent in Pictorialism. Gertrude Käsebier, the most illustrious of the female portraitists, was praised for having done more for artistic portraiture *(pl. no. 387)* than any other of her time—painter or photographer—by her discerning sense of "what to leave out."[28] Many women, among them Boughton, Zaida Ben-Yusuf, Mary Devens, Emma Farnsworth, Clara Sipprell, Eva Watson-Schütze, and Mathilde Weil, specialized in portraiture and refined themes, exemplified by *The Rose (pl. no. 388)*—a portrait in Pre-Raphaelite style by Watson-Schütze. The nude, sometimes conceived in allegorical terms, attracted Anne W. Brigman, Adelaide Hanscom, and Jane Reece; Brigman's 1905 work *The Bubble (pl. no. 389)* is typical of the idyllic treatment accorded this subject by both men and women at a time when such camera images were just becoming accepted by sophisticated viewers. Women also were among the early professional photojournalists in the United States; Frances Benjamin Johnston, who exhibited at salons and joined the Photo-Secession, was a freelance magazine photographer of note *(see Chapter 8)*. In 1900, she collected and took abroad 142 works by 28 women photographers for exhibition in France and Russia—further evidence that as a medium without a long tradition of male-dominated academies, photography offered female

with much Pictorialist photography outside of London, Paris, and New York, artistic camera work in Poland was firmly tied to naturalism and the Barbizon tradition, to which the so-called ennobling processes added a sense of atmosphere; eventually these means were integrated into the modernist style that emerged in Poland in the 1920s *(see Chapter 9)*.

Around 1900, the concept of art photography attracted a number of Russian photographers of landscape and genre, who heeded the call by Nikolai Petrov, later artistic director of the Pictorialist journal *Vestnik Fotografi (Herald of Photography)*, to go beyond the unfeeling representation of nature. Employing gum and pigment processes, they, too, adopted a creative approach to subjects taken from Russian village life. This work, exemplified in photographs by Sergei Lobovikov *(pl. no. 384)* that were exhibited in Dresden, Hamburg, and Paris as well as in Russia, also evolved from the concept of the nobility of peasant life, but with their subtle balance of art, documentation, and compassion they have a distinctive character

386. F. HOLLAND DAY. *An Ethiopian Chief,* c. 1896. Platinum print.
Metropolitan Museum of Art, New York; Alfred Stieglitz Collection, 1933.

participants an opportunity for self-expression denied them in the traditional visual arts.[29]

Another difference between Americans and Europeans involved attitudes toward the manipulation of prints that made photographs look like works of graphic art. Reflecting the considerable disagreement among American critics about the virtues of handwork on negatives and prints, photographers in the United States chose less frequently to work with processes that completely obscured the mechanical origin of camera images. Whether members of the Photo-Secession or not, they preferred platinum, carbon, and, less often, gum-bichromate, sometimes in combination with platinum, to bromoil and oil pigment materials. Even when availing themselves of the variety of colorations made possible with gum-bichromate, they favored, with several notable exceptions, direct printing without hand intervention on relatively smooth rather than heavily textured papers.

Traces of a wide variety of tendencies current in graphic art are to be seen in the work of American Pictorialists.

387. GERTRUDE KÄSEBIER. *Robert Henri*, c. 1907.
Silver print toned and coated to simulate gum print.
Sheldon Memorial Art Gallery, University of Nebraska,
Lincoln; F. M. Hall Collection.

388. EVA WATSON-SCHÜTZE. *The Rose,*
1903 or before. Gum bichromate print.
Metropolitan Museum of Art, New York;
Alfred Stieglitz Collection, 1949.

Within the Photo-Secession and in some of the better-organized Pictorialist societies in the East, the dominant styles were derived from Tonalist and Symbolist paintings, but the influence of other movements in the arts, in particular that of the French Barbizon painters, is also visible. Toward 1900, the art of the Japanese became an especially potent influence, reaching both graphic artists and photographers in the United States in part through the writings of the eminent art teacher Arthur Wesley Dow, who translated its concepts into a system of flat tonal harmonies called *notan*. With its emphasis on subtle ungraduated tonalities, this manner of handling chiaroscuro, in concert with simplicity of composition and absence of deep spatial perspective, imparted a distinctively decorative aspect to many Pictorialist images.

Several regional Pictorialist groups were primarily concerned with landscape imagery. Many members of the Photographic Society of Philadelphia—a venerable club organized in 1862 and the first to actively promote artistic photography—drew nourishment from the earlier tradition of landscape imagery supported by *The Philadelphia Photographer (see Chapter 3)*, as well as from the Naturalistic concepts of Emerson. Individual members, among them Robert S. Redfield, Henry Troth, and Woodbridge endeavored to achieve "unity of style and harmony of effect"[30] and to subordinate description to artistic purpose

in subtly modulated landscapes printed on platinum *(pl. no. 390)*. In New York State, another such group, the Buffalo Camera Club (organized 1888) also displayed a reverential attitude toward nature. Asserting the need for attention to "harmonious composition and well-managed lights and shadows,"[31] their handling of light and atmosphere, exemplified in founding member Wilbur H. Porterfield's *September Morning*, 1906, *(pl. no. 391)*, projects a melancholy mood similar to that in the tonalist paintings of Inness, Ranger, and Alexander Wyant.

Photographers in these groups and others working on their own in the same tradition often were not considered first-rate by the mentors of Pictorialism, in part because they tended to cling to outdated attitudes regarding theme and treatment. For instance, Leigh Richmond Miner, instructor of art at Virginia's Hampton Institute around the turn of the century, viewed the black farmers and fishermen living on the islands off the coast of South Carolina with reverence and cast his many images of them in a heroic mold. Other photographers of Southern rural life,

among them Clarence B. Moore, a member of the Photographic Society of Philadelphia, and Rudolf Eickemeyer, Jr., a well-known New York Pictorialist, transformed rural people into ingratiating genre types, emphasizing industriousness and nobility of character through their choices of lighting and pose. Remnants of this approach lingered into the 1930s, as can be seen in portraits made by Prentice Hall Polk, official photographer at Tuskeegee Institute *(pl. no. 392)*, and by New York portraitist Doris Ulmann, who idealized the inhabitants of the Appalachian highlands where she photographed in the late 1920s and '30s *(pl. no. 393)*.

Similar picturesque qualities characterize many of the portraits made by Arnold Genthe of the inhabitants of San Francisco's Chinese quarter *(see Chapter 6)*, except that a number of his images, though seen through the haze of a romanticizing vision, have a refreshing spontaneity that distinguishes them from more statically posed rural genre images. Genthe was a member of the California Camera Club, which was organized in 1890 in San Francisco and,

389. ANNE W. BRIGMAN. *The Bubble*, 1905. Gelatin silver print. Art Museum, Princeton University, Princeton, N.J.; gift of Mrs. Raymond C. Collins.

390. LOUISE DESHONG
WOODBRIDGE. *Outlet on the
Lake*, 1885. Platinum print, 1898.
Janet Lehr, Inc., New York.

391. WILBUR H. PORTERFIELD.
September Morning, 1906.
Gelatin silver print. Buffalo and
Erie County Historical Society,
Buffalo, N.Y. © Cowles-Media.

with 400 or so members, was for many years the primary enclave of art photography on the West Coast. Although members of the group, including Laura Adams Armer, Anne W. Brigman, William Dassonville, and Oscar Maurer, participated in Salon exhibitions on the East Coast and in Europe, and several became members of the Photo-Secession, no cohesive style of California photography emerged.

Instead, the flat massing of tonal areas, seen in Armer's *Chinatown (pl. no. 394)* and in many other examples from this region, seems related to the pervasive interest in the arts of Japan that affected photography everywhere in the United States during the last decade of the 19th century.

Idealization was the keynote of the extensive pictorial document of American Indian life undertaken in 1899 by

392. PRENTICE HALL POLK. *The Boss*, 1933. gelatin silver print. Courtesy and © Prentice Hall Polk.

Edward S. Curtis. While camera studies of Indian life were being made at the time by a number of photographers, Curtis (funded in part by the financier J. P. Morgan) may be considered with the Pictorialists because he selected for his portrayal of the "vanishing race" picturesque individuals—mainly women and elders—and on occasion even provided them with appealing costumes. He composed and cropped scenes carefully and printed on platinum paper or by gravure, eventually producing 20 volumes and a like number of portfolios of text and images entitled *The North American Indian*. The photographer's endeavor to conjure up a rhapsodical vision of American Indian experience, as well as to make an ethnographically correct document, is exemplified in *The Vanishing Race (pl. no. 196)*. His work, which briefly found a market soon after the turn of the century, appealed to Americans who had begun to regard Native Americans as an "exotic spectacle" to be promoted as a tourist activity. However, until 1970, this portrayal had for nearly half a century remained unknown to the photographic community and the public alike.

The Photo-Secession

With adherents throughout the nation who embraced a variety of approaches and a wide latitude of standards with regard to artistic photography, the Pictorialist movement was spread out and amorphous during the last years of the 19th century. Cohesiveness, direction, and exclusivity followed the formation in 1902 of the Photo-Secession. Organized by Stieglitz to compel "the serious recognition of photography as an additional medium of pictorial expression"[32] and of himself as a prime figure, it grew out of works selected and sent abroad in 1900 by Day and Stieglitz, both of whom were eager to demonstrate the high quality of aesthetic photography in the United States. Nevertheless, although Day's exhibition, "The New American School of Photography," had been exceptionally well-received in London and Paris, by 1902 he was forced to recognize that Stieglitz had emerged as leader of a vanguard movement that he baptized the Photo-Secession. Eventually numbering some 100 members, the founders included John G. Bullock, of the Photographic Society of Philadelphia, Eugene, Käsebier, Joseph Keiley—an important critic and publicist for the movement—Edward Steichen, and Clarence H. White. All were prominent in organizing and showing work in the national and international exhibitions of art photography held around 1900. While constituted as a national body, the Photo-Secession was most active in New York City, where Stieglitz served as editor of its publication, *Camera Work*, and presided over 291.

The formidable role played by Stieglitz in the establishment of this elite wing of American Pictorialism has received ample attention, but the active participation of Steichen, who found and installed the exhibition space, designed the cover and publicity for *Camera Work*, and initiated contacts with the French graphic artists whose works eventually formed an important part of Secession exhibits and publicatons, is less well known. Steichen's own work in photography during this early period (before he gave up painting) displayed a mastery of manipulative techniques that enabled him to use gum and pigment processes as well as platinum to suggest subtle nuances with a distinctive flair *(pl. no. 336)*. Because his later work in advertising photography had an even more signal effect on American photography, his contribution will be discussed more fully in Chapter 10.

Another of the founders, White *(see Profile)* was active in aesthetic photography *(pl. no. 395)* first in the Midwest and after 1906 in New York, where he turned to teaching both as a way of making a living and of imparting to others his profound belief in the expressive potential of the medium. Involved primarily with light and its symbolism, he used it to invest ordinary domestic scenes with subtlety, tenderness, and a genteel quality similar to that found in the work of American painters William Merritt Chase, John Singer Sargent, and James Abbott McNeill Whistler.

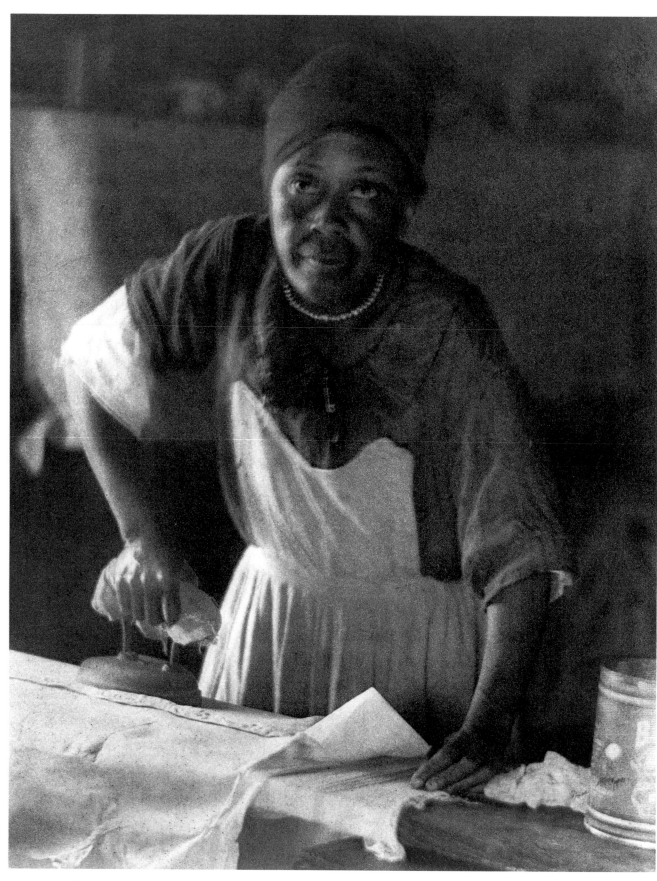

393. DORIS ULMANN. *Untitled*, c. 1925–34. Gravure print.
Museum of Modern Art, New York; gift of Mrs. John D. Rockefeller, III.

394. LAURA ADAMS ARMER. *Chinatown*, c. 1908. Gelatin silver print. California Historical Society Library, San Francisco.

395. CLARENCE H. WHITE. *The Orchard*, 1902. Gravure print. Private Collection.

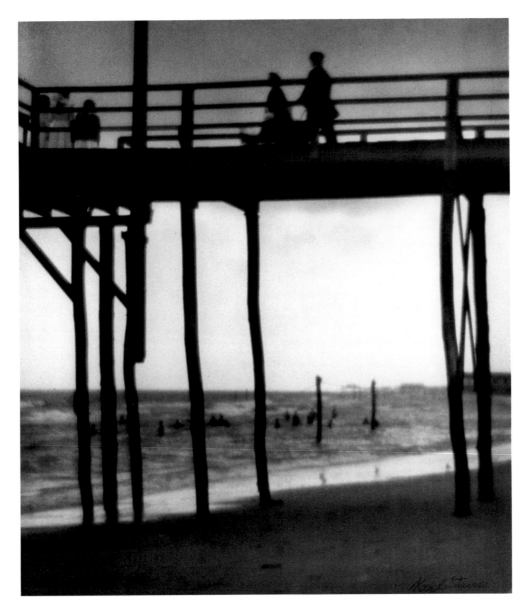

In the main, Photo-Secession members produced landscapes, figure studies, and portraits—themes favored by Pictorialists everywhere—but a small group that included Coburn, Paul Haviland, Steichen, Stieglitz, and Karl Struss undertook to portray the city—heretofore an "untrodden field" in artistic photography.[33] In common with their contemporaries, the painters of the New York Realist school (The Eight, later known popularly as the Ashcan painters), these photographers found their subjects in the bridges, skyscrapers, and construction sites they regarded as affirmations of the vitality of urban life during the opening years of the 20th century. The Flatiron building, a looming prow-shaped structure completed in 1902, was seen as a symbol of power and culture—"a new Parthenon"—in images by Coburn, Haviland, Steichen, and Stieglitz. The harbor, with traffic that brought new work-

ers to the continent and day workers to the city, inspired Coburn, Haviland, and Stieglitz. Brooklyn Bridge and other East River crossings still under construction were photographed by Steichen, Struss *(pl. no. 396)*, and Coburn *(pl. no. 397)*, who actually considered these structures metaphors for the conquest of nature by human intelligence.

Coburn in particular regarded the camera as the only instrument, and photography the only medium, capable of encapsulating the constantly changing grandeur of the modern city.[34] As a younger Secessionist—he was twenty-two when he joined in 1904—his willingness to experiment with a variety of themes that included portraiture, urban views *(pl. no. 398)*, and industrial scenes animated the Secession's activities during its early years despite his fairly regular travels between the United States and England. A consummate printer in platinum and gum,

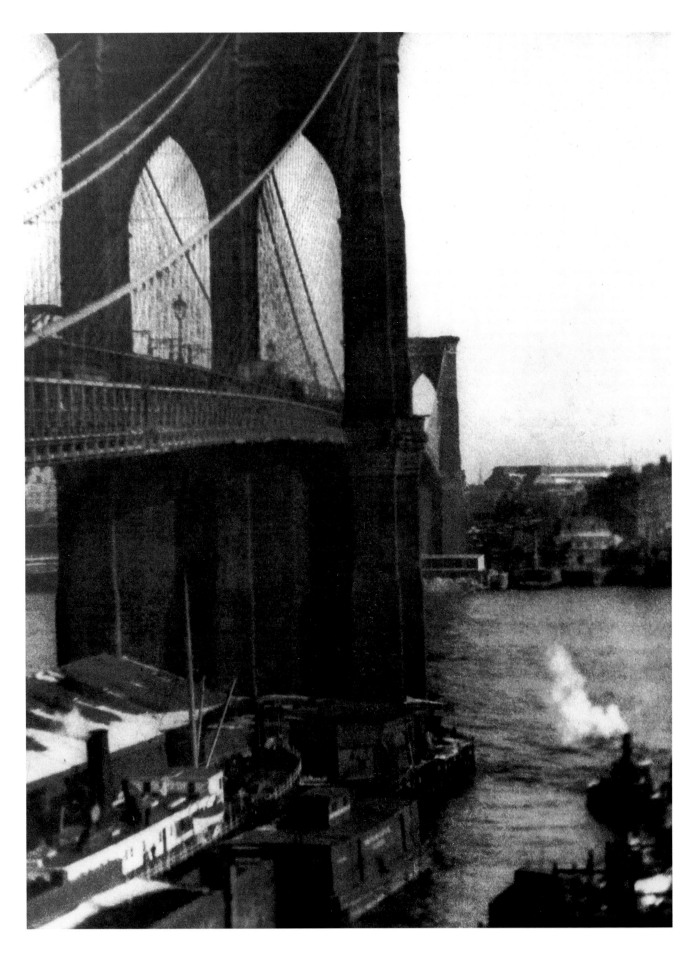

398. ALVIN LANGDON COBURN. *The Octopus*, 1912. Platinum print. International Museum of Photography at George Eastman House, Rochester, N.Y.

399. ADOLF DE MEYER. *Water Lilies*, 1906. Platinum print. Metropolitan Museum of Art, New York; Alfred Stieglitz Collection, 1933.

Coburn also worked in gravure, setting up his own press in London in 1909 and experimenting extensively with Autochrome. In spite of the brilliance of his early work and the avant-garde nature of the abstractions he made in 1917 *(see Chapter 9)*, after World War I he gave up serious involvement with the medium to pursue other interests.

In terms of vitality and influence, the American Pictorialist movement expired during the second decade of the 20th century despite efforts by several Pictorialists, among them White and Coburn, to keep an organization and periodical afloat.[35] The Photo-Secession had from the start planned to show other visual art along with photographs at its gallery, but, following their introduction in 1907, camera images began to play a less important role in both the exhibition schedule of 291 and in *Camera Work*, largely as a result of Stieglitz's conviction that little creative work was being produced in photography. This view was strengthened by criticism (by Hartmann and others) of the camera images shown at the Dresden Exposition of 1909 and in the Albright Gallery in Buffalo in 1910—the last large-scale exhibition of Pictorialist photography sponsored by the Secession. Between 1911 and 1916, only three photographic shows were held at 291: portraits and still lifes by Adolf de Meyer *(pl. no. 399)*, a German-born photographer who was just beginning a fashionable career in Lon-

don; Stieglitz's own work, timed to coincide with the Armory Show of modern art in 1913; and the last exhibition of photographs before the gallery closed—the work of Paul Strand in 1916, which included early soft-focus landscapes as well as cityscapes. The choice of these startling "candid" portraits of New York street people and of the virtually abstract studies by Strand for the final issue of *Camera Work* signaled the shift in sensibility that was taking place on an international scale at the time.

In Europe, most of the aesthetic movement, already by 1910 a victim of organizational dissension and prewar malaise, was abruptly terminated by the first World War, which put an end to the leisurely life that had provided much of its impetus and thematic material. After 1914, individual European photographers were scattered and isolated, with artistic interchange in virtually all media difficult. Even before the hostilities, however, the new aesthetic concepts that had become visible in the other visual arts began to influence photographers. In addition to the reaction against extensive hand-manipulation of the print, which had been in the air for a number of years, some photographers, among them Dubreuil and Kuehn, began to introduce greater definition and to deal with form in the more abstract fashion visible in Kuehn's *Artist's Umbrella* of 1910 *(pl. no. 400)*, a work in which the view from above

400. HEINRICH KUEHN. *Artist's Umbrella*, before 1910. Gravure print. Metropolitan Museum of Art, New York; Alfred Stieglitz Collection, 1949.

converts the picture plane into a two-dimensional design. A new interest in realism also emerged to herald the concern with straight photography and modernist style that would engage the next generation of photographers.

Pictorialism was an instrument that enabled the aesthetic photograph to be regarded as a persuasive expression of personal temperament and choice. Despite misguided attempts to emulate traditional paintings and works of graphic art, despite disagreements about the qualities that give the photographic prints their unique character, and despite many images that now seem hackneyed and uninspired, a body of forceful work was created under the banner of aesthetic photography. Both the seriousness of purpose and the efforts by the movement to erase the division between the way critics and the public viewed images made entirely by hand and those produced by a machine have continued to be vital concepts that still engage photographers and graphic artists alike.

Profile: Alfred Stieglitz

Alfred Stieglitz proclaimed his belief in the uniqueness of his native heritage in a credo written for an exhibition of

401. ALFRED STIEGLITZ.
Sun's Rays—Paula, Berlin, 1889.
Gelatin silver print.
Art Institute of Chicago;
Alfred Stieglitz Collection.

402. ALFRED STIEGLITZ.
The Steerage, 1907.
Gravure print.
Private Collection.

his work in 1921: "I was born in Hoboken. I am an American. Photography is my passion. The search for truth my obsession."[36] Nevertheless, as a body, his images suggest a complexity of influences and sources of which the American component was at first the least marked. The oldest of six children of a part-Jewish German family that had emigrated to the United States in 1849, Stieglitz spent his youth in a comfortable milieu that placed unusual emphasis on education, culture, and attainment. Taken to Germany in 1881 to complete his education, he enrolled in a course in photochemistry given by the eminent Dr. Hermann Wilhelm Vogel; from then on he was absorbed

mainly by photography and by other visual art, although he continued an interest in science, music, and literature. *Sun's Rays—Paula, Berlin (pl. no. 401)*, a study made in Berlin by Stieglitz in 1889, reveals a fascination with the role of light and with the replicative possibilities of photography, as well as an understanding of how to organize forms to express feeling.

After almost ten years abroad, during which his ability as a photographer had become recognized, Stieglitz returned to New York City in 1890 and became a partner in the Photochrome Engraving Company. He soon found himself more interested in campaigns to promote the rec-

403. ALFRED STIEGLITZ.
Equivalent, 1929. Gelatin
silver print. Art Institute
of Chicago; Alfred
Stieglitz Collection.

ognition of photography as a means of artistic expression, working at first as editor of the journal *American Amateur Photographer*, then through the Camera Club of New York and its periodical *Camera Notes*, and finally through the Photo-Secession and *Camera Work*, which he published and edited from 1903 to 1917. Besides organizing and judging national exhibitions of Pictorialist photography, Stieglitz presided, until 1917, over 291, the Photo-Secession gallery, where, along with Steichen and, later, with Paul Haviland and Marius de Zayas, he helped awaken the American public and critics to modern European movements in the visual arts. He was in contact for a brief period in 1915

with the New York Dada movement through the journal *291* and the Modern Gallery.

In his development as a photographer, Stieglitz began to draw upon the urban scene for his subjects shortly after his return to New York in 1890 *(pl. no. 312)*. At the time, his motifs were considered inappropriate for artistic treatment in photography even though Realist and Impressionist painters in Europe had been dealing with similar material for over 40 years. As his personal style evolved, the influence of German *fin-de-siècle* painting, of the Japanese woodblock, and of Symbolist and Cubist *(pl. no. 402)* currents became visibly interwoven into coherently structured and

moving images that seem to embody the reality of their time. Following the closing of the gallery and journal in 1917, Stieglitz turned full attention to his own work—a many-faceted portrait of his wife-to-be, the painter Georgia O'Keeffe. In the early 1920s, he undertook what he called *Equivalents (pl. no. 403)*—images of clouds and sky made to demonstrate, he claimed, that in visual art, form, and not specific subject matter, conveys emotional and psychological meaning. Another series from later years consists of views of New York skyscrapers taken from the window of his room in the Shelton Hotel *(pl. no. 404),* which incorporate abstract patterns of light and shadow that express the fascination and the loathing that he had come to feel for the city.

Feeling incomplete without a gallery or publication, between 1917 and 1925 Stieglitz used rooms at the Anderson Galleries to promote the work of a circle of American modernists in painting and photography that comprised, besides himself, Arthur Dove, Marsden Hartley, John Marin, O'Keeffe, and Strand. The Intimate Gallery opened in 1925, lasted four years, and was followed by An American Place, which endured until his death in 1946. Aside from exhibitions of his own work, only four of photography were held between 1925 and 1946, suggesting that his interest in the medium had become parochial.

Stieglitz's career spanned the transition from the Victorian to the modern world, and his sensibilities reflected this amplitude of experience. His creative contribution,

404. ALFRED STIEGLITZ. *From the Shelton Westward— New York*, 1931–32. Gelatin silver print. Philadelphia Museum of Art; lent by Dorothy Norman.

405. CLARENCE H. WHITE. *Ring Toss*, 1899. Platinum print. Library of Congress, Washington, D.C.

summed up by Theodore Dreiser in 1899 as a "desire to do new things" in order to express "the sentiment and tender beauty in subjects previously thought devoid of charm,"[37] was conjoined to a great sense of mission. While not unique, his efforts to improve the way photographs were presented at exhibitions and reproduced in periodicals were notably effective in the campaign for the recognition of the photograph as an art object, while his openness to new sensibilities enabled him to introduce Americans to European modernism and to the avant-garde styles of native artists. In both roles—as expressive photographer and impresario—he may well have had a more profound influence on the course of aesthetic photography in America than any other individual.

Profile: Clarence H. White

Clarence H. White may be considered the archetypal Pictorialist photographer of the United States. Neither flamboyant in personality nor bohemian in taste, he emerged from a background of hardworking Midwestern provincialism to create works of unusual artistic sensitivity and sweet compassion, with the people and places of his intimate surroundings as subjects. His best images, among them *Ring Toss (pl. no. 405)*, reveal a perceptive appreciation of the special qualities of domesticity and feminine activi-

406. JOHN SINGER SARGENT. *The Daughters of Edward D. Boit*, 1882. Oil on canvas. Museum of Fine Arts, Boston; gift of Mary Louise Boit, Jane Hubbart Boit, and Julia Overing Boit, in memory of their father.

ties, themes that also attracted a number of the painters of the time, including William Merritt Chase and John Singer Sargent *(pl. no. 406)*. Despite his preference for genre and allegorical subjects, White's camera images rarely are hackneyed or sentimental. His receptivity to a variety of aesthetic influences—the art of Japan, the Pre-Raphaelites, Whistler, and *Art Nouveau*—which had reached middle America in contemporary magazine illustration, may account for the captivating freshness of his vision.

Working full-time as an accountant for a wholesale grocery firm, White still found opportunities for his own photography and time to promote Pictorialism in the Newark (Ohio) Camera Club. Shortly before 1900, he joined with Day, Käsebier, and Stieglitz in organizing and jurying the major American exhibitions of Pictorialist photography. During his lifetime, he showed work in more than 40 national and international exhibitions, frequently garnering top honors and critical acclaim. In 1906, two years after leaving his job to devote him entirely to his medium, he moved his family to New York City in the hope that it might be more possible to earn a living in photography. A year later, White began to teach, first at Columbia University, then at the Brooklyn Institute of Arts and Sciences, and finally at his own Clarence White School of Photography, which he founded in 1914. Among his celebrated students were Margaret Bourke-White, Anton Bruehl, Laura Gilpin, Dorothea Lange, Paul Outerbridge, Ralph Steiner, and Doris Ulmann, attesting to the marked influence of this school on many photographers of the next generation.

During White's first years in New York, he and Stieglitz collaborated on a series of nude studies, exemplified by a sensuous image of *Miss Thompson (pl. no. 407)*, but on the whole, White's creativity did not flourish in the city, perhaps due to the time and energy required to pursue a teaching career and manage a school. Although his contributions to Pictorialism were recognized by Stieglitz when the latter assigned him a special gallery in the 1910 "International Exhibition of Pictorial Photography" in Buffalo, the relationship between the two started to deteriorate as Stieglitz identified White with Pictorialist themes and styles he now considered repetitive and insipid. In 1916, White joined with other disaffected Secessionists to form The Pictorial Photographers of America, hoping thereby to support aesthetic photography while keeping alive the group idea, which to his mind had been one of the appealing aspects of the Photo-Secession.

Towards the 1920s, White's images began to reflect some of the changes in outlook occasioned by American awareness of modernist trends in art, but in 1925, before he could integrate the new vision into his own refined sensibility, he died while accompanying a student expedition to

Mexico. With their concentration on light and atmosphere, their carefully realized tonal and spatial tensions, and an authentic sense of domestic grace, White's photographs embody the tonalist style in American Pictorialism.

Profile: Heinrich Kuehn

Both the career and imagery of Heinrich Kuehn may be said to personify the ideals of Pictorialism in central Europe. According to a modern critic, his "works repre-sent a clear expression of the aspirations of . . . [the] period," which were to "confirm the artistic quality of photography."[38] Kuehn's sensitivity to the expressive aspects of composition, light, and form, as well as his deep involvement with a wide variety of photographic printing processes, may seem unusual in view of his background in medicine and microscopic photography, but the 1891 exhibition in Vienna of the work of The Linked Ring appears to have redirected his interest from science to aesthetics.

On joining the *Wiener Kamera Klub* in 1894 after mov-

407. CLARENCE H. WHITE and ALFRED STIEGLITZ. *Miss Thompson*, 1907. Gravure print. Private Collection.

408. FRANK EUGENE. *Frank Eugene, Alfred Stieglitz, Heinrich Kuehn, and Edward Steichen.* Gum bichromate print. Royal Photographic Society, Bath, England.

ing to Innsbruck, Austria, from his birthplace Dresden, Kuehn formed a friendship with Hugo Henneberg, a club member who introduced him and Hans Watzek to the gum printing methods used by Demachy in Paris. From about 1898 to 1903, these three photographers worked and exhibited together, signing their images with the clover leaf monogram that invited the name *Trifolium* or *Kleeblatt*. After Watzek's death in 1902 and Henneberg's shift of interest to printmaking in 1905, Kuehn continued to organize photographic events, to work on his own experiments with gum, and to publish technical articles. His contacts with British and American Pictorialists, Stieglitz in particular, now provided the inspiration he formerly had derived from the *Kleeblatt*. A meeting in Bavaria in 1907 with Eugene, Stieglitz, and Steichen *(pl. no. 408)* led to experiments by all four photographers with the new Autochrome color plates. Around 1906, Kuehn began also to associate with members of the Vienna Secession and the founders of *Wiener Werkstätte* (Vienna Workshop), easily integrating Viennese Art Nouveau into his personal approach.

Kuehn's themes and motifs reflect a tranquil middle-class domestic existence, not entirely dissimilar from the provincial small-town life that inspired White's most moving images. In portraits of family and friends *(pl. no. 349)*, spacious interiors, and gracious still lifes, as well as in occasional genre scenes, he was profoundly concerned, as was White, with light and with decorative design. Besides the influences of Art Nouveau, one can also discern in Kuehn's photographs the impact of *fin-de-siècle* European painting, in particular that of the Germans Max Liebermann and Franz von Lenbach. A suggestion of the new concepts with which the visual arts would be concerned began to surface in Kuehn's crisper delineations of form around 1910 *(pl. no. 400)*, but on the whole his stylistic and thematic approach changed very little, and while aesthetic photography was supplanted in the 1920s and '30s by *Die Neue Sachlichkeit* (The New Objectivity), Kuehn, unlike his friend and associate Stieglitz, seems to have been unwilling or unable to embrace these new perceptions even though he continued to photograph and write on into the 1930s.

8.

DOCUMENTATION: THE SOCIAL SCENE *TO 1945*

The true use for the imaginative faculty of modern times is to give ultimate vivification to facts, to science and to common lives.

—*Walt Whitman, 1860*[1]

Documentary: That's a sophisticated and misleading word. And not really clear. . . . The term should be documentary style*. . . . You see, a document has use, whereas art is really useless.*

—*Walker Evans, 1971*[2]

AS AN INEXPENSIVE AND REPLICATIBLE MEANS of presenting (supposedly) truthful verifications of visual fact, camera images were bound to become important adjuncts of the campaigns waged by reformers in industrialized nations during the 19th century to improve inequitable social conditions. Nevertheless, while photography's potential for this purpose was recognized soon after the medium's inception, a characteristic form for social documentation did not emerge until the end of the century. Then, shaped by both the emergence of organized social reform movements and the invention of an inexpensive means of mechanically reproducing the photograph's halftones, social photography began to flower in the aspect that we know today.

A tandem phrase, social documentary, is sometimes used to describe works in which social themes and social goals are paramount, because the word documentary could refer to any photograph whose primary purpose is the truthful depiction of reality. Indeed before 1880, nearly all unposed and unmanipulated images were considered documentation; since then, millions of such records of people, places, and events have been made. The word social also presents problems when used to describe the intent of a photograph because many camera images have as their subject some aspect of social behavior. For instance, commercial *cartes (pl. no. 409)*, snapshots, postcards, artistic and photojournalistic images often depict social situations; that is, they deal with people, their relationships to one another and the way they live and work even though the motives of their makers have nothing to do with social commitment or programs. This said, however, it also must be emphasized that one cannot be too categorical about such distinctions, since all photographs defy attempts to define their essential nature too narrowly, and in the case of works that have social change as their prime goal the passage of time has been especially effectual in altering purpose, meaning, and resonance.

Documentary, as Evans observed, refers also to a particular style or approach. Although it began to emerge in the late 19th century, the documentary mode was not clearly defined as such until the 1930s, when American photography historian Beaumont Newhall noted that while the social documentary photographer is neither a mere recorder nor an "artist for arts sake, his reports are often brilliant technically and highly artistic"—that is, documentary

images involve imagination and art in that they imbue fact with feeling.[3] With their focus mainly on people and social conditions, images in the documentary style combine lucid pictorial organization with an often passionate commitment to humanistic values—to ideals of dignity, the right to decent conditions of living and work, to truthfulness. Lewis Hine, one of the early partisans of social documentation *(see Profile)*, explained its goals when he declared that light was required to illuminate the dark

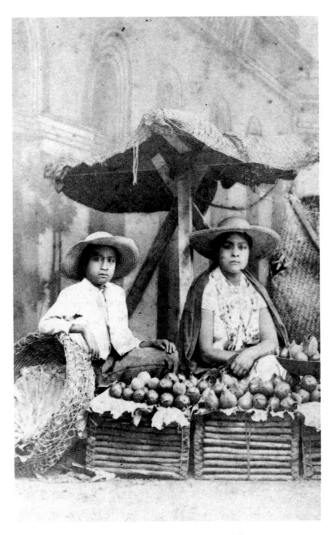

409. CRUCES AND CO. *Fruit Vendors*, 1870s. Albumen print. Bancroft Library, University of California, Berkeley.

areas of social existence, but where to shine the light and how to frame the subject in the camera are the creative decisions that have become the measure of the effectiveness of this style to both inform and move the viewer.[4]

A crucial aspect of social documentation involves the context in which the work is seen. Almost from the start, photographs meant as part of campaigns to improve social conditions were presented as groups of images rather than individually. Although they were included at times in displays at international expositions held in Europe and the United States in the late-19th and early-20th centuries, such works were not ordinarily shown in the salons and exhibitions devoted either to artistic images or snapshots. They were not sold individually in the manner of genre, landscape, and architectural scenes. Instead, socially purposive images reached viewers as lantern slides or as illustrations in pamphlets and periodicals, usually accompanied by explanatory lectures and texts. Indeed, the development of social documentary photography is so closely tied to advances in printing technology and the growth of the popular press that the flowering of the movement would be unthinkable without the capability of the halftone process printing plate to transmute silver image into inked print *(see A Short Technical History, Part II)*. In this regard, social documentation has much in common with photoreportage or photojournalism, but while this kind of camera documentation often involved social themes, the images usually were not aimed at social change.

Early Social Documentation

Few images of a socially provocative nature were made in the period directly following the 1839 announcements of the twin births of photography. The small size, reflective surfaces, and uniqueness of the daguerreotype did not suit it for this role despite attempts by some to document such events as the workers' rallies sponsored by the Chartist Movement in England in 1848 *(pl. no. 331)*. The slow exposure time and broad definition of the calotype also made it an inefficient tool for social documentation. Of greater importance, however, is the fact that the need for accurate visual documentation in support of programs for social change was a matter of ideology rather than just technology; it was not until reformers grasped the connections between poverty, living conditions, and the social behavior of the work force (and its economic consequences) that the photograph was called upon to act as a "witness" and sway public opinion.

Nevertheless, although social betterment was not initially involved, images of working people were made soon after portraiture became possible. Usually commissioned by the sitters themselves, some images straddle the line between individual portrait and genre scene, as in a daguerreotype by an unknown American depicting blacksmiths at work *(pl. no. 330)*. Its particularity of detail—it includes surroundings, tools, work garments, and individual facial characteristics—coupled with the revelation of a sense of the upright dignity of the two men pictured, reflects attitudes toward rural and artisan labor similar to those embodied in the work of the American genre painters such as William Sidney Mount.

Calotypists who favored the picturesque genre tradition generally regarded working people as types rather than individuals, and portrayed them in tableauxlike scenes such as one of hunters by the French photographer Louis Adolphe Humbert de Molard *(pl. no. 257)*. Others found more natural poses and more evocative lighting in order to place greater emphasis on individual expression and stance rather than on tools and emblems of a particular occupa-

410. T. G. DUGDALE. *Pit Brow Girl, Shevington*, 1867. Albumen *carte-de-visite*. A. J. Munby Collection, Trinity College Library, Cambridge, England.

411. WILLIAM CARRICK. *Russian Types (Milkgirl)*, c. 1859.
Albumen *carte-de-visite*. Collection and © Felicity
Ashbee, London.

412. WILLIAM CARRICK. *Russian Types (Balalaika Player)*,
c. 1859. Albumen *carte-de-visite*. Collection and © Felicity
Ashbee, London.

tion or station in life. This approach, visible in images of
farm laborers made by William Henry Fox Talbot on his
estate at Lacock and of fisherfolk in Newhaven by David
Octavius Hill and Robert Adamson, may be seen as indica-
tions of the growing interest among artists and intellectu-
als not only in the theme of work but in working people as
individuals.

A consciously conceived effort involving the depiction
of working people was undertaken in 1845 by Hill and
Adamson. Probably the first photographic project to em-
brace a socially beneficial purpose, it apparently was sug-
gested that calotypes might serve as a means of raising
funds to provide properly decked boats and better fishing
tackle that would improve the safety of the fishermen of
the village of Newhaven, Scotland. Intending to present

their subject in as favorable light as possible for cosmopoli-
tan viewers, Hill and Adamson made beautifully composed
and lighted calotypes of individuals *(pl. no. 51)* and groups
that may be seen as especially picturesque forerunners of
the documentary style.

After the invention of the collodion negative, which
made possible the inexpensive Ambrotype, and the still
cheaper and easily replicated albumen print on paper,
working people began to be photographed more frequent-
ly, appearing on *cartes-de-visite* and other formats. With
the subjects posed in studios in front of plain backdrops,
often with the tools of their trade, these works, meant
either as mementos for the sitter or souvenir images for
travelers, ordinarily pay little attention to actual conditions
of work or to the expressive use of light and form to reveal

character. The incongruity between studio decor and occupation, for example, is obvious in an 1867 English *carte* of a female mine worker *(pl. no. 410)* who, appropriately clothed for work in clogs, trousers, and headscarf, stands squarely before a classy paneled wall with a studio prop of a shovel by her side. One exception to the generally undistinguished character of such *cartes* is the work of Danish photographer Heinrich Tönnies, who maintained a studio in the provincial town of Aalborg between 1856 and 1903.[5] In common with many such portraitists, Tönnies photographed all classes of people—carpenters, housemaids, chimney sweeps, waiters—as well as the town's more prosperous folk, but despite the anomaly of the decorated studio carpet and occasional painted backdrop, his images reveal a feeling for character that endows these working-class sitters with unusual individual presence *(pl. no. 69)*.

Similar images of working people in cultures outside of western Europe and the United States served mainly as souvenirs. To cite but two examples, William Carrick, a Scottish photographer who opened a studio in St. Petersburg, Russia, in 1859, and Eugenio Maunoury, a French national working in Peru at about the same time, each produced *cartes* of peddlers, street traders, and peasants. The distinctive quality of Carrick's *Russian Types (pl. nos. 411 and 412)*, a series of over 40 images made in Simbirsk that fall partway between portraiture and picturesque genre, probably is owed to the photographer's expressed sympathy for humble clients to whom he devoted special attention.[6] Maunoury, said to have been associated with Nadar's studio in Paris before appearing in Lima in 1861, may have been the first to introduce the genre *carte* to this part of South America, but his static studio scenes depict working-class types as glum and inert *(pl. no. 413)*.

Commercial photographers working in the Near and Far East in the latter part of the 19th century produced larger-format views in which working people, social life, native customs, and seemingly exotic dress were featured. Felix Bonfils, whose scenic views of the Near East were mentioned earlier, was a prolific producer of such socially informative views, many of which show the women of the Ottoman Empire in characteristic dress and activity but with uncharacteristic ease of pose and expression *(pl. no. 414)*. This naturalness, and the fact that in a number of instances native women posed without veils, is attributable to the pictures being taken not by Bonfils himself but by his wife, Marie Lydie Cabannis Bonfils, who worked in the family studios in Beirut, Baalbeck, and Jerusalem between 1867 and 1916. In South America, a similar engagement with the life of the lower classes can be seen in the images of field peasants by Argentinian photographer Benito Panunzi *(pl. no. 415)*.

Unquestionably, the most graceful studio portrayals of artisans, laborers, and geisha are the large-format albumen prints turned out in the Japanese commercial establishments of Félice Beato, Reteniz von Stillfried, and Kusakabe Kimbei. The subtle handling of light and the artful arrangements of props and figures create a rare tension between information—what work is done, what garments are worn—and idealization. Enhanced further at times by delicate hand-coloring or by vignetting *(pl. no. 333)*, these highly decorative images may be seen as camera equivalents of the *Ukiyo-e* woodblock prints that also often featured depictions of working people.

Social life and ways of work engrossed amateur as well as commercial photographers working or traveling in these parts of the world. During 1857, compositions by British amateur William Johnson appeared each month in the periodical *Indian Amateurs Photographic Album* under the title "Costumes and Characters of Western India" *(pl. no. 191)*. Photographs of lower-caste Hindus taken by British

413. EUGENIO MAUNOURY. *Three Portraits*, c. 1863. Albumen *cartes-de-visite*. Collection H. L. Hoffenberg, New York.

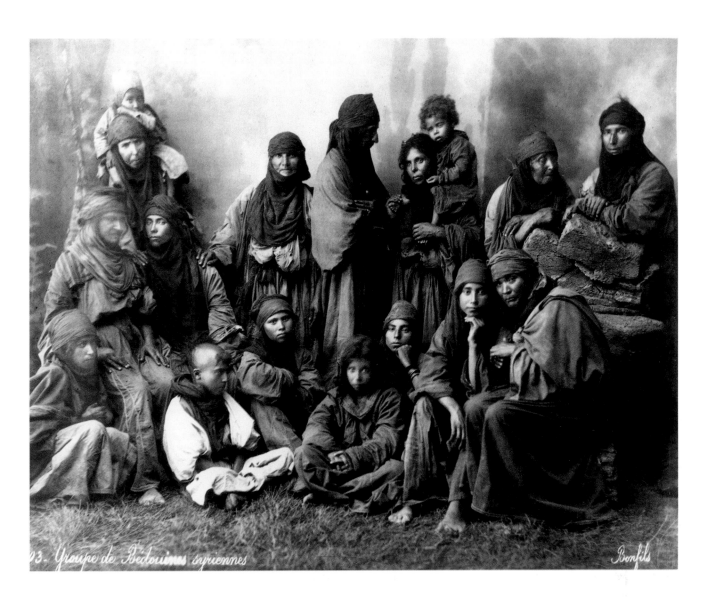

414. Marie Lydie Cabannis Bonfils. *Group of Syrian Bedouin Women*, c. 1870. Albumen print. Semitic Museum, Harvard University, Cambridge, Mass.

415. Benito Panunzi. *Settlers in the Countryside*, c. 1905. Albumen print. Collection H. L. Hoffenberg, New York.

416. WILLOUGHBY WALLACE HOOPER. *The Last of the Herd, Madras Famine,* 1876–78. Albumen print. Royal Geographic Society, London.

Army Captain Willoughby Wallace Hooper are further indications of the growing interest among Westerners in the social problems of the lower classes around the world *(pl. no. 416)*. Perhaps the most completely realized result of a kind of curiosity about the way people live is a four-volume work entitled *Illustrations of China and Its People,* published by photographer John Thomson in England in 1873/74. With a lively text and 200 photographs taken during the photographer's four-year stay in China, the work attempted to make an arcane and exotic way of life understandable and acceptable to the British public by showing industrious and well-disposed natives *(pl. no. 192)* interspersed with unusual architectural and natural monuments *(pl. no. 138)*. In so doing, Thomson helped create a style and format for documentation that carried over to projects concerned with social inequities.

A somewhat different view of the non-Westerner emerged in the photographs of Native American tribesmen by cameramen attached to the geographical and geological surveys of the American West. Early images by the Canadian Humphrey Lloyd Hime, and later works by the Americans Jack Hillers, William Henry Jackson, and Timo-

thy O'Sullivan, for example, depict "native races" with a sober directness unleavened by the least sense of the picturesque. Hillers's views of the Southern Paiute and Ute tribes, made on the Powell Expedition of 1872, were especially influential in establishing a style of ethnic and social documentation that had as its goal the presentation of information in a clear fashion without either idealization or undue artistry. This approach was taken over by the Bureau of American Ethnology after 1879, and it became a cornerstone of the social documentary style that began to emerge in the late 19th century. This style also informed such sociologically oriented documents as *Report on the Men of Marwar State,* mentioned in Chapter 2 *(pl. no. 417)*.

Although the works discussed so far were sometimes published in books and albums, or were sold commercially, their impact on Western viewers is difficult to gauge. On the other hand, there is no question about the impact of the hundreds of thousands of stereograph views of similar social material published by commercial stereograph firms. From 1860 on, as capitalist nations opened up large areas of Africa, Asia, and South America for trade, exploitation, and colonization, companies such as Negretti and

Zambra, the London Stereoscopic Company, and Underwood and Underwood sent photographers—some known, some still anonymous—to record people at work and their housing, dress, and social customs. These three-dimensional views, accepted by the public as truth that "cannot deceive or extenuate,"[7] were in fact taken from the point of view of the industrialized Westerner; but while the scenes frequently were chosen to emphasize the cultural gap between the civilized European or American and the backward non-white, it is possible that glimpses of social life, such as two stereographic views of conditions in Cuba at the turn of the century *(pl. nos. 418 and 419)*, inadvertently awakened viewers to inequities in colonized areas.

Toward the close of the 19th century, interest in social customs led some photographers to capture on glass plate and film indigenous peoples and folk customs that were in

417. UNKNOWN PHOTOGRAPHER. *1 of 1565 Aahirs; He Sells Cow Dung* (from *Report on the Men of Marwar State [Jodhpur]*, 3rd volume), c. 1891. Albumen print. American Institute of Indian Studies, Chicago.

418. UNDERWOOD and UNDERWOOD (Publishers). *Wretched Poverty of a Cuban Peasant Home, Province of Santiago*, 1899. One-half of an albumen stereograph. Keystone-Mast Collection, California Museum of Photography, University of California, Riverside.

419. UNDERWOOD and UNDERWOOD (Publishers). *The Courtyard of a Typical Cuban Home, Remedios*, 1899. One-half of an albumen stereograph. Keystone-Mast Collection, California Museum of Photography, University of California, Riverside.

420. CHARLES L'HERMITTE. *On the Coast of Plomarc'h, Douarnenez*, 1912. Gelatin silver print. Explorer, Paris.

danger of extinction. In Europe, this role was assumed in the 1880s by Sir Benjamin Stone, a comfortably situated English manufacturer who hoped that a "record of ancient customs, which still linger in remote villages," would provide future generations with an understanding of British cultural and social history.[8] Somewhat later, José Ortíz Echagüe, a well-to-do Spanish industrialist, and Charles L'Hermitte, the son of a renowned French Salon painter, undertook similar projects, seeking out customs, costumes, and folkways in provincial byways that they believed would soon vanish with the spread of urbanization. Exemplified by L'Hermitte's photograph of lace-makers in Brittany made in 1912 *(pl. no. 420)*, such images tend toward nostalgia in that they romanticize handwork and folk mannerisms while seldom suggesting the difficulties and boredom of provincial life.

Similar attempts to use the camera both to arrest time and to make a comparative statement about past and pre-

sent can also be seen in the work of several photographers in the United States who turned their attention to native tribal life just before the turn of the century. In contrast to the earlier unnuanced records by Hillers and others of Indian dress and living arrangements, these projects—undertaken between 1895 and about 1910 by Edward S. Curtis, Karl E. Moon, Robert and Frances Flaherty, and Adam Clark Vroman—were designed to play up the positive aspects of tribal life, in particular the sense of community and the oneness of the individual Native American with nature. This attitude is especially visible in the 20-volume survey published by Curtis, which owing to its strongly Pictorialist interpretation was discussed in Chapter 7. The handsome portraits and artfully arranged group scenes made by Moon in the Southwest, and the close-ups of cheerful and determined Inuit tribespeople of the far north *(pl. no. 197)* photographed by Robert Flaherty, embody a similar desire to make their subjects palatable to

421. UNKNOWN
PHOTOGRAPHER. *Blind
Russian Beggars*, 1870.
Albumen print. Benjamin
Stone Collection,
Birmingham Central
Library, Birmingham,
England.

white Americans with strong ethnocentric biases. As pio-
neers in documentary film in the United States in the early
1920s, the Flahertys became known for their ability to give
dramatic form to mundane events, and among the 1,500 or
so still photographs that Robert made of the Inuit are
works that seem arranged and posed to accord with a con-
cept of these subjects as heroic and energetic.

A project of more limited proportions than the one
envisioned by Curtis occupied Adam Clark Vroman, a
successful California book merchant who also saw in pho-
tography a means to emphasize the virtues of American
tribal life. His images, of which *Hopi Maiden* is an example
(pl. no. 195), were carefully framed to suggest the grace,

dignity, and industriousness of the natives of the American
Southwest, but Vroman did not entirely romanticize his
theme or obscure the hardships shaping Indian society in
his time. In true documentary fashion, he used the pho-
tographs in slide lectures and publications in order to
awaken white Americans to the plight of the Native
American.

The interest in making images of a social nature
relates to the collections of photographs of people at
work, at home, and at play that were initiated toward the
end of the century by individuals who believed such
reservoirs of images would facilitate the study of history.
Benjamin Stone, for example, not only photographed vanish-

422. JAMES JOSEPH FORRESTER.
Peasants of the Alto Douro, 1856.
From *The Photographic Album,* 1857.
Albumen print. Gernsheim Collection,
Humanities Research Center,
University of Texas, Austin.

423. GUSTAVE COURBET. *The
Stonebreakers,* 1851–52. Oil on canvas.
Destroyed; formerly Staatliche
Kunstsammlung, Dresden, Germany.

424. FORD MADDOX BROWN. *Work*, 1852. Oil on canvas. City Art Gallery, Manchester, England.

ing customs but, an inveterate traveler, he collected camera images of social experiences around the world, typified by a photograph of blind beggars in St. Petersburg by an unknown photographer *(pl. no. 421)*. He advocated the establishment of photographic surveys to be housed in local museums and libraries throughout Britain, a concept that actually was realized around the turn of the century with the establishment by Francis Greenwood Peabody, professor of social ethics at Harvard University, of a "Social Museum" that eventually comprised over 10,000 documents, including photographs, of social experience around the world.

It should be emphasized again that it is difficult to categorize many images that at first glance seem concerned with social themes such as work and living conditions, in that the goals of the makers were varied and complex. For example, should one regard views of workers on Talbot's estate at Lacock or of peasants in Portuguese vineyards owned by the family of photographer James Joseph Forrester *(pl. no. 422)* as more than a new type of picturesque genre imagery because they show us tools, dress, and relationships? *Children on a Fish Weir (pl. no. 274)* by the Venetian photographer-publisher Carlo Naya transforms the reality of working youngsters into an idyllic episode; should such commercial views be considered social documentation also? Can one really decide whether Curtis's views of tribal life in the United States are authentic documents or Pictorialist fictions?

Perhaps all of these images, no matter what their purpose, might be seen as aspects of the growing interest in problems of work and social existence on the part of Western artists and intellectuals. From the 1850s on, alongside the serious but idealized treatment of the European peasantry by Barbizon painters, realistic portrayals of less bucolic kinds of work associated with advancing industrialization had begun to appear in graphic art and literature. Exemplified by *The Stonebreakers (pl. no. 423)* of 1851/52 by French realist Gustave Courbet and by *Work (pl. no. 424),* a grandiose composition begun in 1852 by the English Pre-Raphaelite Ford Maddox Brown, such themes signaled the mounting concern among elements of the middle class for the social and ethical consequences of rampant industrialization—a concern that helped prepare for the role of the documentary photograph in campaigns for social change.

Obviously, the complexity of ideas explored in the painting *Work,* which deals with the roles and kinds of labor necessary to the functioning of industrialized society, is difficult if not impossible to encompass in photography. Nevertheless, an effort was made by Oscar Gustav Rejlander. His composite picture *Two Ways of Life (pl. no. 253*—discussed in Chapter 5) can be seen as an attempt to deal with the moral and ethical implications of labor in a society in which the working class faces a choice between virtuous hard work or sinful ease. While Rejlander's image is derivative in style and moralistic in concept, other of his photographs embody less complex social themes and are more successful. For instance, the anxiety of unemployment is imaginatively handled in the composite image *Hard Times (pl. no. 266)* while portraits of chimney sweeps reveal an individualized grace that does not depend on social class.

425–26. UNKNOWN PHOTOGRAPHER. *Before and After Photographs of a Young Boy,* c. 1875. Albumen prints. Barnardo Photographic Archive, Ilford, England.

The Social Uses of Photographic Documentation

The concept of using camera documentation to improve social conditions could not evolve so long as poverty was regarded as a punishment for sinful behavior. Nevertheless, even before such Calvinistic attitudes were replaced by an understanding that improved housing and working conditions might produce better behavior and a more efficient labor force, the photograph began to find a place in campaigns for social betterment. *Carte* portraits were turned into a quasi-sociological tool by Dr. Thomas John Barnardo, a self-appointed evangelical missionary who opened his first home for destitute boys in London in 1871 and went on to organize a network of so-called charitable institutions. To illustrate the effectiveness of his programs, Barnardo installed a photographic department to document the "before" and "after" transformations of street waifs into obedient slaveys *(pl. nos. 425 and 426);* the prints were kept as records and sold to raise funds.

Such works have little value as expression, but they raised issues that have continued to be perceived as significant problems in social documentation. Because the transformations seen in the photographs were at best little more than cosmetic, the result of a wash and a new wardrobe, and at worst entirely fictitious, Barnardo was accused of falsifying truth for the camera; he responded that he was seeking generic rather than individual truths about poverty. This attitude was considered flawed by subsequent social documentary photographers, who endeavored to make absolutely authentic records while also expressing what they saw as the larger truth of a situation. Nevertheless, the "before" and "after" image became a staple of social documentation, appearing in American tracts of the 1890s and on the other side of the world in the photographs made by the firm of Raja Lala Deen Dayal, for the nizam of Hyderabad to show the efficacy of relief programs for the starving *(pl. nos. 427 and 428).*

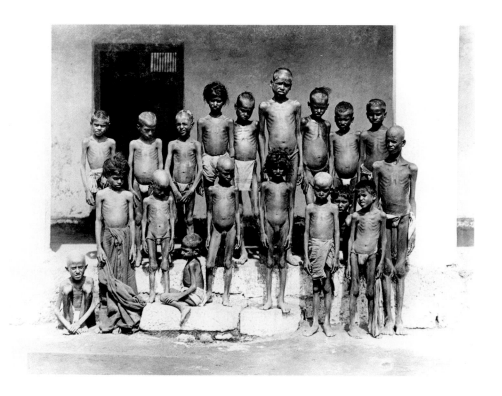

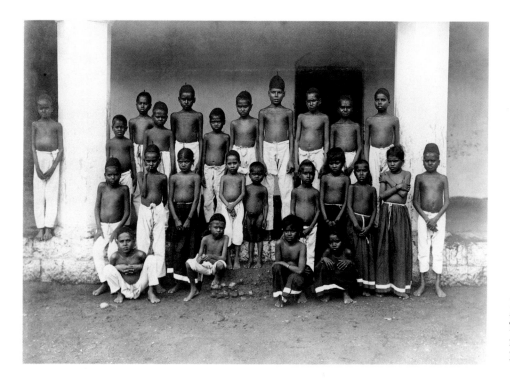

427–28. Raja Lala Deen Dayal.
Before and After (from
Types of Emaciation, Aurangabad),
1899–1900. Gelatin silver prints.
Private collection.

As photographs came to be accepted as evidence in campaigns to improve social conditions, it became apparent that in themselves images could not necessarily be counted on to convey specific meanings—that how they were perceived often depended on the outlook and social bias of the viewer. The *carte* images of women mineworkers mentioned earlier are a case in point; introduced before a British industrial commission as evidence that women were deprived of their feminine charms because mine work forced them to wear trousers, the same images suggested to others that hard work induced independence and good health in women.[9] Naturally, not all photographic

429. HORACE W. NICHOLLS. *Delivering Coal*, c. 1916. Gelatin silver print. Royal Photographic Society, Bath, England.

430. TIMOTHY O'SULLIVAN. *Miner at Work, Comstock Lode*, 1867. Albumen print. National Archives, Washington, D.C.

images can be as broadly construed as these bland *cartes* obviously were, but one of the basic tenets of the developing documentary style was that images should not only provide visual facts, they should be as unambiguous as possible in tone. For instance, in an interesting contrast to the *cartes* under discussion, an image of a young woman delivering coal *(pl. no. 429)*, taken some 50 years later by Horace Nicholls as part of a project to investigate the role of women doing "men's work" during World War I, leaves little question as to the subject's feelings.

As a social theme, mining became a subject of special

appeal to artists, writers, and photographers in the late-19th and early-20th centuries owing to its difficulties and dangers and to the perception of the mineworker as one who mixed individualism and fearlessness. One of the earliest American mine images, an 1850 daguerreotype of California goldminers *(pl. no. 431)*, presents this occupation as an open-air enterprise that seems not to entail hours of backbreaking "panning." The first underground mining pictures were made in England in 1864; some three years later, while on the Clarence King expedition, Timothy O'Sullivan documented silver miners at work in images that suggest the constriction of space and the physical difficulty of the work *(pl. no. 430)*. In the final several decades of the 19th century, mining companies themselves commissioned photographs of their operations and often displayed them at international expositions. Between 1884 and 1895, George Bretz, who pioneered subterranean photography with electric light in the United States, focused almost exclusively on mining in Pennsylvania hard-coal collieries. *Breaker Boys, Eagle Hill Colliery (pl. no. 432)* was one of a number of works acclaimed for unusual subject, technical expertise, and directness of treatment.[10] Not long afterward, Gustav Marrissiaux, a Belgian photographer commissioned by mining interests in Liège, depicted (among

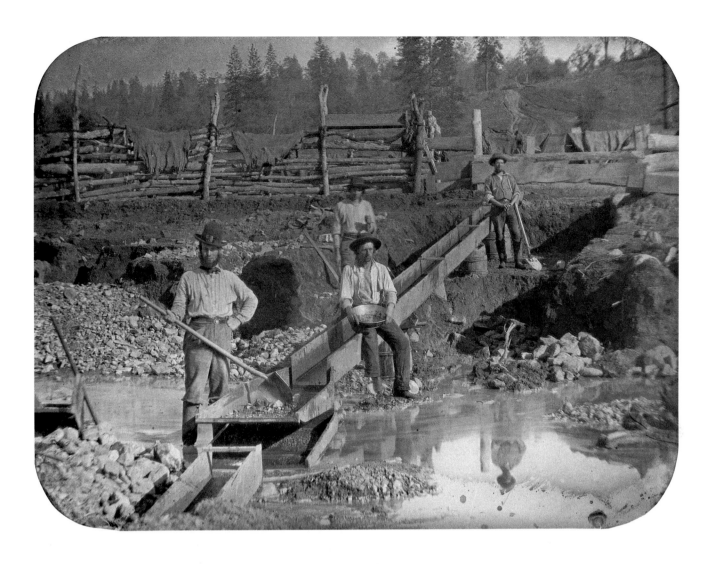

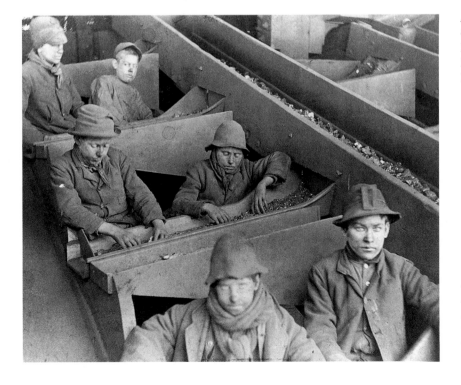

431. UNKNOWN PHOTOGRAPHER.
Goldminers, California, 1850.
Daguerreotype. International Museum of
Photography at George Eastman House,
Rochester, N.Y.

432. GEORGE BRETZ. *Breaker Boys, Eagle
Hill Colliery,* c. 1884. Gelatin silver print.
Edward L. Bafford Photography
Collection, Albin O. Kuhn Library and
Gallery, University of Maryland,
Baltimore.

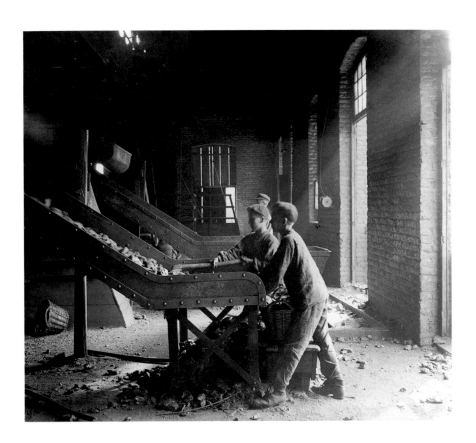

LEFT:

433. GUSTAV MARRISSIAUX. *Breaker Boys,* 1904. Gelatin silver print. Musée de la Vie Wallone, Liége, Belgium.

BELOW LEFT:

434. W. ROBERTS. *Street-Seller of Birds Nests,* c. 1850. Wood engraving after a daguerreotype by Richard Beard or assistant; an illustration from *London Labour and the London Poor* by Henry Mayhew. New York Public Library, Astor, Lenox, and Tilden Foundations.

BELOW RIGHT:

435. JOHN THOMSON. *The Crawlers* from *Street Life in London,* (an album of 36 original photographs), 1877. Woodburytype. Museum of Modern Art, New York; gift of Edward Steichen.

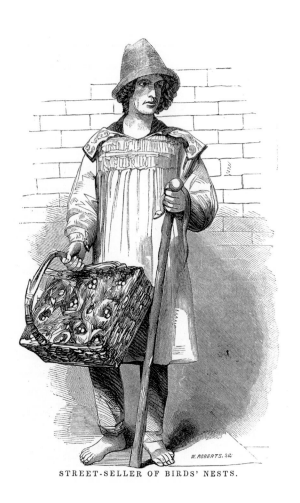

STREET-SELLER OF BIRDS' NESTS.

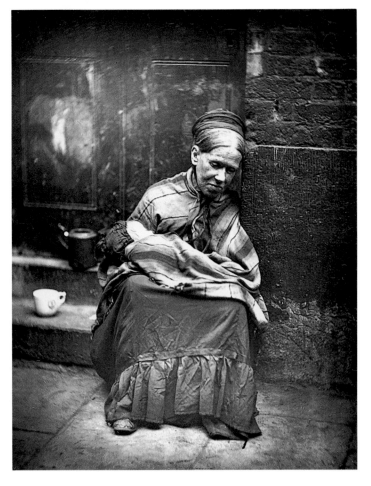

other operations) young boys similarly occupied in separating coal from slag *(pl. no. 433)*. Perhaps the most compelling images of this subject are those taken by Lewis Hine around 1910 as part of the campaign against the unconstrained use of children in heavy industry being waged by the National Child Labor Committee *(pl. nol. 474)*.

The directness of style associated with social documentation emerged around 1850, the consequence of expanded camera documentations on paper and glass of historic and modern structures—building, railroads, bridges, and, on occasion, social facilities *(see Chapter 4)*. Commissioned mainly by government bodies, railroad lines, and publishers, the photographers involved with this work demonstrated an ernest respect for actuality and an attentive regard for the expressive properties of light. While they did not seek to obscure or mystify their subjects, they realized that the judicious management of light added an aesthetic dimension to the description of objects and events. One such documentation eloquently confirms that while actuality may be depicted without artifice, it can be made suggestive; *The Linen Room (pl. no. 436)* by Charles Négre avoids the picturesqueness this photographer brought to his images of street types and draws one into the scene by an alternating cadence of dark and light notes that seem to imbue the scene with a mysterious silence. The series of which this is part was commissioned in 1859 by Napoleon III to demonstrate the government's benevolent concern for industrial workers injured on the job.

Social Photography in Publication

Despite the realization that photographs might be useful in campaigns for social improvement, it took a while for the medium of photography and the message of social activism to be effectively harnessed together. One early sociological venture involving camera images was Henry Mayhew's pioneering work, *London Labour and The London Poor,* which first appeared toward the end of 1850. Combining illustrations based on daguerreotypes taken under the supervision of Richard Beard with "unvarnished" language in the text portions, the author sought to enliven his account of lower-class urban life, but in the translation from camera image to wood engraving the London "poor" became little more than stiffly positioned genre types *(pl. no. 434)*. Furthermore, with the backgrounds only sketchily indicated, the figures of street vendors and workers seem extracted from their environment, a visual anomaly in view of Mayhew's desire to bring the reality of working-class existence home to his readers. Curiously, the same lack of veracity characterizes his later work on English prison conditions even though by this time the engraver had access to albumen prints from collodion negatives supplied

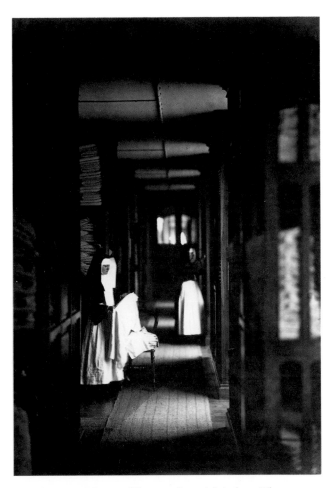

436. CHARLES NÈGRE. *Vincennes Imperial Asylum: The Linen Room,* 1859. Albumen print. Collection André Jammes, Paris; Courtesy National Gallery of Canada, Ottawa.

by the photographer Herbert Watkins. Even so, the format that was established—authentic language supposedly from firsthand interviews and accurate visual illustration from photographs—became the bedrock of sociological documentation—one that is still used today.

A later work, Street Life in London, a serial that began publication in 1877, repeated this scheme, but instead of line engravings it was illustrated with Woodburytypes made from photographs taken expressly for this project by Thomson, after his return from China. The 36 images that illustrate written vignettes supplied by author Adolphe Smith seemed to accord with the canons of the documentary style even though the text was a mixture of sensationalist reporting and moralistic opinions. The work was not a condemnation of the class system or of poverty as such, but an attempt to make the middle class more sympathetic to the plight of the poor and thus more eager to ameliorate conditions. In keeping with the tone of the writing, Thomson photographed vendors and other work-

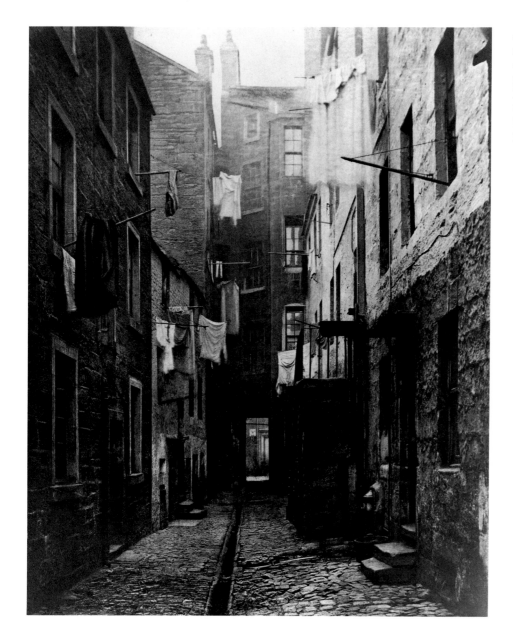

437. THOMAS ANNAN. *Close No. 75 High Street* from *Old Closes and Streets of Glasgow*, 1868. Albumen print. Edward L. Bafford Photography Collection, Albin O. Kuhn Library and Gallery, University of Maryland, Baltimore.

ing-class Londoners in an agreeable light, on the whole choosing pleasant-looking individuals and consciously arranging them in tableauxlike genre scenes. Nevertheless, at least one image—*The Crawlers (pl. no. 435)* —must have left readers with a disturbing feeling in that it depicts with considerable force and no self-consciousness an enfeebled woman seated in a scabrous doorway holding an infant. While *Street Life* may seem ambiguous in terms of purpose, one of its goals that met with eventual success was the building of an embankment to prevent the Thames River from periodically flooding the homes of the London poor.

A project that originated in the desire to make a record of slum buildings slated for demolition in central Glasgow also helped establish the documentary style even though its purpose was nostalgic rather than reformist. In 1868 and

again in 1877, during a period of unsettling urban growth, the Glasgow Improvement Trust commissioned Thomas Annan, a Scottish photographer of architecture, portraits, and works of art to "record many old and interesting landmarks."[11] The results, originally printed in albumen in 1868, were reissued with later images added as carbon prints in 1878 and in two editions of gravure prints in 1900 with the title *Old Closes and Streets of Glasgow*. Because this project was not conceived in a reformist spirit, no statistical information about living conditions or comments by the inhabitants—who appear only incidentally in the images—were included. Nevertheless, Annan's images might be seen as the earliest visual record of what has come to be called the inner city slum—in this case one that excelled in "filth . . . drunkenness . . . evil smell and all that

makes city poverty disgusting."[12] The vantage points selected by the photographer and the use of light to reveal the slimy and fetid dampness of the place transform scenes that might have been merely picturesque into a document that suggests the reality of life in such an environment *(pl. no. 437)*.

Whatever the initial purpose of the commission and despite their equivocal status as social documentation, many of Annan's images are surprisingly close in viewpoint to those of Jacob Riis, one of the first in America to conceive of camera images as an instrument for social change. Sensitivity to the manner in which light gives form and dimension to inert objects also links Annan's work with that of the French photographers Charles Marville and Eugène Atget and supplies further evidence that the documentary style in itself is not specific to images commissioned for activist programs. This becomes even more apparent in the work of the photographer Waldemar Franz Herman Titzenthaler, one of the first in his native Germany to understand that the dry plate gave the urban photographer unprecedented access to the social scene. Whether documenting urban slums, industrial enterprises, workers *(pl. no. 438)*, army cadets, or street life, Titzenthaler's images all display the same careful attention to pictorial structure and the disposition of light. Indeed, the stylistic similarities between such images and those made to realize specific social goals suggests that in addition to a particular approach on the part of the photographer, social documentation requires text and context to make its message understood.

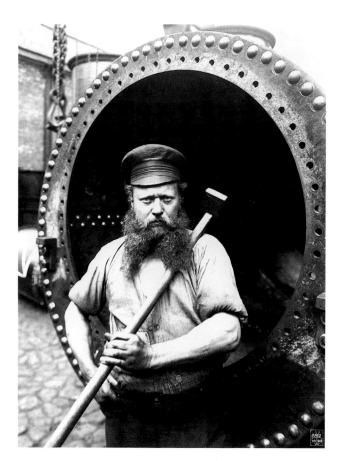

438. WALDEMAR FRANZ HERMAN TITZENTHALER. *Boiler Maker (Types of German Workers)*, c. 1900. Gold-toned printing-out paper. Carpenter Center for the Visual Arts, Harvard University, Cambridge, Mass.

Social Documentation in the United States

Riis was the link in the United States between older Victorian concepts and emerging Reform attitudes toward social problems. His subject was the tenement world—where the poverty-stricken half of New York's population lived. In the late 1880s, on the eve of the Reform era, millions of immigrants from Europe, largely from the eastern and southern sections, were induced by the promise of jobs to come to the United States. Needed as cheap labor for seemingly insatiable industrial appetites, those uprooted workers became the first victims of the economic collapse that lasted from 1882 until 1887 (one of the many in the post–Civil War era). Disgracefully ill-housed in tenements or actually living in the streets of major American cities, with New York by far the most overcrowded and disease-ridden, impoverished immigrants were thought by most middle-class people to be responsible for their own poverty. Before 1890, the problems of the urban poor were completely ignored by public officials, while private

charitable organizations contented themselves with providing soup kitchens and moral uplift.

As a police reporter for the *New York Herald*, Riis, who was thrust squarely into a densely populated and malignant slum called Mulberry Bend, started to use camera images, taken by himself or under his supervision, to prove the truth of his words and to make the relationship between poverty and social behavior clear to influential people. The photographs were seen as a way to produce incontrovertible evidence of the existence of vagrant children, squalid housing, and the disgraceful lodgings provided by the police for the homeless. As lantern slides for Riis's popular lectures and as illustrations for articles and books, these pictures were significant elements of the successful campaigns to eliminate the most pestilential shanties in Mulberry Bend and to close down the police lodging houses. The first and most influential publication by Riis, *How the Other Half Lives: Studies Among the Tenements of New York*, which appeared in book form in 1890, consisted of reportage based on his personal investigation

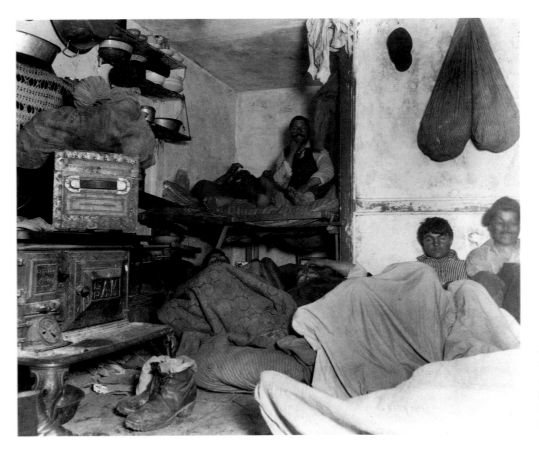

439. JACOB A. RIIS. *Five Cents Lodging, Bayard Street*, c. 1889. Gelatin silver print. Jacob A. Riis Collection, Museum of the City of New York.

440. KENYON COX. *Lodgers in a Crowded Bayard Street Tenement*, 1890. Wood engraving from *How the Other Half Lives*.

and was illustrated by 40 plates, 17 of which were direct halftone reproductions of photographs.[13] Despite the poor quality of these early halftones, images such as *Five Cents Lodging, Bayard Street (pl. no. 439)* clearly are more persuasive as photographs than as line drawings *(pl. no. 440)*.

Neither their social intent nor the fact that Riis thought himself an inept photographer, uninterested in the techniques or aesthetics of printing, should blind one to the discernment with which these images were made. Fully aware of the purpose to be served, the photographer selected appropriate vantage points and ways to frame the subject, at times transcending the limitation implied in the title—that of an outsider looking at slum life from across the deep chasm separating middle- from lower-class life. While he may not have entered very deeply into the space occupied by the "other," his was not a casual view. Compare for example, the Jersey Street sheds *(pl. no. 441)* in which the figures are placed in a rigidly circumscribed patch of sunlight, hemmed in by areas of brick and shadow and so disposed that the eye must focus on them while also taking in the surrounding details, with a contemporaneous image by an unknown photographer of a London slum courtyard *(pl. no. 442)*. This scene, with its random arrangement of figures, may actually seem more authentically real to modern viewers than Riis's image, but the slice-of-life naturalism it represents did not interest social documentarians. Because social images were meant to persuade, photographers felt it necessary to communicate a belief that slum dwellers were capable of human emotions and that they were being kept from fully realizing their human qualities by their surroundings. As a result, photographs used in campaigns for social reform not only provided truthful evidence but embodied a commitment to humanistic ideals. By selecting sympathetic types and contrasting the individual's expression and gesture with the shabbiness of the physical surroundings, the photographer frequently was able to transform a mundane record of what exists into a fervent plea for what might be. This idealism became a basic tenet of the social documentary concept.

Before 1890, tracts on social problems in the United States had been largely religious in nature, stressing "redemption of the erring and sinful."[14] Such works usually were illustrated with engravings that at times acknowledged a photographic source and at others gave the artistic imagination free reign. After the appearance of *How The Other Half Lives*, however, photographic "evidence" became the rule for publications dealing with social problems even though the texts might still consider poverty to be the result of moral inadequacy rather than economic laws. In one example, *Darkness and Daylight*, an 1897 compendium of interviews, sensationalist reporting, and sermonizing, readers were assured that all the illustrations were "scenes presented to the camera's merciless and unfailing eye," notwithstanding the fact that they actually were engraved by artists using photographs.[15]

As halftone printing techniques advanced and reformist ideas took the place of religiously motivated charity, social photography became the "embodiment of progressive values,"[16] largely through the work of Hine. His career spanned 40 years, during which he enlarged on Riis's objectives and formulated new concepts and techniques. Involvement in *The Pittsburgh Survey*, a pioneering study of working and living conditions in the nation's foremost industrial city, aided Hine in developing a forceful and distinctive personal style, exemplified by the previously mentioned *Breaker Boys (pl. no. 474)*. This complex organization of informative detail and affecting expression bathed in somber light creates a miniature netherworld of intersecting triangles, a visual counterpart to Hine's characterization of child labor as "deadening in its monotony, exhausting physically, irregular," and of child workers as "condemned."[17]

The confident atmosphere engendered by the Progressive Era sustained other projects in which camera images were used to document social conditions, but few photographers were as committed to lobbying for social change as Riis and Hine. Many worked for the expanding periodical press that by 1886 had increased its use of photographs to the point where Frances Benjamin Johnston could describe herself as "making a business of photographic illustration and the writing of descriptive articles for magazines, illustrated weeklies and newspapers"[18] (at the time an unusual career for women). Her early assignments are indicative of the growing popular interest in work and workers; they include a story on coal mines, a spread on the employees in the United States Mint, one on iron workers on the Mesabi Range and on women in the mills of New England, besides news stories on the illustrious doings of celebrities. Her most fully realized commissioned documentation (as contrasted with her magazine stories) was undertaken in 1899 to publicize the educational program offered by the Hampton Institute—a school in Virginia that incorporated the Reform ideal of industrial training in a program designed to eliminate poverty among rural blacks and Indians. Johnston's highly styled arrangements, classical poses, and overall clarity of illumination—seen in *Students at Work on the Stairway (pl. no. 443)* and now so unexpected in documentary images—seem designed to suggest the temperate and disciplined approach that the school emphasized. Others who supplied imagery on social themes to the press were Arthur Hewitt, a member of the Camera Club of New York whose Pictorialist style colored his photographs of bridge-builders and longshoremen for *Everybody's Magazine*, and Jesse Tarbox Beals, whose prosaic

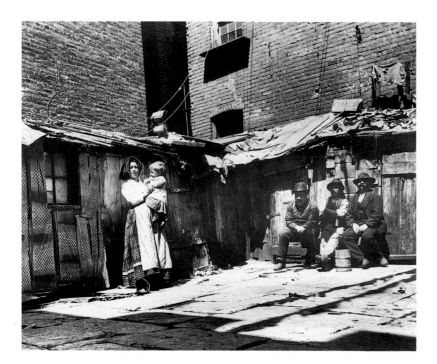

441. JACOB RIIS. *Yard, Jersey Street Tenement*, c. 1888. Gelatin silver print. Jacob A. Riis Collection, Museum of the City of New York.

442. UNKNOWN PHOTOGRAPHER. *London Slum*, c. 1889. Gelatin silver print. BBC Hulton Picture Library/Bettman Archive.

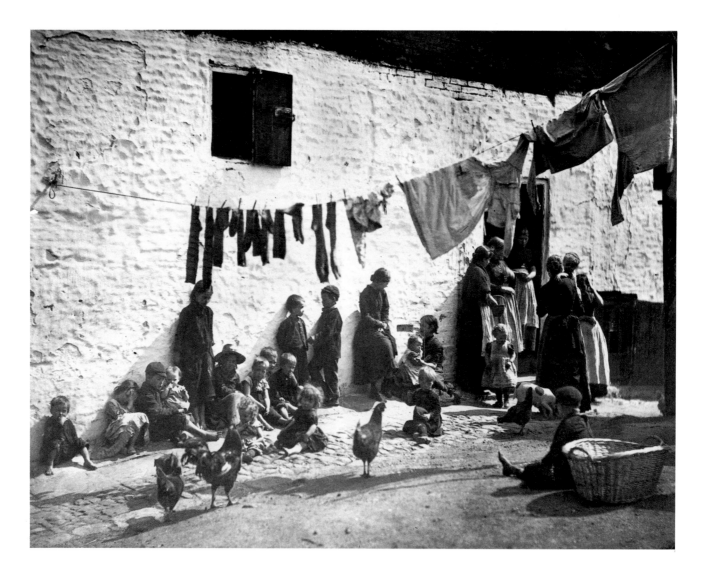

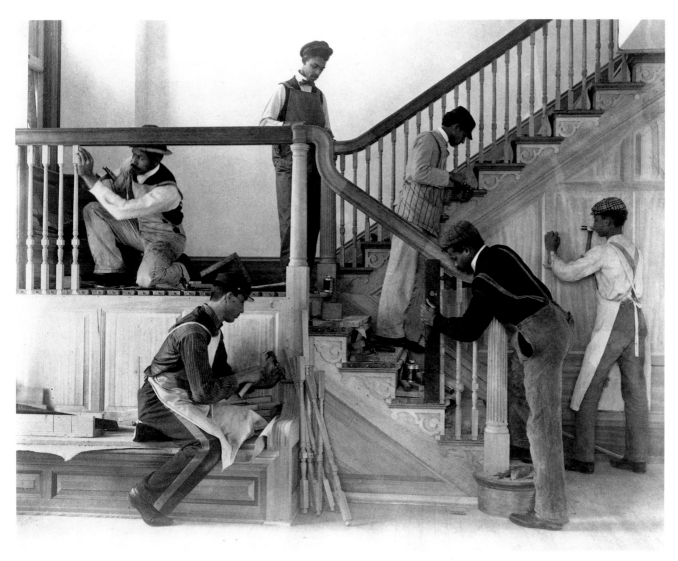

443. FRANCES BENJAMIN JOHNSTON. *Hampton Institute: Students at Work on the Stairway*, 1899–1900. Gelatin silver print. Library of Congress, Washington, D.C.

record shots of tenement life were commissioned by the charity organizations that eventually merged into the Community Services Society.

After 1915, Reformist ideals and programs withered as American energies were redirected to the crisis occasioned by the first World War. With social issues receding in importance, there was less demand for photographs that give dimension to these concerns, and at the same time fresh aesthetic winds, generated by the Armory Show of 1913, quickened interest in the European avant-garde movements in the arts. Abstraction, Expressionism, and Dadaism were some of the new styles and concepts that made Realism and the expression of human emotion and sentiment in visual art seem old-fashioned and contributed to a brief eclipse of the social documentary sensibility during the 1920s.

The Portrait as Social Document

In the United States, these changes were reflected not only in the direction taken by aesthetic photographers but in the images appearing in the periodical press, which joined with the new institution of advertising to project an image of the nation as an energetic titan ruled by rational industrial forces *(see Chapter 10)*. Few photographers other than Hine regarded working people as the source of industrial wealth, and even his emphasis shifted from documenting "negative" factors such as exploitation and boredom to portraying the "positive" contributions made by individual men and women in industry. In his "Work Portraits," which appeared sporadically in industrial trade journals during the 1920s, he attempted to bring out the human component in industry through facial close-ups and by relating the

444. EMIL O. HOPPÉ. *Flower Seller,* 1921. Gelatin silver print. The E. O. Hoppé Curatorial Assistance Trust, Los Angeles.

forms of worker and machine *(pl. no. 446)*, an endeavor that culminated in the documentation of the construction of the Empire State Building in 1930 and 1931.

Owing to the emphasis in Europe on political action rather than social reform, European photographers during the first decades of the 20th century were not given the opportunity to produce social documentation in the manner of Riis or Hine. Nevertheless, as individuals, Emil O. Hoppé, Helmar Lerski, and August Sander *(see Profile)* sought to create, in Sander's word, an "honest" document of an age [19] through portraits that presumably would awaken the viewer to the character of different classes and occupations in society. Of the three, Hoppé, who opened a studio in London in 1907 after leaving Germany, actually was a commercial photographer of taste and discernment who undertook to photograph women workers *(pl. no. 444)* and became adept at reusing these images in a variety of contexts in publication and advertising work. Lerski, born in Strasbourg and trained as an actor, spent many years in the United States, where he became interested in photography about 1911. Theatrical lighting effects and large-scale facial close-ups that entirely fill the

picture space *(pl. no. 445)* characterize his attempt to create a sociopsychological portrait of people in a variety of occupations, which he published in Germany in 1931 as *Kopfe des Alltags (Ordinary Faces)*.

The towering figure in this kind of documentation through portraiture is Sander. From 1910 until he was censured by the Nazi regime in 1934, he made beautifully lighted and composed images of individuals and groups from all professions and classes in Germany *(pl. no. 447)*. The clarity and directness with which he approached social portraiture connect his work with both 19th-century Realist painting and the New Objectivity *(Neue Sachlichkeit)* style that emerged in German visual art in the 1920s. Individually and as an aggregate his images are infused with an ironic dimension that suggests the entrenched role of stratified social hierarchies in the Germany of his time. Sander's project culminated in 1929 in the publication of *Antlitz der Zeit (Face of Our Time)*, in which only a small number of the more than 500 images initially envisioned for this work were reproduced. The book was later banned in part because the images showed Germans to be greatly more varied in facial characteristics and temperament than the official mythology decreed.

445. HELMAR LERSKI. *German Metal Worker,* 1930. Gelatin silver print. Gernsheim Collection, Humanities Research Center, University of Texas, Austin.

446. LEWIS W. HINE. *Powerhouse Mechanic*, 1925.
Gelatin silver print. Private collection.

No American photographer of the time attempted such a vast project dealing with portraiture of all sectors of society. Of the few who were attracted to "everyday" faces, Hine limited himself to portraits of skilled industrial workers, while Doris Ulmann, a sophisticated New York portraitist trained at the Clarence White School, sought to document the rural population of the Southern highlands and plains in a style that invokes Pictorialist ideas as much as social documentation *(pl. no. 393)*. Inspired by the revived interest in rural customs and handicraft as a way of preserving America's pre-industrial heritage, her portraits, made in natural light with a large-format view camera and soft-focus lens, embody the photographer's conviction that simplicity and closeness to the soil were of greater moment than progress.

A similar idea about the independent character of rural folk can be seen in *The Boss (pl. no. 392)*, an image by Prentice Hall Polk, photographer for Tuskeegee Institute, that verges on being an idealized genre type rather than a document of social reality. Indeed, even commercial por-

trait photographers in the 20th century were sometimes in a position to provide a sociological document of the people among whom they lived. One thinks of James Van Der Zee, whose images of Harlem's middle- and upper-class citizens *(pl. no. 322)* are poignant testimony to their aspirations. A similar view into the social structure of a provincial society can be seen in the work of the Peruvian portraitist Martín Chambi, a pioneer of the photo post-card in his own country. In the careful attention to details of dress and ambience, his individual and group portraits made in a studio in Cuzco or in remote highlands during the 1930s not only reveal the sitters' physical features but also suggest social hierarchies *(pl. no. 448)*.

Social Photography During the Depression

The documentary movement was born afresh in the United States in the 1930s. As William Stott has pointed out in his study of the period, the motive force was the "invisible nature" of the economic and social catastrophe known as the Great Depression.[20] Lasting about ten years,

447. AUGUST SANDER. *Pastry Cook, Cologne*, 1928. Gelatin silver print. Sander Gallery, New York; © Estate of August Sander.

from 1931 until American entry into the second World War, the period was characterized by high unemployment, labor unrest, and agricultural disaster caused by persistent drought and misuse of the land. Pervasive rural poverty resulted in waves of internal migrations as families from the heartland made their way west in search of jobs and arable land. The upheaval, both urban and rural, moved the Federal government under President Franklin Delano Roosevelt's New Deal to relieve the suffering of "one third of a nation" by providing resettlement loans to farmers and work programs for the urban unemployed.

The most completely realized photography project of the period—one of a number sponsored by government agencies—was undertaken by the Historic Section of the Resettlement Administration, later the Farm Security Administration or F.S.A. *(see Profile)*.[21] The project represented the New Deal's understanding that a visual documentation of conditions of work and life faced by farmers who suffered the calamities of drought and economic depression, and were in the process of being driven permanently from the land, was required to justify Federal expenditures for relief projects. Eventually in response to Congressional displeasure at the depiction of unrelieved poverty, photographers were directed to portray more positive aspects of the national experience. This project should be seen in relation to other Federally sponsored cultural endeavors in that all originated from the practical necessity of providing jobs and recording the effects of relief and reconstruction programs. Besides the immediate relief they

offered those on their payroll, they were influential in directing interest to the American scene and reviving a taste for realistic representation in the visual arts; as a result, in the United States the realist style enjoyed a brief period of coexistence with more formally conceived modes of expression derived from European modernist movements.

The patronage of the R.A./F.S.A. in particular exerted a bracing effect on social-documentary style because the Section Director, Roy E. Stryker, a brilliant if somewhat narrowly focused propagandist *(pl. no. 449)* and the photographers not only recognized the need for evoking compassion, but possessed a fresh eye and a high regard for their craft. Another factor in the exceptional caliber of this project, which produced some 270,000 images, was the variety of artistic approaches employed by the individual photographers.[22] For example, Ben Shahn, who worked with a 35mm camera, directed Stryker's attention to the human element as a source of emotional appeal; Dorothea Lange, who worked with a Rollei, upheld the need for the photographer to exercise control over the negatives, while Walker Evans, using an 8 x 10 inch view camera, insisted on the right to realize his own particular concept of documentation.

In common with other government agencies that embraced photographic projects, the F.S.A. supplied prints for reproduction in the daily and periodical press. In that project photographers were given shooting scripts from which to work, did not own their negatives,[23] and had no control over how the pictures might be cropped, arranged, and captioned, their position was similar to that of photo-

449. UNKNOWN PHOTOGRAPHER. *Arthur Rothstein and Roy Stryker,* 1941. Gelatin silver print. Formerly collection Arthur Rothstein, New York.

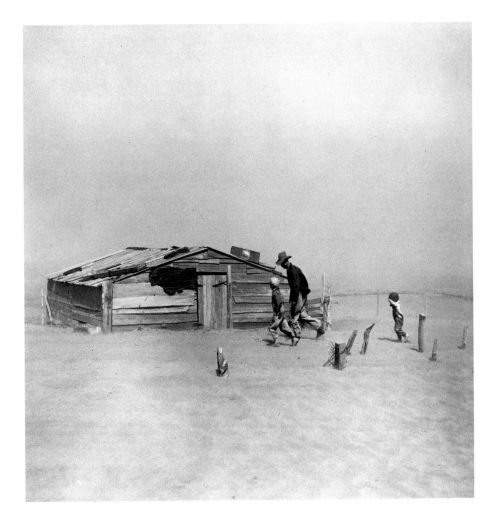

450. ARTHUR ROTHSTEIN. *Dust Storm, Cimarron County,* 1937. Gelatin silver print. Library of Congress, Washington, D.C.

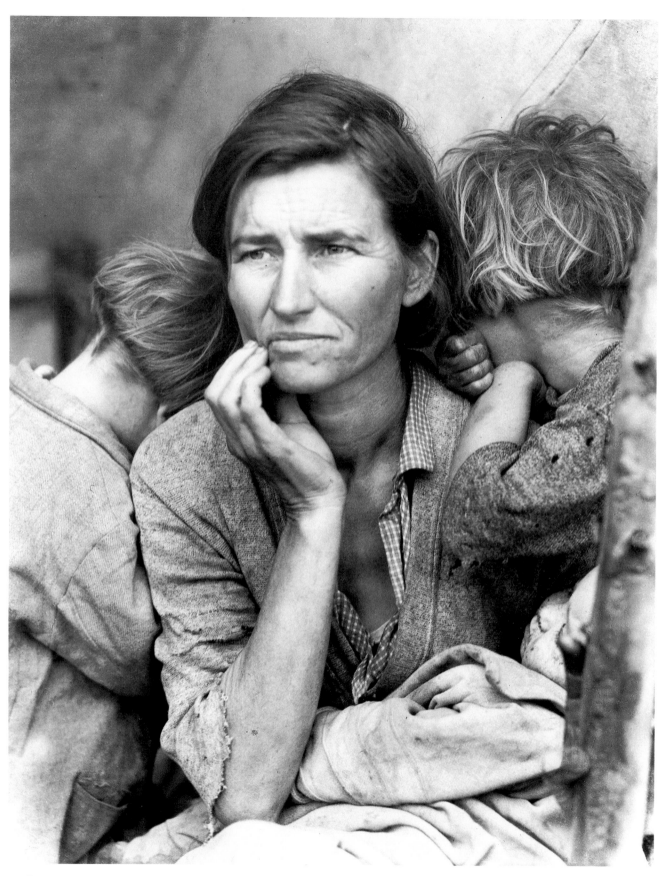

451. DOROTHEA LANGE. *Migrant Mother, Nipomo, California*, 1936.
Gelatin silver print. Library of Congress, Washington, D.C.

452. MARGARET BOURKE-WHITE. *Two Women, Lansdale, Arkansas,* 1936. Gelatin silver print. George Arents Research Library, Syracuse University, Syracuse, N.Y.

453. BERENICE ABBOTT. *Cedar Street from William Street, New York,* 1939. Gelatin silver print. Private collection. © Berenice Abbott/Commerce Graphics Limited, Inc.

journalists working for the commercial press—a situation that both Evans and Lange found particularly distasteful. The images were transformed into photographic works of art when they were exhibited under the auspices of the Museum of Modern Art.[24] For the first time, photographs made to document social conditions were accorded the kind of recognition formerly reserved for aesthetically conceived camera images.

The F.S.A. images were considered truthful expression by some and socialistic propaganda by others who mistook the emphasis on social issues for socialism itself, but Americans were nonetheless affected by them. Furthermore, the impact of the Great Depression on rural communities has been perceived by later generations on the basis of certain key images. Arthur Rothstein's *Dust Storm, Cimarron County (pl. no. 450)* and Lange's *Migrant Mother, Nipomo, California (pl. no. 451)* are the most famous icons of the time—the latter selected by Stryker as *the* picture to symbolize the concern of the government for displaced farmers—but it is the sum of the images that creates their force.[25]

Few other officially sanctioned projects that dealt with

rural themes used photography as successfully as the F.S.A., but both this and other New Deal efforts opened opportunities for African-American male photographers. The best known of this group, Gordon Parks *(pl. no. 692),* went on to fame in photojournalism and film; others, among them Robert McNeill and James Stephen Wright, found niches in picture agencies. Women, too, were included in the New Deal projects; besides Lange, Marion Post Wolcott toured the country for the F.S.A., and other agencies employed Esther Bubley, Marjory Collins, and Martha McMillan Roberts. An effort by the writer Erskine Caldwell and the industrial-photographer-turned-photojournalist Margaret Bourke-White resulted in *You Have Seen Their Faces,* an influential amalgam of text and image. It contained dramatic close-ups of Southern tenant-farm families *(pl. no. 452)* that were offset by a relatively reserved text based on interviews and documentation of the conditions of farm tenancy. This inexpensive paperback revivified the form established by earlier social-reform tracts and helped prepare the way for the profusion of post–World War II photographic books on a wide spectrum of social issues.

454. BERENICE ABBOTT. *New York at Night,* 1933. Gelatin silver print. Museum of Modern Art, New York; Stephen R. Currier Memorial Fund. © Berenice Abbott/Commerce Graphics Limited, Inc.

455. WALTER BALLHAUSE. *Untitled,* 1930–33. From the series *Kinder in der Grosstadt (City Children).* Gelatin silver print. Schirmer/Mosel, Munich. © Rolf Ballhause.

The urban experience during the Depression was photographed under the banners of the Federal Art Project and the Works Progress Administration, and by a group of socially committed photographers who formed the Film and Photo League, from which the Photo League (to be discussed shortly) emerged in 1936. The most fully realized project was a documentation of New York City initiated by Berenice Abbott. On the basis of her experiences as a photographer in Paris, and inspired by the work of Atget, she conceived of the city as a theme that might reflect "life at its greatest intensity."[26] In Abbott's vision, *Changing New York*, as the project came to be called, was meant to evoke "an intuition of past, present and future,"

and to include, besides single images, series of related pictures supported by texts. With its strong contrast between the heavy geometrical curves of the buildings and the narrow shaft of light representing the sky, *Cedar Street from William Street (pl. no. 453)*, one of a number of views that suggest something of the stable commercial underpinnings of the city, is typical of the resonant clarity of the photographs she made for the project *(see also pl. no. 454)*.

Documentation of the urban scene from the point of view of the political left became an issue toward the end of the 1920s when photographers in Europe especially felt moved to deal with unemployment and the rising strength of the working class. However, the aims of those involved

456. ROMAN VISHNIAC. *Entrance to the Ghetto, Cracow*, 1937. Gelatin silver print. International Center of Photography, New York; Purchase. Courtesy Mara Vishniac Kohn.

457. ROMAN VISHNIAC. *Granddaughter and Grandfather, Warsaw,* 1938. Gelatin silver print. International Center of Photography, New York; International Fund for Concerned Photography, Purchase. Courtesy Mara Vishniac Kohn.

in what came to be known as the worker–photographer movement differed significantly from the reformist goals of social documentarians like Riis and Hine. Instead of images meant to provide middle-class viewers with evidence of the need to improve conditions, photographs by participants in the worker–photographer organizations were intended to make other working people conscious of their conditions and their political strengths. European photographers of the left took their cue from social and stylistic developments in the Soviet Union *(see Chapter 9)*, exhibiting camera images in places where working people congregated and reproducing them in the leftist press. For example, *Der Arbeiter–Fotograf (The Worker–Photographer),* a publication of the German worker–photographer movement, promoted the camera as a "weapon" in an ideological struggle, claiming that a "proletarian eye was essential for capturing a world invisible to the more privileged."[27] That this outlook did not interfere with the expression of a poetic vision can be seen in images made by Walter Ballhause, a working-class activist who used a Leica camera in the early 1930s to portray the unemployed, the elderly, and the children of the poor in Hannover *(pl. no. 455)*. In the singular gesture of the child, anchored within a symmetrical and barren urbanscape, one senses the pervading uneasiness of the time. With politically oriented photographers most active in Eastern Europe, the style of leftist

imagery was varied; indeed, a Czech publication of 1934— *Sociální fotografie (Social Photography)*—specifically discussed the integration of avant-garde visual ideas and leftist political ideology. Images with strong political content were shown in two large international exhibitions held in Prague in 1933 and 1934, in which photographers from Czechoslovakia, Hungary, the Soviet Union, Belgium, Holland, and France participated.

Motivated less by political ideology than by a sense of impending catastrophe, Roman Vishniac, living in Berlin as a refugee from the Soviet Union where he had been trained in the biological sciences,[28] produced an extensive documentation of Eastern European Jews in Poland on the eve of the Holocaust. Photographed on the streets and indoors, his subjects generally were unaware of being filmed, a circumstance that lends a vitality to this document of some 5,000 images, of which *Entrance to the Ghetto, Cracow (pl. no. 456)* is one; they are made especially poignant by our knowledge today that almost everything— people, places, traditions—has vanished *(see also pl. no. 457)*.

The worker–photographer movement had fleeting successes in England, where concern for the problems of the under-class was prompted more by personal sympathy than by class-conscious considerations. The well-known English photographer Humphrey Spender, employed as a photographer for the *London Daily Mail,* in 1937–38 par-

458. HUMPHREY SPENDER. *Street Scene in a Milltown*, 1937–38. (From *Mass-Observation* published as *Worktown People*, 1982). Gelatin silver print. Falling Wall Press, Bristol, England. © Humphrey Spender.

459. BILL BRANDT. *Halifax*, 1936. Gelatin silver print. © Bill Brandt/ Photo Researchers.

ticipated in a project called "Mass-Observation," which was designed to be an absolutely "objective documentation," in the manner of an anthropological study, of life in the mill towns of the industrial north *(pl. no. 458)*. Bill Brandt, initially attracted to Surrealism, returned to his British homeland in 1931 to depict the divisions between social classes in London as well as working-class life in mining villages. The long, bleak vista and inhospitable structures that all but engulf the tiny figures in *Halifax (pl. no. 459)* seem to symbolize the enduring human spirit that is all but crushed by poverty and industrialism.

During this same period, a number of Japanese photographers, with great interest in Western attitudes toward art and photography, found in the "new photography" (to be discussed in Chapter 9) the means for a humane portrayal of the hitherto despised and unrecorded lower classes. Horino Masao, a photographer of great versatility who also was interested in montage and industrial imagery, made large close-up portraits of working men, beggars *(pl. no. 460)*, and street people. Similar subjects and approach can be seen in vibrant street images by Kuwabara Kineo *(pl. no. 461)* and in documentations of life in the occupied territories of Manchuria by several of Japan's most notable photographers. By the 1940s, however, photographers had put their cameras at the service of the government bureaucracy or they portrayed the pleasures of rural life, as in the images made by Hamaya Hiroshi between 1940 and 1944 for *Snow Country (pl. no. 462)*. The conflict that had

460. HORINO MASAO. *Beggar*, 1932. Gelatin silver print.
© 1971 Japan Professional Photographers Society.

461. KUWABARA KINEO.
Scene at a Fair, 1936.
Gelatin silver print.
© 1971 Japan Professional
Photographers Society.

462. HAMAYA HIROSHI. *Untitled*, from *Snow Country, a Record of Folk Customs During the Lunar New Year Celebrations in Niigata Prefecture*, 1940–44. Gelatin silver print. © 1971 Japan Professional Photographers Society.

463. SID GROSSMAN. *Coney Island*, 1947. Gelatin silver print. National Gallery of Canada, Ottawa. © Miriam Grossman Cohen; Courtesy Howard Greenberg Gallery, New York.

expanded from China to a confrontation with the United States on the Pacific islands effectively ended a brief but exhilarating period of expressive documentation.

In the United States, the Photo League, formed in the mid-1930s by a group of politically conscious photographers, was committed to the tradition of straight picture-making that its members traced back to Hill and Adamson, Stieglitz, and Hine. With this concept, the League eventually encompassed a broad range of styles and goals, but, as initially conceived by its photographer-founders Sid Grossman *(pl. no. 463)* and Sol Libsohn, its specific purpose was the promotion of documentary photography through a school and the establishment of "feature groups"—units organized to depict the less picturesque aspects of urban life, which they felt were being ignored by art photographers and Pictorialists. Projects included the Chelsea and Pitt Street documents, with the most fully realized being the Harlem Document.[29] This was a three-year effort headed by Aaron Siskind and including Harold Corsini, Morris Engel, and Jack Manning (all later respected professionals), which produced a searching but sympathetic look at life in New York's most significant black neighborhood. An image of a woman and children *(pl. no. 478)* by Engel (who became an independent filmmaker) encapsulates both the claustrophobia and the humanity of the ghetto, while Siskind's many images of street life in the same community reveal the way blacks "grasped a patch of happiness whenever and wherever they could find it."[30]

Responding to the general movement in the arts

toward more personalized modes of expression, League members adopted the concept of creative photography in the late 1940s, but despite this subtle shift away from pure documentation many former members continued their commitment to humanist ideals even after the organization's politically inspired demise in 1952.[31] Former League president Walter Rosenblum, for instance, undertook a series of self-motivated projects to document life in East Harlem, in Haiti, and in the South Bronx *(pl. no. 465)*; W.

464. BERNARD COLE. *Shoemaker's Lunch, Newark, N.J.,* 1944. Gelatin silver print. Courtesy Gwen Cole, Shelter Island, N.Y.

465. WALTER ROSENBLUM. *Mullaly Park, Bronx, New York,* 1980. Gelatin silver print. Courtesy and © Walter Rosenblum.

Eugene Smith *(pl. no. 475)*, also a former president, continued his commitment to these ideals in Minamata; while others, among them Bernard Cole *(pl. no. 464)*, Arthur Leipzig, and Dan Weiner, found a limited opportunity to treat humanistic themes in the flourishing field of postwar photojournalism *(see Chapter 10)*.

Before the 1930s, Pictorialists and their supporters subscribed to the idea that art ought not to be utilitarian. In consequence, they were blind to the fact that genuine feeling and innovative vision might imbue camera images made for a social purpose with imagination and meaning. At the same time, those who used documentary works frequently disregarded the individual photographer and reproduced the images without credit and at times without permission. Often social documentary photographers were unknown unless their work was used in a specific context. The outstanding quality of the work done under the aegis of the F.S.A. and by Abbott for *Changing New York* were factors that helped transform this situation, demonstrating to the photographic community and to viewers at large that divisions between art and document are difficult to maintain when dealing with images of actuality. These and other works made clear that, no matter what its purpose, any camera image may transcend the mundaneness of its immediate subject and transmute matter into thought and feeling—the essential goal of all visual art. Recognizing that purposeful photographs also may enlarge vision and inspire compassion even after the specific problems they addressed have disappeared, the generation of photographers that grew to maturity after the second World War rejected the compartmentalization of photographic expression that had been the legacy of the Pictorialist movement. Instead they sought to imbue their work, no matter what its ultimate purpose, with the passion and immediacy found in social documentation at its best.

Profile: Lewis W. Hine

Lewis Hine, whose sociological horizons gave his images focus and form, was a photographer in touch with his time. When the twenty-seven-year-old Hine came east in 1900 from his birthplace in Oshkosh, Wisconsin, to teach natural sciences, he already had experienced the exploitation of the workplace that he was to spend a good part of his life documenting. His first serious photographs were made in response to a desire on the part of his principal at the Ethical Culture School in New York to use the camera as an educational tool. As an arm of the Progressive Movement, the school sought in photography a means of counteracting the rampant prejudice among many Americans against the newly arrived peoples from eastern and southern Europe, so, besides recording school activities and teaching photography, in 1904 Hine began photographing immigrants entering Ellis Island. Notwithstanding the chaos of the surroundings, his inability to communicate verbally, and his cumbersome 5 x 7 inch view camera and flash powder equipment, he succeeded in producing images that invest the individual immigrant with dignity and humanity in contrast to the more common distanced view.

In 1907, after convincing a group of social welfare agencies that photographs would provide incontrovertible evidence for their reform campaigns, Hine (along with graphic artist Joseph Stella) was invited to participate in *The Pittsburgh Survey*, a pioneer sociological investigation of working and living conditions in the nations's most

466. LEWIS HINE. *Making Human Junk*, c. 1915. Poster. Library of Congress, Washington, D.C.

industrialized city; after this experience he left teaching and set himself up as a professional "social photographer." From then until 1917, he was the staff photographer for the National Child Labor Committee, traveling more than 50,000 miles from Maine to Texas to photograph youngsters in mines, mills, canneries, fields, and working on the streets, in order to provide "photographic proof" that "no anonymous or signed denials" could contradict.[32] The images were used in pamphlets, magazines, books, slide lectures, and traveling exhibits *(pl. no. 466),* many of which Hine organized and designed.

Toward the end of the first World War, when the waning interest in social-welfare programs became apparent, Hine went overseas as a photographer on an American Red Cross relief mission to France and the Balkans. On his return, he embarked on a project of "positive documentation," hoping to portray the "human side of the system," which he felt should be recognized by a society convinced that machines run themselves. This period started with a series of individual portraits—"Work Portraits"—which were critically acclaimed although not greatly successful financially, and culminated for Hine in his 1930 commission to photograph the construction of the Empire State Building. The photographer followed its progress floor by dizzying floor, clambering over girders and even being swung out in a cement bucket to take pictures. At the conclusion of the project, he organized a number of the images along with others from the "Work Portrait" series into *Men at Work,* a pioneering photographic picture book that featured good reproduction, full-page bleeds, and simple modern typography.

The last decade of Hine's life coincided with the Great Depression, but while F.S.A. photographers were given the opportunity to produce a stirring document of social conditions, the photographic programs of the agencies for which Hine worked—the Rural Electrification Agency, the Tennessee Valley Authority, and the Works Progress Administration—had little creative vision concerning the use of photographs in this manner. The frustration of Hine's last years was offset to a degree by the efforts of Berenice Abbott, Elizabeth McCausland, and the Photo League to rescue his work from oblivion with a retrospective exhibition in New York in 1939.

Profile: August Sander

August Sander's dream was to create a visual document of "Man in 20th-Century Germany." He hoped that through a series of portraits, sequenced in a "sociological arc" that began with peasants, ascended through students, professional artists, and statesmen, and descended through urban labor to the unemployed, he would make viewers aware of the social and cultural dimensions as well as the stratification of real life. After the publication of only one volume, which appeared in 1929 as *Antlitz der Zeit (Face of Our Time),* this ambitious project was banned as presenting a version contrary to official Nazi teachings about class and race, and Sander was forced to abandon it.

Born in 1876 in a provincial village near Cologne to a family deeply rooted in traditional peasant culture, Sander was introduced fortuitously to photography while employed as a worker in the local mines. He soon began to make straightforward, unretouched portraits of local families; this approach, along with his later apprenticeship as a photographer of architectural structures and his training in fine art at the Dresden Academy of Art, helped establish the hallmarks of his mature vision. Though for a time the portraits he turned out in a commercial studio he opened in Linz displayed his mastery of Pictorialist techniques, he preferred, as he wrote in a publicity brochure for another of his studios a few years later, "simple, natural portraits that show the subject in an environment corresponding to their own individuality."[33] This attitude soon found its fruition in the grand project that began in earnest after the end of the first World War.

A thoughtful man, well-read in classical German literature, Sander drew his ideas from the twin concepts of physiognomic harmony and truth to nature. The former (discussed in Chapter 2) held that moral character was reflected in facial type and expression, a notion that the photographer enlarged upon by introducing the effect of environment on creating social types as well as typical individuals *(pl. no. 447).* Sander was convinced also that universal knowledge was to be gained from the careful probing and truthful representation of every aspect of the natural world—animals, plants, earth, and the heavens. To this rationalist belief he added an ironic view of German society as a permanent, almost medieval hierarchy of trades, occupations, and classes.

Sander's circle of friends in Cologne during the 1920s included intellectuals and artists, many of whom were partisans of the New Realism or New Objectivity. While the work of these artists may have influenced his ideas, it is at least as possible that the simple frontal poses, firm outlines, and undramatized illumination visible in paintings by the German artists Otto Dix and Edwin Merz, for example, owe something to Sander's portraiture; that all shared a belief in the probing nature of visual art to dissect truth beneath appearances also is evident.

The suppression of Sander's work by the Nazis was followed by the harassment of his family and the loss of many of his friends in the arts, who were either in exile or had been put to death. Sander, forced to turn his camera lens to landscape and industrial scenes, sought in land-

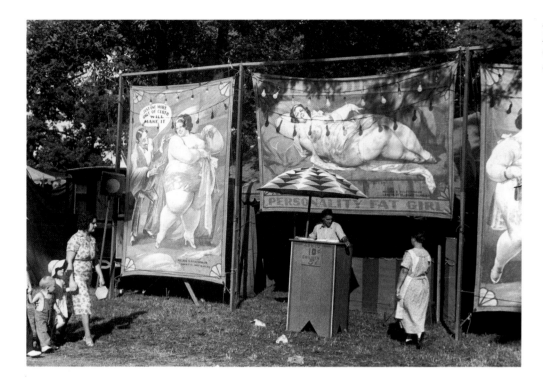

467. BEN SHAHN. *County Fair, Central Ohio,* 1938. Gelatin silver print. Private collection.

scapes of the farming communities of his native region to insinuate a suggestion of the historical role of the human intelligence in shaping the land, while the detailed close-ups of organic forms may have been meant as symbols of his abiding faith in the rational spirit. He survived the second World War, the deaths of several family members, and the loss of his negatives in a fire, to find his work republished and himself honored by photographers throughout the world.

Profile: The Historical Section Project, F.S.A.

The photographic documentation sponsored by the U.S. government under the auspices of the Historical Section of the Farm Security Administration, known popularly as the F.S.A. project, is a paradigm of what can be accomplished when sensitive photographers working with a stubborn yet visionary director are given opportunities and financial and psychological support in their efforts to make visual statements about compelling social conditions. When Roy E. Stryker, a former teacher in the Economics Department at Columbia University, was called to Washington in 1935 to head the Historical Section under the direction of the New Deal planner Rexford Guy Tugwell, he envisaged an effort that would use photographs to record the activities of the government in

helping destitute farmers. Ultimately, the project demonstrated that the New Deal recognized the powerful role that photographs played in creating a visual analogue of the humanistic social outlook voiced in the novels, dramas, and folk-music of the period. Now regarded as a "national treasure," this documentation was the work of eleven photographers: Arthur Rothstein, Theo Jung, Ben Shahn, Walker Evans, Dorothea Lange, Carl Mydans, Russell Lee, Marion Post Wolcott, Jack Delano, John Vachon, and John Collier (listed in the order in which they were hired). All of them helped shape the overall result through their discussions and their images.

Rothstein, a former Columbia University student who was the first photographer hired, set up the files and darkroom and recorded the activities of the section before being sent to the South and West. While on assignment in drought-stricken regions in 1936, where he made the famous *Dust Storm, Cimarron County (pl. no. 450)*, he also photographed a bleached steer skull in several positions; it was an experiment that precipitated a bizarre political controversy about the truthfulness of images made under government sponsorship and raised questions concerning the legitimacy of social documentation.[34] In its wake, some documentary photographers supported the photographer's right to find essential rather than literal truths in any situation, while others, notably Evans, insisted on absolute veracity, maintaining that for images to be true to both

468. RUSSELL LEE. *Second Hand Tires, San Marcos, Texas,* 1940. Gelatin silver print. Library of Congress, Washington, D.C.

469. MARION POST WOLCOTT. *Family of Migrant Packinghouse Workers, Homestead, Florida,* 1939. Gelatin silver print. Library of Congress, Washington, D.C.

470. Jack Delano. *In the Convict Camp, Greene County, Georgia*, 1941. Gelatin silver print. Library of Congress, Washington, D.C.

471. Ben Shahn. *Cotton Pickers, Pulaski County, Arkansas*, 1935. Gelatin silver print. Fogg Art Museum, Harvard University, Cambridge, Massachusetts; gift of Mrs. Bernarda B. Shahn.

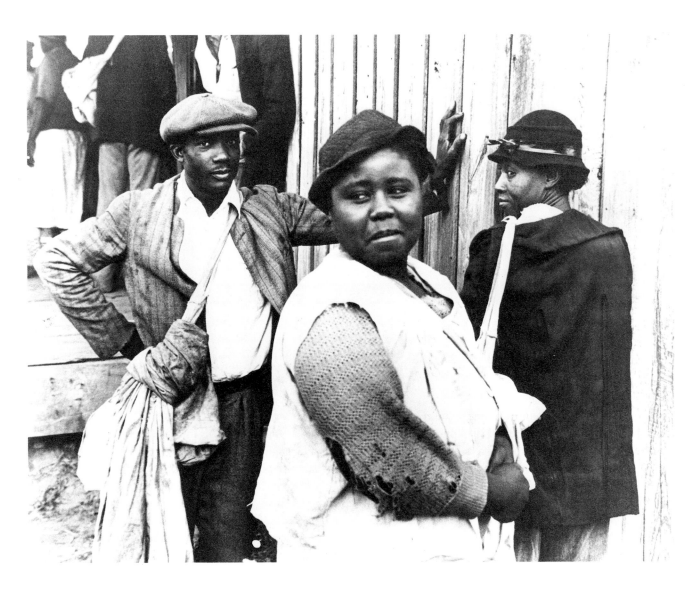

472. WALKER EVANS.
Window Display, Bethlehem,
Pennsylvania, Nov., 1935.
Gelatin silver print.
Library of Congress,
Washington, D.C.

medium and event, situations should be found, not re-enacted.

The painter Shahn, employed by the Special Skills Department of the Resettlement Administration, may have been the most persuasive voice in shaping attitudes and approaches on the project in that he convinced Stryker that record photographs were not sufficient to dramatize social issues, that what was needed were moving and vibrant images that captured the essence of social dislocation. Briefly instructed by Evans in the use of the Leica, Shahn had made candid exposures in New York streets for use in his graphic art. He displayed a vivid understanding of the

dimensions of documentation; his discussions with Stryker and the other photographers helped clarify the need for interesting and compassionate pictures instead of mere visual records whether they portrayed inanimate objects or people. In themselves, his images reveal a profound social awareness and a vivid sense of organization that captures the seamlessness of actuality *(pl. no. 471)*.

Although quite different, the rigorous aesthetic and craft standards maintained by Evans, who was employed by the section for about two years, also broadened Stryker's understanding of the potential of photography to do more than record surface appearances. The only photographer

to consistently use the 8 x 10 inch view camera (as well as smaller formats), Evans photographed extensively in the South, engrossed by its "atmosphere . . . smell and signs." His subjects were exceptionally diverse, including portraits, interiors, domestic and factory architecture, folk craft, and popular artifacts *(pl. no. 472)*. Of all the section photographers, he was least in sympathy with the social implications of the project and regarded with indifference Stryker's call for file photographs and the bureaucratic restrictions of the project. Therefore Evans was not unhappy to receive a leave in 1936 to work with the writer James Agee on an article about tenant farmers for *Fortune* magazine. Following this experience and the resulting publication, *Let Us Now Praise Famous Men*, Evans used a hidden camera to portray New York's subway riders.

The compassionate vision of Lange, "the supreme humanist," also influenced Stryker and the direction taken by the section, even though they were at odds over the question of printing, which the photographer preferred to do herself rather than leave to the darkroom technicians at the F.S.A. A former portraitist trained in the Pictorialist aesthetic, Lange was employed first on a California rural relief project, where her innate capacity to penetrate beneath appearances was recognized. Concentrating on gesture and expression, and possessing the patience to wait for the telling moment *(pl. no. 451)*, she seemed able to distill the meaning of the crisis to the individuals involved in terms that the nation at large could understand. On occasion, her pictures actually impelled authorities to take immediate steps to relieve suffering among migrant farm families. After leaving the project in 1940, Lange continued to work on her own in the same tradition, producing a memorable series of photographs of Japanese-Americans who had been unjustly interned by the federal government during the hysteria that accompanied the opening of hostilities between Japan and the United States.

Of the other photographers, both Mydans and Jung worked on the project for relatively short times. Lee, called "the great cataloguer" by Lange, took over Mydans's place when the latter was asked to join the staff of the newly established *Life*, and he remained with the section the longest. Though Lee was most committed to amassing as complete a visual record as possible, his images celebrate individuality and spunk and display a wry humor *(pl. no. 468)*. Post Wolcott, one of the relatively few female professional newspaper photographers of the time, was hired in 1938, when the direction of the project was being shifted toward a more positive view of the activities of the F.S.A. *(pl. no. 469)*. Delano, whose W.P.A. photographs of a bootleg mining operation in Pennsylvania came to the attention of Stryker when he was looking for a replacement for Rothstein in 1940, was also expected to make positive images, but a long stay in Greene County, Georgia, where he was among the first to photograph prisons and labor camps, resulted in moving evocations of anguish and loneliness *(pl. no. 470)*. Vachon, hired originally as a messenger, was responsible for the ever-growing picture file. Taught to handle a camera by both Shahn and Evans, Vachon saw his pictures begin to find their way into the file, and in 1940 he was promoted to photographer. Collier, the last hired for the project, barely had time to work in the field before the Historical Section was transferred to the Office of War Information in 1942.

The interrelationship between photographer, government agency, and public was crucial to the formation of this unique document, and it owes much to Stryker's capacity to direct the project toward ends in line with the New Deal's goal of offering minimal assistance to those being permanently displaced from the land by economic and social factors. Despite a certain resistance to the poetic resonance of camera images, and an autocratic attitude toward the use and cropping of the photographs; despite a willingness to bow to demands for superficial and positive images of the American experience, Stryker was an effective buffer between photographers, bureaucrats, and the press, and he created the conditions for an exceptional achievement. A small number of images in this extensive document have been consistently visible since the 1940s, when Stryker turned the collection over to the Library of Congress, whose archives are more accessible than those of other federal entities. Those few images have come to symbolize the documentary mode, but lesser-known works, along with images in other archives, also make vivid the degree of displacement suffered by the nation's rural population during the Great Depression.

Illuminating Injustice: The Camera and Social Issues

In the late 19th century, the camera became a tool for providing authentic visual evidence of social inequities, in particular those relating to industrialization and urbanization. At the time, a small number of photographers either were commissioned or felt self-impelled to photograph unsafe and unsavory circumstances of housing and work. Such images became useful in the United States especially in campaigns undertaken by a sector of the middle class to insure regulation of the conditions of living and work for the immigrant working class. From this beginning, documentary style in photography emerged, eventually expanding to include images of conditions in rural areas and underdeveloped nations as well.

In general, documentary style embraces two goals: the depiction of a verifiable social fact and the evocation of empathy with the individuals concerned. Photographs of this nature were employed in conjunction with written texts, either in public lectures, printed publications, or exhibitions, and usually involving a series rather than a single image. This perspective reached a zenith between 1889 and 1949 in the work of Jacob Riis, Lewis Hine, the photographers engaged by the Farm Security Administration, and a number working in the Photo League.

The documentary role eventually was taken over, and in the process transformed, by television journalism and by advertising, with the result that its strategies and rationales have become suspect among some contemporary photographers concerned with social issues. Nevertheless, the style still retains its strong appeal for those who are convinced that through a compassionate portrayal, the viewer might become emotionally disposed to support changes in inequitous conditions. This Album includes the work of photographers who were uniquely concerned with this approach to camera documentation.

473. PETER MAGUBANE. *Fenced in Child, Vrederdorp*, 1967.
Gelatin silver print. Courtesy and © Peter Magubane.

474. LEWIS W. HINE. *Breaker Boys in a Coal Mine, South Pittston, Pa.*, 1911.
Gelatin silver print. Private collection.

OPPOSITE ABOVE:

475. W. EUGENE SMITH. *Tomoko in Her Bath, Minamata, Japan*, 1972.
Gelatin silver print. W. E. Smith Foundation.

OPPOSITE BELOW:

476. LEWIS W. HINE. *Ten-Year-Old Spinner, North Carolina Cotton Mill*, 1908–09.
Gelatin silver print. Private collection.

477. Inge Morath.
*Buckingham Palace
Mall, London,*
1954. Courtesy and
© Inge Morath/
Magnum.

478. Morris Engel. *Rebecca,
Harlem,* 1947. Gelatin silver
print. Private collection.
© 1947 Morris Engel.

479. JACOB RIIS. *The Man Slept in This Cellar for About 4 Years*, c. 1890.
Gelatin silver print. Museum of the City of New York.

480. WENDY WATRISS. *Agent Orange,*
Gelatin silver print. © Wendy Watriss
courtesy Woodfin Camp.

481. DOROTHEA LANGE. *Grayson,*
San Joaquin Valley, California, 1938.
Gelatin silver print. Courtesy of the
Dorothea Lange Collection. © 1938
The City of Oakland, Oakland
Museum, Oakland, California.

482. SEBASTIÃO SALGADO. *The Drought in Mali*, 1985.
Gelatin silver print. Courtesy and © Sebastião Salgado/Magnum.

9.

ART, PHOTOGRAPHY, AND MODERNISM
1920–1945

The new camera counts the stars and discovers a new planet sister to our earth, it peers down a drop of water and discovers microcosms. The camera searches out the texture of flower petals and moth wings as well as the surface of concrete. It has things to reveal about the curve of a girl's cheek and the internal structure of steel.

—Egmont Arens, 1939 [1]

IF ANY PERIOD can be said to have encompassed the full potential of photography it would have to be the era between the two World Wars. Some 80 years after the medium first appeared, photographers and their patrons discovered forms and uses for camera images that imbued them with exceptional inventiveness and immediacy. Photography was not only enriched by expanded roles in journalism, advertising, and publicity, but it was nourished also by acceptance within avant-garde movements in the graphic arts. In fact, it might with justice be claimed that except for holography all later directions were foretold during this period. The extraordinary vitality of the medium was apparent in many different localities—in England, France, Central Europe, the Soviet Union, Japan, and North America—yet photographs also retained distinctive national characteristics. This chapter will survey the range of experimentation and explore the relationship of the "new vision," as it is sometimes called, to other visual art of the time; Chapter 10 will be concerned with the flowering of the medium in journalism, advertising, and book publication.

A distinguishing feature of the photography of the 1920s was the emergence of a wide variety of techniques, styles, and approaches, all displaying unusual vigor. Responding to greater economic opportunities in the medium and involved in the intense intellectual, political, and cultural ferment that followed the first World War, many photographers became conscious of the effects of technology, urbanization, cinema, and graphic art on camera expression. In addition to the "isms" of prewar avant-garde art—especially Cubism—the aesthetic concepts associated with Constructivism, Dadaism, and Surrealism inspired a climate of experimentation, with photo-collage, montage, cameraless images, nonobjective forms, unusual angles, and extreme close-ups marking the photographic expression of the era. In common with other visual artists, photographers also took note of Freudian and related theories of the psyche and of the part that images might play in the social and political struggles of the times.

In Europe the new vision was nurtured by the complex artistic and social tendencies that emerged following the revolutionary uprisings at the end of the first World War. Embodied in Russian Constructivism, the German Bauhaus—a school of architecture and design—and the *Deutsches Werkbund* (German Work Alliance), these movements and organizations viewed artistic expression as concerned with the analysis and rational reconstruction of industrial society rather than as a means of producing unique decorative objects based on personal feelings or experiences for an elite class. With art activity conceived as a way to improve the lives of ordinary people through the redesign of their physical and mental environments, the artist emerged as an individual who "remained true . . . to reality [in order] to reveal the true face of our time."[2] In the eyes of a significant number of artists, the various media were no longer regarded as discrete entities; the applied arts were considered as important as the "fine" arts of painting and sculpture; and respect for machine technology led to a high regard for both printing press and camera as the most effective visual instruments of the age.

Experimentation in Europe: Light Graphics

The developments that followed the end of the first World War had been heralded earlier in the breakdown of conventional modes of artistic expression. As the 1914–18 conflict raged in Europe, Dadaists urged that the moribund art of the past be jettisoned; that new themes and new forms be found to express the irrational nature of society. This attitude opened fertile fields for all kinds of visual experimentation, including the production of cameraless photographic images. It will be recalled that "photogenic drawing"—Talbot's name for prints made by exposing real objects placed directly on light-sensitive paper—actually had preceded photography through the use of a camera. In updating this concept, photographers of the new vision employed a variety of substances and light sources to create nonrepresentational images. The earliest examples were made in 1918 by Christian Schad, a German artist soon to become a leading exponent of the New Objectivity in painting, who exposed chance arrangements of found objects and waste materials—torn tickets, receipts, rags—on photographic film (*pl. no. 483*); the results, baptized Schadographs by the Dada leader Tristan Tzara, expressed the Dadaist interest in making art from junk materials.

Independently, the American Man Ray (born Em-

manuel Radnitsky), a close associate of Duchamp and Francis Picabia during their New York Dada period, undertook similar experiments that the photographer called Rayographs *(pl. no. 484)*, a designation incorporating both his name and a reference to their source in light. Made soon after Man Ray's arrival in Paris in 1921, these cameraless images were effected by arranging translucent and opaque materials on photographic paper, at times actually immersed in the developer during their exposure to moving or stationary light sources. Indifferent to conventional distinctions between fine and applied art yet devoted to the expression of intuitive states of being and chance effects, Man Ray sought commercial as well as artistic outlets for his extensive visual output that, besides Rayographs, included straight photographs, paintings, collages, assemblages, and constructions.

Cameraless images also were called photograms *(pl. no. 485)*, the name given the technique worked out together by Lucia Moholy and László Moholy-Nagy. Originally from Czechoslovakia and Hungary, respectively, but active after 1923 at the Bauhaus in Germany, these two

484. MAN RAY. *Untitled (Wire Spiral and Smoke)*, 1923. Gelatin silver print. Private collection, New York. © Man Ray 2015 Trust/Artists Rights Society, New York/ADAGP, Paris.

artists held that, like other products produced by machine, photographic images—cameraless and other—should not deal with conventional sentiments or personal feelings but should be concerned with light and form. It is ironic that even though they promoted photography as the most fitting visual form for the machine age precisely because the camera image could be easily and exactly replicated, photograms are unique examples for which no matrix exists for duplication. Other Europeans who experimented with cameraless imagery—or light graphics, as this aspect of photography came to be called—include Raoul Hausmann, Gyorgy Kepes, Kurt Schwitters, the Russians El Lissitzky and Alexander Rodchenko, the Czech artist Jaromir Funke, and Curtis Moffat, an English assistant to Man Ray. For reasons to be discussed presently, interest in this form of expression did not develop in the United States until after the Bauhaus relocated in Chicago in 1938 as the Institute of Design.

Collage and Montage

In Europe, an even more fertile field for experimentation involved collage and montage—techniques whose

483. CHRISTIAN SCHAD. *Schadograph*, 1918. Gelatin silver print. Edward L. Bafford Photography Collection, Albin O. Kuhn Library and Gallery, University of Maryland, Baltimore. Courtesy Mrs. Christian Schad. © G. A. Richter Rottach-Egern.

485. László Moholy-Nagy. *Photogram*, n.d. Gelatin silver print.
Art Institute of Chicago; Gift of Mr. and Mrs. George Barford.
© Estate of László Moholy-Nagy/Artists Rights Society (ARS), New York.

486. HANNAH HÖCH. *The Cut of the Kitchen Knife*, 1919. Montage. Nationalgalerie, Staatliche Museen Preussischer Kulturbesitz, Berlin. © 2019 Artists Rights Society (ARS), New York/ VG Bild-Kunst, Bonn.

487. RAOUL HAUSMANN. *Mechanical Toys*, 1957. Gelatin silver print; double exposure of two photographs showing Hausmann's Dadaist sculpture *Mechanischer Kopf*, 1919. Schirmer/Mosel, Munich.
© 2019 Artists Rights Society (ARS), New York/ADAGP, Paris.

488. JOHN HEARTFIELD. *Adolf the Superman; He Eats Gold and Spews Idiocies*, 1932. Gelatin silver print. Courtesy Mrs. Gertrud Heartfield, Berlin. © The Heartfield Community of Heirs/Artists Rights Society (ARS), New York/VG Bild-Kunst, Bonn, 2019.

489. GEORGE GROSZ. *The Engineer Heartfield (Dada Monteur)*, 1920. Watercolor and collage of pasted postcard and halftone. Museum of Modern Art, New York; Gift of A. Conger Goodyear.

terms sometimes are used interchangeably. The former (from the French *coller*, to glue) describes a recombination of already existing visual materials effected by pasting them together on a nonsensitized support and, if desired, re-photographing the result *(pl. no. 486)*. Montage refers to the combining of camera images on film or photographic paper in the darkroom *(pl. no. 487)*. The creation of a new visual entity from existing materials appealed to avant-garde artists in part because it was a technique employed by naive persons to create pictures—a folkcraft, so-to-speak —and in part because it used mass-produced images and therefore did not carry the aura of an elitist activity. These artists also felt that the juxtaposition of unlikely materials might serve to arouse feelings in the spectator that conventional photographic views no longer had the power to evoke. Besides, collage and montage promised to be extremely malleable—amenable to the expression of both political concerns and private dreams. Constructivists in the Soviet Union, who regarded the visual arts as a means

to serve revolutionary ideals, hailed collage and montage as a means to embody social and political messages in an unhackneyed way, while for artists involved with personal fantasies these techniques served to evoke witty, mysterious, or inexplicable dimensions. Still other individuals, inspired by the aesthetic elements of Cubism, used these techniques to control texture, form, and tonality to achieve nuanced formal effects.

Although a number of artists have claimed to be inventors of montage, as with cameraless photography it was an old idea whose time had come. Hausmann, painter, poet, and editor of a Dada journal, was one of its earliest partisans, realizing in the summer of 1918, as he later recalled, "that it is possible to create pictures out of cut-up photographs."[3] Needing a name for the process, he, along with artists George Grosz, Helmut Herzfelde (who later renamed himself John Heartfield), and Hannah Höch, selected photomontage as a term that implies an image "engineered" rather than "created." To these origi-

490. ANTON GIULIO and ARTURO BRAGAGLIA. *The Smoker*, 1913. Gelatin silver print. Weston Gallery, Inc., Carmel, Cal.

491. ALEXANDER RODCHENKO. *Montage*, c. 1923. Gelatin silver print. *Sovfoto Magazine* and VAAP, Moscow.

nators, montage seemed to reflect "the chaos of war and revolution,"[4] visible in Hausmann's preoccupation with savagery and irrationality and in Höch's expressions of socially generated fantasies. A strong political component characterizes the work of Heartfield *(pl. no. 488),* who was initially a Dadaist and was pictured by his colleague Grosz as the quintessential photomontagist, or *"Dada Monteur,"* of the era *(pl. no. 489).*

Photographers in Italy found montage a versatile technique with which to express "spiritual dynamism," the term they used to describe their interest in urbanism, energy, and movement that had emerged in the wake of the Futurist Manifesto of 1908. Then, the brothers Anton Giulio and Arturo Bragaglia (among others) had incorporated the scientific experiments of Marey into what they called "Photodynamics," making multiple exposures on a single plate *(pl. no. 490)* to suggest a world in flux. After World War I, Italian modernists, among them Vincio Paladini and Wanda Wulz, continued in this vein, combining printed and pasted materials in two and three dimensions with multiple exposures.

Montage found favor in the Soviet Union during the 1920s as an instrument for revealing what was termed "documentary truth." Instead of relying on conventional time-consuming modes of graphic representation, Constructivists, notably Lissitzky and Rodchenko, sought to awaken working-class viewers to the meaning of contemporary socialist existence by utilizing photographs and text in visual messages *(pl. no. 491).* Like their counterparts in Russian film (then considered the most advanced of the era), they were convinced that montage—which they called "deformation" of the photograph—and straight camera images taken extremely close to the subject or from unusual angles could communicate new realities.[5]

Toward the end of the 1920s, true photographic montage, effected on light-sensitive materials rather than by cutting and pasting, became more commonplace and was sometimes combined with other darkroom manipulations such as solarization.[6] Owing to its flexibility, montage could be structured to serve different stylistic and thematic ends—personal as well as political. To cite only a few examples, Anton Stankowski, working in Germany, explored an enigmatic psychological component in *Eye-Montage (pl. no. 492)* of 1927; the Czech photographer Karel Teige embraced a similar theme in a 1937 cover for a Surrealist journal *(pl. no. 493);* and Man Ray's ironic wit is seen in the oft-reproduced *Violon d'Ingres (pl. no. 494).* Socially oriented concerns were expressed by Alice Lex-Nerlinger, part of a German husband and wife team, in *Seamstress (pl. no. 495)* of 1930. Incidentally, the themes of eye, hand, and work visible in several of these images engaged many photographers of the period whether they worked with

495. ALICE LEX-NERLINGER.
Seamstress, 1930. Gelatin silver
print. Art Institute of Chicago;
Julien Levy Collection, Gift of
Jean and Julien Levy, 1975.

montage or straight images. The eye obviously can be taken as a symbol for camera or photographer, while the combined emphasis on all of these elements suggest that camera work was seen as the result of both craft and vision, a concept embodied in the theories and programs of Constructivism, the Bauhaus, and the *Werkbund.*

The New Vision: Straight Photography in Europe

The new vision invigorated straight photography by presenting the known world in uncharacteristic ways. Even though polemical messages may have been more difficult to convey than in montage, photographers found that they could express social and psychological attitudes and explore aesthetic ideas through a variety of visual initiatives. These included making use of actual reflections, unusual angles, and close-ups. Inspiration for many of these experiments in seeing can be traced to the avant-garde cinema, which, in the opinion of at least one photographer of the time, saved still photography from itself.[7] Reflections, which in former times had aided photographers in composing interior scenes and landscapes, now offered them a means to explore the expressive possibilities of industrially produced refractive surfaces such as plate glass and polished metals. The overlay of natural forms and geometric pat-

terns reflected in the shop windows of Atget's images *(pl. no. 319)* frequently evokes a dreamlike aura; in the hands of modernist photographers this stratagem served to confound one's sense of space or to introduce seemingly unrelated visual references. To select but a single example, in *Frau G. Kesting*, 1930, *(pl. no. 496)* German photographer Edmund Kesting structured an image resonant with restlessness and ambiguity from the reflections in the automobile windshield, the tense expression on his wife's face, and the tectonic elements of car and building.

Distorted reflections, effected by using special mirrors and lenses or by capturing objects refracted in spherical forms, provided a device that might serve to mimic the formal experiments of Cubist painters as well as to express disturbing personal or social realities. First seen in 1888, when Ducos du Hauron produced a series of experimental portraits *(pl. no. 497)*, the distorted image was reintroduced in the late 1920s by Hungarian photographer André Kertész

(pl. no. 498), whose interest had been aroused initially as he photographed the bodies of swimmers refracted in a pool. In 1933, using a special mirror, he produced a series of nudes similar in treatment to the deformations of the human body that engrossed Picasso at the time. The potential of this technique in social or personal comment was explored by Polish photographers Marian and Witold Dederko *(pl. no. 499)* whose work in the modernist vein is combined with old-fashioned gum printing techniques, while the distorted scene refracted in the polished headlamp of a car in *The Fierce-Eyed Building (pl. no. 500)*, by American neo-Romantic Clarence John Laughlin, seems to signify the photographer's view of modern urban life as inhumane.

Photographers especially influenced by Surrealism sought to express intuitive perceptions through found symbols as well as accidental reflections. In *Optic Parable (pl. no. 501)*, by Mexican photographer Manuel Alvarez Bravo, reflections in a shop window combine with the repetitive

496. EDMUND KESTING. *Frau G. Kesting*, 1930. Gelatin silver print. San Francisco Museum of Modern Art; purchase, Mrs. Ferdinand C. Smith Fund.

ABOVE LEFT:

497. LOUIS DUCOS DU HAURON. *Self-Portrait*, c. 1888.
Gelatin silver print. Société Française de Photographie,
Paris.

ABOVE RIGHT:

498. ANDRÉ KERTÉSZ. *Distortion No. 4,* 1933.
Gelatin silver print. Susan Harder Gallery, New York.
© Estate of André Kertész.

LEFT:

499. MARIAN AND WITOLD DEDERKO. *Study A,* 1926.
Gum bichromate print. National Museum, Wroclaw,
Poland. International Center of Photography, New York.

500. CLARENCE JOHN
LAUGHLIN. *The
Fierce-Eyed Building,* 1938.
Gelatin silver print.
Courtesy Robert Miller
Gallery, New York.
© Historic New Orleans
Collection.

forms of a naively painted eye-glass sign, seen in reverse as if to intimate an all-seeing but perverse presence. Bravo's style, formed during the 1930s cultural renaissance in his native land, suggests a complex amalgam of sophisticated theories of the unconscious, elements of indigenous folk culture, and commitment to the humanist ideals of the Mexican revolution.

The influence of the "isms" of art culture—Cubism, Constructivism, Surrealism, Precisionism—are visible in the work of virtually all photographers of the new vision,

but while most regarded these concepts as allowing them the freedom to fragment and restructure reality, some individuals actually included in their photographs the typical geometric furnishings of Constructivist and Cubist paintings. Cones, spheres, and overlapping transparent planes found their way into the work of European photographers Herbert Bayer and Walter Peterhans, both of the Bauhaus, as well as that of Funke, Florence Henri, and the American Paul Outerbridge. Henri's studies at the Bauhaus and with painter Fernand Léger may account for her preference

501. MANUEL ALVAREZ BRAVO. *Optic Parable*, 1931. Gelatin silver print. Museum of Modern Art, New York; gift of N. Carol Lipis. © Manuel Alvarez Bravo.

502. FLORENCE HENRI. *Abstract Composition*, 1929. Gelatin silver print. © Galerie Wilde, Cologne.

for the mirrors and spheres that appear again and again in her abstract compositions *(pl. no. 502)* and portraits; other Cubist photographers allowed themselves greater latitude in the artifacts they assembled for Cubist-like still lifes. In the same fashion, the emblems of Surrealism—endless vistas, melting clocks, and checkerboard patterns—appeared in photographs by Man Ray, the British theatrical portraitist Angus McBean, and the American theatrical and fashion photographer George Platt Lynes *(see Chapter 10)*.

Perhaps the most striking characteristic of the straight photography of this time is the predominance of unconventional vantage points. This development was forecast in the work done in the second decade of this century by American photographers Stieglitz, Coburn, Steichen, and Strand following their exposure to modern European art exhibited at 291, The Armory Show, and the Modern Gallery. Indeed, the downward view and the rigorous organization of all the tectonic elements in Stieglitz's 1907 image *The Steerage (pl. no. 402)* resulted in a complex formal structure that is said to have impelled Picasso later to remark that the two artists were working in the same avant-garde spirit. Fresh points of view, unhackneyed themes, geometry, and sharp definition were heralded by Coburn, who observed that photographers "need throw off the shackles of conventional expression."[8] His image *The Octopus (pl. no. 398)* of 1913 is a flattened arrangement

503. ALVIN LANGDON COBURN. *Vortograph No. 1*, 1917. Gelatin silver print. Museum of Modern Art, New York; gift of Alvin Langdon Coburn.

504. PAUL STRAND. *Orange and Bowls, Twin Lakes, Conn.*, 1916. Platinum print. © 1981 The Paul Strand Archive, Lakeville, Conn.

505. HERBERT BAYER. *Pont Transbordeur, over Marseilles*, 1928. Gelatin silver print. © Estate of Herbert Bayer.

of planes and arcs achieved by photographing downward from a position high over Madison Square Park in New York City. Three years later, Coburn's involvement in Vorticism, the English variant of Cubism, led him to photograph through a kaleidoscope-like device consisting of three mirrors; these completely abstract formations were dubbed Vortographs *(pl. no. 503)* by Wyndham Lewis, the British leader of the movement.

Around 1916, Strand created a series of near-abstractions using ordinary household objects. Exemplified by *Orange and Bowls (pl. no. 504)*, these images concentrated on form, movement, and tonality rather than on naturalistic depiction or atmospheric lighting. Although abstraction as such did not interest him for long, Strand's utilization of unconventional angles and his high regard for pictorial structure also can be seen in the downward views of New

506. JAN LAUSCHMANN.
Castle Staircase, 1927.
Gelatin silver print.
© Estate of Jan Lauschmann.

York streets and the close-ups of anonymous street people and of machine and organic forms with which he was preoccupied until the end of the 1920s. No Americans besides Coburn and Strand went quite so far in experimenting with abstraction before the twenties, but some, including Stieglitz, Charles Sheeler, Morton L. Schamberg, Steichen, Karl Struss, and Paul Lewis Anderson showed themselves exceptionally sensitive to geometric elements as they appeared in reality and to formal structure in their images.

The fact that mundane scenes and ordinary objects could be revealed in a fresh light made the unconventional vantage point a favorite of those associated with Constructivism and the Bauhaus precisely because these groups were dedicated to viewing everyday society in new ways. *Pont Transbordeur (pl. no. 505)*, a view by Bayer from a

bridge looking down on the streets of Marseilles, typifies the many images of the time in which the visual field is transformed into a relatively flat pattern—one that retains just enough suggestion of depth and texture to be ambiguous. Besides unusual camera angle, the abstract orchestration of tonality, seen in *Castle Staircase (pl. no. 506)* by Czech photographer Jan Lauschmann, can produce a work that is spatially baffling but visually authoritative. Lauschmann, a photochemist by profession, was one of the first in his country to conclude that photography should be an independent branch of art, and that straight printing was more relevant to modern concerns than the hand-manipulated gum printing techniques that lingered in Eastern Europe until the 1930s.

In another example of the downward view that is arrest-

507. ANDRÉ KERTÉSZ.
Satiric Dancer, Paris, 1926.
Gelatin silver print.
Susan Harder Gallery,
New York. © Estate of
André Kertész.

ing from several positions—*Carrefour, Blois (pl. no. 508)* by Kertész—the puzzling configuration of lines and shapes of architectural elements seen from above serve as a foil for the animate forms, resulting in a refreshing vision of a scene that had been more commonly photographed from street level. Neither a Pictorialist nor yet an entirely objective photographer, Kertész supported himself as a freelance journalist soon after moving to Paris from his native Hungary in 1925; using the newly invented Leica camera *(see A Short Technical History, Part III)* he embraced the new vision as a means to extract lyrical moments from the ordinariness of daily existence. While he utilized virtually the entire vocabulary of modernism—reflections, close-ups,

and unusual vantage points—his images seem to project wit *(pl. no. 507)*, human compassion, and poetry rather than a concern with formal problems or didactic ideas.

The view from above made possible the ambiguous reading of shadow and substance visible in a work of 1929 entitled *Little Men, Long Shadows (pl. no. 509)* by Vilho Setälä, a skillful Finnish professional photographer whose visual interplay of figures and shadows suggests a typically urban experience of anonymity and mechanized existence. At times the relationship between shadow and substance in photographs taken from this viewpoint is so tenuous that the images can be viewed from any angle with equal comprehension. As a result of increased attention to camera

508. ANDRÉ KERTÉSZ. *Carrefour Blois,* 1930. Gelatin silver print. Susan Harder Gallery, New York. © Estate of André Kertész.

509. VILHO SETÄLÄ. *Little Men, Long Shadows,* 1929. Gelatin silver print. Photographic Museum of Finland, Helsinki.

510. T. Lux Feininger. *Clemens Röseler*, c. 1920s.
Gelatin silver print. Prakapas Gallery, Bronxville, N.Y.

511. Karl Blossfeldt. *Impatiens Glandulifera, Balsamine,
Springkraut*, 1927. Gelatin silver print. Galerie Wilde, Cologne.
© Karl Blossfeldt Archiv/Ann and Jürgen Wilde, Cologne,
Germany/Artists Rights Society (ARS), New York.

angle, a portrait of Clemens Röseler *(pl. no. 510)* by T. Lux Feininger, who was involved with the theater and dance program at the Bauhaus, is imbued with tension and fresh interest through the extreme foreshortening.

Another hallmark of the new vision is the close-up, a view in which the lens acts like an enlarging device to call attention to patterns, textures, and structures that might ordinarily pass unnoticed. Reflecting in part the advances in scientific photography during the 20th century, the close-up was regarded as one means for "the objective presentation of fact," which frees the viewer from the confusion of individual representation.[9] This concentration on discrete objects also signified that to some photographers the camera seemed to be more suitable for revealing specific appearances than for depicting complex psychological or social relationships. The close-up recommended itself strongly to German partisans of the New Objectivity, among them professor of art Karl Blossfeldt who sought through his images of plant forms to establish a link between form in a natural world "governed by some fixed and eternal force"[10] and in art *(pl. no. 511)*.

The New Objectivity's most renowned advocate, Albert Renger-Patzsch, a professional photographer in Germany, also sought to make his lens reveal analogies between natural formations and factory-produced objects, in order to suggest the formal structures that are basic to plants, bridges, factories and their products. Focusing his large-format camera on intrinsic design elements and searching out repetitive pattern, he eliminated atmosphere, chance illuminations, and all personal subjective reactions to achieve a transcendental level of pure decoration in images such as *Sempervivum Percarneum*, 1922, *(pl. no. 512)*. At times his work seemed to approach abstraction despite his expressed "aloofness to art for art's sake." A similar attentiveness to the clarity of line and form characterizes Werner Mantz's views of German modern architecture of the 1920s and '30s, while Hans Finsler, Swiss-born but influential as a teacher and professional in Germany, used the camera to make vivid the precise geometries of mass-produced machined objects *(pl. no. 513)*.

The camera close-up, especially as it served the ideals of the New Objectivity, garnered international adherents

owing to the acclaim outside Germany for Blossfeldt's *Unformen der Kunst (Art Forms in Nature)*, published in 1928, and Renger-Patzsch's *Die Welt Ist Schön (The World Is Beautiful)*—the latter considered by the photographer "a model book of objects and things."[11] The style and its typical themes informed the work of many other Europeans, including French photographer Emmanuel Sougez and Dutch photographer Piet Zwart *(pl. no. 515)*, whose robust image of a cabbage can be compared with a similar image by Czech photographer Ladislav Berka *(pl. no. 514)*.

While the close-up opened a fresh way of viewing that most commonplace of subjects—the human face and form—it did not prevent the photographer from introducing personal feelings. Indeed, Rodchenko's *Portrait of My Mother (pl. no. 516)*, reveals the shape, texture, and forms of aging, and also expresses a tender though unsentimental compassion. Tonal contrast, outsize scale, and asymmetrical placement in Lucia Moholy's *Portrait of Florence Henri (pl. no. 518)* strikingly exemplify the formalistic concerns of the photographer yet suggest the essence of the sitter's personality. *Eye of Lotte (pl. no. 517)*, by the influential

512. ALBERT RENGER-PATZSCH. *Sempervivum Percarneum*, c. 1922. Gelatin silver print. Folkwang Museum, Essen, Germany. © 2019 Albert Renger-Patzch Archiv/Ann u. Jürgen Wilde, Zülpich/Artists Rights Society (ARS), New York.

513. Hans Finsler. *Ceramic Tubing*, c. 1930. Gelatin silver print. Sander Gallery, New York.

514. LADISLAV BERKA. *Leaves*, 1929. Gelatin silver print.
© Ladislav Berka.

515. PIET ZWART. *Cabbage*, 1930. Gelatin silver print. Haags
Gemeentemuseum, The Hague, Netherlands. © 2019 Artists
Rights Society (ARS), New York/c/o Pictoright Amsterdam.

German teacher Max Burchartz, a work that undoubtedly
was considered the "leit-motif for the modern photography
movement,"[12] because it so fully embraces the stylistic
devices of the era—the close-up, unusual framing, emphatic
geometrical design—at the same time projecting the inno-
cence and freshness of youth. As seen in *Child's Hands (pl.
no. 519)* by German photographer Aenne Biermann and the
image of work-hardened hands *(pl. no. 520)* by Italian pho-
tographer Tina Modotti, the close-up view obviously can
be imbued with either personal or social comment.

The New Vision in Japan

Japanese photographers were attracted to the new
vision as a result of the curiosity about Western ideas in
general that surfaced during the so-called "Taisho democra-
cy" of the 1920s. Access to articles, exhibitions, and repro-
ductions of camera images from Europe led to the expan-
sion of photographic activity beyond the previously limited
areas of portraiture and genre scenes and brought about an
invigorating diversity of stylistic and thematic directions.
While a late-blooming pictorialism continued to evoke a

"redundancy of misty scenes and blurry figures,"[13] many
more photographers, who were engaged in documentation
and portraiture (including that of the despised lower
classes—see Chapter 8) or in exploring new approaches to
still life and the nude, embraced the entire vocabulary of
the "new photography," as it was called in Japan as well as
in the West. Urged to "recognize the mechanistic nature of
the medium,"[14] photographers began to use sharper lenses
and to experiment with close-ups, montage, and solariza-
tion, producing during the 1930s works clearly influenced
by Surrealism *(pl. no. 521)* and the New Objectivity. Images
such as *Hosokawa Chikako (pl. no. 522)*, a portrait by Kozo
Nojima reminiscent of the Burchartz image mentioned
earlier, or the emphatically geometric *Ochanomizu Station*,
1933, *(pl. no. 523)*, by Yoshio Watanabe, were instrumental
in bringing Japanese photography into the modern era.

The New Vision in the United States:
Precisionism

Within limits, the new vision attracted all significant
photographers in the United States in the 1920s, many of

516. ALEXANDER RODCHENKO. *Portrait of My Mother*, 1924.
Gelatin silver print. Collection Alexander Lavrientiev, Moscow.

517. MAX BURCHARTZ. *Eye of Lotte*, c. 1928. Gelatin silver print. Folkwang Museum, Essen, Germany. © 2019 Artists Rights Society (ARS), New York/VG Bild-Kunst, Bonn.

518. LUCIA MOHOLY. *Portrait of Florence Henri*, 1926–27. Gelatin silver print. Art Institute of Chicago; Julien Levy Collection.

519. Aenne Biermann. *Child's Hands*, 1929. Gelatin silver print. Kunstbibliothek, Staatliche Museen Preussischer Kulturbesitz, Berlin.

520. Tina Modotti. *Number 21 (Hands Resting on a Tool)*, n.d. Gelatin silver print. Museum of Modern Art, New York; anonymous gift.

521. GINGO HANAWA. *Concept of Machinery of the Creator*, 1931. Photocollage. © 1971 Japan Professional Photographers Society.

522. KOZO NOJIMA. *Hosokawa Chikako*, 1932. Gelatin silver print. © 1971 Japan Professional Photographers Society.

523. YOSHIO WATANABE. *Ochanomizu Station*, 1933.
Gelatin silver print. © 1971 Japan Professional
Photographers Society.

whom accepted the idea that "absolute unqualified objectivity" constituted the unique property of the camera image.[15] Whether depicting nature, person, artifact, machinery, or architecture, American photographers emphasized the material properties of the real world even as they sought to embrace modern aesthetic ideas, an attitude they shared with the Precisionist painters of the period.

Of the older generation, neither Steichen nor Stieglitz, with their roots in Pictorialism, adhered strictly to the vocabulary of the New Objectivity, though both incorporated elements of the style with brilliant results. Steichen's preference for sharper definition and his interest in compositional theory in the postwar years is owed in part to his experiences in an aerial photography unit during the first World War. In 1923, a unique opportunity to become chief photographer for Condé Nast publications enabled him to fuse his extensive experience and intuitive decorative flair in a practical enterprise to be discussed in Chapter 10. As for Stieglitz, his consistent belief in the primacy of subjective feeling underlay the stylistic devices he chose to incorporate into his imagery, as the close-ups of O'Keeffe, the abstraction of the Equivalents, and the assertive geometry of the late New York scenes all affirm.

As the first World War was ending, Strand (whose role was discussed earlier) and Precisionist painter–photographers Schamberg and Sheeler emerged as the flag-bearers of the new approach. Schamberg, probably the first American to incorporate abstract machine forms in painting, used the camera for portraiture and to create complex Cubist-like juxtapositions of geometric shapes in the few urban landscapes *(pl. no. 524)* he made before his untimely death in 1918. In early images of rural architecture, Sheeler,

who began in 1912 to sustain his painting activity with commercial architectural photography, sought out the clarity of simple geometric relationships. He collaborated in 1920 with Strand on *Manhatta*, a short expressive film about New York City based on portions of Whitman's *Leaves of Grass*, and, following a stint in advertising and publicity photography, landed a coveted commission in 1927 to photograph the nation's largest automotive plant—the Ford Motor Works at River Rouge. Though Sheeler often exhibited paintings and photographs together and his work was included in the prestigious German *Film Und Foto* (Fifo) exhibition in 1929 *(see below)*, a growing ambivalence about the creative nature of photography eventually caused him to regard the camera as a tool for making studies, as in the untitled arrangement of stacks and funnels *(pl. no. 525)* that he transformed into the lucid oil *Upper Deck (pl. no. 526)*.

The Clarence White School of Photography proved to be a fountainhead of modernist ideas despite the Pictorialist outlook of its director, perhaps because in pursuing its goal of training photographers for jobs in advertising and publicity it needed to stress modern design. The successful transformation of the vocabulary of the new vision into a style of both personal expressiveness and commercial util-

524. MORTON SCHAMBERG. *Cityscape*, 1916. Gelatin
silver print. New Orleans Museum of Art, New Orleans.

525. CHARLES SHEELER. *Untitled,* c. 1927. Gelatin silver print. Gilman Paper Company, New York.

526. CHARLES SHEELER. *Upper Deck,* 1929. Oil on canvas. Fogg Art Museum, Harvard University, Cambridge, Mass.; Louise E. Bettens Fund.

ity is visible in the work of a number of illustrious students, notably Ralph Steiner, Outerbridge, Gilpin, Bruehl, and Bourke-White (the latter two will be discussed in Chapter 10). At the outset of Steiner's long career in professional photography and documentary film, he produced *Typewriter Keys (pl. no. 580),* a close-up that in its angled view and insistent pattern predates the appearance of this approach in Europe. This image—later used in an advertising campaign for a paper company—was a harbinger of the facility with which Steiner handled the modernist idiom in both commercial and personal work. Outerbridge's restrained treatment of city architecture and machined objects is exemplified in *Marmon Crankshaft (pl. no. 527),* a work inspired by the series of machine images made by Strand in 1921. After a brief period in attendance at the White School, Gilpin returned to her native Southwest to open a commercial portrait studio. Her handling of local architectural and landscape themes during

the 1920s reveals an interest in abstract geometrical pattern still visible in the stark design of the much later *Church of San Lorenzo, Picuris, New Mexico (pl. no. 529).*

That the aesthetics of the "new vision" also informed the early work of photographers who eventually chose other paths can be seen in the work of Berenice Abbott and Walker Evans, both of whom were in Europe during the cultural ferment of the 1920s *(see Abbott's portrait of James Joyce, pl. no. 528).* The high vantage point and spatial ambiguity in Abbott's view from the elevated tracks above Lincoln Square *(pl. no. 530)* is reminiscent of the handling of such views by European Bauhaus followers, but the image itself suggests the staccato rhythms of New York. Similarly, Evans, whose brief sojourn in Europe occurred before his commitment to photography, imbued the striking geometric pattern of *Wall and Windows (pl. no. 531)* with an emphatic tonal contrast that brings to mind the rude energy of the American urban scene.

527. PAUL OUTERBRIDGE. *Marmon Crankshaft*, 1923. Platinum print. Art Institute of Chicago; Julien Levy Collection. © G. Ray Hawkins Gallery, Los Angeles.

528. BERENICE ABBOTT. *James Joyce*, 1928. Gelatin silver print. Museum of Modern Art, New York; Stephen R. Currier Memorial Fund. © Berenice Abbott/Commerce Graphics Limited, Inc.

Precisionist Photographers: The West Coast

The Americanization of the New Objectivity reached its height in the work of West Coast photographers. Through personal contact, as well as articles and reproductions in European and American periodicals, Johan Hagemeyer, Edward Weston *(see Profile)*, Margrethe Mather, Imogen Cunningham, and Ansel Adams became aware of the new photographic vision. Hagemeyer, a former horticulturist and close friend of Weston, was the first to bring the anti-Pictorialist message back from the East in 1916, but despite his newfound preference for contemporary themes and high vantage points *(pl. no. 532),* a dreamy romanticism continued to pervade his imagery. Weston's attempts to slough off the soft-focus style that had gained him national renown were more successful. In a 1922 image of the American Rolling Mill (Armco) works *(pl. no. 584)* made in the course of a trip east, he handled the industrial theme with sharp definition and singular sensitivity to the dramatic character of stacks and conveyors. Weston described the object-oriented images on which he

concentrated in the late 1920s as revealing "the very substance and quintessence of the thing itself."[16] At times, such intense concentration on form virtually transmuted the object into an abstraction, as in *Eroded Plank from Barley Sifter (pl. no. 533).*

Mather, until 1922 Weston's associate in his California studio, transformed the misty orientalism of her early work into a style marked by sharply defined close-ups and emphasis on pattern *(pl. no. 534),* which reveal her stylish flair. After Cunningham established contact with Weston and saw European examples of the "new vision" in the 1920s, her earlier penchant for fuzzy allegorical figures cavorting on wooded slopes was replaced by an interest in close-ups of plant forms *(pl. no. 535)* and other organisms. Her clean, stark views of industrial structures *(pl. no. 583)* can be considered, along with Weston's, paradigms of the Precisionist style. Beginning around 1927, Brett Weston, following in his father's footsteps, also showed himself intensely concerned with form and texture in images of nature.

A deep respect for the grandeur of the landscape of the American West combined with the active promotion of the straight photograph brought world renown to Ansel

529. LAURA GILPIN. *Church of San Lorenzo, Picuris, New Mexico*, 1963. Gelatin silver print. Centre Canadien d'Architecture/Canadian Center for Architecture, Montreal. © 1979 Amon Carter Museum, Fort Worth, Texas.

530. BERENICE ABBOTT. *El at Columbus and Broadway, New York*, 1929. Gelatin silver print. Art Institute of Chicago. © Berenice Abbott/Commerce Graphics Limited, Inc.

531. WALKER EVANS. *Wall and Windows*, c. 1929.
Gelatin silver print. Art Institute of Chicago.
© Walker Evans Estate.

members included Consuelo Kanaga and Willard Van Dyke—the latter a guiding light in the group's activities who went on to renown as a documentary filmmaker. Ironically, *f/64*'s optimistic celebration of technology, which is exemplified in the crisp forms of Alma Lavenson's starkly geometric *Calaveras Dam II (pl. no. 538)* and Van Dyke's *Funnels (pl. no. 581)*, was about to be supplanted by a different sensibility as the onset of the Great Depression altered general perceptions about the wonders of industrialism.

Photography and Industrialism

Between the Armistice of 1918 and the Depression of the 1930s, the remarkable expansion of industrial capacity throughout the world commanded the attention of forward-looking photographers everywhere. The widespread belief in progress through technology held by followers of the Bauhaus, by Soviet Constructivists, and by American industrialists provided inspiration and, in conjunction with the emergence of pictorial advertising, made possible unprecedented opportunities to photograph industrial sub-

532. JOHAN HAGEMEYER. *Modern American Lyric
(Gasoline Station)*, 1924. Gelatin silver print. Art Institute
of Chicago.

Adams. Involved with the medium throughout the 1920s, though not completely convinced of its transcendental possibilities until about 1930, Adams took an approach to his chosen theme—large-scale nature in all its pristine purity—that is similar in its emphasis on form and texture to that of other Precisionist photographers. His work also embodies a scientific control of exposure, developing, and printing. Adams's special gifts are visible in the incisive translation of scale, detail, and texture into an organic design seen in the early *Frozen Lake and Cliffs, Sierra Nevada (pl. no. 536; see also pl. no. 537)*.

In 1930, the "*f/64*" group, informally established in San Francisco, promoted Precisionism through its advocacy of the large-format view camera, small lens aperture (hence the name), and printing by contact rather than enlarging. Besides Adams, Cunningham, and Weston, its

533. EDWARD WESTON. *Eroded Plank from Barley Sifter,* 1931. Gelatin silver print. © 1981 Arizona Board of Regents, Center for Creative Photography, University of Arizona, Tucson.

534. MARGRETHE MATHER. *Billy Justema in Man's Summer Kimono,* c. 1923. Gelatin silver print. Center for Creative Photography, University of Arizona, Tucson; Courtesy William Justema.

535. IMOGEN CUNNINGHAM. *Two Callas,* 1929. Gelatin silver print. © 1970 Imogen Cunningham Trust, Berkeley, Cal.

536. ANSEL ADAMS. *Frozen Lake and Cliffs, Sierra Nevada,* 1932. Gelatin silver print. © 1996 Trustees of the Ansel Adams Publishing Rights Trust. All rights reserved.

537. ANSEL ADAMS. *Monolith, The Face of Half Dome, Yosemite Valley, California*, c. 1927.
Gelatin silver print. © 1996 Trustees of the Ansel Adams Publishing Rights Trust. All rights reserved.

538. ALMA LAVENSON. *Calveras Dam II*, 1932. Gelatin silver print. Alma Lavenson Association and Susan Ehrens, Berkeley, Cal.

jects and sites. As might be expected, Europeans often treated these themes more experimentally than Americans. For example, Hans Finsler's *Bridge at Halle (pl. no. 539)* and the American Sherril V. Schell's *Brooklyn Bridge (pl. no. 540)* are each concerned with geometric design, but the vertiginous angle of the former is at once disorienting and stimulating in contrast to Schell's spatially more comprehensible and starkly decorative treatment. Many Europeans, among them Ilse Bing, Germaine Krull, and Eli Lotar, emphasized abstract qualities and formal relationships *(pl. no. 541)* without suggesting the utilitarian component of their industrial subject matter. In another example, the acute upward angle chosen by Russian photographer Boris Ignatowich *(pl. no. 542)* expresses the force and energy embodied in these structural beams but tells little about the size, shape, or usefulness of the objects pictured.

Not so in the United States, where machine images achieved a balance between expressive and descriptive elements in part because they were commissioned by industrial firms for advertising and public relations. However, even the photographs of machine tools, products, and mills made by Strand *(pl. no. 578)*, Outerbridge, and Weston in the early 1920s idealize technology and suggest that it can be tamed and controlled. The emphasis on line and volume in Sheeler's treatment of the blast furnace and conveyors at the Ford River Rouge plant *(pl. no. 585)* were rightly assumed to express an "industrial mythos," a faith in industrial production as the sensible new American religion.[17] This view was shared initially by Bourke-White, whose expressive handling of modernist vocabulary can be seen in a forceful 1929 image of a bridge structure in Cleveland *(pl. no. 543)* taken before a commission for a large steel company launched her on an illustrious career as one of America's leading industrial photographers *(see also pl.*

539. HANS FINSLER. *Bridge at Halle*, c. 1929. Gelatin silver print.
Kunstgewerbemuseum der Stadt, Zurich, Switzerland.

540. Sherril V. Schell. *Brooklyn Bridge*, n.d. Gelatin silver print. Art Institute of Chicago; Julien Levy Collection.

LEFT:

541. ILSE BING. *Paris, Eiffel Tower Scaffolding with Star*, 1931. Gelatin silver print. Art Institute of Chicago; Julien Levy Collection.

BELOW LEFT:

542. BORIS IGNATOWICH. *On the Construction Site*, 1929. Gelatin silver print. *Sovfoto Magazine* and VAAP, Moscow.

BELOW RIGHT:

543. MARGARET BOURKE-WHITE. *High Level Bridge, Cleveland*, 1929. Gelatin silver print. George Arents Research Library, Syracuse University, Syracuse, N.Y.

no. 582). While Sheeler and Bourke-White were the most renowned, by the mid-1930s Bruehl, John Mudd, William Rittase, and Thurman Rotan also were associated with high quality industrial photography commissioned for advertisements and articles. And although Hine was motivated by a wish to celebrate the worker behind the machine rather than by any reverence for industrial formation as such, his factory images *(pl. no. 446)* and views of the Empire State Building in construction also reflect a belief that machines and technology ultimately were beneficial to mankind.

Industrial images were made mainly for advertisements and publicity in trade journals, but the interest in this theme among artists and intellectuals can be gauged by the many gallery exhibitions and articles in general publications on this theme that appeared during the 1920s and early '30s.[18] One example might suffice: of the images submitted to the Exhibition of Photographic Mural Design, held at the Museum of Modern Art in 1932, the largest number were concerned with industrial subjects. Sheeler submitted a montage triptych based on the River Rouge images *(pl. no. 585)*, while Abbott, Aubrey Bodine, Rotan, and Steichen entered works depicting skyscraper construction, smelting furnaces, and bridge structures. In the late 1920s, industrial and machine images began to appear in popular photographic journals, annuals, and Pictorialist salons also. The acceptance of "Beauty in Ugliness," as one article called it,[19] occurred almost a quarter of a century after Coburn had justly pointed out that both bridgebuilder and photographer were creatures of the modern era.

The New Vision: The Nude

The nude also appealed to photographers of the new vision. A quintessentially artistic theme, it lent itself to a variety of visual experiments in Europe, figuring in montages, solarizations, oblique and close-up views by Feininger, Hausmann, Kesting, Man Ray, Moholy-Nagy, and Tabard *(pl. no. 544)*, among others. The work of Frantisek Drtikol, a Czech, can be taken as typical of the artfulness with which the theme was handled; it was unusual, too, in that Pictorialist darkroom processes, such as pigment printing, were used for avant-garde ends, creating mannered and stylized "art deco" arrangements typified by an untitled image *(pl. no. 545)* of 1927.

As a theme, the nude—male as well as female—inspired special interest among American photographers who were relieved to find the subject more acceptable in straight photography than it had been before. Besides Stieglitz, whose belief in the nude as a symbol of life-giving energy inspired his images of O'Keeffe, others who

sought ways of imbuing this subject with vitality included Cunningham, Outerbridge, Sheeler, Strand, and Weston. A 1928 work by Cunningham *(pl. no. 546)* transforms a torso into a series of irregular triangles that are affecting because the geometrical shapes still intimate the softness of flesh, and evoke a delicately sensual feeling. Weston, according to companion Charis Wilson, found in the female nude image a "lifelong challenge"[20]—an instrument to explore both the formal problems involved in the new vision and his own sexuality. Nude *(pl. no. 547)*, 1926, transforms sentient flesh into stone hardness, suggesting that "the thing itself" can be transmuted according to one's perceptions into something other. While less common, photographs of the male nude or of both sexes together, were made by a small number of photographers, among them Lynes, whose study *(pl. no. 548)* turns reality into fantasy. Through his handling of the shadows that suggest the ambiguous nature of sexuality, Lynes found a means to give photographic form to Surrealist concepts.

544. MAURICE TABARD. *Nude*, 1929. Gelatin silver print. New Orleans Museum of Art; Museum Purchase, 1977, Acquisition Fund Drive.

545. FRANTISEK DRTIKOL. *Untitled*, 1927. Gelatin silver or bromoil print. Private collection.

546. IMOGEN CUNNINGHAM. *Triangles*, 1928. Gelatin silver print. © 1970 Imogen Cunningham Trust, Berkeley, Cal.

In view of the affinities between movements in graphic art and photographic expression during this period, it is not surprising to find the camera used in the late 1920s to explore Surrealist ideas and vocabulary. Montage and other darkroom techniques mentioned earlier provided an obvious means to express fantasy visions, but the desire to present the subconscious as an aspect of reality impelled straight photographers to fabricate, arrange, and illuminate objects and their settings in order to create synthetic realities. Manikins and dolls often were seen as metaphors of sexuality, as in the work of the Argentinian photographer Horacio Coppola *(pl. no. 549)*, or in the bizarre creations of the German artist Hans Bellmer, who made movable *papier mâché* figures that he photographed in various postures and settings *(pl. no. 550)*. A number of photographers, including Umbo (Otto Umbehrs), utilized commercial manikins as symbols of the real/unreal conundrum explored by Surrealists *(pl. no. 551)*. Erwin Blumenfeld, born in Germany but active in fashion photography in Paris and later the United States, romanticized the Surrealist genre by draping the nude figure in wet muslin; the results *(pl. no. 552)* suggest classical sculpture given rapturous animation. As one of the few who successfully adapted Surrealism to fashion photography, his contribution will be discussed in the next chapter, along with oth-

547. EDWARD WESTON. *Nude*, 1926. Gelatin silver print. © 1981 Arizona Board of Regents, Center for Creative Photography, University of Arizona, Tucson.

548. GEORGE PLATT LYNES. *Arthur Lee's Model*, 1940. Gelatin silver print. Robert Miller Gallery, New York.

ers who made commercial use of the style. Still others, whose interest in enigmas, dreams, and fantasies did not begin until the late 1930s and '40s, will be treated in subsequent chapters.

Until the 1930s, light graphics, montages, solarizations, and other darkroom manipulations appealed to few American photographers besides Man Ray (who in any case lived in Paris) and Francis Bruguière, a former California member of the Photo-Secession who had gained renown as a New York theatrical photographer. Around 1926, Bruguière began to work with multiple exposures and what he called "light abstractions" *(pl. no. 553)* made by illuminating and exposing cut paper shapes. At times these works transcend the technique of their manufacture, and the flowing abstract forms express a sense of drama and mystery. Following a move to England, Bruguière continued to "create his own world,"[21] producing Surrealist photographs and abstract films, among them *Light Rhythms*.

After the Bauhaus was reincarnated in the Institute of Design in 1938, montage and cameraless photography came to the attention of a wider spectrum of Americans. Lotte Jacobi, a former Berlin portraitist resettled in New York, began to produce photogenics *(pl. no. 554)*, the term she used to describe combinations of light graphics and straight imagery. Others who started to regard photography as a way of working with light rather than solely as representing objects included Carlotta Corpron, who embarked on a series of light graphics *(pl. no. 555)* in response to the teaching of Kepes, Arthur Siegel, whose tenure at the Institute of Design prompted several generations of students to investigate experimental photography, and Barbara Morgan, a former painter open to the full range of experimentalist ideas. In a work entitled *Spring on Madison Square*, 1938, *(pl. no. 556)* Morgan invoked both montage and cameraless imagery to express the visual and kinetic energy she discerned in New York City *(see also* her photographs of dancer Martha Graham, *pl. no. 557)*.

Toward the end of the 1920s, the key concepts behind the new photography had become clearly articulated. A 1928 article entitled *"Nicht Mehr lesen, Sehen"* ("Forget Reading, See") acclaimed camera images as "the greatest of all contemporary physical, chemical, technological wonders," with the capacity to "be one of the most effective weapons against . . . the mechanization of spirit,"[22] a statement that in essence repeats the ideas expressed a decade earlier by Strand. The following year, this grand concept was embodied in both the exhibition *Film Und Foto (Fifo)* organized by the *Deutsches Werkbund* at Stuttgart, Germany, and in the publication based on it by photographer Franz Roh and graphic designer Jan Tschichold

ABOVE LEFT:

549. HORACIO COPPOLA. *Grandmother's Doll*, 1932. Gelatin silver print. San Francisco Museum of Modern Art; purchase. Courtesy Sander Gallery, New York.

ABOVE RIGHT:

550. HANS BELLMER. *Les Jeux de la Poupée (Doll's Games), plate VIII*, 1936. Gelatin silver print with applied color. Robert Miller Gallery, New York. © 2019 Artists Rights Society (ARS), New York/ ADAGP, Paris.

LEFT:

551. UMBO (OTTO UMBEHRS). *Untitled (Three Mannikins)*, 1928. Gelatin silver print. Art Institute of Chicago; Julien Levy Collection.

552. ERWIN BLUMENFELD. *Wet Veil, Paris,* 1937. Gelatin silver print. Witkin Gallery, New York. Courtesy Marina Schinz, New York.

553. Francis Bruguière. *Light Abstraction,* 1920s. Gelatin silver print. J. Paul Getty Museum, Los Angeles.

554. Lotte Jacobi. *Photogenic,* c. 1940s–50s. Gelatin silver print. The Lotte Jacobi Collection. © University of New Hampshire, Durham.

555. CARLOTTA CORPRON. *Mardi Gras,* c. 1946. Gelatin silver print. © 1988 Amon Carter Museum, Fort Worth, Texas.

556. BARBARA MORGAN. *Spring on Madison Square,* 1938. Gelatin silver print. © Barbara and Willard Morgan Archives, Dobbs Ferry, N.Y.

557. BARBARA MORGAN. *Martha Graham: Letter to the World (Kick)*, 1940.
Gelatin silver print. © Barbara and Willard Morgan Archives, Dobbs Ferry, N.Y.

entitled *Foto Auge/Oeil et Photo/Photo Eye*. The exhibit, its dramatic poster depicting man and camera dominating the world *(pl. no. 558)*, included photographs by Europeans and Americans, the latter, selected by Steichen and Weston.[23] Included were scientific works, publicity, advertising, and fashion photographs, collages, montages, light graphics, movie stills, and straight images made as personal expression.

This show (as well as others in various localities that both preceded and followed it) summed up the extraordinary vitality of photographic communication of the time and revealed avenues that have continued to invigorate the medium up until the present. It reflected an ardent belief that the fresh vision of reality that issued from the camera would, in common with other products of the machine, improve the quality of ordinary life and permit the creative control of technology. Curiously *Fifo* omitted photo-journalism, a technological force that already had begun to exert a compelling (and not always beneficial) influence on the reading public's perception of events. Along with the development of advertising and publicity, the relationship of word and image in print journalism became increasingly significant factors and will be explored in the following chapter.

Profile: Lázsló Moholy-Nagy

László Moholy-Nagy, a "Renaissance" figure of the technical era, was active in a spectrum of endeavors that included painting, photography, film, and industrial and graphic design. He ignored traditional distinctions between graphic and photographic expression, between art for self-expression and for utility, and between practice and theory to work creatively in all the styles and media of his choice.

INTERNATIONALE AUSSTELLUNG
DES DEUTSCHEN WERKBUNDS

FILM
und
FOTO

BERLIN 1929
FOTO-AUSSTELLUNG VOM 19. OKT. BIS 17. NOV.
IM LICHTHOF DES EHEM. KUNSTGEWERBE-MUSEUMS, PRINZ-ALBRECHT-STR. 7
FILM-SONDERVORFÜHRUNGEN VOM 19. OKT. BIS 19. NOV.
SONDERPROGRAMM DER KAMERA. UNTER DEN LINDEN. „DER GUTE
FILM". SONNTAGS-VORMITTAGS-VORSTELLUNGEN IM CAPITOL.
AM 27. X., 3. XI., 10. XI., 17. XI., 24. XI.

558. *Film und Foto International Exhibition*, Stuttgart,
Germany, 1929. Poster. Kunstbibliothek mit Museum für
Architektur, Modebild und Grafik-Design; Staatliche
Museen Preussischer Kulturbesitz, Berlin.

As a writer and teacher, he explored many of the unconventional areas of visual activity that continue to engage artists—among them, abstract film, light shows, constructed environments, and mixed-media events.

Born in a provincial section of Hungary in 1895, Moholy-Nagy studied law while also participating in art and literary activities in his native land and in Vienna before and after his army service during World War I. He moved to Berlin in 1920, making contact with the Dadaists and soon becoming well known in avant-garde circles for his paintings, light graphics, and articles based on Constructivist theory. While he was serving as director of the metal workshop and later of the foundation course of the Bauhaus, Moholy-Nagy and his wife, Lucia Moholy (herself a photographer), worked together to explore the potentials of light for plastic expression. As "manipulators of light," they suggested that through the technological medium of photography artists in the industrial era could arrive at individualized nonmechanical expression.

After leaving the Bauhaus in 1928, Moholy-Nagy worked on exhibitions, stage designs, and films in Berlin before being forced by events in Germany to emigrate to Amsterdam in 1935. A year later he moved to London, and in order to support himself took on commercial assignments in photography, including a commission to illustrate several books. In 1937, he was invited to head a reactivated Bauhaus being set up in the United States, which a year later was established as the School of Design (later Institute of Design) in Chicago. He died in that city in 1946.

Moholy-Nagy's photographic output spanned the entire range of ideas, processes, and techniques embraced by the concept of the "new vision," which he had helped to formulate. Included are views from above and below, close-ups, collages, montages, reflections, refractions, and cameraless images made by manipulating light through various devices. Moholy-Nagy embraced portraiture, landscape, the nude, architecture, the machine, organic form, and the urban street scene. His work does not fall exclusively within any one of the distinctive styles of the period, but one unifying thread is its extraordinary liveliness, reflective of the photographer's interest in actual life as well as in problems of form.

Moholy-Nagy's oft-quoted statement that "the illiterate of the future will be ignorant of camera and pen alike"[24] stems from his understanding of the camera as a modern graphic tool—a device for capturing aspects of reality that could stand by themselves or be reworked into other visual statements. In addition to his book *Malerei Fotografie Film (Painting Photography Film)*, 1925, these concepts were embodied in numerous other publications, which include "Light—A Medium of Plastic Expression," published in the American magazine *Broom* in 1923, and *Vision in Motion*, which appeared posthumously in 1947. Though Moholy-Nagy has long been admired mainly as theorist and teacher, it is possible that in the future his photographs themselves will be regarded as equally significant expressions of his ideas.

Profile: Paul Strand

Paul Strand's debut in photography coincided with the first stirrings of modernism in the visual arts in America. Born in New York in 1890, he attended both the class and the club in photography taught by Hine at the Ethical Culture School in 1908. A visit to Stieglitz's 291 gallery arranged by Hine inspired Strand to explore the expressive possibilities of the medium, which until then he had considered a hobby. Although he was active for a brief period at the Camera Club of New York, whose darkrooms he continued to use for about 20 years, his ideas derived first from the circle around Stieglitz and then from the group that

evolved around the Modern Gallery in 1915, including Sheeler and Schamberg. Strand's work, which was exhibited at 291, the Modern Gallery, and the Camera Club, gained prizes at the Wanamaker Photography exhibitions and was featured in the last two issues of *Camera Work.* From about 1915 on, he explored the visual problems that were to become fundamental to the modernist aesthetic as it evolved in both Europe and the United States. During the 1920s he mainly photographed urban sites, continued with the machine forms *(pl. no. 578)* begun earlier, and turned his attention to nature, using 5 x 7 and 8 x 10 inch view cameras and making contact prints on platinum paper. In these works, acknowledged as seminal in the evolution of the New Objectivity, form and feeling are indivisible and intense. In addition, Strand's writings, beginning in 1917 with "Photography and the New God," set forth the necessity for the photographer to evolve an aesthetic based

on the objective nature of reality and on the intrinsic capabilities of the large-format camera with sharp lens.

After service in the Army Medical Corps, where he was introduced to X-ray and other medical camera procedures, Strand collaborated with Sheeler on *Manhatta*, released as *New York the Magnificent* in 1921. Shortly afterward, he purchased an Akeley movie camera and began to work as a free-lance cinematographer, a career that he followed until the early 1930s when the industry for making news and short features was transferred from New York to the West Coast. Aware of the revolutionary social ideas being tested in Mexico through his visits to the Southwest, Strand sought the opportunity to make still photographs and to produce government-sponsored documentary films; *Redes*, or *The Wave*, released in 1934, depicted the economic problems confronting a fishing village near Vera Cruz. Following a futile attempt to assist the Russian director Sergei

559. PAUL STRAND. *The Family, View II, Luzzara, Italy,* 1953. Gelatin silver print.
© 1976, 1982 The Paul Strand Archive, Lakeville, Conn.

560. EDWARD WESTON. *Shells*, 1927. Gelatin silver print. Witkin Gallery, New York. © 1981 Arizona Board of Regents, Center for Creative Photography, University of Arizona, Tucson.

Eisenstein in the Soviet Union in 1935, Strand worked with Pare Lorentz on *The Plough that Broke the Plains*, following which he and other progressive filmmakers organized Frontier Films to produce a series of pro-labor and anti-Fascist movies. Their most ambitious production, *Native Land*, which evolved from a Congressional hearing into antilabor activities, was released in 1941 on the eve of the second World War, at which time its message was considered politically divisive.

Unable to finance filmmaking after World War II, Strand turned to the printed publication for a format that might integrate image and text in a matter akin to the cinema. *Time in New England*, a collaboration with Nancy Newhall, sought to evoke a sense of past and present through images of artifact and nature combined with quotations from the region's most lucid writers. Strand continued with enterprises of this nature after he moved to Europe in 1950, eventually producing *La France de profil (A Profile of France)* with Claude Roy (1952), *Un Paese (A Village)* with Cesare Zavattini (1955), and *Tir a' Mhurain* with Basil Davidson (1962), among other works. At his death in 1976, he had been photographing for nearly three-quarters of a century, gradually finding his ideal of beauty and decorum in nature and the simple life *(pl. no. 559)*.

561. EDWARD WESTON. *Pepper*, 1930. Gelatin silver print. Witkin Gallery, New York. © 1981 Arizona Board of Regents, Center for Creative Photography, University of Arizona, Tucson.

Profile: Edward Weston

From an accomplished commercial photographer of Pictorialist persuasion, Edward Weston developed into the quintessential American artist/photographer of his time. Born in Illinois in 1886, he opened a portrait studio in California in 1911, finding time also to exhibit at Pictorialist salons. After his definitive break with Pictorialism, seen in the 1922 *Armco* images *(pl. no. 584)*, Weston embarked on the life of an impecunious but free artist, singlemindedly devoted to creative endeavor. Convinced at this time that "the photographer . . . can depart from the literal recording to whatever extent he chooses" as long as the methods remain "photographic,"[25] he controlled form and tone through choice of motif, exposure time, and the use of the

ground-glass focusing screen of the large-format camera. This way of working, which he called pre-visualization, was a factor in Weston's exclusion of temporal and transient effects of light, atmosphere, and movement in order to concentrate on revealing the object in its "deepest moment of perception."

Following a four-year period in Mexico, during which he opened a portrait studio with Tina Modotti and became part of the revitalized Mexican artistic movement of the period, Weston returned to a simple existence in Carmel, California. In 1927, he began to photograph single objects —both organic forms and artifacts—removed from their ordinary contexts. In addition to the well-known nautilus shells *(pl. no. 560)* and green peppers *(pl. no. 561)*, he arranged and illuminated a series of household implements whose shapes seemed intrinsically beautiful, and photographed them close-up with great precision in order to reveal "an essence of what lies before the . . . lens," thus creating an "image more real and comprehensible than the actual object."[26] The nude was especially significant in Weston's work, representing, as it also did for Stieglitz, more than a convenient artistic theme. The cool and elegant forms of the more than one hundred nude studies Weston produced between 1918 and 1945 not only represent his search for formal perfection but also reflect the erotic and sexual enigmas with which he struggled for much of his life.

Freedom from financial strain, made possible by Guggenheim grants in 1937 and 1938—the first awarded to a photographer—enabled Weston to embark on a period of sustained work. In fusing the formal insights gained during the late 1920s with his intense feeling for the California landscape, Weston achieved the richest and most personally nuanced imagery of his career. A selection of these photographs appeared in *California and the West*, published in 1940, and ten years later in an elegantly printed portfolio, *My Camera at Point Lobos*. Starting in 1923 and continuing for 20 years, Weston kept a daily journal. Published in 1961, three years after his death, his *Daybooks*, edited by Nancy Newhall, detail the problems of daily existence and creative activity in the photographer's life. A unique document, it lays bare the inner resolve that impelled this photographer to transcend financial distress and emotional anxiety and create works that seem untouched by the mundane or temporal.

A Short Technical History: Part II

MATERIALS, EQUIPMENT, AND PROCESSES

The unwieldy nature of wet collodion on glass led to continued efforts to find other supports of chemical substances for negatives during the third quarter of the 19th century. Collodion dry plates, invented by French scientist Dr. J. M. Taupenot and manufactured in England in 1860, were too slow in action to replace the wet plate. In the late 1870s, experiments by English physician Dr. Richard Leach Maddox to substitute a gelatin bromide plate for collodion and refinements made in 1873 by John Burgess and Richard Kennett, and in 1878 by Charles Harper Bennet, led to a practicable dry plate. These appeared on the market in 1878 and were soon being manufactured by firms in Europe and the United States, ushering in a new era in photography. Consisting initially of a glass support coated with a silver bromide emulsion on a specially prepared gelatin ground (produced either by "ripening" or "digestion"), the fragile glass was replaced by celluloid[1] in 1883, after it had become possible to manufacture this material in standardized sheets of about .01 inch thickness.

A paper roll film (first conceived by British inventor Arthur James Melhuish in 1854—*see below*) was commercially produced by the Eastman Company in Rochester, New York, in 1888. At first, the gelatin emulsion had to be removed or "stripped" from the paper backing, transferred to glass, and then developed and printed, but with the substitution of transparent celluloid roll film in 1889,[2] and the addition in 1895 of a paper backing that enabled the film to be loaded in daylight, roll film as it is known today came into being.

The improvement of the color sensitivity of black-and-white film began during the collodion era when the renowned German photochemist Hermann Wilhelm Vogel added dyes to silver bromide emulsions. This process, called optical sensitizing, in 1873 produced the first orthochromatic plates (sensitive to all but red and oversensitive to blue light) and it was applied to gelatin dry plates when they supplanted collodion. Experiments, notably by Adolphe Miethe of the German Agfa works in 1903, resulted in the development of panchromatic film sensitive to all colors but still requiring a yellow filter to cut down the sensitivity to all blue light.

Permanence and long tonal scale in printing papers were difficult problems to solve satisfactorily because of the many variables (such as atmospheric conditions, water quality, amount and thoroughness of washing) that characterized photographic printing procedures. In spite of its uneven performance, albumen paper continued to be manufactured until the end of the 19th century, but new papers were being developed to respond to the need for sharper definition and speed created by the increased use of camera images for records, documentation, and reproduction in newspapers and magazines. Two types of printing papers were produced: printing-out paper and developing-out paper. Gelatin-silver-chloride emulsion papers (marketed in the United States under the names Aristotype and Solio), which required no chemical development, became available in 1890, while developing-out papers coated with silver bromide emulsions became popular in the late 1880s even though this product had been introduced as early as 1873. Gelatin-silver-chloride paper for printing by gas light (known as Velox) also appeared around 1890. At the same time that these materials were manufactured to serve com-

562. *Hare Camera.* On George Hare's camera of 1882, screwed rods (A) were used to secure the front panel (B), which could be moved toward the rear panel (C). When the lens was removed, the hinged baseboard (D) could be folded up.

563. *Sanderson Camera.* Frederick Sanderson used two slotted stays on either side of the lens panel in his 1895 camera. This allowed a considerable degree of vertical, horizontal, and swing movement to be applied to the lens panel.

mercial needs, platinum paper, based on John Herschel's discovery of the light sensitivity of chloride of platinum, was produced in England under the trade name Platinotype. This expensive material appealed to well-to-do amateurs and serious photographers who required a printing paper of permanence with a long tonal scale.

The standardization of papers went hand-in-hand with the automation of large-scale photographic printing. Improving on the steam-driven machines that had made it possible to expose, print, and fix *carte-de-visite* portraits and stereographs during the 1860s, the new machinery installed by large photographic firms such as Automatic Photographs of New York and Loescher and Petsch in Berlin was capable, for example, of exposing 245 cabinet-size pictures a minute and turning out 147,000 prints daily on the new fast-acting bromide paper.[3]

During the first 30 years of photography, camera design was subject to continual experimentation. Instruments were made in large and small formats to accommodate plate sizes that ranged from mammoth to tiny postage size, while multiple lenses and septums were added to boxes to make *cartes de visite (pl. no. 226)* and stereographs *(pl. no. 225)*. By the 1880s, camera design needed to expand further to accommodate new negative materials—the dry plate and celluloid film. The folding-bed view cameras, introduced in England in 1882 by camera designer George Hare became the prototype for similar instruments manufactured in other parts of Europe and the United States *(pl. no. 562)*. Variations of the basic instrument incorporated the capacity to advance the rear element, change from hori-

zontal to vertical format, and fold the front element down into the base. Some models were given sliding racks that enabled the bellows to be greatly extended. As improved by British designer Frederick H. Sanderson in 1895 *(pl. no. 563)*, the view camera became an instrument of great sensitivity and precision, provided the subject was immobile.

A serious effort to make possible fast exposure, control over focus, and large image size resulted in the development of the single-lens reflex camera. Based on the use of a mirror to redirect the light rays to a horizontal ground-glass focusing surface, an early model of this type was patented in 1861 by Thomas Sutton. The most influential design was that of the Graflex, introduced by Folmer and Schwing in 1898; it assumed its inimitable shape of cubic box with bellows extension and four-sided hood on top around 1900 *(pl. no. 564)*. A mirror, usually inserted at a 45 degree angle to the axis of the lens focused the image onto a screen within the hood and dropped out of the way when the exposure was made. In the hand or on the tripod, reflex cameras (which came in a variety of sizes and shapes) were flexible enough to accommodate naturalists in the field, news and portrait photographers, and individuals looking for street subjects.

Reputable equipment with which one could almost simultaneously view the scene, make the exposure, and advance the film in ordinary daylight did not become generally available until the 1920s *(see A Short Technical His-*

564. *Graflex Camera.* The No. 1A Graflex camera of 1910 was a single-lens reflex camera for roll-films. It was fitted with the Graflex multispeed focal plane shutter.

565. *Photo-Revolver de Poche.*
E. Enjalbert's *Photo-Revolver de Poche* of 1882 carried small plates (A) in a compartment (B) in the chamber (C). When a catch (D) was slid, a plate moved into the exposing position (E). When the chamber was rotated through 180°, the exposed plate was transferred to a second compartment (F). The chamber was turned again to its original position for the next exposure. This movement also set the rotary shutter (G), which was released by the trigger (H). The lens (I) was mounted in the barrel. The hammer (J) held and located the plate chamber (C).

566. *Stirn Secret Camera.* The Carl P. and Rudolph Stirn Secret or Waistcoat camera of 1886 was worn under a waistcoat, the lens (A) poking through a buttonhole. The circular plate was turned and the shutter set when the pointer (B) was rotated. Exposures were made by pulling on a string (C).

567. *Walking-Stick Camera.* Emile Kronke's walking-stick camera of 1902 took spools of roll-film (A), carried in the handle. Storage space (B) for three spare spools was provided. A shutter release knob (C) was placed underneath the front of the handle. (D) Lens panel. (E) Winding-on key.

568. *Eastman's Kodak Camera of 1888.* (1) Sectional view, (2) roll-holder as seen from above, (3) cutaway view, (4) external view. The camera had an integral roll-holder (A), in which George Eastman's American Film (B) was first fed over a metering roller (C), the end of which carried a disc with an index mark visible through a window (D) on the top of the camera. The film was then fed past the circular exposing aperture (E) and onto the take-up roller (F), which was turned by a key (G). The cylindrical shutter (H) was set by pulling a string (I). The lens (J) was fitted within the shutter. (5) A new model, designated the No. 1 Kodak camera, was introduced in 1889. It differed from the 1888 version in having a sector shutter (K); the positions of the shutter release (L) and setting string (M) were also altered. Both models had lens plugs (N) for protection; the plugs also permitted time exposures to be made.

569. *Schmid Camera.* In 1883, the first popular hand-held dry plate camera was designed by William Schmid.

570. *Lens Cap.* Until the advent of the gelatin dry plate in the 1870s, most exposures were made by removing the lens cap and replacing it after a suitable interval of seconds—or minutes.

571. *Sliding cap shutter.* Some early lenses were fitted with sliding cap shutters. This example was made by N. P. Lerebours and is a close copy of the shutter on the Daguerre-Giroux camera of 1839.

tory, Part III), but long before then it was possible to capture some street action using small cameras with a single short-focus lens. Other than the 1886 Gray-Stirn Vest Camera *(pl. no. 566)*, an instrument designed to be worn under a waistcoat and that took 1¾ inch diameter negatives, these instruments, made to look like books, binoculars, revolvers *(pl. no. 565)*, and walking sticks *(pl. no. 567)*, were little more than novelties. The dry-plate hand cameras that began to appear in the early 1880s were a different story; they became known as detective cameras because, though larger than the concealed cameras, they too were inconspicuous to operate and could capture spontaneous activity under certain conditions. An early, widely sold model was the Patent Detective Camera *(pl. no. 569)*, invented by the American William Schmid in 1883, but the Kodak *(pl. no. 568)*, announced in 1888 by The Eastman Company, was both easier to operate and revolutionary in that it created a completely new system and a different constituency for

572. *Guerry's Flap Shutter.* C. I. Guerry's flap shutter of 1883 had two pivoted flaps, which were connected by a string-and-pulley system (A), set on the side. As a pneumatic release (B) was pressed, the two flaps were raised to uncover and cover the lens in turn. A screw-adjusted device (C), bearing on the string, was used to vary the period of opening by altering the relationship between the two flaps.

573. Goerz Sector Shutter. In the improved Goerz sector shutter of 1904, designed by Carl Paul Goerz, the functions of an iris diaphragm and a shutter were combined. The apertures and speeds were set on dials (A). The shutter was cocked by a lever (B) and released by a pneumatic cylinder (C). Slow speeds were provided by a pneumatic delay cylinder (D).

photography. This simple box, incorporating spools to hold roll film, a winding key to advance the film, and a string to open the shutter for the exposure, was an immediate success and prompted other manufacturers to design similar apparatus that would make use of the Kodak roll film. Actually, roll film attachments for plate cameras had been invented in 1854 by Melhuish and Joseph Blakeley Spencer, and in the following years Humbert de Molard and Camille Silvy also designed such devices. In 1875 Leon Warnerke, a Russian émigré in London, patented a practicable holder that accommodated stripping film in 100 exposure lengths, but the film itself was not sensitive enough for the camera's capabilities. This was followed by a similar holder invented in 1884 by George Eastman and William H. Walker, which also had to be attached to a plate camera. Undoubtedly it was the simplicity of a camera with integral roll-film holder, the ease of operation, and the freedom from the necessity of processing that attracted amateurs to the "smallest, lightest and simplest of all Detective cameras"⁴—the Kodak. The Eastman Company, which

from the start had been involved with both the manufacture and the processing, soon gave up the processing aspects. Like Lumière, its counterpart in France, Eastman employed many women workers as it continued to provide photographic supplies and develop new processes and equipment for a growing market.

In the early years of photography, exposure usually was effected by removing and replacing the lens cap manually *(pl. no. 570)* or by moving a simple plate that pivoted over the lens *(pl. no. 571)*. Although shutters had at times been used earlier, with the coming of the more sensitive gelatin dry films they became a necessity. They could be purchased separately to be affixed in front of the camera lens. Commonly of the flap, drop, or sliding plate construction, they were activated either by a string or a pneumatic cylinder attached to a rubber bulb *(pl. no. 572)*. In the late 1880s, sets of metal blades called diaphragm shutters were sometimes mounted within the lens barrel *(pl. no. 573)*, usually with settings of 1/100 to a full second. In about 1904, the compound shutter, designed for the Zeiss Company by Friedrich Deckel, introduced sets of blades totally enclosed within the camera that controlled both the size of the aperture and the length of time it remained open; after improvements it became standard on all better hand cameras *(pl. no. 574)*. The focal plane shutter, positioned in the camera behind the lens but in front of the plate or film, was derived from earlier roller-blind shutters that operated on the principle of a window shade. Various designs for this type were made during the 1870s and '80s, but the most famous, patented in 1888 by the German photographer Ottomar Anschütz for his instantaneous animal studies, made possible exposures at 1/1000 of a second *(pl. no. 575)*.

Improvements in glass manufacture in Jena, Germany, after 1880 made possible new designs in lenses. Besides the all-purpose rapid rectilinear lenses with which hand and view cameras initially were fitted, the German firms of Carl Zeiss and Carl Goerz began in the early 1890s to manufacture anastigmats—lenses that resolved distortion in both vertical and horizontal planes and made possible apertures up to f/4.5. The Dallmeyer firm in England and Bausch & Lomb in the United States also contributed new designs, but between 1890 and 1904 the German firms preempted the field by introducing the Zeiss Protar and Tessar and the Goerz Dagor lenses. While the wide-angle Globe lens, designed by the American Charles C. Harrison, had been used since 1860, the first telephoto lens was patented in 1891 by Thomas Rudolf Dallmeyer.

During the collodion era, exposure meters had not been necessary because wet plates were sensitized differently by different photographers, who determined the correct exposure time on the basis of experience. With the

574. *Deckel's Compound Shutter*. Fredrich Deckel's improved compound shutter of 1911 had slow speeds provided by a pneumatic delay cylinder (A). Speeds were set on a dial (B). This model had a cable release socket (C); earlier models were pneumatically released.

Deckel's Compur Shutter. Deckel's compur shutter of 1912 was based on the Ilex design; (1) exterior view, (2) sectional view. Slow speeds were provided by a train of gears (A), controlled by a rocking pallet (B). A lever (C) was used to cock the shutter; the speeds were set on a dial (D). The shutter was released by another lever (E).

manufacture of standardized silver bromide plates in the late 1870s, methods of measuring the light reflected from an object and relating it to the sensitivity of the negative material became important. The first device to effectively measure and establish this relationship was a slide-rule-type exposure calculator designed and patented in 1888 by Charles Driffield and Ferdinand Hurter *(pl. no. 576)*. Working in England as an engineer and a physical chemist respectively, in 1890 the two jointly published a significant work on sensitometry, having devised the mathematical equations on which to base a table of exposures.[5] Evidence of a consistent relationship between image brightness, exposure, and emulsion sensitivity was welcomed by most

photographers even though this development prompted Peter Henry Emerson to briefly reconsider his ideas about the potential of photography for artistic expression.

Measuring the light reflected from objects was done both with chemical meters—actinometers—that employed a strip of light-sensitive paper that darkened when exposed, and optical or visual devices. The latter, first made in France around 1887, consisted of numbered gradations seen through an eyepiece in which the last number visible gave the exposure time. Design changes on this kind of meter continued to be made until 1940, but none produced a reading as accurate as that produced by a photoelectric cell meter. Making use of the light-sensitive characteristics of selenium, discovered in the 1870s, the photoelectric meter was first marketed in 1932 *(pl. no. 577)*, but until the 1940s it was too expensive to be widely used. In 1938, cameras themselves began to be manufactured with built-in light meters.

Developments in Color

From the earliest days of photography, the absence of color was almost universally deplored, with the result that daguerreotypes were tinted with dry pigments and calotypes were painted with watercolors. In the wake of a patent taken out by Richard Beard in 1842 for a coloring method, instructional manuals and specialized materials appeared on the market and remained popular throughout the collodion era. However, soon after the invention of the medium, efforts by scientists to determine the sensitivity of silver salts to the colors of the spectrum had engendered the hope that photography in color would soon be possible. In these experiments, by Herschel in 1840, by Edmond Becquerel in 1848, by Niepce de Saint-Victor in the 1850s and Alphonse Poitevin in 1865, various chemicals were added to the silver compounds without conclusive results.

In 1851 a method of making daguerreotypes in color, supposedly achieved by American Levi L. Hill, also was found to be inconclusive although it is possible that Hill had stumbled upon a result that he was unable to duplicate. Positive images in color on glass were produced in 1891 by German physicist Gabriel Lippmann on the basis of the interference theory of light waves—the phenomenon one sees in oil slicks and soap bubbles—but while the results were said to be "an admirable reproduction of the colors of nature,"[6] the long exposures and difficulties in viewing the images prevented commercial exploitation.

Experimentation to achieve viable color materials was based on the researches into human vision carried out in England by Thomas Young in the early 1800s, which were later elaborated by Hermann von Helmholtz in Germany.

575. *Anschütz Focal Plane Shutter*. Ottomar Anschütz's focal plane shutter of 1888 was adjusted from the back of the camera. A catch (A) could be set in one of several notches (B) on the lower edge of the upper blind (C). A cord linkage, which was attached to the catch, adjusted the position of the lower blind (D), setting the width of the gap and, thus, affecting the exposure time.

These researchers held that all colors in nature are combinations of three primary colors—red, blue, and green. The full range of spectral colors can be duplicated either by adding portions of the primaries together or by subtracting them by using filters of complementary colors. In 1861, the Scottish physicist James Clerk Maxwell produced a color photograph by superimposing three positive lantern slides of a striped tartan ribbon *(plate no. 337)*; both the taking and the projection were effected through liquid filters. At about the same time in France, Louis Ducos du Hauron attempted to perform similar experiments; in 1869, he and Charles Cros, working independently, published proposals for color processes based on the addition of three primary colors to represent the entire spectrum. However, until the invention of panchromatic film in the early 20th century, the plates used in these experiments were not sensitive enough to all spectral hues to make these efforts truly successful.

In his 1869 publication, *Les Couleurs en photographie (Photography in Color)*, Ducos du Hauron had proposed another method by which the additive theory might result in a color image. This comprised a screen ruled with fine lines in primary colors that, when properly blocked off by their complements, would yield all the hues in nature. In other words, the primaries were to be encompassed on

576. *Hurter and Driffield Actinograph*. The Actinograph, patented in 1888 by Ferdinand Hurter and Vero Charles Driffield, was a slide-rule form of exposure calculator. A rotary cylinder (A) was calibrated for a range of times of day and year; thirteen versions were available for different latitudes.

577. *Weston Exposure Meter.* In the Weston Universal 617 meter of 1932, the electric potential developed by two photoelectric cells was used to deflect the needle of a meter placed between them.

one negative instead of three. Ducos du Hauron did not actually experiment with this idea, but in 1894 John Joly in Dublin produced such a screen by ruling red, green, and blue aniline dyes on a gelatin-coated glass plate. When used in conjunction with an orthochromatic dry plate and a yellow filter, the result was a color image that was limited in accuracy by the lack of sensitivity of the plates then in use. A similar but improved process, patented in 1897 in Chicago, turned out to be too expensive, but Autochrome, a process invented in 1904 by the Lumière brothers in Lyon, produced the first commercially feasible color material based on this idea.

An Autochrome consisted of a glass plate coated with minute granules of potato starch dyed in each of the three primary colors and dusted with a fine black powder to fill in the interstices that would have allowed light to pass through; the glass was then coated with a layer of silver bromide panchromatic emulsion. The result was a positive transparency whose improved color sensitivity and relative ease of processing were immediately successful in spite of the high cost, long exposures, and the fact that the final result had to be seen in a viewer. Until the 1930s, the only real competition for Autochrome was plates manufactured by the French firm of Louis Dufay from about 1908 and by the German Agfa Company beginning in 1916, for which the dyes were poured and rolled on rather than ruled or dusted. Despite these improvements, researches to find an alternative color process continued, since these materials all produced colors that were thought not to be natural enough, the aniline dyes were unstable (a problem that continues to bedevil color photography), and the methods of obtaining prints from transparencies were exceedingly complicated.

Ducos du Hauron's theories also proved to be the wellspring of experiments with subtractive color processes, which involved starting with white light (in which all spectral colors are present) and removing or absorbing those colors not in the subject to be photographed. When three separation negatives taken by orange, green, and violet light are printed as positives on dichromated-gelatin sheets of their complementary colors—cyan (blue green), magenta, yellow—and placed in register, each color absorbs its own complement; together all three produce a full-color image that Ducos du Hauron called a heliochrome. The advantages of subtraction include the avoidance of filters in the making of exposures, thereby enabling more light to reach the plate (with a consequent shortening of exposure time), and greater convenience in the viewing. Neither lines nor granules are visible in the final result, and all the light is absorbed where the primaries overlap, so that the stock on which the images are printed remains unaffected; white paper stays white. Experiments based on this process required the design of equipment to make three color negatives (either one at a time or with multiple backs on the camera) and improved methods of superimposing the three complementary positives. In this endeavor, the contributions of Frederic E. Ives, who had invented a Kromskop camera and viewer in 1895 and produced a Tripak camera that eventually was marketed in 1914 as the Hicro Universal camera, were significant.

To produce color prints, photographers turned first to the carbon process. Following Ducos du Hauron's early heliochromes on tissues dyed magenta, cyan, and yellow, nearly all color printing revolved around gelatin and carbon materials, with the Pinatype process in France, the Ives-Hicro and carbro processes in the United States, and the Jos-

Pe process in Germany the best known. None of these processes survived after the middle of the 20th century, when they were replaced by methods worked out during the 1930s and popularized commercially after the second World War. Ducos du Hauron produced a lithographic reproduction and later announced that his experiments were adaptable to three-color pigment printing on mechanical presses, using red, blue, and yellow ink. Additional impetus came from the discoveries by Hermann W. Vogel regarding increased sensitizing of photographic emulsions to the green and yellow portions of the spectrum.

Experiments with pigmented-ink printing from photographs reflected the great interest in using color images in advertising and periodicals, especially in the United States during the last two decades of the 19th century. Much of the research was carried out by Ives, who by 1885 had exhibited a process for photographing colors and then reproducing them photomechanically, albeit crudely, using a camera that exposed three negatives simultaneously and then line screens to make three relief printing plates, each of which would receive a different color ink relating to the original color of the image. A more accurate process was demonstrated in 1893 by William Kurtz, a commercial photographer in New York City, who had turned his attention to the problems of halftone printing in color. Using techniques similar to Ives's—three single-line halftone blocks—he reproduced a still-life camera image whose color quality was immediately recognized as authentic enough for use in advertising such items as flowers and fruits. Just before the turn of the century, magazines began to print both covers and advertisements using the color-engraving process developed by Kurtz and perfected by others. Whether produced by using three separate halftone color blocks or with black added as a fourth block (as later became common), color images made on glossy paper by the relief printing technique have been creditable since the turn of the century. Intaglio or gravure methods have not been amenable to multiple-plate color printing, in part because of the intrinsic nature of the process and in part due to the amount of handwork required.

Toward the end of the 19th century, photolithography also began to be used for color printing, with collotype producing some of the most delicately colored prints of the era. Throughout the 20th century, as offset printing has replaced relief printing as the preferred technology, it has employed the four-color block method of superimposing magenta, cyan, yellow, and black inks to produce a full-color image. Another discovery in this area involved screenless offset, in which a plate is prepared by graining it with peaks and valleys and random patterning. The tonal range of the print depends on how light exposes the peaks and depressions.

Photomechanical Processes

Photomechanical reproduction developed during the late 19th century in response to the growing demand for photographic reproductions for social documentation and, later, advertising. The possibility of reproducing photographs in printer's ink had occurred to those who had discovered how to make light-generated images. Indeed, as early as the 1820s, Claude and Joseph Nicéphore Niépce, inspired in part by the recent invention of lithography, sought to transfer engraved images onto glass and metal plates through the action of light on asphaltum and then to process the plates so that they could be printed in ink on a press.

This aim was deflected by the death of Joseph Nicéphore Niépce and by the subsequent discovery of the daguerreotype, but because the unique daguerreotype did not provide a negative image for replication, printing by mechanical means continued to be recognized as a goal. Alfred Donné and Hippolyte Fizeau in Paris and Joseph Berres in Vienna were among those who experimented successfully with methods of etching metal daguerreotype plates after the image had been brought out chemically so that they could be inked and printed on a press. A booklet on the process, issued by Berres in 1840 and illustrated with five such prints, is the first work entirely illustrated by photomechanical reproduction. In 1842, two plates reproduced by Fizeau's process were included in Noël Marie Paymal Lerebours's *Excursions daguerriennes*. Notwithstanding these successes, the process required considerable handwork, making it slow and costly.

Given that the contemporaneous discovery of photography by William Henry Fox Talbot in England produced a negative from which prints could be made on sensitized paper, the need for a mechanical means of reproducing photographs might have become less urgent. However, during the 1840s, the limited knowledge about the infant process could not prevent instability in light-generated images, while at the same time the making of paper prints proved to be time consuming. As a consequence, Talbot himself sought methods by which the photographic positive image could be transferred onto a metal block, engraved or etched, inked, and printed on a press.

In Talbot's time, the two traditional methods by which prints were made involved breaking areas of continuous tone into patterns of discrete lines or dots. In relief printing, the areas inked were higher than the other surfaces, which did not print. In intaglio printing, the ink was introduced into cuts below the plate surface, which was wiped clean of ink to create nonprinting areas. Those attempting to utilize the photographic image in relief and intaglio printing recognized that the main challenge was to translate the continuous tonalities rendered in the

original print by the darkening of the silver salts into printed lines, dots, or other patterns that would fool the eye into reading the tonalities as continuous.

The simple step of sensitizing the surface of the printing block (wood, metal, glass, or stone) so that it received light-generated images directly (without the necessity of an interim transfer) was accomplished in 1839, but solving the more complex problem of transferring photography to steel engraving began in earnest only around 1850. Talbot's experimentation, which centered on the intaglio system, is considered the forerunner of photogravure. His first patent in this area involved using potassium dichromated gelatin (the light sensitivity of which had been demonstrated in 1839) on a steel plate, with platinum dichloride as an etchant. A significant aspect of the process was Talbot's recommendation that either "a piece of black gauze" in several thicknesses with the threads intersecting one another or a glass plate on which fine lines at regular intervals had been drawn or fine particles of powdered material dispersed be used to divide the continuous tonalities into discrete elements that could be etched. These suggestions foreshadowed the eventual use of line screens in the successful gravure and halftone processes perfected toward the end of the century, but in the meantime Talbot's initial techniques required laborious handwork by skilled engravers. A second patent, taken out in 1858, improved on the process—now called photoglyphic engraving—by introducing the use of aquatint resin to break up continuous-tone areas and a different procedure for etching the plate. Both improvements simplified the process so that the intervention of the engraver could be minimized.

Talbot was not alone in experimenting with photo-reproduction techniques during the 1850s. With the need for permanent and inexpensively reproduced photographic images becoming so pressing that prize money was offered for a practicable method of making permanent prints, experimentation increased on the Continent. Working in the same direction as Talbot, Claude Félix Abel Niepce de Saint-Victor achieved relatively good results with the use of light-sensitive asphaltum and aquatint techniques on steel plates. A strong attack on the problem was mounted by Paul Pretsch, a Viennese who undertook a systematic study of methods of applying photography to printing. Eventually settling in London, in 1854 he patented a process called photogalvanography. He used potassium dichromated gelatin to produce a mold of thicker and thinner parts, representing lighter and darker areas, which then could be electrotyped and inked so that 300 to 400 impressions could be taken.

The photogravure process that became widely used toward the end of the 19th century, and continues in modified use today, is based on the method developed in 1879 by the Viennese printer Karl Klič. A copper plate dusted with resin—to which adhered a gelatin sheet that had been exposed to light in contact with a positive and developed—was etched in ferric acid. The acid acted more quickly on the metal where the gelatin was thinnest—the dark areas—and more slowly where it was thick, thus producing varying tonalities. Because the resin particles on the plate break up the continuous tonalities into minute grains, this process also is known as grain gravure (not to be confused with sand-grain gravure, a short-lived, complicated technique that produced an image similar in appearance to a mezzotint).

The delicate values it could produce and the soft quality of the overall image made grain gravure the preferred method for photographers who wished to produce artistic images in quantity yet felt that photographic printing was too laborious to be practicable. Starting with Peter Henry Emerson, a number of Pictorialist photographers installed flat-bed printing presses and turned out their own photogravures, which they chose to call original prints instead of reproductions. The process called rotogravure had commercial rather than artistic potential. Based on earlier examples of using engraved cylinders to print textile designs, it was an intaglio method and employed a crossline screen as a means of dividing the tonalities and a rotating cylinder rather than a flat plate to print the images.

Lithography (invented in Bavaria toward the end of the 18th century) required working from a flat (planographic) surface and made use of the fact that fatty ink and water repel each other; where the surface had been prepared to receive the ink, it adhered and was transferred to the printing paper. Because lithography involved the creation of continuous tonalities on a flat surface, it became the process in which a great deal of experimentation took place with methods of reproducing the camera image on stone, glass, and more recently on flat metal plates. Basic to both photolithography and collotype is the fact that when light-sensitive gelatin hardens it reticulates into a network of small areas, thus providing the discrete segments in which the tonal areas of the original photographic image could be divided. The two methods differ in that collotype involves direct printing from the gelatin, whereas photolithography involves transfer of the gelatin matrix to stone or a zinc plate; the latter requires thicker gelatin and consequently results in less reticulation and thus coarser reproduction quality.

In the mid-19th century, Louis Charles Barreswil, Louis Alphonse Davanne, the Lemercier firm, Lerebours, John Pouncy, and most important, Alphonse Louis Poitevin experimented with these materials and processes. Poitevin, the most capable of the group, received a

patent in 1855 for a process that involved sensitizing a lithographic stone with a solution of albumen and potassium dichromate and exposing this surface in contact with a photographic negative. The albumen turned insoluble and reticulated in the darkest areas where the light had passed through. After the unhardened albumen in the areas untouched by light was washed away, the greasy ink would adhere to the stone only in the dark areas.

In 1868 Joseph Albert, the most notable of a group of experimenters, used gelatin-coated glass plates to produce prints (which he called Albertypes) with excellent middle tones, in runs of more than 2,000 prints. The introduction of high-speed cylinder presses in 1873 made possible large editions of photolithographs, which in addition to Albertype went by names such as artotype, autogravure, heliotype, *Lichtdruck*, and *phototypie*. Because of the irregularity and fineness of the dot structure in collotype (the name used to embrace all these efforts), it became the technology of choice for reproducing drawings and paintings in books and art reproductions. Planographic printing methods remained essentially the same until the 1960s, when new methods of setting type provided the impetus for revising photolithographic procedures.

Walter B. Woodbury, working in England in 1866, perfected a process in which a gelatin relief, produced by exposing a dichromated gelatin sheet against a photographic negative, was imbedded in a lead mold, filled with a mixture of gelatin, and then transferred to paper under pressure. The fine definition and absence of grain made the Woodburytype (called *photoglyptie* in France) the most authentic translation of photographic tonalities in reproduction. Though widely used in Europe during the 1870s, the process was difficult to control in large format; and the finished print had to be trimmed and mounted before being inserted into a book or periodical.

However inventive and successful were the processes noted above, none solved the pressing problem of inexpensively reproducing photographs in books and journals simultaneously with the printing of the text, which at the time involved the use of raised metal type. Initially this problem had been solved by having engravers translate onto a wood or metal block the continuous tonal values of the photograph, using a code of dots or lines that more or less reproduced the information in the photograph. This block—which in order to speed up the process was sometimes sawed into sections to be cut by several craftsmen and then reassembled—could be printed with the type. However, the fact that this way of translating photographic tonalities was both time consuming and inexact, combined with the tendency of engravers to add or omit portions of the camera information, necessitated a continued search for better solutions.

The technology that made possible the perfection of a halftone plate that could be used to print photographic images along with texts emerged in the late 1870s. Known generally as zincography, it grew out of early tentative efforts in the 1850s by Charles Gillot and Charles Nègre in France and by a number of printers working in Vienna, Canada, and England to produce photographic etchings in relief (rather than intaglio) on zinc plates. The most significant breakthrough came in 1877, when the Jaffe brothers, owners of a printing establishment in Vienna, turned back to Talbot's use of gauze to break up the solid tones in the photograph. This technique finally became practicable through experimentation by individuals working throughout the industrialized world. Most notable were Stephen Horgan, Frederic E. Ives, George Meisenbach, and Charles Petit, all of whom substituted a screen for the miller's gauze used by the Jaffes. The screen was created by ruling either intersecting or parallel lines on two glass plates, which then were interposed (at an angle to each other) between the photographic negative and the dichromated gelatin layer, producing a printing matrix in which the tonalities were divided into dots. The closeness of the lines on the screen governed the size of the dots; the smaller they were, the more accurate the translation from photographic print to ink print.

The contributions of Ives, an American inventor, are considered to be among the most significant in perfecting this technology. In 1886, he recommended the use of two parallel-ruled screens, superimposed at right angles to each other, to be used in front of the photographic plate in the camera; the screens were further perfected in 1890 by the American printer Max Levy to give sharp, clear definition. In addition, Ives, using copper plates coated with dichromated glue solution, worked out a method of etching the plate with the halftone image to produce a relief matrix, the surface of which would receive the ink at the same time and in the same manner as the raised surface of the text type.

Not until the appearance in the early 1960s of type generated by photographic methods did relief or letterpress printing (the method just described) give way to offset printing. In this method, both text and illustrations are printed by an updated version of photolithography. The image information is transferred to the plate through a screen similar to that used in relief printing, and the inked matrix (affixed to a cylinder) is offset onto a rubber roller before being transferred to paper. Endeavors to enrich the quality of the offset image led to the perfection of duotone printing, which uses two different plates, each with a different exposure of the same image, with one plate reproducing detail in the light areas and the other, the darks; either identical or different colored inks can be used for the plates.

The Machine: Icons of the Industrial Ethos

This album presents a selection of images by eight leading American photographers who worked in the Modernist style in the 1920s and '30s. During this period, photography was hailed as the visual medium most in harmony with the conditions and culture of modern life. Factories, machine tools, assembly lines, multistoried buildings, and mechanized vehicles (in short, the technology that has come to dominate existence in all industrialized societies) attracted photographers who believed that the camera was eminently suited to deal with their forms and textures. In the United States, where the industrial ethos was predominant, reverential attitudes toward machinery and its products were especially strong. Commissions from advertising agencies and publications that sought attractive images of consumer goods and industrial installations made it possible for photographers Edward Steichen and Ralph Steiner to photograph cutlery and typewriters, and for Charles Sheeler and Margaret Bourke-White to celebrate the visual possibilities of the Ford Motor plant and Fort Peck Dam. Others who may have been less convinced of the unalloyed benefits of industrialism—among them Imogen Cunningham, Paul Strand, Willard Van Dyke, and Edward Weston— were nonetheless also drawn to portray water towers, machine tools, ship funnels, and smoke stacks. Whatever the ideological positions of these photographers with regard to machinery, their images reveal a compelling respect for clarity, for clean crisp lines, and for precise geometrical volumes in the products of machine culture.

578. PAUL STRAND. *Lathe No. 3, Akeley Shop, New York*, 1923. Gelatin silver print.
© 1980 The Paul Strand Archive, Lakeville, Conn.

581. WILLARD VAN DYKE. *Funnels*, 1932. Gelatin silver print. © Barbara M. Van Dyke.

LEFT:

582. MARGARET BOURKE-WHITE. *Construction of Giant Pipes Which Will Be Used to Divert a Section of the Missouri River During the Building of the Fort Peck Dam, Montana*, 1936. Gelatin silver print. *Life Magazine* © 1936 Time Inc.; courtesy Life Picture Service, New York.

RIGHT:

583. IMOGEN CUNNINGHAM. *Shredded Wheat Water Tower*, 1928. Gelatin silver print. © 1979 Imogen Cunningham Trust, Berkeley, Cal.

584. EDWARD WESTON. *Armco Steel, Ohio*, 1922. Gelatin silver print. © 1981 Arizona Board of Regents,
Center for Creative Photography, University of Arizona, Tucson, Ariz.

585. CHARLES SHEELER. *Industry*, 1932. (Montage, middle panel of a triptych). Gelatin silver print. Art Institute of Chicago; Julien Levy Collection.

10.

WORDS AND PICTURES: PHOTOGRAPHS IN PRINT MEDIA

1920–1980

Every propagandist knows the value of a tendentious photograph: from advertising to political posters, a photograph if properly chosen, punches, boxes, whistles, grips the heart and conveys the one and only new truth.

—Peter Panter (Kurt Tucholsky), 1926[1]

"HERE COMES THE NEW PHOTOGRAPHER"[2] was the rallying cry of European modernists in the 1920s. This characterization embraced more than just the fresh aesthetic and conceptual viewpoints discussed in the preceding chapter; it applied equally to photoreportage. As halftone printing techniques and materials improved, new outlets for camera images were opened in journalism and advertising. Fast and portable equipment *(see A Short Technical History, Part III)* introduced different ways of working, which in turn changed attitudes about taking, making, and displaying photographs. Even the documentary sensibility, discussed in Chapter 8, was affected by the spread of photojournalism as magazines became the prime vehicle for picture essays. The relationship of trenchant images to carefully organized texts created an interplay of information, attitudes, and effects that, along with the related enterprises of advertising and publicity, revolutionized the role of the photographer, the nature of the image, and the manner in which the public received news and ideas.

Turn of the Century Trends in Print Media

It is difficult to pinpoint any particular time or event as the start of the new forms of photojournalistic communication, because just before the turn of the century the illustrated magazines already had taken on a different complexion, becoming less oriented toward family reading and more concerned with the needs of the literate urbanized individual. Besides providing this readership with informative and entertaining articles on political matters, cultural and sporting events, and issues of social concern, the weeklies began to recognize "the importance of the camera as a means of illustration."[3] It is true that engravings and lithographs based on photographs had enlivened magazines since the mid-1850s, but with the inauguration of halftone screen printing techniques in the 1890s *(see A Short Technical History, Part II)* the photograph no longer had to be redrawn or restructured by an artist to be usable in newspapers or magazines. General interest journals such as *Illustrated American, Illustrated London News, Paris Moderne,* and *Berliner Illustrierte Zeitung,* as well as other periodicals that were directed toward special issues such as social reform (including *World's Work* and *Charities and the Com-*

mons), were among the first to recognize that the photograph was both more convincing and more efficient than the artist's sketch.

At first little imagination governed the way that pictures were incorporated into the text of articles, but soon after 1890 periodicals began to pay more attention to page layouts. The pictures were not simply spotted throughout the story; images of different sizes and shapes began to be deliberately arranged, sometimes in overlapping patterns and even occasionally crossing onto the adjacent page. Also, feature stories and articles consisting of just photographs and captions made an appearance. Along with the more arresting layouts, the work of such photographers as Roll and Vert for the French periodical press and of James H. Hare, J. C. Hemment, and Arthur Hewitt for the American weeklies helped inaugurate an interest in picture journalism; this development was a factor in the eventual success of *Life, Look, Picture Post,* and *Paris Match,* in the 1930s.

The poor quality of newsprint prevented the news dailies from adopting photography as wholeheartedly as the weekly journals did, because newspaper publishers simply preferred a crisply reproduced handmade drawing to an indistinct camera image. However, even when improved paper and platemaking capabilities enabled these publications to shift to halftones soon after 1900, the daily exigencies of deadlines and layouts generally resulted in undistinguished camera images. One exception is the series by Arnold Genthe of the 1906 San Francisco earthquake and fire *(pl. no. 586),* reproduced in the *San Francisco Examiner;*[4] however, these pictures, taken by Genthe with a borrowed camera while his own studio and equipment burned, were not the result of an assignment but were made on his own to record the event and express the eerie beauty of the ruins.

Shortly before the new century began, increasing competition for readers among weekly periodicals prompted editors to feature stories of national concern, among which wars and insurrections figured prominently. Reporters and photographers, armed with field- and hand cameras that were somewhat lighter than those used during the Crimean and American Civil wars were dispatched to battlefields around the world to capture, as the *Illustrated American* put it, "a picturesque chronicling of contemporaneous history."[5] Continuing in the vein explored earlier in the

586. ARNOLD GENTHE.
The San Francisco Fire,
1906. Gelatin silver print.
Museum of Modern Art,
New York; gift of the
photographer.

century by Roger Fenton, Mathew Brady, Alexander Gardner, and George N. Barnard *(see Chapter 4)*, Luigi Barzini photographed the Boxer Rebellion and the Russo-Japanese War (and the Peking to Paris Auto Race of 1907) for the Italian journal *Corriere della Sera*; selections of these articles were later published in book form.[6] Horace W. Nicholls covered the Boer War for the British press, intending to make "truthful images" that also would "appeal to the artistic sense of the most fastidious."[7] However, verism not art was the primary aim of most news photographers, in-

cluding Hare and Agustín Víctor Casasola, both of whom photographed conflicts in the Americas around 1900. Hare, an English-born camera designer who emigrated to the United States in 1889, was sent in 1898 by *Collier's Weekly* to Cuba to cover the Spanish-American War. Using a hand camera, he regularly achieved the sense of real-life immediacy seen in *Carrying Out the Wounded During the Fighting at San Juan (pl. no. 587)*; these and similar scenes by Hare of the later Russo-Japanese War enabled *Collier's* to increase both circulation and advertising, which in turn

587. JIMMY HARE. *Carrying Out the Wounded During the Fighting at San Juan*, 1898. Gelatin silver print. Humanities Research Center, University of Texas, Austin.

prompted other magazines to use photographs more generously. Images of the Mexican revolution by Casasola, probably the first photographer in his country consciously to think of himself as a photojournalist, seem surprisingly modern in feeling even though made with a view camera and tripod. Unfortunately, no picture magazines, such as the later weekly *Nostros*, were on hand to take advantage of this photographer's keen eye for dramatic expression and gesture *(pl. no. 588)*; aside from a poorly reproduced selection published as *Album Gráfico Histórico*[8] in 1920, they remained unseen by the public until recently.

War images continued to be a staple of photoreportage, but during World War I civilian photographers found it difficult to cover the action owing to the strict censorship directed against all civilian cameramen, including the well-regarded Hare who, sent to England and France in 1914 by *Collier's*, complained that "to so much as make a snapshot without official permission in writing means arrest."[9] Compelling visual embodiments of the tension, trauma, or courage associated with this four-year conflict with its nine million fatalities were not often published because military authorities had little conception of the public's appetite for dynamic images.[10] Nevertheless, the setback was only temporary; new attitudes toward reportorial photography, which resulted in part from advances in equipment during the mid-1920s and in part from growing prominence of picture journals, affected combat photography as well as all other kinds of images.

A crucial factor in this development was the invention in Germany of small, lightweight equipment—the small-plate Ermanox camera, but especially the 35mm roll-film Leica that appeared on the market in 1925. Descended from the amusing detective playthings of earlier times, in that they could be used unobserved, these cameras helped to change the way the photographic image looked and the manner in which photojournalism (and eventually much self-expressive photography) was practiced. Easy to handle, with a fast lens and rapid film-advancement mechanism, the Leica called forth intuitive rather than considered responses and permitted its users to make split-second decisions about exposure and framing, which often imbued the image with a powerful sense of being a slice-of-life excised from a seamless actuality. Other 35mm cameras that appeared in quick succession, as well as the somewhat larger twin-lens Rolleiflex in 1930, promoted this kind of naturalism in photoreportage. Owing to the ease with which exposures were made, the small size of the negative, and the pressures of publication deadlines, 35mm film often was developed and printed in professional laboratories, with either the photographer or—more likely—the picture editor selecting and cropping images for reproduction. The freedom from processing, along with the possibility of representing movement, of capturing both evanescent expression and the sometimes surreal-looking juxtapositions of unlikely elements in the visual field, soon appealed to photographers interested in personal expression as well as those engaged in photojournalistic reportage. As a consequence, a new ideological stance concerning camerawork emerged during the 1930s and grew stronger in subsequent decades. With the increasing acceptance of blurred and sometimes enigmatic

shapes and grainy enlargements either in silver print or in printer's ink, this new concept of the photograph differed substantially from the earlier notion of the camera image as a pre-visualized, uniformly sharp, and finely printed artifact.

Photojournalism in Europe: the 1920s and '30s

With other aspects of photography taking on exceptional luster in Germany during the years of the Weimar Republic, it seems natural that photojournalism also should have flourished there. In addition to the well-established *Berliner Illustrierte Zeitung (BIZ)*, which had introduced

halftone reproduction of photographs in the 1890s, a host of new illustrated weeklies appeared after 1918, among them the dynamic *Münchner Illustrierte Presse (MIP)*. The quest for interesting views and layouts *(pl. no. 589)* reflected the desire on the part of cosmopolitan readers for picture stories about social activities, movies, sports, and life in foreign lands. The photographer was expected to shoot sequences that might be cropped, edited, and arranged to form a narrative in pictures with only a minimum of text, making it almost possible to "forget reading" as some were to counsel.[11] The idea for this kind of picture story actually had surfaced almost 40 years earlier when Nadar staged an interview between himself and the chemist/color theorist

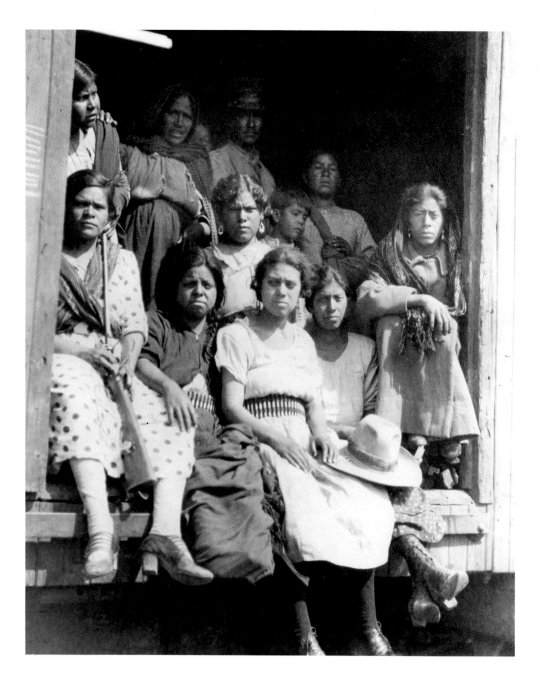

588. Agustín Víctor Casasola. *Mexican Revolution*, c. 1912. Gelatin silver print. Private collection.

21. Juli 1929
Nummer 29
38. Jahrgang

Berliner

Illuftrierte Zeitung

Verlag Ullstein Berlin SW 68

Preis
des Heftes
20 Pfennig

Ferienfreude.

Aufnahme Munkacsi.

589. MARTIN MUNKACSI. *Berliner Illustrierte Zeitung
(BIZ)*, July 21, 1929. Magazine cover. Private collection.

Eugène Chevreul, which his son Paul Nadar photographed using a camera with a roll-film attachment. The 27 images, eight of which appeared in *Le Journal illustré* in 1886 *(pl. nos. 590–593)*, reveal a degree of posturing; this stiffness would later be avoided with faster film, more sensitive lenses, and the easier handling of 35mm equipment.

As magazines began to use sequences of captioned images more extensively, the role of the picture editor became crucial. In Germany, the new vitality in selection, spacing, and arrangement was exemplified by Stefan Lorant, a former Hungarian film editor whose persuasive handling of pictorial material for *MIP* was guided by a keen awareness that readers wished to be entertained as well as informed. The appetite for dynamic picture images also led to a new role for the picture agency. These enterprises had evolved from companies that during the 1890s had stocked large selections of photographs, including stereographs, to meet the demands of middle-class viewers and burgeoning magazines. Agencies now concerned themselves with generating story ideas, making assignments, and collecting fees in addition to maintaining files of pic-

tures from which editors might choose suitable illustrations. In mediating between publisher and photographer, agencies such as *Photodienst*, or *Dephot* as it was known, and *Weltrundschau*, the two main sources of images for German weeklies after 1928, became almost as important to the course of photojournalism as the photographer. Almost, but not quite. The individual photographer was still the "backbone of the new journalism,"[12] as both amateurs and professionals, willing to wait hours "to catch the right moment,"[13] sought provocative and unusual points of view in order to avoid banal or merely descriptive images.

Such reportage using available light emerged in 1928 in the work of Erich Salomon, a German lawyer turned businessman turned photographer who, at age forty-two, began to photograph with the Ermanox (a plate camera of exceptional sensitivity). Well-educated and widely known in political and social circles in Berlin, Salomon, who was in a position to insinuate himself into privileged situations such as political meetings, courtrooms, and diplomatic functions, made his exposures under ordinary lighting conditions; his subjects usually were unaware of the exact instant of exposure even though a shutter speed of about 1/25th of a second and a tripod were required. Artless but full of surprises, these "candid" pictures, as they began to be called, were reproduced in pictorial weeklies in Germany, where their naturalness and psychological intensity contrasted sharply with the usual stiffly posed portraits of politicos and celebrities. Published in book form in 1931 as *Berühmte Zeitgenossen in Unbewachten Augenblicken (Famous Contemporaries in Unguarded Moments)*, Salomon's works convey a delicious sense of spying on the forbidden world of the rich and powerful *(pl. no. 594)*.

In looking back at this period, Tim Gidal, himself a participant, singled out, besides Salomon, Walter Bosshard, Alfred Eisenstaedt, André Kertész, Martin Munkacsi, Felix H. Man (Hans Baumann), Willi Ruge, and Umbo (Otto Umbehrs) as among those who had imposed a distinctive style on their materials. For instance, Munkacsi, initially a painter and sportswriter in Hungary, was exceptionally sensitive to the expressive possibilities of design in split-second reportage, as is apparent in the silhouetted forms of *Liberian Youths (pl. no. 595)*, made on assignment in Africa in 1931. Eisenstaedt, a photojournalist with the Associated Press in Germany until 1935, was more engrossed by gesture and suggestive detail *(pl. no. 596)* than by pictorial design, while Kertész celebrated the poetic quality of ordinary life *(pl. no. 508)* in pictures made for German and French periodicals. The career of Umbo exemplifies the rich and varied background of many of the photojournalists in the early years in that he was trained at the Bauhaus in painting and design and worked in film in Berlin and with the still photographer and montagist Paul Citroën. These

590–93. PAUL NADAR. *The Art of Living a Hundred Years; Three Interviews with Monsieur Chevreul . . . on the Eve of his 101st Year.* From *Le Journal illustré*, September 5, 1886. Bibliothèque Nationale, Paris.

594. ERICH SALOMON. *Presidential Palace in Berlin, Reception in Honor of King Fuad of Egypt*, 1930. Gelatin silver print. Kunstbibliothek, Staatliche Museen Preussischer Kulturbesitz, Berlin.

595. MARTIN MUNKACSI. *Liberian Youths*, 1931. Gelatin silver print. International Center of Photography, New York, and Joan Munkacsi, Woodstock, N.Y.

596. ALFRED EISENSTAEDT. *Feet of Ethiopian Soldier*, 1935. Gelatin silver print. *Life Magazine* © 1944 Time Inc; Life Picture Services, New York.

experiences, coupled with his feeling for the brittle and offhand quality of contemporary life in Berlin, helped produce photographs that are a kind of visual equivalent of "street slang" *(pl. no. 599)*.

The journal *Arbeiter Illustrierte Zeitung (AIZ)*, published between 1925 and 1932 in Germany and later in Czechoslovakia, was exceptional because, in addition to photoreportage, its cover pages featured montages by John Heartfield *(see Chapter 9)*, who combined Dadaist sensibility with left-wing ideology. Inspired by the example of Russian Constructivist artists who used photographic collage and montage for utilitarian ends, Heartfield (along with George Grosz) changed this form from one aimed at shocking elitist viewers out of their complacency into a

tool for clarifying social and political issues for a working-class audience. In the designs for book and magazine covers, for posters and illustrations for the Communist press and the publishing company in which he and his brother were involved, Heartfield transformed object into symbol, constructing meaning from materials clipped from newspapers, magazines, and photographic prints made especially for his purposes *(pl. no. 597)*.

Photography in the Soviet Union has been responsive to the ideological changes that have governed the role of all the visual arts, but the emphasis always has been on the camera image as a utilitarian rather than a private personal statement. From the early period around 1917, when portraits and views of Revolutionary leaders and activities by

HITLERS FRIEDENSTAUBE

AIZ

Montag, den 21. Jänner 1935

Habicht wieder tätig

Wien. (Habet) Das "Neue Wiener Tageblatt" meldet, daß Habicht noch München zurückgekehrt ist und neuerlich die Funktion des "Landesinspekteurs der österreichischen Nationalsozialisten" übernommen hat.

„Die Saar wäre glücklich erledigt, jetzt lasse ICH MEINEN Habicht nach Süden vorstoßen.‟

Fotomontage: John Heartfield

597. JOHN HEARTFIELD. *Hitler's Dove of Peace*, cover from *Arbeiter Illustrierte Zeitung (AIZ)*, January 31, 1935. International Museum of Photography at George Eastman House, Rochester, New York, courtesy Mrs. Gertrud Heartfield. © The Heartfield Community of Heirs/Artists Rights Society (ARS), New York/ VG Bild-Kunst, Bonn, 2019.

Pyotr Otsup and Jakob Steinberg convinced Soviet authorities of the medium's potential in mass communication, to the present, the camera has been conceived as a tool for projecting the constructive aspects of national life in books, magazines, and posters. This socially oriented concept gave the formal Constructivist ideas of Alexander Rodchenko their specific tension and made them acceptable because the techniques he used—montage, the close-up, and the raking view from an unusual angle—were regarded as a means of creating a fresh vision of a society building itself.

The adaptability of montage in particular led Soviet artists to consider it "a direct and successful way of achieving the mammoth task of re-educating, informing, and persuading people."[14] Rodchenko's handling of this technique in designs for book jackets, illustrations—including a series for Vladimir Mayakovsky's poem *Pro Eto* ("About This")—and especially for the magazine of the arts *LEF (Left Front of the Arts)* and *Novyi LEF (New Left) (pl. no. 598)* with which he was associated during the mid-1920s, invigorated Soviet graphic art. A compatriot, the painter El Lissitzky, also contributed photographic montages for book covers and posters that were intended to construct a fresh vision of reality through rearranging reproductions of that very reality. Rodchenko's straight photography also had a significant influence on the photojournalism of the 1920s. For example, the marked tonal contrast and the diagonal forms in an image of a construction site *(pl. no. 542)* by Boris Ignatovich (who with his sister were pupils of Rodchenko) recreate visually the dynamism of the activity itself, while symbolizing its larger meaning for society.

An opposing trend in Russian photojournalism that

598. ALEXANDER RODCHENKO. *Novyi LEF*, August 1928. Magazine cover. Ex Libris, New York.

also was visible at the time, which during the mid-1930s became predominant, favored less formalistic visual means and a more humanistic approach. This attitude is embodied in the work of Arkady Shaikhet, Max Alpert, and Georgy Zelma, to cite but three of the well-regarded photojournalists of the period. Alpert, a photoreporter first for *Pravda* and then for the influential journal *The U.S.S.R. in Construction* (published in four languages), concentrated on stories about major construction projects in the provinces, seeking through the close-up and long shot to project the vastness and communal activity required by such enterprises as the building of the Fergana Grand Canal in Uzbekistan *(pl. no. 600)*. Dmitri Baltermants and Yevgeny Khaldey were Russia's best-known war photographers. In four years of combat during World War II, Khaldey produced almost 1,500 images *(pl. no. 601)*, as well as innumerable other views of Russian life before and after that time, including important documentation of the Nuremberg trials.

Combinations of words and images became a significant force in the graphic arts of other Eastern European nations. In Poland, *Kemal Pasha (pl. no. 603)*, by foremost montagist Mieczyslaw Szczuka, who referred to the form as "visual poetry,"[15] and *City, Mill of Life (pl. no. 604)*, by the avant-garde painter Kazimierz Podsadecki, are two examples of book covers produced under the active influence of Constructivism. Karel Teige was the most prominent of a number of Czech photographers whose montages appeared on publicity and book jackets *(pl. no. 493)*. In these countries, montage, collage, and other modernist techniques continued to prove their vitality up to and beyond the second World War.

Soon after the start of the new small-camera journalism in Germany, *Vu* was introduced in Paris in 1928 by Lucien Vogel, a socially concerned individual who regarded the magazine as "at once a form of expression and a means of action."[16] More stylish and more politically committed than *BIZ*, it departed from German magazine practice by including works by non-photojournalists, reproduced at times solely to introduce a decorative, poetic, or humorous element. In this regard, *Vu* and other French picture magazines of this era reflected the fairly long tradition of piquant photojournalistic images that had been appearing in such weekly journals as *L'Illustration* and *Paris moderne* since the 1890s. Frequently, the reportage commissioned by *Vu* (as well as by others) was neither illustration nor strictly reportorial photojournalism but, as in the case of Kertész *(pl. no. 508)*, pictures whose visual content and formal elegance might be savored without captions or written text. Under the artistic direction of Alexander Liberman (later with *Vogue*), *Vu* also was distinguished by the inventive use of montage on its covers and in many of its feature articles.

Political events in Germany during the 1930s inadvertently aided the spread of the new journalism and popularized the 35mm camera as an expressive instrument. As

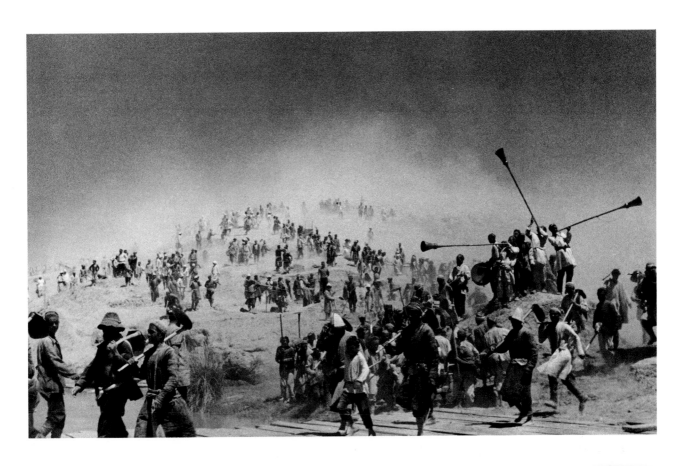

602. MARGARET BOURKE-WHITE. *Fort Peck Dam, Montana*, 1936. First cover of *Life Magazine*, November 23, 1936.
Life Magazine © 1936 Time Inc.; Life Picture Service, New York.

KEMAL PASHA
KEMAL'S CONSTRUCTIVE PROGRAM

M. Szczuka.

603. MIECZYSLAW SZCZUKA. *Kemal Pasha: Kemal's Constructive Program*, c. 1928. Photocollage. Museum of Fine Art, Lodz, Poland; International Center of Photography, New York.

604. KAZIMIERZ PODSADECKI. *City, Mill of Life*, 1929. Photomontage. Museum of Fine Art, Lodz, Poland; International Center of Photography, New York.

illustrated magazines were converted into propaganda arms of the Nazi regime, many of the editors and photographers who had conceived of the idiom fled Germany, carrying their equipment, experiences, and outlook beyond France to England, and—when the second World War engulfed Europe—to the United States. To cite only a few examples of this rich influx of talent, Lorant's stimulating editing enlivened the pages of *Weekly Illustrated* and *Picture Post* in London during the 1930s before he came to the United States where he turned his talent with words and images to book format. After 1933, Munkacsi, working as a fashion photographer for *Harper's Bazaar*, projected a new image of informality in that field, while Eisenstaedt became one of the mainstays of *Life* magazine, which featured over a thousand of his feature stories during the next 40 years. Salomon was one of the few well-known photojournalists to have been trapped by the Nazis; in the midst of an illustrious career in the Netherlands he was arrested for being Jewish and sent to his death in Auschwitz in 1944.

Picture journalism in England during the early 1930s

reflected a variety of influences as photographers drew upon the styles associated with Russian Constructivism and the New Objectivity and on their own picturesque and genre traditions in photography. As was true generally of the picture weeklies everywhere, the competition with cinema newsreels for public attention prompted British journals such as *The Listener* and *Weekly Illustrated* to give greater consideration to lively formats and compelling images that might suggest the complexity of contemporary events. This direction continued and was reinforced with the publication in 1938 of *Picture Post*, a journal that transformed the German photojournalistic experience into an acceptably British product through the efforts of its editor Lorant and the German exile photographers Kurt Hutton (Hübschmann) and Man. Britishers Humphrey Spender and Bill Brandt gave their photojournalistic images a socially oriented direction, while Bert Hardy, who began his career on *Picture Post* in the early 1940s and eventually became known as an "all-round cameraman," established what has been called a "populist idea of Britain."[17]

605. CHIM (DAVID
SEYMOUR). *May Day,
Barcelona*, 1936.
Gelatin silver print.
© Chim (David Seymour)/
Magnum.

Photojournalism—War Reportage

In the United States in the late 1930s, *Life* magazine, which had evolved from ideas and experiences tested in Europe even though it was itself quintessentially American, came to represent a paradigm of photojournalism. For its concept, *Life*, a publication of Henry Luce, drew upon many sources. In addition to the example of the European picture weeklies, it took into account the popularity of cinema newsreels, in particular *The March of Time* with which the Luce publishing enterprise was associated. The

successes of Luce's other publications—the cryptically written *Time* and the lavishly produced *Fortune*, with its extensive use of photographic illustration to give essays on American industrialism an attractive gloss—also were factors in the decision to launch a serious picture weekly that proposed to humanize through photography the complex political and social issues of the time for a mass audience.

Following *Life*'s debut in 1936, with a handsome industrial image of the gigantic concrete structure of Fort Peck Dam by Margaret Bourke-White on its first cover *(pl. no. 602)*, the weekly demonstrated that through selection,

606. ROBERT CAPA.
*Death of a Loyalist
Soldier*, 1936. Gelatin
silver print. © Robert
Capa/Magnum.

607. ROBERT CAPA.
Normandy Invasion,
June 6, 1944. Gelatin
silver print. © Robert
Capa/Magnum.

arrangement, and captioning, photographs could, in the words of its most influential picture editor, Wilson Hicks, "lend themselves to something of the same manipulation as words."[18] Vivid images, well printed on large-size pages of coated stock, attracted a readership that mounted to three million within the magazine's first three years. *Life* was followed by other weeklies with a similar approach, among them *Look* and *Holiday* in the United States, *Picture Post, Heute, Paris Match,* and *Der Spiegel* in Europe.

The first ten years of *Life* coincided with the series of conflicts in Africa, Asia, and Europe that eventually turned into the second World War. Not surprisingly, between 1936 and 1945 images of strife in Abyssinia, China, France, Italy, Spain, the Soviet Union, and Pacific islands filled the pages of the magazine; for the first time, worldwide audiences were provided a front-row seat to observe global conflicts. In response to the insatiable demand for dramatic pictures and despite censorship imposed by military authorities or occasioned by the magazine's own particular editorial policy, war images displayed a definite style, thanks in part to new, efficient camera equipment. The opportunity to convince isolation-prone Americans of the evils of Fascism undoubtedly was a factor in the intense feeling evident in a number of the images by European photojournalists on the battlefields.

In style, these photographs were influenced both by the precise character of the New Objectivity and by the spontaneity facilitated by the small camera. Eisenstaedt's portrayal of an Ethiopian soldier fighting in puttees and bare feet against Mussolini's army during the Italian conquest of Abyssinia in 1935 *(pl. no. 596)* focuses on an unusual and poignant detail to suggest the tragedy of the unprepared Abyssinians confronting a ruthless, well-equipped army. *May Day, Barcelona (pl. no. 605)* by Chim (David Seymour) conveys through harsh contrast and the facial expression of the woman looking upward the intensity with which the Spanish people greeted the insurrection of the exiled government that led to the Spanish Civil War.

An even more famous image of that conflict is *Death of a Loyalist Soldier (pl. no. 606)* by Robert Capa, a Hungarian-born photojournalist whose images of the Civil War appeared in *Vu, Picture Post,* and, in 1938, in a book entitled *Death in the Making.*[19] At the time, Capa's views of civilians, soldiers, and bombed ruins seemed to sum up the shocking irrationality of war; the photographer also established the mystique of the photojournalist's commitment to being part of the action being recorded. While Capa quipped that he preferred to "remain unemployed as a war photographer," he held that "if your pictures aren't good enough you're not close enough."[20] Eventually he found himself photographing the invasion

608. W. Eugene Smith. *Marines under Fire, Saipan,* 1943. Gelatin silver print. © W. Eugene Smith/Black Star.

of Normandy on D-Day *(pl. no. 607)* for *Life;* he died in 1954 on a battlefield in Indochina, where he was killed by a landmine—a fate similar to that of many other photojournalists who photographed war action then and later.

Bourke-White, Lee Miller, Carl Mydans, George Rodger, George Silk, and W. Eugene Smith, among other Allied photojournalists, were active on various fronts during World War II, and photographers in the Armed Services also provided coverage. Despite hesitation on the part of army brass to show the full extent of war's suffering and death and despite their preference for uplifting imagery, photographs that the American photojournalist Smith *(see Profile)* made during the Pacific campaign *(pl. no. 608)* express compassion for the victimized, whether combatants or civilians, who are caught up in incomprehensible circumstances. This attitude continued to be a leitmotif of the imagery made by Western Europeans and Americans during the second World War and its aftermath. It is visible in the work of David Douglas Duncan in Korea, Philip Jones Griffiths in Vietnam, Romano Cagnoni in Cambodia and Pakistan *(pl. no. 610),* and Donald McCullin in Vietnam, Cyprus, and Africa *(pl. no. 611),* to name only a few of the many photojournalists reporting the struggles that continue to erupt in the less-industrial-

the world. At times, these photographers relieved the grimness of events by concentrating on the picturesque aspects of a scene, exemplified by Duncan's image of the Turkish cavalry in the snow *(pl. no. 609)*, in which small figures disposed over the flattened white ground bring to mind Ottoman miniatures rather than contemporary warfare.

The work of Polish and Russian photographers on the Eastern Front in World War II has become better known in the West during the past two decades. Galina Sanko's corpses *(pl. no. 612)* and Dmitri Baltermants's *Identifying the Dead, Russian Front (pl. no. 613)* portray the victims with sorrow, but Soviet war photographers also celebrated vic-

tories, as in Yevgeny Khaldey's raising of the flag *(pl. no. 601)*. Reportage of the liberation of Paris by Albert and Jean Seeberger *(pl. no. 614)* captures determination, heroism, and fear. In general, German and Japanese photographs of the war emphasize feats by native soldiers and civilians, but images of the aftermath of the atom bombing of Nagasaki by the United States Air Force, taken by the Japanese army photographer Yosuke Yamahata, are entirely different. First brought to light some 40 years after the event, these gruesome images—divested of any nationality—are emblems of a nuclear tragedy that had the potential to efface humanity everywhere.

609. DAVID DOUGLAS DUNCAN. *"Black Avni" Turkish Cavalry on Maneuvers*, 1948.
Gelatin silver print. Collection Nina Abrams, New York. © David Douglas Duncan.

610. ROMANO CAGNONI. *East Pakistan: Villagers Welcoming Liberation Forces*, 1971. Gelatin silver print. © Romano Cagnoni/Magnum.

611. DONALD McCULLIN. *Congolese Soldiers Ill-Treating Prisoners Awaiting Death in Stanleyville*, 1964. Gelatin silver print. © Donald McCullin/Magnum.

Photojournalism after WWII

Photographs reproduced in *Life, Look* and other picture journals from 1936 on were by no means solely concerned with war and destruction. The peripatetic photojournalist, pictured in a self-portrait by Andreas Feininger as an odd-looking Creature of indeterminate sex, age, and nationality with camera lenses for eyes *(pl. no. 616)*, roamed widely during the mid-century flowering of print journalism. Through photographs, readers of picture weeklies became more conscious of the immensity of human resources and of the varied forms of social conduct in remote places of the globe, even though these cultures ordinarily were seen from the point of view of Western Capitalist society.

Readers also were introduced to the immensely useful role played by photographs of the scientific aspects of animal and terrestrial life. By including the microphotographs by Roman Vishniac and Fritz Goro (both émigrés to the United States from Hitler's Germany), as well as views taken through telescopes and from airborne vehicles, the magazine expanded knowledge of the sciences generally and provided arresting visual imagery in monochrome and color, which helped prepare the public to accept similar visual abstractions in artistic photography.

In its efforts to encompass global happenings, *Life* included picture stories of the Soviet Union. Taken by Bourke-White, they brought American magazine readers their first glimpse of a largely unknown society. Later, the mysteries of existence in more remote places were revealed by an array of photographers, including the Swiss photojournalists Werner Bischof, René Burri *(pl. no. 615),* and Ernst Haas and the French photographers Henri Cartier-Bresson and Marc Riboud, all of whom aimed their cameras at life in the Far East. Outstanding images of the hinterlands of South America and India were contributed by Bischof, and of subequatorial Africa by Cagnoni, Rodger, Lennart Nilsson, and, in the 1960s, McCullin *(pl. no. 611).* With the need for photographic essays expanding rapidly, picture agencies became even more significant than before, leading to the establishment of new enterprises in the field, including a number of photographers' collaboratives. The best known, Magnum, was founded in 1947 by Robert Capa, Cartier-Bresson, Chim, and Rodger.

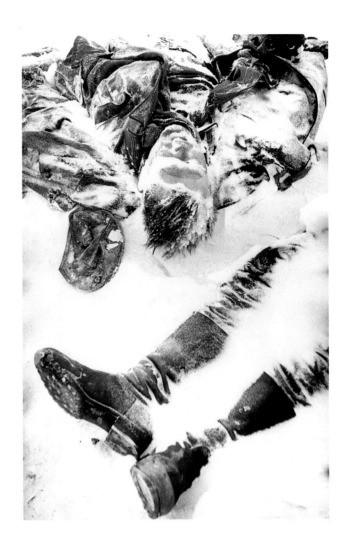

612. GALINA SANKO. *Fallen German Soldiers on Russian Front,* 1941. Gelatin silver print. *Sovfoto Magazine* and VAAP, MOSCOW.

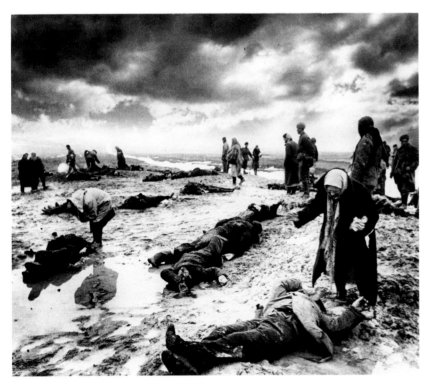

613. DMITRI BALTERMANTS. *Identifying the Dead, Russian Front,* 1942. Gelatin silver print. Courtesy Citizen Exchange Council, New York.

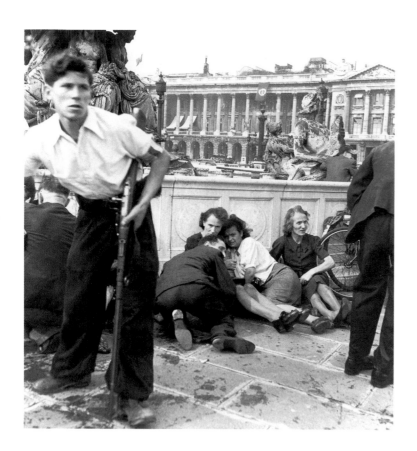

614. ALBERT and JEAN SEEBERGER. *Exchange of Fire at the Place de la Concorde*, 1944. Gelatin silver print. Zabriskie Gallery, New York.

615. RENÉ BURRI. *Tien An Men Square, Beijing*, 1965. Gelatin silver print. © René Burri/ Magnum.

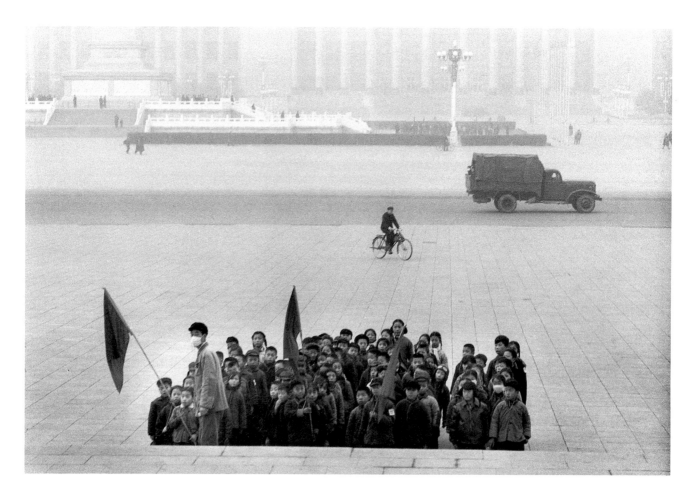

616. ANDREAS FEININGER. *The Photojournalist*, 1955. Gelatin silver print. Life Magazine © 1955 Time Inc.; Life Picture Service, New York.

Gathering bits and pieces of lively "color," these postwar photoreporters and their editors reflected the popular yearning in the West for "one world," an understandable response to the divisiveness of the war. The stability of tradition seen in Constantine Manos's image of Greek villagers pulling a boat *(pl. no. 617)* and the startling contrast of old and new in Bischof's *India: Jamshedpur Steel Factory (pl. no. 618)* are but two examples of recurrent themes. Editors and photographers working for periodicals seemed to agree with the pronouncement that "the most important service photography can render" is to record human relations and "explain man to man" and man to himself.[21] This benign idea, which ignored political and social antagonism on both domestic and foreign fronts,

was the theme of *The Family of Man*, a highly praised exhibition and publication consisting largely of journalistic images. Organized by Edward Steichen in 1955, shortly after he became director of the Department of Photography at the Museum of Modern Art in New York, the exhibition comprised 508 photographs from 68 countries, treated as if in a three-dimensional picture magazine—enlarged, reduced, and fitted into a layout designed by Steichen in collaboration with photographer Wayne Miller and architect Paul Rudolph, ostensibly to celebrate the "essential oneness of mankind throughout the world." Photographers whose work was displayed in *The Family of Man* had no control over size, quality of print (all were processed in commercial laboratories), or the context in

617. CONSTANTINE MANOS. *Beaching a Fishing Boat, Karpathos, Greece,* c. 1963. Gelatin silver print. © Constantine Manos/ Magnum.

618. WERNER BISCHOF. *India: Jamshedpur Steel Factory,* 1951. Gelatin silver print. © Werner Bischof/Magnum.

which their work was shown, an approach that Steichen had adopted from prevailing magazine practice.[22]

An essential aspect often overlooked in photojournalism has been the relationship between editorial policy and the individual photographer, especially in stories dealing with sensitive issues. Whereas underlying humanist attitudes sometimes provide a common ground for editor and photographer, the latter still has to submit to editorial decisions regarding selection, cropping, and captioning. That the photographer's intended meaning might be neutralized or perverted by lack of sufficient time to explore less accessible facets of the situation or by editorial intervention in the sequencing and captioning is illustrated by Smith's experiences at *Life*. His numerous picture essays—of which "Spanish Village" *(pl. nos. 654–58)*, photographed in 1950 and published on April 19, 1951, is an example—gave *Life* a vivid yet compassionate dimension, but the photographer's battle for enough time to shoot and for control over the way his work was used was continual, ending with Smith's resignation in 1954.[23]

Toward the mid-1960s, as newsmagazines went out of business or used fewer stories, it became apparent that photojournalism in print was being supplanted by electronic pictures—by television. In 1967, the Fund for Concerned Photography (later the International Center of Photography) was founded to recognize the contributions made by humanistic journalism during the heyday of the picture weeklies. This endeavor, initiated by Cornell Capa (brother of Robert and himself a freelance photojournalist of repute), celebrated the efforts of "concerned photographers"—initially Bischof, Robert Capa, Leonard Freed, Kertész, Chim, and Dan Weiner—to link photojournalistic images with the humanistic social documentary tradition established by Jacob Riis, Lewis Hine, and the Farm Security Administration photographers. Involving exhibitions, publications, and an educational wing, the center has since broadened its activities to include photographers whose humanism reveals itself through images of artifacts and nature.

Small-Camera Photography in the 1930s

Initially devoted to conveying fact and psychological nuance in news events, the small camera began to appeal to European photographers as an instrument of perceptive personal expression as well. Indeed, the photographs made by Kertész and Cartier-Bresson during the 1930s suggest that it is not always possible to separate self-motivated from assigned work in terms of style and treatment. Kertész saw his work exhibited as art photography at the same time that it was being reproduced in periodicals in Germany and France.[24] What is more, his unusual sensitivity to moments

of intense feeling and his capacity to organize the elements of a scene into an arresting visual structure *(see Chapter 9)* inspired both Cartier-Bresson and Brassaï (Gyula Halász) in their choices of theme and treatment.

Cartier-Bresson approached photography, whether made for himself or in the course of assignments for *Vu* and other periodicals, with intellectual and artistic attitudes summed up in his concept of the "decisive moment." This way of working requires an interrelationship of eye, body, and mind that intuitively recognizes the moment when formal and psychological elements within the visual field take on enriched meanings. For example, in *Place de l'Europe, Paris (pl. no. 619)* one recognizes the ordinary and somewhat humorous gesture of a hurrying person trying to avoid wetting his feet in a street flood, but the picture also involves a visual pun about shadow and substance, life and art. It illustrates (though it hardly exhausts) the photographer's claim that "photography is the simultaneous recognition, in a fraction of a second, of the significance of an event as well as of a precise organization of forms which give the event its proper expression."[25] *(See also pl. nos. 620 and 621.)*

Brassaï, a former painting student transplanted from Hungary to Paris in 1923, found himself mesmerized by the city at night and, on Kertész's suggestion, began to use a camera (a 6.5 x 9 cm Voigtländer Bergheil) to capture the nocturnal life at bars, brothels, and on the streets. By turns piquant, satiric, and enigmatic, Brassaï's images for this project display a sensitive handling of light and atmosphere, whether of fog-enshrouded avenues *(pl. no. 622)* or harshly illuminated bars *(pl. no. 623)*, and they reveal the photographer's keen sense for the moment when gesture and expression add a poignant dimension to the scene.

Interesting in comparison with the subtle suggestiveness of Brassaï's voyeurism evident in *Paris de Nuit (Paris by Night)* (1933) is the stridency of the images included in *Naked City,* a 1936 publication of photographs, many made at night, by the American photographer Weegee (Arthur Fellig). This brash but observant freelance newspaper photographer, who pursued sensationalist news stories with a large press camera, approached scenes of everyday life—and of violence and death—with uncommon feeling and wit. Exemplified by *The Critic (pl. no. 624),* his work transcends the superficial character of most daily photoreportage.

Virtually all subsequent 35mm photography was influenced by Cartier-Bresson's formulation of the "decisive moment." In France, heirs to this concept include Robert Doisneau, Willy Ronis, Izis (Bidermanas), and Edouard Boubat—all active photojournalists during the 1940s and later, whose individual styles express their unique sensibilities. Doisneau, who gave up a career in commercial and

fashion photography late in 1940 to devote himself to depicting life in the street, has brought a delightful and humane humor to his goal of celebrating individuality in the face of encroaching standardization of product and behavior *(pl. no. 625)*. The work of Ronis and Izis *(pl. no. 626)* is lyrical and romantic, while Boubat's images, made during the course of numerous assignments in foreign countries for *Réalités* and *Paris Match*, are tender and touching *(pl. no. 627)*.

A change in attitude toward the photographic print as a visual artifact accompanied the developments discussed so far. Many photographers, Brandt, Brassaï, and Cartier-Bresson among them, refused to consider the photographs they produced as aesthetic objects despite the aesthetic judgments they obviously exercised in making them. The idea, promoted by individuals such as Paul Strand or Edward Weston, that the single print or small edition, sensitively crafted in the individual photographer's darkroom, constituted the paramount standard in expressive photography was challenged when these photographers began to use professional laboratories to process negatives and make prints. With the separation of the act of seeing from the craft of making, there emerged a new aesthetic posture that accepted grainy textures, limited tonal scale, and strong, often harsh contrasts as qualities intrinsic to the photographic medium. This development brought

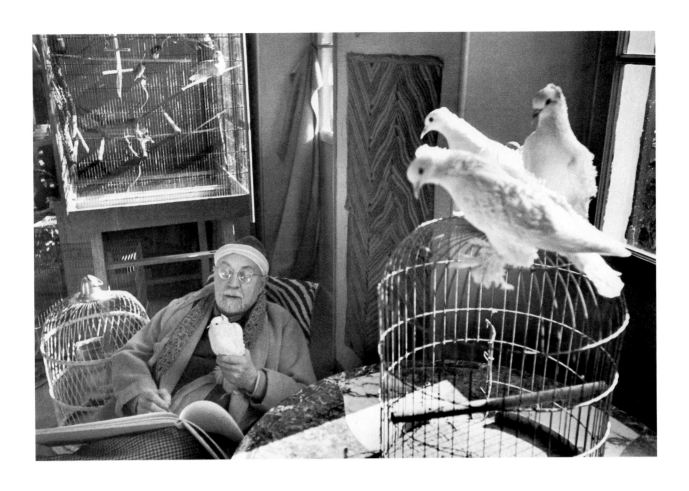

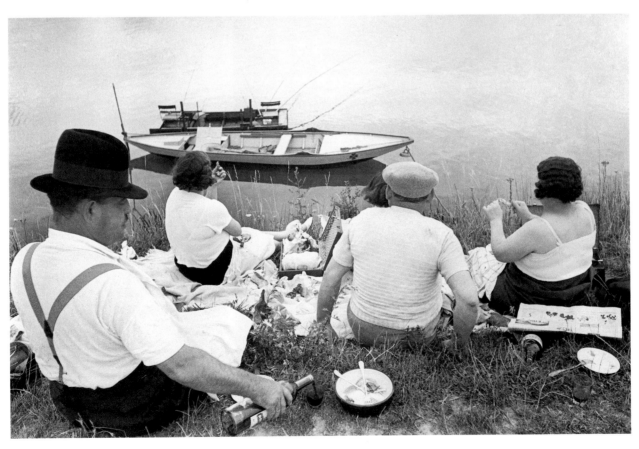

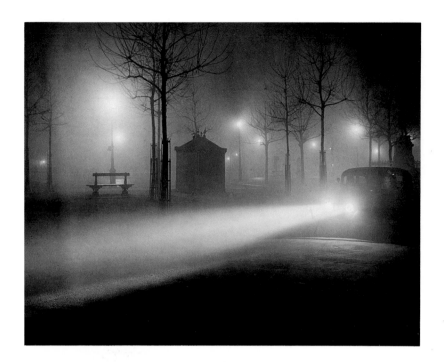

622. BRASSAÏ. *Avenue de l'Observatoire (Paris in the Fog at Night)*, 1934. Gelatin silver print. Metropolitan Museum of Art, New York; Warner Communications, Inc., Purchase Fund, 1980. © Gilberte Brassaï.

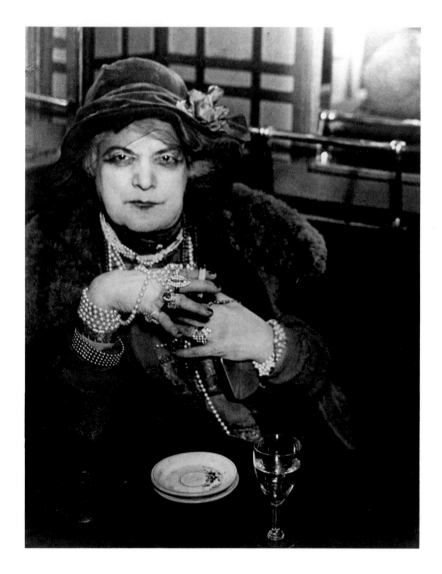

623. BRASSAÏ. *Bijou, Paris*, c. 1933. Gelatin silver print. Marlborough Gallery, New York. © Gilberte Brassaï.

624. WEEGEE (ARTHUR FELLIG). *The Critic (Opening Night at the Opera)*, 1943. Gelatin silver print. Museum of Modern Art, New York.

625. ROBERT DOISNEAU. *Three Children in the Park*, 1971. Gelatin silver print. © Robert Doisneau/Rapho.

626. IZIS. *Place St. André des Arts, Paris*, 1949. Gelatin silver print. Zabriskie Gallery, New York.

RIGHT:

627. EDOUARD BOUBAT. *Portugal*, 1958. Gelatin silver print. Private collection. © Edouard Boubat.

images originally meant for reproduction in periodicals into prominence as aesthetic objects—suitable for savoring in books, hanging on walls, or collecting.

Public acceptance of photojournalism influenced the publication of full-length works combining words and pictures. Aside from the elegant, expensive books and portfolios that carried on the tradition of illustrating texts with original photographs, collotypes, or Woodburytypes (discussed in earlier chapters), publishers on both sides of the Atlantic and in Japan during the 1930s and 1940s increasingly used gravure, offset lithography, and halftone plates to reproduce photographs. Frequently organized around popular themes, books such as the several volumes on arts and monuments illustrated by Pierre Jahan treated image and text in a manner similar to that found in the

essays in picture magazines. Starting in the 1950s, when photojournalistic as well as artistic photographs began to appear more frequently on gallery and museum walls and in collections, publishers seemed more willing to issue books in which the photographs were their own justification. Almost 25 years separate *The World Is Beautiful* (1928), by Albert Renger-Patzsch, from Cartier-Bresson's *Images à la sauvette (The Decisive Moment)* (1952), and in addition to revealing their photographers' antithetical aesthetic ideas and ways of working, the two books represent somewhat different attitudes toward the purpose of photography books. The earlier work utilizes the photograph to point the reader toward concordances of form in nature and industry, whereas *The Decisive Moment* refers to the intervention of the individual photographer's hand and

eye to reveal what Cartier-Bresson called "a rhythm in the world of real things." The commercial success of *The Decisive Moment* indicated to publishers that photographers' images were marketable, and this helped encourage a large literature on and about the medium. From the 1960s on, more and more titles in photography appeared, issued by such specialized publishers as Aperture and David R. Godine in the United States, and Teriade, Delpire, and later, Créatis and Schirmer Mosel in Europe, several of whom also issued periodicals and works on the aesthetics of the medium. Numerous others followed.

Pictures in Print: Advertising

It would be difficult to imagine a world without advertising and ads without photographs, but the importance of camera images in this context was not widely recognized before the 1920s. The advertising field itself was young then, and the problems and expense of halftone reproduction effectively limited the use of photographs to sell goods and services. Nor were the visual possibilities of transforming factual camera records into images of seductive suggestibility clearly foreseen. But during the early 1920s the situation began to change. The British journal *Commercial Art and Industry* noted in 1923 that photography had become "so inexpensive and good" that it should be used more often in ads, and the American trade magazine *Printers' Ink* pointed out the "astounding improvement in papers, presses and inks."[26] Six years later, the prestigious German printing-arts magazine *Gebrauchsgraphik* prophesied that the photograph would soon dominate advertising communication and "present an extraordinarily fruitful field to the gifted artist"[27] because whether distorted or truthful, camera images are grounded in reality and are consequently persuasive to buyers. By 1929, advertising had become "the agent of new processes of thought and creation,"[28] and photographs would play a central role in this creative upsurge.

The new attitudes were the result of a number of factors. As indicated in the preceding chapter, public taste after World War I tended toward styles that suggested objectivity rather than sentimentality; a popular appetite for machine-made rather than handmade objects had developed; and delight in the cinema as a form of visual communication predisposed the public to accept still photographs in advertising. Most important, the realization that the camera could be both factual and persuasive and could imply authenticity while suggesting certain

628. KIYOSHI KOISHI. *Smile Eye-Drops*, 1930. Halftone reproduction. © 1971 Japan Professional Photographers Society.

qualities—manliness, femininity, luxury—made it a desirable tool in this fast-growing and competitive field. In a utopian effort to make excellence available to all by wiping out the distinctions between fine and applied art and between art and the utilitarian object, Bauhaus and Constructivist artists and photographers had promoted the camera image as a means of transcending these traditional divisions. As a result, many photographers in the 1920s began to ignore the division between self-expression and commercial work that the Pictorialists had been at pains to establish around the turn of the century. The advertising industry in all advanced capitalist countries embraced these concepts from the art world and also predicted that advertising would improve the aesthetic taste of the populace by integrating the latest modern ideas into visual communication.

During the 1930s, many photographers of stature produced images for commerce. Herbert Bayer, Cecil Beaton, Laure Albin-Guillot, Man Ray, Moholy-Nagy, Paul Outerbridge, Charles Sheeler, Steichen, and Maurice Tabard were among those eager to work on commission for magazines, advertising agencies, and manufacturers at the same time that they photographed for themselves and were honored as creative individuals by critics. A number—

including Hans Finsler, Bourke-White, Anton Bruehl, Victor Keppler, and Nickolas Muray—worked almost exclusively in the advertising field, convinced that they were making a creative contribution to photography in addition to selling products. In the Far East, Japanese commercial photographers kept abreast of the modernist style, employing close-ups, angled shots, and montages, exemplified by *Smile Eye-Drops (pl. no. 628)*, a 1930 ad by Kiyoshi Koishi, third-place winner in the *First Annual Advertising Photography Exhibition* held in Japan in that year.

This honeymoon between photographer and commercial patron was relatively short-lived. Even though Steichen thought such patronage to be the equivalent of the Medici's support for Renaissance artists, "the purely material subject matter" with which most advertising photographers had to deal could not be considered comparable to Renaissance religion and philosophy, as Outerbridge observed.[29] Nevertheless, commercial commissions have continued to make a substantial impact on photography, affecting not only the kinds of images produced and the taste of the public but also, to some extent, the materials on the market with which all photographers must work.

Sources and influences in advertising photography are difficult to sort out because from the start Americans and Europeans looked to each other for inspiration, with Europeans envious of the munificence of advertising budgets on this side of the Atlantic and Americans aware of the greater freedom for experimentation in Europe. However, no matter where they were produced, the most visually arresting images reflect the ascendant stylistic tendencies in the visual arts in general. One wellspring in the United States was the Clarence White School of Photography. Its curriculum is only now being studied, but its significant contribution to the modernization of advertising photography can be seen in the roll call of faculty and students who became active in the field during the 1920s and '30s. Bruehl, Bourke-White, Outerbridge, Ralph Steiner, and Margaret Watkins translated the design precepts taught in the school into serviceable modernistic imagery, as can be seen in an image for an ad prepared by Watkins in 1925 for the J. Walter Thompson Agency *(pl. no. 629)*.

As might be expected, the style associated with the New Objectivity, with its emphasis on "the thing itself," was of paramount interest. Finsler in Germany, Tabard and the Studio Deberney-Peignot in France, and Steichen in the United States all realized (as did others) that the close-up served as an excellent vehicle to concentrate attention on intrinsic material qualities and to eliminate extraneous matters. One consequence of this emphasis, as an article on advertising photography in the late 1930s noted, is that "the softness of velvet appears even richer and deeper than it actually is and iron becomes even

Thompson), 1925. Gelatin silver print. Light Gallery, New York. © Watkins Estate, Glasgow.

harder";[30] in addition, lighting and arrangement were further manipulated to glamorize the product. Nor were close-ups limited to inanimate still lifes or the products of machines; a view of hands engaged in the precise task of threading a needle *(pl. no. 630)*, photographed by Bruehl as part of a campaign for men's suits, was meant to suggest the care, quality, and handwork (still a sign of luxury goods) that ostensibly went into this line of men's wear.

The provocative nature of bizarre imagery for advertising also was recognized. French commercial photographer Lucien Lorelle suggested that it provided the "shock" needed to "give birth to the acquisitive desire."[31] Startling views of ordinary objects were obtained by selecting ex-

treme angles, by using abstract light patterns, and by montaging disparate objects. Just before 1930, photograms found their way into European advertising in works by Man Ray, Moholy-Nagy, and Piet Zwart, which were produced for an electrical concern, an optical manufacturer, and a radio company, respectively. Montages by Finsler and Bayer were used to sell chocolate and machinery, while distorted views of writing ink by Lissitzky for Pelikan and of automobile tires by Tabard for Michelin were considered acceptable. Americans, on the other hand, were warned away from excessive distortion. Product pictures by Bruehl, Muray *(pl. no. 631)*, Outerbridge, Steichen *(pl. no. 579)*, and Ralph Steiner *(pl. no. 580)* are essentially precise still lifes

of recognizable objects. Even the dramatic angles chosen by Bourke-White to convey the sweep and power of large-scale American industrial machinery were selected with regard for the clarity of the forms being presented. Eventually, when montages and multiple images did enter American advertising vocabulary, these techniques were used for fashion and celebrity images and only after World War II for more prosaic consumer goods.

Most advertising images in the United States (and elsewhere) were not conceived in the modernist idiom by any means. Heavily retouched, banal photographic illustrations filled the mail-order catalogs issued by Sears, Roebuck and Montgomery Ward, while the advertising pages of popular magazines and trade journals were full of ordinary and often silly or sentimental concoctions. However,

some very competent work was done by individuals working in an old-fashioned vein. The highly acclaimed arrangements photographed by Lejaren à Hiller *(see Chapter 8)* required historically researched costumes and construction of sets in addition to careful attention to lighting. While technically a photograph, tableaux such as *Surgery Through the Ages (pl. no. 632)*, part of a campaign for a pharmaceutical company, are really forerunners of contemporary video advertising in that they rely on theatrical and dramatic content rather than aesthetic means to get their message across.

After the second World War, a number of photojournalists continued to be involved with an amalgam of advertising imagery and journalistic reporting that had made its initial appearance in the feature sections of *Fortune*

630. ANTON BRUEHL. *Hands Threading a Needle* (Weber and Heilbroner Advertising Campaign), c. 1929. Gelatin silver print. International Museum of Photography at George Eastman House, Rochester, New York.

631. NICKOLAS MURAY. *Still Life*, 1943. Reproduced in *McCall's Magazine*. Carbro (assembly) print.
International Museum of Photography at George Eastman House, Rochester, N.Y.

in the 1930s. Even during the nadir of the Depression, articles illustrated with well-reproduced, stylish photographs and signed artwork "sold" the positive aspects of the American corporate structure; indeed, Bourke-White felt that "the grandeur of industry," which she pictured for *Fortune*'s pages, exerted the same appeal on manufacturer and photographer alike.[32] While she herself revised this opinion, and later photojournalists may not have been as sanguine about the benefits of large-scale industrial enterprises, photographing for the broad range of print media that emerged after the war made it necessary for photographers to present "clear, coherent and vivid" pictures of business activities. As a result, the glossy corporate image that appears in annual reports in the guise of photojournalistic reporting has come down as one of the legacies of photojournalism to advertising and an example of the difficulties in categorizing contemporary photographs.

An important aspect of the alluring quality of current advertising images is the use of color. By 1925, according to the British graphic arts magazine *Penrose's Annual*, the public had come to expect "coloured covers and illustrations [in] . . . books and magazines . . . posters . . . showcards . . . catalogues, booklets and all forms of commercial advertising."[33] Even so, the desire for such materials did not immediately produce accurate and inexpensive color images on film or printed page; it was not until the late 1930s that both amateurs and professionals obtained negatives, positive transparencies, and prints with the capacity to render a seductive range of values and colors in natural and artificial light *(See A Short Technical History, Part III)*. Even though these materials were flawed by their impermanence—as they still are—such means were acceptable because their use in print media satisfied the public craving for color.

A method commonly used to create color images for advertisements during the Depression was the trichrome/carbro print, made from separation negatives produced in a repeating-back camera such as the Ives Kromskop. Based on the addition of dyes to gelatin carbon printing methods, carbro printing was a highly complicated procedure involving as many as 80 different steps; but despite the expense and the special facilities required, it flourished because "the commercial aspects of color were as important as the aesthetic or technical angles"[34] in determining the kind of color work that publishers and agencies, competing for a limited market, favored. Condé Nast was one of the first publishers to print the richly hued advertising photographs by Bruehl and Fernand Bourges in *Vogue* in 1932. In the mid-1930s, the Bruehl-Bourges studio did color work for a range of product manufacturers reading like a veritable who's who of American corporations, while Will Connell, Lejaren à Hiller, Keppler, Muray, Outerbridge, Valentine Sarra, and H. I. Williams also were active in working out eye-catching spectrums for ads for food *(pl. no. 631)*, fashion, and manufactured goods that appeared in *House Beautiful* and similar magazines.

There can be little argument that in modern capitalist societies the camera has proved to be an absolutely indispensable tool for the makers of consumer goods, for those

632. LEJAREN À HILLER. *Hugh of Lucca (d. 1251) from the Surgery Through the Ages Series*, (Pharmaceutical advertising campaign) 1937. Gelatin silver print. Visual Studies Workshop, Rochester, N.Y.

MOVE IT Trucks haul tons of freight, and diesel engines give them the power to do it. United Technologies Diesel Systems Company designs and produces fuel injection systems for cars and trucks. Diesel Systems is part of a corporation that includes great names like Pratt & Whitney, Otis, Carrier and Sikorsky. We're on the move as the seventh largest manufacturing company in the U.S. United Technologies, Hartford, CT 06101.

633. JAY MAISEL. *United Technologies*, 1982. Advertisement. Art Director, Gordon Bowman. Copywriters, Gordon Bowman/Christine Rothenberg. Courtesy and © 1982 United Technologies, Hartford, Conn.

634. RICHARD AVEDON.
The Veiled Reds, 1978.
Advertisement. Courtesy
and © 1978 Charles
Revson, Inc.

involved with public relations and for those who sell ideas and services. Camera images have been able to make invented "realities" seem not at all fraudulent and have permitted viewers to suspend disbelief while remaining aware that the scene has been contrived.[35] The availability of sophisticated materials and apparatus, of good processing facilities, and the fact that large numbers of proficient photographers graduate yearly from art schools and technical institutions, combined with the generous budgets allocated for advertising, guarantee a high level of excellence in contemporary advertising images *(pl. nos. 633 and 634)*. As in the past, the photographs deemed exceptional often reflect current stylistic ideas embraced in the arts as a whole and in personally expressive photography in particular; indeed, the dividing line between styles in advertising and in personal expression can be a thin one, with a number of prominent figures working with equal facility in both areas.

The imagination that inspired early enthusiasts (such as Brodovitch) to foresee in advertising a great creative force is less evident in contemporary advertising photography. Whether picturing industrial equipment or luxury goods, the fact is that for the most part the style and content of such images are controlled by the manufacturer and ad agency, and not by the individual photographer. Designed to attract the greatest number of viewers, there is little compass for personal approach, while the images that are considered exceptional tend to generate considerable emulation. The bland sameness that characterizes the field has been more true of advertising imagery in the

United States than in Europe, owing to the larger budgets and greater role that advertising plays in American life, but it also reflects the fact that in the past there was more leeway in Europe for visual experimentation in applied photography and graphic design.

Pictures in Print:
Fashion and Celebrities

Commercial uses of photography always have included fashion and celebrity images, a specialty that is neither strictly documentation nor advertising. The appearance in the 1920s of specialized periodicals devoted to fashion enlarged the creative opportunities for photographers interested in these subjects. Often they were permitted a more fanciful approach than was considered suitable in ordinary product advertising or photojournalism because their goal was to create an illusion, in which artifice was a prime ingredient. Made to establish canons of taste while attracting buyers, these pictorial configurations of model, garment, pose, and decor are as much indications of changing styles in the arts as of attire. And it can be argued also that fashion imagery is significant as an index of transformations in social, cultural, and sexual mores and thus is indicative of attitudes by and toward women in society.

Fashion imagery, as might be expected, got its start in the world's fashion capital—Paris—where in the late 1800s the Reutlinger Studio *(pl. no. 635)*, Bissonais et Taponnier, and Seeberger Frères, among others, provided images for

635. REUTLINGER STUDIO, Paris. *Dinner Dress by Panem*, published in *Les Modes Magazine*, March, 1906. Halftone reproduction. Fashion Institute of Technology, New York; Edward C. Blum Design Laboratory.

Parisian magazines. But it was the transformation of *Vogue*, late in the second decade of this century, from a society journal to a magazine devoted to presenting elegant attire for the elite that marked the real beginning of fashion photography as a genre. Published in three separate editions in London, New York, and Paris by Condé Nast, *Vogue* at first featured opulent soft-focus confections *(pl. no. 636)* exemplified by the work of Pictorialist Adolf de Meyer (known as Baron), who was replaced by Steichen in 1923, but continued to photograph in what had become an outmoded style for *Harper's Bazaar*. Steichen, in his role as chief photographer for Condé Nast publications in the United States, was the catalyst behind the "new look" in fashion photography during the 1920s; he arranged and composed individual models, groups, and properties into vividly patterned ensembles that displayed an instinctive flair for dramatic contrasts and for the decorative possibilities of geometric shapes. His work was immediately recog-

636. BARON ADOLF DE MEYER. *A Wedding Dress, Modeled by Helen Lee Worthing*, 1920. Gelatin silver print. *Vogue*, New York. © 1920 (renewed 1948) by The Condé Nast Publications, Inc., New York.

nized as stylistically consistent with other emblems of 1920s modernism—the skyscraper, machine forms, and jazz. And toward the end of the decade, as the New Objectivity came to the fore, Steichen transformed this style into a chic yet expressive language suitable for both fashion and celebrity images, as can be seen in his close-up of actress Anna May Wong *(pl. no. 637),* which, in addition to creating an arresting design reminiscent of Brancusi's sculptured heads, suggests characteristics of inwardness and mystery.

Steichen's influence was felt in Europe as well as in the United States. In its wake, George Hoyningen-Huene (born in Russia and active in France between 1925 and 1935, during which time he contributed regularly to Paris *Vogue*) combined his strong admiration for the statuary of classical antiquity with the clean functionalism of the New Objectivity, achieving the distinctive if somewhat bizarre style typified by his 1930 spread for bathing attire *(pl. no. 638)*. In France at the time, Madame D'Ora and Egidio

Scaione, an Italian photographer with a large commercial practice, handled similar themes with an icy elegance that epitomizes the *style moderne*—the French version of the New Objectivity. When inventive British photographer and stage designer Beaton turned to celebrity and fashion images in 1929, he joined his penchant for lush baroque fantasies with a modern touch, producing alluring pictures such as *Marlene Dietrich (pl. no. 639)*. The British editions of both *Vogue* and *Harper's Bazaar* provided commissions for a number of British fashion photographers, among them Dorothy Wilding and Barbara Ker-Seymer, who transferred the mechanistic suavities of the objective manner to their portraits of celebrities.

Involved primarily with form—indeed, the content is seldom the actual personage or garment but the "aura" created by the photographer—fashion and celebrity images were especially quick to relect changes in aesthetic sensibility. During the Depression, the cool hermetic elegance of

637. EDWARD STEICHEN. *Anna May Wong*, 1930. Gelatin silver print. Collection George H. Dalsheimer, Baltimore. *Vanity Fair*, New York. © 1930 (renewed 1958) by The Condé Nast Publications, Inc., New York.

638. GEORGE HOYNINGEN-HUENE. *Untitled*, (*Fashion Izod*), 1930. *Vogue*, New York. © 1930 (renewed 1958) by The Condé Nast Publications, Inc., New York.

the New Objectivity was challenged in the United States both by the naturalism of small-camera photojournalistic documentation and by the preference for American-made products that prompted editors to avoid what they conceived as aesthetic styles imported from Europe. Also, as a consequence of the search for a wide readership, fashion imagery became more democratic in theme and approach. Ironically, this breath of air was imported; as noted earlier, it was the Hungarian Munkacsi who first applied candid techniques to fashion photography, snapping a bathing-suit model running on a beach *(pl. no. 640)*. These unstilted images of active, athletic models photographed out-of-doors in natural light established this approach as one of the two poles between which fashion imagery has continually rebounded, the other extreme being the contrived studio shot. The American Toni Frissell was one of a number of fashion photographers who combined natural settings and the casual stances of photojournalism with angled shots and stark silhouettes, exemplified in a 1939 series for *Vogue* featuring fur garments out-of-doors *(pl. no. 641)*.

Images that ostensibly explored the landscape of the

mind and reflected the prevailing interest in psychoanalysis and the Surrealist art movement began to appear in fashion work during the 1930s. Horst Peter Horst, a former student of Purist architecture in Paris, devised montages and mirror tricks to confound reality with *trompe l'oeil* settings. Others—including the Londoners Yevonde Cumbers (Madame Yevonde) and Angus McBean, who ordered a Daliesque background to be constructed and painted especially for a portrait of the actress Elsa Lanchester *(pl. no. 642)*—were directly inspired by Surrealist paintings. Besides the well-known Dalí, the painters Christian Bérard, Giorgio de Chirico, and Yves Tanguy influenced fashion images by the English painter-photographer Peter Rose-Pulham and the Americans Clifford Coffin and George Platt Lynes, for example. Surrealist photographs were a natural offshoot of Beaton's preoccupation with fantasy, while Man Ray, in arranging a couturier beach robe against a backdrop of his own painting entitled *Observatory Time—The Lovers (pl. no. 644)* for a spread in *Harper's Bazaar*, came to this languid mix of luxury and desire from the even more irrational pre-

639. CECIL BEATON. *Marlene Dietrich,* 1932. Gelatin silver print. J. Paul Getty Museum, Los Angeles.

640. MARTIN MUNKACSI. *Untitled,* 1934. Reproduced in *Harper's Bazaar,* December 1934. Gelatin silver print. Joan Munkacsi, Woodstock, N.Y.

cincts of Dadaism. Continued interest in the temporal and spatial confusions of dreams combined during the 1940s with awareness of the war in Europe to give fashion images, as conceived by Erwin Blumenfeld and the American John Rawlings, a macabre aspect. Rawlings, a former director of *Vogue*'s London studio, arranged mirrors to create a sense of undefined time and place *(pl. no. 643)* suggestive of austerity and even regimentation for a *Vogue* cover that came out during the second World War in 1944. A multiple image by Blumenfeld *(pl. no. 645)*, who worked in the United States after his release from a Nazi internment camp, brings to mind the shattering experiences of war and incarceration rather than the seductive fantasies one usually finds in fashion pictures.

In the postwar years, fashion photographers were heir to a wealth of traditions that included New Objectivity, Surrealism, and the documentary mode. They sought to integrate these concepts with the revived taste for luxury, at the same time developing distinctive individual styles. Less elitist than formerly but often more opulent because fashion images were now made largely in color for a reader-

ship eager to make up for wartime austerity, the new sensibility is apparent in the work of Richard Avedon, Lillian Bassman, Louise Dahl-Wolfe, Irving Penn, and Bert Stern, and in the still lifes of Leslie Gill, to name only a small number of those active in the field after the war.

Richly patterned colors and decor were orchestrated for *Harper's Bazaar* by Dahl-Wolfe (originally a painter), who rose to prominence on the strength of an impeccable color sense combined with skill in arranging the more naturalistic decor now desired in fashion photography *(pl. no. 646)*. Her task, along with that of others in the field, was made easier by the increase in air travel that enabled photographers to drop themselves and their models virtually anywhere around the globe—on Caribbean beaches and western American deserts, in front of monuments and palaces in North Africa, India, and Europe. Penn (also a trained painter) created elegant confections that often make reference in their arrangements and color schemes to well-known paintings, as in an image featuring model Lisa Fonssagrives taken in an exotic setting in Morocco *(pl. no. 649)*. Working in similar style but with still-life objects rather

641. TONI FRISSELL. *Boom for Brown Beavers*, 1939. Reproduced in *Vogue*, August 1, 1939. Gelatin silver print. Toni Frissell Collection, Library of Congress, Washington, D.C.

642. ANGUS MCBEAN. *Elsa Lanchester*, 1938. Reproduced in *The Sketch*, June 22, 1938. Gelatin silver print. © Estate of Angus McBean.

than live models, Gill created numerous covers and spreads of uncluttered opulence for *Harper's Bazaar* over more than a 20-year period beginning in 1935 *(pl. no. 650)*. From the 1960s on, Avedon, whose stated desire was to "never bring the same mental attitude toward the same problem twice"[36] probably had the greatest influence on fashion photography. The style of his own work veered between an early somewhat frenetic naturalism, derived from Munkacsi, and a later taste for highly contrived lighting, pose, and camera angle, as in *Donyale Luna in Dress by Paco Rabanne (pl. no. 651)*, which appeared in *Vogue* in December, 1966. This particular treatment of female form and dress has been seen as a reflection of the decade's profound changes in sexual and social mores rather than merely as a search for novelty to attract the jaded eye. Both naturalism and mannerism continued to inspire up-and-coming fashion photographers to frame individualized approaches. Casual documentation ostensibly characterized the fashion style of Diane Arbus, William Klein, and Bob Richardson, while Stern updated the Surrealism of Blumenfeld and the mannerism of Penn with a touch of "pop" culture. In the 1970s, Hiro (born Yasuhiro Wakebayashi in Shanghai), working in the United States for *Vogue*, achieved a distinctive amalgam combining athleticism and elegance with his own aesthetic heritage *(pl. no. 647)*.

Eclipsed by Americans during the war and immediate postwar years, the European fashion world regained its aplomb at the beginning of the 1960s with David Bailey's work in London; by the 1970s, when Paris *Vogue* featured the work of European newcomers Guy Bourdin and Helmut Newton, it reflected changing perceptions of women (by men and women themselves). Bourdin's macabre fantasies depict them as graceless, vulnerable, and frenzied while Newton shows them as sexually aggressive yet frigid. These strange visions, photographed in strident color, inspired the French photographer Sarah Moon *(pl. no. 648)* and the American Deborah Turbeville *(pl. no. 652)*, but, though still concerned with alienation and uneasiness, both have softened the vision of women as social and sexual predators, in part through the atmospheric backgrounds and muted impressionist color they favored.

One major development of the 1980s was the attention paid to male fashion by both manufacturers and the fashion industry, but it is doubtful whether this new thrust has

643. JOHN RAWLINGS. *Untitled*, 1944. *Vogue* cover, January 1, 1944. Halftone reproduction. Fashion Institute of Technology, New York; Edward C. Blum Design Laboratory. *Vogue*, New York. © 1944 (renewed 1972) by The Condé Nast Publications, Inc., New York.

Against his surrealist painting "Observatory Time—The Lovers," Man Ray photographs

a beach coat by Heim of white silk printed with little brown foxes. Hattie Carnegie.

644. MAN RAY. *Untitled*, 1936. Published in *Harper's Bazaar*, November, 1936. Halftone reproduction. New York Public Library, Astor, Lenox, and Tilden Foundations.

645. ERWIN BLUMENFELD. *What Looks New*, 1947. Reproduced in *Vogue*, March 15, 1947. Color (chromogenic development) transparency. Collection Marina Schinz, New York.

646. LOUISE DAHL-WOLFE. *The Covert Look*, 1949. Reproduced in *Harper's Bazaar*, August, 1949. Color (chromogenic development) transparency. Fashion Institute of Technology, New York; Edward C. Blum Design Laboratory.

647. Hiro. *Fabric, Harper's Bazaar*, February, 1967. Color (chromogenic development) transparency. Courtesy and © 1967 Hiro.

648. Sarah Moon. *Faces*, 1973. Reproduced in *French Vogue*, February, 1973. Color (chromogenic development) transparency. Courtesy the artist.

649. IRVING PENN. *Woman in Moroccan Palace (Lisa Fonssagrives), Morocco*, 1951. Gelatin silver print. *Vogue*, New York. © 1951 (renewed 1979) by The Condé Nast Publications, Inc., New York.

650. LESLIE GILL. *Chocolate Pot and Apples I*, 1950. Gelatin silver print. Courtesy and © 1982 Frances McLaughlin Gill, New York.

651. RICHARD AVEDON. *Donyale Luna in Dress by Paco Rabanne, New York Studio,* January, 1966. Gelatin silver print. Courtesy and © Richard Avedon.

forestalled the problems faced by arbiters of fashion as the democratization of this once elitist interest continues in Europe as well as in the United States. With a broad range of styles offering a heterogeneous public many choices of how to look, prominent fashion photographers found themselves with greater freedom to choose models, styles, decor, and ambience and even to suggest how their work be used in publication. At the same time, however, as fashion images also are collected and studied as aesthetic artifacts, photographers in this field have been competing with a wider spectrum of image-makers for a place on gallery and museum walls and in the critical sun, as well as on the printed page.

"The transformation of everything into images" has had an unsettling effect on perception, as Roland Barthes noted in *Camera Lucida*.[37] The omnipresent photograph may not have served to "de-realize the human world of conflicts and desires" to the extent this author suggests, but there is no question that it has affected responses to pain, suffering, and pleasure in real life, making these facets of human experience seem somehow commonplace, less intensely felt, and less urgent. Advertising photography in particular has promoted a continuous search for pictorial novelty; while this emphasis may be of value in selling products in consumer-oriented societies, it is open to question as an end in itself in creative expression. The fact that commercial photographs may be seen only subliminally, with the message registered but the relationship of forms and the disposition of light unremarked, has

653. FLORINE STETTHEIMER. *Sunday Afternoon in the Country*, 1917. Oil on canvas. Cleveland Museum of Art, Cleveland, Ohio; gift of Ettie Stettheimer.

influenced the casual way in which the public approaches expressive camera images in general. Conversely, it also is true that the prevalence of the photographic image in print, whether in advertising or journalism, has made the public more willing to accept camera images in all their guises and has led to a more sophisticated appreciation of them, providing readers for books on photography, viewers for exhibitions, and collectors for individual works.

Profile: Edward Steichen

In the range and quality of his production in the fashion and advertising fields, Edward Steichen might be said to embody the development of utilitarian photography in the 20th century. Steichen was engaged with much that was vital and new in the medium during the 20th century, from a beginning as a Pictorialist photographer through activities in the commercial sector to a position as director of the most prestigious museum photography department in the United States (at the Museum of Modern Art). As a creative individual, as a designer of exhibitions and periodicals, as a director of projects, he left an unmistakable imprint on the photographic trends of his time.

Born Eduard Steichen, in Luxembourg in 1879, he was brought to the United States as an infant. When he displayed artistic ability he was apprenticed after 1894 to a firm of lithographers in Milwaukee; he both painted and photographed, submitting to Pictorialist salons during the 1890s. Clarence H. White noticed him in 1900 and soon after brought him to the attention of Stieglitz, with whom he shortly began to collaborate on the installations for the gallery 291 and on the founding of *Camera Work*, for which he designed the first cover and the initial publicity. Still not entirely committed to photography, Steichen spent the greater part of the period before the first World War painting in France. There his knowledge of Symbolism, Expressionism, and Cubism enabled him to direct Stieglitz's attention to these significant art movements. Besides paintings (nearly all of which he later destroyed), Steichen made sensitive photographs in the Symbolist style of landscapes, genre scenes, and New York cityscapes *(pl. no. 336)* and perceptive portraits of wealthy and creative individuals in Paris and New York during this period. As part of the active New York art scene of the time, he was portrayed photographing Marcel Duchamp in *Sunday Afternoon in the Country*, a 1917 oil by Florine Stettheimer *(pl. no. 653)*. Other photographers included in the painted scene are Arnold Genthe and Baron de Meyer.

Steichen's experiences as director of aerial photography for the Allied Forces during World War I, followed by a period of several years of photographic experimentation based on his interest in the theory of dynamic sym-

metry, enabled him to shed the vestiges of his Pictorialist sensibility and open himself up to modernist ideas. In his position with Condé Nast from 1923 and also as a freelance advertising photographer, he explored the vocabulary of the New Objectivity during the 1920s in order to create ingenious advertising and fashion images in what was still a relatively fresh field. This phase of Steichen's career, which he brought to an end in 1937 when he realized that commercial work was no longer personally stimulating, prepared him to embrace a broader concept of photography and to assume a role as administrator. Although not himself involved in photoreportage or the documentary movement, by the late 1930s he was convinced that the fine quality of work produced by photographers working for the Farm Security Administration and for *Life* had effectively erased aesthetic distinctions among images made as personal expression, as photojournalism, or as social commentary.

In 1947, after serving as director of Naval Combat Photography during World War II, Steichen accepted the directorship of the Department of Photography of the Museum of Modern Art. His purpose, he said, was to make sure that what he called the "aliveness in the melting pot of American photography" and "the restless seekings, probing aspirations and experiments of younger photographers"[38] would be represented in the museum collection. During his tenure, which lasted until 1962, he organized and promoted exhibitions, wrote numerous articles, helped publish books on the medium, and was instrumental in making photographic images acceptable in a museum setting. In 1955, Steichen organized *The Family of Man* exhibition and catalog, which he considered the culmination of his career. He believed that this show promoted photography as "a tool for penetrating beneath the surface of things" and that it proved that journalistic photographs had their own aesthetic forms. Long before he died in 1973, he was recognized as one of the small group of individuals whose ideas, energy, and images had helped shape photography in the 20th century.

Profile: W. Eugene Smith

A strong sense of compassion made W. Eugene Smith a legend in his own time. Whatever the circumstances and settings of his assignments—and the range of those assignments was broad—he thought of his camera as an extension of his conscience and his images as reflections of his need to get to the heart of the matter. Following a semester as a student at the University of Notre Dame, Smith came to New York City in 1937 at a time when photoreportage was changing the nature of magazine journalism and providing unparalleled opportunities for

young photographers. Immediately successful, his early work showed such skillfulness that within two years Smith, though only nineteen years old, found himself on part-time contract to *Life* magazine.

Demanding of himself as well as others, Smith at first found many assignments trivial, but he continued to cover domestic events for *Life,* and later *Collier's* and *Parade.* As the war expanded to involve the United States, he felt impelled toward the field of conflict in the South Pacific, where he went in 1943 on an assignment for *Flying* magazine. Eventually he returned to this front, sent by *Life* to cover the action on the Pacific islands. Involvement on the field of battle changed Smith's understanding of war and influenced his photographic style, moving him to compose his images as if sharing the same emotionally charged space as his subjects *(pl. no. 608).* Compulsively driven to partake of the reality of combat, he was seriously wounded in Okinawa in 1945.

Smith's continued advocacy of the moral responsibility of the photojournalist prompted him to join the Photo League after World War II, and to accept its presidency in 1949. He also rejoined the staff of *Life* in 1946 in an effort to have his images reach as wide an audience as possible. Despite ongoing battles over deadlines, picture size, layout, and captioning, more than 50 of his essays were used between 1946 and 1952, among them the memorable "Spanish Village" *(pl. nos. 654–658),* "Country Doctor," and "Nurse Midwife." Smith resigned permanently in 1954 when he realized that he could not alter publication policies that denied the photographer a voice in the final appearance and meaning of the published photo essay.

In the following years, Smith took on a variety of photojournalistic projects that gave him freedom to develop his craft and ideas. Although their free-lance nature meant that his income was irregular, his work of this period enabled him to explore the photo essay form more profoundly in order to "force the genre in an epic poetic mode."[39] Works that exemplify this ambitious concept include an extensive essay on Pittsburgh published in *Popular Photography Annual, 1959,* under the title "A

654–658. W. EUGENE SMITH. *Spanish Village,* April 9, 1951 issue of *Life Magazine.* From halftone reproductions. Designer: Bernard Quint. *Life Magazine* © 1951 Time Inc.; Courtesy Life Picture Service.

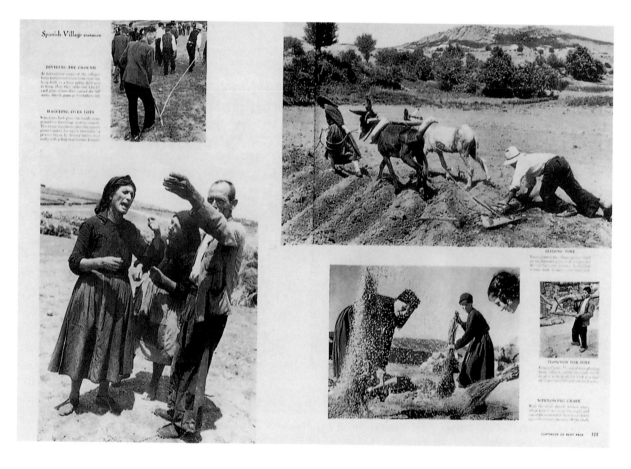

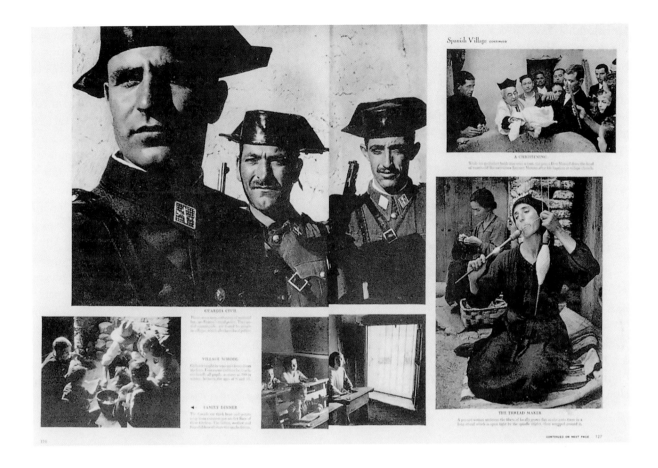

A CHRISTENING

THE THREAD MAKER

GUARDIA CIVIL

VILLAGE SCHOOL

FAMILY DINNER

CONTINUED ON NEXT PAGE 127

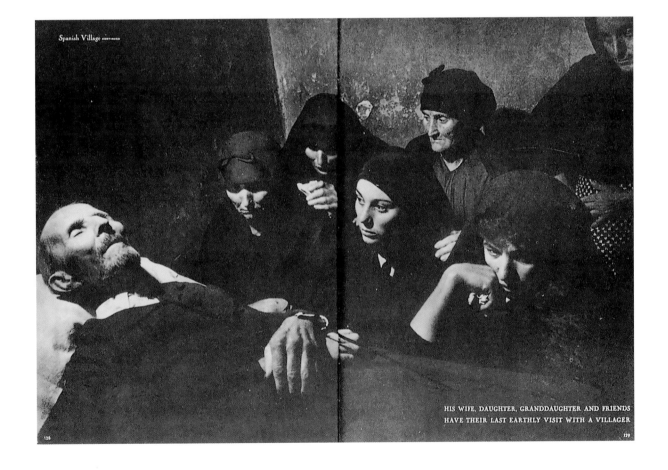

HIS WIFE, DAUGHTER, GRANDDAUGHTER AND FRIENDS
HAVE THEIR LAST EARTHLY VISIT WITH A VILLAGER

Labyrinthine Walk" (part of this work also appeared in the book mentioned earlier on that city by Lorant), and a lyrical story entitled "As from My Window I Sometimes Glance," which evokes the tempo of urban life as it is affected by changing seasons, weather, atmosphere, and mood. A project undertaken by the photographer and his second wife from 1971 to 1975 in Minamata, Japan, reveals the agonizing human price of industrial pollution. It includes an image that recalls Michelangelo's *Pietà* (*pl. no. 475*) and represents Smith's culminating endeavor to use photography to "right what is wrong."

Profile: Henri Cartier-Bresson

Called "equivocal, ambivalent and accidental"[40] when first exhibited at the Julien Levy Gallery in New York in 1933, the work of French photographer Henri Cartier-Bresson has come to be regarded as one of the seminal visions of the 20th century. After studying painting for a number of years, including a year with André Lhote, Cartier-Bresson began to photograph with a Leica around 1930, soon revealing a remarkable ability to create images that invest moments in time with enduring mystery or humor. Throughout a career of some 35 years, he consistently upheld the primacy of individuality and spontaneity in the photographic process, maintaining that "you have to be yourself and you have to forget yourself" in order to discover the exact instant and position from which the photographer might be able to extract a moment of meaning from ongoing existence.[41]

Commissions from *Harper's Bazaar* and *Vu* in 1932 started Cartier-Bresson in photojournalism. Convinced of the constraints of preconception, he approached actuality with an intuitive sense for forms ripe with emblematic significance and an eye for precise visual organization. Although he has often avowed that his way of working is unlearnable, he also has acknowledged the influence on his ideas of the early journalistic images by Kertész, Munkacsi, and Umbo, all of whom shared a similar capacity to give photographic form and structure to evanescent moments of human experience. For example, the disparities of scale and the seemingly irrational juxtapositions of forms in images made in Spain in 1933, among them *Arena, Valencia, Spain (pl. no. 660)*,

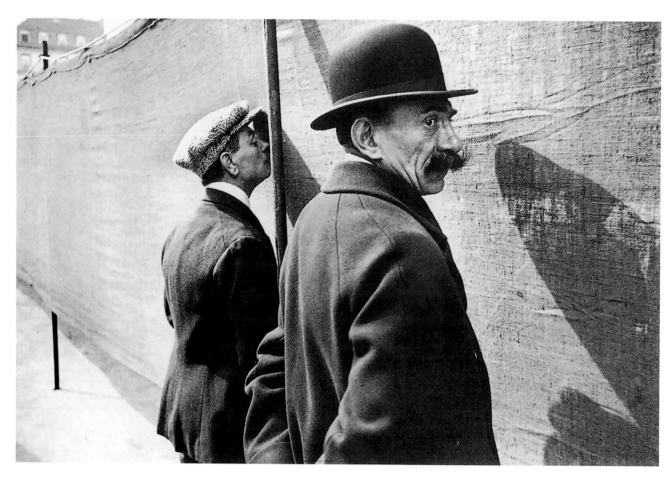

659. HENRI CARTIER-BRESSON. *Brussels*, 1932. © 1976 by Henri Cartier-Bresson/Magnum.

660. HENRI CARTIER-BRESSON. *Arena, Valencia, Spain*, 1933. © Henri Cartier-Bresson/Magnum.

suggest the uneasy tensions that eventually erupted into civil war, even though their intent was poetic rather than political. During the 1930s, he photographed in Mexico and the United States, seeking not only the momentary action framed in the viewfinder of the camera but some essential truth about the larger society of which it was a part. Cartier-Bresson approached portraiture in the same way, contending that in the transient expressions of the many figures in the arts whom he photographed during the 1940s in the United States and France can be found the key to their individual personalities.

Cartier-Bresson also studied film technique, working with Strand in the United States and with Jean Renoir in France. In 1937, for Frontier Films, he produced *Return to Life*, a film about the delivery of medical aid to Spanish Loyalists, and in 1945, after his own escape from 36 months of captivity as a German prisoner-of-war, he made the film *Le Retour* about the return of French soldiers and prisoners to their homeland. Following a retrospective exhibi-

tion of his still photographs at the Museum of Modern Art in 1946, and the founding a year later of the collaborative agency Magnum, Cartier-Bresson embarked on indefatigable travels in Europe, Asia, and the Americas to make photographs. He published the results in scores of magazine articles and more than a dozen books, including *D'Une Chine à l'Autre (China in Transition)* (1954), *Moscou (The People of Moscow)* (1955), and *Visage d'Asie (Face of Asia)* (1972). While insisting that he was not interested in documenting particular peoples and events but evoking universal dreams and intuitions, he drew nourishment from the political and social contingencies of the events he witnessed and at the same time affirmed the vitality and intensity of life everywhere. His ideas have had a profound influence on several generations of younger photographers, a number of whom have transformed his concepts into personal styles that encompass their expressive goals. Towards the end of his life, he gave up photography and returned to painting.

11.

PHOTOGRAPHY SINCE 1950: THE STRAIGHT IMAGE

There is one thing the photograph must contain, the humanity of the moment. This kind of photography is realism. But realism is not enough— there has to be vision and the two together can make a good photograph. It is difficult to describe this thin line where matter ends and mind begins.

—Robert Frank, 1962 [1]

IN 1850 IT WOULD HAVE BEEN unusual to meet someone who had handled a camera or looked at a photograph. One hundred years later the reverse was true. The camera had become a ubiquitous device, its basic techniques easily mastered by even the clumsiest and least sophisticated person. By 1950 photographic images in silver, in colored dyes, and in printer's ink had penetrated all parts of the globe, through all layers of society, and had become the daily visual diet of everyone living in the urban centers of the West. In the second half of the 20th century, the photograph was perceived as the paramount means of visual communication, attracting gifted and imaginative artists as well as commercial practitioners and amateurs, and infiltrating the art marketplace as a commodity while continuing to fulfill established roles in communications and advertising. Traditional photographic methods and materials continued to be refined throughout this period until the 1980s, when the discovery of ways to produce and alter images digitally relegated many aspects of conventional photography to the dustbin at the same time as it raised still-unresolved issues about authorship, copyright, and truthfulness.

After World War II photographs became more pervasive than ever before, partly due to the weekly picture magazines, which continued to be popular through the 1970s despite increasing competition from television. With their accomplished reportage, seductive advertising, and striking scientific pictures made possible by new techniques in aerial photography (pl. no. 661) and microphotography, picture journals helped prepare the way for public acceptance of a wide range of imagery—abstractions, series, color, and visual manipulations of various kinds. In the late 1960s and '70s, photographs earned greater respect as objects; they began to be reproduced more frequently in book format, exhibited more often in galleries and museums, and collected with more enthusiasm by private individuals and business enterprises. As a result, their history and provenance became subjects of increasing scholarly study. Concurrently, the widespread effect of photography on perceptions of reality and on the nature of perception itself became the stuff of intellectual speculation. During the 1980s the photograph was seen not only as an object capable of affording information or pleasure but also as a tract on which might be inscribed (sometimes in actual words) an unmistakable social, personal, or political message.

In the years since its invention, photography had become an international medium. That photographic processes and concepts had traversed national boundaries with ease owed much to competition among industrial nations in the 19th century. England and France, especially, carefully monitored each other's discoveries in all scientific and industrial fields, while the similarity of life in industrialized societies increasingly elicited similar kinds of pictorial documentation. However, despite the vitality of international photographic activity up through the 1930s, after World War II the wellspring of visual culture shifted temporarily to the United States as European and Asian countries struggled to rebuild their shattered economies. Physically undamaged by the war and entering a period of relative economic well-being, the United States provided the conditions that photography—and indeed all the visual arts—needed in order to flourish. Eventually publications, traveling exhibitions, and peripatetic photographers on assignment acquainted Europeans with the diverse styles of American postwar camera expression, which they enriched with ideas originating from their own cultures.

As stability returned, camera activity in Europe, Latin America, and parts of Asia thrived. By the 1990s, photographs made in places as far apart as China and Brazil featured ideas and modes similar to those generally prevailing in the United States and Western Europe. In Russia, for example, the medium has been transformed from government-sanctioned straight reportage to a diversity of manipulative practices that embrace postmodern themes, while Chinese photographers, long in thrall to an idealized (if not propagandistic) view of their own society, adopted a more discerning, journalistic approach. In view of this historical sequence, it seems logical to discuss development in the United States first, and in somewhat greater detail, before turning to tendencies abroad.

Postwar Trends in the United States

Using wars as demarcations of cultural eras may seem simplistic, but there is little question that a new sensibility made its appearance in the United States after World War II. As the nation began a period that was characterized

661. UNKNOWN PHOTOGRAPHER. *Mount Vesuvius, Italy, after the Eruption of 1944*, 1944. Gelatin silver print. Imperial War Museum, London.

mer members of the armed forces, which enabled those who wished to attend art schools and colleges to do so, at government expense. This education introduced many young people to photography as a way to make a living and as a means of personal expression. One important educational fountainhead was the Institute of Design in Chicago—the American incarnation of the Bauhaus, led by László Moholy-Nagy—which proposed that photographers be first and foremost concerned with the expressive manipulation of light, "free from cultural indoctrination."[3] Setting aside the social intent and utopian ideals explicit in the original Bauhaus programs in Weimar and Dessau, the institute advocated a "new vision" (Moholy-Nagy's term) that was primarily dedicated to finding fresh, personal ways of looking at the commonplace. Another pioneer in photographic pedagogy was Black Mountain College in North Carolina, which espoused the progressive view that the study of art should be an integral part of a liberal-arts education. Photography, as taught there in courses led by Harry Callahan, Hazel Larsen, Beaumont Newhall, Arthur Siegel, Aaron Siskind, and others, was a factor in this mission.

Of the photographers associated with the Institute of Design in its early days, Callahan and Siskind were the most influential in terms of their own work. Reflecting the school's emphasis on experimentation, Callahan used both 35mm and 8 x 10 inch formats, worked in black and white

(until the mid-1960s) by domestic peace, political conformism, and expansive consumerism, many in the arts began to grapple with problems of pure form, with the expression of inner visions, and with representing new perceptions of social realities. Reflecting this trend, one significant group of photographers concentrated on what have been called "private realities,"[2] drawing ideas and inspiration from a variety of sources—among them, Abstract Expressionist painting, psychoanalytic thought, Zen, and other systems of Eastern philosophy. Others were inspired by the photographic experimentalism implanted on American soil by refugees from Europe who organized the American Bauhaus as well as by the tendency of many painters to obscure the traditional line between photographic and graphic expression by mixing their media *(see Chapter 12)*. The work of young photographers who continued to espouse straight photography also exhibited subtle changes, becoming tinged by more subjective or ironic attitudes. Alongside these new sensibilities, traditional approaches to image making still attracted adherents, giving the medium extraordinary range and vitality.

The explosion of photographic activity in the United States stemmed in part from the scholarships given to for-

662. HARRY CALLAHAN. *Weed Against Sky, Detroit*, 1948. Gelatin silver print. Pace/MacGill Gallery, New York. © Harry Callahan.

663. HARRY CALLAHAN.
Eleanor, Port Huron, 1954.
Gelatin silver print. Pace/
MacGill Gallery, New
York. © Harry Callahan.

and in color, and made multiple exposures, montages, and collages. His straight images exemplify attempts to find a visual means of "revealing the subject in a new way to intensify it,"[4] as in his early *Weed Against Sky, Detroit (pl. no. 662; see also pl. no. 663)*. Siskind's attraction to abstract forms in nature and in the built world, already made visible in the architectural details he had photographed on Martha's Vineyard during the mid-1930s, became stronger over the next few decades as the photographer committed himself to "relaxing beliefs . . . to seeing the world clean, fresh and alive."[5] Acknowledging the influence of the accidental and spontaneous gestures favored by Abstract Expressionist painters, Siskind found in the canvases of Willem de Kooning, Franz Kline, and Jackson Pollock suggestions for the motifs he extracted from street environments *(pl. no. 664)*. Much of the experimentalism fostered by the institute took the form of manipulative interventions, but a number of graduates—including Linda

Connor, Art Sinsabaugh, and Geoffrey Winningham—applied the precepts to straight photography, at times using unusual formats or special lenses to express a fresh vision of reality.

Another dimension was given to postwar photography by Minor White, whose search for allusive or metaphorical meanings in the appearances of reality attracted a devoted, indeed almost cultish, following during the 1960s. Through extensive teaching and publishing activities, White persuasively urged that photographs be made to embody a mystic essence, that the camera reveal "things for what they are" and "for what else they are."[6] Unsympathetic to the idea that the medium should emulate painting and drawing, White sought instead to continue the directions in straight photography mapped out by Alfred Stieglitz and Edward Weston—to approach nature with a large-format camera, a sharp lens, and an eye for equivalences between form and feeling. Like Weston, White

664. AARON SISKIND. *New York No. 6*, 1951. Gelatin silver print. Courtesy Robert Mann Gallery. © Aaron Siskind Foundation.

offered no clues to size or geographic locale, giving his images the enigmatic quality seen in *Moencopi Strata, Capitol Reef, Utah (pl. no. 665)*, a work that is a depiction of actual rock formations, an arresting visual design, and an invitation to see within it whatever the viewer desires to see.

Younger photographers inspired by the intensity of White's credo and the force of Weston's images sought in natural phenomena of all kinds forms that might express their feelings of being at one with nature. Eroded surfaces, tangled branches, translucent petals, watery environments, and rock structures photographed close-up and with large-format cameras were favored by Walter Chappell and Paul Caponigro *(pl. no. 666)* as means of going beyond perception to evoke the mystic divinity in all nature. The power of light to unlock "the greatest secrets of the unknown"[7] is central also to the imagery of Wynn Bullock *(pl. no. 667)*, a Californian who was close to Weston personally and ideologically. A similar attitude about the transcendent meaning of nature has inspired Linda Connor's images of sacred trees, rocks, and waterfalls, taken in many parts of the world. Another means of investing the landscape with fresh regard has been to view it from an unusual angle. William A. Garnett *(pl. no. 668)* and Bradford Washington both photographed from the air, transform-

ing the shifting patterns of the desert, eroded soil, and farmland into elegantly structured abstractions through framing and the quality and direction of the light.

During the 1960s, this concept of the camera image as a lofty emblem of universal truth was challenged by several groups—by those who believed that "the interior truth ultimately is the only truth,"[8] by those grappling with aesthetic or conceptual issues, and by those who responded to social realities in a subjective fashion. The first two groups turned to manipulative and directorial photography; chroniclers of the social scene continued, for the most part, to favor straight photography. The changing character of American life, coupled with the popularity of the 35mm camera and fresh ideas about photographic aesthetics, also yielded a distinctive new style in straight street photography, with the prevailing tone becoming distanced and ironic. This approach had surfaced first in street images made in the early 1940s by Callahan, Walker Evans, and Louis Faurer, but impetus from Europeans working in the United States from the 1930s on—many of them fleeing rising political tensions and persecution—also must be recognized. One of the earliest, John Gutmann (a German artist who arrived in 1933), focused on the urban scene in his travels across the country. His use of the medium to record the signs and symbols of American popular culture resembled Evans's approach in some respects, but Gutmann's earlier exposure to German Expressionism gave rise to a more caustic wit *(pl. no. 669)*.

The mordant views of bench sitters in Monte Carlo *(pl. no. 670)* by Lisette Model (who was born in Vienna, then worked in France before settling in the United States in 1938) were followed by sardonic images she made in the streets of New York. An influential teacher in New York, Model found a receptive following among young photographers, including Diane Arbus, who was one of her students. Robert Frank, a Swiss-born émigré, was even more dominant in establishing a tone and style for the next generation. Awarded a Guggenheim grant in 1955, Frank used the money to take a photographic odyssey through the United States, working with his 35mm Leica. As an outsider, he regarded cherished national institutions and pastimes with detached skepticism, while his sensitive eye transformed situations into metaphors for the factiousness and consumerism of American postwar society. For example, in *Trolley, New Orleans (pl. no. 671)*, the contrasts in the facial expressions and gestures of the riders, as well as the structural organization of the image itself, convey without rhetoric the psychological and emotional complexities as well as the physical divisions that characterized racial relationships in the southern United States. Frank's images, which were meant to be seen as a group rather than individually, were published in book format—first in France

665. MINOR WHITE. *Moencopi Strata, Capitol Reef, Utah*, 1962. Gelatin silver print.
Museum of Modern Art, New York; Purchase. Courtesy and © The Minor White Archive, Princeton University, Princeton, N.J.

666. PAUL CAPONIGRO. *Schoodic Point, Maine,* 1960. Gelatin silver print.
International Museum of Photography at George Eastman House, Rochester, N.Y. © 1960 Paul Caponigro.

667. WYNN BULLOCK. *Point Lobos Wave*, 1958.
Gelatin silver print.
Collection Robert E. Abrams, New York.
© Wynn and Edna Bullock Trust.

668. WILLIAM A. GARNETT. *Two Trees on a
Hill with Shadows, Paso Robles, California*, 1947.
Daniel Wolf, Inc., New York.
© William A. Garnett.

669. JOHN GUTMANN. *The Jump*, 1939.
Gelatin silver print. Courtesy Castelli Graphics.

670. LISETTE MODEL. *French Riviera*, 1937.
Gelatin silver print. Private collection.
© Estate of Lisette Model, courtesy Sander
Gallery, New York.

and later, in 1959, in the United States as *The Americans*. Their irreverent, unposed, erratically framed *(pl. no. 672)*, and sometimes blurred forms (reflective also of their maker's famously anti-aesthetic attitude toward print quality) were dismissed by American critics as too harsh but were hailed by young Americans who had had their fill of glamorized heroes and icons.

William Klein's raw, grating views of New York in the 1950s were, for some, even less palatable as a vision of American society. Klein—an American resident of France who is a painter, graphic designer, and filmmaker in addition to being a fashion and street photographer—also ignored traditional precepts about sharpness, tonal range, and print quality. His *Garment Center (pl. no. 673)* resonates with the anxieties of modern urban existence. Images by Frank and Klein were considered critical of the American middle class. Another response to that group can be seen in the derisive treatment by Arbus of so-called normal individuals and her compassion for those dismissed as fringe outsiders by conventional society—transvestites, homosexuals, prostitutes, and the mentally challenged, for example. Prompted by what she termed the "ceremonies of our present,"[9] Arbus, whose mentor was Model and whose model was Weegee *(pl. no. 624)*, approached such outcasts without moral prejudgment. Whatever her subject, she usually favored direct, head-on poses that often mimic the style of the family snapshot, as in *Mother Holding Her Child, N.J. (pl. no. 674)*—arguably one of the most alienated images of motherhood in the history of visual art.

The "snapshot aesthetic" was a signal influence on straight camera images during the 1960s. The appetite

673. WILLIAM KLEIN.
Garment Center, 1954.
Gelatin silver print.
Courtesy and
© William Klein.

674. DIANE ARBUS. *Mother Holding
Her Child, N.J.*, 1967. Gelatin silver print.
Courtesy and © 1967 Estate of Diane Arbus.

675. GARRY WINOGRAND. *Untitled*, c. 1964. Gelatin silver print. Courtesy Fraenkel Gallery, San Francisco, and the Garry Winogrand Estate.

for naive camera imagery accorded with the era's taste for vernacular and pop culture—a taste also reflected in the themes and techniques of graphic art. Like their Pop art colleagues painting soup cans, road signs, and comic-book characters, photographers were attracted by the omnipresent emblems of contemporary culture—automobiles, billboards, graffiti, and storefronts. They recorded these artifacts, as well as people and situations, in a casual style that seemed to paraphrase the lack of artifice and the neutral emotional tone of most snapshots. In 1966 the photographer-educator Nathan Lyons coined the phrase "social landscape"[10] to characterize this type of documentation, which he and others felt avoided the sentimentality they perceived in the older documentary style. The "social landscape" approach appealed especially to photographers whose view of reality tended to be disjunctive and who no longer canonized the previsualized, beautifully printed, large-format camera image.

The desire to make pictures that affirmed the camera's potential for neutral observation emerged as a significant impulse, nurtured from the late 1960s through

1991 by John Szarkowski, longtime director of the Department of Photography at the Museum of Modern Art in New York. In theory, the avoidance of overt psychological or ideological interpretation in a photograph allows the viewer to read the work without the interference of the photographer's political or social biases. This mode of working is exemplified by Garry Winogrand, whose images, according to Szarkowski, are statements about "the uniquely prejudicial (intrinsic) qualities of photographic description"[11] and not about their ostensible subjects. Winogrand's photograph of a young woman *(pl. no. 675)* is arresting in the way it integrates and structures the reflections and geometric elements, relating the principal figure to the manikin and to the city background, but it is an ambiguous statement that allows the viewer to interpret its meaning freely.

Lee Friedlander made views of city streets that are similarly equivocal *(pl. no. 676)* but nevertheless suggestive of an uneasy urban tension. Along with the uninflected portrayals of ordinary people by Tod Papageorge and Larry Fink and the street views by Joel Meyerowitz—to cite but

676. LEE FRIEDLANDER.
Cincinnati, Ohio, 1963. Gelatin
silver print. Courtesy and
© Lee Friedlander.

three more of the numerous photographers who were ini-
tially attracted to this uninflected style—such works per-
mit viewers to decide for themselves whether a particular
image is derisive or amusing, is an example of the formal
problems of picture-making, or, like the vast majority of
photographs, is just momentarily eye-catching.

This vernacular mode had an unexpected side effect: it
prepared the way for the acceptance of humor in seriously
conceived images. In the United States, Pictorialists and
modernists alike had been fairly earnest about photogra-
phy; witty or humorous images were relegated to advertis-
ing or popular entertainment or family snapshots. Within
the diversity of photographic expression that emerged in
the 1960s, humor came to be seen as a legitimate element.
Elliott Erwitt *(pl. no. 677)* and Burk Uzzle, for example,
are both successful photojournalists who regard people,

animals, and artifacts with disarming wit. Although this vein still has not been extensively mined in the United States, other photographers, among them Geoffrey Winningham and Bill Owens, gently satirize obviously comical anomalies in contemporary culture. The selling strategies of advertising, the pomposities of high art, and the excesses of performance art inspire William Wegman's antic dog images *(pl. no. 678)*.

Evolving out of the concept of "social landscape," images that present the artifacts and landscapes of contemporary industrial culture without emotional shading were given the name "New Topographics."[12] Robert Adams, Lewis Baltz, Frank Gohlke, Roger Mertin, Bill Owens, and Stephen Shore, among others, photographed tract housing, factory buildings, western land developments, and urban streets, recording despoiled landscapes seemingly without personal comment. Adams may have shared with Ansel Adams (no relation) a concern for the beauty of the land from the Missouri River westward, but for his photographs he selects vantage points and effects of light that show how its grandeur was diminished by roads, lumber camps, and housing developments. Owens's portrayal of suburban life depends for effect not only on the image but on the comments of the subjects that he appended to them.

South Wall, Mazda Motors (pl. no. 679), one of a 1974 series on industrial parks by Baltz, is meant to provide "sterile" information, with "no emotional content," according

677. ELLIOTT ERWITT. *Alabama, U.S.A.*, 1974. Gelatin silver print. © Elliott Erwitt/Magnum.

678. WILLIAM WEGMAN. *Man Ray with Sculpture*, 1978. Gelatin silver print with ink applied. Museum Ludwig, Cologne, Germany. Courtesy Holly Solomon Gallery, New York. © William Wegman.

to the photographer.[13] Nevertheless, all photographers make decisions concerning the selection of a motif, the management of light, and the organization of form. The fact that "topographical" images usually are highly structured suggests that their uneventfulness and lack of emotionality are in themselves emblems of a style and are no more factual as records of what actually exists than images that reflect more socially oriented points of view. One consequence of the supposedly neutral approach is that such images may serve multiple purposes—aesthetic, informational, propagandistic.

The deadpan quality of "topographical" views—whether Baltz's factories or Gohlke's grain elevators—often makes them indistinguishable from images commissioned to illustrate corporate reports, but photographers with strong feelings about the desecration of the landscape have sought to make more pointed statements. One solution was "rephotography" projects: groups of photographers working in California and Colorado during the 1980s selected the same vantage points recorded by Timothy O'Sullivan and William Henry Jackson during the exploratory expeditions of the 19th century; the purpose was to produce a comparison to the terrain's appearance then and now. (Similarly, a French group, taking inspiration from the 19th-century project by the Missions héliographiques, photographed the pernicious effects of industrialization on their country's landscape.) More recently, individual photographers have explored a variety of formats in their work dealing with industrial pollution. Robert Glenn Ketchum, Richard Misrach, Barbara Norfleet, and others used color film to contrast the subtle beauties of nature with the despoliation caused by ill-conceived engineering projects *(pl. no. 786)* or with garish consumer refuse *(pl. no. 787)*. At a further remove from traditional documentary mode, John Pfahl added some object—a ribbon, a stake—to make the point that the human presence always alters the natural landscape. As environmental concerns such as pollution, climate change, and threats to biodiversity have intensified over the decades, a new generation of photographers—both documentarians and artists—is engaged in bringing these issues to the fore *(see Chapter 13)*.

Other landscape photographers argued for a less damning view of the relationship between land and people. Works by Linda Connor and Marilyn Bridges reveal ancient markings on rocks and earth made by people who seem to have lived in greater harmony with nature. Working throughout the world, Bridges made a large body of photographs from the air, often with a view to preserving archaeological records she feared were in danger of disappearing because of turmoil and war in the Middle East *(pl. no. 681)*. With her portrayals of the domesticated New England landscape of field, garden, and woods, Lois Conner, in her photographs of nature and culture in Asia *(pl. no. 680)*, treats the built and the natural worlds as forming a unity rather than as antagonistic to each other.

680. LOIS CONNER. *Halong Bay*, 1993. Platinum print. Laurence Miller Gallery, New York.

681. MARILYN BRIDGES. *Miletos Theater and Bysentine Fort, Turkey*, 2004. Gelatin silver print. Courtesy and © Marilyn Bridges.

682. LYNN DAVIS. *Statue V*, 1989. Selenium-toned gelatin silver. Houk Friedman Gallery, New York.

Photographers have also revitalized themes that were prominent in 19th-century documentation, emphasizing, as in images of ancient Egyptian tomb sculpture by Lynn Davis *(pl. no. 682)*, the aesthetic qualities of structures and monuments that have essentially become an integral part of the landscape. Respect for the artful historical documentation of artifacts—revealing the object in its most attractive light—can be seen in Linda Butler's photographs of Shaker buildings and interiors, of Japanese handcrafts, and of Italian artifacts, as well as in Richard Pare's images of classical statuary. Like their antecedents, such works explore stillness and movement, languor and vigor, and the play of light on forms.

Following World War II, photographers with a broadly humanist outlook—among them Roy DeCarava, Louis Faurer, Leon Levenstein, Helen Levitt, Jerome Liebling, Gordon Parks *(pl. no. 692)*, Walter Rosenblum *(pl. no. 465)*, and Max Yavno—continued to work on a variety of self-motivated projects whose central subject was people. Levitt's lyrical views of youngsters *(pl. no. 683)*, begun in the 1940s in black and white and continued intermittently through the 1970s in color, illuminate the toughness, grace, and humor of New York's inner-city neighborhoods. DeCarava's *Pepsi, New York (pl. no. 684)* may incorporate some components of the vernacular style—consumer products, billboards, ads—but the highly structured handling of light and architecture elements focuses attention on the physical and psychological exhaustion of the central figure, leaving no doubt as to where the photographer's sympathies lie.

683. HELEN LEVITT. *New York*, c. 1945. Gelatin silver print. Collection Judith Mamiye, Oakhurst, N.J. © 1981 Helen Levitt.

Liebling's grasp of abstract form is apparent in the repeated arclike shapes formed by head, shoulders, and plate in *Blind Home, St. Paul, Minnesota (pl. no. 685)*, but these elements also generate a sense of the circumscribed world of the sightless. A cooler romantic sensibility can be felt in the work of George A. Tice, whose careful control of tonality and pictorial structure imbues with a sense of wistfulness the customs and physical surroundings of the Amish in Pennsylvania and of ordinary folk in the small towns of New Jersey *(pl. no. 686)*.

In the 1960s, despite the inroads of film and television documentaries, the still image again came to be seen as a significant element in socially useful programs. Many factors were responsible for the revival of interest in the traditional forms of social documentation. One was the emergence of funding sources both in and out of government. Support from the national and state arts endowments; from private granting bodies such as the John Simon Guggenheim Memorial Foundation (which since 1937 has funded a range of photographic projects);

684. Roy DeCarava. *Pepsi, New York*, 1964. Gelatin silver print. Courtesy and © 1981 Roy DeCarava.

685. JEROME LIEBLING. *Blind Home, St. Paul, Minnesota*, 1963. Gelatin silver print. Courtesy and © Jerome Liebling.

686. GEORGE A. TICE. *Joe's Barbershop, Paterson, N.J.*, 1970. Gelatin silver print. Courtesy and © George A. Tice.

687. BRUCE DAVIDSON. *Untitled, East 100th Street*, 1966. Gelatin silver print. © Bruce Davidson/Magnum.

and from banks, economic assistance programs, and labor unions made possible individual and group camera documentation of decaying and regenerated neighborhoods, rural communities, nuclear and other power installations, and the working conditions of industrial and farm laborers. A multiplicity of projects made use of images in conjunction with words in slide talks, exhibitions, and publications.

Another factor in the upsurge of social documentation was the involvement of photojournalists in increasingly volatile sociopolitical situations in America, Africa, and Europe. Bob Adelman, Bruce Davidson, Leonard Freed, Danny Lyon, Moneta Sleet, and Ernest Withers were among the many photojournalists who covered the civil rights struggles of the 1960s for the press and continued afterward to confront social issues on their own, developing their themes with greater depth than was possible when working on deadline. When Davidson undertook subsequent photographic projects in East Harlem *(pl. no. 687)*,

on the New York subways, and in Central Park, he moved from the somewhat equivocal tone of his very early work toward a more traditional humanism, claiming that the evidence of fear, affection, and hopelessness he captured in these images helped him "to discover who the person was who took the picture."[14]

In the wake of his experiences with the civil rights movement in the South, Lyon, whose initial work included an evocative picture essay on Hell's Angels bikers, depicted life in Texas state prisons. *Conversations with the Dead*, the book that resulted from this project, vividly communicates the photographer's sense of the "unmitigated sorrow"[15] permeating this form of social estrangement *(pl. no. 688)*. The desire to illuminate the psychological consequences of inhumane circumstances has inspired many photographers to depict not only, or even primarily, the squalor of certain environments but also the moments that sum up the effect of life's experiences on the individual. In one such example, Mary Ellen Mark *(see Profile)* was entranced with

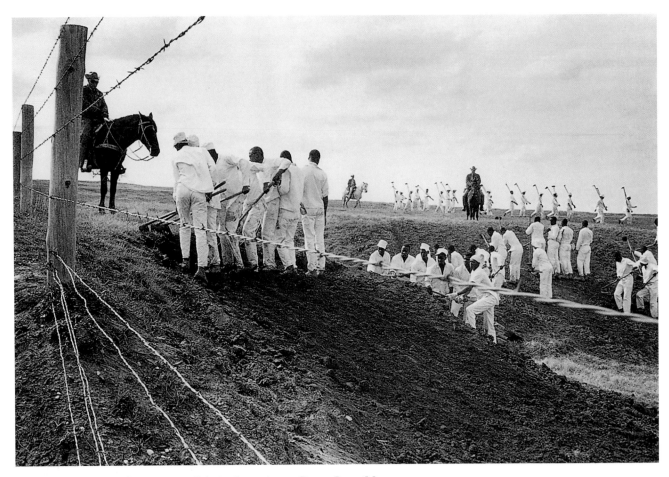

688. Danny Lyon. *The Line*, 1968. Gelatin silver print. © Danny Lyon/Magnum.

the life force of her subject, a girl on the streets of Seattle *(pl. no. 689)*; in another, Eugene Richards, who has photographed in slums, hospitals, and prisons in the United States and Mexico, evokes the indignity of those regarded as predators or victims *(pl. no. 690)*.

The documentation of life in African American communities, the emergence of a number of black professional photographers, and the flowering among African Americans of photography as personal expression also owe something to the social climate of the late 1960s. Roland L. Freeman, for example, began to use a camera while working for the Poor People's Campaign in Washington, D.C., and went on to produce a touching visual document of the Baltimore neighborhood of his youth *(pl. no. 691)*. In 1973 the first *Black Photographers Annual* appeared; in this and subsequent volumes, African American photographers found a forum for a wide range of work. Alongside Gordon Parks *(pl. no. 692)*—who, as a fixture in the pantheon of *Life* photographers, was among the most celebrated—African American photojournalists emerging at this time included Anthony Barboza, Chester Higgins, Jeanne Moutoussamy-Ashe, Marilyn Nance *(pl. no. 693)*, Beuford Smith, Eli Reed, and Dixie Vereen. More recently,

a number of female African American photographers—among them LaToya Ruby Frazier and Deana Lawson *(see pl. no. 830)*—have turned to directorial modes in dealing with issues related to the struggles, comforts, and other experiences in the lives of black people.

While gifted photographers of any race or creed will bring a penetrative eye to depicting a community even if they are outside it, members of that community possess insights and sensitivities that can give them deep access—both practical and emotional—to their subjects. Native and Latin Americans and other minorities in the United States have, often justifiably, regarded their portrayal by others as insensitive or distorted. Postmodern strategies such as the addition of texts to images appeal to a number of photographers from these groups, among them George Longfish (Tuscarora/Seneca), Pamela Shields (Kainai), and Hulleah Tsinhnahjinnie (Taskigi/Diné), who have turned to collage to tell complex stories about Native American life. Straight documentation by Native Americans has gained in vitality since the 1970s, offering Greg Staats (Mohawk Nation), Josué Rivas (Mexica/Otomi; *see pl. no. 834*), and Lee Marmon and Maggie Steber (of Laguna and Cherokee ancestry, respectively) the means to

689. MARY ELLEN MARK. *"Tiny" in Her Halloween Costume, Seattle*, 1983. Gelatin silver
print. Mary Ellen Mark Library, New York.

690. EUGENE RICHARDS. *Young men outside a dormitory in the Neuro-Psychiatric Hospital, Asuncion, Paraguay*, 1999. Gelatin silver print. Courtesy and © Eugene Richards/ VII Photo Agency.

explore what they regard as their own personal and social identities. Their images provide a sympathetic view of ceremonies, rituals, and modes of living with which few outsiders are familiar.

Photographers commissioned by labor unions and government agencies during the 1960s and '70s continued the tradition of social documentation, producing images intended to expose conditions that needed changing. In the manner of Jacob Riis, Dorothea Lange, and Lewis Hine, photographers such as Earl Dotter and Michael Rougier sought to do more than just record working and living environments; they wanted to make viewers aware of the effects of degrading conditions on the individual.

The gradual decline of sponsorship by labor and arts agencies, and the reduction in the number of magazines commissioning picture stories (a number that has fallen dramatically further since the advent of the Internet), forced photographers interested in social issues to seek other means of supporting their work. For some time before the digital revolution, images by Ken Light, illuminating the struggle of Mexican immigrants to find jobs in the United States; by Deborah Fleming Caffery of sugarcane workers in Louisiana; and by Eugene Richards and Stephen Shames of the effects of poverty throughout the country reached the public primarily in books and on gallery walls. Nevertheless, commissions for images with a social message did not entirely disappear. Susan Meiselas, working in Nicaragua *(pl. no. 794)* and El Salvador in the 1970s and '80s; Donna Ferrato, shedding light on domestic violence in the United States *(pl. no. 694)*; Maggie Steber and Alex Webb, each photographing the disturbances in Haiti in the early to mid-1990s, were all commissioned by magazines and saw their work exhibited and published

691. ROLAND L. FREEMAN. *Arabber's Helper*, 1969. Gelatin silver print. © Roland L. Freeman/ Magnum.

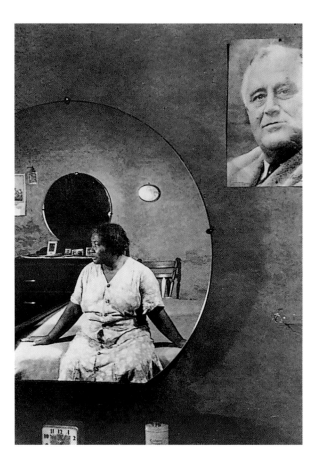

692. GORDON PARKS.
Housewife, Washington, D.C.,
1942. Gelatin silver print.
G. Ray Hawkins Gallery,
Santa Monica, Cal.

693. MARILYN NANCE.
*First Annual Community
Baptism for the Afrikan Family,
New York City*, 1986. Gelatin
silver print. Marie Brown
Associates, New York.

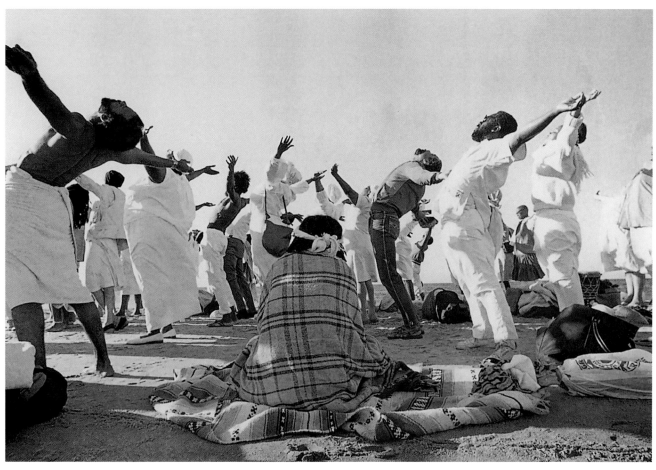

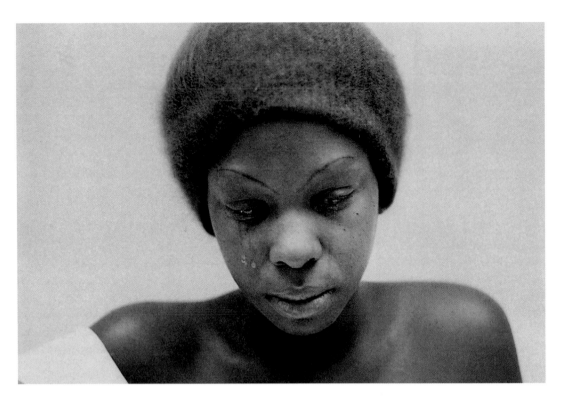

694. DONNA FERRATO. *Jackie in the Hospital, Crying*, 1984. Gelatin silver print. Domestic Abuse Awareness Project, New York.

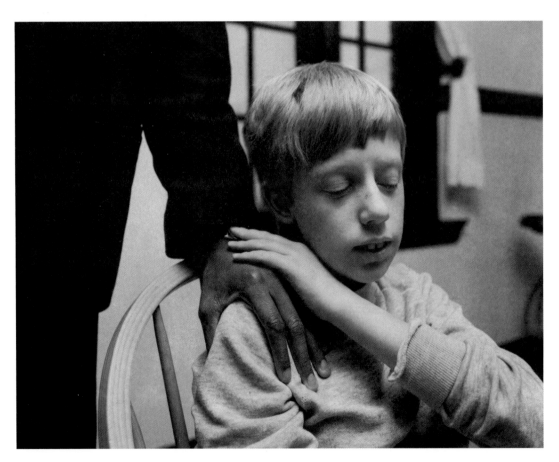

695. NICHOLAS NIXON. *Joel Geiger—Perkins School for the Blind*, 1992. Gelatin silver print. Zabriskie Gallery, New York.

696. SALLY MANN. *Jessie at 9*, 1991. Gelatin silver print. Houk Friedman Gallery, New York.

697. LARRY CLARK. *Untitled*, 1971. Gelatin silver print. Courtesy Larry Clark.

in books. More recently, James Nachtwey, known for his moving coverage in conflict zones around the world, undertook a major magazine commission to document the opioid crisis in the United States. In the 1980s and '90s, photographers with social agendas faced not only a shrinking number of outlets for their images but also shorter assignment periods, which made photographing complex social and political situations difficult. In addition, they confronted loss of control over their images, brought about by the digitization of photography and editing. At the same time, such images could now reach much wider audiences when they began to appear on websites devoted to social issues *(see Chapters 12 and 13)*.

Photographers working on their own socially motivated projects during the 1980s and '90s faced other challenges. One was the observation on the part of some critics that photographing the poor (other than by someone within the community) was a form of exploitation; another was that street photography in inner-city areas had become more dangerous. A few individuals continued their forays into difficult neighborhoods—among them Thomas Frederick Arndt, Eugene Richards, and Joseph

Rodríguez—but many wishing to address the human condition essayed other subjects. Their projects might be socially oriented, such as Nicholas Nixon's work among the visually impaired *(pl. no. 695)*, or personally directed, as in Nan Goldin's investigation into the illusions and actualities of relationships with her *Ballad of Sexual Dependency* *(pl. no. 698)*.

The 1970s saw the emergence of a newly tolerant attitude toward drugs and sex among young people in the United States. One example of this new freedom to document explicit behavior can be seen in the 1971 book *Tulsa* *(pl. no. 697)* by Larry Clark (who went on to direct motion pictures depicting similarly rebellious activities). These images convey the unsettling self-destructiveness of young people who, finding no niche for themselves in bourgeois society, have become part of the drug culture. Clark's work obtained something close to cult status and offered permission to subsequent photographers to investigate areas previously considered off-limits. Goldin was among these in the 1990s, as were contemporaries such as JH Engström, Peter Hujar, Dash Snow, Wolfgang Tillmans, and David Wojnarowicz.

698. NAN GOLDIN. *Cookie at Tin Pan Alley, New York City*, 1983. Courtesy and © Nan Goldin.

The relaxation of restrictive notions as to what kind of sexual imagery might constitute serious photographic expression, rather than simply pornography, coincided with the emergence in the 1970s of the feminist and gay rights movements, which sought to raise consciousness about gender roles in society and specifically about the depiction of women and homosexuals. Many of the photographers addressing these issues found straight photography too confining *(see Chapter 12)*, but a number did employ this mode to picture their own lives and genders. Anne Noggle depicted herself after cosmetic surgery and as she aged; Judy Dater photographed her own body in the nude as well as making portraits of other women as they wished to be presented; and Robert Mapplethorpe portrayed aspects of homoerotic experience. Paradoxically, the explicit sexuality in some of this imagery, along with the greater publicity given to all types of sexual behavior in the media, triggered a backlash, with legal actions being initiated even against parents who portray their own children in the nude. One notable subject of controversy is the work of Sally Mann, whose long-term photographic study of the cloistered lives of her three children has stirred up much discussion *(pl. no. 696)*.

Straight Photography in Canada and Latin America

Like their counterparts below the border, many Canadian photographers have turned away from perceiving camera images as basically descriptive or informative. They became engaged by the cooler, more ironic approach initiated by Frank and the social landscapists of the 1960s. Sharing this sensibility, Lynne Cohen *(pl. no. 699)*, Charles Gagnon, and Gabor Szilasi *(pl. no. 700)* are among those who have transformed uningratiating interiors and urban environments into deliberately structured visual entities, at times infused with biting humor. Along with increased activity among Canadian photographers, interest in the history of the medium spurred James Borcoman of the National Gallery of Canada in Ottawa to organize a national collection of photography in 1967 (since 2015 under the auspices of the Canadian Photography Institute); other museums, such as the Canadian Centre for Architecture in Montreal, have acquired specialized collections, and still others, archives of local work.

For many Latin American photographers, the year 1977 signaled the end (in the words of their cultural forebear

699. LYNNE COHEN. *Corridor*, n.d. Gelatin silver print. Courtesy Motel Fine Arts, New York.

700. GABOR SZILASI. *St. Joseph de Beauce, Quebec*, 1973. Gelatin silver print. Courtesy and © Gabor Szilasi.

701. SANDRA ELETA. *Lovers from Portobelo*, 1977. Gelatin silver print. Courtesy and © Sandra Eleta.

Diego Rivera) of "the utter obstinacy which persisted in denying photography its quality as art."[16] A hemisphere-wide conference held that year in Mexico City revealed the vigor and diversity of camera expression throughout the region. During the 1970s and '80s, numerous photographers in both Central and South America were interested in exploring the effects of rapid social and economic change on the traditions of their societies. Although most were initially less involved with aesthetic experimentation for its own sake or with the picturing of private realities, recent work suggests that these concepts have now found fertile ground.

A range of attitudes characterized Latin American portrayals of urban and provincial life, which for the most part were seen by the public in books and periodicals rather than on gallery walls. The strength of the humanist tradition is exemplified by Panamanian photographer Sandra Eleta, whose spirited images of working people in Portobelo *(pl. no. 701)* are infused with grace and transcend the moment to convey the vibrancy of intimate relationships. A similar intensity transformed studies of the Yanomani

and Xingu tribesmen by the Brazilian photographers Claudia Andujar and Maureen Bisilliat from routine anthropological documentation to inspired interpretation. Brazilian-born Sebastião Salgado has gained international recognition for his ongoing revelatory images of work and workers throughout the world. By the late 1980s, photography in Brazil had expanded to include images made by Mario Cravo Neto, Miguel Rio Branco *(pl. no. 795)*, and Ana Regina Nogueira. Those involved with the medium reached out beyond the country's borders, initiating international conferences, opening a museum for photography in São Paulo, and launching publication programs.

One direction in social documentation that found adherents throughout Latin America can be seen in work by the Argentine photographers Alicia D'Amico and Sara Facio, who together founded the publishing house La Azotea. Grete Stern, after her initial career in Weimar Germany (as part of Ringl + Pit, with collaborator Ellen Auerbach), moved to Argentina and became a noted portraitist. Although the predominant interest throughout much of Latin America was centered on the human condi-

702. JOSÉ GIMENO CASALS.
Puruchuco, 1979–80. Gelatin silver
print. Courtesy and
© José Gimeno Casals.

703. PEDRO MEYER. *The Unmasking in the Square*, 1981. Gelatin silver print. Courtesy and © Pedro Meyer.

tion, notable landscapes, still lifes, and architectural views have also been made, by Christian Alckmin Mascaro of Brazil and José Gimeno Casals of Peru *(pl. no. 702)*.

An opposing approach to social documentation, which inspired the work of a small number of photographers—notably Paolo Gasparini in Venezuela—was intended to illuminate the social and economic consequences of the intrusion of foreign capital and culture into Latin American life by appending unequivocal texts to images. One might have expected that this didactic view of social documentation would be espoused by the first generation of photographers working in Cuba after the revolution of 1959. Instead, they were influenced by the diverse directions being pursued in the United States. The buoyant humor in the work of the Cuban photographers Raúl Corrales, Maria Eugenia Haya, and Mario García Joya —working mainly in the 1970s and '80s—was unusual in Latin American photography, which is generally more

earnest in dealing with reality. With its use of serial imagery, texts, set-ups, colorization, and montages, later work by Cubans, among them José A. Figueroa and Raúl Cañibano, demonstrated even greater familiarity with current trends in the United States—despite the difficulties in obtaining materials for color processing. Cuba also has provided subject matter for numerous American photographers, prominent among them David Alan Harvey. Of course, 21st-century political upheavals in both Cuba and Venezuela have made these countries far less approachable for foreign photographers.

During the 1920s and '30s, Mexico attracted such influential foreign photographers as Tina Modotti, Paul Strand, and Edward Weston. Governmental support of the arts enabled Mexican photographers to respond to the need for social documentation even as they personalized the medium. The nation's most highly regarded native-born photographer, Manuel Alvarez Bravo, found it possible to

704. GRACIELA ITURBIDE. *Nuestra Señora de las Iguanas (Our Lady of the Iguanas), Juchitán, Oaxaca*, 1979. Gelatin silver print. Courtesy Graciela Iturbide.

705. JOSÉ ANGEL RODRIGUEZ. *Campesina (Peasant)*, 1977. Gelatin silver print. Collection Jain and George W. Kelly, New York © José Angel Rodriguez.

embrace the mythic implications of his own culture while acknowledging modes, such as Surrealism, imported from Europe and the United States *(pl. no. 501)*. A similar focus on indigenous culture—emphasizing both popular rituals and artistic and intellectual activities—characterized the work of Alvarez Bravo's first wife, Lola Alvarez Bravo, whose portraits of distinguished individuals have only recently been acknowledged for their artistic and documentary value.

Images by Pedro Meyer, born in Spain but active in Mexico after 1962 and in the United States in the 1990s, suggest the mysterious nature of ritual, through harsh tonal contrasts, ambiguous gestures, and the intensity of facial expressions, as in *The Unmasking in the Square (pl. no. 703)*. In recent years, Meyer has become more concerned with personal autobiography while embracing computerized methods of production. With the establishment of his website ZoneZero in 1995, he became an early exponent of the Internet as a means of disseminating information and images. Other contemporary Mexican photographers who were engaged by folk culture and ritual include Flor Garduño, Graciela Iturbide *(pl. no. 704)*, Pablo Ortíz Monasterio, José Angel Rodriguez *(pl. no. 705)*, and Mariana Yampolsky.

Straight Photography in Europe

World War II upended cultural life in Europe but did not entirely wipe out photographic activity there. August Sander, for example, was prevented from continuing his documentation of German society *(pl. no. 447)* but made luminous landscapes of his native region. In Czechoslovakia, Josef Sudek, whose photographic ideas had been nurtured by both Pictorialism and the New Objectivity, continued to produce lyrical tabletop still lifes *(pl. no. 706)* as well as neo-Romantic garden scenes. And of course many European photographers were consumed with the perilous project of documenting the traumatic theater of war itself; among the many were Magnum founders Robert Capa, Henri Cartier-Bresson, and George Rodger.

By the mid-1960s, Europeans had recovered sufficiently from the dislocations of the war to welcome a range of fresh ideas about photography. The numerous directions being explored in America soon attracted photographers who were initially tempted to varying degrees by abstraction, conceptualism, and symbolism. Perhaps the most telling influence was Robert Frank's ironic approach to documentation, or to "subjective realism," as the German photographer Otto Steinert called "humanized and individualized photography."[17] Even though critical acclaim and financial support for the photograph as an art commodity was still insignificant in Europe compared

with the United States, and even though photographers could find employment primarily only as photojournalists, a variety of modes began to flourish as new equipment and materials, including Polaroid and color film at first, and electronic cameras and digitization later, became available and less expensive.

Along with embracing photojournalistic ways of depicting actuality, by the late 1970s some younger Europeans looked to the subjective and conceptual approaches popular in the United States. Others became aware of the experimentalism practiced by a previous generation of European photographers and elected to work with collage, montage, and sequencing. Like their American counterparts, they created narratives using sequenced photographs and took part in performances that they documented and exhibited. These productions sometimes obscured the distinctions between what was found in nature and what was enacted, between straight depiction and hand manipulation of print processes, between what was recorded through the effects of light and what was added by the application of pigments. Combining drama, photography, and graphic art, they sought to infuse photographic expression with greater complexity than they thought was possible in straight images *(see Chapter 12)*.

As photographs became more frequently exhibited, collected, and reproduced in Europe, the quickening of interest in contemporary output prompted the establishment of workshops, conferences, and foundations for the support of the medium. Even though the high-quality photographic print as such remained less esteemed in Europe than in the United States, photography theory attracted philosophers such as Roland Barthes, giving the medium an intellectual cachet that was formerly lacking.

These developments were accompanied by increased concern for the rich treasuries of historical images housed in national and private archives and by a consequent attentiveness to historical scholarship and preservation. Leading European figures who supervised the creation of archives in their countries were Ute Eskildsen and Otto Steinert, who assembled a distinguished collection of German photographs at the Museum Folkwang in Essen; Fritz Kempe, director of the Staatliche Landesbildstelle in Hamburg; the Italians Claudio de Polo Saibanti, who founded a national museum of photography from the Alinari collection in Florence, and Enrica Viganò, who has helped bring attention to overlooked photojournalists; Samuel Morozov in the former Soviet Union; Jean-Claude Lemagny in France; Terence Pepper in England; and Vladimír Birgus in the Czech lands. As collections grew, they engendered investigations into the history of the medium, resulting in serious publications in Czechoslovakia, England, France, Germany, Greece, Hungary,

706. JOSEF SUDEK.
Window in the Rain,
1944. Gelatin silver print.
Collection Jaroslav Andel,
New York.

Italy, and Spain. To give but one example, the Swedish photographer and filmmaker Rune Hassner encouraged interest in the history of American and European photojournalism and social documentation through his extensive curatorial, research, and publishing activities.

Among British photographers the documentary tendency remained strong. Curiously, the focus on informational content in England had been reinforced by Moholy-Nagy; during a brief sojourn in London in 1936 this catalyst of experimentalism in Germany and the United States had promoted the camera image as a way to observe "a fragment of present-day reality from a social and economic point of view."[18] Traditional documentation was carried on and modified after the war by the photojournalists Philip Jones Griffiths, Bert Hardy, Thurston Hopkins, Don McCullin, Grace Robertson, and George Rodger,

among others. It was transformed in the 1960s by Roger Mayne, who sought to give documentation a somewhat more consciously aesthetic and equivocal aspect, and by Tony Ray-Jones, whose work displayed an ironic but charitable humor. His *Glyndebourne (pl. no. 707)* is a witty view of upper-class pleasures that suggests Bill Brandt's themes, Robert Doisneau's whimsicality, and Frank's irony.

Brandt, perhaps Britain's best-known photographer of the postwar years, was a unique phenomenon. He had been involved with Surrealism through his association with Man Ray in the 1920s and with the documentation of contrasts among the classes in the 1930s, which he collected in his first publication, *The English at Home* (1936). Brandt's portraits, landscapes, and nude studies made after the war encompass a variety of different approaches. In the search for what he termed "something beyond

707. Tony Ray-Jones. *Glyndebourne*, 1967. Gelatin silver print. Courtesy and © Anna Ray-Jones, New York.

708. Bill Brandt. *Nude, East Sussex Coast*, 1953. Gelatin silver print. © Bill Brandt/Photo Researchers.

709. MARIO GIACOMELLI. *Landscape #289*, 1958. Gelatin silver print. Bristol Workshops in Photography, Bristol, R.I. © Mario Giacomelli.

real,"[19] he found that optic distortions *(pl. no. 708)* — the result of using an extremely wide-angle lens and a very small aperture—produced a curious yet poetic landscape in which human form and nature merged. Brandt's emphasis was on capturing inner realities through the imaginative use of light. Though more attuned to the sociological changes occurring in Britain during the 1970s and '80s, Chris Killip's documentations of working-class life also reflect his understanding that photographs can be considered aesthetic objects as well as records of actuality. A humorous approach to consumption and leisure-time activities can be seen in Martin Parr's ongoing investigation into middle-class existence and indulgences in England and elsewhere.

The revitalization of photography in France after the war was evident in several developments. One was the establishment of a movement to encourage artistic photography. In the South of France, members of the Expression libre (Free Expression) group, founded in 1964, sought to enhance the status of photography by urging, among other measures, that it be introduced into university curricula. Acknowledgment of photography's visual significance spurred the opening in 1982 of the Ecole Nationale de Photographie in Arles, the establishment of galleries devoted to the medium in Paris and Toulouse, and the initiation of annual and biennial photographic festivals in Arles, Perpignan, and Paris. With the support of the government, the Maison Européenne de la Photographie was founded in Paris in 1996 and to date houses more than 21,000 prints.

In their own productions, the photographers initially active in this resurgence—Denis Brihat *(pl. no. 766)*, Jean Dieuzaide *(pl. no. 767)*, and Lucien Clergue *(pl. no. 768)* among them—intervened in the photographic process by directing the model, establishing the settings, or manipulating negative and print. The straight work of

710. LUIGI GHIRRI. *Versailles*, 1985. Vintage c-print. Courtesy Matthew Marks Gallery. © The Estate of Luigi Ghirri.

Bernard Plossu followed the direction known as "subjective realism"; the themes appear to be social in nature, but the photographer was concerned mainly with expressing what a colleague called "a personal vibration . . . an autobiographical sign."[20] An approach to nature that combines lyricism and cynicism in a disquieting manner can be seen in the landscapes of former battlefields by Jeanloup Sieff. The work of Raymond Depardon, photojournalist founder of the agency Gamma, who has covered wars and turmoil in Africa *(pl. no. 712)*, Asia, and South America, demonstrates a sensitivity to the human consequences of such events.

In Italy during the 1960s, and in Spain and Portugal somewhat later, photographers emerged from what has been called a "peripheral ghetto"[21]—the result of more than 20 years of cultural isolation and widespread indifference to the camera as an expressive tool. For example, no retrospective of Portuguese photography was held until

1991, with the result that work made in the earlier years of the 20th century was virtually unknown both in that country and to the rest of the world. With increased tourism from the United States and Latin America, with the advent of the Internet facilitating the exchange of ideas, and with greater opportunities in their own countries for exhibition and publication, photographers have increasingly embraced a full array of contemporary modes.

The Italian photographs that seem to have achieved the greatest formal resolution in terms of conventional straight photography are landscapes. The beauty of the land, made even more poignant by encroaching industrialization, inspired Luigi Ghirri *(pl. no. 710)*, whose elegant images combining feeling and aesthetic rigor served as a guidepost for Gianni Berengo Gardin, Franco Fontana, and Mario Giacomelli—all of whom also had careers as photojournalists—to produce views of nature that are romantic in tenor and transcendent in effect. Exemplified

by an early depiction by Giacomelli of the harvest in the Marches region *(pl. no. 709)*, these images sustain interest partly because they mediate so compellingly between the world as it is and as it is photographed.

In the years following World War II, Italian street photography achieved new levels of vitality. Both individual photographers and the press turned their attention to the ways ordinary Italians went about reconstructing their lives. The Neorealists, as this group was called, included Mario De Biasi, Nino Migliori, and Fulvio Roiter, whose images celebrated their country's release from the structures of fascism at the same time that they revealed the hardships of peasant life. Sicilian photographer Letizia Battaglia, best known for her intrepid coverage of Mafia hoodlums and activities, has also brought light to the colorful street life of southern Italy.

In another approach to documentation, Italian photographer and anthropologist Marialba Russo captured the stages of ritual observances in an objective manner that neither heightens nor dramatizes the visual experience. Indigenous rituals also engaged Spanish photog-

rapher Cristina García Rodero, who believed that her extensive "portrait" of such customs revealed "the mysterious, genuine, and magic soul of Spain" *(pl. no. 711)*.[22] As in Italy, photography in Spain tended to be regionally focused and considered; for a long period, photographers gained little recognition beyond the borders of their own communities. Political and social changes, and the arrival of the Internet, have so altered the situation that since 1997 Madrid has been able to host a well-attended biennial photography fair. Other Iberian photography festivals take place regularly in the Portuguese cities of Braga and Porto.

Photojournalism Outside the United States

Photojournalism provided an outlet for the skills of numerous photographers from a variety of countries who contributed to the vitality of both European and American newspapers and picture magazines during the 1960s and '70s: photojournalists tend to be peripatetic internationalists who do not necessarily reside in their countries of origin. Even though by the 1970s photo essays often fell

711. Cristina García Rodero. *Pilgrimage from Lumbier, Spain*, 1980. Gelatin silver print. Gallery of Contemporary Photography, Santa Monica, Cal.

712. RAYMOND DEPARDON. *Angola (Luena, Street Scene)*, February 1994. Gelatin silver print. Magnum Photos, New York.

into a predictable stylistic pattern and, following dictates of popularity and editorial exigencies, were sometimes superficial in content, individual photographers were often able to transcend these limitations. Many photojournalists managed to produce in-depth documentation of social circumstances no matter where they came from or where they were assigned. Images by Sabine Weiss explore the delights of childhood play in Paris neighborhoods, for example, while those by Raymond Depardon bring insight to the terrain and the forms of daily life in Africa *(pl. no. 712)*.

Two outstanding examples of illuminating reporting are the careers of South Africa's Peter Magubane and Ernest Cole. Magubane's images of the struggles of black South Africans, among them a photograph of a gesture that seems to symbolize their sorrow and anger *(pl. no. 473)*, were no doubt intensified by the photographer's own imprisonment under apartheid. Cole, who left South Africa in 1966, produced the powerful book *House of Bondage* before his death at the age of 50. Both photographers inspired the work of Johannesburg-born photoreporter Themba Hadebe. Most of the photojournalists documenting black African life in the divided South Africa were white men, but in the years since apartheid's formal repeal, in 1991, the prevalence of digitization and the Internet as well as acceptance into the international photographic community have greatly expanded opportunities in the field for all South African photographers.

British-Nigerian photographer Akinbode Akinbiyi has brought a steady and perceptive eye to life in Africa's larger cities while maintaining a compassionate connection to his subjects. His work has in turn impacted that of younger Africans such as Aïda Muluneh, from Ethiopia, and Eric Gyamfi, from Ghana. Since its inception in 1994, the biennial Rencontres Africaines de la Photographie in Bamako, Mali, has attracted a broad international audience; while the festival features photographs from all over the world, it has helped to draw attention specifically to African work, including that of Malian photographers such as Mamadou Konaté and Racine Keïta. In recent years, Malian master photographers Malick Sidibé and Seydou Keïta *(pl. no. 713)* have been the subjects of well-deserved attention and scholarship.

During the 1970s, a number of European photojournalists joined collectives, such as Saftra in Sweden and Viva in France, in order to carry out progressive social documentation. Martine Franck, one of the founders of Viva, used a rigorous formal structure to document the effects of middle-class culture on the individual *(pl. no. 714)*. Gilles Peress, on the other hand, has documented strife in Ireland, France, the Balkans, and the Middle East—notably with his landmark 1984 book *Telex Iran*. His photoreportage is distinctively personal, using the forms of the picture to create a powerful sense of alienation and chaos *(pl. no. 715)*.

Many photojournalists have shaped their own projects, among them Depardon, Josef Koudelka, and Sebastião Salgado, all one-time members of Magnum. For his documentation of Roma life, Koudelka worked in his native Czech region, Romania, Spain, France, and the British

713. SEYDOU KEÏTA. *Untitled*, 1949. Gelatin silver print. Courtesy
Fonds Nationale d'Art Contemporain, Ministere de la Culture et de la
Communication, Paris, #95139.

714. MARTINE FRANCK. *Provence*, 1976. Gelatin silver print. © Martine Franck/Magnum.

715. GILLES PERESS. *N. Ireland: Loyalists vs. Nationalists*, 1986. Gelatin silver print. © Gilles Peress/Magnum.

Isles throughout much of the 1960s, probing the varied aspects of the nomadic existence—familial affection, pride in animals *(pl. no. 716)*, love of the dramatic gesture, isolation from the larger culture. Koudelka uses blurs, tipped horizons, and unusual angles effectively to evoke emotion in his photographs. He has also made panoramic images of the despoliation of land and waterways in Eastern Europe caused by industrial pollution, as well as a series of images on the wall separating Israel and Palestine. Salgado, whose magazine assignments have brought him face to face with desperately struggling populations in India, South America, and Africa *(pl. no. 482)*, has undertaken his own extensive and poignant documentation of the conditions of poor laborers throughout the world. At the start of the 21st century he created *Genesis*, a monumental photographic study of the natural environment and humanity's place in it.

In India, Raghubir Singh—an early exponent of color in photojournalism—endeavored to reveal both the inner and outer worlds of life in his homeland. Raghu Rai, a protégé of Henri Cartier-Bresson, has brought his discerning lens to the changing cultural landscape in India since the mid-1960s. Among the shining lights of the subsequent generation of straight photographers in the country is Dayanita Singh, whose 2001 project *Myself Mona Ahmed* took a pioneering look at a gender-fluid member of the "third sex" in New Delhi; Singh's empathetic documentary work is often disseminated in innovative multivolume book projects. Swapan Parekh (son of renowned photojournalist Kishor Parekh) has a sharp and rigorous eye for form that gives geometric elegance to his compositions. In his dramatically colorful work, Arko Datta draws attention to aspects of the political climate in India, Malaysia, and Indonesia through dreamlike images of urban moments. Sohrab Hura, from west Bengal and now based in New Delhi, has recently published a trilogy of books collectively titled *Sweet Life*; he has earned himself an associate Magnum membership with his vibrant, sometimes surreal documentary photographs.

It may go without saying that photojournalism can be a dangerous business, particularly in politically unstable parts of the world. Pakistani photographer Aziz Ullah Haidari, a Reuters correspondent, was one of three journalists captured and killed by the Taliban in 2001. His wife, Saadia Sehar Haidari, has picked up the mantle and now works as a photojournalist based in Islamabad. Saiyna Bashir, also in Islamabad, has made an in-depth study of the Pakistani transgender community; she contributes photographs to newspapers and magazines around the world. The digital revolution and the Internet have made outreach and new projects possible for photographers in this part of the world, as elsewhere. A quieter side of

Pakistan is seen in the social-media feeds of photographers Khaula Jamil (in particular her *Humans of Karachi* project) and Mobeen Ansari (who has made an in-depth study of religious minorities in the country), and in the Instagram platform *Everyday Pakistan*, run by journalist Anas Saleem.

Photojournalism was the predominant concern of photographers in the Soviet Union before its dissolution in 1989. With few exceptions, photography as a personal means of artistic expression or as a foil for texts with messages other than those required by the press or by Communist ideology received little official support or exposure. Nevertheless, many of the photographers who came of age during the 1960s and '70s embraced the same techniques used in both subjective and photojournalistic photography in the West. Among these was Boris Savelev, whose treatment of light gave his casual-seeming black-and-white and color images made on the streets of Moscow and Leningrad (before it was renamed St. Petersburg) an agreeable romantic dimension. Others employed the distortion of spatial perspective, or blurred part of the visual field, or incorporated lens reflections to convey a grittier view of life, or—in the case of Lithuanian photographer Aleksandras Macijauskas, for example—used a wide-angle lens to heighten the viewer's sense of the emotional drama. Since 1989 photography in other parts of the former USSR has begun to evolve beyond what some refer to as "postcard" images—that is, picture-perfect depictions of workers, peasants, and monuments. As is true everywhere, Russian photographic practice has broadened as the Internet has introduced photographic images from around the world, as galleries have opened, and as Moscow has hosted a photographic fair.

The violence that has shaken Ukraine since late 2013, beginning with protests in Kiev and escalating to bloody warfare, has been captured compellingly by photojournalists both Ukrainian, among them Evgeny Maloletka, and foreign, such as Giorgio Bianchi from Italy. Boris Mikhailov is one example of a Ukrainian photographer who has focused pointedly on the grittier aspects and fallen ideals of the former Soviet Union; his project *Case History* focuses on the plight of the homeless in Ukraine in the post-Soviet era.

The countries of the Middle East have long and complex histories, and conflicts in the region have provided numerous photojournalists with a lifetime's worth of material. In the context of this survey, we can name only a handful from this area; they have covered a range of topics from religion to violence to home life to street life. An important archive for the study of photography and its history in this region is the Arab Image Foundation, established in 1997 by Lebanese photographers Samer Mohdad, Fouad Elkoury, and Akram Zaatari. Based in Beirut, this

716. JOSEF KOUDELKA. *Romania*, 1968. Gelatin silver print.
© Josef Koudelka/Magnum.

717. AHMED JADALLAH. From *Home Base Gaza*, 2003. © Ahmed Jadallah/Reuters.

institution's aim is to find and preserve photographic records of the Middle Eastern countries, North Africa, and the Arab diaspora in general; as of now, the foundation has amassed more than 600,000 images. Another resource is Aina, a nonprofit media center in Kabul that trains young photographers—among them the Afghan photojournalist Massoud Hossaini, who was awarded a Pulitzer Prize in 2012 for his photograph of a girl in the aftermath of a suicide bombing in Kabul. Aina is the brainchild of Iranian-French photojournalist Reza (born Reza Deghati), whose humanitarian vision includes empowering underserved populations—among them children, women, survivors of wars—with the agency of photography.

The work of female photographers from the Arab world has long been overlooked, but this situation is rapidly changing, particularly as the Internet brings photographers from all backgrounds and genders onto something of an even playing field. Beirut-born Greta Torossian looks at urban settings both abroad and in her home city, often rendering streetscapes of dilapidated buildings in jarringly brilliant color. Algerian photographer Farida Hamak, who made her name as a war reporter, has at times benefited by her gender, shooting in intimate spaces accessible only to women. The Franco-Algerian photographer Nadia Benchallal has explored the lives of Muslim women all over the world, and has brought her incisive eye to a study of children who were, like her, born in France of North African parents.

The conflict between the Israelis and the Palestinians over land and faith is one of the most intractable and volatile disputes of our time; it has been covered in countless ways by reporters. Palestinian photojournalist Ahmed Jadallah has worked extensively in the Gaza Strip as a Reuters correspondent; his image of a boy on a Gaza street, seen through a bullet-hole-riddled car windshield webbed with cracks, gives a palpable sense of the tension and chaos in the area *(pl. no. 717)*.

East Asia

Given the homogenization of contemporary global culture, one would expect to find photographers of East Asia responding to the same influences as Americans and Europeans. While this has indeed been the case in much of this vast region, photography in Japan evolved under unique conditions and is its own case. After a brief but rich period of modernist creativity during the 1920s, non-commercial photography in Japan tended to take on the soft-focus style of Pictorialism. Following World War II and until about 1960, Japanese artists, with exceptions such as Ken Domon *(pl. no. 719)* and Shōji Ueda, showed relatively little interest in photography as artistic expression. The concepts of modernist experimentalism and of large-format camerawork as conceived by Edward Weston were brought to Japan by Yasuhiro Ishimoto when he returned in 1953 after studying at the Institute of Design in Chicago. But the network for disseminating photographs that emerged, which was very different from that in the States, influenced the kind of photographs that were produced. Because the museum and commercial gallery activities that sustained the West's market for artistic camera images did not exist in Japan, most Japanese photographers worked mainly for books and magazines, favoring a realistic style and images arranged in sequences rather than the single print. As a consequence, until recently Japanese photographers tended not to produce fine prints or engage in experimenting with processes and techniques to create singular artistic objects. Museums and galleries devoted exclusively to photography did not develop in Japan until the 1990s.

The goal of Japanese photographers during the 1960s and '70s, according to the critic Shōji Yamagishi, was to "demonstrate that photography is a kind of consciousness that can be shared by everyone in his daily life, rather than simply an expression of one's own personality or identity."[23] This concept is central to the work of Shōmei Tōmatsu, a former photojournalist and the author of numerous photographic books (including one on the Hiroshima and Nagasaki bombings, created in collaboration with Domon). *Sandwich Man, Tokyo (pl. no. 718)*, from Tōmatsu's book *Nippon*, is a forceful but enigmatic image of a tradition on the verge of obliteration due to the radical changes in contemporary Japanese life—a theme that has engaged this photographer since the 1960s. The socially oriented images by Daidō Moriyama—among them a series called *Nippon Theater*—involve ideas related to Tōmatsu's; Moriyama's work is known for its close-ups, graininess, blurs, and stark tonal contrasts used to heighten the emotional pitch of the situations they depict.

Polished images of nudes and landscape by Kishin Shinoyama fit stylistically and thematically into the tradition of *ukiyo-e* woodblock art at the same time that they satisfied the modern demand for unambiguous photographic representation. In contrast, Nobuyoshi Araki deals with less conventional behavior—mainly involving women. His interests, which encompass urban street scenes, still lifes, ambiguous sexual forms, and overtly masochistic stagings of women in bondage, are considered by some to be a mirror of Japanese reality. As such, Araki has exerted a strong influence on the country's current younger crop of photographers.

For some years, starting in the mid-20th century, the dominating presence of the West shaped the work of many photographers in Japan, including Ikkō (born Ikkō

718. Shōmei Tōmatsu. *Sandwich Man, Tokyo,* 1962. Gelatin silver print. Museum of Modern Art, New York; Gift of the artist. © Shōmei Tōmatsu.

719. Ken Domon. *Detail (Left Hand of the Sitting Image of Buddha Shakamuni in the Hall of Miroku, the Muro-ji),* c. 1960s. Gelatin silver print. © Ken Domon/ Pacific Press Service.

720. LIU BAN NONG.
Construction, early 1930s.
Gravure. Courtesy Zhang
Shuicheng, Beijing.

721. ZHANG YIN QUAN. *Cart
Pullers*, 1935. Gelatin silver print.
Courtesy Zhang Shuicheng,
Beijing.

Narahara), who is among the Japanese photographers best known internationally. American influence, in particular that of Weston's work, moved Toshio Shibata to use the direct expressive power of the camera to produce enigmatic images of land and water. Notions about gender equality, largely emanating from the United States, have led to an increase in the number of women photographers active in Japan in recent years. Among them are Miyako Ishiuchi, who has dealt with issues of aging by photographing the hands, feet, and personal possessions of her mother, and Yoshino Oishi, a prominent contemporary photojournalist.

Photography in China during the 20th century has contrasted with developments elsewhere. For some 80 years, camerawork was valued almost entirely in terms of its contributions to the political struggles that consumed the nation. Decades-long isolation from Europe and the United States, as well as China's relative underdevelopment, deprived photographers of access to the creative ideas of modernism and Western traditions of

722. XIE HAILONG. *The Entire School, Nanyantou Village, Shenyougou Township, Shanxi Province*, 1992. Gelatin silver print. China Photography Publishing House, Beijing.

social documentation. In the wake of the revolutionary ferment during the first decade of the 20th century, Chinese picture-news journals emerged to promote photoreportage as a means to document the facts of life while emphasizing the country's political and economic advances. Following the outbreak of the war with Japan in 1937, photoreportage on the Communist side was limited by the scarcity of materials. In an effort to gain adherents to their cause, the Communists devoted their few resources almost exclusively to presenting information about the activities of the Eighth Route Army in remote areas of northwestern China.

After the establishment of the People's Republic in 1949, the appearance of picture magazines such as *China Pictorial* and *China Reconstructs* increased the demand for photojournalistic images, but the images became less factual and more frankly propagandistic, a role they continued to play during the Cultural Revolution. Remaining somewhat proscribed until the 1980s, photographers continued to portray industrial workers, peasants, and indeed all sectors of the populace in a confident and picturesque fashion. Though technically proficient, their images seldom probed beyond superficial appearances or investigated problematic aspects of life in China.

Given China's political and social turmoil throughout the 20th century, it is hardly surprising that photography as an artistic expression did not receive the same support as photoreportage. Books of scenic views emphasizing the beauty of the countryside were published in Shanghai in the early part of the 20th century, and in the 1930s the Pictorialist style attracted a small following of amateurs and professionals who sent works to international salons and competitions. Among them was Wu Yinbo, the most consciously artistic of professionals, who later became a photojournalist for *China Pictorial*. The era brought an emulation of the themes, compositions, and styles of scroll painting that characterized Chinese Pictorialist photography, with calligraphed characters sometimes added to the negative or brushed into the print—this process would still be seen into the 1980s. An effort was made during the 1930s to adapt traditional styles to working-class themes, as in *Construction (pl. no. 720)* by Liu Ban Nong. In another approach *(pl. no. 721)* Zhang Yin Quan tried to fuse the European experimental ideas of the "new vision" with socially significant subjects. (Both attempts were short-lived.) On the whole, although there were fine photographers at work, such as the veteran photojournalist Zhang Shuicheng, Chinese photography was circumscribed by a number of factors: the high cost of materials and of reproduction in a relatively poor nation, the strong grip of traditionalism on all visual expression, and the limited interest within officialdom (where funding was controlled) in the medium's potential to create images that would transcend utilitarian purposes.

As China moved from the 20th into the 21st century, this situation began to change dramatically: the country's economy boomed, and photography has become a veritable passion among the Chinese. The practice of the medium has become diversified, with individuals not only working for government agencies but also freelancing by selling their work for publication and taking pictures as personal expression.[24] Work by this generation of photographers reflects the unprecedented transformations taking place in all aspects of Chinese society. Many of these changes have been triggered by increased interactions with photographers in the West, by what can be seen on the Internet, and by easier access to materials now that foreign manufacturers of photographic equipment and film have established factories in China. In addition, for the first time, officials in charge of cultural activities admit that differing concepts of photography exist, freeing practitioners to choose their

724. Chen Changfen. *Environmental Metamorphic Fission*, c. 1983.
Chromogenic color print. Chinese Photographers Association, Beijing.

own directions. Bolstering this flourishing scene, China's robust economic growth has led to the emergence of a new wave of photography collectors in the country.

Many Chinese photographers involved in social documentation in recent decades have shown themselves to be disinclined to idealization. The inadequate schools that rural children must endure have been pictured by Xie Hailong *(pl. no. 722)*, and the rapid changes brought about by unchecked building are presented as mixed blessings in Xu Yong's images of disappearing *hutongs* (neighborhoods) in Beijing *(pl. no. 723)*. Widespread excavations in China of archaeological remains provided photographers with the occasion to document their country's ancient culture. Acknowledgment of the medium's encompassing aesthetic potential afforded former pilot Chen Changfen an opportunity to combine aerial views in color of earth, moon, and sun, merging modern aesthetic concepts with ancient philosophical ideas *(pl. no. 724)*.

Even as China's photographic community has lately undergone such momentous transformations and growth, it bears noting that in the first decades of the 21st century

a number of figures in the Chinese photography and art world—including photographer and historian Zhensheng Li, photojournalist Lu Guang *(see pl. no. 833)*, and prominent conceptual artist Ai Weiwei—have been the subjects of government censorship and crackdowns on what are perceived as cultural voices of dissent.

While Western photographic approaches, both historic and contemporary, have inevitably made a deep impact throughout East Asia, each of the nations in this large region has its own history, and its own vital traditions of visual culture. Many books have been devoted to these countries' individual photographic legacies and current production, and further scholarship is deserved and sure to come. In recent years, with increased contact via the Internet and with new sociopolitical alliances and engagements, cultural cross-pollinations have been taking place not only from West to East but from East to West as well.

An example of this mutable trajectory can be found in the work of photographer Chien-Chi Chang, who has focused both on aspects of life in his native Taiwan *(see pl. no. 825)* and on the population of immigrants in New York's

725. SIM CHI YIN. *Shifting Sands*, 2017–ongoing. Digital color.
© Sim Chi Yin/Magnum Photos.

Chinatown. Taiwan has been characterized as a "state of exception"—under the rule of mainland China, yet with its own government—by artist Chieh-Jen Chen, who often addresses issues of displacement and marginalization in his photographs and videos.[25] Other photographers contending with the nation's ambiguous status through their work are Jui-Chung Yao and Shun-Chu Chen.

Hong Kong has a particularly complicated past that conflates Eastern and Western identities. Shanghai-born Fan Ho lived there from 1949 until his death in 2016, and throughout his long career used a Rolleiflex K4A to document the life and streets of the frenetic and vibrant metropolis. Canadian photographer Greg Girard was based in Hong Kong for many years; his 1993 book *City of Darkness* explores the chaotic jumble that was Kowloon's so-called Walled City.

Photographers in the countries of Southeast Asia are likewise engaged with the complexities and traumas of their histories, even as they look toward the future. Cambodia and Vietnam, both haunted by periods of horrendous violence in the 20th century, have entered the new millennium with strong photographic presences. Among the recent generation of Cambodian photographers tackling this painful legacy is Rattana Vandy, whose forceful series *Bomb Ponds* considers the indelible effects of U.S. bombing operations on Cambodia's landscape and collective memory. One of the few prominent women photographers in Cambodia is Moniroth Chiart Chan, who has made a boldly colorful study of homeless children, a series with the poignant title *Cinderella*. Mixing humor with social conscience, Kim Hak has taken a close look at people fast asleep on the streets of Phnom Penh. Along with a spate of new galleries devoted to photography that have opened in Phnom Penh over the past two decades, the Angkor Photo Festival in Siem Riep was launched in 2005, and the Photo Phnom Penh gathering (directed by French photography specialist Christian Caujolle) in 2008.

A number of Vietnamese photographers continue to confront the lasting repercussions of the Vietnam War. Doan Duc Minh's 2000–2005 series *Suffering and Smiles*, for example, looks at victims of Agent Orange. And Binh Danh, who came to the United States with his family in 1980, borrowed *Life* magazine's 1969 photographic chronicle of the faces of U.S. military casualties for his project *One Week's Dead*—but here the portraits are reproduced by Danh as chlorophyll prints on leaves. Others have been turning their lenses toward more contemporary social issues. In her 2011–12 series *The Pink Choice*, Maika Elan (born Nguyen Thanh Hai) looks at queer life in urban Vietnam, while Lam Hieu Thuan considers the transformed architectural landscape of Ho Chi Minh City in his project *Apartments* (2005–6). As the country's economic policies have opened up to some extent in the 21st century, Vietnamese photographers have benefited from newly diverse sources of funding for the arts, and from increased numbers of exhibition venues and (again largely due to the Internet) international attention.

Other Southeast Asian countries are producing compelling work in the new, globally connected photographic community. To cite only a few: Malaysian photographer Eiffel Chong, in his 2017 project *A Trace of Mortality*, looks at liminal spaces between life and death: hospitals and other bleak institutional settings—balanced incongruously with broad, painterly images of seascapes. A lighter note is struck by Manit Sriwanichpoom of Thailand, who inserts the figure of a gentleman dressed in a bright suit—he dubs him "the Pink Man"—into his photographs made in locations around the world, as an anomalous leitmotif. Often using muted tones in his images, Singaporean photographer Robert Zhao Renhui has conducted a study of wildlife that, while beautiful, is imbued with a sense of impending loss. Photographers Isa Lorenzo and Rachel Rillo founded the Silverlens gallery in Manila, Philippines, in 2004; the space represents numerous Southeast Asian photographers, including Martha Atienza, Frank Callaghan, Wawi Navarroza, Gina Osterloh, and I-Lann Yee.

Singapore-born photojournalist Sim Chi Yin's ongoing project *Shifting Sands (pl. no. 725)* considers the depletion of sand on the planet, in images that are well researched, informative, and decidedly eerie. Chi Yin has worked throughout Asia for numerous press organizations, from Singapore's *Straits Times* to the *New York Times*, and she is as of this writing Magnum's first Southeast Asian nominee.

It is clear that, with the advent of digital technologies and the World Wide Web, photographers in the countries of East Asia, as in the rest of the world, are now part of a relatively equitable global field in terms of exposure.

Portraiture and Self-Portraiture

Formal portraiture—a time-honored photographic specialty that still engages photographers everywhere—has been, aesthetically speaking, less influenced than other types of photography by changes in theory and technique during the postwar years *(see also Chapter 13)*. The basic treatment of the human face has, in fact, changed little since the medium's infancy. Expression, gesture, lighting, and decor continue to be seen as key to revealing the sitter's class, profession, and psychology. This traditional outlook has been encouraged in part by consumers' insatiable desire for images of the famous, which in turn has prompted editors and publishers to reproduce such images in magazines and books. There are notable photographers—

among them Philippe Halsman *(pl. no. 726)*, Peter Hujar, Yousuf Karsh *(pl. no. 727)*, Annie Leibovitz *(pl. no. 733)*, and Arnold Newman—who have devoted themselves almost exclusively to this pursuit.

Working both in color and in black and white, Newman, for instance, incorporated into richly orchestrated representations emblems that suggest his sitter's artistic style or concerns. This approach is exemplified by *Georgia O'Keeffe, Ghost Ranch, New Mexico (pl. no. 728)*, in which the treatment of space and the props are meant to bring to mind the artist's own preoccupation with the landscape of the American West. Leibovitz has adapted this approach to contemporary sensibilities by placing her sitters in settings that at first glance may seem less formal but are equally studied and at times considerably more startling. Richard Avedon, whose interests included portraiture as well as fashion *(see pl. nos. 634, 651)*, occasionally used eye-catching props but nearly always placed sitters against a flat monochromatic backdrop. The luminous black-and-white portraits by Peter Hujar vividly summon the New York demimonde of the 1970s and '80s. Other notable portraitists who worked

either on commission or from personal choice—including Gisele Freund and Madame d'Ora (born Dora Kallmus) in France, Bill Brandt in England, Chargesheimer (born Carl-Heinz Hargesheimer) and Fritz Kempe in Germany, Irving Penn in the United States, and Anatole Sadermann in Argentina—suggested personality by capturing characteristic expression and by manipulating lighting, as in the d'Ora portrait of Colette *(pl. no. 729)*.

Many photographers have portrayed themselves in the course of their life's work, but the late 20th century began to see a distinctive use of the self-portrait to comment upon the anxiety and strangeness of contemporary existence. Francesca Woodman, who died in 1981 at the age of 22, filled her short life as an artist with intense, sometimes troubling, sometimes fanciful black-and-white portraits of herself in stark interior settings *(pl. no. 730)*. The Finnish photographer Arno Rafael Minkkinen directs scenes in which his body—or a portion of it—appears to be an integral part of the landscape, such as an outcropping or rock formation. German artist Dieter Appelt also stages scenes to be photographed—he is known to have tied his nude

726. PHILIPPE HALSMAN. *Dali Atomicus*, 1948. Gelatin silver print. Neikrug Gallery, New York. © Philippe Halsman Estate.

727. YOUSUF KARSH.
Winston Churchill, 1941.
Gelatin silver print.
International Center of
Photography. © 1941
Karsh, Ottawa.

body to trees or encased portions of it in cement *(pl. no. 731)*. Sheng Qi, from China, was so enraged by the events in Tiananmen Square in 1989 that he decided to leave the country. Before doing so, in a gesture of extreme performative drive and personal defiance, he cut off a finger of his left hand—a literal part of himself to leave behind in his homeland; Qi's self-portraits since that dramatic act often focus on that missing feature. For these artists, self-portraiture as such may not be the primary purpose; rather, like Cindy Sherman *(see pl. no. 744)*, they use drama and ritual in conjunction with photography to make their statements.

Uncommissioned portraits of uncelebrated people, often strangers to the photographer, are largely a 20th-century phenomenon made possibly by the camera having become a commonplace, unobtrusive tool. Street photographers from Cartier-Bresson to Winogrand to Philip-Lorca diCorcia have frequently had multiple aims for such portraiture: to capture facial expression and gestures that reveal emotional states, to express subjective feelings about a situation, to serve as a vehicle for statements about the irrationality of existence.

While some photographers, such as Emmet Gowin, continue to view candid portraiture—whether of strangers in the street or family at home *(pl. no. 732)*—as a way of effecting a seamless interplay of fact and feeling, others, such as diCorcia and Dan Winters, have found directorial tech-

728. Arnold Newman. *Georgia O'Keeffe, Ghost Ranch, New Mexico*, 1968.
Gelatin silver print. Courtesy and © Arnold Newman.

729. MADAME D'ORA (DORA KALLMUS). *The Writer Colette*, c. 1953.
Gelatin silver print. Museum für Kunst und Gewerbe, Hamburg.

niques to be a more effective means of expressing feelings and ideas about the individual and society. This approach has been embodied in portraits by a number of women photographers, including Judy Dater, Carrie Mae Weems, and Lorna Simpson, all of whom have in some way subverted portraiture's traditional objectifying lens by giving their subjects a degree of agency in the work. (This idea is discussed further in reference to portraiture of the 21st century in Chapter 13.)

This chapter has shown that individualized expression in straight photography has expanded considerably during the past several decades. Photographers and the public

have come to accept the camera image as a metaphor, as the expression of private experience, as a subjective document, and as a statement about the potential and the limitations of photography.

Although it has been transformed by digital technology, the camera continues to play a vital role in journalism. Owing to the fact that photographs are relatively inexpensive and that they easily move from one country to another (whether as originals or in reproduction or on the Internet), photographic concepts and styles formulated in one place quickly become part of an international mainstream. In effect, camera expression has become a language with a more or less common vocabulary throughout

730. FRANCESCA WOODMAN. *Self-Deceit #1*, 1978. Vintage gelatin silver print. © 2019 Estate of Francesca Woodman/ Charles Woodman/Artists Rights Society (ARS), New York.

731. DIETER APPELT. *Hands*, from *Memory's Trace*, 1978. Gelatin silver print. Shashi Caudill and Alan Cravitz, Chicago.

732. EMMET GOWIN. *Edith, Ruth, and Mae, Danville, Virginia*, 1967. Gelatin silver print. Light Gallery, New York. © Emmet Gowin.

733. ANNIE LEIBOVITZ. *Christiane Amanpour (center), Maria Fleet (left), and Jane Evans (right), CNN War Correspondent and Camerawomen, London, England*, 1999. Courtesy and © Annie Leibovitz/Contact Press Images.

the industrialized and even the less industrialized nations of the world. When one adds the possibilities offered by color and by manipulations of all sorts—to be discussed in the next chapter—this language will be seen to be one of invigorating richness.

Profile: Mary Ellen Mark

Known for her sensitivity to the formal moment of truth and for the profound humanity of her photographs, Mary Ellen Mark created an affecting body of work, primarily in black and white, focusing largely on marginalized populations around the world. Throughout her career, she immersed herself in the lives of her subjects— from patients in a mental hospital to sex workers to circus performers to the destitute—exerting a photographic gaze that is both unflinching and compassionate.

Born in 1940 in Philadelphia, Mark studied painting and art history at the University of Pennsylvania, where she went on to earn a master's degree in photojournalism in 1964. She then traveled to Europe on a Fulbright fellowship, creating images that would provide the material for her first book, *Passport* (1974). Two years later, Mark embarked on a project that established the level of deep engagement she would undertake with subjects for the rest of her life. For 36 days, she lived in a high-security women's ward in an Oregon mental hospital, observing and photographing the wayward moods and agitations of the patients confined there. Partly on the basis of that project, Mark was invited to join the prestigious Magnum Photos agency. One among a very small number of women members at the time, she remained with Magnum

for only a few years, leaving in 1981 to start her own studio.

Mark's abiding interest in social outcasts is manifest in her 1981 book of color photographs, *Falkland Road: Prostitutes of Bombay.* India fascinated her *(pl. no. 734)*, and she visited the country many times, making it the subject of later books, among them *Photographs of Mother Teresa's Missions of Charity in Calcutta, India* (1985) and *Indian Circus* (1993).

Mark produced a total of 19 photo books in her lifetime and contributed to most of the celebrated illustrated magazines of her era, from *Life, Look, Vanity Fair, New Yorker,* and *Rolling Stone* to overseas publications such as *Paris Match* and *Stern.* In 1983 she created a photo essay for *Life* documenting the lives of runaway children on the streets of Seattle, a motley group of small-time drug dealers, panhandlers, and sex workers, including a 13-year-old waif named Tiny *(pl. no. 689)*. Compelled by their lives and stories, Mark returned to the city later that year and, together with her husband, filmmaker Martin Bell, made the documentary *Streetwise* (1984) about this dispossessed population; the film was nominated for an Academy Award, and the project was published in book form in 1988.

Mark's work was influenced by the great documentarians of the 20th century, including Henri Cartier-Bresson, Bruce Davidson, and Robert Frank, but it is to Diane Arbus that she is most often compared. Both women were keenly interested in society's fringe dwellers; however, their psychological approaches were very different: where Arbus went after the oddness and eccentricities of the people she photographed in an almost predatory fashion, Mark was driven by empathy. "I didn't want to use them," she once said of her subjects. "I wanted them to use me."[26]

Along with her documentary work, Mark took commissions from fashion magazines and made photographs for a range of advertising campaigns. She also established herself as an on-set photographer for films, working with such directors as Francis Ford Coppola, Federico Fellini, Baz Luhrmann, and Mike Nichols. She was an extraordinary portraitist as well, often using a 20 x 24 inch Polaroid Land camera; the resulting images are rich with detail and tonality—from indulgent blacks to fulsome whites—capturing the full candor of the faces before her lens.

A consummate storyteller, Mark took on topics ranging from high school proms to dogs, cancer survivors to autistic children, movie stars to homeless families. Her involvement with the lives of subjects evolved, often, over the course of many years. For decades she stayed in touch with Tiny, the Seattle teenager, ultimately revisiting her as a grown woman—now a mother of ten—in the 2015 book *Tiny: Streetwise Revisited*. Mark, a cancer victim, died of myelodysplastic syndrome before the book was published.

Mark's photographs are always charged with life and energy—and often humor—but she understood the gravity of her responsibility as a photographer. "I just think it's important to be direct and honest with people about why you're photographing them and what you're doing," she once said. "After all, you are taking some of their soul, and I think you have to be clear about that."[27]

734. MARY ELLEN MARK. *Ram Prakash Singh with His Elephant Shayama, Great Golden Circus, Ahmedabad, India*, 1990. Platinum print. Courtesy and © Mary Ellen Mark.

12.

PHOTOGRAPHY SINCE 1950: MANIPULATIONS AND COLOR

The camera . . . on the one hand extends our comprehension of the necessities that rule our lives; on the other, it manages to assure us of an immense and unexpected field of action.

—*Walter Benjamin, 1930*[1]

The destiny of photography has taken it far beyond the role to which is was originally thought to be limited: to give more accurate reports on reality. . . . Photography is the reality; the real object is often experienced as a letdown.

—*Susan Sontag, 1973*[2]

IN THE SECOND HALF of the 20th century there was a surge of interest among many photographers in *creating* images rather than documenting actuality. The emergence of a commercial market for artistic photography beginning in the mid-1970s has meant that manipulative concepts in creative photography have attracted many more practitioners than at any previous time. Reflecting the experimentalist attitudes prevailing in contemporary art as a whole, photographers have invented images by directing the action of the subject before the lens, or by manipulating photographic processes, or by mixing graphic, photographic, and electronic procedures, or by bypassing the camera entirely. As photographers became more familiar with the medium's history (as a result of the increased literature in the field), they also recognized that manipulation has been a common practice since at least the 1920s. The fragmented and reconstituted "realities" visible on magazine pages, billboards, and eventually television screens—which required constructing sets, directing models, cropping, retouching, and combining photographs—have served (consciously or not) as a pattern book of possibilities. An additional spur to the interest in photographic experimentalism has been the influence of art directors and photography teachers, who have promoted to a wide spectrum of students the techniques and ideas used in advertising.

In the United States after World War II, artists working with unconventional materials (industrial paint, steel, plastics) and trying out unusual techniques (pouring, staining, welding) tended to ignore time-honored distinctions between the various categories of visual expression. Mixed-media performances (part theatrical, part graphic, part photographic) and assemblages (agglomerations of seemingly unrelated elements) made it clear that painting, sculpture, printmaking, and photography might no longer be regarded as discrete processes. At the same time, photographers began to reevaluate their assumptions regarding the distinctions between pure and documentary photography and to consider new ways of expressing their own feelings and private dream worlds as well as public realities. They adopted new means that ranged from the pairings and sequencing of straight camera images, to the invention of scenes to be photographed, to the manipulation of images either by manually reassembling portions of photographs or by intervening in optical and chemical processes.

Conceptualizing the Photograph

Conceptual photography is an approach that often regards the medium as a way to make statements about itself rather than about the ostensible subject before the lens. It is based on the belief that photographs are, in essence, uninflected records of information rather than emotionally nuanced experiences or works of fine art. One way to suggest this has been to present photographs in pairs or sequences. This presentation not only parallels the way that images are commonly shown in picture journals or in advertising but also serves to underline the point of view that how reality is framed in the camera depends on the inherent properties of the medium and on where the photographer is stationed. The photograph, some seem to be saying, is whatever the light reveals, the lens embraces, and the chemical substances make visible. It has little to do with ultimate truths: change the position of the camera, and another angle—just as truthful—will reveal itself. In presenting paired views of the same scene, Eve Sonneman *(pl. no. 735)* suggested that there is not just one "decisive moment" in documenting reality. With the passage of time or a shift in vantage point, the same situation will take on a different appearance—neither one especially decisive.

Producing a series of uninflected images of objects of the same sort arranged in an arbitrary sequence—sometimes called a "typology"—constitutes another approach that avoids making a personal comment about the subject matter at hand. Referring to a series of deadpan photographs in his book with the self-explanatory title *Thirtyfour Parking Lots in Los Angeles*—exemplified by the single frame shown here *(pl. no. 736)*—the California painter-photographer Edward Ruscha claimed to be providing "a catalog of neutral objective facts."[3] The images themselves—suggestive of attitudes implicit in the "New Topographics" *(see Chapter 11)*—also bring to mind the repetition used in advertising photography to emphasize the abundance of material goods. Besides Ruscha, this approach attracted the influential German photographers Bernd and Hilla Becher and the Canadian Lynne Cohen. In addition to achieving their stated goal of description, many typological images are also appealing for their architectonic qualities, which relate them to the work of Minimalist artists, most notably Sol LeWitt, who were engaged

735. EVE SONNEMAN. *Oranges, Manhattan*, 1978. Cibachrome (silver-dye bleach) print. Castelli Graphics, New York. © Eve Sonneman.

in producing serial, geometric paintings and sculpture during the 1960s.

Concentrating on size, shape, materials, and topography in their photographs of industrial structures in Europe and the United States, the Bechers claimed to be documenting similarities rather than celebrating distinctiveness *(pl. no. 737)*.[4] Moreover, their images, arranged in configurations that juxtapose from three to dozens of photographs and at times measure some six feet tall or wide, demonstrate that camera images can provide the kind of visual detail that the human eye might be able to take in only over a long period of familiarity with an object. The makers of such informational images, whether they be of parking lots, cooling towers, or spheres, disavowed aesthetic intentions, but the appeal of these works is undoubtedly due to their artistic character rather than just to the information they provide.

The photographs and ideas of the Bechers, who taught for 20 years at the Kunstakademie Düsseldorf, were highly influential to a generation of German photographers who studied with the pair in the 1970s, many of whom rose to prominence in the 1980s and '90s. Notable among their following, a group that has come to be known as the Düsseldorf School of photography, are Andreas Gursky, Candida Höfer, Axel Hütte, Thomas Ruff, and Thomas Struth, each of whom in his or her way internalized and modified the approach of these teachers, applying new technical possibilities and a personal vision, while retaining the rigorous documentary method the Bechers propounded.

But as the work of the Bechers and others demonstrates, no matter the rigor of the approach, it is doubtful that any two-dimensional translation (whether painting or photograph) of the complex interaction of space, volume,

and atmosphere that constitutes an architectural experience can be accepted as "accurate" documentation. Despite the fact that specialists who have documented architecture and interiors—notably Lizzie Himmel and Ezra Stoller—have taken views from various angles and in differing light conditions in order to re-create a sense of the actual space, the physical and psychological aspects of the architectural experience (like the installation experience) cannot be fully apprehended through a photograph.

Photographers also use sequences, at times combined with texts of their own devising, as a way of communicating subjective experience or commenting on cultural attitudes. Like a significant number of other photographers who wish to reveal private realities, Duane Michals used himself as a model or directed others in staged sequences such as *Chance Meeting (pl. no. 738)*—six visually unexceptional shots that use for private expressive ends the narrative technique common in photojournalism and advertising. Inspired by Surrealist ideas, in particular those of the painter René Magritte, and by the cool irony of Robert Frank's imagery, Michals emphasized the primacy of subjective vision; his embrace of the sequential format struck a chord among many young photographers in the United States and Europe. A creator of fictions rather than of documents, in the mid-1970s Michals first began to write and then to paint on his photographs, thereby suggesting that the artist may have to go beyond what the camera lens sees in order to deal with phenomena such as chance and death.

The addition of script may also convey a political or social message. Clarissa T. Sligh, who creates installations and books, combined images and texts in her series of montages dealing with African American childhood experience *(pl. no. 739)*. The texts she derived from old-fashioned Dick and Jane school readers, in conjunction

736. EDWARD RUSCHA. *State Board of Equalization, 14601 Sherman Way, Van Nuys, California,* c. 1967. From *Thirtyfour Parking Lots in Los Angeles,* 1967. Gelatin silver print. Leo Castelli Gallery, New York. © 1967 Edward Ruscha.

737. BERND AND HILLA BECHER. *Winding Towers* (1976–82), 1983. Gelatin silver prints. Sonnabend Gallery, New York. © Bernd and Hilla Becher.

738. DUANE MICHALS. *Chance Meeting*, 1969. Gelatin silver prints. Courtesy and © Duane Michals.

with family snapshots of children at play, bring together concepts of innocence, deception, and falsehood. A seemingly unmanipulated but in fact artfully set up series of images by Carrie Mae Weems *(pl. no. 740)* includes key words in boldface type that bring to mind billboards. Their ironic messages commenting on black family relationships were aimed at putting in place "a new documentary" style that "champion[s] activism and chance" and is concerned with the status of African Americans.[5]

Other examples that exploit the replication made possible by photography are the sequential arrangements of figures favored by the German photographers Floris M. Neusüss, Klaus Rinke, and Manfred Willman, as well as the grids assembled from landscape photographs by the Dutch graphic artist Ger Dekkers, and those of images of shadows collected by the Polish photographer Andrzej Lachowicz. Many very large sequential works have been influenced by the expanded size of high-art canvases

Jim, if you choose to accept, the mission
is to land on your own two feet.

as well as by billboards and cinema screens. Working on a grand scale has attracted straight photographers as well as those involved with manipulation or directorial strategies. Over the last several decades of the 20th century, as larger sheets of silver-emulsion printing paper became available, Richard Avedon, Robert Mapplethorpe, and Cindy Sherman achieved effects that are more startling for having been realized on an expansive scale. Canadian artist Edward Burtynsky's massive photographs focus on ravaged industrial landscapes *(see pl. no. 837)*, while his countryman Jeff Wall is known for a dramatic use of light boxes with nearly cinema-size images of invented scenarios such as his *A Sudden Gust of Wind (after Hokusai) (pl. no. 741)*. A number of European photographer-artists have similarly expanded the size of their work and also share the conviction that by itself the single straight documentary photograph is not adequate for their expressive purposes. Employing a variety of formats and techniques, Gilbert and George in Britain *(pl. no. 742)*; and the Bechers, Joseph Beuys, and more recently Gursky and Thomas Struth *(pl. no. 743)* in Germany—among many others—have all chosen to work in dimensions that range between four and nine feet.

Conceptual photographers do not, of course, always work with sequential images. In staging his wry scenes that show a photograph within a photograph, American photographer Kenneth Josephson comments on the supposed reality that the camera captures—which, in some cases, is just another camera picture. Investigating the relation of photograph to reality, which is the central theme in such works, has an antecedent in Alfred Stieglitz's 1886 image *Sun's Rays—Paula, Berlin (pl. no. 401)*, in which the photographer alluded to the characteristics and potentials of the medium by including a variety of camera pictures of the sitter made at other times and in different positions.

The 1980s saw the emergence of a new approach to art making, logically dubbed postmodernism. In photography, this development represented, in part, a conceptual effort to counter the transformation of the photograph from document into aesthetic commodity. At the same time, new relationships were being formulated between the camera image and social realities. Postmodernists held that camera images of real life could not claim uniqueness, in that (unlike one-of-a-kind handmade images) they appropriate—that is, replicate—something that already

741. JEFF WALL. *A Sudden Gust of Wind (after Hokusai)*, 1993. Transparency in light box. Courtesy and © Jeff Wall.

742. GILBERT AND GEORGE. *Eye*, 1992. Four-panel photo piece. Robert Miller Gallery, New York.

743. THOMAS STRUTH. *Paradise 34, The Big Island*, 2006. C-print. Galerie Max Hetzler, Düsseldorf, Germany.

exists. Furthermore, they proposed that since neither photographer nor viewer can reach beyond the shared cultural patterns of their time to invest the camera image with a timeless aesthetic character or an emotional tone that will be invariably understood by all, the photographer should endeavor instead to provoke consideration and questions about current social phenomena.[6]

Following this track, certain photographers devised ways to express skeptical attitudes toward cultural stereotypes in general and toward the particular claims of the photograph as a highly valued aesthetic object. Some—including Sherrie Levine, who rephotographed well-known photographic images, and Richard Prince, whose subjects are plucked from camera images in slick magazines—sought to impugn the modernist idea of the artist-photographer as a charismatic figure with unique creative powers. Postmodern strategies ran a gamut from mimicking films stills and high-gloss advertising photographs, as in Cindy Sherman's portraits of herself in a variety of guises *(pl. no. 744)*, to arranging scenes in which live models or dolls imitate photographic illustrations in con-

sumer magazines or impersonate real-life situations, as in Laurie Simmons's tableaux *(pl. no. 745)*. Although humorous in tone, Sandy Skoglund's interiors—full of animal and human forms that she sculpted, posed, and painted in unnatural colors—serve as metaphors for the conditions of life in America.

Another postmodern approach, which recalls the idea of deforming the image, prevalent during the late 1910s and the 1920s (see, for example, Hannah Höch's *Cut of the Kitchen Knife, pl. no. 486)*, "deconstructed" the myths of contemporary society by using found photographs and attaching texts intended to make the viewer aware of attitudes implicit in the popular media. British photographer Victor Burgin, for example, appended his own messages, set in type, to photographs of common scenes, which he then rephotographed *(pl. no. 746)*.

All these photographic maneuvers were meant to reposition such imagery in the viewer's awareness, bringing to light underlying consumerist and sexist messages, rather than appealing to feelings or a sense of aesthetics. They helped women photographers not only to investigate the

744. CINDY SHERMAN. *Untitled (#156)*, 1985. C-print. Courtesy Metro Pictures, New York.

745. LAURIE SIMMONS. *Pink Bathroom*, 1984.
Cibachrome print. Courtesy Metro Pictures, New York.

746. VICTOR BURGIN. *Four-Word Looking*, from *U.S. 77*, 1977.
Gelatin silver print. John Weber Gallery, New York.
© Victor Burgin.

747. BARBARA KRUGER. *Untitled (You Get Away with Murder)*, 1987. Dye-coupler print with screen-print lettering. The Hallmark Photographic Collection, Kansas City, Mo. Courtesy Mary Boone Gallery, New York.

748. RUTH THORNE-THOMSEN. *Parable*, from *Songs of the Sea*, 1991. Toned gelatin silver print. Ehlers Caudill Gallery, Chicago.

749. LALLA ESSAYDI. *Converging Territories #26*, 2004. Color print with applied calligraphy. Edwynn Houk Gallery, New York.

750. ABELARDO MORELL. *Camera Obscura: View of Central Park Looking North—Summer 2008*, 2008. Archival pigment print. Courtesy Edwynn Houk Gallery, New York. © Abelardo Morell.

751. OTTO STEINERT. *Children's Carnival*, 1971. Gelatin silver print. Folkwang Museum, Essen, Germany. Courtesy Mrs. Marlie Steinert.

752. ADAM FÜSS. *Love*, 1992.
Unique Cibachrome photogram.
Robert Miller Gallery, New York.

ways their lives were being transformed into stereotypes in the commercial media but also to examine their own needs and roles. Barbara Kruger addressed issues of patriarchy and the dynamics of power by adding her own captions—in sloganlike phrasings—often composed of cutout letters, to large-scale images whose graininess mimics that of newspaper ads *(pl. no. 747)*. *Autobiographical Stories*, a semi-fictional series of images and texts by French photographer Sophie Calle, is another visual exploration of a woman's life. Similar tactics have been adopted by Lalla Essaydi, a Morocco-born photographer who applies calligraphy and henna to photographs to make a statement about the role of women in North Africa *(pl. no. 749)*. Awareness that calligraphy is an art form reserved for males, while henna is a traditional female adornment, is necessary in order to recognize the political and social implications of this imagery.

Interventions and Manipulations

Intervention in the physical production of camera images and manipulation of the chemical processes have taken various forms, all of which have as their central principle the freedom of the photographer to be as spontaneous and inventive as the graphic artist, while preserving the replicative aspects of the medium. Such interventions have attained new levels of complication and ubiquity with the arrival of digital technologies—but manipulation has been a potential in photography since the time of its invention, and photographers and artists of recent years have made increasingly purposeful use of it. Choosing to use a camera with a pinhole instead of a lens, when cameras now come equipped with the fastest, sharpest optical devices, is a simple means of adjusting the photographic process to one's expressive needs; the results can be seen in the strangely elegiac landscapes by Ruth Thorne-Thomsen

(pl. no. 748). Abelardo Morell has mastered the use of the *camera obscura*—one of the oldest proto-photographic methods of projecting an image *(see A Short Technical History, Part I)*—to create evocative and confoundingly dreamlike still lifes and interiors *(pl. no. 750)*. The type of camera lens used can also provide photographers with a creative tool, either by giving actual scenes a sense of unreality through subtle distortion or by dramatically deforming expression and gesture. In the 1950s, following earlier experiments by André Kertész and others, Berenice Abbott and Weegee—both advocates until then of straight

photography—distorted figures and objects by using special lenses, but their images were, on the whole, tentative.

A more resolved body of work to emerge from experimentation with extremely wide-angle lenses is that of Bill Brandt *(see pl. no. 708)*. Adopting a style more closely related to classic Surrealism, Swiss photographer Christian Vogt, best known as a journalist, has also made distorted images that recall the fantasy landscapes of Giorgio de Chirico. Many of those whose interest lay in imagined worlds employed a wide-angle lens to invest both ordinary scenes and staged enactments with an unnerving sense of infinite

754. BROOMBERG & CHANARIN. *The Jail Break, June 12, 2008*, from *The Day Nobody Died*, 2008.
C-41 mounted on aluminum. Courtesy Broomberg & Chanarin/Lisson Gallery.

755. RAY K. METZKER. *Arches*, 1967. Gelatin silver print. © 1967 Ray K. Metzker.

depth. Accidental lens distortions can also be used to dramatize gestures and expressions in scenes where no fantasy is intended, as in many examples from straight photography and photojournalism—among them, Otto Steinert's *Children's Carnival (pl. no. 751)*. Indeed, distortion serves as an element of expression in the work of many photographers, both photojournalists who feel that it adds a measure of reality to their images and creative and fashion photographers for whom it serves as an aesthetic device.

Techniques requiring more extensive intervention in the optical process include images made without a cam-era (photograms) and joining disparate images together in photo-collages or montages. Photographic collage involves cropping and recombining camera images, either original or reproduced, by physically gluing them together; montage refers to uniting them in the enlarger or the computer. Given the experimentalism implicit in these approaches to photography, it is not surprising that all these techniques, which assert the nonmechanical aspects of the medium and emphasize the individual imagination, were part of the avant-garde curriculum at the 1920s Bauhaus. Nor is it surprising that the advent of electronic

756. JOYCE NEIMANAS. *Untitled*, 1981. SX-70 (internal dye-diffusion transfer) prints. Courtesy and © 1981 Joyce Neimanas.

757. WILLIAM MORTENSEN. *L'Amour*, c. 1936. Gelatin silver print with textured screen. Courtesy and © 1980 Mortensen Estate.

and digital imaging has made such procedures as montage easier to use and thus more attractive to larger numbers.

The photogram is a unique cameraless image created either by playing a beam of light across a sheet of sensitized paper or by exposing to a fixed or moving light source various translucent and opaque objects arranged on sensitized paper. An early 19th-century invention, it was updated during the 1920s *(see Chapter 9)* and again in the 1940s, when it was sometimes combined with other procedures. In the United States, Carlotta Corpron, Lotte Jacobi, Nathan Lerner, and Barbara Morgan were among those who involved themselves with this procedure, as exemplified in the lyrical abstractions that Jacobi called "photogenics" *(see pl. no. 554)*. Morgan, who frequently combined light drawing, photograms, and montage in the same image *(see pl. no. 556)*, began her experiments with these techniques in 1938 by photographing the moving light patterns made by a dancer holding a flashlight. During the 1950s several Europeans, including Herbert W. Franke in Austria and

Peter Keetman in Germany, used oscilloscopes and prisms to produce geometric abstractions, a number of which bring to mind the work of the Constructivist sculptors Naum Gabo and Antoine Pevsner. The flexibility inherent in making photograms also inspired work by Floris M. Neusüss, who created large-scale, flowerlike images that are both decorative and mysterious.

Another type of cameraless imagery that attracted attention in the 1950s combined photogram techniques with a modern version of *cliché verre*. Random patterns formed on glass by such substances as viscous liquids and crystals provided a negative for printing on sensitized paper. Henry Holmes Smith, one of the first Americans to use this procedure, manipulated a syrupy mixture on glass plates to create nonobjective images that he would print either on monochromatic silver or on multichrome dye-transfer materials. Smith's onetime student Jaromir Stephany experimented with similar techniques, using ink on film in both 4 x 5 inch and 35mm formats to create

visionary images that suggest galactic events. The imaginative possibilities of *cliché verre* appealed to the photographer-artist Frederick Sommer, who worked with glass and cellophane in the 1950s, painting on or fuming these materials with smoke to create abstracted shapes. Sommer, a complex personality as fascinated by putrescence as by living beauty, also made montages, assemblages *(pl. no. 753)*, and straight photographs, seeking in all to give visible form to the mysteries he discovered in both the real and the imaginary worlds. Highly colored creations by Adam Füss have been generated from unorthodox substances—balloons, powder, animals and their entrails *(pl. no. 752)*—exposed directly on Cibachrome paper; to some, their appeal is aesthetic, to others, their metaphorical meaning is paramount.

In the 1950s, the French photographer Jean-Pierre Sudre explored the aesthetic and analogical possibilities offered by random arrangements of chemical salts on glass—a technique he called "crystallography." Heinz Hajek-Halke, who began work both with cameras and with cameraless techniques after a quarter-century as a successful press and scientific cameraman in Germany, created "luminograms" with moving beams of light by exposing granular and liquid substances on film to directed light sources. More recently, the artist duo Oliver Chanarin and Adam Broomberg used the luminogram process in their conceptual approach to imaging war. For their 2008 project *The Day Nobody Died (pl. no. 754)*, they exposed a roll of photographic paper to light at the front lines of the conflict in Afghanistan, and filmed British troops transporting the cardboard box containing the paper from one battle station to another. The luminograms, boldly colored abstractions, challenge both the notion of "embedding" photographers with troops and the capacity of art to provide an adequate representation of war.

The "chemigrams" created by Belgian photographer Pierre Cordier in the 1950s were produced in normal light without a camera by combining in a novel way the chemicals

759. EIKOH HOSOE. *Ordeal by Roses #29*, 1961–62.
Gelatin silver print. Light Gallery, New York.
© Eikoh Hosoe.

760. ROBERT HEINECKEN. *Le Voyeur/Robbe-Grillet #1*, 1972. Photographic emulsion on canvas; bleached; pastel chalk. International Museum of Photography at George Eastman House, Rochester, N.Y. Light Gallery, New York © Robert Heinecken.

associated with painting—varnish, wax, and oil—and those used in photography: photosensitive emulsions, colored dyes, developer, and fixer. This experimental practice, too, has been taken up by artists in recent years, among them Christina Z. Anderson and James Welling.

In the 1950s and '60s, collage techniques attracted a number of photographers in the United States (many associated with the Institute of Design in Chicago) as a means of generating fresh visions of commonplace experiences. These composites generally were created from straight photographs that were cropped, repeated, and rearranged to form a freshly synthesized statement. *Arches* (*pl. no. 755*), a characteristic work in this mode by Ray K. Metzker, although visually pleasing in its patterns, is meant not as a decorative object but as an expression in new form of the emotional texture of the generating experiences—in this case the excitement of street life in downtown Philadelphia. Barbara Crane has worked with cropped and repeated strips of images of built structures and organic matter, combining them with other experimentalist elements such as photograms. Rejecting the usual lenticular description of space as an uninterrupted continuum, Joyce Neimanas made collage works with arrangements of SX-70 Polaroid prints (*pl. no. 756*). A different approach to collage is seen in the work of Carl Chiarenza, who created miniature still lifes from torn paper and photographic packaging materials that he then photographed; enlarged greatly, these works take on the aspect of mysterious landscapes.

Both collage and montage were seen by the postwar generation as especially fruitful methods of projecting private visions, of dealing with the possibility that, as the American photographer Jerry N. Uelsmann has observed, "the mind knows more than the eye and camera can see."[7] Even in the early 1930s, printing multiple images on one photographic support enabled some American photographers to explore mysterious realms that seemed impossible to evoke through straight photographs. At that time, William Mortensen, whose "medieval sensibility"[8] led him to imagine scenes that were at once bizarre and amusing to many contemporaries, resorted to montage to create his visions of wickedness and lust (*pl. no. 757*). In the same era, Clarence John Laughlin, bemused by the "unreality of the real and the reality of the unreal," not only worked with montage but created settings, costumed models, and directed scenarios to give form to his conviction that "the physical object is merely a stepping stone to an inner world" (*see pl. no. 500*).[9] Soon after, Edmund Teske combined chemical manipulation with montage to make poignant his sense of the melancholy eroticism of small-town American life.

Uelsmann is one of a group of photographers who, since the 1960s, have consistently used photomontage to create poetic fantasies. Pieced together from an array of his own negatives, his work achieves a seamless merging of the real and the imagined, as seen in an untitled interior with clouds (*pl. no. 758*), which bears an obvious relationship to Magritte's paintings. The complex montages by Japanese photographer Eikoh Hosoe (*pl. no. 759*) reflect their maker's belief that the camera has introduced him to an "abnormal, warped, sarcastic, grotesque, savage and promiscuous world."[10] In like manner, montages by the California artist Robert Heinecken are full of gritty allusions to the sex, and sexism, rampant on magazine pages, billboards, and television screens. Produced on a scale that reinforces their affinity to commercial advertising, his images seem to mix condemnation with a certain sense of wish fulfillment (*pl. no. 760*).

Given the wide acceptance of collage and montage by Surrealist artists in Europe before World War II, it is unsurprising that subsequent generations of European photographers also turned to these means. Psychoanalytical concepts engaged Czech photographers Martin Hruska and Jan Saudek, who are among those who have created dreamlike visions and erotic statements both by staging scenes and by combining images in the enlarger. On occasion their work and that by other individuals concerned with the psyche recall spatial configurations and symbols invented by the painters Salvador Dalí and de Chirico, but their images are also informed by concepts and iconography taken from postwar advertising, popular entertainment, and television.

Montage can serve to extend visual experience beyond that based on a single image taken from one position at one moment in time. Germans Klaus Rinke and Manfred Willman and the Italian photographer Franco Vaccari, among others, combined complete or partial photographs of the same object, place, or individual taken from different vantage points and at different times. Their aim was to suggest the "incomplete, unstable and unending forms that reality assumes,"[11] and to provide images with such large dimensions that they require the viewer to include time as an element in their perception of them. In societies as disparate as Cuba, Egypt, England, Lebanon, Venezuela, and Russia, the dawn of digitization enabled photographers to embrace the possibilities inherent in montage in order to express the profound sense of instability they experienced as their countries grew more chaotic or underwent catastrophic economic and social change.

The extensive use of models acting out scenes in fabricated settings that suggest the irrational content of dreams and visions is another singular change that occurred in photography beginning in the 1960s. Like artists working with montage, photographers engaged in such directorial practices have drawn upon ideas that surfaced earlier

761. RALPH EUGENE MEATYARD. *Cranston Ritchie*, 1964. Gelatin silver print. Collection Jain and George W. Kelly, New York. © The Ralph Eugene Meatyard Estate.

in the century in graphic art and still- and motion-picture photography, upon which they have sometimes layered elements borrowed from popular culture. In constructing their own realities for the camera lens, some alter settings only slightly, while others stage complete fictions, with sets, models, costumes, and action directed entirely by the photographer. As an early example of the former approach, Ralph Eugene Meatyard photographed family and friends posed in unpretentious settings, but here *(pl. no. 761)* the suggestive presence of an empty mirror and a mysteriously clothed dress dummy adds a dimension of psychological disquiet. Elsewhere in his photographs, figures wear masks, and the shapes of shadows and the blurs caused by movement intimate ghostly presences.

Fabricating fictional identities is a time-honored form of creating drama, one that female photographers have been exploring at least since Claude Cahun shaved her head and whitened her lips in the early 1920s. Donned personas are perennially compelling as photographic subjects, a fact perhaps most famously established by Cindy Sherman *(pl. no. 744)*. British artist-photographer Gillian Wearing, too, has worked in this realm to an almost obsessive de-

gree, making use of prosthetic masks and wigs in portraits of herself and others. For these photographers and others working in this mode, such transformations are of course not merely about playful masquerading, but investigations into cultural types and stereotypes, female subjectivity, and the mutability of identity. (It bears mentioning that a number of male artists—from Marcel Duchamp to Stan Douglas to Yasumasa Morimura—have undertaken similar inquiries.)

A few photographers have given themselves the ambitious task of inventing entire worlds with alternative histories to the one we know. *The Fae Richards Photo Archive (pl. no. 762)*, Zoe Leonard's collaboration with filmmaker Cheryl Dunye, charts the life of a fictional African American actress, born in the early 20th century, through her involvement in the civil rights movement to her old age. The "archive" is entirely plausible—including everything from 8 x 10 glossies of the make-believe actress to her photobooth portraits and family snapshots—perhaps prompting the question, how many real women's lives have been obscured in the fog of history? Addressing similar issues about the truthfulness of photography, archive fabulist

762. ZOE LEONARD. *The Fae Richards Photo Archive*, 1993–96. Gelatin silver prints and chromogenic prints with typewritten text on paper. Courtesy Galerie Gisela Capitain/Hauser & Wirth. © Zoe Leonard.

763. JOEL-PETER WITKIN. *Expulsion from Paradise of Adam and Eve, New Mexico*, 1981. Toned gelatin silver print © Joel-Peter Witkin. Courtesy Pace/MacGill Gallery, New York; Fraenkel Gallery, San Francisco.

764. M. Richard Kirstel. From
Water Babies, 1976. Gelatin silver print.
Courtesy and © M. Richard Kirstel.

765. Stéphane Couturier.
Toyota No. 19, Melting Point, 2005.
Digital montage, color print. Courtesy
Stéphane Couturier/Laurence Miller
Gallery, New York.

Joan Fontcuberta has provided photographic "evidence" of such fantasies as botanical and zoological chimeras *(pl. no. 771)*, nonexistent photo works by Picasso and other Spanish painters, and Soviet space missions that never actually took place.

A number of photographers—including M. Richard Kirstel *(pl. no. 764)*, Les Krims, Laurie Simmons *(pl. no. 745)*, Arthur Tress, and Joel-Peter Witkin in the United States, and Paul de Nooijer, Bernard Faucon, and Jan Saudek, along with Fontcuberta, in Europe—have created fantasies that are entirely invented. Krims used the iconography of both Surrealism and Pop art in his sardonic, at times horrifying, statements about middle-class life in modern America, while Tress (who worked in this mode as well as with montage beginning the 1970s) brought a sensibility that ranged from the morbid to the whimsical to his dramas. Faucon has devoted considerable time to creating backgrounds and settings, fabricating figures, and managing lighting effects for energetic works that draw upon popular entertainments for their humor. Witkin's macabre—sometimes downright grisly—arrangements of costumed or bare human figures, or of corpses or body parts, are usually freighted with historical or mythical attributes, as in *Expulsion from Paradise of Adam and Eve (pl. no. 763)*; while his work can be viewed as terrifying, it also evinces an element of humor.

In the past, creating photographic fabrications in the darkroom could be extraordinarily time-consuming, but the computer has greatly simplified the process *(see A Short Technical History, Part III, and Chapter 13)*. Straight camera images can be easily juxtaposed or layered in the computer and then further manipulated to create works that seem at first glance less like photographs than like Expressionist paintings, as do montages by French photographer

766. DENIS BRIHAT. *William Pear*, 1972. Gelatin silver print. Courtesy and © Denis Brihat.

767. JEAN DIEUZAIDE. *My Adventure
with Pitch*, 1958. Gelatin silver print.
Courtesy and © Jean Dieuzaide.

768. LUCIEN CLERGUE. *Nude*, 1962.
Gelatin silver print. Worcester Art
Museum, Worcester, Mass.
© Lucien Clergue.

769. Hiroshi Sugimoto. *Conceptual Form 0036*, 2004. Gelatin silver print. Courtesy Sonnabend Gallery, New York.

Stéphane Couturier *(pl. no. 765)*. These large-scale images, initially photographed in the interior of a Toyota factory in France and then altered digitally, also capture the sense that industrial work no longer depends on the relationship of man to machine, and indeed is no longer purely mechanical.

Whatever the means used to produce them, however the elements are arranged and lighted, whether they deal with classical psychoanalytic symbolism or idiosyncratic combinations of objects and figures, whether they rely on formal appeal or contain ideological messages, the effectiveness of the resulting images depended in the past on whether the viewer believed that what appears in a photograph has to be truthful, at least to a degree. In the digital age, and as fantasy pervades advertising and motion picture imagery to a much greater extent than before, the notion of unreality in still photographs has become greatly more acceptable, and even expected.

Of course, staging photographs does not invariably result in conceptual, fantastic, or grotesque imagery, as photographs of both still lifes and the nude prove. Denis Brihat, one of the founders of the French photography group Expression libre, brought out the commonalities between flesh and stone by carefully positioning the fruit in *William Pear (pl. no. 766)* and by intervening in the chemical processing. Similarly, in a series titled *My Adventure with Pitch*, Jean Dieuzaide photographed the abstract shapes and forms suggestive of human anatomy

(*pl. no. 767*) produced by the manipulation of this coal by-product. Lucien Clergue (another founder of Expression libre) posed nude models in a landscape of sea and sand for close-up views that ostensibly are evocations of earth goddesses (*pl. no. 768*). In one of his many meditative serial projects, Hiroshi Sugimoto took mechanisms that once served as teaching models for engineering students and, through lighting and close-up, imbued them with a mysterious and elegant presence (*pl. no. 769*).

Nearly all still-life images are the result of some level of prearrangement or staging. Usually their objectives are fairly simple: to make an aesthetic statement unencumbered by political or social issues. However, they may have more than aesthetic aims. Those by Michiko Kon (*pl. no. 770*),

which consist of strange conjunctions of organic matter—fish scales, vegetables—arranged at times in the form of ordinary garments, may be simply banal statements (we are what we eat), or they may suggest a more profound relationship between organic and manufactured entities.

The staging of scenes for the camera has been influenced not only by print advertising but also by cinema and television, so it is logical that photographers have sometimes given their productions greater impact by installing them in specific configurations, as Fontcuberta has done. In addition to exhibiting in galleries and publishing in book format, Nan Goldin (*pl. no. 698*) projected slide shows of her photographs in prearranged sequences accompanied by words and music. Lorie Novak, using a number

770. MICHIKO KON.
Dress of Peas, 1994.
Gelatin silver print.
Robert Mann Gallery,
New York.

of projectors, combined images of personal history and public events. In installations by other photographers, objects and images of all sorts—newspaper clippings, stuffed animals, snapshots, bits of clothing—have been hung on walls or on specially built structures to create a nuanced environment that might convey a personal or political message, as in work by French photographers Christian Boltanski *(pl. no. 772)* and Annette Messager.

Gregory Crewdson, in series such as *Twilight* (1998–2002) and *Beneath the Roses* (2003–8), created decidedly cinematic scenarios and moods, building elaborate sets and hiring actors and crews of up to a hundred people. The tenor in his images is both menacing and uncanny, evoking the films of Alfred Hitchcock and David Lynch, both of whom Crewdson credits as influences *(pl. no. 773)*.

The power of theater can also be deployed photographically to make a forceful political comment. In his installation project *The Eyes of Gutete Emerita*, Chilean artist Alfredo Jaar considers the atrocities of the 1994 genocide in Rwanda. Rather than images of carnage, the violence is described—in one iteration of the work—in texts displayed on a light box. In sequential transparencies, viewers read that the young Gutete Emerita witnessed the murders of her husband and two sons; finally, they are confronted with two slides showing her wary eyes *(pl. no. 774)*. Jaar first conceived this installation in a different, but equally insistent, configuration: as a large light table covered with one million slides, each one holding the image of Emerita's eyes. Such expedients suggest that, for some artists, dealing with profound and difficult themes such as

family life, sexuality, or violence is beyond the scope of direct documentation and the single image.

The various methods and procedures used to give form to a landscape of the imagination often overlap. Collages and montages at times include negative and positive versions of the same or different photographs; some elements may be distorted, or solarized (a technique for partially reversing the tonality of the negative by exposing it to light during development). Photographers who use these techniques have often manipulated the chemical development process to make the image foggy or grainy, or they have added tone to it.

All these interventions and many more besides can now be made using computers and specialized programs, allowing the photographer greater means to assert the right to make imaginative or conceptual as well as realistic statements with the camera. This attitude toward the medium can be traced back to the work of Julia Margaret Cameron, Oscar Gustav Rejlander, and Henry Peach Robinson in the 19th century, even though these forerunners could not possibly have imagined how the means to express an engagement with imagination would expand.

The New Era of Color Photography

An especially significant transformation of camera imagery since the 1960s was the increase in the number of creative photographers working with dye-color materials. Improvements in color film and processing during the last decades of the 20th century resulted in the predominance

773. GREGORY CREWDSON. *Untitled*, 2003–5. Digital chromogenic print. Courtesy Gagosian. © Gregory Crewdson.

774. ALFREDO JAAR. *The Eyes of Gutete Emerita*, 1996. Quad-vision light boxes with color transparencies. Courtesy and © Alfredo Jaar.

775. ARTHUR SIEGEL. *Untitled (Drycleaners)*, 1946. Color (chromogenic development) transparency. Courtesy Edwynn Houk Gallery, Chicago. © The Siegel Estate.

of color imagery, first for advertising and publicity photographs, and eventually for personal expression. The absence of color in photographs had been regretted by many from the beginning; hand-coloring was considered not just acceptable but essential to enliven the pallid tones of daguerreotype and paper portraits, as well as some scenic views. Because both photographers and the public believed that images in color were more artistic and more natural, efforts to find workable color processes occupied individuals throughout the latter part of the 19th century.

When the Lumières began to market Autochrome in 1907, it was immediately successful *(see pl. nos. 342–52)*. The chromatic effects achieved on Autochrome plates were the result of adding starch granules stained with dyes to silver emulsion on glass. Later experiments to improve and simplify color photography were based on a different theory *(see A Short Technical History, Part II)*, but they, too, involved the incorporation of dyes with silver. However, by the time a practicable dye-color film appeared on the market (three-color Kodachrome and Agfacolor Neu in 1936, followed by Ektachrome in 1946), the aesthetic of photography had changed. Most creative photographers of the time favored straight images of reality and found the opulent colors of the dyes used in film unsuitable for the depiction of the landscape, the documentation of social conditions, or even the conjuring up of subjective feelings. As a result, early color film was used primarily by amateurs and advertising photographers.

While most documentarians and aesthetic photographers ignored (or deplored) color photography, and snapshot amateurs seemed content with its cheery colors during the 1940s and '50s, the advertising community was determined to explore the potential of color for making "the implausible plausible."[12] Arriving on the scene during the severe economic depression of the 1930s, color film was regarded as a way to glamorize images of hard-to-sell products. By coupling real and unreal, by creating abstractions and surreal statements, and by giving consumer goods an attractive gloss, these early enthusiasts of commercial color helped establish a direction for

776. HARRY CALLAHAN. *Chicago*, 1951. Dye-transfer (dye-imbibition) print. Pace/MacGill Gallery, New York. © Harry Callahan.

work in color. Since the 1960s, large numbers of photographers primarily concerned with self-expression have widely expanded the boundaries of color photography, with new digital processes adding new potentials to their investigations.

Given the emphasis on abstraction in American visual art of the immediate postwar period, it is not surprising that of the few noncommercial photographers who did experiment with color film in the early years, several were most intrigued by its formal possibilities rather than its descriptive ability. In a 1946 semi-abstraction *(pl. no. 775)*, Arthur Siegel treated the red neon tubing as an element in an allover linear pattern—a visual metaphor of nervous energy that not only evokes the tensions of modern urban life but also suggests the calligraphic style of certain Abstract Expressionist painters. The subdued tonality of the image compared with what is currently possible suggests the limitations with which the early color enthusiasts had to work. Seemingly more illusionistic in terms of its depiction of space is Harry Callahan's color image *(pl. no. 776)* that plays off blocks of intense blue-green, black, and reds in a mun-

dane view of a street stall, giving pleasure with its geometric simplicity and its color contrasts.

The natural landscape rather than the built environment engaged the interest of several early noncommercial color photographers. Color film enabled Eliot Porter *(pl. no. 777)* and Charles Pratt, for example, to create formally satisfying images and at the same time to capture the array of colors found in foliage and rocks under varying conditions of light. Porter, who began his career as a naturalist photographer of bird life, often emphasized the delicate tracery of patterns and colors in foliage and grasses. As color materials improved, a greater number of those drawn to the natural world as subject turned to color as a vehicle for their statements about either its beauty or its destruction.

In the 1970s, interest in abstraction among a small group of European and Asian photographers was moderated by an attachment to the real world and a desire to celebrate its wonders in a fresh way. Landscapes by Italian photographer Franco Fontana that may on first glance appear to be abstractions reveal themselves on closer

777. ELIOT PORTER. *Red Bud Trees in Bottomland near Red River Gorge, Kentucky*, 1968.
Dye-transfer (dye-imbibition) print. Daniel Wolf, Inc., New York. © Eliot Porter.

778. FRANCO FONTANA. *Landscape*, 1975. Color (chromogenic development) transparency. Courtesy and © Franco Fontana.

779. RUTH ORKIN. *Balloon*, 1977. Gelatin silver print. © Estate of Ruth Orkin.

inspection to be fields of wheat *(pl. no. 778)*, flowers, up-turned soil, roadways, or sky and water. His countryman Luigi Ghirri brought a deadpan wit and an astute color sensibility to his investigations into the humor and magic inherent in banal instances *(see pl. no. 710)*. On the other side of the world, Hiroshi Hamaya of Japan and Grant Mudford of Australia exemplify photographers who handle color as an element both of nature and of art, seeking moments when light creates extraordinary chromatic happenings. The colors in Ruth Orkin's views from the window of her New York apartment evoke the beauty of atmospheric and seasonal change in nature as reorganized by the human hand *(pl. no. 779)*. As the natural landscape shrinks from the sight of most urban dwellers, it continues to attract photographers. Images by Thomas Struth, such as *Paradise 34 (pl. no. 743)*, assert their presence through their discriminating attention to the multiplicity of detail, the elegance of nature's colors, and their grand scale.

Influenced by the pervasive interest in popular culture that has continued unabated since the 1970s, many photographers turned to color to express their reactions to the consumerist emblems of American middle-class life—automobiles, eating places, swimming pools, supermarkets, advertising, and street signage. Among them is William Eggleston, who was singled out by John Szarkowski (longtime curator of photographs at the Museum of Modern Art) as the individual responsible for virtually inventing color photography.[13] Eggleston used color film to scrutinize the deserted streets, detritus, and abandoned cars in his home environment in the South *(pl. no. 780)*. Others who, like Eggleston, produce what may seem at first glance to be a color catalog of visual facts of the American scene include William Christenberry, who since 1960 has documented in color the changes wrought by time on his surroundings in Alabama. While color work by Joel Meyerowitz encompasses a broad range of street activity, his series of Cape Cod views *(pl. no. 781)* also used the potentials of color to reveal the changing effects of light on a single built structure. The color in Stephen Shore's depictions of city streets and buildings throughout the United States *(pl. no. 782)* lends these banal entities a degree of interest that would otherwise be lacking.

780. WILLIAM EGGLESTON. *Memphis, Tennessee*, 1971. Dye-transfer (dye-imbibition) print. Middendorf Gallery, Washington, D.C. © William Eggleston.

781. JOEL MEYEROWITZ. *Porch, Provincetown*, 1977. Ektacolor (chromogenic development) print. Courtesy and © Joel Meyerowitz.

782. STEPHEN SHORE. *Beverly Boulevard and La Brea Avenue, Los Angeles, California*, June 21, 1975. Ektacolor (chromogenic development) print. Courtesy and © Stephen Shore.

783. MITCH EPSTEIN. *Pushkar Camel Fair, Rajasthan, India*, 1978. Ektacolor (chromogenic development) print. Courtesy and © Mitch Epstein.

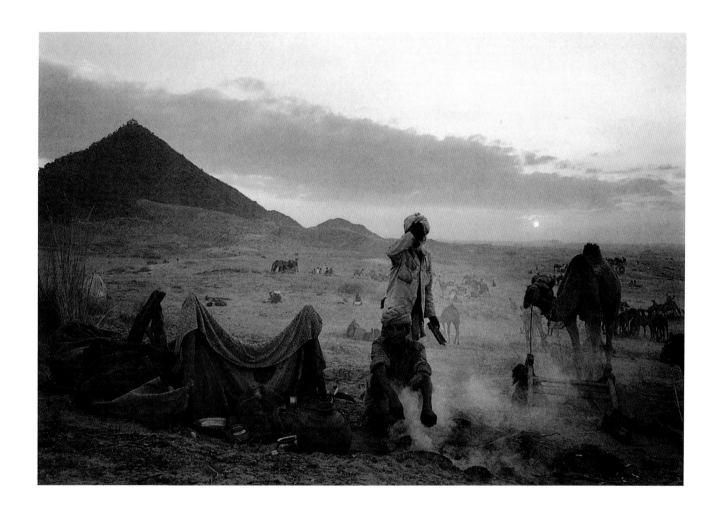

784. KISHIN SHINOYAMA. *House*, 1975. Color (chromogenic development) transparency. © Kishin Shinoyama/Pacific Press Service.

That dye-color materials tend to cast a rosy tint over landscape and urban scenes is evident in works by Mitch Epstein, Len Jenshel, and Joel Sternfeld, among others. Contrasting the muted grays and browns of the terrain and buildings with the ethereal glow of the setting sun *(pl. no. 783)*, Epstein views the landscape of India as a stage setting for exotic effects, thus continuing in color a tradition established during the 1850s in black-and-white photographs of the Near and Far East. In the same sense, the stylish hues of the interiors by Japanese photographer Kishin Shinoyama seem to exude a romantic aura *(pl. no. 784)*. These colorful works, along with such images as Meyerowitz's *Cape Cod* and *St. Louis Arch* series, have invited comparison with the glossy ads and color pages in travel magazines. In terms of lushness of color, the results of today's digital printing processes rival these, as seen in the chromogenic prints of Dubai photographer Lamya

Gargash, who brings a formal incisiveness to interiors of homes and hotels in her homeland, all in saturated hues *(pl. no. 785)*.

A somewhat different approach to color can be seen in the work of photographers who play up less pleasing contrasts between the natural and the manmade. David T. Hanson, David Maisel, Richard Misrach *(pl. no. 786)*, and Barbara Norfleet *(pl. no. 787)* are among the many who have found that color film can reveal the depredations caused by the dumping of industrial waste in the natural landscape.

Another aspect of the phenomena brought on by advancing industrialism is addressed in color photographs by Candida Höfer, who reveals the tedium of institutional life in the uniformly somber tones of the lecture halls, libraries, and lobbies she documents. Andreas Gursky photographs emblems of consumption, such as stock-market

785. LAMYA GARGASH. *Pink Ninja*, 2005–7. C-print. Courtesy Lamya Gargash/The Third Line.

trading floors and giant supermarkets, and enhances the images digitally to create statements about the overabundance of contemporary life in advanced industrial nations.

Controlling the color, whether by physical, chemical, or digital means, gives the photographer one more expressive tool in handling his or her chosen subject matter. This is as true of still life and portraiture as it is of the natural scene or the built environment. Those who mainly depended on physical and chemical means include Jan Groover, whose intelligent handling of form is apparent in her tabletop still lifes made in the 1970s and '80s *(pl. no. 788)*.

The illustrative settings and highly saturated hues that characterize Neal Slavin's group portraits lend a sprightly note to works that parody both commercial group portraiture of the past and the confabulations of television ads. Today, portraitists with very different agendas use a wide range of color materials to make their points; among the many are Argentinian photographer Gaby Messina, who photographs the elderly at home, and the American Jen Davis, who uses self-portraiture to counter stereotypes about those who are greatly overweight. Katy Grannan, who has worked in both photography and film, investigates color to great effect in projects such as *The 99* and *Boulevard*, for which she has photographed strangers, printing their likenesses at grand scale.

Color and photographic manipulations work well together. Indeed, whether color is achieved by using dye-color films and prints, by employing historical processes such as Fresson (a complicated gum process), gum bichromate, and cyanotype, by hand-tinting images, or by selecting hues from among the millions available in computer programs, it usually heightens the aesthetic and affective impact of these creations, as can be seen in a range of examples from the past several decades. Olivia Parker transforms

786. RICHARD MISRACH. *Flood, Salton Sea*, 1983. Chromogenic dye-coupler print. Robert Mann Gallery, New York.

787. BARBARA NORFLEET. *Catbird and Bedspring Debris*, 1984. Cibachrome print. Courtesy and © Barbara Norfleet.

788. JAN GROOVER. *Untitled*, 1979. Type-C (chromogenic development) print. Blum Helman Gallery, New York.

789. OLIVIA PARKER. *Four Pears*, 1979. Polacolor (internal dye-diffusion transfer) print.
Marcuse Pfeifer Gallery, New York. © Olivia Parker.

790. LUCAS SAMARAS. *March 19, 1983*, 1983. Polaroid (internal dye-diffusion transfer) prints.
Pace Wildenstein Gallery, New York. © Lucas Samaras.

791. Barbara Kasten. *El Medol, Roman Quarry, Tarragona, Spain*, 1992. Digital photo painting on vinyl acrylic, back-lit. Courtesy and © Barbara Kasten.

792. Richard Mosse. *Colonel Soleil's Boys*, 2010. Digital c-print. Courtesy Richard Mosse/Jack Shainman Gallery, New York. © Richard Mosse.

793. Janice Mehlman. *Veiled Emotions*, 2017. Pigment print on watercolor paper. Courtesy and © Janice Mehlman.

ordinary objects by isolating and attaching them to other objects—for example the bright red cords that contrast sharply with the muted tonalities of her decaying pears *(pl. no. 789)*. By massaging the wet emulsion of Polaroid film, Lucas Samaras created lurid dripping colors to accentuate erotic fantasies *(pl. no. 790)*; today such effects are more easily created digitally. Similarly, the vibrant colors in Barbara Kasten's early architectural and natural scenes *(pl. no. 791)*, which resulted from her use of tinted filters and gels to transform mundane structures into chromatic extravaganzas, can now be accessed on the computer. Irish artist Richard Mosse *(pl. no. 792)* utilizes infrared film to introduce jarringly garish tints to landscapes, compelling viewers to consider these vistas—places of violence, or sites vulnerable to ecological devastation—literally in a new light.

For a period, the revival of interest in historical processes prompted some contemporary photographers to bypass problems associated with dye-color materials by turning to hand-tinting. Whether subtle, as in the work of Christopher James, one of the leading figures in revitalizing old photographic processes, or strongly chromatic, as in images by Janice Mehlman that reveal a tenuous balance between painting and photography *(pl. no. 793)*, this was one method of transforming the mechanically produced photographic object into a unique entity. Turn-of-the-century processes such as Fresson printing were taken up by French photographer Bernard Plossu and American Sheila Metzner. Others, among them Betty Hahn *(pl. no. 797)* and Bea Nettles *(pl. no. 799)*, favored gum bichromate (another Pictorialist printing preference) in combination with other manipulations. Adopting such processes allowed photographers to project images onto canvas and to use bleaching agents, pastels, and tinting colors to achieve their ends.

In the hands of creative photographers, color can be romantically nuanced, bellicose, eerie, chic, or sensuous, but for a long time it rarely was considered to be *real* looking. In fact, in the past, photographs of real situations in color were believed to have an aura of ambiguity, triggering an element of distrust on the part of viewers, perhaps because the saturated dyes of color film seemed to have an equivocal relationship to the harsher realities of social conditions or actual life. Changes in taste—resulting at least partly from the fact that virtually all video transmissions and movies, as well as images used in advertisements, are in color—have made its use in socially oriented documentation and photojournalistic images greatly more acceptable. Bruce Davidson, Saul Leiter, Helen Levitt, and Danny Lyon were among the early users of color film to encapsulate their perceptions of the urban street scene. In her color images, Levitt captured dissonances and harmonies, focusing on the contrasts between the drab tenement backgrounds and the lively colors of the clothing worn by her working-class subjects. The hues in Davidson's subway pictures are sometimes lurid and sometimes pretty, giving an edginess to the gestures and expressions of New York's underground riders. Like several others, Davidson eventually returned to black and white, preferring the expressive possibilities of panoramic format and optic distortion to strident color.

That color became acceptable to photographers who documented social realities was in part due to the ubiquity of color images in magazines and newspapers. Both the dye-color films that were perfected just before World War II and improved printing materials and processes enabled the media to employ greater numbers of color images. This is not to suggest that magazines had not printed color photographs before this time. In fact, in the 1910s some magazines, notably *National Geographic*, regularly featured color reproduction from Autochrome plates. In general, though, color processes and the methods of making engraved or lithographic color plates for periodicals were too expensive and too time-consuming for popular periodicals. The color images made by several of the Farm Security Administration photographers, for example, were not felt to be evocative enough, in contrast to their work in black and white, to warrant the expense of reproducing them in print media. *Life* magazine reproduced its first picture story in color—a series of views of New York by Ernst Haas—only in 1952. A former painter, Haas found color to be an inspiring tool for "transforming an object from what it is to what you want it to be."[14]

During the 1970s and '80s, color film improved and magazines were even more willing to print in color, prompting greater numbers of photojournalists to use this material to express a wide range of perceptions about the actualities framed by their viewfinders. Color images of disasters, from scenes of war's ravages to those of nature's destructive forces, became commonplace, and now are seen even in daily newspapers. Color added a compelling dimension to both Larry Burrows's images of Vietnam and Susan Meiselas's photographs of the Sandinista uprising in Nicaragua *(pl. no. 794)*. Maggie Steber and Alex Webb are just two of the well-regarded American photojournalists who have transformed reportage by using color. That color might alter the effect of the image is attested by Brazilian photographer Miguel Rio Branco, who held that his initial social interest in the realities his camera recorded in the Maciel district of Salvador was transformed by color into something more aesthetically oriented *(pl. no. 795)*. Recently, some photojournalists, among them Paolo Pellegrin, photographing the civil turmoil in Darfur *(pl. no. 796)*, and Eugene Richards, documenting conditions in various prisons and mental wards in Latin American countries *(see pl. no. 690)*, have opted to return to black and

794. SUSAN MEISELAS. *Nicaragua*, 1978. Color (chromogenic development) transparency. © Susan Meiselas/Magnum.

795. MIGUEL RIO BRANCO. *Prostitutes of Maciel, Salvador, Brazil,* 1976. Color (chromogenic development) transparency. © Miguel Rio Branco/Magnum.

796. PAOLO PELLEGRIN. *Women Waiting for Food Rations, South Darfur, Sudan*, 2004.
Gelatin silver print. Magnum Photos, New York.

white to better convey the starkness of the events before their lenses. But there is little question that documentation in color will continue to predominate.

Photography and Printing Technologies

The conjoining of photographic and mechanical printing processes was contemplated from the medium's inception; with the development of photogravure, Woodburytype, heliotype, and the process half-tone plate, it became an accomplished fact. The later addition of screen printing and, more recently, the perfection of more sophisticated electronic reproduction methods, along with the involvement since the 1920s of photographers in advertising and journalism, have made the reproduced camera image part of a vast network of utilitarian images taken for granted in contemporary societies. It also should be recalled that printing photographs on materials other than sensitized paper was a common practice during the latter part of the 19th century, when camera images appeared on glass, porcelain, tile, leather, and fabric, usually as part of the process of manufacture.

Around the 1960s, attitudes about printing changed as photographers themselves became involved in using mechanical and electronic processes rather than just allowing printing firms to effect such transformations. The interest in "process as medium"[15] led to images being printed on various unlikely materials and to procedures not intrinsic to photography. Print technology became valued by creative photographers less for its ability to reproduce images than as a means to produce unique objects that often depended primarily on the processes used for their aesthetic interest. This changed attitude toward mechanical and, eventually, electronic printing might also be viewed as an aspect of a new brand of Pictorialism, in that the images are meant not as utilitarian objects—that is, advertising or political posters—but primarily as unique artifacts.

The ease with which established mechanical printing processes could be manipulated led many photographers, starting in the 1960s, to explore etching, engraving, lithography, and screen printing. The capacity of photoetching to retain an aura of reality while avoiding verisimilitude was recognized by both photographers and graphic artists. Naomi Savage, who worked with this technique, was

797. BETTY HAHN. *Road and Rainbow*, 1971. Gum bichromate on cotton with stitching.
Courtesy and © 1971 Betty Hahn.

interested in changes in coloration obtainable from printing intaglio plates in ink. Thomas Barrow *(pl. no. 798)*, Scott Hyde, William Larsen, Joan Lyons, Bea Nettles *(pl. no. 799)*, Robert Rauschenberg, Todd Walker, and Andy Warhol *(pl. no. 804)*, among numbers of other Americans, were involved with photolithography and screen printing—processes well suited to reproducing straight photographs, collages, and montages on a variety of materials. For a brief period, until computer-generated laser printing took over, electronic techniques such as xerography, Kwikprinting, and Verifaxing appealed to photographers interested in modern replicative technologies, in part because, unlike offset printing, they were easily accessed. They also produced a dot pattern that served almost as *facture* does in handmade works of art—proclaiming the distance between reality and the image. The resulting photographs could be additionally manipulated to achieve unusual effects by folding, stitching, quilting, or shaping into irregular three-dimensional forms.

The authors of works that employed such nonphotographic processes were often making the point that valid camera expressions need not be limited to the modernist canon of straight silver images. Betty Hahn, for example, made use of mechanically produced images embellished with age-old handcraft *(pl. no. 797)* and employed early photographic processes such as bichromate and cyanotype. Experimentation with processes embraced a range from fairly direct methods of offset lithography and dichromate printing to complex amalgams of screen printing, pencil, and brush marks laminated to unusual supports such as handmade papers or aluminum sheets. Beginning in the 1960s, Rauschenberg *(pl. no. 803)*, for instance, produced a large body of work that merged procedures traditionally associated with the so-called fine and mechanical arts, breaking down the separate categories formulated by modernist theory.

Digital Imaging

Photography's ability to document events and to promote the material goods of the expanding globalized industrial world has been enormously expedited by the development of digital cameras, computers, scanners, and laser printers *(see Chapter 13)*. By the end of the 1980s, digital

798. THOMAS BARROW. *Films*, 1978. Photolithographic print. Art Museum, University of New Mexico, Albuquerque. © Thomas Barrow.

799. BEA NETTLES. *Tomato Fantasy*, 1976. Kwikprint. International Museum of Photography at George Eastman House, Rochester, N.Y. © 1976 Bea Nettles.

800. LARA BALADI. *Sandouk el Dounia (The World in a Box)*, 2001. Color photomontage. Courtesy and © Lara Baladi.

imaging had emerged as a transformative technology, welcomed in fields of advertising, cinema, journalism, and the medical and physical sciences *(see A Short Technical History, Part III)*. Attracted by the new range of potential effects, artist-photographers began to comprehend the ease with which disparate elements of reality and fantasy, as well as myriad colors, could be combined. The computer could now serve as a storehouse; almost any image, whether photographic or hand-drawn, in black and white or in color, from virtually any public and many private sources, could be scanned, digitally combined, and recombined with itself or others and printed on papers, fabrics, and other materials.

In advertising and filmmaking, digital techniques allowed elements from different times and places to be put together and multiplied within a picture, irrelevant or undesired parts to be removed, and the almost infinite numbers of colors and shapes available to be ordered and reordered. This restructuring of reality could, it was found,

take place with greater speed than the older methods of photographic special effects could ever make possible.

Initially, however, the use of digital methods in photojournalism was seen as problematic because viewers expected news images to be factual and unmanipulated. Of course, the idea that photographs of newsworthy events have ever been entirely objective has been challenged by contemporary commentators, who point out that since the camera image translates a three-dimensional real world into a two-dimensional arrangement of tonalities—within frames selected by the photographer—its relationship to reality is inevitably subject to interpretation and distortion. Objectivity is even further undercut because photojournalists, editors, and government representatives have particular points of view that govern their production and use of camera images.

Digitizing is certainly not the first technique used to alter or falsify news photographs.[16] However, in the past,

801. MARTINA LOPEZ. *Revolutions in Time, 1,* 1994. Cibachrome print. Schneider Gallery, Chicago.

montaging and retouching were slow and costly processes, whereas current ways of confounding truth by digital manipulation are immeasurably more efficient, less obvious—and hence more tempting. Immediately after digital imaging became possible, reputable journals such as *National Geographic* discovered the ease of being able to reposition elements within a photograph; famously, in a 1982 cover picture of a Giza horizon, one of the Egyptian pyramids was moved closer to another simply to fit a vertical rather than horizontal format. Fiddling with images can have more serious consequences, as attested by the outcry that greeted the digital darkening of African American football celebrity and murder suspect O. J. Simpson on a 1994 *Time* magazine cover. Tabloid magazines have routinely appended heads to bodies not their own or added figures and objects to make their pictures more enticing. For those critics who believed that journalism is rarely truthful anyway, the digital altering of news images posed little increased threat, but others recognized that the fictions made possible through this technology would require ever more sophisticated scrutiny by viewers determined to filter the false from the true in the news. The arrival of the computer software Photoshop, created in 1988 by software engineers Thomas Knoll and John Knoll, made it obvious that every photograph, even those

not created digitally, could be easily and effectively manipulated by nonprofessionals as well as experts. Conversely, by allowing photographers to edit their own images and texts, computerization allows them greater control over how their work is used.

Early efforts to incorporate digital technology into photography depended in great part on scanning—the electronic duplication of an image that was then entered into a computer and could be, with the proper program, altered. Soon, however, digital cameras were designed to produce images that can be downloaded directly to the computer, thereby obviating the need for scanning. This advance in technology has had a tremendous impact on photojournalistic practice, and indeed on the entire news industry. What once was termed the "news cycle," the pace of which was governed by the daily publication of print newspapers, has been transformed to a 24-hour phenomenon, in which images, information, and of course misinformation are instantaneously disseminated.

Many artist-photographers have been attracted to digital imaging because of its ease of manipulation and startling range of expressive possibilities. As discussed, montage, which has long been favored by camera artists, can draw on many choices of imagery through scanning, while computer programs afford great flexibility in dealing

with tonality, color, and sharpness. Esther Parada, a pioneer of digital manipulation, used scanned and digitally produced images that were printed by ink-jet method on large panels in works that often challenge preconceptions about historical events in the United States and Latin America. In the early 1990s computerized imagery in the service of cultural and political ideas attracted a range of photographers, among them the British artist Roshini Kempadoo, whose images often comment on complex social institutions. In a 9 x 12 foot photomontage, Egyptian artist Lara Baladi assembled hundreds of images that express her sense of the frenetic character of women's roles in popular culture today *(pl. no. 800)*.

In this period, new software programs allowed for the creation of synthetic realities, such as those by Manual (the husband-and-wife team of Suzanne Bloom and Ed Hill), who combined photographic images, digital animations, and video in three-dimensional installations dealing with technology's intrusion into a natural Eden. Nancy Burson's early interest in digital technology led her (some-times in collaboration with husband David Kramlich) to experiment with morphing and layering images together, as means of examining issues of race and categorization *(pl. no. 802)*. Commentary on contemporary capitalist culture can be discerned in the large-scale prints of allover images, made with the aid of the computer, by Andreas Gursky and Stéphane Couturier. Of course the computer is capable of serving more personal ends as well. In montages made by Martina Lopez in the mid-1990s, the gestures and expressions visible in 19th-century portraits were scanned, reassembled, and placed digitally within fabricated landscapes *(pl. no. 801)* to create a dreamlike personal history.

When digital images first appeared, the question of whether they should be called *photographs* arose. Digital methods of rendering images are conceptually closer to creating paintings or works of graphic art than to the conventional notion of making a photograph. In dealing with representations of visible reality, painters have traditionally reorganized the scene and restructured elements of color and design, according to their individual sensibilities. They

802. NANCY BURSON. *Untitled*, 1988. Digitally produced from a gelatin silver negative shot from the computer screen. Courtesy and © Nancy Burson.

803. ROBERT RAUSCHENBERG. *Kiesler*, 1966.
Offset lithograph. Museum of Modern Art,
New York; John B. Turner Fund.

are free to transform the image as they work to resolve coloristic, expressive, and spatial problems. The conventionally produced photograph, per se, is a more or less frozen entity once it has been captured on film; to change the image substantially required manipulations akin to those associated with the graphic arts. Even handmade collages and montages ultimately become fixed objects.

By contrast, digitally generated imagery is constantly and infinitely mutable. Digital colors and forms can be shifted unendingly; even after being printed, they exist in the computer as changeable electronic impulses rather than as elements of a fixed image. Furthermore, digital pictures now surround us in such quantities that we relate to them differently, value them differently. Because virtually any image can be scanned or otherwise digitized, plagiarism and copyright are matters of great concern—yet while the increased propensity to adopt and adapt material generated by others has elicited considerable comment, there has been little resolution.

Painting and Photography

In the course of its first century and a half, the camera-generated image assumed unparalleled importance—showing us both the grandeur and the degradation of our land, the demeanor of our elected representatives, the violence of war, the beauty of family and community—in short, giving us countless insights into the conditions of life. Does the advent of digital imaging mean the death of photography as we knew it? Despite dire prophecies, painting did not "die" when many of its functions were taken over by the camera after 1839. It did, however, change form and shed some of its traditional roles—and many of those changes were clearly caused by the presence of the camera.

From the moment it was invented, photography helped artists by making factual information available; before long it was transforming the way artists treated the organization of form and space. In the 19th century, photographs made in the street with short-focal-length lenses revealed real life to be casually cluttered rather than hieratically composed of discrete elements. When the rectangular frame of the photographic plate sliced through figures, structures, and events with little respect for the tidiness of classical composition, artists considered new ways to depict life around them. Employing strategies that gave their work a naturalistic vivacity, they represented scenes from unusual angles, included portions of figures cut off by the edge of the canvas or paper, or reproduced events as though the participants had been surprised in the midst of activity. At the same time, this acknowledgment of the natural world's chaos was accompanied by the emergence of works of art that represented figures and objects with *diminished* illusion of three-dimensionality, at times flattened and abstracted into shallow pictorial space. Like the Japanese woodblock prints that arrived in Europe starting in the 1860s, photographs exerted a telling influence on both Realist and Impressionist painters.

During the early 20th century, this cordial if not readily acknowledged relationship between painting and photography continued and actually became more intimate in some respects. Although some artists adamantly denied the aesthetic potential of photography, American painters as precise in style as Charles Sheeler and as tonally oriented as Edward Steichen worked with equal dedication in both media; ironically, the former eventually elevated painting and the latter photography to a favored position. In Europe during the 1910s and '20s, Dadaists, Futurists, and Constructivists went even further, transforming scientific photographs such as the stop-motion studies by Etienne Jules Marey and Eadweard Muybridge into images expressive of the tempo and energy of modern

804. ANDY WARHOL. *Red Elvis*, 1962. Acrylic and screen print on linen. Galerie Bruno Bischofberger, Zurich. © 2019 The Andy Warhol Foundation for the Visual Arts, Inc./Licensed by Artists Rights Society (ARS), New York.

life. Some artists even began to combine graphic and photographic material in the same works, calling for an end to established terminology and concepts based on traditional divisions among media and forecasting renewed interest in this amalgam—which would take place with greater insistence in the later years of the 20th century and onward.

Photography and painting assumed more distinctive identities during the mid-century flowering of Regionalism, Social Realism, and, later, Abstract Expressionism, but in the 1960s the cross-fertilization resumed. As the most ubiquitous emblem of mass culture, photographs were embraced by those intent on repudiating the elite character of Abstract Expressionism, and so they found an obvious place in Pop art. To cite only a few examples, Larry Rivers and Robert Rauschenberg *(pl. no. 803)*—the latter a photographer as well as a painter—employed screen-printing techniques and incorporated snapshots and news photographs along with the array of junk materials to sug-

gest the gritty, chaotic texture of contemporary urban life. James Rosenquist and Andy Warhol *(pl. no. 804)* in the United States and Richard Hamilton in England were among the painters who mined (and mimed) billboard and other photographic advertising imagery (Hamilton eventually turned to black-and-white photography). The mixing of media was exemplified by the assemblages created by Doug Starn and Mike Starn, twin brothers who have combined camera images, reproductions of art, musical scores, building materials, and sometimes live insects in their work.

Camera images have also been regarded by painters as found objects, to be assembled as testaments to individual taste or to a sense of irony—contemporary analogues of Duchamp's "readymades." (This practice of making use of extant images has expanded greatly with the advent of the Internet, from which users may choose from literally trillions of uploaded images; *see Chapter 13*.) Photographs have supplied John Baldessari *(pl. no. 805)* in the United

805. JOHN BALDESSARI. *Chimpanzees and Man with Arms in Arc*, 1984. Two gelatin silver prints. Courtesy Sonnabend Gallery, New York.

806. DAVID HOCKNEY. *Christopher Isherwood Talking to Bob Holman, Santa Monica, March 14, 1983*, 1983. Collage of 98 Ektachrome prints. John and Mable Ringling Museum of Art, Sarasota, Fla.

807. RICHARD ESTES. *Central Savings*, 1975. Oil on canvas. Nelson-Atkins Museum of Art, Kansas City, Mo. Courtesy Allan Stone Gallery, New York.

States (and, earlier, Joseph Beuys in Germany) with the means to investigate the meaning of art itself. The sometimes banal, sometimes bizarre conjunctions of objects and events in Baldessari's work attest to his interest in the photograph not as an aesthetic or descriptive object but as a means of exploring the very process of selecting as a form of art.

Artists wishing to avoid the convention of representing a single point of view and a single moment in time also have turned to photography. David Hockney made use of an array of small color prints, images made over a period of time and from different vantage points, to create a large collage work *(pl. no. 806)* that repudiates the frozen moment characteristic of conventional paintings (and photographs). The artist Chuck Close pieces his large-scale portraits together from image parts, the seams between them fully apparent, to avoid the illusionism characteristic of the photograph while still exploiting its ability to cap-

ture detailed facial expression. Rather than just using photographs to represent reality, these artists have employed them to transform their work into statements about the process of making art.

Almost in tandem with Pop art, sharp-focus realism—sometimes called Photorealism—emerged as a distinctive style in American painting in the late 1960s. A sort of Precisionism revisited, it, too, often derived its energizing ideas from the consumer goods and built environments so prominently featured in advertising. Photorealist painters, like their Precisionist forebears in the 1920s (as well as many photographers) are usually more interested in the abstract appearance of reality than in "realism" itself, finding the formal configurations of actuality "far more exciting than most abstract painting."[17] The quest for the meticulous representation of the real world—in particular the machine-made portion of reality—prompted this generation of painters to look to the camera for aid in

translating three-dimensional space onto a flat surface. Indeed, many painters employed projection techniques that had been perfected earlier as methods for advertising illustration.

In Photorealist painting, the photograph is more than just a preparatory device or an aid to verisimilitude. Photographs help the painter objectify the subject, theoretically bypassing choice and subjective feelings and substituting a neutral facture for the artist's hand. These paintings mimic the visual appearance of photographs, portraying space in the specific manner of certain lens capabilities or from a vantage point peculiar to camera images. Synthesized at times from a number of camera images, as in the work of Richard Estes *(pl. no. 807)*, such paintings paraphrase the high-gloss surface emulsions and dye-color properties of color photographs.

At the opposite end of the critical spectrum, photographs also have played a role in Conceptual art, which rose to prominence in the late 1960s, even though a connection between these least and most abstract visual forms seems curious. But, as Sol LeWitt noted, "Ideas [in art] . . . are the chain in the development that may eventually find some form," and the photograph has become one of these forms.[18] LeWitt's series of spheres are emblems of the artist's desire to reveal the role of light on form rather than to create work with aesthetic, personal, or social content. Photographs also played a documentary role in works that were intended to be created and then destroyed or dismantled—Yves Klein's body art, Robert Smithson's earthworks, Christo's wrappings, and more recently Sara VanDerBeek's sculptures—as well as in time-based performance works by artists such as Chris Burden, Karen Finley, Yoko Ono, and many others.

In sum, as difficult as it would be to imagine contemporary photography without taking into account developments in the graphic arts, it is even less possible to visualize contemporary art without its alter ego, the photograph. Many of today's photographers began their careers as students in art academies and schools, and many continue to paint or work in other artistic modes as well as photography. This affiliation is recognized also in the marketplace by galleries that now handle photography, painting, and mixed-media creations as equals.

The arrival of digital media has had an immeasurable impact on all the visual arts, but it has not precluded or canceled out the media that preceded it. Indeed—as is discussed in Chapter 13—although the world of photography is now dominated by digital modes, there exists something of an "analog backlash": an interest in handwork, darkroom chemistry, and the physicality of photographs—all near-novelties among the younger generation of the early 21st-century artists. While it might have been feared by some at the close of the 20th century that photography as we knew it was a thing of the past, it has by no means died. Rather, it is now one of an expanded, and expanding, number of players in the latest media revolution, which we have been experiencing over the course of the past few decades, and which continues to unfold.

13.

NAVIGATING NEW SEAS: PHOTOGRAPHY AT THE START OF THE 21ST CENTURY

Diana C. Stoll

> *Our media, in the digital environment, will profoundly and permanently change us—our worldview, our concept of soul and art, our sense of possibility. We are busily reinventing media under the guise of what is essentially a marketing term, the "digital revolution," not daring to admit, in these perilous times, that what we are really reinventing is ourselves.*
>
> —Fred Ritchin, 2008[1]

As we sail forward through the 21st century, the waters of photography are shifting wildly. Advancing digital technologies have reshaped the way most photographers work, think, and see. They allow for once-undreamed-of modes of image dispersal, which have led to myriad new forms of human engagement with photography. The medium's parameters have been democratized and expanded to embrace countless *other* media, from ancient ones like sculpture and storytelling to brave new universes like Instagram and augmented reality. Perhaps most important: we are all connected in this new global space, where friends and strangers across the planet are never more than a click away, and where societal concepts of *hub* and *periphery* are rapidly losing their meaning. The photographers of the coming generation are more diverse in terms of nationality, ethnicity, race, and gender, and they are addressing society's dilemmas and urgent ecological issues with intense focus, both as artists and as straight documentarians.

This paradigm shift is ongoing as of this writing and surely will continue into the distant future. From the perspective of this fast-moving vessel, even as the seascape rushes by, a few new patterns and trends—and some old familiar ones—can yet be identified. Photographs, no matter what form they take or how they are transmitted, retain the potential to shed light and help us see the meaning in these times.

We Are All Photographers Now

The impact of digitization on photography—as on nearly everything—is impossible to overstate. Most of us in the developed world are equipped with sophisticated, relatively inexpensive camera technology: smartphones tucked handily in our pockets or purses, ready for a multitude of decisive moments at any second. In the course of 2017, humans on planet Earth made an unfathomable 1.2 trillion photographs, the great majority of them on smartphones; undoubtedly that figure will continue to rise exponentially as time moves on.[2] These numbers are compounded by photographic images that are initiated and produced by technology itself: in this age of surveillance cameras, drone cameras, medical scans, satellite imaging, and images generated by artificial intelligence, the production of photography is by no means the exclusive domain of humans.[3]

Yet, in a sense, all humans are photographers now. And this new technological agency—the "democratization of the image"—combined with the ubiquity of images in our time, has inevitably altered how we engage with photographs.[4] While the general public's visual literacy has not necessarily become more sophisticated, our lives, our memories, and indeed our identities are defined and driven by photographs in ways that could scarcely have been imagined until recently.

As noted in Chapter 12, there has been some debate about applying the term *photography* to digitally produced imagery. When Sir John Herschel first used the word in 1839, it was poetically descriptive of the mechanical/chemical procedure in question: "light writing." The making of even the most straightforward digital image is fundamentally different from the traditional photographic process. Stated simply, instead of recording patterns of light and shadow on film, digital cameras translate light electronically into long strings of numbers—digits. Furthermore, making and working with digital images may be understood as an active process of rendering, in contrast to film-based photography, a process of capturing. Despite these differences, in this discussion we will avoid the contested neologism *post-photography*—coined to indicate the completeness of the medium's transformation—and use the term *photography*, understood here in its commonly used and encompassing sense.

While the advent of digital media has changed the way light-generated images are produced, its most revolutionary effect may be how it has altered the way images are disseminated. The accessibility, affordability, and capabilities of mobile phones have been central in this.[5] The pace of digital-platform development and change is so rapid that identifying popular modes of transmission by name seems almost futile: the dominant social-media platforms of today—Instagram, Facebook, Twitter, Tumblr, Flickr, and so on—are in fact very young in the larger scheme of photography's history, and may well be superseded by new modes before this book's next edition appears (if not before these words have been typeset). Whatever the vehicle, however, such social-media tools serve to link users with one another in an ever-increasing matrix of connectivity. A

hilariously manipulated selfie created by a bored schoolgirl in Kyoto can be instantaneously transmitted to the Instagram and Facebook feeds of close friends, as well as those of strangers across the planet. If the stars align, the image will be shared and exponentially reshared; it may be "liked" by so many viewers that it goes *viral*—in what has come to be termed the "like economy." For an instant, that selfie may be familiar to nearly everyone who is plugged in to social media. Indeed, it may impact the online community so effectively as to be considered, however briefly, a *meme*: a charged nugget of cultural essence that spreads as uncontrollably as the plague.

During the Arab Spring uprisings of 2010–11, photographs and messages communicated via social media facilitated interactions among participants of political demonstrations in Tunisia, Syria, Egypt, and other countries in the region. Pro- and anti-government protesters used social media to organize demonstrations and to disseminate information about their activities, while photographs sent out to the world raised global awareness of the events as they unfolded. It was an early indication of how social media could play a decisive role in history.

Social media has enabled the formation of new communities—from foodies to white supremacists to avant-garde artists—made up of people around the world who have never met and will never meet one another. Within those communities, for better and worse, participants discover cohorts that inspire them to take their ideas further than they might have gone in isolation.

The definition of photography remains fundamentally unchanged. To the observer, the still image on its own is not so different today from its analog forebears. Photography serves the same purposes as ever—documentary, personal, artistic, journalistic, casual, crucially evidentiary. And yet the medium will never be the same.

Transformations in Photography Publishing and Marketing

By the second decade of the 21st century, many reliable and once-powerful print vehicles for photographers—newspapers and newsmagazines, illustrated journals, arts journals—found that they had to either change their publishing tactics or face their doom. Unable to maintain their footing in an increasingly slippery media landscape, a number of them ceased publication or were reincarnated in exclusively digital iterations.[6] Conversely, certain publications that embraced and exploited the new potentials of the Internet early on found themselves welcoming unanticipated new levels of exposure.

Publishers of photography books, too, have been forced to reckon with the impact of digitization. For digital natives (those born during the Internet era), the act of physically turning the pages of a book—let alone holding a photographic print in one's hands—is becoming something of a novelty. A number of the more adventurous publishing houses have looked for ways to engage with the Internet creatively and profitably, utilizing social media's powerful channels, promoting their products online, and in some cases publishing e-books and other formats suited to the digital world. Interestingly, however, the arena of high-end illustrated books in print has been affected somewhat differently than other realms of publishing, which have struggled mightily in the digital age. In a world that is becoming ever more screen-centric, where images and information come to us in discrete bits, fleeting, disordered, and disembodied, the *book as object* takes on a new significance. A well-designed photo book is now, as ever, a pleasure to leaf through. It provides a comfortingly (and increasingly uncommon) linear experience. The featured photographs may be sequenced and sized in such a rhythmic way that one activates the next with an almost cinematic energy. And of course the look of a richly printed photograph is very different from that of one seen on a glowing screen—and there are photographs that benefit from one viewing mode more than the other.

The production of photo books and magazines is no longer limited, however, by the marketing criteria and editorial whims of established publishing houses. One of the biggest transformations the digital age has wrought on the photography world, and an important factor in the "democratization of the image," is the unprecedented ease with which photographers (and other artists, and writers too) can take the reins and produce their own publications. Once derided in the conventional publishing world as "vanity" projects, self-published books are now posing some competition in the field of arts publishing. A number of recent monographic photo books—whether self-published or under the imprint of major houses—could not have come to fruition without the help of Internet-driven crowd-funding platforms such as Kickstarter and GoFundMe. And photographers can easily, and fairly inexpensively, design and produce their own books with the help of online services such as Blurb, which provide layout templates (resulting in some degree of cookie-cutter similarity in design) and allow books to be printed on demand.

A number of small imprints have cropped up with a view to streamlining the self-publishing process, creating new opportunities for experimental book ideas, and helping to guide photographers through the editing, design, and production processes. Among these is Self Publish, Be Happy, established in 2010 by Bruno Ceschel, which to date has guided more than 3,000 self-published photo books to light. Alec Soth, a well-respected Magnum

808. ALEC SOTH. *Jesse. Dover Burial Park, Dover, Ohio*, 2012. Archival pigment print mounted to Dibond. Courtesy Sean Kelly Gallery, New York.

photographer *(pl. no. 808)* with several mainstream published monographs under his belt, founded the Little Brown Mushroom press in 2008. Like other small, independent publishing ventures, this imprint welcomed the spirit of experimentalism to the production and distribution of photo books by such artists as Anouk Kruithof, Charlie White, and Soth himself.

In some ways, magazines have led the pack in the world of photographic self-publishing. Homemade journals, or zines, often associated with countercultural movements— and sometimes assembled with production equipment no more elaborate than a photocopy machine and a stapler— have been around since at least the 1930s, well before the digital age. More recently, little photo magazines (some with evocative titles such as *Toiletpaper*, *Lay Flat*, and *Tell Mum Everything Is OK*) are easy and inexpensive to create with new digital production and printing facilities. Although most of these publications may ultimately prove

the validity of the term *ephemera*, their spirited efforts have made an impact on the field of photography.

Striving to play a role in the dynamic worldwide network of image sharing, and to benefit from it whenever possible, are myriad photography-related websites. Some of these, such as PetaPixel, are educational, seeking to introduce viewers to images that they might not otherwise be aware of, by photographers who may not be part of the traditional gallery world; others, such as *LensCulture*, *Daylight*, and *Lenscratch*, are regular photography publications that live only on the Internet. Major print outlets have created online photography-focused sites, such as *Time* magazine's LightBox, and *National Geographic*'s Picture Stories and Sunday Stills, and the *California Sunday Magazine*. Distinguished photo magazines like *Aperture* and the *British Journal of Photography* have very active websites—featuring blogs, reviews, and other online-only programming— while daily news of the photography world (and the larger

809. LYNSEY ADDARIO. *Operation Rock Avalanche, Korengal Valley, Iraq, October 18–23, 2007*, 2007. Courtesy Getty Images.

art world) can be gleaned from web digests such as *Pro Photo Daily*, *Artsy*, *Lenscratch*, and *Hyperallergic*. Photography historians and researchers now have the extraordinary resource of *Luminous-Lint* and access to such digital archives as the New York Public Library's picture collection, the Harry Ransom Center collection, and *New York Times* Past Tense. Furthermore, the virtual space of the Internet permits images to be reproduced in quantities that would be prohibitively costly in print (a mixed blessing for users susceptible to visual overload).

The World Wide Web also serves as a vital forum for the photography market. Dealers tout their wares online, and museums feature highlights of their collections on the Internet. Today it is the rare artist who does not spend a good deal of time regularly updating his or her own website. Both as pristine silver or platinum prints and as digital productions of various kinds, images that have a photographic origin have become marketable to a degree Alfred Stieglitz only dreamed of back in the early 1900s, when he sought to elevate the medium to the status of art. In the United States, the clientele for photography has been

building since the 1970s; more recently the markets for works of photographic art in Europe, Russia, and China have grown substantially more robust. Auction houses in the United States and Europe have seen a spectacular increase in interest in the medium, with a concomitant elevation in the price of individual images. It is not unheard of now, at the start of the new millennium, for photographs by living artists to sell at auction for more than a million dollars (with Andreas Gursky, Richard Prince, and Cindy Sherman leading the fray: as of this writing, all three have sold individual works for in excess of $3 million).[7] Whether driven by love, financial tactics, or the spirit of competitive acquisition, clearly collectors are interested, and the Internet is playing a central role in energizing them.

The Photography World Is Flat

As journalist Thomas L. Friedman has succinctly observed, the world is flat.[8] Or it is at least getting flatter: in this era of busy global crosscurrents, the hub of the action

810. SHAHIDUL ALAM. *Boatmen in Dal Lake clearing weeds early in the morning in Srinagar, Kashmir, India, May 2008*, 2008. Courtesy Getty Images.

is wherever the Internet takes us, or wherever we take it. This is as true in the world of photography—its market and its production—as it is in any other aspect of today's culture. The Web allows practitioners of all sorts and from all over the world—from Chien-Chi Chang in Taiwan to Yto Barrada in Tangier; from Mike Smith in the American South to Zanele Muholi in South Africa—to operate on a more or less even field. A photojournalist such as Lynsey Addario, embedded with U.S. soldiers in Iraq's Korengal Valley, can send the results of a day's shoot to her editor in New York for publication, and the world will see her photographs within hours *(pl. no. 809)*. Collaborative photography projects—artworks, books, exhibitions—can take shape even when the participants are spread out across the planet. Some forward-thinking museums have organized exhibitions that do not require visitors to leave the comfort of their desk chairs, wherever they may be. Harvard University's Peabody Museum, for example, curates online shows that allow its substantial photography holdings to be studied and admired, while New York's New Museum has an ongoing collaboration with the digital-arts organization Rhizome to bring exhibitions of "net art" to the public, on-screen only.[9]

In the meantime, the real world (or "RW," as some committed Internet users call it) is flattening in other ways. Many countries host photography trade shows and festivals that bring works by international practitioners—both established masters and newcomers—together, allowing large numbers of attendees to see a range of images, network, and enjoy the celebratory festival vibe. In the 21st century, many new annual or biennial gatherings have cropped up outside the Western world, drawing new attention to under-recognized photographic communities. Among these are China's Pingyao International Photography Festival; Mali's Biennale Africaine de la Photographie in Bamako; Cambodia's Photo Phnom Penh Festival; and Ethiopia's Addis Foto Fest. Organizing a photography festival is a taxing prospect in itself, but in certain countries the project's high profile can present serious risks. Photographer Shahidul Alam *(pl. no. 810)*, founder of the Chobi Mela biennial in Dhaka, was arrested and held for three months in 2018 for his outspoken views on the Bangladeshi government.

Curators at photography-oriented museums, too, are making concerted efforts to diversify both their exhibitions and their collections, to be more inclusive in terms not only of gender and race but also of nationality. Since 2000, several important new institutions have entered this arena, including the Fotografiemuseum Amsterdam (better known as FOAM), Pier 24 Photography in San Francisco, Fotografiska in Stockholm and New York, and the Lianzhou Museum of Photography (a spinoff of the Chinese city's biennial photo festival, founded in 2005). The Victoria and Albert Museum in London, long valued as an important repository for the medium, opened its new Photography Centre in 2018.

An Open Field of Processes for Art Photography

What does it mean to be an artist in the digital age? Among other things, it means having an abundance of new creative opportunities, offered by digital media, new imaging processes, and the expansive presence of the Internet—all of which are voraciously explored by a vast number of photographic artists (and shunned by a handful of others). Within the multifarious approaches of today's artists, a few patterns of practice may be discerned.

INVENTORIES

The writer John Berger made a prescient proposal back in 1968: "If everything that existed were continually being photographed, every photograph would become meaningless."[10] And indeed, the leverage of photographs in this age of image ubiquity has inevitably changed. In her 2009 essay "In Defense of the Poor Image," German artist Hito Steyerl traces the life of the digital image:

> The poor image has been uploaded, downloaded, shared, reformatted, and reedited. It transforms quality into accessibility, exhibition value into cult value, films into clips, contemplation into distraction. The image is liberated from the vaults of cinemas and archives and thrust into digital uncertainty, at the expense of its own substance.[11]

The uncountable quantities of images available on the Web—from uncountable sources, algorithmically arranged in uncountable ways—proffer an extraordinary resource of *objets trouvés* to the artist with an accumulative bent. Penelope Umbrico has trawled the Internet and gathered thousands of like photographs into groupings—all showing birthday cakes, say, or blank television screens, or sunsets *(pl. no. 811)*. Other artists working in this vein

811. PENELOPE UMBRICO. *541,795 Suns from Sunsets from Flickr (Partial) 01/23/06* (detail), 2006. 2,000 4 x 6 inch machine prints. Courtesy Penelope Umbrico.

812. EMMET GOWIN. *Index 14, Panama, August 2007*, 2007, from the series *Mariposas Nocturnas*. Digital inkjet print. Courtesy Pace/MacGill Gallery, New York.

are Eric Oglander (in his *Craigslist Mirrors* series), Dina Kelberman (*I'm Google*), and Joachim Schmid, who has organized images pilfered from the Web into a series of thematic books collectively titled (what else?) Other People's Photographs. There is humor and perhaps some pathos in the endeavors of Dutch artist Erik Kessels; for his 2011 project *24 Hours in Photos*, he printed out *all* the images posted on Flickr in a single day; the results—some 350,000 photographs—filled a room like a swelling sea. Each of these artists has, in his or her way, blazed a route through the unprecedented image overload.

A number of other contemporary photographers have taken to organizing their own photographs into taxonomic sets, in a gesture reminiscent of the "typologies" assembled by Bernd and Hilla Becher (*see pl. no. 737*). In some ways formally similar to the collections of pictures obsessively drawn from the Internet by Umbrico and others, these images are gathered for different conceptual ends; while visually compelling, the groupings also serve as records of

things and ideas that may soon disappear. Emmet Gowin, who has conducted a career-long photographic study of his wife, Edith (*see pl. no. 732*), has brought characteristic focus and dedication to a body of work titled *Mariposas Nocturnas (pl. no. 812)*, a collection of hundreds of photographs of moths living in the imperiled forests of Central and South America. These entomological "portraits" are arranged in electrically colorful grids, compelling in both splendor and quantity. Driven by a similar impulse to document a threatened ecological asset, Dornith Doherty has traveled the world photographing the holdings of seed banks for her project *Archiving Eden (pl. no. 813)*. Utilizing the archives' on-site X-ray equipment (normally used to assess the viability of seeds), Doherty documents the seeds' development and then collages the images together before presenting them as dizzying large-scale lenticular prints.

Other inventories are equally evocative, if theoretically more abstruse. Multidisciplinary artist Taryn Simon often arranges her images and ideas into "indices"—as, for example, in her 2007 project *An American Index of the Hidden and Unfamiliar*, in which Simon used a large-format camera to document things and actions that are generally unseen by the ordinary U.S. citizen—everything from a nuclear-waste storage facility to a hibernating black bear. Ilit Azoulay is known for her intuitively arranged digital collages of images of materials assembled from demolished buildings, or of rarely displayed objects languishing in museum archives (*pl. no. 814*). Her concatenations are sometimes expanded to massive murals, magnifying their visual impact.

COMBINING MATERIALS AND MODES

Azoulay, who worked strictly with an analog camera and darkroom up until 2009, is among the multitude of photographic artists who have now taken on the digital as a modus operandi that is indispensable to them not only technically but artistically. The resources offered by such software as Adobe Photoshop, Lightroom, and countless other post-processing tools have shaped and sometimes defined these artists' creative output. But beyond the sheer utility of the media, there has been something of an existential shift. As one young digital-native artist, Joshua Citarella, has noted: "RGB pixels are implicated as a new *prima materia*, delivering objects from the dim confines of materiality into omnipresent electronic radiance. A global network of images has transfigured all bodies and materials into exchanges of energy."[12] As Marshall McLuhan might remind us, the medium may be understood, yet again, as the message.

Further stretching the conceptual boundaries of photography as such, a number of artists are integrating photo imagery into three-dimensional sculptural forms,

813. DORNITH DOHERTY. *More Than This*, 2015.
Digital chromogenic lenticular photograph.
Courtesy Dornith Doherty/Holly Johnson Gallery.

installations, or video works. Some venturesome individuals have recently been investigating the potentials of augmented reality (AR)—as, for example, Lucas Blalock in his 2016 volume *Making Memeries*, in which images can be "activated" with the use of an application downloaded to readers' mobile phones or tablets. Known for his deadpan, intentionally maladroit image amalgams *(pl. no. 815)*, here Blalock used AR technology to expand the viewer's experience of the images with sound and animation. Nina Berman's 2017 book *An Autobiography of Miss Wish (pl. no. 816)*, a collaboration with her longtime subject Kimberly Stevens that incorporates photographs, drawings, diary entries, and more, uses AR to link to video interviews between the two women.

Among the many contemporary figures incorporating photographs into installation format is the British artist Edmund Clark, whose work addresses structures of power, particularly with regard to systems of incarceration and the so-called War on Terror. For his compelling 2017 project *In Place of Hate*, Clark undertook a collaboration with inmates at a "therapeutic prison" in Britain. The resulting installation filled a series of rooms and incorporated light boxes, video monitors, projections, and an enclosure that

814. ILIT AZOULAY. *One may ask how, for what principle, does the world persist?*, 2017. Inkjet print and gold leaves.
Courtesy Ilit Azoulay and Braverman Gallery, Tel Aviv.

mimicked the dimensions of a cell, creating an enveloping spatial experience for visitors.

The materiality and objecthood of photographs have new resonance—perhaps even novelty—for some artists in this moment of ubiquitous incorporeal images. Sara Cwynar's practice blends collage, still life, and portraiture with materials sourced from flea markets and online auctions. The transitory sculptural configurations of Sara VanDerBeek's photographic collages combine found images with bits of wood, metal, and string; the artist disassembles the works after photographing them. Daisuke Yokota has been known to treat images with heat and iron powder, and subjects others to rephotographing, rescanning, and reprinting. Kate Steciw combines physical materials—glass beads, car ornaments, bandages—with digital imagery she pulls from the Web. Her works explore the relationships between three-dimensional objects and their two-dimensional counterparts online, forming a multidimensional hall of mirrors *(pl. no. 817)*.

815. Lucas Blalock. *The Seer*, 2017. Archival inkjet print. Courtesy Galerie Eva Presenhuber, Zurich/New York. © Lucas Blalock.

816. Nina Berman. *Portrait of Kim taken in Nina's apartment*, 2015. Digital photograph. Courtesy Nina Berman/NOOR.

In this era of such wide-ranging photographic possibilities, it is not surprising that many artist-photographers feel no need to limit themselves to either analog or digital processes, and freely engage in both. James Welling has worked in a spectrum of modes, from abstract photograms to straight documentary-style landscapes. The images in his series *Choreograph* were made by placing black-and-white photographs into Adobe Photoshop's red, green, and blue color channels, yielding layered images reminiscent of old-fashioned analog double exposures; he then alters the images using Photoshop tools, with a view to achieving what he refers to (citing Johann Wolfgang von Goethe) as "pathological color" *(pl. no. 818)*.[13] In his photographic work Thomas Ruff, too, disregards the medium's ostensible boundaries: he might use digital manipulation for one subject and antiquated darkroom techniques for another. Ruff, who studied with the Bechers in the 1970s and '80s, works in rigorously conceived series with an eclectic range of subjects, from domestic interiors to computer-generated 3-D-printed Pop imagery, pornography, and machines *(pl. no. 819)*.

Korean artist Jungjin Lee combines techniques from Eastern and Western traditions of both painting and photography, and analog and digital processes *(pl. no. 820)*. She creates prints in the darkroom, scans them to make adjustments digitally, and finally makes large-scale pigment prints from the digital files on sheets of handmade mulberry paper coated with a silver emulsion. It is a laborious process, but Lee's results are deeply contemplative and

817. KATE STECIW. *Construction 145*, 2016. Dye sublimation prints on aluminum, wood frame. Courtesy Kate Steciw/Brand New Gallery, Milan.

818. JAMES WELLING. *9472*, 2015. Multichannel inkjet print. Courtesy David Zwirner Gallery.

819. THOMAS RUFF. *1219*, from *Maschinen*, 2003. Chromogenic color print. Courtesy David Zwirner Gallery, New York. © 2019 Artists Rights Society (ARS), New York/VG Bild-Kunst, Bonn.

820. JUNGJIN LEE. *Unnamed Road #002*, 2011. Archival pigment print. Courtesy Howard Greenberg Gallery, New York. © Jungjin Lee.

painterly, evidence—as if we needed it—that it is the artist, not the medium, that gives the work its life and power.

Film photography has such an august history, it is inevitable that there should be practitioners who remain staunchly (if not exclusively) devoted to it. Italian master Guido Guidi is among these holdouts, as are the American artists David Benjamin Sherry and Dan Winters, and photojournalists Jessica Dimmock and Rena Effendi. LaToya Ruby Frazier, whose photographs often bring focus to issues of social justice, uses film as part of her acknowledgment of photography's history. "If I want my work to have a visual language that's in conversation with the social documentary work of the 20th century then I need to use that medium and their tools," she says. "So when my work stands next to a Walker Evans or a Gordon Parks in the museum, there's a continuity." Certainly the aesthetics and physicality of film play a role in the analog choice as well. As Winters puts it: "I love seeing that image appear through the chemistry and smelling the darkroom chemicals. . . . That grounds me."[14]

Many art photographers operating in more conceptual veins are likewise attracted to photography's foundational processes, although most are, unsurprisingly, reluctant to restrict themselves to a single approach to production. Walead Beshty has worked in a gamut of photographic modes, sometimes removing the camera from the equation altogether in his monumentally scaled photograms

The past and the present of photography are not necessarily so far removed from one another. An engaging dialogue took place recently between one of the medium's progenitors and the technologies of the 21st century. *Thresholds*, an installation conceived by British artist Mat Collishaw, restaged the world's first major photography exhibition—organized in 1839 by William Henry Fox Talbot—as an immersive virtual-reality experience. The show (which opened in 2017 at London's Somerset House and traveled from there) contained no real-world artifacts, and yet visitors, bedecked with cumbersome headsets, were able to see, hear, and even touch the objects on "display."[15] One wonders what the inventive Talbot would have thought, and what he might have accomplished with such tools.

INTERNET, IDENTITY, AND STORYTELLING

Let us consider again those trillions of images that exist on the Web, and the trillions more that are in the process of being uploaded and shared. What purpose do they serve? Who is aware of them? The American artist Trevor Paglen, in his percipient 2016 essay "Invisible Images (Your Pictures Are Looking at You)," explores the notion that while we use the Internet, it is equally true that the Internet uses us. He writes:

When you put an image on Facebook or other social media, you're feeding an array of immensely powerful artificial intelligence systems information about how to identify people and how to recognize places and objects, habits and preferences, race, class, and gender identifications, economic statuses, and much more.[16]

A disquieting proposal, but one that is substantiated afresh every day, as our personal identities and proclivities are further exposed each time we touch our keyboards.

Playing with this fire, a number of artists have used the Internet as a stage on which to engage in inventive identity games. Over the course of several months in 2014, Amalia Ulman used her social-media profile to stage a fictional extreme-makeover performance she titled *Excellences & Perfections (pl. no. 821)*. Unlike earlier self-modification ventures, by artists from Orlan (who underwent plastic surgery as a performative artwork) to Adrian Piper (who presented herself as a different race or gender in various projects), Ulman's undertaking is driven to expansive proportions by the reach and capabilities of the Web. Throwing a wrench into the "like economy," Dutch conceptualist Constant Dullaart fabricated a horde of thousands of Facebook followers—an enviable entourage of fans—for his 2016 project *The Possibility of an Army*. Such bodies of work exist only (or primarily) on the Web, as does *The Jogging*, the Tumblr blog inaugurated by Brad Troemel and Lauren

821. AMALIA ULMAN. *Excellences & Perfections (Instagram Update 22nd June 2014)*, 2014. Instagram post. Courtesy Amalia Ulman/Arcadia Missa, London.

Christiansen in 2009, where thousands of oddball images have been posted, clouding the distinction between art and meme (and artist and prankster).

The enticements of social media as a vehicle have proven irresistible even to established photographers who made their names long before these platforms existed: Cindy Sherman, Nan Goldin, Stephen Shore, and Alec Soth, for example, are among those making productive use of Instagram. Shore commends the platform for celebrating "images that are diaristic, that are brief glances, that are visual jottings, that are one-liners. It accepts complexity, but doesn't demand it. . . . I find it very satisfying that [there is] a group of people who look at each other's work every day, and they're all over the world." By contrast, Soth, who admits to having been initially "hooked" by Instagram, confesses: "I don't think I have ever been moved [by Instagram] the way I have with a great artwork, film or novel. Instead, the platform gives me little pellets of pleasure. I guess that's what I dislike about it too—the addictive quality of those pellets rarely satisfies."[17]

Those pellets can, however, deliver brief buzzes of pure enjoyment. Jason Evans's website *The Daily Nice* offers visitors one satisfyingly transient image each day. While the fleeting pictures have a haphazard quality, they are all driven by this photographer's "enthusiasm for looking and being" and made cohesive by his highly discerning eye.[18] Jonathan Harris's project *Today* likewise followed a diurnal schedule *(pl. no. 822)*. Over the course of 440 days, beginning on his 30th birthday, in 2009, he made one photograph a day, accompanied it with a short text, and posted it to his site before going to sleep—a simple, initially private pursuit that before long was followed by thousands of people around the globe. Harris describes the experience of *Today* as a "walkabout . . . thinking of life itself as a creation, as a story that you're writing."[19]

This notion of storytelling—that most ancient of tribal traditions—has in recent years been seized upon as a useful conceit by economists and marketers alike, perhaps in response to the swarm of disembodied info bytes on the Web. In 2011 Harris initiated Cowbird.com, a social network forum on which invited participants shared long-form, personal tales, told in pictures, sounds, and words. Such projects offer a model of how social media can function as a synthesizing tool to connect people in a positive way.

822. JONATHAN HARRIS. *February 27, 2010*, 2010. Digital photograph. Courtesy and © Jonathan Harris.

Investigating the Human Condition: Families and Portraits

Of course, photography has always been a medium well suited to telling compelling stories and to bringing new light to the human condition.

To counter Tolstoy: all families are different—whether happy or unhappy—and their intimacies and complexities are unique when seen through the eyes of different photographers. That range is made apparent when comparing works by Sally Mann (*see pl. no. 696*), Christopher Anderson (*pl. no. 823*), and Osamu James Nakagawa (*pl. no. 824*), all of whom have conducted indefatigable, loving, unsentimental studies of their children in the process of growing up. Elinor Carucci includes her husband, children, and parents in the family drama, in images imbued with both style and humor, while Chien-Chi Chang looks with some bemusement at the institution of marriage and the Taiwanese wedding industry (*pl. no. 825*). The uproarious chaos of family life is investigated in Motoyuki Daifu's dauntless images of relatives eating, sleeping, watching TV, drooling, picking teeth. Sage Sohier, Larry Sultan, and Phil Toledano have taken unflinching looks at what can be a difficult subject: aging parents' later years. In her series *The Notion of Family*, LaToya Ruby Frazier considers the legacy of racism and its impact on three generations: her grandmother, her mother, and herself.

A family can, of course, be made up of more than just blood relatives. Ryan McGinley's exuberant images of young people, often photographed nude, cavorting in natural settings (*pl. no. 826*), suggest a sense of intimate camaraderie. Catherine Opie, who fondly describes her days as part of an S-M cohort as familial—"all about community"—brings that same tender sensibility to photographs of her son.[20] Rob Amberg (*pl. no. 827*) has undertaken a decades-long, affectionate study of the landscapes and people of the southern Appalachian Mountains, including the tight-knit communities that give the region its distinctive character. In her project *Faces and Phases*, Zanele Muholi (*pl. no. 828*) has extensively documented the lives of people of the lesbian, gay, bisexual, transgender, and intersex (LGBTI) community in her native South Africa—a family of sorts, united against societal stigmas attached to queer identity. Muholi's investigation is made up largely of lushly contrasted black-and-white portraits (including a series of striking self-portraits).

Portraiture is one of photography's greatest arenas of achievement and discovery, and has been since the medium's earliest days. What makes a portrait meaningful to viewers? Beauty, expressiveness, celebrity, timely relevance, an instant of candid connection with the lens; an attentive portrait photographer will be attuned to all these

823. CHRISTOPHER ANDERSON. *Marion and Atlas in the Shower*, 2009. Digital color. © Christopher Anderson/ Magnum Photos.

things and more. Rineke Dijkstra (*pl. no. 829*) has honed a signature portrait style that seems to draw from the art historical legacy of her native Netherlands. Known for the "warts and all" frankness of his portrayals, Richard Burbridge uses photography, he says, "as a tool to create an image that is sharper than what we can experience."[21] Near the other end of the aesthetic spectrum, the photographs of Ruven Afanador are as formally stylized as Brancusi sculptures. Among the many other fine photographers producing compelling portraits in recent years are Nadav Kander, Hellen van Meene, Lise Sarfati, Martin Schoeller, and Rosalind Fox Solomon.

Deana Lawson (*pl. no. 830*) projects a sense of both theatricality and intimacy in her color portraits, printed at a grand scale, often showing her subjects in interior settings that are just as meaningful as their clothes or expressions. She has said that she too thinks of her subjects as family (although, in fact, most of them are strangers to her). Another kind of kinship is seen in the work of Iranian-American artist Shirin Neshat, who has long investigated the social, political, and psychological dimensions of contemporary Islamic societies in terms of both politics and individual

824. OSAMU JAMES NAKAGAWA.
*Morning Light, Bloomington, Indiana,
Spring 1999*, from the series *Kai*, 1999.
Silver gelatin print. Courtesy Osamu
James Nakagawa/PGI, Tokyo.

825. CHIEN-CHI CHANG. *A Newlywed
Couple and Flower Children*, from the project
I Do I Do I Do, 1997. © Chien-Chi Chang/
Magnum Photos.

826. RYAN MCGINLEY. *Jake (Fall Foliage)*, 2011. C-print.
Courtesy Ryan McGinley Studios and team (gallery, inc.), New York.

827. ROB AMBERG. *At Cricket's Birthday Party, Big Pine, Madison County, NC*, 2011.
Archival pigment print. Courtesy and © Rob Amberg.

828. ZANELE MUHOLI. *Tumi Nkopane, KwaThema, Springs, Johannesburg*, 2010. Gelatin silver print. Courtesy Yancey Richardson Gallery.

829. RINEKE DIJKSTRA. *Olivier, Camp Général de Gaulle, Libreville, Gabon, June 2, 2002*, 2002. C-print. Courtesy the artist and Marian Goodman Gallery. © Rineke Dijkstra.

830. DEANA LAWSON. *Sons of Cush*, 2016. Pigment print. Courtesy Sikkema Jenkins & Co., New York/ Rhona Hoffman Gallery, Chicago. Artwork © Deana Lawson.

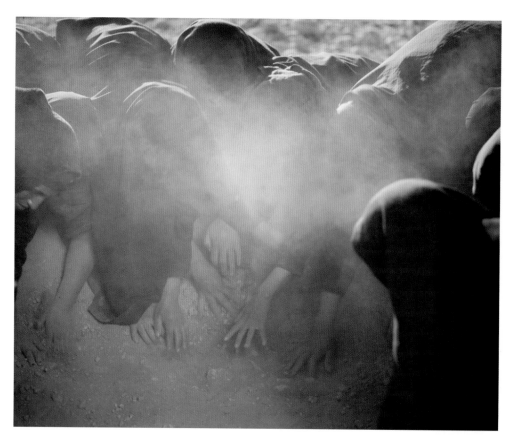

831. SHIRIN NESHAT. *Passage Series*, 2001. Cibachrome print. Courtesy the artist and Gladstone Gallery, New York and Brussels. © Shirin Neshat.

identity. A contemporary counterbalance to Félix and Marie Lydie Cabannis Bonfils, 19th-century French photographers who examined the people and customs of the Middle East from the perspective of curious outsiders *(see pl. no. 414)*, Neshat considers the links and ruptures between 21st-century Iran and its mythical and historical past with the insights of a native daughter *(pl. no. 831)*.

Photojournalism and Integrity

MAKING AN IMPACT

In the midst of a cyclone of images, can a single photograph still make an impact? Consider some precedents from the world of photojournalism: Dorothea Lange's *Migrant Mother (pl. no. 451)*; W. Eugene Smith's *Tomoko in Her Bath (pl. no. 475)*; Robert Capa's *Normandy Invasion (pl. no. 607)*. Is it possible for a photograph today to be incised in our minds as those are—so indelibly that we scarcely need to see them to call them to mind? Those photographs were generally isolated for viewers by photo editors, who chose them from an exponentially smaller selection of photographs than exist today, made by an infinitesimally smaller number of photographers. Further, they came to the public eye via news media that were acknowledged by most readers as authoritative—and, in the case of *Life* magazine, which first published Smith's *Tomoko* and Capa's *Invasion*, world-famous for groundbreaking photography—all of which, in the minds of readers, likely added gravitas and validity to these already extraordinary pictures.

Today, the average Internet-conscious photography buff can meander through thousands upon thousands of images in a 24-hour period—some of them powerful, some not, but each one sapping a portion of our day's allotment of time and attentiveness. Those newspapers that still produce a print edition usually continue to select one photograph to run "above the fold"—accompanying the top headline—an image that they believe best encapsulates what their news editors have deemed the most important story of the day. But those select photographs no longer have the weight of solitude in our minds.

In order to outmuscle its hive mates, a news photograph today should be the *first* to reach the public, and it must touch people in a number of ways. It has to be compelling as a picture in itself, but further it must have timely relevance and specific cultural or political resonance.[22] It must address the moment so aptly that viewers stop when they see it, long enough to register its meaning and then click a key and pass it along to the next person, who will

continue the chain of transmission until the world has a new "icon," or meme.

In recent years only a few photographs have met these mysterious criteria, usually by illuminating some aspect of world conflict that elicits a sharp emotional response: Horror and fear on September 11, 2001 (although it might be said that no single image stands out from the thousands made on that ghastly day). Shock, nausea, and anger in the case of the images released in 2004 of detainees at Iraq's Abu Ghraib prison (pictures made not by professional photographers but U.S. soldiers). In 2015 journalist Nilüfer Demir was covering the pandemonium of incoming Syrian refugees at Bodrum, on the Turkish coast, when she saw and photographed the drowned body of three-year-old Aylan Shenu, washed up on the shore *(pl. no. 832)*. It is an emotionally wrenching image: the sight of the dead child is of course harrowing, but the strange stillness of the picture compounds its sadness and power. This is a brief instant of charged silence following one horror and preceding another. Demir's photograph was widely published and quickly shared and has been characterized as the defining photograph of the Syrian war and refugee crisis. It is not possible, of course, to precisely measure the political impact of a photograph, but it may be hoped that, because the image of Aylan Shenu entered the public consciousness so forcefully, it played some part in increasing awareness of the tragic upheavals of the migration calamity.

832. NILÜFER DEMIR. *A migrant child's dead body (Aylan Shenu) lies on the shores in Bodrum, southern Turkey, on September 2, 2015 after a boat carrying refugees sank while reaching the Greek island of Kos. Thousands of refugees and migrants arrived in Athens on September 2, as Greek ministers held talks on the crisis, with Europe struggling to cope with the huge influx fleeing war and repression in the Middle East and Africa*, 2015. © Nilüfer Demir/AFP/Getty Images.

833. LU GUANG. *Workers in the factories have no immunity defenses. They get ill after one or two years on the job. Wuhai City, Inner Mongolia*, 2005. Digital photograph. Courtesy Contact Press Images.

834. Josué Rivas. *Women at the frontlines. Oceti Sakowin Camp, Cannon Ball, ND, USA. November 11, 2016*, 2016. Digital photograph. Courtesy and © Josué Rivas.

Fake News vs. Real News

The ravenous 24-hour news cycle does not allow time for much deliberation. The phrase "fake news" has recently been used, and abused, so often that its very meaning is in question. Information that is construed as libelous or otherwise objectionable by its subject might be dubbed "fake news" in the hope that the label will dismiss, or at least confuse, its impact. Or the news might be truly false—disseminated by mistake in the rush for a scoop, or intentionally in the rush to attract and inflame readers and viewers. And the more inflammatory the item, it would seem, the quicker and wider its spread. The wider its spread, the smaller the chance of ever getting the story straight in the public mind.

A journalistic or documentary photograph may be misleadingly used, or staged (entirely or slightly), or manipulated to represent something that never transpired before the lens. But this is nothing new: as discussed in Chapter 12, the notion of "truth" in photojournalism has been in question since well before the invention of Photoshop. But today's digital technologies make adjustments and manipulations easier than ever to effect and more difficult than ever to discern. Italian photojournalist Paolo Pellegrin *(see pl. no. 796)* addresses the ethics of these issues:

In reportage—especially in photojournalism—there is an unspoken but very binding contract between three entities: the subject, the photographer, and the viewer. . . . With photojournalism, I think of the idea of function: these are visual records, and they are part of our cultural collective memory. So it's the absolute cornerstone of what we do that they *not* be staged. Because if they are, then they lose their potential purpose entirely.[23]

Journalists who go into war zones around the world—as Pellegrin has—have a particular stake in this issue. He is one of many dauntless reporters who have been wounded on the job. Photojournalists regularly endure harsh conditions, as Josué Rivas did when he camped by the banks of the Cannonball River in North Dakota with Standing Rock protesters hoping to stop the installation of the Dakota Access oil pipeline *(pl. no. 834)*. Others have been kidnapped (among them Lynsey Addario, Tyler Hicks, Matthew Schrier), incarcerated (including Shahidul Alam in Bangladesh and Mahmoud Abou Zeid in Egypt), "disappeared" (for example, Lu Guang, *pl. no. 833*, arrested by Chinese authorities in 2018 and still missing as of this writing), or killed in the field (Dmitry Chebotayev, Tim Hetherington, Chris Hondros, Shah Marai, and others).

835. SIMON NORFOLK. *Balloon Seller, Kabul*, 2000. Archival digital c-print. From the book *Afghanistan Chronotopia* (Manchester: Dewi Lewis Publishing, 2002). Courtesy Michael Hoppen Gallery, London.

Why risk it all in the line of fire if the images you are going after can be faked? When photographs are manipulated, says Pellegrin, "*everything* becomes questionable. . . . As a photographer I defend the integrity of the image with all I have. I feel strongly and passionately that it's the one thing you cannot compromise."[24] We may hope that others feel the same way, as the technology for adjustment—or outright manipulation—becomes more accessible and easier to use every day.

Could there be some good to come from the idea of "fake news"? Perhaps the prevalence of the notion will teach us all, when it comes to the news, to be the skeptics we should always have been and to question the authority of those who disseminate our daily streams of information.

Photography as Agent of Action

When the integrity is there, though, and is compounded by the medium's unique ability to convey stories and truths, it is clear that photography can serve as a powerful spur for action—this has been the case throughout the medium's history. In the early 21st century, attention has intensified on a number of social, political, and environmental issues, much of it photographically motivated.

The threats to our planet—from climate change to pollution to imperiled biodiversity—have galvanized many photojournalists as well as art photographers from all parts of the globe. At least a few journalists who established themselves as combat photographers on battlefields have expressed their recognition that the greatest conflict we face now is the warming planet. Pellegrin is one of these, as

836. CAMILLE SEAMAN. *Stranded Iceberg, Cape Bird, Antarctica*, 2005. Ultrachrome digital print. Courtesy Camille Seaman.

837. EDWARD BURTYNSKY. *Clearcut # 1, Palm Oil Plantation, Borneo, Malaysia*, 2016. Courtesy Howard Greenberg Gallery. © Edward Burtynsky.

838. PIERPAOLO MITTICA. *Forest and wildfires are raging nearby the, as a result of the reactor accident in 1986, evacuated and since then abandoned and neglected city of Pripyat. Pripyat, Chernobyl Exclusion Zone, 2015.* Digital photograph. Courtesy and © Pierpaolo Mittica.

839. MICHAEL NICHOLS. *Charging Elephant, Dzanga Bai, Central African Republic, 1993.* © Michael Nichols/National Geographic.

840. ADRIAN PIPER. *Everything # 2.8*, 2003. Private collection. © Adrian Piper Research Archive Foundation Berlin.

is Simon Norfolk, well known for his work on war and its aftermath *(pl. no. 835)*. Others who have been turning their lenses toward the terrible topic of diminishing ice and its effects are Camille Seaman *(pl. no. 836)*, Jim Brandenburg, and Vadim Balakin. James Balog's ongoing *Extreme Ice Survey* photography and film projects have helped to widen the public's attention to this urgent issue. Ice is inarguably a photogenic subject, formally speaking—sculptural, monumental, nearly monochromatic—and as such it presents a dilemma to photographers who wish to convey the direness of this ugly ecological situation. Balog has created time-lapse images to show the process of recession, while Norfolk, in his series *When I Am Laid in Earth*, illustrates the warming of Mount Kenya by drawing lines of fire to demarcate receding glacial boundaries. The caption, of course, is a particularly effective tool for the photographer here: it can let viewers know in the most straightforward way that the magnificent entity they are looking at will soon be gone.

As humans have not yet stopped discarding vast amounts of waste, pollution continues to threaten the health of the planet. Rampant industrialization, pollution, and deforestation are frequent subjects of Canadian photographer Edward Burtynsky *(pl. no. 837)*, whose huge prints provide a vertiginously immersive experience of these bleak landscapes. David Maisel creates aerial photographs frequently showing gloriously colorful disturbances to the environment that might almost be read as abstractions; he has coined the poetic oxymoron "apocalyptic sublime" to describe them. Ghana's Agbogbloshie dump—a small ocean of garbage and electronic detritus attracting desperate scavengers—provides a perfect visual metaphor for the earth as wasteland, and as such it has fascinated such eminent photographers as Pieter Hugo, Carl De Keyzer, and Nikos Economopoulos. China's dust bowl has been a long-term subject of photographer Benoit Aquin, while the country's increasing industry and environmental degradation have provided visual fodder for

841. HANK WILLIS THOMAS. *Scarred Chest*, 2003.
Lambda photograph. Courtesy Hank Willis Thomas/
Jack Shainman Gallery, New York. © Hank Willis Thomas.

many photographers, including Wu Di, Xu Baokuan, and Bai Yanling—and are among the politically sensitive topics Lu Guang has taken on *(pl. no. 833)*. Italian photographer Pierpaolo Mittica has traveled the world investigating the fallout of nuclear disasters, from Chernobyl to Fukushima *(pl. no. 838)*; his photographs remind us that these events will continue to have repercussions into the distant future.

Like Emmet Gowin and Dornith Doherty, mentioned earlier, many photographers are eager to document the earth's endangered species, either to make a record of them before they vanish or to alert the world to their importance and thus perhaps urge us to find a way to preserve them if possible. *National Geographic* has made a valiant campaign to this end, showing the work of countless talented wildlife photographers, including Cristina Mittermeier, Paul Nicklen, Joe Riis, Brent Stirton, and Ami Vitale, among many others. Joel Sartore is compiling what he refers to as the Photo Ark, a systematic chronicle of endangered species, photographed in the studio against a seamless backdrop, one creature at a time. Sebastião Salgado's *Genesis* project, begun in 2004, is the result of an eight-year survey of the earth, its wildlife, landscapes, seascapes, and indigenous peoples, produced with the goal of raising funds and awareness about threats to the environment.

One of the most celebrated photographers working in the wild is Michael "Nick" Nichols, who throughout his career has collaborated closely with scientists on his adventurous projects, which have taken him to some of the remotest areas of the world *(pl. no. 839)*. Gratifyingly, Nichols's work has made tangible impacts on conservation: for example, when his photographs of Gabon's wildlife were shown to the country's president, Omar Bongo, in 2002, by biologist J. Michael Fay, Bongo made the decision to set aside some 11,300 square miles of Gabon to be protected as national parkland.[25]

842. AN-MY LÊ. *29 Palms: Colonel Greenwood*, 2003–4. Gelatin silver print. Courtesy Marian Goodman Gallery.

843. FAZAL SHEIKH. *Afghan child born in exile*, from *The Victor Weeps*, 1998. Toned gelatin silver print. Courtesy and © Fazal Sheikh.

Alongside straight documentary photographers are a number of artists who have adopted a more conceptual approach to issues of ecological vulnerability, such as Christina Seely, the duo Susannah Sayler and Edward Morris, and Thomas Struth, whose recent *memento mori* of animals offer a metaphor for mortality. Moroccan-French multidisciplinary artist Yto Barrada's work explores the barriers—environmental, political, psychological—that frame the city of Tangier and the lives of its inhabitants. The creative strategies of these and other artists can deliver a message of urgency with remarkable effectiveness and emotional power.

At this moment in the 21st century, a number of entrenched ideas about societal norms are undergoing a process of reexamination or upheaval; among the topics in contentious discussion are the status and rights of women, the fluidity of gender, and shifting relations among people of different ethnicities and races.

Of the many photography projects bringing light to the changing role of women, among the most disturbing are Laia Abril's, which deal frankly with such charged topics as abortion, rape, and anorexia. Also forceful are Stephanie Sinclair's photographs, which center on human rights and women's issues around the globe, from incidents of polygamy in the United States to child brides in Afghanistan. Nina Berman's long-term collaboration with Kimberly Stevens, a survivor of child pornography and sex trafficking, submits a new way of showing the life and essence of a female subject, one that avoids objectification. Working in a more formal (and indeed, perhaps objectifying) vein, Annie Leibovitz has continued to add to her epic profusion of portraits with updates to her *Women* series *(see pl. no. 733)*. While it is by no means only female photographers who are turning their gazes to women's issues, their concentration is, not surprisingly, acute in this area; and indeed, this may be one sphere in which women photographers have a decided working advantage.[26]

With the recent legalization of gay marriage in the United States and other countries, the acceptance of LGBTI life passed a milestone—but queerness and gender identity are complicated issues, and there are many more thresholds to cross. A number of photographers—among them Jess T. Dugan, Ren Hang, Zanele Muholi, and Paul Mpagi Sepuya—have explored and expanded understanding of queer identity with deeply personal photographic projects. Gender fluidity is at issue in the work of Mariette Pathy Allen and April Dawn Alison, who have been photographing transgender individuals over the course of four decades, and in the photographs of Shigeyuki Kihara, a multimedia and performance artist who sometimes borrows the style of 19th-century studio tableaux in exploring themes of Pacific culture and gender identity. In recent years, curators and critics have been reexamining bodies of work by Berenice Abbott, Cecil Beaton, Hannah Höch, Frances Benjamin Johnston, Minor White, and other established masters, considering how their sexuality might have informed their gaze.

Racial politics and inequities have been on the minds of photographers since the medium's earliest days. In the United States, a culminating moment was the civil rights era of the 1950s and '60s, during which photography by such figures as Bob Adelman, Bruce Davidson, Danny Lyon, and Ernest Withers helped shape the public's awareness of what was happening across the country *(see Chapter 11)*. Today, a much wider group of photojournalists continues to supply us with crucial information about racial strife and oppression going on around the world: from Damir Sagolj, creating work on the Rohingya in Myanmar, to Carolyn Drake, conducting a long-term study of the Uighur people in western China; from Ahmed Jadallah in Gaza *(see pl. no. 717)* to Ryan Kelly in Charlottesville, Virginia.

Along with the photojournalists, a number of artist-photographers have devoted their talents to bringing new conceptual light to these issues. Among those looking at black-white racial friction in the United States are Dawoud Bey, Kwame Brathwaite, LaToya Ruby Frazier, and Carrie Mae Weems. In very different bodies of work, Adrian Piper and Hank Willis Thomas both combine photography with other media as vehicles to investigate the larger contexts that have led to racial divides. Piper, who has been considering questions of racism, sexism, and otherness in her work since the 1970s, combines drawings, video, collage, text, and more with photographs, with a view to illuminating insidious, deep-seated cultural biases *(pl. no. 840)*. Thomas incorporates recognizable advertising and branding icons into his work, playing with how they reinforce generalizations developed around race, gender, and ethnicity *(pl. no. 841)*.

Estrangement from the hub of power comes in many forms. An-My Lê *(pl. no. 842)* was born in Saigon and came to the United States as a teenager, in the final year of the Vietnam War. Her photographs, which incorporate reality and fictional drama, engage memories of home and war, landscape and violence, displacement and the psychic impossibility of return. A similar approach to loss and yearning permeates the work of the Eritrean-born photographer Dawit L. Petros, whose project *The Stranger's Notebook* examines ideas of statelessness and the waywardness of identity. In his numerous publications and exhibitions, American photographer Fazal Sheikh documents people living in marginalized communities around the world. His principal medium is the portrait, but his projects (like Petros's) frequently also include other elements: found

844. WILLIAM ANDERS. *AS08-14-2383* (*Earthrise*), 1968. NASA.

photographs and other archival materials, sounds, texts. For his series *The Victor Weeps* (*pl. no. 843*), Sheikh made photographs at Afghan refugee camps in northern Pakistan; there he encountered faces troubled by anger, sadness, longing, and difficult wisdom.

Broadly speaking, none of these topics is new to the purview of photography (nor to the larger arena of the arts in general); social, racial, economic, and ecological upheavals, conflicts, and other interactions have always been important parts of the substance of our lives. What has changed over the course of the past 20 years is the manner of making and disseminating images of these things. When a potentially impactful photograph moves out to the larger world today, it is in competition with innumerable rivals. In answer to Berger's 1968 proposition: today, it would seem, everything that exists *is* continually being photographed —

and yet it cannot be said that every photograph has become meaningless, exactly. It is simply that there is more news in the world than we can possibly take in, let alone understand, and there are more images than we can conceivably ever see. What good, we might ask, can they do?

The new connectivity the world is experiencing is a phenomenon that is still to be gauged: it has opened infinite new possibilities, while altering our engagement with one another and with our surroundings in ways we have not yet been able to assess. We are loving the changes and benefiting from them; we are hating them and battling against them too. In photography, as in all expressive arts, it is not fundamentally the medium that matters most but the creative mind and soul making use of it. It is to be hoped that, on this organism that is our planet, our new technologies are offering us a way to pool our ideas and move them forward together.

In his 1974 book *The Lives of a Cell*, biologist Lewis Thomas imagined humans sending a message out to sentient beings in another part of the universe. What news about our planet and our kind would we send? "I would vote for Bach," he mused, "all of Bach, streamed out into space, over and over again. We would be bragging of course, but it is surely excusable to put the best possible face on at the beginning of such an acquaintance. We can tell the harder truths later."[27]

Others have been similarly inspired to consider what language might be best suited to space communication. For his remarkably ambitious project *The Last Pictures*, Trevor Paglen spent five years consulting with scientists, artists, anthropologists, and philosophers on this subject. He worked with a team of MIT researchers to develop a micro-etched disc holding 100 photographs, encased in a gold-plated shell, designed to last—inconceivably—for billions of years. The disc was affixed to a satellite that launched in 2012 from the Baikonur Cosmodrome in southern Kazakhstan; it joins more than 800 spacecraft launched since 1963 that form a human-made ring of satellites around the earth.

The selection of images on that disc seems amusingly random (despite the committee of experts that chose them); presumably they are meant to convey an objective cross section of the earthly experience. Among them are pictures of a dust storm, a group of children by the sea, Leon Trotsky's brain, and the Lascaux cave paintings in France. Perhaps the most evocative to whatever space dweller, or remnant of humanity, might someday run across them will be NASA's 1968 image of Earth rising above the horizon of the moon, as seen photographically for the first time by humans *(pl. no. 844)*.

It is heartening, somehow, to think that photographs might still be communicating at some distant point in the future, and that their meaning might endure and provoke a reply—just as the Lascaux cave paintings invite us to respond to a dialogue initiated some 20,000 or so years ago. If that future interchange is fruitful, it will be a testament to the power of the photographic image, whatever technology was used to produce it.

A Short Technical History: Part III

Cameras and Equipment

In the early years of the 20th century, refinements in camera equipment were made in response to new demands for different kinds of images for advertising, documentation, and photojournalism. Two flexible-plate cameras, incorporating features from earlier cameras, were introduced around 1910 — the Linhof *(pl. no. 845)*, designed by Valentin Linhof in Germany, and the Speed Graphic *(pl. no. 846)*, patented by William Folmer of the Folmer and Schwing Division of the Eastman Kodak Company in Rochester, New York; both remained relatively unchanged in design into the 1950s. The range of up and down, in and out movement of these hand and stand cameras, which could be used with or without tripods, became integral to modern view and studio cameras.

846. Speed Graphic Camera. A favorite with American press photographers in the 1940s, Speed Graphic is here shown (in a later model) with a flash-gun, which is connected to an electromagnetic release on the between-the-lens shutter. The shutter thus opened as the flash-gun was fired.

845. Linhof Camera. In 1910, the first model of the famous and versatile Linhof press and professional camera appeared. It had a full range of movements and adjustments.

Single-lens reflex (SLR) cameras were improved by being made smaller and lighter. Suggestions that such cameras be equipped with a pentaprism (a device for correcting the upside down reversed image seen through the lens) in order to make eye-level viewing possible eventually led to the (East) German Zeiss-Ikon Company's introduction in 1949 of the Contax S—the first camera produced with a pentaprism built in *(pl. no. 851)*. All single-lens reflex (SLR) cameras now have either a pentaprism or another method for normalizing the inverted image.

The modern twin-lens reflex camera evolved from an apparatus developed in the 19th century in which the image received in the upper viewing lens was reflected by a

mirror onto a ground glass at the top of the camera in order to facilitate focusing. Several different models were introduced from 1889 on, but it was not until the appearance of the Rolleiflex (pl. no. 849) in 1928 that this type of camera achieved wide public acceptance.

A notable 20th century advance in professional equipment was the invention of a small, lightweight 35mm roll-film camera. The Leica (pl. no. 850), introduced in 1925 (but based on a 1913 model devised by Oskar Barnack of the Leitz Company to make use of leftover movie film), became the first commercially successful instrument to offer instantaneous exposure, fast film advance, and a high level of image definition under a variety of lighting conditions. The earlier Ermanox (pl. no. 852), a small-plate camera with an exceptionally fast lens, had performed well in low--light situations, but the Leica was better suited to make repeated exposures without attracting the attention of the subject. This camera and the other 35mm instruments that quickly followed transformed photojournalism. The images they produced were sharp enough to be enlarged, and when reproduced, the multiple shots could be arranged in sequences that paralleled the action they recorded. Eventually, 35mm cameras inspired new aesthetic standards in personal photographic expression, too. Later improvements to 35mm equipment included motor drives that automatically advance the film and prepare the shutter for the next exposure. Cameras used by professionals later were equipped with both manual and electronic controls for focus, flash, and film advance, and they could read ASA ratings from a bar code on the film. Built-in light meters measured light either from various spots, or from the center, or matched the light to logarithms compiled from thousands of test pictures and built into the camera.

Camera equipment designed for amateur use also underwent significant improvement during the 20th century. The fixed-focus Eastman Brownie camera (pl. no. 855), introduced in 1900 as the cheapest and simplest camera on the market, was revised over the years until by 1963 it had evolved into the Kodak Instamatic (pl. no. 856)—a lightweight eye-level instrument that accepted film cassettes; by 1972 it had become small enough to be called a pocket Instamatic, accepting 16mm film. Later changes in equipment for recreational use included the Advanced Photo System, which was developed by a consortium of equipment and film manufacturers; the system featured a redesigned camera and drop in cassette, which did not have to be wound on a spool by the user and could be removed and reinserted no matter how many exposures were made.

An outstanding event in the amateur field was the introduction in 1948 of a camera and film that made instant one-step photography possible. The Polaroid camera (pl. no. 848), designed by Edwin H. Land, was based on an idea virtually as old as photography itself—that of sensitizing and processing the film inside the camera. A number of 19th- and early-20th-century inventions, exemplified by the Dubroni (pl. no. 847), had incorporated this concept,

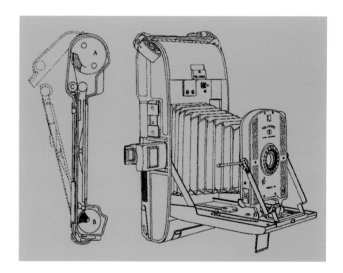

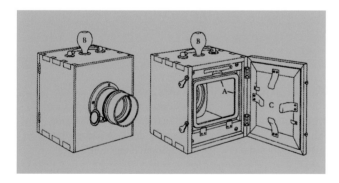

847. Dubroni Camera. The Dubroni camera of 1864 took a collodion-coated plate, which was held firmly against the flat-ground edges (A) of a ceramic or glass container, forming the inside of the camera. The sensitizing silver nitrate solution was introduced through a hole in the top of the camera by means of a pipette (B) and was made to flow over the plate when the camera was tilted onto its back. After exposure had taken place, the sensitizing solution was sucked out of the camera and processing chemicals were introduced into it, again by using the pipette. A yellow glass (C) in the rear door allowed the progress of development to be inspected.

848. Polaroid Land Camera. The first instant-print camera was the Polaroid Land 95 camera of 1948. A large roll of print paper (A) and a smaller roll of negative paper (B), connected by a leader, fitted into the top and bottom of the camera back. By means of the leader, the negative paper and the print paper were brought together and drawn between a pair of rollers (C), which broke a pod of processing chemicals, carried on the print strip, and spread its contents evenly between the two strips. After one minute, the finished print could be removed from the camera through a flap in the back.

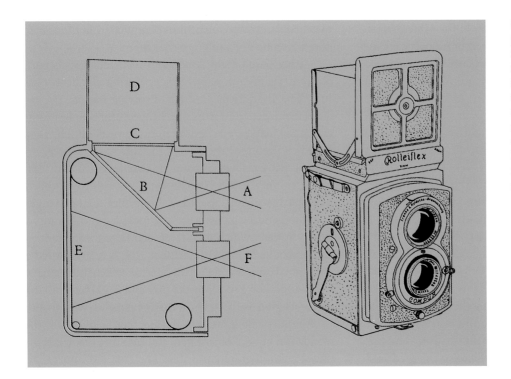

849. Rolleiflex Camera. The principle of the twin-lens reflex camera: Light, passing through the upper lens (A), is reflected from a mirror (B) onto a ground-glass focusing screen (C), which is viewed through a hood (D). The film (E) is exposed through the lower lens (F). The Rolleiflex camera of 1928 was the first of the modern twin-lens reflex cameras.

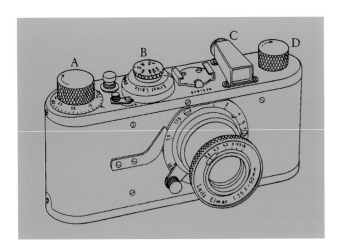

850. Leica Camera. The Leica camera of 1925: the film winding knob (A) also set the shutter, the six speeds of which were set on a dial (B). A direct-vision, optical viewfinder (C) was fitted near the film rewind knob (D). The noninterchangeable lens was set in a helically focused, telescoping mount.

851. Contax S Camera. The Contax S camera of 1949 was the first 35mm single-lens reflex camera to be equipped with a built-in pentaprism; it was set in the viewfinder housing. The camera's specification included a delayed-action shutter mechanism and screw-mounted, interchangeable lenses.

but the Polaroid was the first instant-print camera, requiring in its original version just one minute after exposure to produce a monochromatic positive print by means of a sealed pod of developer-fixer and a complicated image receiver. Because this system also provided a simple way to make test shots to previsualize the composition, lighting, and decor in advertising and fashion work, Polaroid film was adapted for use in professional studio and field cameras. There were a wide range of instant-print professional Polaroid films, including Polacolor film, which was introduced in 1962, and ProVivid, introduced in 1995. The apparatus was continually improved; the SX-70 system, introduced in 1972, was later supplanted by a 600 system that features automatic focus and electronic flash, with the batteries incorporated in the high-speed instant-color film pack.

852. Ermanox Camera. The Ernemann Ermanox camera of 1924 carried its *f*/2 Ernostar lens in a helical focusing mount. A folding, optical frame viewfinder was fitted, and the focal plane shutter gave speeds from 1/20 to 1/1,000 second.

853. Ceramic Magnesium Lamp. A ceramic magnesium lamp, typical of the powder flash lamps made in the 1890s. A charge of magnesium powder was placed in the funnel (A), which was surrounded by a circular tray (B). When lit, the spirit-soaked cotton wool in this tray gave a circular flame. A rubber bulb (C) was squeezed to inflate a thin-walled rubber bag (D), connected to the lamp by a clamped (E) tube. When the clamp was released, the puff of air propelled the magnesium powder through the flame.

One innovation in photographic technology was the use of standard color negative film in specially designed 35mm cameras to produce three-dimensional images in color that could be viewed in the hand, without a special viewer. Another involved a camera and film system based on a disk (rather than a roll of film) that could be inserted in a camera the size of a cigarette box. Both developments, which were aimed at the mass photography market—where, it has been estimated, amateur photographers have taken over 10 billion pictures a year since 1980[1]—had only limited success.

A development of great service to both amateur and professional photographers was that of electric flash illumination. Magnesium, in wire, ribbon, and powder form, had been ignited by several methods from the 1860s on *(pl. no. 290)*, but most uses became obsolete after the introduction in 1925 of the flashbulb, invented in Germany by Dr. Paul Vierkötter. By encasing the magnesium wire in glass, artificial illumination was made safer and smoke-free, and it produced less contrast. Foil-filled lamps appeared in 1929; like the wire bulbs, they were set off by batteries *(pl. no. 853)* and eventually could be triggered by the exposure mechanism of the camera. After World War II, flash synchronization became a built-in feature of virtually all cameras *(pl. no. 854)*; a modern mini-version is the flash cube. After 1950, the development of dry-cell-battery-powered circuitry and transistors made possible even lighter units. High-speed electric flash (known since Talbot's 1852 experiments), with flash duration of about

854. Burvin Synchronizer. The Burvin Synchronizer of 1934 was designed for miniature cameras, notably the Leica. It was fitted to the underside of the camera and was coupled to the shutter by means of a cable release. The synchronizer could be precisely adjusted so that the flash was fired when the shutter was fully open.

1/100,000 second, required laboratory facilities; it was mainly available for special projects such as those carried on by Ernst Mach in Czechoslovakia in 1887 and Harold Edgerton in the United States starting in 1940. Heavy-duty electric flash systems for studio use were introduced by Kodak in the 1940s and were followed by gradually lighter and more portable electronic flash (stroboscopic) equipment; a unit designed in 1939 by Edward Rolke Farber, an American newscameraman, was probably the first.

855. Eastman's Brownie Camera. The original Brownie camera of 1900 had the shutter release (A) and the film winding key (B) on the top; the film rolls (C) were placed vertically. To help in aiming the camera, V-lines (D) were marked on it. The first Brownie models had a push-on back (E) with a red window (F), but an improved back, hinged at the bottom and with a sliding catch at the top, was soon introduced.

856. Kodak Instamatic Camera. The Kodak Instamatic cameras were introduced in 1963. They took a drop-in cartridge that greatly simplified the loading of the cameras. Like most of the Instamatic cameras, the model 100 had a built-in, pop-up flash gun, released by a button.

Materials and Processes

Photographic material and equipment have undergone considerable refinement since the invention of the medium, but perhaps the most significant change has been in the increase in the light-sensitivity of film emulsions. It has been estimated that from the daguerreotype of 1839 to the new materials of the late 1970s, the sensitivity of film in full sunlight at *f*/16 aperture has increased 24 million times.[2] Both black-and-white and color film differ in sensitivity according to the size of the silver halide crystals suspended in the gelatin emulsion. Black-and-white and color films are

rated from slow (ASA/ISO 25) to fast (ASA/ISO 1000 or more), with the larger crystals in the faster film more sensitive to light, thereby enabling faster shutter speeds to be used in making the exposure. In the past, the larger crystals in high-speed film usually resulted in grainier and less tonally defined images (especially in enlargement), but in recent years both black-and-white and color positive and negative films were vastly improved in terms of speed and resolution. For use in scientific documentation and for penetrating haze conditions, infrared film, sensitive to light that is not visible to the human eye, was used.

For black-and-white prints, two basic kinds of paper were available: resin-coated (RC) and fiber-based. Both have a gelatin coating over the light-sensitive emulsion on a paper base, but the RC papers carry extra plastic layers on the bottom and beneath the emulsion layer. Both came in different grades of contrast.

Color Printing

One very significant development in the 20th century with regard to materials and processing has been the improvement of color. Photographs in color (photochromy) were desired from the inception of the medium, but despite early experiments by Herschel and Becquerel, which indicated the possibility of achieving this goal, a practicable chemical color process did not come into being until the opening years of the 20th century. Following the invention of Autochrome plates (*see A Short Technical History: Part II*), a variety of color materials appeared (Dufay Dioptichrome, Fenske's Aurora, Szezepanik-Hollborn Veracolor, Whitfield's Paget Colour Plates, Dawson's Leto Colour Plates, and Agfacolor), all of which were based on additive-color principles. From the second decade of this century on, George Eastman and the Kodak Research Laboratory worked on color materials, exploring additive processes that would enable amateurs and snapshooters to obtain color images without mastering complex technical skills. By 1925, as the demand for color grew stronger, so did the efforts to find a practicable system based on subtractive principles, a search that was further stimulated by competition among commercial firms and the Hollywood film industry, which looked toward color as an inducement to moviegoers during the Great Depression. During the 1930s, this goal became achievable with the discovery of new and more stable sensitizing dyes.

The possibility of adapting subtractive color theory to the production of color film was suggested early in the century by Karl Schinzel of Austria and Rudolph Fischer of Germany. They envisaged the formation of a triple-layer emulsion containing dye-couplers in primary colors that would block out their complements, which was realized

some 25 years later in Kodachrome. Invented by American amateur chemists and musicians Leopold Godowsky and Leopold Mannes in collaboration with Kodak Research Laboratory personnel, Kodachrome became the first tripack film to be released — first in 1935 as movie film, then as sheet film in 1938, and as a negative Kodacolor roll film in 1942. The German Agfa Company — which introduced a color plate that rivaled Autochrome in 1916 and had been experimenting with tripack systems based on subtractive theory — in 1936 announced Agfacolor Neu, a three-layer film in which the dye couplers were incorporated in the layers and released during development; this enabled the film to be processed in individual darkrooms. An almost identical product was marketed in 1939 by Ansco, the American firm affiliated with Agfa. In 1946, Eastman Kodak marketed Ektachrome, a positive transparency film that could be processed in home darkrooms; shortly thereafter, the same firm introduced Ektacolor — a color negative film from which prints could be made. Eventually color films became some 32 times faster than the early versions, and processing time was reduced from hours to minutes.

Initially, Kodak color products were sent back to the company for processing and were returned to the customers in the form of positive transparencies rather than color prints. In consequence, the use of 35mm color film gave rise to renewed interest among amateurs in slides and slide projection during the late 1940s. Color positive films (transparencies) were preferred by many professionals because they had a finer grain and were therefore sharper than corresponding color negative film, with the result that the projection of images was no longer just an amateur pastime but became of interest to educational institutions and corporations who found color slides and sophisticated multiple imaging systems to be successful teaching and sales tools.

Starting with Louis Ducos du Hauron (see *A Short Technical History: Part II*), color prints had been made by using a variant of the carbon process that is now called assembly printing. This procedure was transformed into ozobrome — a monochromatic print — invented in 1905 by Thomas Manley in England, from which carbro (or trichrome carbro) evolved into a full-color print during the early 1920s and remained popular until World War II. The Eastman wash-off relief process, introduced in 1935, was similar to the carbro process except that greater control ensured that there were fewer variations from print to print. In 1946 Eastman introduced a substitute — the Kodak dye-transfer (or dye-imbibition) system — whereby three separation negatives were used to produce three gelatin relief images that were dyed magenta, cyan, and yellow; eventually the three images were made directly from a tripack negative film by exposing it through filters. For the print,

the three dyed reliefs were transferred in exact register to gelatin-coated paper.

Eventually, negative and positive color images were created by one of two methods: the chromogenic system in which dyes were created during the processing, and the dye-destruction (or dye-bleach) system, in which a complete set of dyes is present at the start and the ones not needed to form the image were subsequently removed by bleaching. The latter method, which evolved from experiments undertaken in Hungary in 1930 by Bela Gaspar, is basic to Cibachrome. Within the chromogenic system, two methods are used: the dye-injection system mentioned above in connection with Kodachrome and the dye-incorporation method. In the latter — used in the manufacture of nearly all well-known color films and color printing papers — the chemicals that will form the dyes are included in each layer of the emulsion and are activated during processing.

Printing Color Photographs in Ink

Methods of printing photographs in pigmented ink had achieved a measure of success in the 19th century. The procedures used were based on the knowledge of primary colors and on the technique of using different plates to receive red, yellow, and blue printing inks, which when superimposed could produce all possible shades of color. Such methods received a boost from the successful efforts in 1861 of Scottish physicist James Clerk Maxwell to produce three negatives, each made through a different color filter, which he then superimposed through filters to project a photographic image in natural colors.

Three-color superimposition was the basis of work being done by Louis Ducos du Hauron and Charles Cros (independently from each other) in France during the late 1860s. Du Hauron's significant contributions involved the use of a screen "with extremely fine lines of red, yellow, and blue of equal size, with no space between them," and the invention of a three-color camera, in which three-color separations could be made simultaneously. While these procedures were actually designed for three-color printing of the photographic positive, in 1870 Du Hauron produced a lithographic reproduction and later announced that his experiments were adaptable to three-color pigment printing on mechanical presses using red, blue, and yellow ink. Additional impetus came from the discoveries by Hermann W. Vogel regarding increased sensitizing of photographic emulsions to the green and yellow portion of the spectrum.

A period of heightened activity in pigmented-ink printing from photographs reflected the great interest in using color images in advertising and periodicals, especially in the United States in the last two decades of the 19th century.

Much of the research was carried out by Frederic E. Ives, whose earlier efforts in the perfection of halftone process plates for relief printing has been noted above. By 1885, he exhibited a process for photographing colors and then reproducing them photomechanically, albeit crudely, using a camera that exposed three negatives simultaneously and employing line screens to make three relief printing plates, each of which would receive a different color ink relating to the original color of the image. A more accurate process was demonstrated in 1893 by William Kurtz, a commercial photographer in New York City, who had turned his attention to the problems of halftone printing in color. Using similar techniques — three single-line halftone blocks — he reproduced a still-life camera image whose color quality was immediately recognized as authentic enough for use in advertising such items as flowers and fruits. Just before the turn of the century, magazines began to print both covers and advertisements using the color-engraving process developed by Kurtz and perfected by others. Whether using three separate halftone color blocks or adding black as a fourth block (as later became common), color images produced on glossy paper by the relief printing technique have been creditable since the turn of the century. Intaglio or gravure methods have not been amenable to multiple-plate color printing, in part because of the intrinsic nature of the process and partly due to the amount of handwork required.

Toward the end of the 19th century, photolithography also began to be used for color printing, with collotype producing some of the most delicately colored prints of the era. Throughout the twentieth century, when offset printing replaced relief printing as the preferred technology, it employed the four-color block method of superimposing magenta, cyan, yellow, and black inks to produce a full-color image. The 20th-century monochromatic and color processes used screens as a means of dividing photographic tonalities into discrete segments. The latest discoveries in this area involve screenless offset, in which a plate is prepared by graining it with peaks and valleys and random patterning. The tonal range of the print will depend on how light exposes the peaks and depressions.

Conservation

As greater numbers of serious photographers began to work in color during the 1970s, questions regarding the stability of the images became more pressing. Central to the problem is the fact that magenta, cyan, and yellow dyes change and fade at differing rates when exposed to regular light and to ultraviolet radiation. Also, color materials are affected to an even greater degree than monochromatic silver crystals by humidity, heat, and chemicals in the environment. With both color and black-and-white images being collected by individuals and museums, increasing awareness of the potential problems in the conservation of photographic materials has prompted efforts on the part of manufacturers to produce more stable products. Specialists in conservation have devised strategies to print, store, and display all types of photographs in ways that will minimize their deterioration. At the same time, interest in restoring works that have already deteriorated has grown. These developments reflect the fact that the photograph has become an artistic commodity with market value, but they also offer a promise that diverse images can be preserved, no matter what their original purpose may have been.

Digital Photography

Miriam Leuchter

Digital photography has come to dominate the medium: It affords greater resolution, in images captured in much lower light and at much faster speeds, than is possible with chemical processes. It permits the transmission of images from places impractical to reach with film, whether the far reaches of the galaxy or the inside of a living blood vessel. It allows photographs to be reproduced *ad infinitum* without loss of quality and to be seen around the world simultaneously. It facilitates the alteration of images to such an extent that photographs can depict objects, people, and settings that do not exist in reality. And it has put cameras into the pockets of billions of people and given them the means to share their photographs widely.

This section focuses primarily on mainstream applications of digital photography. Its history in specialized fields—medical imaging, astronomy and space exploration, metallurgy, military intelligence, robotics, cinema, and many others—follows parallel, and often intersecting, technological paths from the same origins.

Although digital technology arose in the late 20th century, attempts to achieve many of its aims began more than 100 years earlier. Chief among these were inventions meant to transmit images over telegraph wires through binary code, a building block of all things digital. This succeeded in the early 20th century with the transmission of halftone photographs over telephone lines, the so-called wire photo. The invention of television, with its transmission of moving images over radio waves for display on a cathode-ray tube monitor, was another critical precursor.

But it took the advent of computers in the 1950s for true digital imaging to emerge. Computing pioneer Russell A. Kirsch created the now-familiar square pixels along with the first digitized image—and laid the path for all digital imaging to follow. Working at the National Bureau

of Standards on the first programmable computer in the United States in 1957, Kirsch cut a two-inch square, just the baby's face, from a photograph of himself holding his infant son Walden. He and his colleagues scanned it, using a drum scanner they had built, which included a mask that broke images into tiny squares in a 176 x 176 square grid. They had written a binary code that rendered the image in stark black and white and displayed it on a cathode-ray oscilloscope attached to the computer, then experimented with layering multiple scans taken at different thresholds to create a grayscale image.[3]

Kirsch and his colleagues' experiments led directly to the development of digital photography as we know it. They wrote algorithms for producing greater contrast at the edges of objects in an image and for measuring the objects, both crucial to image processing and analysis and to pattern recognition. Their work also contributed to the creation of specialized instruments for digital imaging in the physical sciences, including astronomy, metallurgy, chemistry, biology, and medicine.

Among the earliest developers of digital imaging was the National Aeronautics and Space Administration (NASA). In the 1960s, NASA's Jet Propulsion Lab (JPL) decided to apply its burgeoning computer power to enhancing images from video footage of celestial bodies collected by the U.S. space program. Starting in 1963, JPL engineers—including Frederic Billingsley, the first to publish the term *pixel*, short for "picture element," in 1965—devised the Video Film Converter to transform analog signals into digital data and wrote the algorithms to obtain more detail. The processing of still images from video footage would become a hallmark of early digital cameras.

Another crucial invention made digital cameras possible. The single-chip microprocessor, patented by a team from Intel in 1971, paved the way for the digital revolution in every area of technology. The 4 x 3 mm Intel 4004 microchip held 2,300 metal-oxide semiconductor transistors, making it the first general-purpose programmable processor on the market.

Core Technology

Digital photography depends on four intertwined, core technologies: the image sensor (capture), file creation and storage (processing and memory), image editing, and display. All of these have evolved rapidly in the past few decades, and new variations and inventions are always on the horizon.

The process begins with the sensor. The charged-couple device (CCD), invented in 1969 by William S. Boyle and George E. Smith of Bell Labs, is an integrated circuit that captures and transforms light into a stored electrical charge.[4] The CCD comprises an array of metal-oxide semiconductor (MOS) capacitors, each one a pixel. (The standard unit of measurement today is the megapixel, equal to about one million pixels.) In 1971 Michael Tompsett, also of Bell Labs, received the first patent for applying the CCD to imaging. He developed a series of shoebox-size cameras, with which he took the first digital color image, of his wife, Margaret, in 1972.[5]

Rapid improvement in CCD sensors came thanks to the work of Nobukazu Teranishi, then at NEC, who developed the pinned photodiode (PPD) in the early 1980s. This buried-diode structure vastly improved the light-gathering abilities of pixels, allowing them to be shrunk and thus fit in greater quantity on a sensor, which could then produce images with much higher resolution and clarity.[6]

In 1993, Eric Fossum of NASA's Jet Propulsion Lab proposed to adapt another type of integrated circuit, the complementary metal-oxide semiconductor (CMOS), to imaging use. CMOS chips use far less power and can be made much smaller and more cheaply than CCD sensors.[7] Fossum called his invention the CMOS active pixel sensor and the next year proposed adding the PPD structure and another architecture called backside illumination, which essentially moves the wiring to the back of the chip, allowing more light to reach the pixels.[8] Working with Eastman Kodak, Fossum's team succeeded in adding the PPD to CMOS sensors in 1995, and by the early 2000s these sensors equaled and eventually surpassed CCD sensors in imaging performance. Backside illumination also went a long way to improving image quality, especially as advances in manufacturing applied it to image sensors of increasing physical dimensions through the 2010s. Today CMOS is by far the dominant sensor format in digital photography, found in nearly every camera and smartphone.

But the camera's capture of light through a sensor is just the very beginning of the process of digital photography. The sensor's electronic signals must be processed and stored as a digital file in order to be seen and reproduced, both inside the camera and outside it. Therefore, the development of digital photography has depended on a simultaneous revolution in data processing that has made computers ever more powerful—and brought this power to ever smaller digital devices. The desktop computing boom that began in the 1980s put image taking, processing, and manipulation into more people's hands as the decades progressed. And the exponential increase in chip speed and memory has made cameras much faster and better, not just at capturing and passing along image data but also at manipulating and combining it in different ways internally, such as stitching together separate frames for panoramas or higher-resolution images, and applying color and/or distortion filters to change the look of a picture.

The data files captured by a digital camera must be saved and then transferred, usually to a computer. Image files often start in a proprietary raw format but can be converted into a universally readable one such as JPEG, the file form most people now see and share online. Early digital cameras used an accessory or built-in hard drive, but as memory media became more stable and robust, removable memory in the form first of floppy disks and then solid-state flash memory (CompactFlash, SD, and other card formats) became a crucial component in cameras. Some smartphones also use removable flash memory, while some store images only in built-in memory, but all can upload images to Internet-based cloud storage for sharing among devices or backing up data-intensive picture files. In studio settings, where file sizes are generally much larger, a camera may be tethered directly to a computer; wireless connections are also common. Increases in memory capacity and speed have allowed digital cameras to handle larger files faster and to collect more images before downloading them.

In digital photography, the term *processing* describes the conversion of light to digital data and the conversion of that data into an image that is visible on a screen or in print. Processing subjects image files to varying degrees of compression and data loss, and it presents photographers with trade-offs in terms of file size and interoperability. Raw files retain the most image data, but these generally must be converted to another format, such as TIFF or JPEG, to be read by a device other than the camera or a computer that is outfitted with the camera maker's software. The JPEG file format has become a default standard for most digital photography, since it can be read by web browsers and across devices. JPEG files can be saved along a continuum of compression levels (to reduce file size), though at a cost of image quality. Any image editing on the file beyond processing is *post-processing*. Imaging work in post-processing can range from straight fixes, such as color correction or balancing exposure, to complicated manipulations such as compositing and retouching.

Digital photographs may be printed, or they may be displayed on any number of devices: smartphones, tablets, headsets, computer monitors, televisions, projector screens. As resolution and image quality (in both the original file and the display device or print medium) increase, digital photographs may be rendered at far larger sizes and in sharper detail than are possible with photographs from film. Digital technology, specifically inkjet printing, also allows photographs to be printed on a wide variety of surfaces without the light-sensitive emulsions needed for printing from film.

Digital Cameras

Although Michael Tompsett got there first, Kodak engineer Steven Sasson and his colleagues, in 1975, built what is considered the first portable, working, prototype digital camera. Incorporating a 100 x 100 pixel CCD sensor, for a 10,000-pixel monochrome image, it was the size of a large toaster, weighed some eight pounds, and took 23 seconds to record a single image to a digital cassette tape.[9]

It wasn't until 1990 that the first commercially available digital camera came to market. The Dycam Model 1, also sold as the Logitech Fotoman, had a 376 x 240 pixel sensor that captured low-resolution monochrome images. In 1991, Kodak introduced the DCS, the first commercial digital single-lens reflex (DSLR) camera. Kodak's 1.3-megapixel CCD incorporated a color-filter array, invented by Bryce Bayer, whose pattern of red, green, and blue microfilters remains in widespread use in digital sensors today. The DCS camera had a Nikon F3 body, with the image sensor replacing the film chamber, and required an external file-storage unit.[10]

Innovation in digital cameras continued through the 1990s, but few photographers embraced the new technology. The first camera to use stable solid-state memory, the first to transmit directly over phone lines, the first to add a liquid-crystal display (LCD) on the back as a viewfinder and display—all arrived in the early part of the decade. It wasn't until 1997 that digital photography had its first breakout hit, Sony's Digital Mavica, which stored images on a 3.5-inch floppy disk.[11]

In 1994, Kodak again teamed with Nikon, and this time with the Associated Press as well, to produce a digital single-lens reflex specifically for photojournalists; the *Vancouver Sun* became the first newspaper in the world to convert to all-digital photography. It took years for many others to follow, but the arrival of the Nikon D1 in 1999 heralded a new age in digital photography. With a 2.7-megapixel CCD sensor, it presented a serious challenge to film-based cameras. Digital single-lens reflex cameras from Canon, Fujifilm, and Olympus debuted soon after.[12]

Until 2002, the typical sensors used in digital cameras (Advanced Photo System type-C), at about 16 x 24 mm, were less than half the size of the 24 x 36 mm frame for the 35mm film used in traditional single-lens reflex cameras. This changed with the advent of three professional full-frame models that year from Contax, Kodak, and Canon (the EOS-1Ds). The physical size of the sensor has an impact on image quality, since larger chips have space for more and bigger pixels, yielding greater fine detail and requiring less light; they also permit shallower focus, for a greater sense of dimensionality and depth in a photograph.[13]

Also in 2002, for the first time annual global sales of digital cameras outstripped film cameras. By the end of 2003, the difference in sales was vast. In the years since then, film has become a specialty product, while digital photography has completely taken over the mainstream.[14]

Over the first decade of the 2000s, compact point-and-shoot cameras became smaller, slimmer, and richer in features. Cameras with fixed, long zoom lenses appeared. More important for serious photographers, the technical capabilities of digital single-lens reflex cameras—including the critical factors of resolution, speed, image quality, and available-light capture—soared.

Optical lens manufacturers also took large strides during this period to keep up with the drive toward greater resolution, speed, and compactness. New types of optical glass and coatings and the miniaturization of electronic components improved lenses' sharpness, size, weight, light-gathering ability, and autofocus, especially in the 2010s.

The trend of perpetual improvement in digital single-lens reflex cameras continued through the 2010s. However, in 2007 and 2008, two new types of cameras emerged. Both would transform the photographic industry; one would transform photography itself.

In 2008, Panasonic introduced the Lumix DMC-G1, trading the reflex mirror and optical viewfinder of the digital single-lens reflex camera for an electronic finder and greatly reducing the distance between the lens mount, which accommodated an array of lenses, and the focal plane on the sensor. This new type of camera, called a mirrorless interchangeable-lens compact, quickly gained traction against digital single-lens reflex cameras, thanks to its smaller size, lighter weight, and greater agility and speed.[15] In 2013, Sony succeeded in putting a full-frame CMOS sensor in a compact body with its Alpha 7 series. It took five years for other camera makers to follow suit with full-frame mirrorless interchangeable-lens compacts.

But a product that arrived in 2007 had an even bigger impact on photography: Apple's iPhone. Earlier mobile phones (the first camera-phone came in 1999) may have had better cameras, but this groundbreaking smartphone brought the convergence into the mainstream. It combined a simple interface, intuitive image downloading and sharing tools, and, with the advent of third-party imaging apps in 2008, myriad options for editing, enhancing, and playing with photos—all on the phone itself. Other smartphone makers and app developers, using Google's Android mobile operating system, quickly followed.[16]

With so many people now carrying cameras in the form of phones—which let them share photos with friends and the world at large instantly—sales of dedicated cameras, especially point-and-shoots, plummeted. For a few years, increasing sales of digital single-lens reflex cameras and mirrorless interchangeable-lens compacts buoyed the camera market: The number of digital still cameras produced annually peaked at nearly 122 million in 2010. But by 2018 annual digital camera production had plunged to just 19.5 million, its lowest since 2001.[17] Nonetheless, the number of digital images created each year keeps growing; people shot an estimated 1.2 trillion photographs in 2017.[18]

Software and Post-Processing

Even before digital cameras, imaging software played a big role in photography, especially for graphic designers working with scanned film and prints in advertising, publishing, and other commercial markets—as well as technicians in medicine, scientific research, and government projects such as space exploration, mapping, and military intelligence. But one piece of software brought digital imaging to a much broader market of creative professionals and enthusiasts: Photoshop.

Created by image-processing PhD student Thomas Knoll and his brother John Knoll, who worked at special-effects studio Industrial Light and Magic, the program started in 1987 as a hack. It went through several iterations and names before hitting on Photoshop and then landing a long-term wholesale licensing deal with Adobe. Adobe Photoshop 1.0 for the Apple Macintosh computer launched in February 1990; the first Microsoft Windows edition arrived in 1992. Among Photoshop's earliest innovations were its method for selecting and manipulating only part of an image, its capability to load and save image files in different formats, and—unheard of outside of specialized lab settings—its use of controls for tones, balance, hue, and saturation. Other crucial advances were layers, the digital equivalent of the graphic designer's translucent acetate sheets, used to affect the look of what is underneath, and a structure that accommodates plug-in software to augment the program's capabilities.[19] Neither layers nor plug-ins originated with Photoshop, but Adobe's adoption of these structures brought them to many more users.

Photoshop, like its eventual offshoots and competitors, allows image data to come to its full potential as a finished photograph. It has changed the very nature of photography. So ubiquitous is its influence that the trademark has morphed into a generic verb: *to photoshop* means to alter an image. While it is far from the only imaging software in wide use, it both paved the way for others and remains the industry standard well into the 21st century.

Showing and Sharing Digital Photography

None of these innovations would be possible without the screen. The rise of television from its origins in the 1920s through the 1950s accustomed people to the idea of looking at images on a cathode-ray tube. Kodak's 1965 introduction of the Carousel 35mm slide projector, a successor to the older magic lanterns and the straight-sided slide projectors of the 1950s, popularized the sharing of photographs by allowing users to flash them on a screen for gatherings at home and audiences in public. Digital photography's development over the past 30 years, including the display and sharing of images, has depended on the ever-increasing capabilities of both computer monitors and the small screens built into cameras and now smartphones and other mobile devices.

Three critical technologies continue to play a role in this dynamic: liquid-crystal display (LCD), light-emitting diode (LED), and the graphical Web browser. LCD technology is based on electrically sensitive materials that can flow like a liquid but have the hard structure of a crystal. Flat LCD panels arose in the 1960s in electronic watches, calculators, and clocks; now, with vast improvements in technology, they are the basis of every flat screen in use, from mobile phones to mural-size televisions.

Contemporary screens require backlighting from LEDs and their more sophisticated kin (organic LED, or OLED, and active matrix OLED, or AMOLED), which render images in an increasingly wide color gamut with ever-greater resolution. By the end of 2018, computer monitors used by image editors had screen resolutions of 2560 x 1440 pixels, and some larger ones reached 3840 x 2160 pixels (so-called 4K).[20] With 7680 x 4320 pixel (8K) televisions on the market, the resolution of monitors may double some time in the next several years.

Connecting all these devices, of course, is the Internet, the World Wide Web (the global, open, hypertext system invented by computer scientist Tim Berners-Lee in 1989), and the countless Web servers that enable digital images, like all other digital information, to be shared. As the Web has expanded, photography is everywhere, on every device. Photo-sharing services and websites began in the mid- to late 1990s; Shutterfly, which launched in 1999, is one of the longest-term survivors of those early years. In the 2010s, photo sharing became a province of mobile apps, led by Instagram, created by Kevin Systrom and Mike Krieger and launched on the iPhone in 2010. Since then, tens of billions of photographs have been uploaded to Instagram alone.

Augmented and Virtual Reality

Digital photography also adds dimensionality beyond stereoscopic and other early forms of three-dimensional imagery. It has enabled the rise of holography, which creates three-dimensional images by interfering with beams of light, usually from lasers. It allows for the printing of actual three-dimensional objects, which has begun to revolutionize manufacturing and has made an appearance in art practice. And it makes possible immersive and interactive augmented reality (often referred to simply as AR), virtual reality (VR), and spherical images.

Augmented reality, a blending of the virtual and the actual, began with military applications in the early 1990s. By overlaying digital images onto real-world environments using a projector, headset, or mobile device, augmented reality brings archived data into the here and now. Virtual reality and spherical images are photographed either with a set of linked cameras for very high resolution or with a single camera that has several (or even just two) sensors and lenses built in. Images or video from each of the sensors are then combined to let the viewer see in every direction. Virtual reality requires a special headset; the viewer looks around physically to see different angles on a digital scene. These three-dimensional display technologies are still quite new, and their impact will become clear only with time.

As has been the case with conventional photographic technology throughout its 180-odd years of existence, the means and methods of digital imaging currently in use will continue to change—in all probability, with greater rapidity than was true of photography based on silver processes. Whatever these changes entail, there can be little doubt that in the future, a great many of the tasks previously undertaken by conventional photography will be affected digitally.

Notes

1. THE EARLY YEARS

1. Unsigned article, *Journal of the Franklin Institute* (April 23, 1839): 263.

2. C. R. Leslie, *Memoirs of the Life of John Constable Composed Chiefly of His Letters* (1845; reprint, London, 1951), p. 323.

3. See *Technical History I*, n. 5.

4. An annuity of 6,000 francs for Daguerre and 4,000 for Isidore Niépce, with whom Daguerre had renegotiated the contract after the death of Isidore's father, was paid by the French government; see Helmut and Alison Gernsheim, *L.J.M. Daguerre: The History of the Diorama and the Daguerreotype*, 2d ed. (New York, 1968), pp. 92–93, for text of the contract between the parties.

5. Josef Maria Eder, *History of Photography* (reprint of 3d edition, New York, 1978), p. 246.

6. S. D. Humphrey, "On the Daguerreotype," *Humphrey's Journal* 20, 10 (February 15, 1859): 307.

7. Oliver Wendell Holmes, "The Stereoscope and the Stereograph," *Atlantic Monthly* 8 (June 1859): 739. Holmes was himself an amateur photographer; see Carol Schloss, "Oliver Wendell Holmes as an Amateur Photographer," *History of Photography* 5, 2 (April 1981): 119–24.

8. This definition obviously is inadequate in view of the possibilities of producing direct positive prints, combination prints with both positive and negative images, one-step images, and one-of-a-kind light graphics without a camera. It might be restated as "any process by which images are rendered by the action of light on a photosensitive surface."

9. John W. Herschel to William Henry Fox Talbot, May 9, 1839, Science Museum, London, in which Herschel praises the fine detail of the daguerreotype.

10. See Weston J. Naef, "Hercules Florence, 'Inventor do Photo-graphia,'" *Artforum* (February 1976): 58; the information about Florence was first brought to light by the Brazilians Alfred Santos Pressaco in 1965 and Boris Kossoy in 1973. Maedler's use of the word *photography* is mentioned in Erich Stenger, "The Word *Photography*," *British Journal of Photography* 3777, LXXIX (September 23, 1932): 578–79.

11. Talbot took out four patents on photographic processes—in 1841, 1843, 1849 (with Thomas Malone), and 1851.

12. H.J.P. Arnold, *William Henry Fox Talbot: Pioneer of Photography and Man of Science* (London, 1977), p. 211.

13. From an article in the *Economist* (July 26, 1851): 812; in Arnold, Talbot, pp. 177, 341 n. 5.

14. *Atheneum* (March 1845); in Arnold, *Talbot*, p. 155.

15. Bayard received 600 francs to improve equipment and subsidize further experiments, with a request to defer publication of his process; see H. and A. Gernsheim, *Daguerre,* p. 88.

16. Talbot was involved in only one court case against an unfranchised user of the calotype process, but in 1854 he brought suits against James Henderson and Martin Laroche for the unlicensed use of sensitized collodion. The Laroche case came to trial first and was decided against Talbot.

17. Holmes, "Stereoscope and the Stereograph," p. 728.

18. See Edward W. Earle, ed., *Points of View: The Stereograph in America—A Cultural History* (Rochester, N.Y., 1979). While interest in stereograph photography and viewing was somewhat cyclical in the 19th century, it did not seriously decline until the improvement in magazine printing, which was made possible by the invention of the process halftone plate toward the end of the century.

19. H. and A. Gernsheim, *Daguerre,* pp. 192–94.

20. Literary Gazette, February 5, 1841; in Gail Buckland, *Fox Talbot and the Invention of Photography* (Boston, 1980), p. 62.

2. A PLENITUDE OF PORTRAITS

1. Charles Baudelaire, "The Modern Public and Photography," 1859; trans. and reprinted in Alan Trachtenberg, ed., *Classic Essays on Photography* (New Haven, Conn., 1980), pp. 86–87.

2. Albert S. Southworth, "An Address to the National Photographic Association of the United States"; in the *Philadelphia Photographer* VIII (October 1871): 320.

3. Johann Kaspar Lavater, *Essays on Physiognomy* (1789); in Elizabeth Anne McCauley, *Likenesses: Portrait Photography in Europe, 1850–1870* (Albuquerque, N.M., 1980), p. 3.

4. According to Helmut and Alison Gernsheim, *L.J.M. Daguerre: The History of the Diorama and the Daguerreotype*, 2d ed. (New York, 1968), p. 116, up to 2,000 prints could be made from a physionotrace plate, but unless the copper plates were refaced and re-etched, this seems unlikely.

5. Baudelaire, "Modern Public and Photography," in Trachtenberg, ed., *Classic Essays on Photography,* p. 87.

6. Antoine Claudet, "Progress and Present State of the Daguerre-otype Art," *Journal of the Franklin Institute* 10, 3d ser. (July 1845), p. 45.

7. Stuart Bennett, "Jabez Hogg Daguerreotype," *History of Photography* 1, 4 (October 1977): 318. The sitter is thought to be William Johnson, father of John Johnson, inventor with Wolcott of the mirror camera.

8. Unsigned article, *Bath and Cheltenham Gazette*, April 5, 1842, p. 4. Daguerreotypes also were likened to "fried whiting glued to a silver plate" by Francis Wey, an eminent French essayist and author of *"Théorie du portrait,"* a series that appeared in the photographic journal *La Lumière*; see part 2, May 1851, p. 511.

9. Fritz Kempe, *Daguerreotypie im Deutschland: Vom Charme der frühen Fotografie* (Seebruck am Chiemsee, Germany, 1979), p. 26.

10. Branibor Debeljkovi´c "Early Serbian Photography," *History of Photography* 3, 3 (July 1979): 234.

11. Nathaniel Hawthorne, *The House of the Seven Gables,* paperback ed. (New York, 1967), p. 153.

12. Unknown author, "Reporting by Photography," *Humphrey's Journal* 1, 6 (April 15, 1854): 15. Brady signed his name with a middle initial B although no middle name has come to light. For a discussion of the photographer's relationships with the political and commercial figures of the time, see Roy Meredith, *Mathew Brady's Portrait of an Era* (New York and London, 1982), pp. 30, 47. See also Josephine Cobb, "Mathew B. Brady's Photographic Gallery in Washington," *Records of the Columbia Historical Society of Washington, D.C.,* 1959, pp. 28–67.

13. Southworth, "Address to the National Photographic Association," p. 320.

14. Unknown author, "Daguerreotypes, Etc.," *Ballou's Pictorial Drawing-Room Companion* IX, 8 (August 25, 1855): 125.

15. N. G. Burgess, "The Value of Daguerreotype Likenesses," *Photographic and Fine Art Journal* VIII, 1 (January 1855): 19.

16. Walt Whitman, in Justin Kaplan, *Walt Whitman: A Life* (New York, 1980), p. 112.

17. Richard Rudisill, *Mirror Image: The Influence of the Daguerreotype on American Society* (Albuquerque, N.M., 1971), p. 238.

18. David Octavius Hill, in *The Hill/Adamson Albums* (London, 1973), unpaged.

19. Hamilton L. Smith invented the process. The patent was taken over by William and Peter Neff, who called the product a melainotype, and by Victor M. Griswold, who called it a ferro-type; later it became known as a tintype. See Beaumont Newhall, *The History of Photography from 1839 to the Present,* rev. and enl. ed. (New York, 1982), p. 63.

20. Anthony Trollope, *Barchester Towers,* paperback ed. (New York, 1963), p. 181.

21. Originally ascribed to Adolphe Braun; re-ascribed by Jan Coppens to Louis Pierson, who joined the firm of Ad. Braun et Cie. in 1878. See J. Coppens, "La Castiglione," *Foto* 29 (December 1974): 36–39; "Mayer en Pierson portretfotografen onder het tweede keizerrijk," *Foto* 30 (February 1975): 26–27.

22. Quoted in Nigel Gosling, *Nadar* (New York, 1976), p. 37.

23. Philippe Burty, "Nadar's Portraits at the Exhibition of the French Society of Photography" (1859); trans. and reprinted in Beaumont Newhall, *Photography: Essays and Images* (New York, 1980), p. 109.

24. This portrait is one of a series of stereographic portraits taken by Gardner sometime between early February and the second week in April 1865; see James Mellon, *The Face of Lincoln* (New York, 1979), pp. 184–85, 201. Stefan Lorant, *Lincoln: Picture Story of His Life,* rev. ed. (New York, 1957), p. 258, dates it to April 10, 1865, as the last portrait made of Lincoln.

25. William Henry Shelton, "Artist Life in New York in the Days of Oliver Horn," *Critic* XLIII (1903); in Ben L. Bassham, *The Theatrical Photographs of Napoleon Sarony* (Kent, Ohio, 1978), p. 13.

26. Unknown author, "How the Camera Came to Japan," *East* XVI, 5–6 (June 1980): 32; see also John Dower, introduction to *A Century of Japanese Photography* (New York, 1980), p. 3.

27. Judith Mara Gutman, *Through Indian Eyes: 19th- and Early-20th-Century Photography from India* (New York, 1982), pp. 15–16 ff; her thesis is that native photographers photographed differently from Westerners.

28. Quoted in Brian Hill, *Julia Margaret Cameron: A Victorian Family Portrait* (London, 1973), p. 127.

29. Unknown author, "Report of the Exhibition Committee," *Photographic Journal* 162 (October 16, 1865): 161.

30. Mrs. George Frederick Watts, in Charles-Harvey Gibbs-Smith, "Mrs. Julia Margaret Cameron, Victorian Photographer," in *One Hundred Years of Photographic History: Essays in Honor of Beaumont Newhall,* ed. Van Deren Coke (Albuquerque, N.M., 1975), p. 71.

31. Gosling, *Nadar,* p. 27.

3. LANDSCAPE AND ARCHITECTURE

1. Marcus Aurelius Root, *The Camera and the Pencil* (New York, 1864), p. XVI.

2. Oliver Wendell Holmes, "The Stereoscope and the Stereograph," *Atlantic Monthly* 8 (June 1859): 747–48.

3. Quoted in André Jammes and Robert Sobieszek, *French Primitive Photography* (New York, 1970), unpaged.

4. Patrick Connor, *Savage Ruskin* (Detroit, 1979), p. 49.

5. Richard Rudisill, *Mirror Image: The Influence of the Daguerreotype on American Society* (Albuquerque, N.M., 1971), p. 12.

6. Ibid., pp. 142–49.

7. Unknown author, "The Application of the Talbotype," *Art Union* (July 1846): 195.

8. See André Jammes and Eugenia Parry Janis, *The Art of French Calotype* (Princeton, N.J., 1983), pp. 55–56, for a discussion of this question.

9. Quoted in Robert Hershkowitz, *The British Photographer Abroad* (London, 1980), p. 82.

10. Francis Steegmuller, ed., *Flaubert in Egypt: A Sensibility on Tour* (Boston, 1972), pp. 23–24; Du Camp used Blanquart-Evrard's improved damp calotype process.

11. First commercially published album in France to be illustrated with photographs, issued by Gide and Baudry in 1852 with images from negatives made by Du Camp; see Isabelle Jammes, *Blanquart-Evrard et les origines de l'édition photographique française: Catalogue raisonné des albums photographiques édités, 1851–1855* (Geneva, 1981), p. 81. According to Nissan Perez, "Aimé Rochas, Daguerreotypist," *Image* (June 1970): 11, three photo-graphs in this album were by Aimé Rochas, a French daguerreotypist traveling in the Near East at the same time. The metal plates were rephotographed on albumen-coated glass from which prints were made.

12. James Borcoman, *The Painter as Photographer* (Vancouver, 1978), unpaged.

13. Unsigned article [Lady Elizabeth Eastlake], "Photography," *Quarterly Review* CI (April 1857): 462; see chap. 5, n. 1.

14. Another version exists in oval format, according to Mark Haworth-Booth, "Landscape in Amber: Camille Silvy's River Scene," in *Mid-19th-Century Photography: Images on Paper* (Edin-burgh, 1979), pp. 6–7. Silvey's work was praised by an unknown author in *Photographic Journal* 78 (February 5, 1859): 179.

15. For a discussion of Le Gray's seascapes, see Nils Walter Ramstedt, "The Photographs of Gustave Le Gray" (Ph.D. diss., University of California, Santa Barbara, 1977), pp. 147–76.

16. Quoted in Ian Jeffrey, "British Photography from Fox Talbot to E. O. Hoppé," in *The Real Thing: An Anthology of British Photographs, 1840–50* (London, 1975), p. 16.

17. This point was expressed by Holmes in "The Stereoscope and the Stereograph," p. 747, as "Form is henceforth divorced from matter. In fact, matter as a visible object is of no great use any longer."

18. John Hannavy, *Roger Fenton of Crimble Hall* (Boston, 1975), p. 180.

19. See Rolf S. Schutze, *Victorian Books with Original Photographs* (London, 1962). Julia Van Haaften, curator of photographs at the New York Public Library, estimates the number of books illustrated with photographs issued between 1855 and 1915 as closer to 4,000 (conversation with author, May 1984).

20. Quoted in Gerda Peterich, "G.W.W.," *Image* (March 1956): 22.

21. Robert Sobieszek, "Vedute della camera," *Image* (March 1979): 1.

22. From the *London Times*, 1857; in Helmut and Alison Gernsheim, *The History of Photography* (New York, 1969), p. 286.

23. Quoted in Bill Jay, *Victorian Cameraman: Francis Frith's Views of Rural England, 1850–1898* (Newton Abbot, England, 1973), p. 22.

24. First of eleven volumes and three sets of stereographs illustrated with Frith images; published by J. S. Virtue, London, 1858. Included among other Frith publications is *The Holy Bible: Containing the Old and New Testaments . . . Illustrated with Photographs by Frith*, Glasgow, 1862–63.

25. Italo Zannier, *Antonio e Felice Beato* (Venice: Ikona Gallery, 1983), unpaged.

26. Alexander Hunter, *Madras Exhibition of Raw Products and Manufactures of South India;* in G. Thomas, "Linnaeus Tripe in Madras Presidency," *History of Photography* 5, 3 (October 1981): 330.

27. For example, Walter Woodbury, "Photography in Java," *Photographic News* 129 (February 22, 1861), notes the "twenty-seven coolies" who carried apparatus and provisions. Adolphe Braun required the services of fifteen porters to make five exposures when he ascended the Stralhorn in the Alps; see William Culp Darrah, *Stereo Views: A History of Stereographs in America and Their Collection* (Gettysburg, Pa., 1964), p. 56.

28. Clark Worswick and Ainslee Embree, *The Last Empire: Photography in British India, 1855–1911* (Millerton, N.Y., 1976), p. 56.

29. John Thomson, *The Straits of Malacca, Indo-China and China* (New York, 1875), pp. 188–89.

30. See Keith F. Davis, *Désiré Charnay—Expeditionary Photographer* (Albuquerque, N.M., 1981), pp. 104–7, for mention of other photographers who documented archaeological sites in Central America.

31. Diary entry, September 14, 1872; in Don D. Fowler, ed., *Photographed All the Best Scenery: Jack Hillers's Diary of the Powell Expedition, 1871–1875* (Salt Lake City, 1972), p. 143.

32. William Goetzmann, *Exploration and Empire: The Explorer and the Scientist in the Winning of the American West* (New York, 1966), p. 479, notes that "throughout the seventies the various surveys vied with one another in these lavish photographic productions for propaganda purposes."

33. Richard J. Huyda, *H. L. Hime, Photographer, 1858: Camera in the Interior* (Toronto, 1975), pp. 19–20.

34. Samuel Bourne, "A Photographic Journey Through the Higher Himalayas," *British Journal of Photography* XVII, 515 (March 18, 1870): 28–29.

35. This was a judgment about Frith's work. See unknown author, "Photographic Contributions to Knowledge," *British Journal of Photography* VII, 111 (February 1, 1860): 32.

36. Weston J. Naef and James N. Wood, *Era of Exploration: The Rise of Landscape Photography in the American West, 1860–1885* (Buffalo and New York, 1975), pp. 129–30.

4. OBJECTS AND EVENTS

1. Oliver Wendell Holmes, "Doings of the Sunbeam," *Atlantic Monthly* 12 (July 1863): 11.

2. Oliver Wendell Holmes, "The Stereoscope and the Stereograph," *Atlantic Monthly* 8 (June 1859): 744.

3. William M. Ivins, Jr., *Prints and Visual Communication* (Cambridge, Mass., 1953), p. 94.

4. Four volumes with 155 photographic prints issued in 1852 in an edition of 140; see Nancy B. Keller, "Illustrating the 'Reports by the Juries' of the Great Exhibition of 1851: Talbot, Henneman and Their Failed Commission," *History of Photography* 6, 3 (July 1982): 257–72.

5. John Szarkowski, *Looking at Photographs* (New York, 1973), p. 18.

6. F. Jack Hurley, ed., *Industry and the Photographic Image: 153 Great Prints from 1850 to the Present* (New York and Rochester, N.Y., 1980), p. 3.

7. John Thomson, *Illustrations of China and Its People* (1873; reprint, New York, 1982), unpaged.

8. For a discussion of Curtis's attitude toward his subject, see Christopher M. Lyman, *The Vanishing Race and Other Illusions: Photographs of Indians by Edward S. Curtis* (New York, 1982), pp. 17–23.

9. Unsigned article, "On the Application of Photography to Printing," *Harper's New Monthly Magazine* LXXVI, 13 (September 1856): 433.

10. Alison Gernsheim, "Medical Photography in the Nineteenth Century," parts 1 and 2, *Medical and Biological Illustration* XI, 2 (April 1961): 87; (July 1961): 147–55.

11. Alex J. Macfarlan, "On the Application of Photography to the Delineation of Disease with Remarks on Stereo-micro-photography," *Photographic Journal* 116 (December 16, 1861): 326–29.

12. For a full discussion, see George S. Layne, "Kirkbride-Langenheim Collection: Early Use of Photography in Psychiatric Treatment in Philadelphia," *Pennsylvania Magazine of History and Biography* CV, 2 (April 1981): 182–202.

13. Others who photographed during the Crimean War were Carol (Charles) Popp de Szathmari, photographer to the Rumanian court, and the French army colonel Jean Charles Langlois. See Constantin Savulescu, "First Photographic War Reportage," *Image* (March 1973): 13–16.

14. Helmut and Alison Gernsheim, *Roger Fenton: Photographer of the Crimean War* (1954; reprint, New York, 1973), p. 22, indicates that the entire collection consisted of 360 photographs. Weston J. Naef, "From Illusion to Truth and Back Again," in Weston J. Naef and Lucien Goldschmidt, *The Truthful Lens: A Survey of the Photographically Illustrated Book, 1844–1914* (New York, 1980), p. 27, notes that 660 negatives were made by Fenton.

15. Roger Fenton to William Agnew, May 18 and May 20, 1855; in H. and A. Gernsheim, *Roger Fenton*, p. 75.

16. Roger Fenton to William Agnew, April 19, 1855; ibid., p. 62.

17. Unknown author, "Photographs from Sebastopol," *Art Journal* (October 1, 1855): 285.

18. Jorge Lewinski, *The Camera at War* (New York, 1978), p. 43.

19. Donald E. English, *Political Uses of Photography in the Third French Republic, 1871–1914* (Ann Arbor, Mich., 1981), pp. 33–46.

20. William J. Hoppin, *U.S. Army and Navy Journal*, 1863–64, p. 350; in *The Civil War: A Centennial Exhibition of Eyewitness Drawings* (Washington, D.C., 1961), p. 22. The view that Civil War photographs lacked "the beauty of finish and fidelity which distinguishes the better European artists" was expressed by the unknown author of "American Photographs," *Photographic Times* I, 22 (September 15, 1862): 184–85.

21. Joel Snyder and Doug Manson, *The Documentary Photograph as a Work of Art: American Photographs, 1860–1876* (Chicago, 1976), p. 22.

22. According to Philip Kunhardt, Jr., "Images of Which History Was Made Bore the Mathew Brady Label," *Smithsonian Magazine* 8, 4 (July 1977): 33, Gardner claimed that the idea for a photographic documentation of the Civil War originated with him.

23. Alexander Gardner, "A Harvest of Death," *Gardner's Photographic Sketchbook of the Civil War* (reprint, New York, 1959), pl. no. 36.

24. Unknown author, "Photographic Views of Sherman's Campaign by George N. Barnard," *Harper's Weekly* X, 519 (December 8, 1866): 771.

25. See chap. 2, n. 24.

26. Linda Nochlin, *Realism* (Harmondsworth, England, 1971), p. 31.

27. For a discussion of Fenton's attitude toward this development, see John Hannavy, *Roger Fenton of Crimble Hall* (Boston, 1975), pp. 95–98.

TECHNICAL HISTORY I

1. See Arthur K. Wheelock, Jr., "Constantijn Huygens and Early Attitudes Towards the Camera Obscura," *History of Photography* 1, 2 (April 1977): 93–103; also, Kathleen Kissick, "Count Algarotti on the Camera Obscura," *History of Photography* 3, 3 (July 1979): 193–94.

2. Actinic rays are those having the radiant energy needed to produce chemical changes, as in photography.

3. John A. Hammond, *The Camera Obscura: A Chronicle* (Bristol, England, 1981), pp. 58–60.

4. "An Account of a Method of Copying Paintings on Glass and Making Profiles by the Agency of Light upon Silver Nitrate Invented by T. Wedgwood with Observations by H. Davy," *Journal of the Royal Institute* (London) I (1802).

5. According to Pierre G. Harmant, "Paleophotographic Studies: Was Photography Born in the 18th Century?" *History of Photography* 4, 1 (January 1980): 39–45, the Niépce brothers may have experimented with an image-making process as early as 1798.

6. Gail Buckland, *Fox Talbot and the Invention of Photography* (Boston, 1980), p. 62.

7. See chap. 1, n. 10; Naef states that Florence first used the term *photography* in 1832.

8. See chap. 1, n. 5.

9. Guncotton was discovered in 1846 by the Swiss chemist C. F. Schonbein; in the following year a method of dissolving the substance in alcohol was discovered. Called *collodion*, its initial use was as a medical dressing for wounds.

10. Fred Beyrich, "Concerning the Use of Albumenized Paper," *Humphrey's Journal* (December 1, 1864): 236.

11. Unknown author, "The Solar Camera," *Photographic News* (July 29, 1859): 244.

5. PHOTOGRAPHY AND ART

1. Unsigned article [Lady Elizabeth Eastlake], "Photography," *Quarterly Review* CI (April 1857): 461. Elizabeth Rigby was the most frequent female sitter for David Octavius Hill and Robert Adamson, appearing in sixteen portraits and three group scenes. In 1849, she married Charles Eastlake, who was knighted in 1850 and became director of the Royal Academy in 1855. Lady Eastlake published art criticism and travel journals.

2. Unknown author, "Photography and Chromolithography: Their Influence on Art and Culture," *Philadelphia Photographer* 5, 52 (April 1868): 115.

3. François Arago, *Comptes rendus des séances de l'Académie des Sciences* IX (August 19, 1839): 260; see also Helmut and Alison Gernsheim, *The History of Photography from the Camera Obscura to the Beginning of the Modern Era* (New York, 1969), p. 70; Gisèle Freund, *Photography and Society* (Boston, 1980), p. 26.

4. William Hauptman, "Ingres and Photographic Vision," *History of Photography* 1, 2 (April 1977): 117–28; Aaron Scharf, *Art and Photography* (Baltimore, 1969), p. 27.

5. Ernest Lacan, "Esquisses photographiques: La Physiologie du photographe," *La Lumière* (1852); in André Jammes, "Histoire," *Terre d'Images* 2 (1964): 231; see also Aaron Sheon, "French Art and Science in the Mid-Nineteenth Century: Some Points of Contact," *Art Quarterly* (winter 1971): 434.

6. Francis Wey, "De l'influence de l'héliographie sur les beaux-arts," *La Lumière* (1851); in Heinz Buddemeier, *Panorama, Diorama, Photographie* (Munich, 1970), p. 262.

7. Charles Baudelaire, "The Modern Public and Photography," 1859; trans. and reprinted in Alan Trachtenberg, ed., *Classic Essays on Photography* (New Haven, Conn., 1980), p. 88.

8. Quoted in François Boucher, introduction to *Au temps de Baudelaire, Guys et Nadar*, by A. d'Eugny and R. Coursaget (Paris, 1945), p. 12.

9. Eugène Delacroix, journal entry, May 21, 1853, *The Journal of Eugène Delacroix*, trans. Walter Pach (New York, 1948), p. 314. In 1865, when Philippe Burty, critic for the *Gazette des Beaux-Arts*, purchased an album of 32 photographs by Eugène Durieu from the Delacroix estate sale, he noted: "He often used them as reference material"; see Scharf, *Art and Photography*, pp. 89–94, 267–68.

10. Robert Hunt, *A Popular Treatise on the Art of Photography* (1841; facsimile ed., Athens, Ohio, 1973), p. 92.

11. Philip Gilbert Hamerton, "The Relationship Between Photog-raphy and Painting," 1860; in *Thoughts About Art* (Boston, 1874), p. 52.

12. Ruskin's changing view of photography is discussed in R. N. Watson, "Art Photography and John Ruskin," parts 1–3, *British Journal of Photography* XCI (March 10, 1944): 82–83; (March 24): 100–101; (April 7): 118–19.

13. Scharf, *Art and Photography*, p. 79.

14. Unknown author, "Photography in Its Relation to the Fine Arts," *Photographic Journal* 117 (January 15, 1862): 359.

15. Louis Figuier, *La Photographie au Salon de 1859* (Paris, 1860), p. 14.

16. The process involves drawing with a sharp tool on a glass plate that has been coated with either fogged collodion or etching ground and then exposing the plate against a sheet of sensitized paper to sunlight. A less common technique, used by Corot, involves painting in various degrees of opacity on the glass plate before exposing it against the sensitized paper.

17. See Elizabeth Glassman, "Cliché-verre in the 19th Century," in *Cliché-verre: Hand-Drawn, Light-Printed* (Detroit, 1980), p. 30.

18. G. Sadoul, "Peinture et photographie," *Arts de France* 19–20 (1948): 5–23; Van Deren Coke, *The Painter and the Photograph, from Delacroix to Warhol* (Albuquerque, N.M., 1964); Scharf, *Art and Photography*. For a different interpretation, see Kirk Varnedoe, "The Artifice of Candor: Impressionism and Photography Reconsidered," *Art in America* (January 1980): 66–78, and Varnedoe, "The Ideology of Time: Degas and Photography," *Art in America* (summer 1980): 96–110.

19. In the mid-19th century, articles on photographic copyright laws began to appear in the British press; toward the end of the 1860s a Fine Art Copyright Bill, relating to photography, was introduced in Parliament. Painters and graphic artists have continued to use photographs without acknowledging their authorship despite suits filed by photographers to protect their work. See Marianne Goodwin, "Artists Pressure Agencies to Heed Their Rights," *Adweek* (April 4, 1983): 28, 30, for a contemporary discussion.

20. Unknown author, "Review of the Sunbeam," *Photographic Notes* 11 (November 15, 1856): 83.

21. See Edgar Yoxall Jones, *Father of Art Photography: O. G. Rejlander, 1813–1875* (Greenwich, Conn., 1973), p. 74. Nigel Gosling, *Nadar* (New York, 1976), p. 68, suggests that an 1855 Nadar nude study of Christine Roux may have inspired Ingres in his painting *La Source;* however, that work was begun in 1820 and finished in 1856.

22. Gordon Hendricks, *The Photographs of Thomas Eakins* (New York, 1972), p. 6, states that these photographs "are not connected in any direct way with Eakins's plans for a painting," but details of landscape and figures accord with the camera images. Despite the painter's discreet handling, Edward Horner Coates, who had commissioned the work, exchanged it for a painting without nudity.

23. Quoted in *After Daguerre: Masterworks of French Photography (1848–1900) from the Bibliothèque Nationale* (New York, 1980), unpaged, pl. no. 6.

24. Alfred Frankenstein, *After the Hunt* (Berkeley and Los Angeles, 1969), p. 66, suggests that William Harnett, the American painter of *trompe l'oeil* still lifes, may have been directly inspired by these images.

25. Jones, *Father of Art Photography*, p. 18.

26. Unknown author, "Fifth Annual Photographic Exhibition," *Art Journal* (April 1, 1858): 120–21.

27. O. G. Rejlander, "Photographic Criticism Addressed to an Art-Critic," *British Journal of Photography Almanac* (1870): 148.

28. Henry Peach Robinson, "Paradoxes of Art, Science, and Photography," *Photo-American* III, 7 (May 1892): 179.

29. Henry Peach Robinson, "Some Remarks on Composition in Landscape Photography," *Eye* (August 28, 1886): 5.

30. Antonio Errera, "*Storia e statistica delle industrie venete,*" 1870; in Italo Zannier, *Venice: The Naya Collection* (Venice, 1981), p. 38.

31. Rev. Henry J. Morton, "The Sister Art," *Philadelphia Photographer* 3, 27 (March 1866): 71.

32. Quoted in Samuel I. Prime, *The Life of Samuel F. B. Morse* (New York, 1875), p. 404.

33. Elizabeth L. Cock, "The Influence of Photography on American Landscape Painting" (Ph.D. diss., New York University, 1967); see also Cock, "Frederic Church's Stereographic Vision," *Art in America* (September–October, 1973): 71–77. Van Deren Coke, *Painter and the Photographer,* p. 200, notes that a stereograph view of the Parthenon by D. Constantin, found in Church's studio, Olana, on the Hudson, served as a guide for his 1871 painting *The Parthenon.* See also David C. Huntington, *The Landscapes of Frederic Edwin Church* (New York, 1966).

34. Grant B. Romer, "Gabriel Harrison, the Poetic Daguerrian," *Image* (September 1979): 8.

35. Douglas G. Severson, "Oliver Wendell Holmes: Poet of Realism," *History of Photography* 2, 3 (July 1978): 235.

36. Unknown author, "Composition Photographs," *Philadelphia Photographer* 4, 39 (March 1867): 79.

37. These characteristics of photographic expression were discussed throughout Peter Henry Emerson, *Naturalistic Photography for Students of the Art;* see, for example, 3d edition, New York, 1899, pp. 30, 174–75.

38. Ibid., pp. 31–32.

39. Naomi Rosenblum, "Adolphe Braun: A 19th-Century Career in Photography," *History of Photography* 3, 4 (October 1979): 365, 371 n. 36.

40. This problem is discussed by James Marston Fitch, "Physical and Metaphysical in Architectural Criticism," *Architectural Record* (July 1982): 114–19, in which the author states that whereas "a work of art is designed only to be seen . . . perceiving [buildings] visually is only one component of [a] complex experience."

41. Félix Roubaud, "Revue scientifique," *L'Illustration* 619 (January 1855); in James Borcorman, *Charles Nègre, 1820–1880* (Ottawa, 1976), p. 42.

42. Emerson's emphasis on "truthful pictures" was meant to contradict Henry Peach Robinson's "antiquated notions and book"; see Nancy Newhall, *P. H. Emerson: The Fight for Photography as a Fine Art* (Millerton, N.Y., 1975), p. 67.

43. Emerson, *Naturalistic Photography,* p. 58.

6. NEW TECHNOLOGY

1. William M. Ivins, Jr., *Prints and Visual Communication* (Cambridge, Mass., 1953), p. 134.

2. Oliver Wendell Holmes, "Doings of the Sunbeam," *Atlantic Monthly* 12 (July 1863): 12.

3. See Beaumont Newhall, *Airborne Camera: The World from the Air and Outer Space* (New York, 1969), p. 27.

4. Invented in 1855 by the German chemist Robert Wilhelm Bunsen, who later worked with the British scientist Henry Roscoe on the use of actinometers to measure sunlight.

5. *Literary Gazette,* June 28, 1851, p. 443; in H.J.P. Arnold, *William Henry Fox Talbot, Pioneer of Photography and Man of Science* (London, 1977), p. 172.

6. Following his exoneration in the shooting death of his wife's lover, Muybridge traveled to Central America and did not resume his experiments with stop-motion photography until 1877, when he again was associated with Leland Stanford. In 1882, Stanford agreed to the publication of *The Horse in Motion* with J. D. Stillman rather than Muybridge as author, contending in a deposition following a suit by the photographer that the success of the venture was the result of following his (Stanford's) directives and suggestions.

7. The first discussion of the erroneous representation of the horse in art appeared in Emile Duhousset, *Le Cheval* (Paris, 1874); see Françoise Forster-Hahn, "Marey, Muybridge and Meissonier: The Study of Movement in Science and Art," in *Eadweard Muybridge: The Stanford Years, 1872–1882* (Palo Alto, Calif., 1972), p. 87.

8. Robert Bartlett Haas, *Muybridge: Man in Motion* (Berkeley, Los Angeles, London, 1976), p. 155.

9. In 1878, Muybridge copyrighted and published *The Horse in Motion*—a set of six views of horses running and trotting; these were sold in Europe and the United States for $2.50; see *Muybridge: The Stanford Years,* p. 66.

10. *E. J. Marey:* 1830–1904, *La Photographie du mouvement* (Paris, 1977), pp. 30–31.

11. Motion pictures are dependent on a phenomenon called the persistence of vision. The reconstitution of motion using instantaneous photographs was discussed in Etienne Jules Marey, *Animal Mechanism* (New York, 1874), p. 137. See also M. Langlois, "The Kinescope," *Photographic News* XIII, 552 (April 2, 1869): 165.

12. Quoted in Haas, *Muybridge: Man in Motion,* p. 120. See also William I. Homer and J. Talbot, "Eakins, Muybridge and the Motion Picture Process," *Art Quarterly* 2 (summer 1963): 18–35.

13. Aaron Scharf, *Art and Photography* (Baltimore, 1969), pp. 255–68. See also Forster-Hahn, "Marey, Muybridge and Meissonier: The Study of Movement in Science and Art," in *Muybridge: The Stanford Years,* p. 103.

14. Unknown author, untitled article, *Photographic News* 84 (October 1859): 239–40; see also Gerda Peterich, "G.W.W.," *Image* (December 1956): 21, in which George Washington Wilson is quoted as saying: "My aim is to secure some fleeting effect, which could only be caught if caught quickly."

15. Scharf, *Art and Photography,* p. 179. See also Kirk Varnedoe, "The Artifice of Candor: Impressionism and Photography Reconsidered," *Art in America* (January 1980): 66–78, and

Varnedoe, "The Ideology of Time: Degas and Photography," *Art in America* (summer 1980): 96–110.

16. Brian Coe and Paul Gates, *The Snapshot Photograph* (London, 1977), p. 14. Regarding the number of snapshots, see unknown author, "From the British Side," *American Amateur Photographer* IX, 12 (December 1897): 549, in which it is noted that 25,000 entries were received in a Kodak competition held in London and later sent to New York; see also *Critic* 29 (January 1898): 31.

17. Alfred Stieglitz, "The Hand Camera—Its Present Importance," *American Annual of Photography* (1897): 19.

18. John A. Tennant, "Street Photography," *Photo-Miniature* II, 14 (May 1900): 50.

19. Wm. Geo. Oppenheim, "The Law of Privacy," *American Amateur Photographer* IX, 1 (January 1897): 5.

20. Roy Flukinger, Larry Schaaf, and Standish Meacham, *Paul Martin: Victorian Photographer* (Austin, Tex., and London, 1977), p. 47.

21. Paul Martin, *Victorian Snapshots* (New York, 1939), p. 18.

22. Sadakichi Hartmann, "A Plea for the Picturesqueness of New York," *Camera Notes* 4, 2 (October 1900): 91–97.

23. Stieglitz, "Hand Camera," p. 22.

24. Arnold Genthe, *As I Remember* (New York, 1936), p. 32.

25. See, for instance, E. J. Bellocq, *Storyville Portraits: Photographs from the New Orleans Red-Light District, Circa 1912*, ed. John Szarkowski (New York, 1970).

26. Until after the first World War, not many women were involved in the major commercial enterprises or camera associations in Europe.

27. H. C. Price, *How to Make Pictures: Easy Lessons for Amateur Photographers* (New York, 1882).

28. Georges Herscher, "Conversations with J. H. Lartigue," in *The Autochromes of J. H. Lartigue* (New York, 1980), unpaged.

29. R. W. Buss, "On the Uses of Photography to Artists," *Journal of the Photographic Society* (June 21, 1853): 75.

30. John Szarkowski and Maria Morris Hambourg, *The Work of Atget*, 4 vols.: vol. 1, *Old France* (New York, 1981); vol. 2, *The Art of Old Paris* (New York, 1982); vol. 3, *The Ancien Régime* (New York, 1984); and vol. 4, *Modern Times* (New York, 1985).

7. ART PHOTOGRAPHY

1. William Howe Downes, "Massachusetts Photographer's Work," *Photo Era* 4, 3 (March 1900): 69.

2. Antony Guest, *Art and the Camera* (London, 1907), p. 25.

3. Alfred Stieglitz, "Pictorial Photography," *Scribner's Magazine* 26, 5 (November 1899): 528. The same phrase was used much earlier; see "Correspondence," *Photographic Notes* IX (December 1, 1864): 69.

4. Hector E. Murchison, "The Photography of the Future," *British Journal of Photography* XLII (December 27, 1895): 823.

5. Andrew Pringle, "The Naissance of Art in Photography," *Studio* 1, 3 (June 1893); in Peter Bunnell, ed., *A Photographic Vision: Pictorial Photography, 1889–1923* (Salt Lake City, 1980), p. 21.

6. Joseph Pennell, "Is Photography Among the Fine Arts?" *Contemporary Review* (December 1897); in Bunnell, ed., *Photographic Vision*, p. 51.

7. Today, *dichromate* is the preferred term for this chemical compound containing two chromium atoms per anion (negatively charged ion).

8. Samuel Morozov, "Early Photography in Eastern Europe—Russia," *History of Photography* 1, 4 (October 1977): 345.

9. J. Craig Annan, "Photography as a Means of Artistic Expression," *Photographic Journal* 46 (1899): 319.

10. Stieglitz's choice of subject was influenced by where he found himself; between 1890 and 1907, on trips to Europe he photographed rural peasantry; while in New York City during the same years he favored street genre scenes. In both cases he saw each scene as symbolic; see Ian Jeffrey, *Photography: A Concise History* (New York and Toronto, 1981), p. 101.

11. John La Farge, *Higher Life in Art* (New York, 1908); in Peter Bermingham, *American Art in the Barbizon Mood* (Washington, D.C., 1975), p. 96.

12. Gleeson White, "The Nude in Photography," *Photographic Times* XXIX, 5 (May 1897): 210.

13. Ibid., p. 209. For a discussion of changing attitudes toward photographing the nude, see Robert Sobieszek, "Addressing the Erotic: Reflections on the Nude Photograph," and Ben Maddow, "Nude in a Social Landscape," in Constance Sullivan, ed., *Nude Photographs, 1850–1980* (New York, 1980), pp. 167–79, 181–96.

14. J.M.B.W., "A Note on Some Open-Air Nude Studies," *Amateur Photographer and Photographic News* (July 5, 1910): 20–21.

15. Unknown author, "The Nude in Photography, with Some Studies Taken in the Open Air," *Studio* 1 (1898): 108.

16. Marmaduke Humphrey, "Triumph in Amateur Photography," *Godey's Magazine* (January 1898); in Estelle Jussim, *Slave to Beauty: The Eccentric Life and Controversial Career of F. Holland Day* (Boston, 1981), p. 119.

17. Charles H. Caffin, "Philadelphia Photographic Salon," *Harper's Weekly* (November 5, 1898): 118.

18. J. J. Vezey, letter to the editors, *British Journal of Photography* (November 9, 1900); in Jussim, *Slave to Beauty*, p. 135.

19. For a discussion of the reception of Autochrome color photography, see J. Nilsen Laurvik, "The New Color-Photography," *Century Magazine* 75, 3 (January 1908): 323–30; see also Charles Holme, ed., *Colour Photography and Other Recent Developments of the Art of the Camera* (London, Paris, New York, 1908).

20. Roland Rood, "The Three Factors in American Pictorial Photography," *American Amateur Photographer* 16 (August 1904); in Harry W. Lawton and George Know, eds., *The Valiant Knights of Daguerre: Selected Critical Essays on Photography and Profiles of Photographic Pioneers by Sadakichi Hartmann* (Berkeley, Los Angeles, London, 1978), p. 4.

21. See Margaret Harker, *The Linked Ring: The Secession Movement in Photography in Britain, 1892–1910* (London, 1979), p. ix.

22. Ibid.

23. In 1883 the firm of T. & R. Annan, owned by J. Craig's father, purchased the sole rights in Great Britain to the Karl Klič photogravure process; in consequence, J. Craig Annan became outstanding in gravure printing.

24. E. J. Constant Puyo, "La Photographie synthétique," *La Revue de photographie* 2 (April 15, May 15, and June 15, 1904); in Bunnell, *Photographic Vision*, p. 168.

25. José Ortíz Echagüe, *España: Tipos y trajes; España: Pueblos y paisajes; España mística;* and *España: Castillos y alcazares.* Ten editions were published in Madrid between 1937 and 1957.

26. Quoted in Adam Sobota, "Art Photography in Poland," *History of Photography* 4, 1 (January 1980): 25.

27. Unknown author, "The Work of the Year," *Photograms of the Year* (London, 1900), p. 66.

28. Unknown author, "The Käsebier Exhibit," *Photo Era* 4, 4 (April 1900): 128, in which Harvard art professor Denman Ross is quoted; see also R. A. Cram, "Mrs. Käsebier's Work," *Photo Era* 4, 5 (May 1900): 131.

29. Toby Quitsland, "Her Feminine Colleagues," in Josephine Withers, *Women Artists* in *Washington Collections* (College Park, Md., 1979), unpaged.

30. For a discussion of the conflict between Pictorialist attitudes in New York and Philadelphia, see Mary Panzer, *Philadelphia Naturalist Photography, 1865–1906* (New Haven, Conn., 1982).

31. Elizabeth Flint Wade, "Artistic Pictures: Suggestions How To Make Them," *American Amateur Photographer* V, 10 (October 1893): 441.

32. Alfred Stieglitz, "The Photo Secession," in *Bausch and Lomb Lens Souvenir,* 1903; in Sarah Greenough and Juan Hamilton, *Alfred Stieglitz: Photographs and Writings* (Washington, D.C., and New York, 1983), p. 190.

33. Sadakichi Hartmann, "A Plea for the Picturesqueness of New York," *Camera Notes* 4, 2 (October 1900): 97.

34. Stieglitz's reference to the "new Parthenon" is mentioned in Dorothy Norman, *Alfred Stieglitz: An American Seer* (New York, 1973), p. 76; Coburn's attitude toward modern structures is cited in J. J. Firebaugh, "Coburn, Henry James's Photographer," *American Quarterly* 2 (1955): 224.

35. Coburn, Käsebier, and White launched *Platinum Print* in 1913 and established the Pictorial Photographers of America in 1915.

36. Alfred Stieglitz, *Catalogue of an Exhibition of Photographs* (New York: Anderson Gallery, 1921).

37. Theodore Dreiser, "The Camera Club of New York," *Ainslee's* 4, 3 (October 1899): 328.

38. Odette M. Appel-Heyne, *Heinrich Kühn* (Cologne, 1981), p. 63.

8. THE SOCIAL SCENE

1. Quoted in William Stott, *Documentary Expression and Thirties America* (New York, 1973), p. vii.

2. Leslie Katz, "Interview with Walker Evans," *Art in America* (March–April 1971): 87.

3. Beaumont Newhall, "Documentary Approach to Photography," *Parnassus* 10 (March 1938): 5.

4. Stott, *Documentary Expression*, p. 12 ff, suggests that there are two tendencies in documentation—one informative and the other expressive.

5. The work of Tönnies was rediscovered by Alexander Alland, Sr., during researches into the background of Jacob Riis; see Alexander Alland, Sr., *Heinrich Tönnies: Carte-de-Visite Photographer Extraordinaire* (New York, 1978).

6. See Felicity Ashbee, "William Carrick: A Scots Photographer in St. Petersburg," *History of Photography* 2, 3 (July 1978): 207–22.

7. Unknown author, "America in the Stereoscope," *Art Journal,* 1860; in Edward W. Earle, ed., *Points of View: The Stereograph in America—A Cultural History* (Rochester, N.Y., 1979), p. 32.

8. Sir Benjamin Stone, in Bill Jay, *Customs and Faces: Photographs by Sir Benjamin Stone, 1838–1914* (London and New York, 1972), unpaged.

9. See Michael Hiley, *Victorian Working Women: Portraits from Life* (London, 1979), pp. 36–80.

10. See Tom Beck, *George M. Bretz: Photographer in the Mines* (Baltimore, 1977), pp. 10–13.

11. Anita Ventura Mozley, introduction to *Thomas Annan: Photographs of the Old Closes and Streets of Glasgow, 1868–1877* (New York, 1977), p. v.

12. Nathaniel Hawthorne, while the American consul in Liverpool, visited Glasgow during the mid-1850s; quoted ibid., p. vi.

13. Alexander Alland, Sr., *Jacob A. Riis: Photographer and Citizen* (Millerton, N.Y., 1974), p. 30, notes that *How the Other Half Lives: Studies Among the Tenements of New York* (1890) was one of the first full-length publications in the United States to use halftone reproduction of photographs for many of its illustrations. Through Alland's efforts, Riis's negatives were found and donated to the Museum of the City of New York.

14. Mrs. Helen E. Campbell, Col. Thomas W. Knox, and Superintendent Thomas Byrnes, *Darkness and Daylight, or Lights and Shadows of New York Life* (Hartford, Conn., 1897), p. 41.

15. Preface to *Darkness and Daylight*, p. x; the publishers claimed also that "the modern camera is the basis for every illustration in the volume. . . . Every illustration is from a photograph made from life."

16. Alan Trachtenberg, "Essay," in Walter Rosenblum, Naomi Rosenblum, and Alan Trachtenberg, *America and Lewis Hine: Photographs, 1904–1940* (Millerton, N.Y., 1977), p. 122.

17. Lewis Hine, "Baltimore to Biloxi and Back," *Survey* 30 (May 3, 1913): 167.

18. Quoted in Pete Daniel and Raymond Smock, *A Talent for Detail: The Photographs of Miss Frances Benjamin Johnston, 1889–1910* (New York, 1974), p. 23.

19. "Therefore let me speak the truth in all honesty about our age and the people of our age"; in Robert Kramer, "Historical Commentary," in *August Sander: Photographs of an Epoch, 1904–1959* (Millerton, N.Y., 1980), p. 27.

20. Stott, *Documentary Expression*, p. 67.

21. Photographic projects were undertaken by a number of federal agencies, including the Rural Electrification Administration, the Tennessee Valley Authority, and the Works Progress Admin-istration, but despite the excellent photographers employed, the images were not used in the same fashion as those made for the F.S.A.

22. This figure is given by Grace M. Mayer in Edward Steichen, ed., *The Bitter Years, 1935–1941* (New York, 1962), p. iv. Hank O'Neal, *A Vision Shared: A Classic Portrait of America and Its People, 1935–1943* (New York, 1976), p. 300, mentions 200,000 unprinted negatives in the Library of Congress F.S.A. Collection. *America 1935–1945*, a circular announcing the availability of these images on microfiche, notes that there are 87,000 captioned images in the F.S.A. and O.W.I. (Office of War Information) collections.

23. See F. Jack Hurley, *Portrait of a Decade: Roy Stryker and the Development of Documentary Photography in the Thirties* (Baton Rouge, La., 1972), pp. 56–58, 128, 130.

24. Seventy prints were exhibited in the International Photographic Exhibition at the Grand Central Palace in New York in 1938 and subsequently traveled throughout the United States under the auspices of the Museum of Modern Art, New York; see Hurley, *Portrait of a Decade*, p. 134. Walker Evans's F.S.A. work was included in his exhibition, American Photographs, at the Museum of Modern Art in 1938.

25. During the period in which the F.S.A. functioned, it sent out prepackaged exhibition panels to local communities and state fairs. Selections of the photographs were published in some 15 books, among them James Agee and Walker Evans, *Let Us Now Praise Famous Men*, 1941; Sherwood Anderson, *Home Town: The Face of America*, 1940; Dorothea Lange and Paul Schuster Taylor, *An American Exodus: A Record of Human Erosion*, 1939; Archibald MacLeish, *Land of the Free*, 1938. *Life, Look, Survey Graphic*, and *U.S. Camera* magazines used F.S.A. photographs in multipicture stories, whereas newspapers used mainly individual images.

26. Both this and the following quotations are from Michael G. Sundell, *Berenice Abbott: Documentary Photographs of the 1930s* (Cleveland, 1980), pp. 6, 7.

27. Edwin Hoernle, "The Working Man's Eye," *Der Arbeiter-Fotograf;* in David Mellor, ed., *Germany: The New Photography, 1927–1933* (London, 1978), p. 48.

28. Roman Vishniac, who had advanced degrees in both medicine and zoology, was renowned for his photomicrographs, especially of insect and marine life.

29. See Anne Tucker, "The Photo League," *OVO Magazine* 10, 40–41 (1981): 3–9.

30. Gordon Parks, foreword to *Harlem Document: Photographs, 1932–1940: Aaron Siskind*, edited by Ann Banks and Charles Traub (Providence, R.I., 1981), p. 5.

31. The Photo League was placed on the Attorney General's list of "subversive" organizations in 1950; during the ensuing period of political conservatism, it found itself unable to battle against this designation and in 1952 went out of existence.

32. O. R. Lovejoy, *Report to the Board of the National Child Labor Committee*, Samuel McCune Lindsay Papers, Rare Book and Manuscript Library, Columbia University, New York.

33. Quoted in Kramer, "Historical Commentary," in *August Sander*, p. 17.

34. By moving a bleached steer skull, found in North Dakota, from its original location to another nearby in order to photograph it in several ways, Rothstein provided political opponents of the New Deal, who objected to the employment of artists and photographers on federal projects, with an opportunity to claim that documentary photographs were being "faked"; see Hurley, *Portrait of a Decade*, pp. 86–90.

9. PHOTOGRAPHY AND MODERNISM

1. Egmont Arens, American social critic and magazine editor, in W. G. Briggs, *The Camera in Advertising and Industry* (London, 1939), p. 5.

2. Gustav Hartlaub, in Peter Selz, "The Artist as Social Critic," in *German Realism of the Twenties* (Minneapolis, 1980), p. 32.

3. Quoted in Dawn Ades, *Photomontage* (New York, 1976), p. 10.

4. Raoul Hausmann, in Jean A. Keim, "Photomontage After World War I," in Van Deren Coke, ed., *One Hundred Years of Photographic History: Essays in Honor of Beaumont Newhall* (Albuquerque, N.M., 1975), p. 86.

5. See Ades, *Photomontage*, pp. 15–16.

6. Although initially somewhat different in meaning, *solarization* is now used to refer to a partial reversal of image tone caused by exposing the image to light during development. Another term for this phenomenon is *Sabattier effect*, after Armand Sabattier, who first described it in 1862.

7. The interrelationship between still and motion picture photography and its effect on the new vision is discussed in John Willett, "The Camera Eye, New Photography, Russian and Avant-Garde Films," in *Art and Politics in the Weimar Period: The New Sobriety, 1917–1933* (New York, 1978), pp. 139–49.

8. Alvin Langdon Coburn, "The Future of Pictorial Photography," *Photograms of the Year* 12 (1916); in Peter Bunnell, ed., *A Photographic Vision: Pictorial Photography, 1889–1923* (Salt Lake City, 1980), p. 194.

9. Andreas Haus, *Moholy-Nagy: Photographs and Photograms* (New York, 1980), p. 20.

10. Karl Nierendorf, preface to *Urformen der Kunst*, 1928; trans. and reprinted in David Mellor, ed., *Germany: The New Photography, 1927–33* (London, 1978), p. 17.

11. The title, *Die Welt ist schön*, was chosen by the publisher in place of Renger-Patzsch's original title, *Die Dinge* (*Things* or *Objects*); see Herbert Molderings, "Urbanism and Techno-

logical Utopianism: Thoughts on the Photography of Neue Sachlichkeit and the Bauhaus," in Mellor, ed., *Germany: The New Photography,* p. 91. See also Fritz Kempe, "The World Is Beautiful: A Model Book of Objects and Things," in *Albert Renger-Patzsch: 100 Photographs, 1928* (Cologne, Germany, and Paris, 1979), p. 7.

12. Van Deren Coke, introduction to *Avant-Garde Photographs in Germany, 1919–1939* (San Francisco, 1980), p. 13.

13. John W. Dower, introduction to *A Century of Japanese Photog-raphy* (New York, 1980), p. 16.

14. Nobuo Ina, "Return to Photography," 1932; ibid., p. 17.

15. Paul Strand, "Photography," *Seven Arts* 2 (August 1917): 524.

16. Edward Weston, "Photography—Not Pictorial," *Camera Craft* 37, 7 (1930); in Nathan Lyons, ed., *Photographers on Photog-raphy* (Englewood Cliffs, N.J., and Rochester, N.Y., 1966), p. 155.

17. Charles Sheeler, manuscript autobiography (1937), Archives of American Art, Smithsonian Institution, Washington, D.C. See also Susan Fillin Yeh, "Charles Sheeler's Upper Deck," *Arts Magazine* 55, 5 (January 1979): 90, and Martin Friedman, *Charles Sheeler* (New York, 1975), p. 65.

18. Among the exhibitions held in the late 1920s and early '30s in the United States were *The Art Center and Industry* (New York, 1926); *The Machine Age Exposition* (New York, 1927); *Art and Industry* (Chicago, 1933); and *Machine Art* (New York, 1934). For a discussion of the attitude among artists and intellectuals toward machine imagery, see R.F.B. [Richard F. Bach], "Macha-nalia," *Magazine of Art* 22, 2 (February 1931): 101–2, and Dickran Tasjian, *Skyscraper Primitives: Dada and the American Avant-Garde, 1910–1925* (Middletown, Conn., 1975), pp. 204–26.

19. Edward D. Wilson, "Beauty in Ugliness," *Photo Era* 64 (June 1930): 303–4.

20. Charis Wilson, "Remembrance," in *Edward Weston: Nudes* (Millerton, N.Y., 1977), unpaged.

21. Francis Bruguière, "Creative Photography," *Modern Photog-raphy Annual* (1935–36); in Lyons, *Photographers on Photography,* p. 34.

22. Johannes Molzahn, "Nicht mehr lesen, sehen," *Das Kunst-blatt* (1928); in Ute Eskildsen, "Photography and the Neue Sachlichkeit Movement," in Mellor, ed., *Germany: The New Photography,* p. 91.

23. Weston was asked by the architect Richard Neutra to select a representative group of American photographs and to write a catalog foreword; see Nancy Newhall, ed., *The Daybooks of Edward Weston: California* (New York and Rochester, N.Y., 1966), p. 103.

24. László Moholy-Nagy, "From Pigment to Light," *Telehor* (1936); trans. and reprinted in Lyons, *Photographers on Photog-raphy,* p. 80.

25. Edward Weston, "Seeing Photographically," *Complete Photographer* 9, 49 (1943); ibid., p. 159.

26. Ibid., p. 163.

TECHNICAL HISTORY II

1. Celluloid was invented in 1855 by Alexander Parkes. In 1888, when it could be rolled thin enough, it became practicable as a base for photographic emulsion. John Carbutt was the first on the market with a celluloid dry-plate film; see William Welling, *Photography in America: The Formative Years, 1839–1900* (New York, 1978), p. 324.

2. Reverend Hannibal Goodwin applied for a patent for cel-luloid roll film in 1887 but, lacking funds, did not produce a product. A patent was granted to Henry A. Reichenbach for a flexible film for the Kodak camera in 1889. After Goodwin's death, his patent was acquired by the Anthony Company, which sued the Eastman Dry Plate and Film Company, claiming that the Eastman product was essentially the same as the product covered by the Goodwin patent. After 12 years of litigation, the suit was settled in favor of the Anthony Company, which by that time had merged with the Scovill Company to become Ansco.

3. Made possible by machinery invented in 1894 and used by the Automatic Photograph Company; see Welling, *Photography in America,* pp. 362–63.

4. Eaton S. Lothrop, Jr., *A Century of Cameras from the Collection of the International Museum of Photography at George Eastman House* (Dobbs Ferry, N.Y., and Rochester, N.Y., 1973), p. 37.

5. In 1888, Charles Driffield and Ferdinand Hurter patented an actinograph—a slide-rule arrangement that enabled the user to equate variables governing exposure. In 1890, they jointly published *Photochemical Investigations and a New Method of Deter-mining the Sensitiveness of Photographic Plates.*

6. Quoted in Brian Coe, *Colour Photography: The First Hundred Years, 1840–1940* (London, 1978), p. 21.

10. WORDS AND PICTURES

1. Peter Panter [Kurt Tucholsky], "Ein Bild saght mehr als 1000 worte" (A picture is worth more than 1,000 words), *UHU* 3, 2 (1926–27): 83. In addition to the pseudonym Peter Panter, Tucholsky, a well-known satirist and social critic in Germany during the Weimar years, used the names Theobold Tiger, Ignaz Wrobel, and Kaspar Hauser. In 1929, he collaborated with John Heartfield on a book with satirical text and montages entitled *Deutschland, Deutschland über Alles* (facsimile ed. in English, Amherst, Mass., 1972).

2. Werner Gräff, *Es kommt der neue Fotograf!* (Here comes the new photographer!) (Berlin, 1929); a plea to photographers to transcend the limitations of verisimilitude.

3. A. Lee Snelling, "Photographic Illustration," *The Interna-tional Annual of Anthony's Photographic Bulletin,* VI (New York, 1893): 184.

4. On finding his own camera damaged by falling debris in his studio, Genthe borrowed a 3A Kodak Special from a camera shop, and for several weeks he used this equipment to record the disaster; see Arnold Genthe, *As I Remember* (New York, 1936), p. 89.

5. Unknown author, "As a News Magazine—The Illustrated American," *Illustrated American* 1 (March 1, 1890): 48.

6. Luigi Barzini, *La Battaglia di Mukden* (The battle of Mukden), 1907; in Jorge Lewinski, The *Camera at War* (New York, 1978), pp. 59, 236.

7. Lewinski, *Camera at War,* p. 56.

8. Augustín Victor Casasola began an extensive archive called the File of the Mexican Revolution that was continued by his sons, both of whom were also photojournalists; see Carlos Monsiváis, "The Continuity of Images," *Artes visuales* 2 (October–December 1976): 37–38.

9. Quoted in Lewis L. Gould and Richard Greffe, *Photojournalist: The Career of Jimmy Hare* (Austin, Tex., 1977), p. 123.

10. According to Lewinski, *Camera at War,* p. 63, "the public saw very few pictures of the war, only those of the most innocuous kind." Since thousands upon thousands of photographs of the conflict were made by press and official armed-forces photographers, censorship must have played a decisive role in deciding what images the public would see.

11. Johannes Molzahn, "Nicht mehr lesen, sehen" (Forget reading, see), *Das Kunstblatt* 12 (1928): 79.

12. Tim N. Gidal, *Modern Photojournalism: Origins and Evolution,* 1910–1933 (New York, 1972), p. 19.

13. Umbo (Otto Umbehrs), in Wilhelm Marckwardt, *Die Illustrierten der Weimar Zeit* (The illustrated weeklies of the Weimar period) (Munich, 1980), p. 128.

14. Dawn Ades, *Photomontage* (New York, 1976), p. 16.

15. Quoted in Urszula Czartoryska, "Twentieth-Century Experimentation," in *Fotografia Polska,* 1839–1945 (New York, 1979), p. 16.

16. Sandra S. Phillips, "The French Magazine *Vu,*" in *Picture Magazines Before Life* (Woodstock, N.Y., 1982), unpaged.

17. See David Mellor, "Patterns of Naturalism, Hoppé to Hardy," in *The Real Thing: An Anthology of British Photographs,* 1840–1950 (London, 1975), p. 35, and Tom Hopkinson, introduction to *Bert Hardy* (London, 1975).

18. Wilson Hicks, *Words and Pictures* (New York, 1952), p. 42.

19. Questions raised by O. D. Gallagher and cited in Lewinski, *Camera at War,* p. 88, concerning the authenticity of this image (which was used on the dust jacket for Robert Capa, *Death in the Making* [New York, 1938]) appear to be without foundation, according to Richard Whelan, *Robert Capa: A Biography* (New York, 1985), pp. 122–25.

20. Quoted in *The Concerned Photographer* (New York, 1968), unpaged.

21. Edward Steichen, introduction to *The Family of Man* (New York, 1955), pp. 3–4.

22. According to Steichen, some two million photographs were submitted; they were narrowed down by Steichen and his staff to 10,000, and then to 503. See *The Family of Man,* p. 4, and Edward Steichen, *A Life in Photography* (Garden City, N.Y., 1963), unpaged.

23. See essays by William Johnson and John Morris in "W. Eugene Smith: Early Work," *Center for Creative Photography Bulletin* (Tucson, Ariz.) 12 (July 1980): 5–20, 21–26.

24. Kertész's first exhibition in 1927, at the gallery Le Sacre de Printemps, was the first one-man show of photography held in Paris; see Carol DiGrappa, "The Diarist," *Camera Arts* 1, 1 (January–February 1981). At the time, Kertész's photographs appeared in *UHU, Berlin Illustrierte,* and *Vu,* among other magazines.

25. Quoted in Beaumont Newhall, "The Instant Vision of Henri Cartier-Bresson," *Camera* (October 1955): 485.

26. Unknown author, "Help from the Camera," *Commercial Art and Industry* (London) (November 1923): 311; see also Herman Blauvelt, "When the Modernist Invades Advertising," *Printers' Ink Monthly* (May 1925): 65.

27. R. L. Dupuy, "Advertising Photo in France," *Gebrauchsgraphik* 6, 8 (August 1929): 17.

28. Pierre Mac Orlan, "Graphismes," *Arts et métiers graphiques* 11 (May–June 1929), unpaged, with drawings and layout by Alexey Brodovitch.

29. Paul Outerbridge, Jr., *Photographing in Color* (New York, 1940), p. 55. For Steichen's attitude, see Carl Sandburg, *Steichen the Photographer* (New York, 1929), p. 53.

30. Ansel Adams, in Jacob Deschin, "Photography in the 'Ads,'" *Scientific American* 152 (April 1935): 175.

31. Lucien Lorelle and D. Langelaan, *La Photographie publicitaire* (Paris, 1949), unpaged.

32. Margaret Bourke-White, "Photographing This World," *Nation* (February 19, 1936); in Theodore M. Brown, *Margaret Bourke-White: Photojournalist* (Ithaca, N.Y., 1972), p. 43.

33. Quoted in Louis Walton Sipley, *A Half-Century of Color* (New York, 1951), pp. 66–67.

34. Ibid., p. 86.

35. See Sally A. Stein, "The Composite Photographic Image and the Composition of Consumer Ideology," *Art Journal* 41, 1 (spring 1981): 39–45.

36. Quoted in Nancy Hall-Duncan, *The History of Fashion Photography* (New York, 1977), p. 142.

37. Roland Barthes, *Camera Lucida: Reflections on Photography* (New York, 1981), p. 118.

38. Press release, Museum of Modern Art, New York, 1947.

39. William S. Johnson, ed., *W. Eugene Smith: Master of the Photographic Essay* (Millerton, N.Y., 1981), pp. 41, 46.

40. Sheila Turner Sheed, "Henri Cartier-Bresson" (interview), *Popular Photography* (May 1974): 142.

41. Quoted in B. Newhall, "Instant Vision of Henri Cartier-Bresson," p. 485.

II. THE STRAIGHT IMAGE

1. Robert Frank, in Ben Maddow, *Faces: A Narrative History of the Portrait in Photography* (Boston, 1977), p. 527.

2. The name given to an exhibition and catalog of photographs concerned with the expression of subjective visions; see Clifford S. Ackley, *Private Realities* (Boston, 1974).

3. Henry Holmes Smith, in Charles H. Traub and John Grimes, *The New Vision: Forty Years of Photography at the Institute of Design* (Millerton, N.Y., 1982), p. 30.

4. Harry Callahan, in John Szarkowski, ed., *Callahan* (Millerton, N.Y., 1976), p. 14; see also Traub and Grimes, *New Vision*, p. 27.

5. Aaron Siskind, in Carl Chiarenza, "Aaron Siskind and His Critics," *Center for Creative Photography Bulletin* (Tucson, Ariz.), nos. 7–8 (September 1978): 5.

6. Minor White, *Mirrors Messages Manifestations* (Millerton, N.Y., 1969), p. 106.

7. Wynn Bullock, in *Wynn Bullock* (Millerton, N.Y., 1976), p. 5.

8. Duane Michals, in Barbaralee Diamonstein, *Visions and Images: American Photographers on Photography* (New York, 1981), p. 118.

9. From Diane Arbus's application for a Guggenheim grant in 1963, in *Diane Arbus: A Monograph of Seventeen Photographs* (Los Angeles, 1980), unpaged.

10. Nathan Lyons, ed., *Contemporary Photographers: Toward a Social Landscape* (New York and Rochester, N.Y., 1966).

11. John Szarkowski, *Mirrors and Windows* (New York, 1978), pp. 23–24.

12. *New Topographics: Photographs of a Man-Altered Landscape* (Rochester, N.Y., 1975).

13. Lewis Baltz, in Lee D. Witkin and Barbara London, *The Photograph Collector's Guide* (Boston, 1979), p. 78; see also Jonathan Green, *American Photography: A Critical History, 1945 to the Present* (New York, 1984), p. 166.

14. Bruce Davidson, in Witkin and London, *Photograph Collector's Guide*, p. 120.

15. Danny Lyon, *Conversations with the Dead* (New York, 1971), p. 12.

16. Diego Rivera, in Raquel Tibol, "Hecho en Latino America," in *Venezia 79* (New York, 1979), p. 248.

17. Otto Steinert, in Allan Porter, "Otto Steinert," in *Contemporary Photographers*, p. 723.

18. László Moholy-Nagy, introduction to *Street Markets of London* (1936), in David Mellor, "Patterns of Naturalism, Hoppé to Hardy," in *The Real Thing: An Anthology of British Photographs, 1840–1950* (London, 1975), p. 33.

19. Bill Brandt, in Aaron Scharf, "The Shadowy World of Bill Brandt," in *Bill Brandt, Photographs* (London, 1970), p. 18.

20. Claude Nori, "Bernard Plossu," in *Contemporary Photographers*, p. 602.

21. Italo Zannier, "Contemporary Italian Photography," in *Venezia 79*, p. 280.

22. Cristina García Rodero, in Emma Dent Coad, "Woman of La Mancha: Interview with Cristina García Rodero," *British Journal of Photography* (August 16, 1993): 16.

23. Shōji Yamagishi, introduction to *New Japanese Photography*, by John Szarkowski (New York, 1974), p. 12.

24. Much of this information comes from meetings and correspondence over the past several years with Lin Shaozhang, senior editor of *Chinese Photography*, Beijing.

25. Chieh-Jen Chen, in Ben Sloat, "State of Exception: Contemporary Photography from Taiwan," *Aperture*, no. 201 (Winter 2010): 52.

26. Mary Ellen Mark, in Ronald H. Bailey, "Ward 81: Mary Ellen Mark's Poignant Scrapbook," *American Photographer*, June 1978, http://www.maryellenmark.com/text/magazines/american%20photographer/911T-000-001.html.

27. Mary Ellen Mark, unpublished interview with Marianne Fulton, February 12, 1990, http://www.maryellenmark.com/text/books/25_years/text001_25years.html#text_018.

12. MANIPULATIONS AND COLOR

1. Walter Benjamin, "The Work of Art in the Age of Mechanical Reproduction," *Zeitschrift für Sozialforschung* 5, 1 (1936); trans. in Hannah Arendt, ed., *Illuminations: Walter Benjamin* (New York, 1969), p. 236.

2. Susan Sontag, *On Photography* (New York, 1973), p. 147.

3. This concept of photography as documentation without style or emotion has been called "Scientific Realism"; see Jonathan Green, *American Photography: A Critical History, 1945 to the Present* (New York, 1984), pp. 220–21.

4. Klaus Honnef, "Bernd and Hilla Becher," in *Contemporary Photographers* (New York, 1983), pp. 53–54; see also William Jenkins, introduction to *New Topographics: Photographs of a Man-Altered Landscape* (Rochester, N.Y., 1975), p. 7.

5. Carrie Mae Weems, in "Aperture 40 Years," *Aperture* 129 (Fall 1992): 47.

6. See Abigail Solomon-Godeau, "Winning the Game When the Rules Have Been Changed: Art Photography and Post-Modernism"; and Christopher Burnett, "Photography, Post-modernism, Contradictions," *New Mexico Studies in the Fine Arts* 8 (1983): 5–13, 21–27. See also Michael Starenko, "Post-modernism as Bricolage; Or, Can Cindy Sherman Act?" *Exposure* 21, 2 (1983): 20–23.

7. Jerry N. Uelsmann, in William E. Parker, "Uelsmann's Unitary Reality," *Aperture* 13, no. 3 (1967), unpaged.

8. A. D. Coleman, *The Grotesque in Photography* (New York, 1977), p. 150.

9. Clarence John Laughlin, "A Statement by the Photographer," in *Clarence John Laughlin* (Millerton, N.Y., 1973), pp. 13, 14.

10. Eikoh Hosoe, in Edward Putzar, *Japanese Photography, 1945–1985* (Tucson, Ariz., 1987), p. 15.

11. Michael Badura, in Jean Luc Daval, *Photography: History of an Art* (New York, 1982), p. 244.

12. Aline B. Louchheim, introduction to *The Art and Technique of Color Photography*, ed. Alexander Liberman (New York, 1951), p. xiv.

13. See John Szarkowski, introduction to *William Eggleston's Guide* (New York, 1976).

14. Ernst Haas, in *Color* (New York, 1970), p. 166.

15. Rosanne T. Livingston, introduction to *Photographic Process as Medium* (New Brunswick, N.J., 1975), p. 5.

16. See Mia Fineman, *Faking It: Manipulating Photography before Photoshop* (New York, 2012).

17. Richard Estes, in John Canaday and John Arthur, *Richard Estes: The Urban Landscape* (Boston, 1978); in John Arthur, *Realism Photorealism* (Tulsa, Okla., 1980), p. 67.

18. Sol LeWitt, "On Conceptual Art," in Alicia Legg, *Sol LeWitt* (New York, 1978); in Ellen H. Johnson, ed., *American Artists on Art: From 1940 to 1980* (New York, 1982), p. 126.

13. NAVIGATING NEW SEAS

1. Fred Ritchin, *After Photography* (New York, 2008), p. 10.

2. This statistic has been tossed around virally. It is based on 2017 marketing estimates from InfoTrends. See Felix Richter, "Smartphones Cause Photography Boom," *Statista*, August 31, 2017.

3. See Joanna Zylinska, *Nonhuman Photography* (Cambridge, Mass., 2017). See also Sean O'Hagan, "What Next for Photography in the Age of Instagram?," *Guardian*, October 14, 2018, https://www.theguardian.com/artanddesign/2018/oct/14/future-photography-in-the-age-of-instagram-essay-sean-o-hagan.

4. "Democratization of the Image" was the title of a panel discussion held at the International Center of Photography, New York, October 25, 2016.

5. According to a 2018 Pew Research Center study, 95 percent of Americans own cell phones; 77 percent own smartphones. See Pew Research Center, "Demographics of Mobile Device Ownership and Adoption in the United States," February 5, 2018, https://www.pewinternet.org/fact-sheet/mobile/. It is predicted that by 2020, 75 percent of the world's population will be connected by mobile devices. See *Business Insider*, "Two-Thirds of the World's Population Are Now Connected by Mobile Devices," September 19, 2017, https://www.businessinsider.com/world-population-mobile-devices-2017-9.

6. *Newsweek* magazine, for example—an important photography vehicle for many decades—discontinued its print publication and moved to digital in 2012, citing a dearth of both advertising and subscribers. It returned to print in 2014, however, after changing hands. See Christine Haughney, "*Newsweek* Plans to Return to Print," *New York Times*, December 3, 2013.

7. See Amy Fern Nuttall, "The 20 Most Expensive Photos Sold at Auction (as of 2017)," PetaPixel, December 21, 2017. https://petapixel.com/2017/12/21/20-expensive-photos-sold-auction-2017/.

8. Thomas L. Friedman, *The World Is Flat* (New York, 2005).

9. See Peabody Museum of Archaeology and Ethnology at Harvard University, "Online Exhibitions: Photography," https://www.peabody.harvard.edu/all-exhibitions/54. On the New Museum and Rhizome collaboration, see https://www.newmuseum.org/pages/view/rhizome.

10. John Berger, "Understanding a Photograph" (first published in *New Society*, October 17, 1968), in *Understanding a Photograph*, ed. Geoff Dyer (New York, 2013), p. 25.

11. Hito Steyerl, "In Defense of the Poor Image," *e-flux*, no. 10 (November 2009), https://www.e-flux.com/journal/10/61362/in-defense-of-the-poor-image/.

12. Joshua Citarella, in Charlotte Cotton, *Photography Is Magic* (New York, 2015), p. 352.

13. James Welling, "Pathological Color," Rouse Visiting Artist Lecture, Harvard University, Cambridge, Mass., November 13, 2017, https://www.gsd.harvard.edu/event/james-welling-pathological-color/.

14. LaToya Ruby Frazier and Dan Winters, quoted in Alexandra Genova, "These Professional Photographers Are Still Shooting Film. Here's Why," *Time LightBox*, January 26, 2017, http://time.com/4646116/film-photography-inspiration/.

15. Talbot first presented his prints at King Edward's School in Birmingham in 1839. On the *Thresholds* exhibition, see https://matcollishaw.com/exhibitions/https-www-scienceandmediamuseum-org-uk-whats-on-thresholds/.

16. Trevor Paglen, "Invisible Images (Your Pictures Are Looking at You)," *New Inquiry*, December 8, 2016, https://thenewinquiry.com/invisible-images-your-pictures-are-looking-at-you/.

17. Stephen Shore and Alec Soth, quoted in O'Hagan, "What Next for Photography?"

18. See Jason Evans, http://www.thedailynice.com/.

19. Jonathan Harris, in Scott Thrift's short film *Today*, on Harris's website, http://number27.org/today.php.

20. Catherine Opie, in Ariel Levy, "Catherine Opie: All-American Subversive," *New Yorker*, March 13, 2017, https://www.newyorker.com/magazine/2017/03/13/catherine-opie-all-american-subversive.

21. Richard Burbridge, in Kathy Ryan, ed., *The New York Times Magazine Photographs* (New York, 2011), p. 34.

22. See Nicole Smith Dahmen, Natalia Mielczarek, and David D. Perlmutter, "The Influence-Network Model of the Photojournalistic Icon," *Journalism and Communication Monographs* 20, no. 4 (October 30, 2018), 264–313, https://doi.org/10.1177/1522637918803351.

23. Paolo Pellegrin, phone conversation with the author, July 18, 2011.

24. Ibid.

25. See Melissa Harris, *A Wild Life: A Visual Biography of Photographer Michael Nichols* (New York, 2017), p. 208.

26. See Nina Strochlik, "How Women Photographers Access Worlds Hidden from Men," *National Geographic* online, March 8, 2019, https://www.nationalgeographic.com/culture/2019/03/how-women-photographers-access-world-hidden-from-men/.

27. Lewis Thomas, *The Lives of a Cell: Notes of a Biology Watcher* (New York, 1974), p. 43.

TECHNICAL HISTORY III

1. "The Photographic Industry, 1980–81," *The Wolfman Report on the Photographic Industry in the United States, 1981–82*, p. 24.

2. Unknown author, "Kodak Research Today," *Kodak Studio Light*, Centennial Issue, 1980, p. 69.

3. National Institute of Standards and Technology, U.S. Department of Commerce, "Fiftieth Anniversary of First Digital Image Marked," May 24, 2007, https://www.nist.gov/news-events/news/2007/05/fiftieth-anniversary-first-digital-image-marked; Russell A. Kirsch, "SEAC and the Start of Image Processing at the National Bureau of Standards," exhibition at National Institute of Standards and Technology, U.S. Department of Commerce, 2014, https://web.archive.org/web/20140719103629/http://museum.nist.gov/panels/seac/EARLIEST.HTM.

4. George E. Smith, "Nobel Lecture: The Invention and Early History of the CCD," *Reviews of Modern Physics* 82 (July–September 2010), pp. 2307–12.

5. M. F. Tompsett, W. J. Bertram, D. A. Sealer, and C. H. Séquin, "Charge-Coupling Improves Its Image, Challenging Video Camera Tubes," *Electronics* 46, 2 (January 18, 1973), cover, pp. 3, 162–69.

6. Eric R. Fossum and Donald B. Hondongwa, "A Review of the Pinned Photodiode for CCD and CMOS Image Sensors," *IEEE Journal of the Electron Devices Society* 2, 3 (May 2014), pp. 33–43.

7. Eric R. Fossum, "Active Pixel Sensors: Are CCDs Dinosaurs?," *Proceedings of SPIE: Charge-Coupled Devices and Solid State Optical Sensors III*, vol. 1900 (July 12, 1993), pp. 2–14.

8. Eric R. Fossum, "Ultra Low Power Imaging Systems Using CMOS Image Sensor Technology," *Proceedings of SPIE: Advanced Microdevices and Space Science Sensors*, vol. 2267 (September 23, 1994), pp. 107–11.

9. David Friedman, "Inventor Portrait: Steven Sasson," Vimeo video, 3:20, [2011], https://vimeo.com/22180298; Dan Richards, "The 30 Most Important Digital Cameras Ever," *Popular Photography* 77, 11 (November 2013), pp. 58–63.

10. Richards, "30 Most Important Digital Cameras."

11. Ibid.

12. Ibid.

13. Ibid.

14. Camera and Imaging Products Association (CIPA), "Total Shipments of Digital Still Cameras (Classified by Type)," http://www.cipa.jp/stats/documents/common/cr300.pdf; "Total Shipments of Film Cameras (Classified by Model)," http://www.cipa.jp/stats/documents/common/cr400.pdf.

15. Richards, "30 Most Important Digital Cameras."

16. Ibid.

17. "CIPA Companies' Production of Digital Still Cameras Worldwide from 1999 to 2018 (in million units)," https://www.statista.com/statistics/264336/world-production-of-digital-cameras-since-1999/; see also, CIPA, Digital Cameras, Statistical Data, http://www.cipa.jp/stats/dc_e.html.

18. Ed Lee, "Our Best Photos Deserve to Be Printed," in "State of the Industry 2018," *Digital Imaging Reporter*, September 8, 2018, https://www.direporter.com/state-of-the-industry/digital-imaging-reporters-state-industry-2018.

19. K. Mahesh, "History of Photoshop: Journey from Photoshop 1.0 to Photoshop CS5," *Creative Overflow*, September 12, 2011, https://creativeoverflow.net/history-of-photoshop-journey-from-photoshop-1-0-to-photoshop-cs5/.

20. Tony Hoffman, "The Best Computer Monitors for 2019," *PCMag.com*, May 6, 2019.

A Photography Time Line

1816–1829

· **1816**
Brothers Nicéphor and Claude Niépce in France begin experiments to record images by using light-sensitive materials.

· **1819**
British scientist John Herschel discovers that hyposulphite of soda dissolves silver salts.

· **1826**
German lithographer Aloys Senefelder invents color lithography process.

· **1827**
German physicist Simon Ohm identifies units of electrical resistance.

· **1829**
French artist Louis Jacques Mandé Daguerre enters into partnership with Nicéphore Niépce in France; discovers light sensitivity of silver iodide.

1830–1839

· **1832**
French inventor Hercules Florence, in Brazil, devises a method of obtaining images by the action of light.

· **1833**
British scientist William Henry Fox Talbot initiates activity that leads to his recording images on paper by the action of light.

· **1837**
Electric telegraph is patented in England; Samuel F. B. Morse demonstrates magnetic telegraph in the United States.

· **1838**
British physicist Charles Wheatstone discovers principle of stereoscopic projection.

· **1839**
Daguerre's process for achieving images by the action of light on silver-coated copper plate is announced. The French government purchases rights to the process and makes it available to the French people.
German painter Friederike Wilhelmine von Wunsch claims to have invented a photographic process that produces both miniature and life-size portraits.
Scottish scientist Mungo Ponton discovers light-sensitive properties of potassium dichromate.

Hippolyte Bayard, in France, exhibits direct positive images made by the action of light on sensitized paper in the camera.
Talbot announces to the British Royal Academy his process for achieving images on paper by the action of light.
Herschel presents a paper to the Royal Society of London titled "Note on the Art of Photography, or The Application of the Chemical Rays of Light to the Purpose of Pictorial Representation": the first public use of the word *photography*.

1840–1849

· **1840**
Alfred François Donné, director of the Hôpital de la Charité, Paris, photographs sections of bones and teeth by making daguerreotypes through a microscope; it is the first application of photography in medicine.

· **1841**
Talbot patents calotype process.
Herschel invents cyanotype process.
First photograph taken in Australia, a daguerreotype of Bridge Street, Sydney, is made by Augustin Lucas, a visiting naval captain.
Thomas Cook escorts some 500 people on his first package tour, initiating mass tourism.

· **1843**
David Octavius Hill and Robert Adamson begin collaboration to produce calotype portraits of Scottish ministers and others.
Anna Atkins publishes *Photographs of British Algae: Cyanotype Impressions*, the first book illustrated with photographic images.

· **1844**
Talbot publishes the first installment of *The Pencil of Nature* (six parts in total).

· **1846**
Carl Zeiss opens optical instruments factory in Jena, Germany.

· **1847**
Louis Désiré Blanquart-Evrard improves Talbot's calotype process and sets up photographic printing establishment in Lille, France.
Claude Félix Abel Niépce de Saint-Victor proposes using a glass plate coated with albumen and silver halides as a negative.
Calotype Club is founded in London.

· **1848**
First daguerreotype camera enters Japan, imported from the Netherlands by Ueno Toshinojō.

· **1849**
Scottish physicist David Brewster invents stereoscopic viewer.
Gustave Le Gray introduces waxed-paper process in France.
In the United States, Mathew B. Brady issues *A Gallery of Illustrious Americans*, with lithographic portraits made from daguerreotypes of 24 eminent Americans.

1850–1859

· **1850–51**
British sculptor Frederick Scott Archer invents collodion wet-plate process.
Blanquart-Evrard announces process for making photographic prints on paper coated with albumen.

· **1851**
Talbot makes first photographs using electric spark as illumination.
Missions héliographiques project commissions photographers to document French monuments.
Crystal Palace is built for the Great Exhibition of Arts and Industry in London; on display are prints, daguerreotypes, and photographic equipment, including the Brewster stereoscope.

· **1852**
Talbot patents prototype of photoengraving.
Victoria and Albert Museum in London begins collecting photographs.
Bausch and Lomb Optical Company is established in Rochester, New York.

· **1853**
Tintype (ferrotype) process is invented in France.

· **1854**
Collodion positive images (known as "ambrotypes" in the United States) are introduced.
French photographer André Adolphe Eugène Disdéri patents small-format *carte-de-visite*.
First issue of *British Journal of Photography* is published.

Société Française de Photographie is founded in France.
Fratelli Alinari Fotografi Editori is established in Florence by brothers Leopoldo, Giuseppe, and Romualdo Alinari to photograph works of art in Italian museums. The studio will grow to be a major producer of photographs of Italy for tourists; it will remain open until 2016.

· **1854–55**
Roger Fenton, James Robertson, and Carol Popp de Szathmari photograph the Crimean War.

· **1855**
French chemist Alphonse Louis Poitevin receives patent for printing with potassium dichromate, initiating photo-lithography and carbon printing.

· **1857**
Swedish-born photographer Oscar Gustav Rejlander exhibits combination prints.

· **1857–60**
Robertson and Felice Beato photograph the Indian mutinies; Beato photographs conflicts in China and Japan.
British publisher Francis Frith photographs in Egypt.

· **1858**
First known aerial photograph is made by French photographer and balloonist Gaspar Félix Tournachon, known as Nadar.
French archaeologist and traveler Claude-Joseph Désiré Charnay publishes *Album fotografico mexicano*, with 25 salt-paper prints of Mexico City and environs.

1860–1869

· **1860**
Abraham Lincoln's presidential campaign produces tintype buttons bearing the candidate's pictures.

· **1860s–1900**
Photography studios, run by both Chinese and non-Chinese photographers, open and operate in China, including Ouyang Shizhi's Powkee Studio in Shanghai and George R. West and Lai Fong's studios in Hong Kong.

· **1861**
Nadar makes first photographs underground, in Paris, using illumination supplied by Bunsen batteries.

Scottish physicist James Clerk Maxwell superimposes three positive lantern slides to produce one image in color.

In the United States, Carleton E. Watkins makes first trip to Yosemite Valley to photograph using glass-plate negatives.

· 1861–64

U.S. Civil War. Photographic documentation of the conflict is initiated by Brady, whose studio employs George Barnard, Alexander Gardner, Timothy O'Sullivan, Andrew Russell, and others.

· 1862

French physicist Louis Ducos du Hauron describes methods of producing photographic images in color.

Beato travels to Japan to photograph "native types."

· 1863–70

British photographer Samuel Bourne makes copious photographs in India. With Charles Shepherd, he establishes the Bourne & Shepherd photographic studio, first in Shimla and later in Kolkata; it becomes the most successful firm of its kind in the subcontinent. Although the studio and its archive are destroyed by fire in 1991, the firm remains in existence until 2016.

· 1863–75

Julia Margaret Cameron photographs family and friends in England.

· 1864

Walter B. Woodbury, in England, patents the Woodburytype process for photomechanical printing from negatives.

· 1865–80

Era of Western photography in the United States: photographers including William Henry Jackson, Eadweard Muybridge, Timothy O'Sullivan, A. J. Russell, and Carleton Watkins work for photographic firms, railway companies, and government geological surveys.

· 1866

Gardner's Photographic Sketchbook of the War, featuring 100 tipped-in albumen silver prints from glass negatives, is published in the United States.

· 1868

Thomas Annan begins documentation of slums in Glasgow.

Ducos du Hauron and Charles Cros publish independent proposals for additive processes of making color photographs.

British photographer Henry Peach

Robinson publishes *Pictorial Effect in Photography* to acquaint photographers with aesthetic concepts.

John Thomson moves to China and begins work on *Illustrations of China and Its People*, illustrated with Woodburytype images (four volumes, published 1873–74).

1870–1879

· 1870

Henry Heyl patents the magic lantern projector in the United States.

· 1871

Dry-plate silver bromide process is announced by Richard Leach Maddox; it is not perfected until 1878.

· 1872

Commercial production of celluloid begins in United States.

Ducos du Hauron makes first color photograph, of the town of Angoulême, France.

· 1872–87

Muybridge first photographs a horse in motion in 1872, works on motion-study project from 1877 to 1887. Others involved in similar experimentation are the American painter Thomas Eakins, French physiologist Etienne Jules Marey, and German photographer Ottomar Anschütz.

· 1873

Hermann Wilhelm Vogel, in Germany, adds dyes to photographic emulsion to make it more sensitive to spectral light.

Platinum printing method is invented in England.

Maxwell demonstrates possibility of color projection of photographs.

Electricity is first used to run machinery.

Carl Dammann publishes the *Anthropologisch-Ethnologisches Album* (Anthropologies and Ethnologies Album) in Hamburg, featuring 642 albumen portraits by various photographers, organized geographically and by race.

First halftone reproduction of a photograph appears in a New York newspaper, the *Daily Graphic*.

· 1874

French Impressionist painters hold first group exhibition, at Nadar's studio in Paris.

· 1876

Centennial Exhibition opens in Philadelphia, including exhibits on photography.

· 1879

Viennese printer Karl Klič improves photoengraving methods.

1880–1889

· 1881

Frederic E. Ives, in the United States, invents halftone photoengraving process, making possible large-scale reproduction of photographic and other images.

· 1883–90

Introduction of small cameras using dry plate or roll film, in particular George Eastman's Kodak (1888), and the resulting separation between the making of exposures and the commercial processing of film and prints, lead to increased popularity of photography.

· 1884

Eastman invents flexible, paper-based photographic film.

· 1884–1910

Art movements in photography form throughout Europe and the United States: Camera Club of New York, Linked Ring, London Camera Club, Photo-Club de Paris, Kleeblatt, Photo-Secession, and other Pictorialist organizations are initiated.

· 1888

Eastman patents Kodak roll-film camera.

French police clerk Alphonse Bertillon establishes the modern-day mugshot format of two photographs side by side, one full face and one in profile.

National Geographic Society is founded in Washington, D.C.; first issue of *National Geographic Magazine* is published. The first photograph to appear in the magazine will be published the following year.

· 1888–90

Scientists Vero Charles Driffield and Ferdinand Hurter establish methods of measuring image brightness, exposure, and emulsion sensitivity, publishing a work on sensitometry in 1890 in England.

· 1889

Peter Henry Emerson publishes *Naturalistic Photography* in England.

Protar f 7.5, the first successful anastigmatic lens, is invented.

Eastman applies for patent on transparent roll film.

1890–1899

· 1890

Halftone reproductions of photographs appear with increasing frequency in popular periodicals, supplanting engravings and hand-drawn illustration.

Women become increasingly involved in photography, especially in the United States, as both professionals and amateurs.

Jacob Riis, a pioneer in the use of magnesium flash, publishes photographs of New York slums in his book *How the Other Half Lives*.

· 1892

First issue of *Berliner Illustrierte Zeitung* is published in Germany.

· 1893

Kodak launches the "Kodak Girl" advertising campaign at the Chicago World's Columbian Exposition, featuring young women depicted as fashionable, independent tourists with cameras.

· 1894

Première exposition d'art photographique is organized by the Photo-Club de Paris.

· 1895

Brothers Auguste and Louis Lumière demonstrate a cinema projector capable of showing 16 frames per second, in Paris.

Bavarian physicist Wilhelm Conrad Roentgen discovers the X-ray.

· 1896

Guglielmo Marconi develops successful system for wireless telegraphy.

· 1897

Halftones are first printed in newspapers on power press using screen techniques devised by Ives and Stephen Horgan.

· 1898

American photographer Jimmy Hare documents battles in Cuba during Spanish-American War.

Eugène Atget begins photographic documentation of Paris, continuing until 1927.

Gertrude Käsebier photographs Lakota and Sioux people in her New York studio.

· 1899

Frances Benjamin Johnston photographs the buildings and students of the Hampton Normal and Agricultural Institute in Hampton, Virginia. Her photographs will be displayed at *The Exhibit of American Negroes* at the Paris Exposition Universelle the following year.

Jessie Tarbox Beals, the first professional woman photojournalist, is hired by the *Boston Post*.

1900–1909

· **1900**
Fixed-focus Brownie camera is introduced by Eastman Kodak.
Edwin S. Porter makes *The Great Train Robbery*, the first successful American feature film.

· **1902**
First message is sent over Marconi's transatlantic wireless telegraph.
Alfred Stieglitz organizes exhibition of Photo-Secessionists at National Arts Club in New York.

· **1903**
Camera Work photography journal is founded by Stieglitz in the United States.

· **1904**
Lewis Hine begins career as social photographer in New York City.
Lumière brothers patent Autochrome process for making full-color photographs; commercial manufacture begins in 1907.

· **1904–22**
Numerous photography groups are formed in Japan, including Aiyu, Tokyo Shashin Kenkyūkai, and Shashin Geijutsu Sha.

· **1905**
Stieglitz opens Little Galleries of the Photo-Secession at 291 Fifth Avenue, New York.

· **1906**
First panchromatic plates are introduced in Great Britain.

· **1907**
Kodak introduces "real photo postcards."
American photographer Edward S. Curtis begins publication of *The North American Indian*.

· **1909**
Kodak introduces a 35mm "safety" motion-picture film.

· **1909–31**
French banker and philanthropist Albert Kahn begins a project to make a photographic record of the whole world. Photographers are sent to document every continent, using Autochrome, resulting in *The Archives of the Planet*, a collection of 72,000 color photographs produced over the course of 22 years.

1910–1919

· **1910**
Photographer Herbert Ponting travels to the South Pole.

· **1911–12**
Experiments in "photodynamism" by brothers Anton Giulio and Arturo Bragaglia in Italy apply Futurist concepts to camera work.

· **1913**
First 35mm still camera is developed.
Armory Show in New York City displays modern art from Europe, generating extensive controversy.
Condé Nast hires Baron Adolph de Meyer to shoot portraits of models, actresses, and aristocrats for *Vogue* magazine, replacing hand-drawn illustrations for fashion editorial.

· **1914**
Photographer Frank Hurley travels to Antarctica with Ernest Shackleton.
Clarence White School of Photography is founded in New York.

· **1914–18**
World War I; among the photographers to document the conflict are John Warwick Brooke, Ernest Brooks, and Olive Edis.

· **1915**
Modernist ideas—evident in work by Alvin Langdon Coburn, Charles Sheeler, Edward Steichen, Stieglitz, Paul Strand, and others—begin to supplant Pictorialism in the United States.
Dada art movement is established in Zurich.

· **1917**
Camera Work ceases publication.
Coburn exhibits Vortographs and paintings at the London Camera Club.

· **1918**
Cameraless images, produced by manipulation of light and shadow directly on sensitized paper, are made by Christian Schad in Germany, Man Ray in Paris.

· **1919**
Bauhaus is established in Weimar, Germany.

1920–1929

· **1920**
Experimentation with photocollage and photomontage begins in Europe and the United States.
Use of photography in advertising increases in Europe and the United States.

· **1920–28**
Constructivist and Bauhaus photographers, influenced by László Moholy-Nagy and Alexander Rodchenko, attempt new ways of recording actuality by stressing unusual angles and close-ups.

· **1921**
Western Union transmits a halftone photograph over the telegraph for the first time.

· **1922**
At Harvard University, Paul J. Sachs teaches a course on museum curatorship titled "Fine Arts 15a: Museum Work and Museum Problems." Among his students are future curators Beaumont Newhall and Julien Levy.

· **1924**
Neue Sachlichkeit (New Objectivity) movement begins in Germany; among the photographers associated with the movement are Karl Blossfeldt, Albert Renger-Patzsch, and August Sander.
Museum of Fine Arts, Boston, becomes one of the earliest museums in the United States to collect photography.
First issue of *Photo Times* is published in Japan.

· **1924–25**
Introduction of Ermanox and Leica 35mm cameras allows for fast, repeated exposures in available light; a new look in photojournalism results.
André Breton's *Surrealist Manifesto* is published in Paris; among the photographers associated with the Surrealist movement are Hans Bellmer, Georges Hugnet, and Dora Maar.
Indigenous Peruvian photographer Martin Chambi opens a photographic studio in Cuzco, Peru.

· **1925**
Paul Vierkötter invents the flashbulb, in Germany; General Electric launches it in the United States in 1927.
Exposition internationale des arts décoratifs et industriels modernes is held in Paris.
Moholy-Nagy publishes *Malerei Fotografie Film* in Germany (it will be published in English as *Painting Photography Film* in 1967).
Siberian-born Anatol Josepho invents the photobooth in the United States.

· **1926**
First successful underwater color photograph is made off the Florida Keys in the Gulf of Mexico by Dr. William Longley and *National Geographic* staff photographer Charles Martin.
In a review of Robert Flaherty's silent film *Moana of the South Seas*, Scottish filmmaker John Grierson coins the term "documentary."
First issue of *Asahi Camera* is published in Japan.

· **1927**
First demonstration of television is held in the United States.

· **1928**
Eastman Kodak Company produces color film for 16mm movie cameras.
Rolleiflex twin-lens reflex camera is introduced.

· **1929**
Museum of Modern Art opens in New York City.
Blossfeldt publishes highly magnified images of plants for *Urformen der Kunst* (Art Forms in Nature).
Film und Foto exhibition takes place in Stuttgart.

1930–1939

· **1930**
First issue of *SSSR n stroike* (USSR in Construction) photography magazine is published in Russia.

· **1931**
New York gallerist Julien Levy befriends Marcel Duchamp, Man Ray, and Berenice Abbott; through Abbott he comes into possession of a portion of Eugène Atget's personal archive of photographs.

· **1932**
Photoelectric-cell light meter is introduced.
Harlem Renaissance is underway in New York; it is documented by James Van Der Zee and others.
Group f.64 is established with an exhibition at the M. G. de Young Memorial Museum in San Francisco.

· **1933**
First panchromatic roll film is manufactured in the United States.
Bauhaus closes under political pressure in Germany.
Walker Evans: American Photographs is the first solo photography show to be presented at Museum of Modern Art, New York.

· 1935
German cultural critic Walter Benjamin publishes "Das Kunstwerk im Zeitalter seiner technischen Reproduzierbarkeit"; published in English as "The Work of Art in the Age of Mechanical Reproduction" in 1969.

· 1935–42
Rural Resettlement Administration (Farm Security Administration after 1937) sponsors an extensive documentary project led by Roy Stryker in the United States, including photographic assignments for Evans, Dorothea Lange, Arthur Rothstein, Marion Post Wolcott, and others.
Associated Press launches its Wirephoto service, with images transmitted over telephone lines.

· 1936
Photo League is founded in New York; members include Abbott, Hine, Lisette Model, Aaron Siskind, Strand, and Walter Rosenblum.
Kodachrome is introduced in 35mm cartridges and roll film.
First issue of *Life* magazine is published.

· 1937
First single-lens reflex camera is manufactured in Germany.
Institute of Design is established at the Illinois Institute of Technology in Chicago; Moholy-Nagy founds New Bauhaus.
First issues of *Popular Photography* and *Look* magazines are published in the United States.
Edward Weston receives the first John Simon Guggenheim Memorial Foundation fellowship to be awarded to a photographer.
Photographic Society of India is founded.

· 1938
First issue of *Picture Post* is published in England.

· 1939
American news cameraman Edward Rolke Farber invents stroboscopic flash system.

· 1939–45
World War II; among the photographers to document the conflict are Dmitri Baltermants, Robert Capa, Dickey Chapelle (Georgette Louise Meyer), Lee Miller, Wayne Miller, Carl Mydans, and Joe Rosenthal.

1940–1949

· 1940
Ansco, Agfa, and Sakura Natural color films and Kodachrome films and papers are introduced.
Museum of Modern Art, New York, opens department of photography with curator Beaumont Newhall.

· 1944
Kodacolor film is introduced.
First automatic digital computer is constructed at Harvard University.

· 1945
United States drops atomic bombs on Hiroshima and Nagasaki. Detonation at Hiroshima is photographed by Sgt. George R. Caron. Shōmei Tōmatsu and Ken Domon will publish *Hiroshima-Nagasaki Document* on the bombs' aftermath in 1961.
Electronic analog computer is invented.

· 1946
Ektachrome, a positive transparency film that can be processed in home darkrooms, is introduced.
Abstract Expressionist painting is in development in the United States; Siskind engages the style via photography.

· 1947
American physicist Edwin H. Land invents Polaroid camera.
Magnum photography agency is founded in Paris by Robert Capa, Henri Cartier-Bresson, George Rodger, David "Chim" Seymour, and William and Rita Vandivert.

· 1948
35mm Nikon camera is introduced in Japan.
First issue of *Stern* magazine is published in West Germany.

· 1949
First issue of *Paris Match* magazine is published in France.
George Eastman Museum is established in Rochester.
Beaumont Newhall publishes *The History of Photography from 1839 to the Present Day*.

1950–1959

· 1950
First Xerox copying machine is produced in the United States.
Senator Joseph McCarthy initiates anti-liberal movement in the United States; photographers associated with the Photo League and others are implicated.
First issue of *China Pictorial* is published.

· 1951
Photo League disbands.
First issue of *African Drum* photo magazine is published in South Africa.

· 1952
First issue of *Aperture* magazine is published in the United States.
Cartier-Bresson publishes *Images à la sauvette* in France, as *The Decisive Moment* in the United States and Britain.

· 1954
High-speed Tri-x film is introduced by Eastman Kodak.
Helen Gee opens Limelight photography gallery in New York.
First issue of *Camera Mainichi* is published in Japan.

· 1955
The Family of Man exhibition, organized by Edward Steichen, opens at the Museum of Modern Art, New York; the show will tour for eight years and have record-breaking attendance.

· 1956
Martin Luther King Jr. organizes Montgomery, Alabama, bus boycott, furthering civil rights movement in the United States. Photographers documenting the movement over the years include Bob Adelman, Bruce Davidson, Leonard Freed, Danny Lyon, Moneta Sleet, and Ernest Withers.

· 1957
First image scanner developed for use with a computer is built at the U.S. National Bureau of Standards by a team led by Russell A. Kirsch.

· 1958
Pop art is pioneered by Robert Rauschenberg, Jasper Johns, Claes Oldenburg, Andy Warhol, and others.
Robert Frank publishes *Les américains* in France; it will be published in the United States as *The Americans* the following year.

· 1959
Nikon F 35mm single-lens reflex camera is introduced in Japan.
Vivo photography cooperative is founded in Japan.
Agfa introduces Optima, first fully automatic camera.

1960–1969

· 1960
Polaroid introduces high-speed film.
Introduction of laser light enables transmission of holographic images.
Vietnam War is ongoing; among the photojournalists to document the conflict are Larry Burrows, Dickey Chapelle, Philip Jones Griffiths, Don McCullin, and Nick Ut.

· 1961
Faster Kodachrome II color film is introduced.
First silicon chip is made.

· 1962
Polacolor film for one-step photography is introduced; produces color prints in 60 seconds.
John Szarkowski becomes curator of photography department at Museum of Modern Art, New York.
Society for Photographic Education is established by photographer and educator Nathan Lyons.

· 1963
Eastman Kodak introduces Instamatic camera and higher-speed color film.

· 1965
Nikkormat camera is introduced by Nippon Kogaku K. K. in Japan.
Flash cube is introduced in the United States.

· 1966
Gamma photo agency is founded by photographer Raymond Depardon in France.

· 1968
U.S. astronaut William Anders photographs *Earthrise*: Earth seen above the horizon of the moon.
First issue of *Provoke* magazine is published in Japan by critic/photographers Kōji Taki and Takuma Nakahira, photographer Yutaka Takanashi, and writer Takahiko Okada. Daidō Moriyama joins with the second issue.

· 1969
U.S. astronauts walk on the moon; the event is televised.

1970–1979

· 1970
First Rencontres d'Arles festival is held in southern France.

· 1971
Intel 4004, the first microprocessor, is released by Intel.

· 1972
Polaroid SX-70 system is introduced.
NASA astronauts photograph *The Blue Marble*: Earth seen from a distance of 18,000 miles.

· **1973**
First FotoFest gathering is held in Houston, Texas.

· **1974**
International Center of Photography is established in New York by photographer Cornell Capa.

· **1975**
First digital camera prototype is built by Kodak engineer Steven Sasson; it records black-and-white images to cassette tape.
Videotape systems for home use are developed by Sony and Matsushita in Japan.
New Topographics: Photographs of a Man-Altered Landscape, curated by William Jenkins, is presented at the International Museum of Photography at George Eastman House in Rochester.
Center for Creative Photography is established in Tucson, Arizona.

· **1976**
Apple Computer company is founded by Steve Jobs and Steve Wozniak.
Photographs by William Eggleston is first exhibition of color photographs to be presented at Museum of Modern Art, New York.
Bernd Becher joins faculty of Kunstakademie Düsseldorf; he and his wife, Hilla Becher, will catalyze the so-called Düsseldorf School of Photography.

· **1978**
First point-and-shoot auto-focus camera is introduced by Konika.

· **1979**
Scitex company introduces pre-press technology for publishing; computer-based system allows operator to make color separations and montages.

· **1979–88**
Mexican photographer Graciela Iturbide undertakes documentation of Juchitán Zapotec people of Oaxaca; resulting book, *Juchitán de las mujeres*, will be published in 1988.

1980–1989

· **1980**
IBM introduces personal computer.
First iteration of *The Photography Show* is held in New York, organized by AIPAD (Association of International Photography Art Dealers).

· **1982**
Electronic still digital camera is introduced.

· **1983**
Museum of Photographic Arts opens in San Diego.
First annual meeting of photographic curators is organized by Nathan Lyons in Oracle, Arizona. Participants include: Jim Alinder, Cornell Capa, Martha Chahroudi, Charles Desmarais, Jim Enyeart, Roy Flukinger, Merry Foresta, Ted Hartwell, Therese Heyman, Bill Jenkins, Arthur Ollman, Terry Pitts, Marni Sandweiss, and Anne Tucker.

· **1984**
Apple introduces user-friendly Macintosh computer with graphic capability.
Museum of Contemporary Photography opens in Chicago.

· **1985**
Pixar introduces digital-imaging processor.
Virtual-reality research company VPL is founded by Jaron Lanier.

· **1986**
World conference establishes standards for sound, video, and digital recordings for manufacturers of all electronic still photography and still video equipment.
Agence VU photo agency is founded in France by Christian Caujolle and Zina Rouabah.

· **1987**
Photoshop is created by brothers Thomas and John Knoll; it will be launched by Adobe in 1990.

· **1988**
Electronic imaging is increasingly used in science and technology and in the commercial and industrial sectors.
First all-digital camera is demonstrated.
Film and flat-bed scanners are introduced.

· **1989**
Digital single-lens reflex (DSLR) camera prototype is launched by Eastman Kodak.
World Wide Web, a global open, hypertext system, is invented by computer scientist Tim Berners-Lee.
Robert Mapplethorpe: The Perfect Moment exhibition, funded by the National Endowment for the Arts (NEA), is canceled at Corcoran Gallery in Washington, D.C., under pressure from conservatives objecting to federal sponsorship for sexually explicit works.
Tokyo Metropolitan Museum of Photography opens.

1990–1999

· **1990**
Kodak introduces low-cost Photo CD system for digitally storing photographs.
U.S. Congress passes law prohibiting NEA from funding works considered pornographic as defined by U.S. Supreme Court.

· **1990–91**
JPEG (Joint Photographic Experts Group) format is created.

· **1991**
Kodak introduces DCS, the first commercial DSLR camera.

· **1992**
Louis Rosenberg develops Virtual Fixtures, an early augmented-reality system, at U.S. Air Force Research Laboratory.

· **1993**
Fotomuseum Winterthur opens in Switzerland.

· **1994**
Republican majority in U.S. Congress seeks to end government funding of the arts.
Time magazine publishes a digitally altered photograph of O. J. Simpson on the front cover.
Vancouver Sun is first newspaper to convert to all-digital photography.
First Biennale Africaine de la Photographie photography festival is held in Bamako, Mali.

· **1994–96**
First digital cameras enter consumer market.

· **1996**
Kodak introduces Advanced Photo System, developed by a consortium of manufacturers to facilitate more accurate photo processing.
Maison Européenne de la Photographie opens in Paris.
Moscow House of Photography opens, with first iteration of the Moscow Photobiennale.

· **1997**
DVD technology is widely used.
DSLR camera is marketed by Nikon.
Mars Pathfinder lands on Mars; more than 16,000 images are transmitted to Earth.
Getty Communications merges with PhotoDisc to form Getty Images.
New York Times publishes its first front-page color photograph; it is one of the last newspapers in the United States to adopt color photography.
Arab Image Foundation is established in Beirut.

· **1998**
Google is founded by Larry Page and Sergey Brin.

· **1999**
Shutterfly is launched.

2000–2009

· **2000**
First camera phone is introduced by Sharp.
National Museum of Photography opens in Copenhagen.

· **2001**
September 11 terrorist attack on World Trade Center in New York City and Pentagon in Washington, D.C.; the events are documented widely by both professionals and "citizen journalists."
Polaroid company declares bankruptcy; discontinues production of all instant-film products in 2008.
VII Photo Agency is founded.
Foam (Fotografiemuseum Amsterdam) opens; first issue of *Foam* magazine is published the following year.
First Pingyao International Photography Festival is held in Pingyao, China.

· **2002**
Worldwide sales of digital cameras outstrip sales of film cameras for the first time.

· **2003**
Compact DSLR camera is introduced.

· **2004**
Photographs are released of detainees being tortured by U.S. soldiers at Abu Ghraib prison in Iraq.
Eastman Kodak Company ceases production of film cameras.
Facebook (originally "The Facebook") is founded by Mark Zuckerberg.
Flickr is launched.

· **2005**
Video-sharing website YouTube is launched.
Self-publishing platform Blurb is launched.

· **2007**
Apple launches iPhone.

· **2008**
Kodak discontinues Kodachrome film.

· **2009**
Fujifilm launches first digital 3-D camera with printing capability.

2010–2019

· 2010
Pier 24 Photography museum opens in San Francisco. Instagram is launched.

· 2010–11
Arab Spring uprisings take place in Tunisia, Syria, Egypt, and other countries in the region; the events are documented and facilitated via smartphones and social media.

Andreas Gursky's photo *Rhein II* (1999) sells at Christie's, New York, for $4,338,500.

· 2012
Eastman Kodak files for bankruptcy.
Hurricane Sandy hits New York; the storm and its aftermath are covered by *Time* magazine via photographers' Instagram feeds.

· 2013
Chicago Sun-Times lays off its entire staff of photographers, citing a shift toward online video.

· 2015
Migration crisis takes place as thousands of refugees arrive on European shores. The events are documented photographically by Nilüfer Demir, Alex Majoli, Paolo Pellegrin, and others.
New York Times launches virtual-reality platform NYTVR with Google.

· 2017
An estimated 1.2 trillion photographs are made this year, shot primarily with smartphones.
National Gallery of Canada launches Canadian Photography Institute.

· 2018
Kodak resumes production of Ektachrome film.
Instagram has more than 800 million users.

Glossary

ADDITIVE COLOR: The principle by which all colors of light can be mixed optically by combining in different proportions the three primary colors of the spectrum—red, green, and blue. White light is a mixture of all three.

ALBERTYPE—*see* COLLOTYPE

ALBUMEN (*also spelled* ALBUMIN): Eggwhite. Used on glass as a medium for light-sensitive emulsions to make finely detailed negatives. Also, albumen positive prints are made on paper or other substances coated with eggwhite and salt solution and sensitized with silver nitrate. The print is made by exposing the negative against the paper to sunlight.

AMBROTYPE: The name for a glass collodion process patented in 1854 in the United States by James Ambrose Cutting. It produces a glass negative that looks like a positive because of the way the image is developed and backed. Called COLLODION POSITIVES in Great Britain.

APERTURE: The adjustable opening in a lens, which is one determinant (along with shutter sheed) of the amount of light that will pass through. RELATIVE APERTURE is expressed as an *f*/number, which represents the focal length of the lens divided by the diameter of the aperture.

ARCHIVAL PROCESSING: Treatment designed to preserve a print or negative for as long as possible by protecting it against deterioration due to chemical reactions.

ARTOTYPE—*see* COLLOTYPE

AUGMENTED REALITY: A form of digital imaging, used chiefly in smartphones and other electronic devices, that layers images or data over a live camera view on the device's screen.

AUTOCHROME: A positive color transparency on glass made by an additive process in which starch grains dyed the primary colors of light—red, green, and blue—are mixed and sifted onto a glass plate covered with a sticky substance. The plate is then coated with black powder, varnished, coated with a sensitized emulsion, and exposed in the camera; development yields a positive transparency. Plates were manufactured by the Lumière company in France from 1907 to 1940.

AUTOGRAVURE—*see* COLLOTYPE

AUTOTYPE—*see* CARBON PRINT

BICHROMATE—*see* DICHROMATED-COLLOID PROCESS and GUM BICHROMATE

BLUEPRINT—*see* CYANOTYPE

BROMOIL: A print process by which a gelatin silver–bromide contact print or enlargement is treated with a potassium dichromate solution that simultaneously bleaches the dark silver image and hardens the gelatin, which then is soaked to absorb water. The pigment—ordinarily lithographic ink applied by hand, in any one of a variety of colors—adheres in the dark areas, where the gelatin had absorbed less water, and is repelled in the areas where more water was absorbed. The image can be printed in monochrome or in several colors.

BURNING: Using an image editing program to darken part of a photograph.

CABINET CARD: A photograph (initially an albumen print, later a silver gelatin or carbon print), usually a portrait, mounted on stiff card stock measuring about 6G by 4G inches.

CALOTYPE (*also called* TALBOTYPE): The first successful negative/positive process, patented in 1841 by William Henry Fox Talbot. A negative latent image produced by exposing paper sensitized with potassium iodide and silver nitrate solutions in a camera is then developed in acetic and gallic acids plus silver nitrate. Positives—called SALT PRINTS—are subsequently made by contact-printing the paper calotype negatives in daylight onto salted paper (i.e., paper that has been treated with silver nitrate and salt). In current usage, *calotype* refers to the negative.

CAMERA: The instrument with which photographs are taken. Basically, it consists of a lightproof box with an aperture that generally contains a lens to admit and focus the light, as well as a holder for light-sensitive material—either plate or film.

CAMERA LENS: Usually a composite of optically ground glass or plastic disks aligned on an axis, which transmits light from the object being photographed to the film or plate in the camera. Depending on how it is formed or ground, the lens bends the light rays so that they strike the film or plate in a predictable manner.

CAMERA LUCIDA: An instrument consisting of a prism supported by a telescoping stand set over drawing paper. Used for copying drawings and tracing views of nature.

CAMERA OBSCURA: Forerunner of the photographic camera. Originally a darkened room in which observers could view images of outside subjects projected (upside down) through a pinpoint light source onto a facing wall. Later this evolved into a portable box with an aperture, lens, mirror, and viewing screen.

CARBON PRINT: A nonsilver positive print produced by exposing a negative against a pigmented gelatin tissue sensitized with potassium dichromate. The gelatin hardens in proportion to the

amount of light it receives, forming the image. This gelatin image is sandwiched with a second sheet of gelatin-coated paper, and both are then washed. In the process, the original gelatin and any gelatin that remains soft and soluble is washed off, leaving the transferred image intact. Because no silver was present to deteriorate, this was the first truly practical method for producing permanent prints. Carbon prints made by the Autotype Printing and Publishing Company, founded in London in 1868, were known as AUTOTYPES.

CARBRO PRINT: A carbon print made by pressing a silver bromide print against a dichromated-gelatin tissue that has been immersed in a silver-bleaching agent. The gelatin hardens on contact and is then processed like a carbon print. Derived from OZOBROME, a similar process that produced a monochromatic print. Color carbro prints are made by printing three negatives of the same subject, taken through a red, a green, and a blue filter.

CARTE-DE-VISITE: A 3H by 2H inch mounted photographic print popular in the late 19th century, usually a portrait and generally made as one of a number of images on a single photographic plate. Patented by André Adolphe Eugène Disdéri in 1854.

CCD: Charged-couple device. The original image sensor in digital cameras, an integrated circuit comprising an array of metal-oxide semiconductor capacitors that captures, stores, and transforms light into an electrical charge.

CHROMOGENIC PRINT: A color print made from a color transparency or negative on material containing at least three layers of silver salts, each sensitized to one of the three primary colors of light. Dyes are added after initial monochromatic development to form the appropriate colors. The color is not stable.

CLICHÉ VERRE: A drawing made on a glass plate and printed on light-sensitive paper by contact or in an enlarger. When the plate has been covered with an opaque ground—either paint or smoke—and the drawing scratched through the ground, the resulting print has dark lines on a white ground. Drawing with paint or ink on an uncoated glass plate produces a print with white lines on a dark ground.

CMOS: Complementary metal-oxide semiconductor. The most widely used digital image sensor in contemporary photography, it captures, stores, and transforms light into an electrical charge more efficiently, at lower cost, and while generating less heat than a CCD sensor.

COLLAGE: A combination of photographs, graphics, type, and other two-dimensional elements pasted onto a backing sheet.

COLLODION PROCESS: Usually, a wet-plate process in which a negative is made by coating a glass plate with a light-sensitive emulsion of collodion—guncotton dissolved in alcohol and ether—to which potassium iodide and potassium bromide have been added. The plate is inserted into the camera, exposed while wet, and developed immediately thereafter. The DRY-COLLODION PROCESS allows the plate to be exposed and developed at a later time but requires a much longer exposure.

COLLOTYPE: A group of related processes that use metal or glass plates coated with dichromated gelatin to produce a printing surface. After exposure against a negative, the plate is washed and treated with glycerin. The gelatin surface becomes selectively absorbent, and greasy ink adheres more easily to the parts of the image containing the least water; the inked plate is then printed on paper. Variants of the process are called ALBERTYPE, ARTOTYPE, AUTOGRAVURE, HELIOTYPE, LICHTDRUCK, and PHOTOTYPIE.

COLOR SEPARATION: A method of recording on separate sheets of black-and-white film, through filters, each of the three primary color components of a photographic subject, for the purpose of printing it in color.

COMBINATION PRINTING: The technique of printing more than one negative, or multiple exposures of a single negative, on one sheet of sensitized paper.

CONTACT PRINT: A positive made in direct contact with a negative and therefore the same size as the negative.

CYANOTYPE: A low-cost permanent print made by putting an object (i.e., a drawing or plant specimen) directly in contact with paper impregnated with iron salts and potassium ferricyanide, then exposing them to light. The paper darkens except where the object blocks the light. The resulting image usually is white on a blue ground.

DAGUERREOTYPE: The first practical photographic process, in which an image is formed on a copper plate coated with highly polished silver that is sensitized by fumes of iodine to form a light-sensitive coating of silver iodide. Following exposure, the latent image is developed in mercury vapor, resulting in a highly detailed image. It is a unique work, having no negative for replication.

DETECTIVE CAMERA: Early name for small hand-held cameras, many of which were designed to be concealed in clothing or parcels or disguised as books, walking sticks, or other articles.

DEVELOPING-OUT PAPER: Paper on which the image is printed by immersing it in chemical baths, rather than by the action of light alone.

DEVELOPMENT: The process by which exposed film or photographic paper is chemically treated to produce a visible and relatively permanent image.

DICHROMATED-COLLOID PROCESS (formerly called BICHROMATE PROCESS): Any process—e.g., carbon and pigment processes—in which gelatin, fish glue, or gum arabic is mixed with one of the sensitizers ammonium dichromate, potassium dichromate, or sodium dichromate.

DIGITAL CAMERA: A camera in which the picture is captured by an electronic imaging sensor instead of on film.

DIGITAL IMAGE: A picture formed by light-sensitive receptors called PIXELS, which are encoded as digits in computer microchips. Images thus formed can be regenerated at any size onto video screens, photographic film or paper, or other materials.

DODGING: Lightening part of a photograph using an image editing program.

DPI: Dots per inch. A measurement of resolution of digital cameras, printers, and photographs. The higher the number, the greater the resolution.

DRY PLATE: A negative made by exposing a glass plate coated with silver halides suspended in gelatin. Called *dry* to distinguish it from wet-collodion plates.

DSLM: Digital single-lens mirrorless (*also called* mirrorless interchangeable-lens) camera. A digital camera that displays the live view of a scene through the lens in an electronic viewfinder, permitting a smaller and lighter camera body than is possible with a digital single-lens reflex camera.

DSLR: Digital single-lens reflex camera. A camera that uses a mirror mechanism to reflect a scene through the camera lens into an optical viewfinder (the mirror swings out of the way when the camera's shutter is opened), capturing the image on a digital sensor rather than film.

DYE-DESTRUCTION PRINT: A color print made from a color transparency or negative on material containing at least three layers of silver salts and dyes, each sensitized to one of the three primary colors of light. In the development and bleaching process, the appropriate amount of dye is destroyed to achieve the desired colors. This method produces color prints that are more stable than chromogenic prints.

DYE-DIFFUSION PRINT: A color print made on material that has three layers, each sensitized to one of the three primary colors of light. A complicated process results in both a negative and a positive, with the negative being either stripped away or embedded invisibly in the final unique color print.

DYE-TRANSFER PRINT (also called DYE-IMBIBITION PRINT): A color print made when a subject is photographed through filters on three separate gelatin negatives dyed magenta, cyan, and yellow. These are contact-printed in register onto a single sheet of sensitized paper to form a positive color image. This process produces a relatively permanent print because it contains no silver salts.

EMULSION: Any light-sensitive coating applied to photographic film, paper, or other material. Most commonly, it contains silver halide crystals suspended in gelatin.

ENLARGEMENT: A photographic print of larger dimensions than the negative from which it was made, produced by passing light through the negative and then through a magnifying lens.

EXPOSURE: The act of directing light onto a photosensitive material. Also, the amount of light allowed to reach the material.

F/NUMBER—see APERTURE

FERROTYPE—see TINTYPE

FILM: Most commonly, the transparent, flexible acetate or plastic material that supports a layer of light-sensitive emulsion.

FIXING BATH (*also called* HYPO): A chemical solution—usually sodium thiosulfate or ammonium thiosulfate—that makes a photograph insensitive to further exposure to light by dissolving the unaffected silver halides.

FOCAL LENGTH: Commonly used to mean the distance from the lens to the plane on which the image is focused (FOCAL PLANE) when the lens is set on infinity. Wide-angle lenses have a short focal length, and telephoto lenses have a long focal length.

GELATIN: A protein obtained from animal tissue and hooves. Used as a binder to hold silver halide crystals in suspension in modern photographic emulsions and in nonsilver light-sensitive reproduction processes.

GELATIN SILVER PRINT: A paper coated with an emulsion of gelatin and silver salts—either silver bromide or silver chloride, or a mixture of both, called chloro-bromide.

GLASS PLATE: A flat sheet of glass coated with an emulsion of either collodion or albumen, used for making negatives or positives.

GRAYSCALE: A range of monochromatic tones extending from pure white to pure black, rendered as a series of gray tones along a continuum of brightness with no color information.

GUM BICHROMATE: A process that produces a print by exposing a negative against a surface coated with an emulsion of gum arabic, potassium dichromate, and pigment. The emulsion hardens in relation to the amount of light it receives through the negative. Unexposed emulsion is washed away with water to leave the hardened, pigmented image. This process yields a relatively permanent print because it contains no silver salts.

HALFTONE: A reproduction made by re-photographing a picture (photographic or other) through a gridded screen in order to break up the continuous tones into a field of dots. Dark areas of the image appear as large, closely spaced dots; the dots representing light areas are smaller and farther apart. The halftone has been largely superseded by electronic means of preparing photographs and graphic work for reproduction.

HAND CAMERA: Any camera that can be carried and used without a tripod.

HELIOGRAVURE—*see* PHOTOGRAVURE

HELIOTYPE—*see* COLLOTYPE

HOLOGRAPHY: A method of creating the illusion of a three-dimensional image. A laser beam is split into two parts; one part is reflected from an object and interferes with the other part, which comes directly from the laser. The interference pattern created when the two beams merge is recorded on a photographic plate that, when illuminated by laser or white light, produces a three-dimensional image.

HYPO—see FIXING BATH

IMAGE EDITOR: A computer program that makes possible the adjustment of an image by rotating, changing values and adjusting contrast, and/or cropping out details.

IMAGE RESOLUTION: The number of pixels in a digital photograph.

INFRARED: The band of the electromagnetic spectrum that includes radiation of wave lengths longer than that of visible red light but shorter than radio waves. Some films are sensitive to infrared light.

INKJET: A digital printing technology that renders an image by spraying tiny droplets of ink onto a medium such as paper, plastic, fabric, or metal.

INSTANTANEOUS PHOTOGRAPHY: A term used loosely in the early days of photography for exposures of less than one second.

JPEG: The most common digital image file type, permitting compression for smaller file sizes that require less memory and therefore the standard for use on the Internet, social networks, and photo-sharing apps.

LATENT IMAGE: The invisible image produced on a sensitized material by exposure to light, which is converted to a visible image by chemical development.

LASER PRINTING: A printing process where light generated by a laser or diode creates a charge on a photographically sensitive cylinder, which then attracts toner and can be transferred to a surface to create an image.

LCD: Liquid crystal display. A thin, flat display screen used in digital cameras, smartphones, tablets, and many computer monitors, televisions, and other devices.

LED: Light-emitting diode. A semiconductor device that produces visible light when struck by an electrical current, used in all digital display screens and sometimes as a light source in photography.

LICHTDRUCK—see COLLOTYPE

LIGHT GRAPHICS—see PHOTOGRAM

MACROPHOTOGRAPHY: A photographic image of a subject that is life-size or larger, made by placing the lens at a greater distance from the film than the focal length of the lens, accomplished by an extension tube or camera bellows.

MAGNESIUM FLASH: An early device for providing artificial illumination, which made indoor or night photography possible. Igniting magnesium powder or wire produces a bright light.

MATRIX: An image from which prints can be made; specifically, in dye-transfer printing the three dyed gelatin negatives used to make a print on sensitized paper.

MEGAPIXEL: A unit of digital sensor resolution measuring the number of light-gathering cells (photodiodes) on the sensor, equaling roughly one million—technically, 1,048,576 (220)—pixels.

MELAINOTYPE—see TINTYPE

MICROPHOTOGRAPHY: Photography done through a compound microscope, resulting in the enlargement of extremely small subjects.

MONTAGE (also called PHOTOMONTAGE): A composite image made by joining together and printing portions (or all) of more than one negative to synthesize an image not found in reality.

NEGATIVE: Any photographic image in which the tones are the reverse of those in the original subject. Also, the film, plate, or paper exposed to light in a camera and processed to make the negative image.

ONE-STEP PHOTOGRAPHY: A process that produces a positive print within seconds after exposure by rolling a sandwich of a negative, a positive, and development chemicals through the mechanism.

ORTHOCHROMATIC: A film, plate, or emulsion that is sensitive only to blue and green light. It renders all colors except red in tones of gray, in proportion to their relative brilliance in the subject.

OZOBROME—see CARBRO PRINT

PALLADIUM PRINT—see PLATINUM PRINT

PANCHROMATIC: A film, plate, or emulsion that is sensitive to blue and green light and also to some or all of the red portion of the spectrum. It renders the colors in tones of gray, in proportion to their relative brilliance in the subject.

PANORAMIC CAMERA: An instrument designed to take photographs with a much wider lateral field of view than in an ordinary camera. The film may be mounted on a curved back in the camera and the lens may turn on an axis. The exposure is made through a narrow slit that moves with the lens. Panoramic views initially were made using an ordinary camera that was pivoted on its tripod to take overlapping contiguous views of a scenic subject.

PHOTODIODE: A semiconductor device that converts light into an electric signal; it is the crucial component on a digital imaging sensor, whose surface is covered with millions of these light-gathering cells, also commonly called pixels.

PHOTOGENIC DRAWING: An early process for producing paper negatives without a camera. After objects were placed on paper sensitized with table salt and silver nitrate, the paper was exposed to light. It darkened in proportion to the amount of light each area received, resulting in a negative image, which was then fixed with a salt solution.

PHOTOGRAM (also called SCHADOGRAPH, RAYOGRAPH, LIGHT GRAPHICS, PHOTOGENICS): A photographic image made without a camera, either by placing objects on a sensitized surface—paper or film—that is exposed to a moving or stationary source of light, or simply by directing light onto the material.

PHOTOGRAVURE (also called HELIOGRAVURE): A photomechanical printing process for reproducing the appearance of the continuous range of tones in a photograph. A copper plate covered with resin dust and dichromated gelatin is exposed to a transparent positive and etched in an acid bath so that dark areas of the image will hold more ink than the light areas. For artistic reproduction, the inked plate is printed on a flatbed press—a process called HAND-PULLED GRAVURE.

PHOTOLITHOGRAPHY: A process for printing a photographic image that exploits the basic principle of lithography: oil and water repel each other. A metal plate or stone is coated with dichromated gelatin, which when exposed against a negative to light hardens in proportion to the amount of light received. After the soluble gelatin is washed away, the stone or plate is dampened and the greasy ink adheres to the hardened gelatin areas. The print is transferred to paper by pressing it against the inked face of the plate.

PHOTOMONTAGE—see MONTAGE

PHOTOTYPIE—see COLLOTYPE

PINHOLE: A tiny aperture in a camera without a lens. Light passing through it forms an inverted image on film or light-sensitive paper that is less sharp than one produced through a lens.

PIXEL: Digital photographs are composed of these elements, which can be considered their building blocks.

PLATE: Usually a glass or metal sheet (available in a range of sizes) coated with light-sensitive emulsion. When inserted in a camera, the plate receives the image through the aperture.

PLATINUM PRINT (*also called* PLATINOTYPE *after its British trade name*): A print formed by exposing a negative in contact with paper sensitized with iron salts and a platinum compound, then developing it in potassium oxalate. Considered highly permanent. PALLADIUM PRINTS are similar, but use a compound of the less expensive metal palladium for sensitizing the paper.

POSITIVE: A photographic image on any support or material in which the tonalities and colors accord with those of the subject portrayed (as opposed to a negative, in which they are reversed). At times used interchangeably with *print*.

POST-PROCESSING: The work performed on a digital image using software after the camera has captured it and the data has been converted to a standard file type. Post-processing includes image enhancement and alteration.

PRIMARY COLORS: In light, the primary colors are red, green, and blue. When mixed in different proportions, these colors produce all others; together, they produce white light. In pigment (e.g., dyes and printing inks), the primary colors are magenta, cyan (blue-green), and yellow.

PRINT: An image on paper or other substances formed by photographic means; usually, but not invariably, it is a positive image.

PRINTING-OUT PAPER: Photographic paper that produces a visible image when exposed to light, without need for chemical development.

RAYOGRAM—*see* PHOTOGRAM

REFLEX CAMERA: A camera with a built-in mirror that reflects the image in the lens onto a glass viewing screen.

RESOLUTION: The amount of fine detail visible in a photograph or digital image.

SABATTIER EFFECT—*see* SOLARIZATION

SALTED PAPER: A printing-out paper made by soaking writing paper in a weak salt solution and then brushing one side of it with a silver nitrate solution to form light-sensitive silver chloride, which permeates the paper fibers.

SALT PRINT—*see* CALOTYPE

SCHADOGRAPH—*see* PHOTOGRAM

SENSITIZED—*see* SILVER HALIDES

SHUTTER: A device that opens or closes to control the amount of light entering the camera and striking the film or plate. SHUTTER SPEED is the length of time the shutter remains open.

SILVER HALIDES (*also called* SILVER SALTS): Silver chloride, silver bromide, and silver iodide. The light-sensitive components in photographic emulsions, which react to light by turning dark. Film or papers coated with emulsions containing these halides are said to be SENSITIZED.

SOLARIZATION (*also called* SABATTIER EFFECT): A partial reversal of tones in an image, caused by re-exposing a negative or positive to light during the development process. Named after Armand Sabattier, who discovered the phenomenon in 1862. Solarization can also be caused accidentally in the camera by extreme overexposure to a light source.

SPECTRUM: The band of visible wave lengths perceived as color. Consisting of a continuous range of tones from deep violet through blue, green, orange, and red, it becomes visible when white light is diffracted through a prism.

STEREOGRAPH: A pair of side-by-side photographic views taken (using a dual-lens camera) from very slightly different angles and mounted side by side, usually on cardboard. Viewed separately by each eye in a stereoscope viewer, the two images merge in the brain to produce the illusion of three dimensions. A STEREOSCOPE is a device for viewing stereographs, consisting of a set of eyepieces and a holder for one or more stereographs.

SUBTRACTIVE COLOR: The principle underlying most color photography. White light passes through dyes containing varying amounts of the three primary colors of pigment—magenta, cyan, and yellow; these dyes filter out their complementary colors from the white-light spectrum, leaving colors from the rest of the spectrum.

TALBOTYPE—*see* CALOTYPE

TINTYPE (*also called* FERROTYPE and MELAINOTYPE): A positive image formed by exposing in a camera a thin varnished sheet of iron coated with black or brown lacquer and sensitized collodion. Used almost exclusively for inexpensive portraiture.

TONING: A process that alters the color of a silver print either by changing the chemical makeup of the image during development or by coating it with a chemical compound after development.

ULTRAVIOLET: The band of the electromagnetic spectrum that includes radiation of wave lengths shorter than that of visible violet light but longer than that of most X-rays.

VIEW CAMERA: A large-format camera in which the lens forms an inverted image on a glass screen directly at the plane of the film. The image viewed is exactly the same as the image on the film, which replaces the viewing screen during exposure.

VR: Virtual reality. An immersive digital simulation of a three-dimensional environment generally viewed through a head-mounted display device that shows a spherical 360-degree image controlled by the viewer's physical position.

WAXED-PAPER PROCESS: A variation of the calotype process in which the paper negative is treated with wax before being sensitized, making it more transparent, more sensitive to detail, and more stable.

WET PLATE—*see* COLLODION PROCESS

WOODBURYTYPE: An obsolete photomechanical printing process that produces continuous-tone reproductions by exposing a negative to dichromated gelatin to create a relief mold, which is then embedded in lead for the printing. Pigmented gelatin is poured into the mold and transferred to paper under pressure, resulting in an image in which the deepest parts of the mold produce the darkest areas of the print.

Selected Bibliography

In the dozen years since this volume was last revised, a great deal has transpired in the world of photography's historiography. Along with the many new compendia, histories, catalogs, and monographs that have appeared in print from all corners of the world, a significant quantity of historical and critical writing on photography has shifted from book form to the intangible realm of the Internet. While the following bibliography includes a short list of websites useful at the time of this book's publication, in the interest of focusing on enduring resources, a priority of space has been given to books in print. In consideration of this volume's general emphasis on photography's narrative history, the bibliography does not include publications on the technical aspects of the medium or on practices of collecting or conservation. Even with these omissions, however, it would be impossible to include a comprehensive listing of titles on the history of photography in these pages; thus a selection has been made of works deemed significant to the understanding of the medium's history.

HISTORIES: GENERAL

Ang, Tom. *Photography: The Definitive Visual History*. New York: DK, 2014.

Braive, Michel F. *The Era of the Photograph: A Social History*. New York: McGraw-Hill, 1966.

Bunnell, Peter C. *Inside the Photograph: Writings on Twentieth-Century Photography*. New York: Aperture, 2006.

Coe, Brian. *Cameras: From Daguerreotypes to Instant Pictures*. New York: Crown Publishers, 1978.

Demos, T. J. *Vitamin Ph: New Perspectives in Photography*. London: Phaidon, 2006.

Eder, Josef Maria. *History of Photography*. Translated by Edward Epstean. New York: Columbia University Press, 1945, 1972. Reprint, New York: Dover Publications, 1978.

Freund, Gisèle. *Photography and Society*. Boston: David R. Godine, 1980.

Frizot, Michel, ed. *Nouvelle Histoire de la photographie*. Paris: Bordas, 1994.

Frizot, Michel, Pierre Albert, and Colin Harding, eds. *A New History of Photography*. Cologne: Könnemann, 1998.

Gernsheim, Helmut, and Alison Gernsheim. *The Origins of Photography*. Vol. 1 of *The History of Photography*. New York: Thames and Hudson, 1982.

———. *The Rise of Photography, 1850–1880: The Age of Collodion*. Vol. 2 of *The History of Photography*. New York: Thames and Hudson, 1988.

Henisch, Heinz K., and Bridget A. Henisch. *The Photographic Experience, 1839–1914: Images and Attitudes*. University Park: Pennsylvania State University Press, 1994.

Hill, Paul. *Approaching Photography*. New York: Sterling Publishing Co., 2005.

Kicken, Rudolph, Annette Kicken, and Simone Forster, eds. *Points of View: Photographic Masterpieces and Their Histories*. Göttingen, Germany: Steidl/Kicken Gallery, 2007.

Lemagny, Jean-Claude, and André Rouillé, eds. *A History of Photography: Social and Cultural Perspectives*. Translated by Janet Lloyd. Cambridge: Cambridge University Press, 1987.

Lowe, Paul, ed. *A Chronology of Photography: A Cultural Timeline from Camera Obscura to Instagram*. New York: Thames and Hudson, 2019.

Marien, Mary Warner. *Photography: A Cultural History*. New York: Harry N. Abrams, 2002.

Mrazkova, Daniela. *Masters of Photography: A Thematic History*. London: Hamlyn, 1987.

Newhall, Beaumont. *The History of Photography, from 1839 to the Present*. Rev. and enl. ed. New York: Museum of Modern Art, 1982.

Wade, John. *The Camera from the 11th Century to the Present Day*. Leicester, U.K.: Jessop, 1990.

Willsberger, Johann. *The History of Photography: Cameras, Pictures, Photographers*. Leverkusen, Germany: Agfa-Gevaert Foto-Historama, 1977.

HISTORIES: AMERICAN

Bannon, Anthony. *The Photo-Pictorialists of Buffalo*. Buffalo: Media Study, 1981.

The Black Photographers Annual. 4 vols. Brooklyn: Black Photographers Annual, 1973–76.

Breisch, Kenneth A. *Where We Live: Photographs of America from the Berman Collection*. Los Angeles: Getty Trust Publications, 2006.

Carlebach, Michael L. *The Origins of Photojournalism in America*. Washington, D.C.: Smithsonian Institution Press, 1992.

Coar, Valencia Hollins, ed. *A Century of Black Photographers, 1840–1960*. Providence: Rhode Island School of Design, 1983.

Daniel, Pete, Merry A. Foresta, Maren Stange, and Sally Stein. *Official Images: New Deal Photography*. Washington, D.C.: Smithsonian Institution Press, 1987.

Darrah, William Culp. *Stereo Views: A History of Stereographs in America and Their Collection*. Gettysburg, Pa.: Times and News Publishing Co., 1964.

Davis, Keith. *An American Century of Photography: From Dry-Plate to Digital*. Kansas City, Mo.: Hallmark; New York: Harry N. Abrams, 1995.

Earle, Edward W., ed. *Points of View: The Stereograph in America—A Cultural History*. Rochester, N.Y.: Visual Studies Workshop Press; Gallery Association of New York State, 1979.

Easter, Eric, et al., eds. *Songs of My People; African-Americans: A Self-Portrait*. Boston: Little, Brown, 1992.

Eauclaire, Sally. *American Independents: Eighteen Color Photographers*. New York: Abbeville Press, 1987.

Enyeart, James, ed. *Decade by Decade: Twentieth-Century American Photography from the Collection of the Center for Creative Photography*. Boston: Little, Brown, Bulfinch Press, 1989.

Fleischhauer, Carl, and Beverly W. Brannan, eds. *Documenting America*. Berkeley and Los Angeles: University of California Press, 1988.

Fleming, Paula Richardson, and Judith Lynn Luskey. *Grand Endeavors of American Indian Photography*. Washington, D.C.: Smithsonian Institution Press, 1993.

Fulton, Marianne. *Eyes of Time: Photojournalism in America*. Boston: New York Graphic Society, 1988.

Gee, Helen. *Photography of the Fifties: An American Perspective*. Tucson: Center for Creative Photography, University of Arizona, 1980.

Goetzmann, William. *Exploration and Empire: The Explorer and the Scientist in the Winning of the American West*. New York: Alfred A. Knopf, 1966.

Gover, C. Jane. *The Positive Image: Women Photographers in Turn-of-the-Century America*. Albany: State University of New York Press, 1988.

Green, Jonathan. *American Photography: A Critical History, 1945 to the Present*. New York: Harry N. Abrams, 1984.

Guimond, James. *American Photography and the American Dream*. Chapel Hill: University of North Carolina Press, 1991.

Hales, Peter Bacon. *Silver Cities: The Photography of American Urbanization, 1839–1915*. Philadelphia: Temple University Press, 1984.

Heyman, Therese Thau, ed. *Seeing Straight: The f.64 Revolution in Photography*. Oakland, Calif.: Oakland Museum, 1992.

Hurley, F. Jack. *Portrait of a Decade: Roy Stryker and the Development of Documentary Photography in the Thirties*. Baton Rouge: Louisiana State University Press, 1972.

Jenkins, Reese V. *Images and Enterprises: Technology and the American Photographic Industry, 1839–1925*. Baltimore and London: Johns Hopkins University Press, 1975.

Katzman, Louise. *Photography in California, 1945–1980*. New York: Hudson Hills Press; San Francisco: San Francisco Museum of Modern Art, 1984.

Kozloff, Max, Karen Levitov, and Johanna Goldfeld. *New York: City of Photography*. New Haven, Conn.: Yale University Press, 2002.

Morgan, Hal, and Andreas Brown. *Prairie Fires and Paper Moons: The American Photographic Postcard, 1900–1920*. Boston: David R. Godine, 1981.

Moutoussamy-Ashe, Jeanne. *Viewfinders: Black Women Photographers*. New York: Dodd, Mead, 1986. Reprint, New York: Writers and Readers Publishing, 1993.

Naef, Weston J., and James N. Wood. *Era of Exploration: The Rise of Landscape Photography in the American West, 1860–1885*. Buffalo: Albright-Knox Art Gallery; New York: Metropolitan Museum of Art, 1975.

Newhall, Beaumont. *The Daguerreotype in America*. 3d rev. ed. New York: Dover Publications, 1976.

O'Neal, Hank. *A Vision Shared: A Classic Portrait of America and Its People, 1935–1943*. New York: St. Martin's Press, 1976.

Orvell, Miles. *American Photography*. New York: Oxford University Press, 2003.

Panzer, Mary. *Philadelphia Naturalistic Photography, 1865–1906*. New Haven, Conn.: Yale University Art Gallery, 1982.

Pfister, Harold Francis. *Facing the Light: Historic American Portrait Daguerreotypes*. Washington, D.C.: Smithsonian Institution Press; National Portrait Gallery, 1978.

Pictorialism in America: The Minneapolis Salon of Photography, 1932–1946. Minneapolis: Minneapolis Institute of Arts, 1983.

Pictorialism in California: Photographs 1900–1940. Malibu, Calif.: J. Paul Getty Museum; San Marino, Calif.: Henry E. Huntington Library and Art Gallery, 1994.

Points of Entry. A series of three books: *A Nation of Strangers*. Essay by Vicki Goldberg. San Diego: Museum of Photographic Arts, 1995. *Reframing America*. Essay by Andrei Codrescu. Tucson: Center for Creative Photography, University of Arizona, 1995. *Tracing Cultures*. Essays by Rebecca Solnit and Ronald Takaki. San Francisco: Friends of Photography, 1995.

Pultz, John, and Catherine B. Scallen. *Cubism and American Photography, 1910–1930*. Williamstown, Mass.: Sterling and Francine Clark Art Institute, 1981.

Roalf, Peggy, ed. *Strong Hearts: Native American Voices and Visions*. New York: Aperture, 1995.

Rudisill, Richard. *Mirror Image: The Influence of the Daguerreotype on American Society*. Albuquerque: University of New Mexico Press, 1971.

Sandweiss, M. A., ed. *Photography in 19th Century America*. Fort Worth: Amon Carter Museum; New York: Harry N. Abrams, 1991.

Sloan, Mark, and Mark Long. *Southbound: Photographs of and about the New South*. Charleston, S.C.: Halsey Institute of Contemporary Art, 2019.

Smith, Shawn Michelle, *Photography on the Color Line: W.E.B. DuBois, Race and Visual Culture*. Raleigh: Duke University Press, 2004.

Stange, Maren. *Symbols of an Ideal Life: Social Documentary Photography in America, 1890–1950*. Cambridge: Cambridge University Press, 1989.

Stott, William. *Documentary Expression and Thirties America*. New York: Oxford University Press, 1973. Stryker, Roy, and Nancy Wood. *In This Proud Land: America 1935–1943 as Seen in FSA Photographs*. Greenwich, Conn.: New York Graphic Society, 1974.

Taft, Robert. *Photography and the American Scene: A Social History, 1839–1889*. 1938. Reprint, New York: Dover Publications, 1964.

Trachtenberg, Alan, and Lawrence W. Levine. *Documenting America, 1935–1943*. Berkeley: University of California Press, 1988.

Welling, William. *Photography in America: The Formative Years, 1839–1900*. New York: Thomas Y. Crowell Company, 1978.

Wilson, Jackie Napolean. *Hidden Witness: African-American Images from the Dawn of Photography to the Civil War*. New York: St. Martin's Press, 2002.

HISTORIES: INTERNATIONAL

After Daguerre: Masterworks of French Photography (1848–1900) from the Bibliothèque Nationale. New York: Metropolitan Museum of Art; Paris: Berger-Levrault, 1980.

Baumann, Daniela, Joshua Chuang, and Oluremi C. Onabanjo. *Recent Histories: Contemporary African Photography and Video Art*. Neu-Ulm, Germany: Walther Collection; Göttingen, Germany: Steidl, 2017.

Bensusan, Arthur D. *Silver Images: A History of Photography in Africa*. Cape Town: H. Timmins, 1966.

Birgus, Vladimír, ed. *Czech Photographic Avant-Garde, 1918–1948*. Cambridge, Mass.: MIT Press, 2002.

Bretell, Richard, with Roy Flukinger, Nancy Keeler, and Sydney Kilgore. *Paper and Light: The Calotype in Great Britain and France, 1839–1870*. Boston: David R. Godine, 1984.

Buerger, Janet E. *The Era of the French Calotype*. Rochester, N.Y.: International Museum of Photography at George Eastman House, 1982.

———. *French Daguerreotypes*. Chicago: University of Chicago Press, 1989.

Bull, Deborah, and Donald Lorimer. *Up the Nile, A Photographic Excursion: Egypt, 1839–1898*. New York: Clarkson N. Potter, 1979.

Casanova, Rosa, et al., eds. *Mexico: A Photographic History*. Mexico City: Editorial RM, 2007.

Cato, Jack. *The Story of the Camera in Australia*. Melbourne: Georgetown House, 1955.

A Century of Japanese Photography. Introduction by John Dower. New York: Random House, Pantheon Books, 1980.

China: Fifty Years inside the People's Republic. Essay by Rae Yang. New York: Aperture, 1999.

Czech Modernism, 1900–1945. Houston: Museum of Fine Arts; Boston: Little, Brown, Bulfinch Press, 1989.

Enwezor, Okwui. *Snap Judgments: New Positions in Contemporary African Photography*. Göttingen, Germany: Steidl, 2006.

Falzone de Barbaro, Michele, and Italo Zannier. *Fotografia luce della modernità: Torino, 1920–1950: Dal pittorialismo al modernismo*. Florence: Fratelli Alinari, 1991.

Ferrez, Gilberto, and Weston J. Naef. *Pioneer Photographers of Brazil*. New York: Center for Inter-American Relations, 1976.

Fiedler, Jeannine, ed. *Photography at the Bauhaus*. London: Dirk Nishen Publishing, 1990.

Fontanella, Lee. *La historia de la fotografía en España desde sus orígenes hasta 1900*. Madrid: Ediciones El Viso, 1981.

Fotografia Polska, 1839–1945. New York: International Center of Photography, 1979.

Fotografie Lateinamerika von 1860 bis Heute. Zurich: Kunsthaus Zürich, 1981.

The Founding and Development of Modern Photography in Japan. Tokyo: Tokyo Metropolitan Museum of Photography, 1995.

The Frozen Image: Scandinavian Photography. Minneapolis: Walker Art Center; New York: Abbeville Press, 1982.

Greenhill, Ralph, and Andrew Birrell. *Canadian Photography, 1839–1920*. Toronto: Coach House Press, 1979.

Gresh, Kristen, and Michket Krifa. *She Who Tells a Story: Women Photographers from Iran and the Arab World*. Boston: Museum of Fine Arts, 2012.

Harker, Margaret. *The Linked Ring: The Secession Movement in Photography in Britain, 1892–1910*. London: Heinemann, 1979.

Haworth-Booth, Mark. *The Golden Age of British Photography, 1839–1900*. Millerton, N.Y.: Aperture, 1984.

Herskowitz, Robert. *The British Photographer Abroad: The First Thirty Years*. London: Robert Herskowitz, 1980.

Hopkinson, Tom. *Treasures of the Royal Photographic Society, 1839–1919*. London: Focal Press, 1980.

Hung, Wu, Christopher Phillips, et al. *Between Past and Future: New Photography and Video from China*. Chicago: Smart Museum of Art, University of Chicago; New York: International Center of Photography; Göttingen, Germany: Steidl, 2004.

India: A Celebration of Independence, 1947–1997. Essay by Victor Anant. New York: Aperture, 1997.

Italy: One Hundred Years of Photography. Texts by Cesare Colombo and Susan Sontag. Florence: Fratelli Alinari, 1988.

Jammes, André, and Eugenia Parry Janis. *The Art of French Calotype*. Princeton, N.J.: Princeton University Press, 1983.

Jammes, Isabelle. *Blanquart-Evrard et les origines de l'édition photographique française: Catalogue raisonné des albums photographiques édités, 1851–1855*. Geneva and Paris: Librairie Droz, 1981.

Kaneko, Ryushi, Takeba Joe, Dana Friis-Hansen. *The History of Japanese Photography*. New Haven, Conn.: Yale University Press, 2003.

Karlekar, Malavika. *Visualizing Indian Women, 1875–1947*. London: Oxford University Press, 2006.

Kempe, Fritz. *Daguerreotypie in Deutschland: Vom Charme der frühen Fotografie*. Seebruck am Chiemsee, Germany: Heering Verlag, 1979.

Koltun, Lilly, ed. *Private Realms of Light: Amateur Photography in Canada, 1839–1940*. Markham, Canada: Fitzhenry and Whiteside, 1984.

Levine, Robert M. *Images of History: 19th- and Early-20th-Century Latin American Photographs as Documents*. Durham, N.C.: Duke University Press, 1989.

Magelhaes, Claude, and Laurent Roosens. *Photographic Art in Belgium, 1839–1940*. Antwerp, Belgium: Het Sterckshof Museum, 1970.

Magnum Photos: Euro Visions. Essays by Quentin Bajac and Diane Dufour. Göttingen, Germany: Steidl/Magnum, 2006.

Maimon, Vered, and Shiraz Grinbaum. *Activestills: Photography as Protest in Palestine and Israel*. London: PlutoPress, 2016.

Mellor, David, ed. *Germany: The New Photography, 1927–1933*. London: Arts Council of Great Britain, 1978.

Mercier, Jeanne. *Being a Photographer in Africa: The Ten Years of "Afrique in Visu."* Paris: Editions Clémentine de la Férronière, 2017.

Miller-Clark, Denise. *Open Spain: Contemporary Documentary Photography in Spain*. Chicago: Museum of Contemporary Photography, 1992.

Monti, Nicolas, ed. *Africa Then: Photographs, 1840–1918*. New York: Alfred A. Knopf, 1987.

Nazar: Photographs from the Arab World. New York: Aperture; Groningen, Netherlands: Noorderlicht, 2004.

Neue Sachlichkeit and German Realism of the Twenties. London: Arts Council of Great Britain, 1978.

Nir, Yeshayahu. *The Bible and the Image: The History of Photography in the Holy Land, 1839–1899*. Philadelphia: University of Pennsylvania Press, 1985.

Perez, Nissan N. *Focus East: Early Photography in the Near East, 1839–1885*. New York: Harry N. Abrams, 1988.

Phillips, Christopher, Wu Hung, et al. *Life and Dreams: Contemporary Chinese Photography and Media Art*. Göttingen, Germany: Steidl; New York: Walther Collection, 2018.

Photographie futuriste, italienne, 1911–1939. Paris: Musée d'Art Moderne de la Ville de Paris, 1982.

Photography in Switzerland, 1840 to Today. New York: Visual Communications Books, Hastings House, 1974.

Pictorial Photography in Britain, 1900–1920. London: Arts Council of Great Britain, 1978.

Ponting, Herbert, and Frank Hurley. *1910–1916 Antarctic Photographs: Scott, Mawson and Shackleton Expeditions*. South Melbourne: Macmillan Company of Australia, 1979.

Portugal, 1890–1990. Mont-sur-Marchienne, Belgium: Musée de la Photographie, 1991.

Putzar, Edward. *Japanese Photography, 1945–1985*. Tucson, Ariz.: Pacific West, 1987.

Rice, Shelley. *Parisian Views*. Cambridge, Mass.: MIT Press, 1999.

Roberts, Claire. *Photography and China*. London: Reaktion Books, 2012.

Shudakov, Grigory, Olga Suslova, and Lilya Ukhtomskaya. *Pioneers of Soviet Photography*. London: Thames and Hudson, 1983.

Szarkowski, John. *New Japanese Photography*. New York: Museum of Modern Art, 1974.

This Place. Edited by Frédéric Brenner; introduction by Charlotte Cotton. London: MACK Books, 2014.

Thomas, G. *History of Photography, India, 1840–1980*. Hyderabad, India: Akademi of Andhra Pradesh, 1981.

Tucker, Anne Wilkes, et al. *The History of Japanese Photography*. Houston: Museum of Fine Arts, Houston, 2003.

Vaczek, Louis, and Gail Buckland. *Travelers in Ancient Lands: A Portrait of the Middle East, 1839–1919*. Boston: New York Graphic Society, 1981.

Vokes, Richard, ed. *Photography in Africa: Ethnographic Perspectives*. New York: James Currey, 2012.

Watriss, Wendy, et al. *View from Inside: Contemporary Arab Photography, Video, and Mixed-Media Art*. Houston: FotoFest; Amsterdam: Schilt Publishing, 2014.

Watriss, Wendy, Lei Gao, and Frederick Baldwin. *Photography from China, 1934–2008*. Houston: FotoFest, 2008.

Weaver, Mike, ed. *British Photography in the 19th Century: The Fine Art Tradition*. Cambridge: Cambridge University Press, 1989.

Worswick, Clark, and Ainslee Embree. *The Last Empire: Photography in British India, 1855–1911*. Millerton, N.Y.: Aperture, 1976.

Worswick, Clark, and Jonathan Spence. *Imperial China: Photographs, 1850–1912*. Millerton, N.Y.: Aperture, 1976.

Xanthakis, Alkis X. *History of Greek Photography, 1839–1960*. Athens: Hellenic Literary and Historical Archives Society, 1988.

Zhuang, Wubin. *Photography in Southeast Asia: A Survey*. Singapore: NUS Press, 2016.

Ziff, Trisha, ed. *Between Worlds: Contemporary Mexican Photography*. New York: New Amsterdam Books, 1990.

HISTORIES: SPECIALIZED

Auer, Michel. *The Illustrated History of the Camera, from 1839 to the Present*. Boston: New York Graphic Society, [1975].

Barger, M. Susan, and William B. White. *The Daguerreotype: 19th-Century Technology and Modern Science*. Washington, D.C.: Smithsonian Institution Press, 1991.

Beshty, Walead, et al. *Picture Industry: A Provisional History of the Technical Image*. Feldmeilen, Switzerland: LUMA Foundation; Annandale-on-Hudson, New York: Center for Curatorial Studies, Bard College, 2018.

Brewster, Sir David. *The Stereoscope: Its History, Theory and Construction*. Facsimile ed. Dobbs Ferry, N.Y.: Morgan and Morgan, 1971.

Bright, Susan. *Art Photography Now*. New York: Aperture, 2006.

Buerger, Janet E. *The Last Decade: The Emergence of Art Photography in the 1890s*. Rochester, N.Y.: International Museum of Photography at George Eastman House, 1984.

Bunnell, Peter C., ed. *A Photographic Vision: Pictorial Photography, 1889–1923*. Salt Lake City: Peregrine Smith, 1980.

Coe, Brian, ed. *Techniques of the World's Great Photographers*. Secaucus, N.J.: Chartwell Books, 1981.

Coe, Brian, and Paul Gates. *The Snapshot Photograph*. London: Ash and Grant, 1977.

Coke, Van Deren. *The Painter and the Photograph, from Delacroix to Warhol*. Rev. and enl. ed. Albuquerque: University of New Mexico Press, 1972.

Coke, Van Deren, with Diana C. du Pont. *Photography: A Facet of Modernism*. New York: Hudson Hills Press, 1986.

Coleman, A. D. *The Grotesque in Photography*. New York: Ridge Press, Summit Books, 1977.

Coote, Jack H. *The Illustrated History of Colour Photography*. Surrey, U.K.: Fountain Press, 1993.

Crawford, William. *The Keepers of the Light: A History and Working Guide to Early Photographic Processes*. Dobbs Ferry, N.Y.: Morgan and Morgan, 1979.

Devlin, Polly. *Vogue Book of Fashion Photography, 1919–1979*. New York: Simon and Schuster, 1979.

Edgerton, Harold E., and James R. Killian, Jr. *Moments of Vision: The Stroboscopic Revolution in Photography*. Cambridge, Mass.: MIT Press, 1979.

Edwards, Elizabeth, ed. *Anthropology and Photography, 1860–1920*. New Haven, Conn.: Yale University Press, 1992.

Ellenzweig, Allen. *The Homoerotic Photograph*. New York: Columbia University Press, 1992.

Ewing, William A. *Face: The New Photographic Portrait*. London: Thames and Hudson, 2006.

———. *Flora Photographica: Masterpieces of Flower Photography from 1835 to the Present*. 1991. Repr., London: Thames and Hudson, 2002.

Experimental Vision: The Evolution of the Photogram since 1919. Denver: Roberts Rinehart; Denver Art Museum, 1994.

Fabian, Rainer, and Hans-Christian Adam. *One Hundred Thirty Years of War Photography*. London: New English Library, 1985.

Franklin, Stuart. *The Documentary Impulse*. London: Phaidon, 2016.

Fulton, Marianne, ed. *Pictorialism into Modernism: The Clarence H. White School of Photography*. New York: Rizzoli, in association with George Eastman House and Detroit Institute of Arts, 1996.

Galassi, Peter. *Before Photography: Painting and the Invention of Photography*. New York: Museum of Modern Art, 1981.

Gidal, Tim N. *Modern Photojournalism: Origins and Evolution, 1910–1933*. New York: Macmillan, Collier Books, 1972.

Glassman, Elizabeth, and Marilyn F. Symmes. *Cliché-verre: Hand-Drawn, Light-Printed: A Survey of the Medium from 1839 to the Present*. Detroit: Detroit Institute of Arts, 1980.

Glendinning, Peter. *Color Photography: History, Theory and Darkroom Technique*. Englewood Cliffs, N.J.: Prentice-Hall, 1985.

Goldberg, Vicki. *The Power of Photography: How Photographs Changed Our Lives*. New York: Abbeville Press, 1991.

Goldschmidt, Lucien, and Weston J. Naef. *The Truthful Lens: A Survey of the Photographically Illustrated Book, 1844–1914*. New York: Grolier Club, 1980.

Green, Jonathan, ed. *The Snapshot*. Millerton, N.Y.: Aperture, 1974.

Groth, Helen. *Victorian Photography and Literary Nostalgia*. New York: Oxford University Press, 2004.

Grundberg, Andy, and Kathleen Gauss. *Photography and Art: Interactions Since 1946*. New York: Abbeville Press, 1987.

Hall-Duncan, Nancy. *The History of Fashion Photography*. New York: Alpine Book Co., Chanticleer Press Edition, 1977.

Hambourg, Maria Morris, and Christopher Phillips. *The New Vision: Photography Between the World Wars; The Ford Motor Company Collection at the Metropolitan Museum of Art*. New York: Harry N. Abrams, 1989.

Hambourg, Maria Morris, et al. *The Waking Dream: The Gilman Collection of Photography*. New York: Harry N. Abrams; Metropolitan Museum of Art, 1993.

Hammond, John H. *The Camera Obscura: A Chronicle*. Bristol, U.K.: Adam Hilger, 1981.

Harrison, Martin. *Appearances: Fashion Photography since 1945*. London: Jonathan Cape, 1991.

Heiting, Manfred. *50 Jahre moderne Farbfotografie/50 Years of Modern Color Photography, 1936–1986*. Cologne, Germany: Photokina, 1986.

Hicks, Wilson. *Words and Pictures: An Introduction to Photojournalism*. 1952. Repr., New York: Arno Press, 1973.

Hurley, F. Jack. *Industry and the Photographic Image: 153 Great Prints from 1850 to the Present*. New York: Dover Publications; Rochester, N.Y.: George Eastman House, 1980.

Jay, Bill. *Cyanide and Spirits: An Inside-Out View of Early Photography*. Munich: Nazraeli Press, 1991.

Jussim, Estelle. *Visual Communication and the Graphic Arts: Photographic Technologies in the 19th Century*. New York: R. R. Bowker Company, 1974.

Lemann, Nicholas. *Out of the Forties*. New York: Simon and Schuster, 1987.

Lenman, Robin, ed. *The Oxford Companion to Photography*. London: Oxford University Press, 2005.

Lewinski, Jorge. *The Naked and the Nude: A History of Nude Photography*. New York: Crown Publishers, 1987.

Lori, Paul, ed. *Acting the Part: A History of Staged Photography*. London: Merrell Publishers, Ltd., 2006.

Lyons, Claire L., et al. *Antiquity and Photography: Early Views of Ancient Mediterranean Sites*. London: Oxford University Press, 2005.

McCauley, Elizabeth Anne. *Industrial Madness: Commercial Photography in Paris, 1848–1871*. New Haven, Conn., and London: Yale University Press, 1994.

———. *Likenesses: Portrait Photography in Europe, 1850–1870*. Albuquerque: Art Museum, University of New Mexico Press, 1980.

Maddow, Ben. *Faces: A Narrative History of the Portrait in Photography*. Boston: New York Graphic Society, 1977.

Manchester, William. *In Our Time: The World as Seen by Magnum Photographers*. New York: American Federation of the Arts; W. W. Norton, 1989.

Mathews, Oliver. *The Album of Carte-de-visite and Cabinet Portrait Photographs, 1854–1914*. London: Reedminster Publications, 1974.

Mees, C. E. Kenneth. *From Dry Plates to Ektachrome Film*. New York: Ziff-Davis, 1961.

Millstein, Barbara Head, ed. *Committed to the Image: Contemporary Black Photographers*. New York and London: Brooklyn Museum of Art, 2001.

Naef, Weston. *Fifty Pioneers of Modern Photography: The Collection of Alfred Stieglitz*. New York: Metropolitan Museum of Art; Viking Press, 1978.

Newhall, Beaumont. *Focus: Memoirs of a Life in Photography*. Boston: Little, Brown, Bulfinch Press, 1993.

New Topographics: Photographs of a Man-Altered Landscape. Introduction by William Jenkins. Rochester, N.Y.: International Museum of Photography at George Eastman House, 1975.

Panzer, Mary, and Christian Caujolle. *Things as They Are: Photojournalism in Context since 1955*. New York: Aperture, 2007.

Pare, Richard. *Photography and Architecture, 1839–1939*. Montreal: Canadian Centre for Architecture, 1982.

Parr, Martin, and Gerry Badger. *The Photobook: A History*. 2 vols. London: Phaidon, 2004–6.

Pirenne, M. H. *Optics, Painting and Photography*. Cambridge: Cambridge University Press, 1970.

Robinson, Cervin. *Architecture Transformed: A History of the Photographed Building from 1839 to the Present*. Cambridge, Mass.: MIT Press, 1986.

Rosenblum, Naomi. *A History of Women Photographers*. New York: Abbeville Press, 1994.

Roth, Andrew et al. *Book of 101 Books: The Seminal Photographic Books of the Twentieth Century*. New York: PPP Editions with Roth/Horowitz, 2001.

Schaaf, Larry J. *Out of the Shadows: Herschel, Talbot and the Invention of Photography*. New Haven, Conn.: Yale University Press, 1992.

Scherer, Joanna C., ed. *Picturing Cultures: Historical Photographs in Anthropological Inquiry*. New York: Gordon and Breach Science Publishers, 1990.

Sobieszek, Robert A. *The Art of Persuasion: A History of Advertising Photography*. New York: Harry N. Abrams, 1988.

Sobieszek, Robert A., and Deborah Irmas. *The Camera I: Photographic Self-Portraits*. New York: Harry N. Abrams; Los Angeles: Los Angeles County Museum of Art, 1994.

Sullivan, Constance, ed. *Nude Photographs, 1850–1980*. New York: Harper and Row, 1980.

Tucker, Anne Wilkes, Will Michels, et al. *War/Photography: Images of Armed Conflict and Its Aftermath*. New Haven, Conn.: Yale University Press; Houston: Museum of Fine Arts, Houston, 2012.

Tucker, Jean S. *Light Abstractions*. St. Louis: University of Missouri Press, 1980.

Wall, E. J. *The History of Three-Color Photography*. Boston: American Photographic Publishing Company, 1925.

Ware, Mike. *Cyanotype: The History, Science and Art of Photographic Printing in Prussian Blue*. Bradford, U.K.: National Museum of Photography, Film, and Television, 1999.

Weinberg, Adam D. *On the Line: The New Color Photojournalism*. Minneapolis: Walker Art Center, 1986.

Westerbeck, Colin, and Joel Meyerowitz. *Bystander: A History of Street Photography*. Boston: Little, Brown; Bulfinch Press, 1994.

Witkin, Lee D., and Barbara London. *The Photograph Collector's Guide*. Boston: New York Graphic Society, 1979.

Wood, John. *Art of the Autochrome: The Birth of Color Photography*. Iowa City: University of Iowa Press, 1993.

Wood, John, ed. *The Daguerreotype: A Sesquicentennial Celebration*. Iowa City: University of Iowa Press, 1989.

CRITICISM AND ANTHOLOGIES

Adams, Robert. *Beauty in Photography: Essays in Defense of Traditional Values*. Millerton, N.Y.: Aperture, 1981.

Ambler, Louise Todd, and Melissa Banks. *The Invention of Photography and Its Impact on Learning*. Cambridge, Mass.: Harvard University Library, 1989.

Azoulay, Ariella. *The Civil Contract of Photography*. Cambridge, Mass: MIT Press, 2008.

Bajac, Quentin, et al. *Photography at MoMA*. 3 vols.: *1840–1920* (2017); *1920–1960* (2016); *1960–Now* (2015). New York: Museum of Modern Art, 2015–17.

Batchen, Geoffrey. *Burning with Desire: The Conception of Photography*. Cambridge, Mass.: MIT Press, 1999.

——. *Photography's Objects*. Albuquerque: University of New Mexico Museum, 1997.

Barthes, Roland. *Camera Lucida: Reflections on Photography*. New York: Farrar, Straus and Giroux; Hill and Wang, 1981.

Benjamin, Walter. "The Work of Art in the Age of Mechanical Reproduction." In *Illuminations: Walter Benjamin*. Edited by Hannah Arendt. New York: Schocken Books, 1969.

Berger, John. *Understanding a Photograph*. Edited and introduced by Geoff Dyer. New York: Aperture, 2013.

Bloom, John. *Photography at Bay: Interviews, Essays and Reviews*. Albuquerque: University of New Mexico Press, 1993.

Bogre, Michelle. *Photography as Activism: Images for Social Change*. Burlington, Mass.: Focal Press, 2012.

Bright, Susan. *Art Photography Now*. New York: Aperture, 2006.

Bunnell, Peter C. *Degrees of Guidance: Essays on 20th-Century American Photography*. Cambridge: Cambridge University Press, 1993.

——. *Inside the Photograph: Writings on Twentieth-Century Photography*. New York: Aperture, 2006.

Cadava, Eduardo, and Gabriela Nouzeilles. *The Itinerant Languages of Photography*. New Haven, Conn.: Yale University Press, 2013.

Caffin, Charles H. *Photography as a Fine Art*. Facsimile ed. Hastings-on-Hudson, N.Y.: Morgan and Morgan, 1971.

Camera Work, A Photographic Quarterly. Edited and published by Alfred Stieglitz, 1903–17. Repr., New York: Kraus Reprints, 1969.

Coke, Van Deren, ed. *One Hundred Years of Photographic History: Essays in Honor of Beaumont Newhall*. Albuquerque: University of New Mexico Press, 1975.

Cole, Teju. *Blind Spot*. New York: Random House; London: Faber and Faber, 2017.

Coleman, A. D. *Critical Focus: Photography in the International Image Community*. Tucson, Ariz.: Nazraeli Press, 1995.

——. *Depth of Field: Essays on Photography, Mass Media, and Lens Culture*. Albuquerque: University of New Mexico Press, 1998.

Cotton, Charlotte. *The Photograph as Contemporary Art*. London: Thames and Hudson, 2014.

Didi-Huberman, Georges. *Confronting Images: Questioning the Ends of a Certain History of Art*. 1990. Translated by John Goodman. University Park: Pennsylvania State University Press, 2004.

——. *Images in Spite of All: Four Photographs from Auschwitz*. Translated by Shane B. Lillis. Chicago: University of Chicago Press, 2012.

——. *The Last Image: Photography and Death*. Leipzig, Germany: Spector Books, 2019.

Dyer, Geoff. *The Ongoing Moment*. New York: Pantheon, 2005.

Emerson, Peter Henry. *Naturalistic Photography for Students of the Art*. 1889; 3d ed., 1899. Repr., New York: Arno Press, 1973.

Ewing, William A., et al. *The Idealizing Vision*. New York: Aperture, 1991.

Farwell, Beatrice. *The Cult of Images: Baudelaire and the 19th-Century Media Explosion*. Santa Barbara: University of California Press, 1977.

Featherstone, David, ed. *Observations: Essays on Documentary Photography*. Carmel, Calif.: Friends of Photography, 1984.

Flusser, Vilém. *Towards a Philosophy of Photography*. Translated by Anthony Mathews. London: Reaktion Books, 2000.

Fried, Michael. *Why Photography Matters as Art as Never Before*. New Haven, Conn.: Yale University Press, 2008.

Goldberg, Vicki. *Light Matters: Writings on Photography*. New York: Aperture, 2005.

——. *Photography in Print: Writings from 1816 to the Present*. New York: Simon and Schuster, 1981.

Green, Jonathan, ed. *Camera Work: A Critical Anthology*. Millerton, N.Y.: Aperture, 1973.

Grundberg, Andy. *Crisis of the Real: Writings on Photography, 1974–1989*. New York: Aperture, 1990.

Handy, Ellen. *Pictorial Effect, Naturalistic Vision: The Photographs and Theories of Henry Peach Robinson and Peter Henry Emerson*. Norfolk, Va.: Chrysler Museum, 1994.

Hartmann, Sadakichi. *The Valiant Knights of Daguerre: Selected Critical Essays on Photography and Profiles of Photographic Pioneers*. Edited by Harry W. Lawton and George Knox. Berkeley: University of California Press, 1978.

Hill, Paul, and Thomas Cooper, eds. *Dialogue with Photography*. New York: Farrar, Straus and Giroux, 1979.

Hurm, Gerhard, Anke Reitz, and Shamoon Zahir, eds. *The Family of Man Revisited: Photography in a Global Age*. London and New York: I. B. Tauris, 2018.

Jussim, Estelle. *The Eternal Moment: Essays on the Photographic Image*. New York: Aperture, 1989.

Jussim, Estelle, and Elizabeth Lindquist-Cock. *Landscape as Photograph*. New Haven, Conn., and London: Yale University Press, 1985.

Kozloff, Max. *Lone Visions, Crowded Frames: Essays on Photography*. Albuquerque: University of New Mexico Press, 1994.

——. *The Privileged Eye: Essays on Photography*. Albuquerque: University of New Mexico Press, 1987.

Levi Strauss, David. *Between the Eyes: Essays on Photography and Politics*. Introduction by John Berger. New York: Aperture, 2005.

Margolis, Marianne Fulton, ed. *Camera Work: A Pictorial Guide*. New York: Dover Publications, 1978.

Mitchell, William J. *The Reconfigured Eye: Visual Truth in the Post-Photographic Era*. Cambridge, Mass.: MIT Press, 1992.

Morris, Errol. *Believing Is Seeing (Observations on the Mysteries of Photography)*. New York: Penguin Press, 2011.

Newhall, Beaumont, ed. *Photography: Essays and Images*. New York: Museum of Modern Art, 1980.

Phillips, Christopher, ed. *Photography in the Modern Era: European Documents and Critical Writings, 1913–1940*. New York: Metropolitan Museum of Art; Aperture, 1989.

Popper, Frank. *Art in the Electronic Age*. New York: Harry N. Abrams, 1993.

Rexer, Lyle. *The Edge of Vision: The Rise of Abstraction in Photography*. New York: Aperture, 2013.

Ritchin, Fred. *Bending the Frame: Photojournalism, Documentary, and the Citizen*. New York: Aperture, 2013.

——. *In Our Own Image: The Coming Revolution in Photography*. New York: Aperture, 1990.

Roh, Franz, and Jan Tschichold. *Foto-Auge/Oeil et Photo/Photo-Eye*. Tübingen, Germany: Ernst Wasmuth Verlag, 1929. Repr., New York: Arno Press, 1978.

Scharf, Aaron. *Art and Photography*. London: Allen Lane, 1968; Baltimore: Penguin Press, 1969.

Schwarz, Henrich. *Art and Photography: Forerunners and Influences*. Layton, Utah: Peregrine Smith Books, 1985.

Solomon-Godeau, Abigail. *Photography after Photography: Gender, Genre, History*. Durham, N.C.: Duke University Press, 2017.

——. *Photography at the Dock: Essays on Photographic History, Institutions and Practices*. Minneapolis: University of Minnesota Press, 1991.

Sontag, Susan. *On Photography*. New York: Farrar, Straus and Giroux, 1973.

——. *Regarding the Pain of Others*. New York: Picador, 2003.

Soutter, Lucy. *Why Art Photography?* New York: Routledge, 2013.

Squiers, Carol, ed. *The Critical Image: Essays on Contemporary Photography*. Seattle: Bay Press, 1990.

Steichen, Edward. *The Family of Man*. Introduction by Carl Sandburg. New York: Museum of Modern Art, 1955/2015.

Szarkowski, John. *The Photographer's Eye*. New York: Museum of Modern Art; Doubleday and Company, 1966.

Trachtenberg, Alan, ed. *Classic Essays on Photography*. New Haven, Conn.: Leete's Island Books, 1980.

Weaver, Mike. *The Art of Photography*. New Haven, Conn.: Yale University Press, 1989.

BOOKS ON NEW MEDIA

Cotton, Charlotte. *Photography Is Magic*. New York: Aperture, 2015.

——. *Public, Private, Secret: On Photography and the Configuration of Self*. New York: Aperture, 2018.

Flusser, Vilém. *Into the Universe of Technical Images*. Translated by Nancy Ann Roth. Minneapolis: University of Minnesota Press, 2011.

Groys, Boris. *Going Public*. Berlin: Sternberg Press, 2010.

——. *In the Flow*. London, New York: Verso, 2016.

Jurgenson, Nathan. *The Social Photo: On Photography and Social Media*. London, New York: Verso, 2019.

McCluhan, Marshall. *Understanding Media: The Extensions of Man*. 1964. Cambridge, Mass.: MIT Press, 2013.

Ritchin, Fred. *After Photography*. New York: W. W. Norton, 2008.

Shore, Robert. *Post-Photography: The Artist with a Camera*. London: Laurence King, 2014.

Steyerl, Hito. *Duty Free Art: Art in the Age of Planetary Civil War*. London and New York: Verso, 2017.

——. *The Wretched of the Screen*. Berlin: Sternberg Press, 2012.

Van Amelunxen, Hubertus, Stefan Iglhaut, and Florian Rötzer, eds. *Photography after Photography: Memory and Representation in the Digital Age*. Amsterdam: G&B Arts, 1996.

Wolf, Sylvia. *The Digital Eye: Photographic Art in the Electronic Age*. London: Prestel, 2010.

Zylinska, Joanna. *Nonhuman Photography*. Cambridge, Mass. MIT Press, 2017.

WEBSITES

Aperture: https://aperture.org/blog/

British Journal of Photography: https://www.bjp-online.com/

FOAM: https://www.foam.org/

Getty Images: https://www.gettyimages.com

The Guardian, Photography: https://www.theguardian.com/artanddesign/photography

International Center of Photography (New York): https://www.icp.org/

LensCulture: https://www.lensculture.com/

Library of Congress, Prints & Photographs Online Catalog: http://www.loc.gov/pictures/

Life photo archive: http://images.google.com/hosted/life

Loewentheil Collection of African-American Photographs: https://digital.library.cornell.edu/catalog?f%5Bcollection_tesim%5D%5B%5D=Loewentheil+Collection+of+African-American+Photographs

Magnum Photos: https://www.magnumphotos.com/

National Archives (U.S.), Digital Photography Collections: https://www.archives.gov/research/alic/reference/photography

National Geographic: https://www.nationalgeographic.com/

New York Public Library Digital Collections, Photography Collections: https://digitalcollections.nypl.org/collections/lane/photography-collections.

Object:Photo, Modern Photographs, 1909–1949: https://www.moma.org/interactives/objectphoto/#home

Past Tense (*New York Times* image archive): https://www.nytimes.com/spotlight/past-tense

PetaPixel: https://petapixel.com/

Photogrammar: http://photogrammar.yale.edu/

The Photographers' Gallery (London): https://thephotographersgallery.org.uk/

Rhizome: https://rhizome.org

ENCYCLOPEDIAS, DICTIONARIES, AND COMPENDIA

Auer, Michèle, and Michel Auer. *Encyclopédie internationale des photographies de 1839 à nos jours*. 2 vols. Hermance, France: Editions Camera Obscura, 1985.

Baldwin, Gordon. *Looking at Photographs: A Guide to Technical Terms*. Malibu, Calif.: J. Paul Getty Museum; London: British Museum Press, 1991.

Browne, Turner, and Elaine Partnow. *Macmillan Biographical Encyclopedia of Photographic Artists and Innovators*. New York: Macmillan, 1983.

Eskind, Andrew H., and Greg Drake, eds. *Index to American Photographic Collections*. 2d ed. Boston: G. K. Hall and Co., 1990.

The Focal Encyclopedia of Photography. London and New York: Focal Press, 1965.

Jones, Bernard E., ed. *Encyclopedia of Photography*. 1911. Repr., as *Cassell's Cyclopedia of Photography*. New York: Arno Press, 1973.

Life Library of Photography. 17 vols. New York: Time-Life Books, 1970–72.

Morgan, Willard D., ed. *The Encyclopedia of Photography*. 20 vols. New York: Greystone Press, 1963–64.

Nadeau, Luis. *Encyclopedia of Printing, Photographic and Photomechanical Processes*. Fredericton, Canada: Luis Nadeau, 1994.

Palmquist, Peter E., ed. *A Bibliography of Writings by and about Women in Photography, 1850–1990*. 2d ed. Arcata, Calif.: Peter E. Palmquist, 1994.

Walsh, George, Colin Nayor, and Michael Held, eds. *Contemporary Photographers*. Rev. ed. Detroit: St. James Press, 1995.

Willis-Thomas, Deborah. *An Illustrated Bio-Bibliography of Black Photographers, 1940–1988*. New York: Garland, 1989.

SELECTED MONOGRAPHS AND BIOGRAPHIES

BERENICE ABBOTT

Berenice Abbott: Photographs. New York: Horizon, 1970. Repr., Washington, D.C.: Smithsonian Institution Press, 1990.

McCausland, Elizabeth, and Berenice Abbott. *Changing New York*. New York: E. P. Dutton, 1939. Revised ed., *New York in the Thirties, as Photographed by Berenice Abbott*. New York: Dover Publications, 1973.

O'Neal, Hank. *Berenice Abbott, American Photographer*. New York: McGraw-Hill Book Company, Artpress, 1982.

Van Haaften, Julia. *Berenice Abbott: A Life in Photography*. New York: W. W. Norton, 2018.

Van Haaften, Julia, ed. *Berenice Abbott, Photographer: A Modern Vision*. New York: New York Public Library, 1989.

ANSEL ADAMS

Ansel Adams: An Autobiography. Boston: Little, Brown, 1985; paperback ed., 1996.

Ansel Adams: Images, 1923–1974. Boston: New York Graphic Society, 1974.

Newhall, Nancy. *Ansel Adams: The Eloquent Light*. San Francisco: Sierra Club, 1963.

ALINARI BROTHERS (FRATELLI ALINARI, COMPANY)

Zevi, Filippo. *Alinari—Photographers of Florence, 1852–1920*. Florence: Idea Editions and Edizioni Alinari; Edinburgh: Scottish Arts Council, 1978.

MANUEL ALVAREZ BRAVO

Kismaric, Susan. *Manuel Alvarez Bravo*. New York: Museum of Modern Art, 1997.

Livingston, Jane. *M. Alvarez Bravo*. Boston: David R. Godine; Washington, D.C.: Corcoran Gallery of Art, 1978.

Revelaciones: The Art of Manuel Alvarez Bravo. Essay by Nissan Perez. San Diego: Museum of Photographic Arts, 1990.

THOMAS ANNAN

Annan, Thomas. *Photographs of the Old Closes and Streets of Glasgow, 1868–1877*. Introduction by Anita Ventura Mozeley. Repr., New York: Dover Publications, 1977.

Maddox, Amanda, and Sara Stevenson. *Thomas Annan: Photographer of Glasgow*. Los Angeles: J. Paul Getty Museum, 2017.

Stevenson, Sara. *Thomas Annan, 1829–1887*. Edinburgh: National Galleries of Scotland, 1990.

DIETER APPELT

Wolf, Sylvia. *Dieter Appelt*. Chicago: Art Institute of Chicago; Berlin: Ars Nicolai, 1994.

DIANE ARBUS

Arbus, Doon, and Marvin Israel, eds. *Diane Arbus*. Millerton, N.Y.: Aperture; Museum of Modern Art, 1972.

———. *Diane Arbus: Magazine Work*. Millerton, N.Y.: Aperture, 1984.

Bosworth, Patricia. *Diane Arbus: A Biography*. New York: Alfred A. Knopf, 1984.

Lubow, Arthur. *Diane Arbus: Portrait of a Photographer*. New York: Ecco, HarperCollins, 2017.

Rosenheim, Jeff L. *Diane Arbus: In the Beginning*. New York: Metropolitan Museum of Art, 2016.

EVE ARNOLD

di Giovanni, Janine. *Eve Arnold*. Munich: Prestel, 2015.

EUGÈNE ATGET

Nesbit, Molly, ed. *Atget's Seven Albums*. New Haven, Conn.: Yale University Press, 1992.

Szarkowski, John, and Maria Morris Hambourg. *The Work of Atget*. Vol. 1: *Old France*; vol. 2: *The Art of Old Paris*; vol. 3: *The Ancien Régime*; vol. 4: *Modern Times*. New York: Museum of Modern Art, 1981, 1982, 1984, 1985.

ANNA ATKINS

Schaaf, Larry J. *Sun Gardens: Cyanotypes by Anna Atkins*. Edited by Joshua Chuang. New York: New York Public Library, 2018.

———. *Sun Gardens: Victorian Photograms by Anna Atkins*. Millerton, N.Y.: Aperture, 1985.

ALICE AUSTEN

Novotny, Ann. *Alice's World: The Life and Photography of an American Original, 1866–1952*. Old Greenwich, Conn.: Chatham Press, 1976.

RICHARD AVEDON

Avedon, Richard. *In the American West, 1979–1984*. New York: Harry N. Abrams, 1985.

EDOUARD DENIS BALDUS

Daniel, Malcolm R. *The Photographs of Edouard Baldus*. New York: Metropolitan Museum of Art; Montreal: Canadian Centre for Architecture, 1994.

GEORGE N. BARNARD

Barnard, George N. *Photographic Views of Sherman's Campaign*. Preface by Beaumont Newhall. New York: Dover Publications, 1977.

Davis, Keith F., ed. *George N. Barnard: Photographer of Sherman's Campaign*. Kansas City, Mo.: Hallmark Cards, 1990.

HERBERT BAYER

Cohen, Arthur A. *Herbert Bayer: The Complete Work*. Cambridge, Mass.: MIT Press, 1988.

BERND AND HILLA BECHER

Becher, Berndt, Hilla Becher, and Thierry de Duve. *Berndt and Hilla Becher: Basic Forms*. New York: Te Neues, 1999.

Lange, Susanne. *Bernd and Hilla Becher*: Life and Work. Cambridge, Mass.: MIT Press, 2006.

E. J. BELLOCQ

Bellocq, E. J. *Storyville Portraits: Photographs from the New Orleans Red-Light District, circa 1912*. Edited by John Szarkowski. Preface by Lee Friedlander. New York: Museum of Modern Art, 1970.

KARL BLOSSFELDT

Blossfeldt, Karl. *Urformen der Kunst*. Tübingen, Germany: Ernst Wasmuth Verlag, 1928.

ERWIN BLUMENFELD

Teicher, Hendel, ed. *Blumenfeld: My One Hundred Best Photographs*. New York: Rizzoli, 1981.

MARGARET BOURKE-WHITE

Callahan, Sean, ed. *The Photographs of Margaret Bourke-White*. New York: Bonanza; Greenwich, Conn.: New York Graphic Society, 1972.

Goldberg, Vicki. *Margaret Bourke-White: A Biography*. New York: Harper and Row, 1986.

Silverman, Jonathan. *For the World to See: The Life of Margaret Bourke-White*. New York: Viking Press, Studio, 1983.

SAMUEL BOURNE

Ollman, Arthur. *Samuel Bourne: Images of India*. Carmel, Calif.: Friends of Photography, 1983.

MATHEW BRADY

Meredith, Roy. *Mathew Brady's Portrait of an Era*. New York and London: W. W. Norton, 1982.

BILL BRANDT

Bill Brandt Behind the Camera: Photographs, 1928–1983. Introduction by Mark Haworth-Booth. Essay by David Mellor. Millerton, N.Y.: Aperture, 1985.

Warburton, Nigel. *Bill Brandt: Selected Texts and Bibliography*. World Photographers Reference Series, vol. 5. Boston: G. K. Hall, 1993.

BRASSAÏ (GYULA HALÁSZ)

Brassaï. *Paris de nuit*. Paris: Arts et Métiers Graphiques, 1933.

———. *The Secret Paris of the 1930s*. New York: Random House, Pantheon Books, 1976.

Galassi, Peter. *Brassaï*. Barcelona: Fundación MAPFRE; San Francisco: San Francisco Museum of Modern Art, 2018.

Warehime, Marja. *Brassaï: Images of Culture and the Surrealist Observer*. Baton Rouge and London: Louisiana State University Press, 1996.

ADOLPH BRAUN

O'Brien, Maureen and Mary Bergstein, eds. *Image and Enterprise: The Photography of Adolphe Braun*. New York: Thames and Hudson, 2000.

FRANCIS BRUGUIÈRE

Enyeart, James. *Bruguière: His Photographs and His Life*. New York: Alfred A. Knopf, 1977.

WYNN BULLOCK

de Cock, Liliane, ed. *Wynn Bullock, Photography: A Way of Life*. Dobbs Ferry, N.Y.: Morgan and Morgan, 1973.

RUDOLPH BURCKHARDT

Burckhardt, Rudy, and Simon Pettet. *Talk Pictures: The Photographs of Rudy Burckhardt*. Cambridge, Mass.: Zoland Books, 1994.

Rudolph Burckhardt: An Afternoon in Astoria. Introduction by Sarah Hermanson Meister. New York: Museum of Modern Art, 2003.

CLAUDE CAHUN

Cahun, Claude. *Disavowels, or Cancelled Confessions*. Cambridge, Mass.: MIT Press, 2008.

Downe, Louise, ed. *Don't Kiss Me: The Art of Claude Cahun and Marcel Moore*. New York: Aperture, 2006.

HARRY CALLAHAN

Davis, Keith F. *Harry Callahan: New Color, 1978–1987*. Kansas City, Mo.: Hallmark Cards, 1988.

Davis, Keith F., ed. *Harry Callahan: Photographs*. Kansas City, Mo.: Hallmark Cards, 1981.

Salvesen, Britt. *Harry Callahan: The Photographer at Work*. New Haven, Conn.: Yale University Press, 2006.

JULIA MARGARET CAMERON

Cameron, Julia Margaret. *Victorian Photographs of Famous Men and Fair Women*. New York: Harcourt, Brace, 1926. Expanded and reprinted, with an introduction by Virginia Woolf and Roger Fry; preface and notes by Tristam Powell, London: Hogarth Press; Boston: David R. Godine, 1973.

Ford, Colin. *The Cameron Collection: An Album of Photographs by Julia Margaret Cameron Presented to Sir John Herschel*. New York: Van Nostrand Reinhold; London: National Portrait Gallery, 1975.

Weaver, Mike. *Julia Margaret Cameron, 1815–1879*. Boston: Little, Brown, New York Graphic Society, 1984.

CORNELL CAPA

Cornell Capa: Photographer. Boston: Little, Brown, Bulfinch Press, 1992.

ROBERT CAPA

Robert Capa. New York: Random House, Pantheon Books, 1989.

Whelan, Richard. *Robert Capa: A Biography*. New York: Alfred A. Knopf, 1985.

PAUL CAPONIGRO

Paul Caponigro: Masterworks from Forty Years. Carmel, Calif.: Photography West Graphics, 1993.

LEWIS CARROLL (CHARLES LUTWIDGE DODGSON)

Cohen, Morton N. *Lewis Carroll: A Biography*. New York: Alfred A. Knopf, 1995.

Gernsheim, Helmut. *Lewis Carroll, Photographer*. 1949. Rev. ed. New York: Dover Publications, 1979.

Nickel, Douglas R. *Dreaming in Pictures: The Photography of Lewis Carroll*. New Haven, Conn.: Yale University Press, 2002.

HENRI CARTIER-BRESSON

Cartier-Bresson, Henri. *The Decisive Moment*. New York: Simon and Schuster, 1952. Repr., with an essay by Clément Chéroux. Göttingen, Germany: Steidl, 2014.

———. *The Mind's Eye*. New York: Aperture, 1999.

Clair, Jean, and Philippe Arbaizar. *Henri Cartier-Bresson: The Man, the Image, and the World*. London: Thames and Hudson, 2003.

Henri Cartier-Bresson: Photographer. Boston: Little, Brown, 1992.

MARTÍN CHAMBI JIMÉNEZ

Martín Chambi: Photographs, 1920–1950. Washington, D.C.: Smithsonian Institution Press, 1993.

DÉSIRÉ CHARNAY

Davis, Keith F. *Désiré Charnay—Expeditionary Photographer*. Albuquerque: University of New Mexico Press, 1981.

CLEMENTINA, LADY HAWARDEN

Clementina, Viscountess Hawarden, Photographer. London: Victoria and Albert Museum, 1989.

Ovenden, Graham, ed. *Clementina, Lady Hawarden*. London: Academy Editions; New York: St. Martin's Press, 1974.

ALVIN LANGDON COBURN

Weaver, Mike. *Alvin Langdon Coburn: Symbolist Photographer*. New York: Aperture, 1986.

GREGORY CREWDSON

Crewdson, Gregory. *Beneath the Roses*. New York: Harry N. Abrams, 2008.

———. *Twilight*. New York: Harry N. Abrams, 2003.

IMOGEN CUNNINGHAM

Dater, Judy. *Imogen Cunningham: A Portrait*. Boston: New York Graphic Society, 1979.

Lorenz, Roland. *Imogen Cunningham: Ideas Without End: A Life and Photographs*. San Francisco: Chronicle Books, 1993.

Rule, Amy, ed. *Imogen Cunningham: Selected Texts and Bibliography*. World Photographers Reference Series, vol. 2. Boston: G. K. Hall, 1992.

EDWARD S. CURTIS

Davis, Barbara A. *Edward S. Curtis: The Life and Times of a Shadow Catcher*. San Francisco: Chronicle Books, 1985.

Lyman, Christopher M. *The Vanishing Race and Other Illusions: Photographs of Indians by Edward S. Curtis*. New York: Random House, Pantheon Books, 1982.

Native Nations: First Americans as Seen by Edward Curtis. Boston: Little, Brown, Bulfinch Press, 1993.

LOUIS JACQUES MANDÉ DAGUERRE

Daguerre, Louis Jacques Mandé. *An Historical and Descriptive Account of the Various Processes of the Daguerreotype and the Diorama*. 1839. Repr., with an introduction by Beaumont Newhall. New York: Winter House, 1971.

Gernsheim, Helmut, and Alison Gernsheim. *L.J.M. Daguerre: The History of the Diorama and the Daguerreotype*. 2d ed. New York: Dover Publications, 1968.

BRUCE DAVIDSON

Cotton, Charlotte. *Bruce Davidson: Survey*. New York: Aperture 2016.

Davidson, Bruce. *Central Park*. New York: Aperture, 1995.

Goldberg, Vicki. *Bruce Davidson*. Munich: Prestel, 2016.

F. HOLLAND DAY

F. Holland Day: Suffering the Ideal. Essay by James Crump. Santa Fe: Twin Palms Publishers, 1995.

Jussim, Estelle. *Slave to Beauty: The Eccentric Life and Controversial Career of F. Holland Day*. Boston: David R. Godine, 1981.

ROY DeCARAVA

Alinder, James, ed. *Roy DeCarava, Photographs*. Introduction by Sherry Turner DeCarava. Carmel, Calif.: Friends of Photography, 1981.

DeCarava, Roy, and Langston Hughes. *The Sweet Flypaper of Life*. New York: Simon and Schuster, 1955.

Galassi, Peter. *Roy DeCarava: A Retrospective*. New York: Museum of Modern Art, 1996.

RAJA LALA DEEN DAYAL

Worswick, Clark. *Princely India: Photographs by Raja Lala Deen Dayal, Court Photographer (1884–1910) to the Premier Prince of India*. New York: Alfred A. Knopf, Pennwick/Agrinde, 1980.

ROBERT DEMACHY

Robert Demachy—Pictorialist. Paris: Bookking International, 1990.

ADOLF DE MEYER

Ehrenkranz, Anne. *A Singular Elegance: The Photographs of Baron Adolph de Meyer*. San Francisco: Chronicle Books; New York: International Center of Photography, 1994.

PHILIP-LORCA diCORCIA

diCorcia, Philip-Lorca, and Peter Galassi. *Philip-Lorca diCorcia*. New York: Museum of Modern Art, 2003.

ROBERT DOISNEAU

Hamilton, Peter. *Robert Doisneau: A Photographer's Life*. New York: Abbeville Press, 1995.

Le Paris de Robert Doisneau et Max Pol Fouchet. Paris: Les Editeurs Français Réunis, n.d.

Robert Doisneau: Retrospective. Oxford, U.K.: Museum of Modern Art, 1992.

THOMAS EAKINS

Danly, Susan, and Cheryl Leibold. *Eakins and the Photograph: Works by Thomas Eakins and His Circle in the Collection of the Pennsylvania Academy of the Fine Arts*. Washington, D.C.: Smithsonian Institution Press; Philadelphia: Pennsylvania Academy of the Fine Arts, 1994.

Hendricks, Gordon. *The Photographs of Thomas Eakins*. New York: Grossman Publishers, 1972.

HAROLD EDGERTON

Bruce, Roger, ed. *Seeing the Unseen: Dr. Harold Edgerton and the Wonders of Strobe Alley*. Rochester, N.Y.: George Eastman House; Cambridge, Mass.: MIT Press, 1994.

WILLIAM EGGLESTON

Szarkowski, John. *William Eggleston's Guide*. New York: Museum of Modern Art, 2004.

ALFRED EISENSTAEDT

Eisenstaedt, Alfred. *Eisenstaedt on Eisenstaedt*. Introduction by Peter Adam. New York: Abbeville Press, 1985.

———. *Witness to Our Time*. Rev. ed., with a foreword by Henry R. Luce. New York: Viking Press, 1980.

O'Neil, Doris, ed. *Eisenstaedt Remembrances*. Boston: Little, Brown, Bulfinch Press, 1990.

PETER HENRY EMERSON

Newhall, Nancy. *P. H. Emerson: The Fight for Photography as a Fine Art*. Millerton, N.Y.: Aperture, 1975.

ELLIOTT ERWITT

Erwitt, Elliott. *Personal Best*. New York: Te Neues, 2006.

FREDERICK H. EVANS

Hammond, Anne, ed. *Frederick H. Evans: Selected Texts and Bibliography*. World Photographers Reference Series, vol. 1. Boston: G. K. Hall, 1992.

WALKER EVANS

Agee, James, and Walker Evans. *Let Us Now Praise Famous Men*. Boston: Houghton Mifflin Company; Cambridge, Mass.: Riverside Press, 1960.

Greenough, Sarah. *Walker Evans: Subways and Streets*. Washington, D.C.: National Gallery of Art, 1991.

Keller, Judith. *Walker Evans: The Getty Museum Collection*. Malibu, Calif.: J. Paul Getty Museum, 1995.

Mellow, James R. *Walker Evans*. New York: Basic Books, 1999.

Mora, Gilles. *Walker Evans: The Hungry Eye*. New York: Harry N. Abrams, 1993.

Walker Evans: American Photographs. New York: Museum of Modern Art, 1938.

Walker Evans: Photographs from the Farm Security Administration, 1935–1938. Introduction by Jerald C. Maddox. New York: Da Capo Press, 1975.

ROGER FENTON

Hannavy, John. *Roger Fenton of Crimble Hall*. Boston: David R. Godine, 1975.

Lloyd, Valerie. *Roger Fenton: Photographer of the 1850s*. London: South Bank Board, 1988.

ROBERT FRANK

Frank, Robert. *Les Américains*. Paris: Delpire, 1958. Published in English as *The Americans*. Introduction by Jack Kerouac. New York: Grove Press, 1959. Rev. eds. Millerton, N.Y.: Aperture, 1969, 1978.

Greenough, Sarah, and Philip Brookman. *Robert Frank*. Washington, D.C.: National Gallery of Art, 1994.

LATOYA RUBY FRAZIER

Frazier, LaToya Ruby. *The Notion of Family*. New York: Aperture, 2014.

LEE FRIEDLANDER

Friedlander, Lee. *Factory Valleys*. New York: Callaway Editions, 1982.

Galassi, Peter. *Lee Friedlander*. New York: Museum of Modern Art, 2005.

Letters from the People: Photographs by Lee Friedlander. New York: Museum of Modern Art, 1993.

FRANCIS FRITH

Frith, Francis. *Egypt and the Holy Land in Historic Photographs*. 1860s. Repr., New York: Dover Publications, 1980.

Jay, Bill. *Victorian Cameraman: Francis Frith's View of Rural England, 1850–1898*. Newton Abbot, U.K.: David and Charles, 1973.

ALEXANDER GARDNER

Gardner, Alexander. *Gardner's Photographic Sketchbook of the Civil War*. New York: Dover Publications, 1959.

Johnson, Brooks. *An Enduring Interest: The Photographs of Alexander Gardner*. Norfolk, Va.: Chrysler Museum, 1991.

ARNOLD GENTHE

Genthe, Arnold. *As I Remember*. New York: Reynal and Hitchcock, 1936. Repr., New York: Arno Press, 1979.

LUIGI GHIRRI

Ghirri, Luigi. *Kodachrome*. Paris: Contrejour, 1978. Repr. London, MACK, 2013.

It's Beautiful Here, Isn't It . . . : Photographs by Luigi Ghirri. Essay by Germano Celant. New York: Aperture, 2008.

Lingwood, James, ed. *Luigi Ghirri: The Map and the Territory*. Madrid: Museo Nacional Centro de Arte Reina Sofía, London: MACK Books, 2018.

LAURA GILPIN

Sandweiss, Martha A. *Laura Gilpin: An Enduring Grace*. Fort Worth: Amon Carter Museum, 1986.

DAVID GOLDBLATT

David Goldblatt Photographs. Rome: Contrasto Publishers, 2006.

NAN GOLDIN

Goldin, Nan. *The Ballad of Sexual Dependency*. New York: Aperture, 1986.

——. *The Devil's Playground*. London: Phaidon Press, 2003.

PHILIP JONES GRIFFITHS

Griffiths, Philip Jones. *Vietnam Inc.* New York: Collier Books; London: Collier-Macmillan, 1971.

ANDREAS GURSKY

Galassi, Peter. *Andreas Gursky*. New York: Museum of Modern Art, 2001.

JOHN GUTMANN

Kozloff, Max. *The Restless Decade: John Gutmann's Photographs of the Thirties*. New York: Harry N. Abrams, 1984.

JIMMY HARE

Gould, Lewis L., and Richard Greffe. *Photojournalist: The Career of Jimmy Hare*. Austin and London: University of Texas Press, 1977.

RAOUL HAUSMANN

Hausmann, Raoul. *Photographies, 1927–1957*. Paris: Editions Crétis, 1979.

JOHN HEARTFIELD

Pachnicke, Peter, and Klaus Honnef, eds. *John Heartfield*. New York: Harry N. Abrams, 1993.

Tucholsky, Kurt. *Deutschland, Deutschland über Alles*, 1929. Montages by John Heartfield. Amherst: University of Massachusetts Press, 1972.

FLORENCE HENRI

du Pont, Diana C. *Florence Henri: Artist-Photographer of the Avant-Garde*. San Francisco: San Francisco Museum of Modern Art, 1990.

DAVID OCTAVIUS HILL AND ROBERT ADAMSON

Ford, Colin, ed. *An Early Victorian Album: The Photographic Masterpieces (1843–47) of David Octavius Hill and Robert Adamson*. Introduction by Colin Ford; essay by Roy Strong. New York: Alfred A. Knopf, 1976.

Schwarz, Heinrich. *David Octavius Hill: Master of Photography*. London: George C. Harrap, 1932.

Stevenson, Sara. *Facing the Light: The Photography of Hill and Adamson*. Edinburgh: Scottish National Portrait Gallery, 2002.

——. *Hill and Adamson's The Fishermen and Women of the Firth of Forth*. Edinburgh: Trustees of the National Gallery of Scotland, 1991.

LEWIS W. HINE

Gutman, Judith Mara. *Lewis W. Hine and the American Social Conscience*. New York: Walker, 1967.

Kaplan, Daile. *Lewis Hine in Europe: The Lost Photographs*. New York: Abbeville Press, 1988.

Kaplan, Daile, ed. *Photo Story: Selected Letters and Photographs of Lewis Hine*. Washington, D.C.: Smithsonian Institution Press, 1992.

Rosenblum, Walter, Naomi Rosenblum, and Alan Trachtenberg. *America and Lewis Hine: Photographs, 1904–1940*. Millerton, N.Y.: Aperture, 1977.

PETER HUJAR

Smith, Joel, et al. *Peter Hujar: Speed of Life*. New York: Aperture; Barcelona: Fundación MAPFRE, 2017.

WILLIAM HENRY JACKSON

Hales, Peter B. *William Henry Jackson and the Transformation of the American Landscape*. Philadelphia: Temple University Press, 1988.

Jackson, Clarence S. *Picture Maker of the Old West, William Henry Jackson*. New York: Charles Scribner's Sons, 1947.

FRANCES BENJAMIN JOHNSTON

Daniel, Pete, and Raymond Smock. *A Talent for Detail: The Photographs of Miss Frances Benjamin Johnston, 1889–1910*. New York: Harmony Books, 1974.

Johnston, Frances Benjamin. *The Hampton Album*. New York: Museum of Modern Art, 1966.

GERTRUDE KÄSEBIER

Michaels, Barbara. *Gertrude Käsebier: The Photographer and Her Photographs*. New York: Harry N. Abrams, 1992.

ANDRÉ KERTÉSZ

Ducrot, Nicholas, ed. *André Kertész: Sixty Years of Photography, 1912–1972*. New York: Viking Press, Grossman Publishers, 1972.

Kertész, André. *J'aime Paris*. New York: Viking Press, Grossman Publishers, 1974.

——. *Kertész on Kertész*. Introduction by Peter Adam. New York: Abbeville Press, 1985.

Phillips, Sandra S., David Travis, and Weston Naef. *André Kertész: Of Paris and New York*. Chicago: Art Institute of Chicago, 1985.

WILLIAM KLEIN

Klein, William. *Close-up: Photographs and Texts by William Klein*. London: Thames and Hudson, 1990.

William Klein: New York, 1954–1955. 1956. Repr., Manchester, U.K.: Dewi Lewis Publishing, 1995.

JOSEF KOUDELKA

Koudelka, Josef. *Exiles*. London: Thames and Hudson; New York: Aperture, 1988.

——. *Gypsies*. Millerton, N.Y.: Aperture, 1975.

DOROTHEA LANGE

Dorothea Lange: American Photographs. San Francisco: San Francisco Museum of Modern Art; Chronicle Books, 1994.

Dorothea Lange: Photographs of a Lifetime. Millerton, N.Y.: Aperture, 1982.

Lange, Dorothea, and Paul S. Taylor. *An American Exodus*. Oakland, Calif.: Oakland Museum; New Haven, Conn.: Yale University Press, 1969.

Meltzer, Milton. *Dorothea Lange: A Photographer's Life*. New York: Farrar, Straus and Giroux, 1978.

Partridge, Elizabeth, ed. *Dorothea Lange: A Visual Life*. Washington, D.C.: Smithsonian Institution Press, 1994.

JACQUES HENRI LARTIGUE

Lartigue, Jacques Henri. *Boyhood Photos of J. H. Lartigue: The Family Album of a Gilded Age*. Lausanne, Switzerland: Ami Guichard, 1966.

——. *Instants de ma vie*. Paris: Editions du Chêne, 1970.

CLARENCE JOHN LAUGHLIN

Davis, Keith F., ed. *Clarence John Laughlin: Visionary Photographer*. Albuquerque: University of New Mexico Press, 1990.

Laughlin, Clarence John. *Ghosts along the Mississippi*. New York: Bonanza Books, 1961.

DEANA LAWSON

Deana Lawson: An Aperture Monograph. Essay by Zadie Smith. New York: Aperture, 2018.

RUSSELL LEE

Hurley, F. Jack. *Russell Lee, Photographer*. Dobbs Ferry, N.Y.: Morgan and Morgan, 1978.

GUSTAVE LE GRAY

Janis, Eugenia Parry. *The Photography of Gustave Le Gray*. Chicago: Art Institute of Chicago; University of Chicago Press, 1987.

ANNIE LEIBOVITZ

Leibovitz, Annie. *A Photographer's Life: 1990–2005*. New York: Random House, 2006.

HELMAR LERSKI

Lerski, Helmar. *Kopfe des Alltags*. Berlin: Hermann Reckendorf Verlag, 1931.

HELEN LEVITT

Levitt, Helen. *A Way of Seeing*. 3d ed., with additional photographs. Durham, N.C.: Duke University Press, 1989.

Phillips, Sandra S., and Maria Morris Hambourg. *Helen Levitt*. San Francisco: San Francisco Museum of Modern Art, 1991.

DANNY LYON

Danny Lyon: Photo-Film. Tucson, Ariz.: Center for Creative Photography, University of Arizona; Essen, Germany: Museum Folkwang, 1992.

Lyon, Danny. *The Bikeriders*. 1967. Repr., New York: Aperture, 2014.

——. *Conversations with the Dead*. New York: Rinehart and Winston, 1971.

——. *Pictures from the New World*. Millerton, N.Y.: Aperture, 1981.

DORA MAAR

Maddox, Amanda, Dawn Ades, and Karolina Ziebinska-Lewandowska, eds. *Dora Maar*. Los Angeles: J. Paul Getty Museum, 2019.

PETER MAGUBANE

Magubane, Peter. *Magubane's South Africa*. New York: Alfred A. Knopf, 1978.

FELIX H. MAN

Man with a Camera: Photographs from Seven Decades. New York: Schocken Books, 1984.

SALLY MANN

Greenough, Sarah. *Sally Mann: One Thousand Crossings*. New York: Harry N. Abrams, 2018.

Mann, Sally. *Hold Still: A Memoir with Photographs*. New York: Little, Brown, 2015.

Sally Mann: Immediate Family. New York: Aperture, 1992.

MAN RAY (EMMANUEL RADNITZKY)

Foresta, Merry A., et al. *Perpetual Motif: The Art of Man Ray*. New York: Abbeville Press, 1988.

Man Ray. *Self-Portrait*. Boston: Little, Brown, 1963.

ROBERT MAPPLETHORPE

Martineau, Paul, Britt Salvesen, et al. *Robert Mapplethorpe: The Photographs*. Los Angeles: J. Paul Getty Museum, 2016.

Smith, Patti. *Just Kids*. New York: Ecco, 2010.

ETIENNE-JULES MAREY

Braun, Marta. *Picturing Time: The Work of Etienne-Jules Marey (1830–1904)*. Chicago: University of Chicago Press, 1992.

MARY ELLEN MARK

Fulton, Marianne. *Mary Ellen Mark: 25 Years*. Boston: Little, Brown, Bulfinch Press, 1991.

Mary Ellen Mark: The Book of Everything. Göttingen, Germany: Steidl, 2019.

PAUL MARTIN

Haworth-Booth, Mark. *A Yarmouth Holiday: Photographs by Paul Martin*. London: Dirk Nishen Publishing, 1988.

CHARLES MARVILLE

Charles Marville: Photographe de Paris de 1851 à 1879. Paris: La Bibliothèque de la Ville de Paris, 1981.

Kennel, Sarah. *Charles Marville: Photographer of Paris*. Chicago: University of Chicago Press; Washington, D.C.: National Gallery of Art, 2013.

DON McCULLIN

McCullin, Don. *Open Skies*. New York: Harmony Books, 1989.

McCullin, Don, with Lewis Chester. *Unreasonable Behaviour: An Autobiography*. London: Vintage Books, 2002.

RALPH EUGENE MEATYARD

Tannenbaum, Barbara, ed. *Ralph Eugene Meatyard: An American Visionary*. Akron, Ohio: Akron Art Museum; New York: Rizzoli, 1991.

SUSAN MEISELAS

Meiselas, Susan. *Nicaragua, June 1978–July 1979*. New York: Pantheon, 1981. Rev. ed., New York: Aperture, 2008.

PEDRO MEYER

Meyer, Pedro. *Truths and Fictions: A Journey from Documentary to Digital Photography*. New York: Aperture, 1995.

JOEL MEYEROWITZ

Ackley, Clifford S. *Cape Light: Color Photographs by Joel Meyerowitz*. Boston: Museum of Fine Arts, 1978.

Meyerowitz, Joel. *St. Louis and the Arch*. Preface by James N. Wood. Boston: New York Graphic Society; St. Louis: St. Louis Art Museum, 1980.

DUANE MICHALS

The Portraits of Duane Michals, 1958–1988. Pasadena, Calif.: Twelvetrees Press, 1988.

LEE MILLER

Livingston, Jane. *Lee Miller: Photographer*. London and New York: Thames and Hudson, 1989.

Miller, Lee. *Lee Miller's War*. Edited by Antony Penrose. Boston: Little, Brown, Bulfinch Press, 1992.

RICHARD MISRACH

Misrach, Richard. *Desert Cantos*. Albuquerque: University of New Mexico Press, 1987.

——. *Violent Legacies: Three Cantos*. New York: Aperture, 1994.

LISETTE MODEL

Lisette Model. Millerton, N.Y.: Aperture, 1979.

Thomas, Ann. *Lisette Model*. Ottawa: National Gallery of Canada; Chicago: University of Chicago Press, 1990.

TINA MODOTTI

Constantine, Mildred. *Tina Modotti: A Fragile Life*. New York: Rizzoli, 1983. Repr., San Francisco: Chronicle Books, 1993.

Hooks, Margaret. *Tina Modotti: Photographer and Revolutionary*. New York: HarperCollins, Pandora, 1993.

LÁSZLÓ MOHOLY-NAGY

Haus, Andreas. *Moholy-Nagy: Photographs and Photograms*. New York: Random House, Pantheon Books, 1980.

Moholy-Nagy, László. *Malerei Photographie Film, Bauhausbook 8*. Munich: Albert Langen Verlag, 1926; rev. ed., 1927. English ed., *Painting, Photography, Film*, Cambridge, Mass.: MIT Press, 1969.

——. *Vision in Motion*. Chicago: Paul Theobold, 1947.

BARBARA MORGAN

Barbara Morgan: Photomontage. Dobbs Ferry, N.Y.: Morgan and Morgan, 1980.

Morgan, Barbara. *Martha Graham: Sixteen Dances in Photographs*. New York: Duell, Sloan and Pearce, 1941. Rev. ed. Dobbs Ferry, N.Y.: Morgan and Morgan, 1980.

DAIDŌ MORIYAMA

Moriyama, Daidō. *Shashin yo sayōnara*. Tokyo: Shashin hyoronsha, 1972.

WRIGHT MORRIS

Morris, Wright. *Wright Morris: Origin of a Species*. San Francisco: San Francisco Museum of Modern Art, 1992.

ZANELE MUHOLI

Zanele Muholi: Somnyama Ngonyama, Hail the Dark Lioness. New York: Aperture, 2018.

MARTIN MUNKACSI

Morgan, Susan. *Martin Munkacsi*. New York: Aperture, 1992.

Gundlach, F. C., ed. *Martin Munkacsi*. Hamburg: Haus der Photographie, Deichtorhallen Hamburg; Göttingen, Germany: Steidl, 2005.

EADWEARD MUYBRIDGE

Haas, Robert Bartlett. *Muybridge: Man in Motion*. Berkeley, Los Angeles, London: University of California Press, 1976.

Hendricks, Gordon. *Eadweard Muybridge: The Father of the Motion Picture*. New York: Viking Press, Grossman Publishers, 1975.

Muybridge's Complete Human and Animal Locomotion, 3 vols. Introduction by Anita Ventura Mozley. New York: Dover Publications, 1979.

Solnit, Rebecca. *River of Shadows: Eadweard Muybridge and the Technological Wild West*. New York: Penguin Books, 2004.

JAMES NACHTWEY

Nachtwey, James. *Inferno*. London: Phaidon, 1999.

NADAR (GASPARD FÉLIX TOURNACHON)

Hambourg, Maria Morris, Françoise Heilbrun, and Philippe Néagu. *Nadar*. New York: Metropolitan Museum of Art, 1995.

Nadar. *Quand j'étais photographe*. Preface by Léon Daudet. 1900. Repr., New York: Arno Press, 1979.

Prinet, Jean, and Antoinette Dilasser. *Nadar*. Paris: Armand Colin, 1966.

NAYA (COMPANY)

Zannier, Italo. *Venice: The Naya Collection*. Venice: O. Böhm, 1981.

CHARLES NÈGRE

Borcorman, James. *Charles Nègre, 1820–1880*. Ottawa: National Gallery of Canada, 1976.

ARNOLD NEWMAN

Fern, Alan, and Arnold Newman. *Arnold Newman's Americans*. Boston: Little, Brown, Bulfinch Press, 1992.

WILLIAM NOTMAN

Harper, J. R., and S. Triggs. *William Notman: Portrait of a Period*. Montreal: McGill University Press, 1975.

SOLOMON NUNES CARVALHO

Solomon Nunes Carvalho: Painter, Photographer and Prophet in 19th-Century America. Baltimore: Jewish Historical Society of Maryland, 1989.

TIMOTHY O'SULLIVAN

Dingus, Rick. *The Photographic Artifacts of Timothy O'Sullivan*. Albuquerque: University of New Mexico Press, 1982.

Snyder, Joel. *American Frontiers: The Photographs of Timothy H. O'Sullivan, 1867–1874*. Millerton, N.Y.: Aperture, 1981.

PAUL OUTERBRIDGE

Dines, Elaine, ed. *Paul Outerbridge: A Singular Aesthetic; Photographs and Drawings, 1921–1941, A Catalogue Raisonné*. Santa Barbara, Calif.: Arabesque, 1981.

TREVOR PAGLEN

Bryan-Wilson, Julia, et al. *Trevor Paglen*. New York, London: Phaidon Press, 2018.

Paglen, Trevor. *The Last Pictures*. Oakland: University of California Press, 2012.

GORDON PARKS

Parks, Gordon. *Voices in the Mirror: An Autobiography*. New York: Doubleday, Nan A. Talese, 1990.

IRVING PENN

Foresta, Merry A., and William F. Stapp. *Irving Penn: Master Images—The Collections of the National Museum of American Art and the National Portrait Gallery*. Washington, D.C.: Smithsonian Institution Press, 1990.

Hambourg, Maria Morris, and Jeff L. Rosenheim. *Irving Penn: Centennial*. New York: Metropolitan Museum of Art, 2017.

JOHN PFAHL

Pfahl, John. *Arcadia Revisited: Niagara River and Falls from Lake Erie to Lake Ontario*. Albuquerque: University of New Mexico Press, 1991.

ROBERT POLIDORI

After the Flood: Photographs by Robert Polidori. Introduction by Jeff L. Rosenheim. Göttingen, Germany: Steidl, 2006.

ELIOT PORTER

Intimate Landscapes: Photographs by Eliot Porter. Essay by Weston J. Naef. New York: Metropolitan Museum of Art; E. P. Dutton, 1979.

GIUSEPPE PRIMOLI

Vitali, Lamberto. *Un fotografo fin-de-siècle: Il conte Primoli*. 2d ed. Turin, Italy: Einaudi, 1981.

SERGEI MIKHAILOVICH PROKUDIN-GORSKII

Allshouse, Robert H., ed. *Photographs for the Tsar: The Pioneering Color Photography of Sergei Mikhailovich Prokudin-Gorskii*. New York: Dial Press, 1980.

OSCAR GUSTAV REJLANDER

Pauli, Lori, et al. *Oscar G. Rejlander: Artist Photographer*. Ottawa: National Gallery of Canada; New Haven, Conn.: Yale University Press, 2018.

Spencer, Stephanie. *O. G. Rejlander: Photography as Art*. Ann Arbor, Mich.: UMI Press, 1985.

ALBERT RENGER-PATZSCH

Albert Renger-Patzsch: 100 Photographs, 1928. Cologne, Germany, and Boston: Schürmann and Kicken; Paris: Créatis, 1979.

Renger-Patzsch, Albert. *Die Welt ist schön: Einhundert Photographische aufnahme*. Published in English as *The World Is Beautiful*. Munich: Kurt Wolff Verlag, 1928.

EUGENE RICHARDS

Richards, Eugene. *Americans We*. New York: Aperture, 1994.

———. *Cocaine True, Cocaine Blue*. New York: Aperture, 1994.

JACOB A. RIIS

Alland, Alexander, Sr. *Jacob A. Riis: Photographer and Citizen*. Millerton, N.Y.: Aperture, 1974.

Riis, Jacob A. *How the Other Half Lives: Studies Among the Tenements of New York*. New York: Charles Scribner's Sons, 1890. Repr., with added photographs, New York: Dover Publications, 1971.

HENRY PEACH ROBINSON

Harker, Margaret F. *Henry Peach Robinson: Master of Photographic Art, 1830–1901*. Oxford, U.K.: Basil Blackwell, 1988.

Robinson, Henry Peach. *Pictorial Effect in Photography*. Introduction by Robert Sobieszek. Repr., Pawlet, Vt.: Helios, 1972.

ALEXANDER RODCHENKO

Elliot, David, ed. *Alexander Rodchenko, 1891–1956*. Oxford, U.K.: Museum of Modern Art, 1979.

Khan-Magomedov, S. O. *Rodchenko: The Complete Work*. Cambridge, Mass.: MIT Press, 1986.

MILTON ROGOVIN

Keller, Judith. *Milton Rogovin: The Mining Photographs*. Los Angeles: Getty Trust Publications, 2005.

WALTER ROSENBLUM

Walter Rosenblum. Essays by Shelley Rice and Naomi Rosenblum. Dresden, Germany: Verlag der Kunst, 1990.

ARTHUR ROTHSTEIN

Rothstein, Arthur. *The Depression Years as Photographed by Arthur Rothstein*. New York: Dover Publications, 1978.

THOMAS RUFF

Ruff, Thomas, and Carolyn Christov-Bakargiev. *Thomas Ruff*. Milan: Skira, 2009.

Thomas Ruff: Transforming Photography. Interview with Okwui Enwezor. New York: David Zwirner Books, 2019.

SEBASTIÃO SALGADO

Salgado, Sebastião. *Workers: An Archaeology of the Industrial Age*. New York: Aperture, 1993.

Salgado, Sebastião, and Lélia Wanick Salgado. *Genesis*. Cologne: Taschen, 2013.

ERICH SALOMON

Salomon, Erich. *Porträt einer Epoche*. Frankfurt and Berlin: Verlag Ullstein, 1963. Published in English as *Portrait of an Age*. New York: Macmillan Company, 1967.

AUGUST SANDER

August Sander: Photographs of an Epoch, 1904–1959. Preface by Beaumont Newhall; historical commentary by Robert Kramer. Millerton, N.Y.: Aperture, 1980.

Sander, August. *Antlitz der Zeit*. Munich: Kurt Wolff/Transmare Verlag, 1929. English trans., *Face of Our Time*. London: Schirmer Art Books, 2011.

———. *Men Without Masks: Faces of Germany, 1910–1938*. Greenwich, Conn.: New York Graphic Society, 1971.

Sander, Gunther, ed. *August Sander: Citizens of the 20th Century. Portrait Photographs, 1892–1952*. Cambridge, Mass.: MIT Press, 1986.

BEN SHAHN

Pratt, Davis, ed. *The Photographic Eye of Ben Shahn*. Cambridge, Mass.: Harvard University Press, 1975.

CHARLES SHEELER

Stebbins, Theodore E., Jr., and Norman Keyes, Jr. *Charles Sheeler: The Photographs*. Boston: Little, Brown, 1987.

CINDY SHERMAN

Burton, Johanna, ed. *Cindy Sherman*. Cambridge, Mass.: MIT Press, 2006.

Krauss, Rosalind, and Norman Bryson. *Cindy Sherman, 1975–1993*. New York: Rizzoli, 1993.

STEPHEN SHORE

Shore, Stephen. *Uncommon Places*. Essay by Lynne Tillman. New York: Aperture, 2005.

CAMILLE SILVY

Haworth-Booth, Mark. *Camille Silvy: River Scene, France*. Getty Museum Studies on Art. Malibu, Calif.: J. Paul Getty Museum, 1992.

TARYN SIMON

Simon, Taryn. *A Living Man Declared Dead and Other Chapters, I–XVIII*. London: MACK Books, 2011.

AARON SISKIND

Aaron Siskind 100. New York: Robert Mann; Powerhouse Books, 2003.

Chiarenza, Carl. *Aaron Siskind: Pleasures and Terrors*. Boston: New York Graphic Society, 1982.

Siskind, Aaron. *Road Trip: Photographs 1980–1988*. Albuquerque: University of New Mexico Press; Carmel, Calif.: Friends of Photography, 1993.

W. EUGENE SMITH

Hughes, Jim. *W. Eugene Smith: Shadow and Substance; The Life and Work of an American Photographer*. New York: McGraw-Hill, 1989.

Johnson, William S., ed. *W. Eugene Smith: Master of the Photographic Essay*. Millerton, N.Y.: Aperture, 1981.

Smith, W. Eugene, and Aileen M. Smith. *Minamata*. New York: Holt, Rinehart and Winston, 1975.

Willumson, Glenn G. *W. Eugene Smith and the Photographic Essay*. New York: Cambridge University Press, 1992.

FREDERICK SOMMER

Weiss, John, ed. *Venus, Jupiter and Mars: Frederick Sommer*. Wilmington: Delaware Art Museum, 1980.

ALEC SOTH

Soth, Alec. *I Know How Furiously Your Heart Is Beating*. London: MACK Books, 2019.

———. *Sleeping by the Mississippi*. Essays by Anne Wilkes Tucker and Patricia Hampl. Göttingen, Germany: Steidl, 2004.

ALBERT SANDS SOUTHWORTH AND JOSIAH JOHNSON HAWES

Sobieszek, Robert, and Odette M. Appel. *The Spirit of Fact: The Daguerreotypes of Southworth and Hawes*. Boston: David R. Godine; Rochester, N.Y.: International Museum of Photography at George Eastman House, 1975.

EDWARD STEICHEN

Johnston, Patricia A. *Real Fantasies: Edward Steichen's Advertising Photography*. Berkeley: University of California Press, 2000.

Longwell, Dennis. *Steichen: The Master Prints, 1895–1914*. New York: Museum of Modern Art; Boston: New York Graphic Society, 1978.

Steichen, Edward. *A Life in Photography*. Garden City, N.Y.: Doubleday, 1963.

RALPH STEINER

Steiner, Ralph. *In Pursuit of Clouds: Images and Metaphors*. Albuquerque: University of New Mexico Press, 1985.

JOEL STERNFELD

Sternfeld, Joel. *American Prospects*. New York: DAP; Göttingen, Germany: Steidl, 2012.

———. *Sweet Earth: Utopias in America*. Göttingen, Germany: Steidl, 2006.

ALFRED STIEGLITZ

Bochner, Jay. *An American Lens: Scenes from Alfred Stieglitz's New York Secession*. Cambridge, Mass.: MIT Press, 2005.

Greenough, Sarah, and Juan Hamilton. *Alfred Stieglitz, Photographs and Writings*. Washington, D.C.: National Gallery of Art; New York: Callaway Editions, 1983.

Homer, William Innes. *Alfred Stieglitz and the American Avant-Garde*. Boston: New York Graphic Society, 1977.

———. *Alfred Stieglitz and the Photo-Secession*. Boston: Little, Brown, New York Graphic Society, 1983.

Lowe, Sue Davidson. *Stieglitz: A Memoir/Biography*. New York: Farrar, Straus and Giroux, 1983.

Norman, Dorothy. *Alfred Stieglitz: An American Seer*. Millerton, N.Y.: Aperture; New York: Random House, 1973.

Petersen, Christian A. *Alfred Stieglitz's "Camera Notes."* New York: W. W. Norton, 1993.

Waldo, Frank, et al. *America and Alfred Stieglitz: A Collective Portrait*. 1934. Rev. ed. Millerton, N.Y.: Aperture, 1979.

Whelan, Richard. *Alfred Stieglitz: A Biography*. Boston: Little, Brown, 1995.

BENJAMIN STONE

Jay, Bill. *Customs and Faces: Photographs by Sir Benjamin Stone, 1838–1914*. London: Academy Editions; New York: St. Martin's Press, 1972.

PAUL STRAND

Paul Strand: A Retrospective Monograph, the Years 1915–1968. 2 vols. Millerton, N.Y.: Aperture, 1971.

Paul Strand: The World on My Doorstep: The Years 1950–1976. New York: Aperture, 1994.

Stange, Maren, ed. *Paul Strand: Essays on His Life and Work*. New York: Aperture, 1990.

Strand, Paul, and Nancy Newhall. *Time in New England*. New York: Oxford University Press, 1950. Rev. ed. Millerton, N.Y.: Aperture, 1982.

Strand, Paul, and Claude Roy. *La France de profile*. Lausanne, Switzerland: Editions Clairefontaine, 1952.

KARL STRUSS

McCandless, Barbara, Bonnie Yochelson, and Richard Koszarski. *New York to Hollywood: The Photography of Karl Struss*. Fort Worth: Amon Carter Museum, 1995.

THOMAS STRUTH

Eklund, Douglas, et al. *Thomas Struth*. Dallas: Dallas Art Museum, 2002.

JOSEF SUDEK

Fárová, Anna. *Josef Sudek, Poet of Prague: A Photographer's Life*. New York: Aperture, 1990.

Kirschner, Zdenek. *Sudek*. New York: Takarajima Books in association with Museum of Decorative Arts, Prague, 1993.

HIROSHI SUGIMOTO

Hiroshi Sugimoto: Black Box. New York: Aperture; Barcelona: Fundación MAPFRE, 2016.

FRANK SUTCLIFFE

Hiley, Michael. *Frank Sutcliffe*. Boston: David R. Godine, 1974.

WILLIAM HENRY FOX TALBOT

Arnold, H.J.P. *William Henry Fox Talbot: Pioneer of Photography and Man of Science*. London: Hutchinson Benham, 1977.

Buckland, Gail. *Fox Talbot and the Invention of Photography*. Boston: David R. Godine, 1980.

Talbot, William Henry Fox. *The Pencil of Nature*. Facsimile ed. New York: Da Capo Press, 1961.

Weaver, Mike. *Henry Fox Talbot: Selected Texts and Bibliography. World Photographers Reference Series*, vol. 3. Boston: G. K. Hall, 1993.

EDMUND TESKE

Cox, Julian. *Spirit Into Matter: The Photographs of Edmund Teske*. Los Angeles: Getty Trust Publications, 2004.

JOHN THOMSON

Thompson [sic], John, and Adolphe Smith. *Street Life in London*. Facsimile ed. Bronx, N.Y.: Bernard Blom, 1969.

White, Stephen. *John Thomson: Life and Photographs*. Albuquerque: University of New Mexico Press, 1989.

HEINRICH TÖNNIES

Alland, Alexander, Sr. *Heinrich Tönnies: Carte-de-Visite Photographer Extraordinaire*. New York: Camera Graphic Press, 1978.

ARTHUR TRESS

Weiermair, Peter, ed. *Arthur Tress*. Zurich: Edition Stemmle, 1995.

BENJAMIN BRECKNELL TURNER

Barnes, Martin. *Benjamin Brecknell Turner: Rural England Through a Victorian Lens*. New York: Harry N. Abrams, 2002.

JERRY N. UELSMANN

Photo Synthesis: Photographs by Jerry Uelsmann. Gainesville: University of Florida Press, 1992.

Uelsmann, Jerry N. *Silver Meditations*. Dobbs Ferry, N.Y.: Morgan and Morgan, 1975.

DORIS ULMANN

The Darkness and the Light: Photographs by Doris Ulmann. Millerton, N.Y.: Aperture, 1974.

Jacobs, Philip Walker. *The Life and Photography of Doris Ulmann*. Lexington: University Press of Kentucky, 2001.

Williams, Jonathan, et al. *The Appalachian Photographs of Doris Ulmann*. Penland, N.C., Jargon Society. 1971.

JAMES VAN DER ZEE

James Van Der Zee. Dobbs Ferry, N.Y.: Morgan and Morgan, 1973.

Willis-Braithwaite, Deborah. *Van Der Zee: Photographer, 1886–1983*. New York: Harry N. Abrams; Washington, D.C.: National Portrait Gallery, Smithsonian Institution, 1993.

ROMAN VISHNIAC

To Give Them Light: The Legacy of Roman Vishniac. New York: Simon and Schuster, 1993.

ADAM CLARK VROMAN

Webb, William, and Robert A. Weinstein. *Dwellers at the Source: Southwestern Indian Photographs by A. C. Vroman, 1895–1904*. New York: Viking Press, Grossman Publishers, 1973.

CARLETON E. WATKINS

Carleton E. Watkins, Photographs, 1861–1874. San Francisco: Bedford Arts Publishers, 1989.

Palmquist, Peter E. *Carleton E. Watkins: Photographer of the American West*. Albuquerque: University of New Mexico Press, 1983.

Rule, Amy, ed. *Carleton Watkins: Selected Texts and Bibliography*. Oxford, U.K.: Clio Press, 1993.

WEEGEE (ARTHUR FELLIG)

Stettner, Louis, ed. *Weegee*. New York: Alfred A. Knopf, 1977.

Weegee. *Naked City*. New York: Essential Books, 1946.

Weegee's New York: Photographs, 1935–1960. Munich: Schirmer Art Books, 1982, 1996.

WILLIAM WEGMAN

Man's Best Friend: Photographs and Drawings by William Wegman. New York: Harry N. Abrams, 1982.

BRETT WESTON

Brett Weston, Photographs from Five Decades. Millerton, N.Y.: Aperture, 1980.

EDWARD WESTON

Conger, Amy. *Edward Weston: Photographs*. Tucson: Center for Creative Photography, University of Arizona, 1992.

Newhall, Nancy, ed. *Edward Weston: The Flame of Recognition. His Photographs Accompanied by Excerpts from His Daybooks and the Letters*. 1975. Repr., New York: Aperture, 1993.

Stebbins, Theodore E. *Weston's Westons: Portraits and Nudes*. Boston: Museum of Fine Arts, 1989.

Weston, Edward. *My Camera at Point Lobos*. Yosemite National Park, Calif.: Virginia Adams; Boston: Houghton Mifflin Co., 1950.

Wilson, Charis, and Edward Weston. *California and the West*. 1940. Repr., Millerton, N.Y.: Aperture, 1978.

CLARENCE H. WHITE

Homer, William Innes. *Symbolism of Light: The Photographs of Clarence H. White*. Wilmington: Delaware Art Museum, 1977.

McCauley, Anne. *Clarence H. White and His World: The Art and Craft of Photography, 1895–1925*. Princeton, N.J.: Princeton University Art Museum, 2017.

MINOR WHITE

Bunnell, Peter. *Minor White: The Eye That Shapes*. Boston: Little, Brown, Bulfinch Press; Princeton, N.J.: Princeton University Art Museum, 1989.

Martineau, Paul. *Minor White: Manifestations of the Spirit*. Los Angeles: Getty Publications, 2014.

White, Minor. *Mirrors, Messages, Manifestations*. Millerton, N.Y.: Aperture, 1969.

GARRY WINOGRAND

Rubinfien, Leo, Sarah Greenough, et al. *Garry Winogrand*. New Haven, Conn.: Yale University Press, 2013.

Szarkowski, John. *Winogrand: Figments from the Real World*. New York: Museum of Modern Art, 1988.

JOEL-PETER WITKIN

Witkin, Joel-Peter. *Gods of Earth and Heaven*. Altadena, Calif.: Twelvetrees Press, 1989.

MARION POST WOLCOTT

Hendrickson, Paul. *Looking for the Light: The Hidden Life and Art of Marion Post Wolcott*. New York: Alfred A. Knopf, 1992.

Index